DÜRER'S ANIMALS

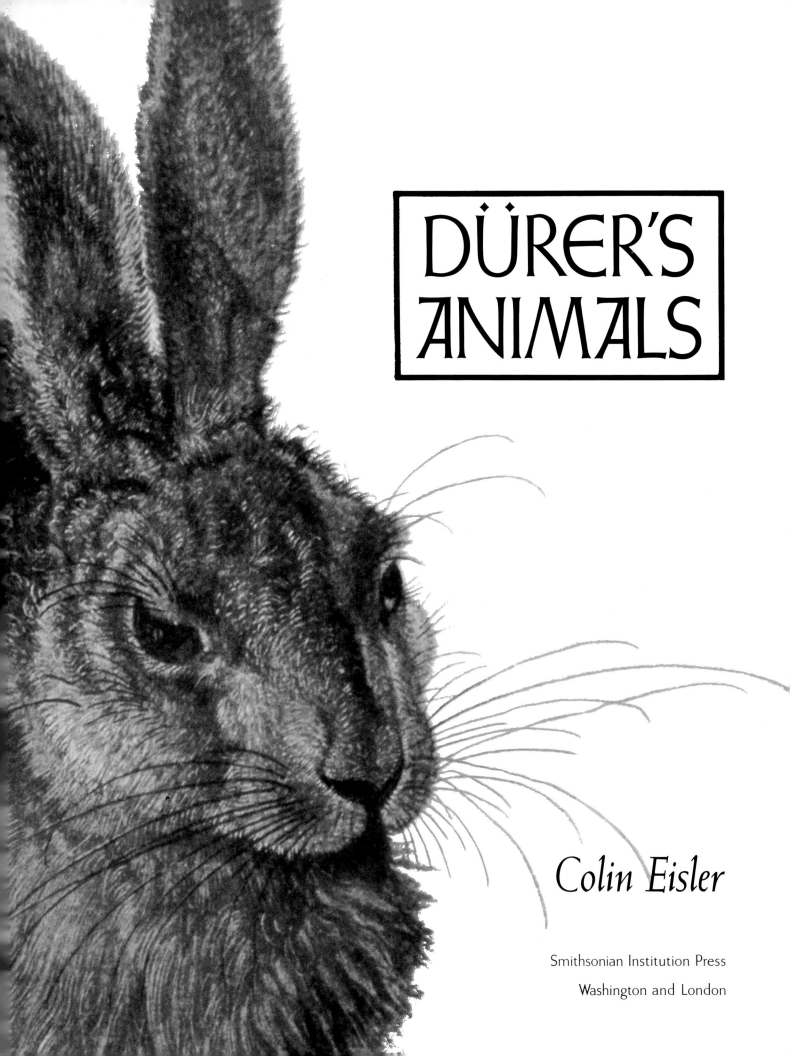

DÜRER'S ANIMALS

Colin Eisler

Smithsonian Institution Press
Washington and London

Copyright © 1991 by Colin Eisler
All rights reserved

Library of Congress Cataloging-in-Publication Data
Eisler, Colin.
Dürer's animals / Colin Eisler.
p. cm.
Includes bibliographical references and index.
ISBN 0-87474-408-3
1. Dürer, Albrecht, 1471–1528—Criticism and interpretation.
2. Animals in art. I. Title.
N6888.D8E57 1991
760'.092—dc20 90-21006 CIP

British Library Cataloging-in-Publication Data available

98 97 96 95 94 93 92 91 5 4 3 2 1

Manufactured in the United States of America
Color plates printed in Hong Kong by South China Printing Company.

⊚The paper used in this publication meets the minimum requirements of the American National Standard for Permanence of Paper for Printed Library Materials Z39.48–1984.

For permission to reproduce illustrations appearing in this book, please correspond directly with the owners of the works, as given in the list of illustrations. The Smithsonian Institution Press does not retain reproduction rights for these illustrations or maintain a file of addresses for photo sources

Sponsoring editor Amy Pastan contributed materially to the development of this volume at every stage. Editorial responsibilities were fulfilled by Jack Kirshbaum. Production was managed by Kenneth J. Sabol. Mechanicals were created by Ken Hancock with book design by Lisa Buck Vann. Book planning and printing was managed by Kathleen Brown. Copy was edited and proofread by Joanne Reams. Illustrations responsibilities were Kathryn Stafford's, with assistance by Susanne Boeller, Susana Wigdale, and Cheryl Anderson. Type was set by Graphic Composition, Inc. The color plates were printed by South China Printing Company. The text was printed and bound by Arcata Graphics-Halliday. Halftone film was provided by York Graphic Services.

This book is for my sister Gerda and in memory of her husband Jack.

Their ever-generous hospitality to man, beast, and relative includes the grateful author.

A man hath no preeminence above a beast.
—ECCLESIASTES

*Ask now the beasts, and they shall teach thee;
and the fowl of the air, and they shall teach thee.*
—JOB

In painting animals Zeuxis set himself up almost as a god. He began to give his works away because he said they were beyond price.
—PLINY, NATURAL HISTORY

Why was man created on the last day? So that he can be told when pride takes hold to him: God created the gnat before thee.
—THE TALMUD

For in truth art is embedded in nature; whoever can tear it out has it.
—DÜRER

Contents

Color Plates ix

Prologue xi

Acknowledgments xv

Chapter One
The Artist as *Animalier* 3

Twice Trained—The Early Years • Journeyman's Travels •
Italy and the Renaissance •

Chapter Two
Our Lady of the Animals 31

Chapter Three
Birds by His Hand 57

Bittern • Blue Roller • Crane • Crow and Raven •
Cuckoo • Dove and Pigeon • Duck • Eagle • Falcon and
Hawk • Finch • Heron • Jay • Lapwing • Magpie •
Owl • Pelican • Pheasant • Siskin • Sparrow •
Spoonbill • Starling • Stork • Swallow • Swan •
Woodpecker •

Chapter Four

Wild in the Woods 93

Badger • Bat • Bear • European Bison (Wisent) • Wild Goat (Chamois) • Deer • Elk • Fox • Hare and Rabbit • Lynx • Squirrel • Stoat • Wild Cat •

Chapter Five

Creatures Hard-Shelled and Cold-Blooded 119

Ant and Bee • Butterfly and Moth • Crab • Fish • Fly • Mayfly • Toad and Frog • Grasshopper and Locust • Lizard • Lobster • Scorpion • Snail • Snake • Squid • Stag Beetle and Scarab • Turtle •

Chapter Six

The Lion, the Saint, and the Artist 139

Chapter Seven

An Artist's Best Friend 163

Chapter Eight

Down on the Farm 185

Ass and Donkey • Buffalo • Cat and Mouse • Cattle • Chicken • Geese • Goat • Pig • Sheep (and Their Shepherds) •

Chapter Nine

Horse and Rider 219

Chapter Ten

In the Stars and over the Seas 251

Ape and Monkey • Camel • Crocodile • Dodo • Elephant • Hippopotamus • Ibis • Parrot • Peacock • Rhinoceros • Sea Turtle • Walrus •

Chapter Eleven

Classical Creatures 277

Basilisk/Cocatrice • Capricorn • Centaur • Dolphin • Griffon • Pegasus • Phoenix • Satyr and Faun • Sea Horse • Sphinx • Triton, Mermaid, Harpy, Siren, and Sea Monster • Stymphalian Birds • Unicorn • Vulpanser or Chenopolex • Wildfolk •

Chapter Twelve

Beastly Temptations, Monstrous Sins 301

Chapter Thirteen

Poached Hares and Copy Cats 327

A Note on Watermarks 335

Illustrations 337

Bibliography 361

Index 365

Color Plates

1. *The Adoration of the Magi*, 1504. Oil on panel. Uffizi, Florence. Photo: Scala/Art Resource, New York.

2. *Our Lady of the Animals*, 1503. Pen and watercolor. Albertina, Vienna.

3. *Madonna with Siskin*, 1506. Oil on panel. Staatliche Museen, Berlin. Photo: Jörg P. Anders, Berlin.

4. *Bird's Wing*, ca. 1502. Pen and wash. Trustees of the British Museum, London. Sloane Collection.

5. *Dead Blue Roller*, 1512. Watercolor and gouache, heightened with gold, on vellum. Albertina, Vienna.

6. *Wing of a Blue Roller*, 1512. Watercolor and gouache on vellum. Albertina, Vienna.

7. Detail from *Saint Jerome in the Wilderness*, ca. 1494. Oil on panel. Fitzwilliam Museum, Cambridge, England.

8. *Lapwing*, 1500. Pen and watercolor. Staatliche Museen, Berlin. Photo: Jörg P. Anders, Berlin.

9. *Owl*, ca. 1502. Watercolor on yellowed paper. Albertina, Vienna.

10. *Stork*, ca. 1502. Pen and ink. Musée des Ixelles, Brussels. Photo: A.C.L., Brussels.

11. *Head of a Red Deer*, 1504. Watercolor and gouache. Bibliothèque Nationale, Paris.

12. *Elk*, ca. 1501. Pen and watercolor. Trustees of the British Museum, London. Sloane Collection.

13. *Hare*, 1502. Watercolor and gouache, heightened with white. Albertina, Vienna.

14. Hans Hoffman. *Squirrel*, 1578. Watercolor, heightened with white, on vellum. Ian Woodner Collection, New York. Photo: Eric Pollitzer.

15. Unknown artist. Maximilian's *Fishing Code*, 24 February 1506. Watercolor and gouache. Archiv der Stadt, Vienna.

16. *Eros the Honey Thief*, 1514. Pen and ink with watercolor. Kunsthistorisches Museum, Vienna. Photo: Marianne Haller.

17. *Crab*, 1495. Watercolor and tempera, heightened with white. Museum Boymans–van Beuningen, Rotterdam.

18. *Lobster*, 1495. Pen and ink with wash,

heightened with white. Staatliche Museen, Berlin. Photo: Jörg P. Anders, Berlin.

19. *Stag Beetle*, 1505. Watercolor and gouache. J. Paul Getty Museum, Malibu.

20. *Lion*, 1494. Gouache, heightened with gold, on vellum. Hamburg.

21. *Saint Jerome in the Wilderness*, ca. 1494. Oil on panel. Fitzwilliam Museum, Cambridge, England.

22. *Lion Perched on Winged Cup*, 1513. Pen and ink with watercolor. Staatliche Museen, Berlin. Photo: Jörg P. Anders, Berlin.

23. Detail from *Sketch of Animals and Landscapes*, 1521. Pen and ink with wash. Sterling and Francine Clark Art Institute, Williamstown, Massachusetts.

24. *Lioness*, 1521. Musée du Louvre, Paris. Edmond de Rothschild Collection.

25. *Christ among the Doctors*, begun 1496. Staatliche Kunstsammlungen, Dresden. Photo: Gerhard, Leipaz-Moiken.

26. *The Flight into Egypt*, 1496. Oil on panel. Staatliche Kunstsammlungen, Dresden.

27. *Paumgartner Altar*, ca. 1504. Oil on panel. Alte Pinakothek, Munich. Photo: Artothek.

28. *Rider*, 1498. Pen and watercolor. Albertina, Vienna.

29. Two musicians, detail from *Jabach Altar*, ca. 1503–4. Wallraf-Richartz Museum, Cologne. Photo: Rheinisches Bildarchiv.

30. *Parrot*, ca. 1500. Pen and watercolor. Biblioteca Ambrosiana, Milan.

31. *Walrus*, 1521. Pen and ink. Trustees of the British Museum, London. Sloane Collection.

32. *Arion*, ca. 1514. Pen and ink with watercolor. Kunsthistorisches Museum, Vienna.

33. *Two Putti on Dolphins*, from Aristotle's *Organum Graece*, ca. 1504. Gouache heightened with gold. Niedersachsiche Landesbibliothek, Hannover.

34. *Chandelier Made of Antlers*, 1513. Pen and watercolor. Kunsthistorisches Museum, Vienna.

35. *Fighting Putti on Unicorns*, from *Aristoteles opera*, 1497. Watercolor and body color over pen and ink, heightened with gold and white. Museum Boymans–van Beuningen, Rotterdam. Photo: Frequin-Photos, Voorburg.

36. *Crane with Scroll*, 1513. Pen and ink with watercolor. Trustees of the British Museum, London. Sloane Collection.

Prologue

The uniquely abundant animal images in Albrecht Dürer's art illuminate many of his greatest gifts and strongest feelings, his closest observings and wildest imaginings, seen at their liveliest in his labors as a new Noah. Filling a richly varied ark, crowding it with all the wonders of nature and fantasy, the Nuremberg master presented animals throughout his life, mastering them in varied media—metalpoint, pen and ink, engraving, etching, and woodcut, along with his painting in watercolor, tempera, and oil. In his works he caught creatures of everyday life as well as demonic specters haunting the mind, recording the newly introduced zoological specimens brought back dead or alive from newly discovered lands and seas to the east and west.

We have always been close companions, human and beast. For help on the farm, in the hunt, for food, clothing, transportation, and amusement, we could not live without animals. Although they are now so often replaced by machines and other discoveries, it is not so long ago that much of human life was determined by animals' presence, by their care, work, or sacrifice. For example, few countries today are entirely dependent upon sheep or cattle for their economy, but in Dürer's time, the late fifteenth and early sixteenth centuries, most European commerce was defined by the value and travel of wool—shorn in England, spun in the Lowlands, processed and woven into cloth in Italy, and then sent to all the trade fairs for sale.

The lives of knight and peasant alike were shaped by animals—horses and cattle, geese and chickens, could make you rich or poor. With steed and hounds the European hunter tracked wild goat, duck and goose, quail and partridge, hare and deer. Traps or arrows caught ermine and squirrel, bear, badger, and wolf so their fine furs could be worn by the wealthy. Only the privileged could ride, astride fine horses, to the hounds, through field and meadow and on to the wild woods beyond, in pursuit of fox or wild birds. Hunters trained falcons to drive game birds down from the skies. None but the "right sort" were allowed to wear fine leather gloves, furs, or feathers, so animals bespoke your life, diet, fashions, sports, and place in society.

Our own baseball teams, buslines, clubs, and state flags still follow animals' special powers: the Baltimore Orioles and Boston Bruins, Greyhound Line, Benevolent Order of Elk, and Lodge of Moose—to all of these, birds

and beasts lend their song, strength, speed, or special dignity. We use animals to say what is best and worst about ourselves, what we love and hate, fear and revere. That is why we can feel as low as a snake or as happy as a lark or a clam at high tide. Someone is grouchy as a bear or having a whale of a good time. Catty or son of a bitch, bird brained, horse faced, or bovine, a mouse or a pig, we take on or are given those qualities seen in animals if we look or behave like them. We are born naked and defenseless, so animals represent all the forces that we wish for—wings, claws, and fur—to defend ourselves in a harsh world. All our faiths are charged with animal symbolism; our hopes and fears are often tied to creature qualities, not our own. That is why we are betrayed by the serpent and saved by the lamb, snatched, we hope, from the jaws of Hell, with its horned and tailed demons, to soar heavenward with the gift of flight.

Dürer was born in 1471 and died in 1528, and his times, far more than our own, valued animals as central to society, to work and play, and to faith and ceremony of state. He admired magnificent feather capes, alligators and frogs cast in Central American gold, blue dragons painted on white Chinese porcelain, rare fossils, stuffed birds of paradise from the Far East, and African birds and beasts caged in stalls along the wharves of Europe's great new seaports. All over Europe, private royal zoos were enlarged to accommodate the wave of new creatures from overseas, prized as new additions to these living museums.

He sketched a walrus preserved like pickles in great wooden barrels; other beasts came stuffed, like Steiff toys of Texan proportions, the taxidermist's skills preceding the painter's. Birds and beasts—ranging in size from the almost invisible engraved flights of birds to the monumentally powerful woodcut rhinoceros—turn up anywhere and everywhere in the artist's works, whether the subject is narrative, biblical, political, armorial, or mythological. Animals creep into the margins of Dürer's illuminated manuscripts and printed books, onto the backs and fronts of his panel paintings, and are found also in his designs for the extravagant pageantry of imperial triumphal entries. The artist's father was a goldsmith, and Dürer was first trained in that demanding craft, so many of his most intricate projects were meant for execution in precious metals. Under the patronage of the Holy Roman emperor Maximilian, Dürer was called upon to work in the "applied" as well as the "fine" arts, to draw vast imaginary cavalcades with hundreds of horsemen and an equally massive triumphal arch on paper with coats of arms, many with miniature animals. He also devised beautiful armor and borders of printed books for Maximilian, all embellished with creatures real and unreal.

Dürer's life and work—evenly divided between the fifteenth and early sixteenth centuries—were stimulated by his journeys, to Italy and to the Lowlands, during which he kept extensive notebooks and made other drawings. His first Italian journey, in the mid 1490s, brought him into direct contact with the Italian artists whose work he had already admired in the prints, books, small bronzes, and panel paintings brought back to Nuremberg by its wealthy, educated trading families.

It was mostly during his twenties that Dürer produced a vast pictorial archive, often in watercolor and gouache, which he consulted for the rest of his life. Prepared with microscopic intensity, these pages proved even more accessible than living models in the studio. Like those drawn by northern Italian masters in the first half of the fifteenth century, Dürer's early animal studies have a matchless freshness and immediacy, without the arid déjà vu that creeps into some of the aging artist's works. This image bank, of hundreds or possibly thousands of pages, was a vastly expanded version of the pattern books used by artists in earlier times. It included studies of birds in flight and at rest, animals of farm, field, and forest, imaginary monsters, and the exotic

creatures found only in princely private zoos or the great seaports of Antwerp, Lisbon, and Venice.

Words as well as pictures help artists find the forms they need, prodding their imaginations, giving them new ideas. This must have been true for Dürer, growing up in a publishing center, where his parents' friends included Anton Koberger, the city's most successful publisher of illustrated books. Predictably, the Bible, and particularly the Book of Revelation, provided the young artist with endless animal imagery. But he had surprisingly little, if any, use for the most popular of all animal tales, the ancient Greek fables of Aesop, printed so many times in the fifteenth century. Nor is Dürer ever known to have drawn upon the equally popular moralizing animal images found in the Christian symbolism of the Bestiary. His lifelong friendship with the Nuremberg merchant-prince and scholar Willibald Pirckheimer (1470–1530) first brought the world of classical wisdom close to the young artist. In his later employ to Emperor Maximilian, ancient animal symbolism came to the fore with Dürer's illustration of the mysterious text of *The Hieroglyphica*, a classical yet fraudulent "key" to the baffling hieroglyphs of Egypt, named for its supposed author, Horus Apollo.

In no other artist's life and work have animals played a richer, more abundant role. They brought out the best in Dürer's art, evoking qualities of warmth and humor often absent in his treatment of human subjects and, sadly, in his own life. He was raised in a somber home by a pious, overworked artisan and his equally devout wife, surrounded by the mournful memories of the deaths of fifteen infant brothers and sisters. Not the first son to bear his father's name, Albrecht was so baptized after two brothers had lost that name in death. In an arranged marriage, Dürer proved a cold husband in a childless union. He drew animals the way other artists portrayed their children, combining loving pride with understanding, presenting them as his own work in every sense of the word. Some of these creatures, like the parrot and the dog, were probably the artist's own pets, sources of constant amusement and companionship.

Other images, such as Dürer's many drawings and prints of horses, were not only beautiful in themselves, but also signs of class, speed, and pleasure, valued like our sports cars or yachts. He was proud of his own good looks, of his cheekbones and high-bridged nose, his lanky yet strong build. Friends who read the poetry of ancient Greece and Rome told him that his appearance recalled Virgil's passage comparing handsome men to fine steeds. Soon recognized as the greatest of living northern artists, Dürer saw himself as a champion and wore his long hair carefully curled and brushed to increase the Virgilian resemblance—it looked like a horse's mane, or that of a regal lion. He painted himself in 1500 in this fashion, proudly fingering a lavishly fur-lined robe as a sign of his fame and fortune.

Unique documentation of his talent, taste, and travels, Dürer's images of animals offer vivid testimony to his readings, to his friendships and commissions, his imagination, faith, and science, his hopes, fears, and humor. These works also document the growth and change in his art, knowledge, and character from early youth to maturity. Above all, his drawings, paintings, and prints bear witness to one greatly talented man's love and respect for nature's infinite variety. So, though this book is titled *Dürer's Animals*, it might more tellingly be called *The Animals' Dürer*.

Acknowledgments

This book began with the welcome suggestion by Dr. Charles Winkelstein that my arcane interests might occasionally be applied to popular, perhaps remunerative, purposes. Little could he (or I) have predicted that what seemed like a profitable lark would require a gestation period longer than that of five successive elephants!

I have benefited from the enthusiastic support of my first editor, Barbara Burn, then at Studio Publications, and by the inspiring example of her husband, the late Dr. Emil Dolensek, the Bronx Zoo's great veterinarian, whose heart equaled the size of that vast institution. Other editors, including Elizabeth Sifton at Viking Penguin, helped prepare the manuscript before it went to Smithsonian Institution Press, where I have enjoyed the caring supervision of Amy Pastan, Jack Kirshbaum, Joanne Reams, Lisa Vann, and Kathryn Stafford. Suzanne Babineau proved a remarkably patient and thoughtful typist of the first draft.

Special thanks to Gerald Slater, my matchmaker with Smithsonian Institution Press. He and his wife, Halcyone, are ever the kindest of Washington hosts. I am deeply indebted to Frances Smyth, editor-in-chief, National Gallery of Art; Stephen E. Ostrow, chief, Prints and Photographs Division, Library of Congress; Lawrence Sullivan and Peter Van Wingen, Rare Book Division, Library of Congress; and Hugh Talman, Printing and Photographic Services, Smithsonian Institution. They facilitated my obtaining many invaluable photographs.

My gratitude, too, goes to the artist and to his subjects for providing so much pleasure over so many years.

DÜRER'S ANIMALS

tua Agla Ananizapta te
tragramaton: que sunt lau-
danda: glorificanda: tremen-
da: et adoranda: nunc et Per
infinita secula seculoru Ame.
Vater Noster.

O Hiesu vera libertas an
gelorum: mundi fabri-
tator: z omniu bonor auctor:
via salutis eterne: verus osten
sor. Memento comprehensio-
nis et temptationis tue: quan
do iudei tanqua leones fero-
tissimi in templo te circumste

Chapter One

The Artist as Animalier

Three wise and gifted men leaned over Albrecht Dürer's cradle in Nuremberg in the year of his birth, 1471. The first was his father, Albrecht, that hard-working and skilled goldsmith to the Holy Roman emperor Frederick III. Born in Hungary, he was descended from a long line of horse and cattle dealers though his own father had been a goldsmith too. He left home to go to the Netherlands, where the young Hungarian may have studied painting as well as goldworking. Before 1455 Albrecht settled in Nuremberg and apprenticed himself to one of the city's best goldsmiths, soon marrying his master's daughter Barbara.

Surrounded by sandy acreage and several rivers, Nuremberg may have looked like no more than a quaint market center when Albrecht came there, but it was already world famous for skilled craftsmanship in the manufacture of scientific and other instruments [10.1]. One of Europe's most active trading centers, Nuremberg was called the central point of the Holy Roman Empire by Pope Pius II. Modern by Old World standards, the city was only founded in 1040. By the midfourteenth century it was decreed that every emperor had to spend the first day of court—the Reichstag—in that city, which soon housed his imperial treasures.

Martin Luther, whose Reformation changed the map of European faith along with Dürer's own, described Nuremberg as the "eye and ear of Germany." All the world came to buy crafts and exchange goods there, located as it was at the crossing point of the north–south and east–west European trade routes. Its merchants helped finance many of the major discoveries of the century. Columbus discovered America when Dürer was twenty-one, and the explorer's letters were printed in Nuremberg, along with Marco Polo's accounts of his explorations to the east [10.9].

Apprenticed to his father, the junior Albrecht was also given a little formal schooling, possibly more than was usual for an artisan's son. In 1486, having completed his four years of work-studies as a goldsmith, Dürer persuaded his reluctant father to let him start all over again, as apprentice to Michael Wolgemut, a leading local artist and woodcut designer who lived and worked just down the street, where he stayed for about three years.

Second of the three wise men was the infant Albrecht's godfather, Anton Koberger. Soon the world's busiest publisher, he founded

his thriving Nuremberg print shop just one year before Dürer's birth. Koberger saw to it that movable type, invented in Germany about three decades earlier, spread his name throughout Europe as the operator of many presses, producing more books faster than anyone else. Working with Michael Wolgemut in the production of lavishly illustrated books, their lively woodcuts keeping the reader awake, Koberger provided his godson with a profitable role model. Dürer too became a publisher, many of his biblical print series [2.16; 3.47] issued in book form with religious commentaries. Their sale throughout Europe made Dürer a famous and wealthy man, turning him away from time-consuming painting with all its demanding patrons. Animal studies were important for all these ventures, and they formed part of his many travel records, found in the extensively illustrated notebooks of his two Italian journeys and his Netherlandish travels.

Last of the three wiseman was Bernhard Walther, whose wife was godmother to Dürer's sister. Like so many of Nuremberg's rich men, he was a merchant with far-flung European and Eastern business interests. To pursue the new discoveries in the stars and the finding of overseas routes to Africa, India, and America that were so important to his trade, Walther became a passionate amateur astronomer and astrologer, passing these interests on to young Dürer, who became a maker of maps and star charts. At the peak of his career, Dürer was able to buy Walther's large house, making its astronomical balcony his own. The skies teem with constellations encompassed by mythological creatures such as centaurs and fauns, and Dürer made several studies of these for his own charts of the northern and southern skies [10.3; 10.4] and many other projects. Walther's agents put Dürer in touch with agents from Nuremberg in other centers, among them Antwerp and Lisbon. They sent him descriptions of strange creatures—walrus [Plate 31] and a rhinoceros—or feathers from the Orient.

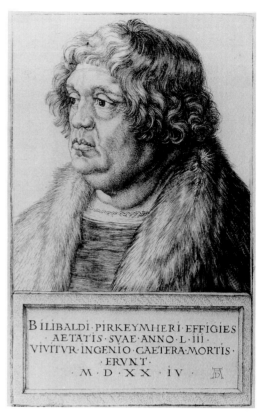

1.1

No godfather but far wiser was Dürer's closest friend, Willibald Pirckheimer [1.1], a local merchant-prince one year his senior. The boys lived opposite one another, the Dürers in the small, dark quarters on the courtyard belonging to the Pirckheimers' grand townhouse. Immensely learned, Willibald was Albrecht's key to the humanities, to the world of ancient Greece and Rome. Many of Dürer's studies inspired by the literature of antiquity, the fauns and satyrs and other mythological creatures so common to Italian art yet still rare in the North, may first have come his way through Pirckheimer's possessions, such as the Venetian illustrated books, prints, and medals in his library. Albrecht depended upon Willibald, and upon the art of northern and central Italy, to show him the way to the past, one so well known to young Pirckheimer. The men in his family before him, and those of many other wealthy local families, were educated at the northern Italian universities of Padua and Pa-

via, where they made profitable trade contacts at an early age. Willibald followed in their footsteps and became friendly with a princely patron of Leonardo da Vinci, bringing back drawings [9.2; 9.45] or bronzes [9.38] after his equestrian statue, and possibly medals by Antonio Pisanello [3.12; 9.12; 9.13] and other masters of that genre. The first two of his three Italian journeys were made at eleven and fourteen—"as soon as [I] was old and strong enough to follow [my] father on horseback." These lines were penned in Pirckheimer's autobiography, written two years after Dürer's. Such a journey took about fourteen days.

Pirckheimer proved Dürer's one-man campus, contributing to the change in his self-image from that of a late medieval craftsman to a Renaissance artist, scientist, and genius. As courtier of Dürer's future patron, the Holy Roman emperor Maximilian, and correspondant of Erasmus, Pirckheimer was Germany's outstanding humanist. Noting how unusual it was for one man to combine great learning, wealth, and generosity, Erasmus called Pirckheimer a *rara avis*—a rare bird. His lack of snobbery, love for men, and sense of adventure are probably what made Willibald willing to take gawky, ignorant, yet highly intelligent young Dürer under his wing. Later, Pirckheimer helped his boyhood neighbor and protégé receive valuable if ultimately tedious patronage from Emperor Maximilian [1.2; 1.3; 12.33].

Even if his father could not control his young son's choice of a livelihood, he did manage his marriage, engaging him to Agnes Frey, daughter of another of the city's most successful metalworkers. She was the ungainly granddaughter of one of Nuremberg's agents for the Medici, that great Florentine banking family. The artist left for his first Italian journey in the fall of 1494 just after marrying Agnes, leaving the poor girl behind to escape the plague-ridden city and not returning until the spring. Though a large dowry came with Agnes, she was ever anxious about money, and, according to Pirckheimer (written in a letter he never

1.2

1.3

mailed), this avarice, with her fanatical piety, drove her overworked husband to his death at age fifty-seven. Before they met, Dürer was already a tremendously industrious artist, however, so it may not be fair to credit Agnes with the multitude of incomparable paintings, drawings, watercolors, and prints that Dürer has left us. Surviving to the present are almost one hundred individual paintings in oil; originally there must have been many, many more. There are 107 engravings, more than 400 woodcuts, and 6 etchings. In addition to that enormous oeuvre, he designed almost 200 woodcuts, mostly cut by artisans, during his travel years. A recent six-volume gathering by Walter L. Strauss of Dürer drawings and color sketches on paper gives their number at almost 1,200, including those in books and manuscripts.

The Dürers, father and son, may have been named after Albertus Magnus [1.4], a thirteenth-century German saint who believed in seeing for himself. He loved hunting on his father's extensive lands, risking life and limb in his climb to the aerie of a sparrow hawk, proving that the "musket" and the sparrow hawk were no more than male and female of the same species. Albertus also explored the mysteries of fish migration and the ways of the walrus, studying animals great and small from the dormouse to the polar bear. His scientific works were first published in 1478, popularized by Conrad von Megenberg as *Bidpai: The Book of Nature* [1.5; 1.6], lavishly illustrated with woodcuts of animal life.

"Animal, Vegetable, Mineral"—the name of that old guessing game—also covers the cosmic range of Albertus Magnus's studies of the natural sciences. Among these is the Dominican's lengthy *De animalibus* (four sections of this work were recently translated by James J. Scanlan as *Man & the Beasts* [Medieval & Renaissance, 1987]). Other works include *De vegetabilibus* (*Of Botany*), in seven books; *De coelo et mundo* (*Of Heaven and Earth*)—on climate, astronomy and navigation); *De natura locorum* (*The Nature of Places*)—on geography and cartography, along with many other investigations of meteors, minerals, and chemistry—almost all these interests shared by Dürer.

Albertus's ideas were often based upon those of antiquity, especially Aristotle's, his study of past scholarship encouraged by the Dominican Order to which he belonged. So vividly were these ancient concepts and discoveries restated that they proved crucial to Columbus's explorations—his annotated copy of Albertus's works still survives in Seville.

Wearing the white robes of a mendicant friar, the young scholar traveled extensively, far more so than Dürer. He examined fossilized seabeds on mountain tops, explored the cold Baltic coast, wandered through the vineyards of France, journeying as far east as the Russian steppes and to northern and central Italy. The awesome breadth of Albertus's concerns comes even closer to Leonardo da Vinci's than to Dürer's, anticipating Renaissance creativity, where the qualities of the scientist and the genius were so often intricately intertwined with

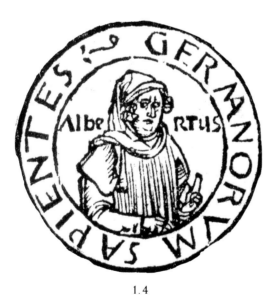

1.4

7 The Artist as *Animalier*

those of the artist, sharing common roots and roles.

Known irreverently as Big Boots, Albertus was so named because, as bishop, he rejected fancy episcopal slippers, keeping friars' hardy footgear so he could still tramp through forest and marsh to see nature's ways and works. His encyclopedic erudition, energy, and enthusiasm made Albertus known as "the wonder and miracle of our times," soon given the awe-inspiring title of *doctor universalis*. Among the scholar's major ancient sources was Pliny the Elder, whose writings Dürer also knew, as so many of them dealt with the role of artists in ancient times. Canonized in 1931, the Dominican was declared special patron of students of the natural sciences a decade later. (His *opera omnia* will soon reappear in a new Latin edition of forty volumes.)

No less than 477 numbered species of animals are recorded in Albertus's *De animalibus*— 113 quadrupeds, 114 flying animals, 140 swimming animals, 61 crawling animals, and 49 worms. He explained how even the most ignoble of animals deserved examination by restating Aristotle's view that "we ought to look at their forms and rejoice in him who is their artificer who made them, and because the artistry of the maker is revealed in the way he works."

Albertus, like Dürer, went to Padua, residing with an uncle there, where he may first have studied the liberal arts at the newly established local university. Admiring the Doge's Chapel (as would Dürer), Albertus noted that the facelike lines in its costly marble revetment were due to geological, not mystical, formation.

In Italy, young Albertus joined the Dominicans in 1223, drawn to the newly founded order for its devotion to preaching and teaching. His justifiably proud monastic recruiter described the German monk as endowed with "a great income . . . [and] truly noble in body and soul." Best known as the teacher of Saint Thomas Aquinas, Albertus spoke of his still

1.5

1.6

more celebrated yet deceptively reticent pupil in frank terms close to his own natural interests—"You call him a dumb ox, but I tell you that the bellowing of this ox will one day be heard around the world." Albertus also taught Thomas of Cantimpre, whose *De natura rerum* (1295) along with Bartholomew the Englishman's *The Book of the Nature of Things* (written in 1260) remained among the most popular nature studies printed throughout the fifteenth century. Bartholomew's book was lavishly illustrated in a Haarlem edition of 1485, so when Dürer was fourteen his first nature studies were still close to Albertus's findings, made over a century before.

Where Dürer would hasten to catch sight of a single beached whale, gone before he arrived at the site, Albertus had already lived with whaling communities three hundred years before, observing those great mammals' capture at sea. Watching them reduced to blubber, he noted how "these facts about the nature of whales have been gleaned from our own experience. We have omitted what the ancients wrote, because they do not agree with the practical knowledge of the experienced fisherman." "Practical" and "experienced" apply equally to Dürer's art and to the strong empirical element that illuminates his vision.

This was the quality—*experientia*—that lead Conrad Celtes to compare the philosopher and the painter in a verse written in 1500, claiming that God had given both men comparable creative powers. The humanist's lines, discovered by Dieter Wuttke ("Dürer und Celtis: Von der Bedeutung des Jahres 1500 für den deutschen Humanismus: Jahrhundertfeier als symbolische Form," *Journal of Medieval and Renaissance Studies*, 10 [1980]: 73ff.), were composed not only at the date ending the northern late medieval tradition but also at the exact midpoint of the artist's life. According to Jane C. Hutchison (*Albrecht Dürer: A Biography* [Princeton University Press], 1990, 68–69), Celtes's comparison of the two is a compliment, founded in part upon the coincidence of names, but largely on Dürer's capacity to illustrate the assertion made by Albertus Magnus in *De pulchro et bono* (*Of the Beautiful and the Good*) that every aspect of creation participates in the beautiful and the good.

Just as the painter is so beloved for his studies of squirrels, Albertus was the first to identify their three different types—those of Germany (red), Poland (gray-brown), and Russia (gray). The Dominican and the artist had little use for the Bestiary, usually dismissing that medieval text with its interplay of mysticism and zoology to yield a symbolic explanation for the form and "attire" of Noah's passengers.

Like most knights, Albertus was a great lover of horseflesh, but once a friar, he could never ride again. His definition of an ideally beautiful horse—an equine word portrait anticipating the look of those by Leonardo—is so vivid that Scanlan (*Man & the Beasts*, 104) believes it to have inspired Shakespeare's lines in *Venus and Adonis* (289–300):

> *Look, when a painter would surpass the life requirements*
> *In limning out a well-proportioned steed,*
> *His art with nature's workmanship at strife,*
> *As if the dead the living should exceed.*

Among Albertus's interests that were close to those of the Renaissance is animal movement or locomotion, the friar's studies based upon his translation of Aristotle's. Leone Batista Alberti, the Florentine humanist so deeply interested in the new visual arts, took up the same subject in the midfifteenth century, dedicating his study to Lionello d'Este, a great lover of racehorses. Dürer, too, was concerned with the way horses moved; he copied their proportion and motion studies from Leonardo's, which, in turn, may go back to those of Alberti and to Albertus's text.

Experiment—that word so close to the nature of science, also nears the science of na-

ture. Albertus often uses the term, as Scanlan has noted, in the sense of a "proof, test or experience." Dürer's more elaborate plant and animal studies should be understood in the same sense, as both analytic *and* descriptive, coming as close to their being as he could, nearing Albertus's view that "only experience provides sure knowledge" of nature.

The Dominican, as a theologian, used his unique command of the facts of animal life to communicate the meaning of faith. In his *Mystical Theology* Albertus maintains the importance of the intellect toward *fides* (faith) by noting how:

The sense of sight of some creatures, like the bat, is totally shattered by sunlight but the vision of others, like human beings', may be briefly directed to the sun, but being weak, cannot do so without the eyes trembling. Other creatures, like the golden eagle, have so strong a sense of sight that they can see the sun in the round. Similarly, the mental vision of people who are held down by earthly affections and bodily images is material and so totally rebuffed by divine radiance. But if their vision draws away from these things toward intellectual speculation then it becomes immaterial, even if still trembling because it looks upon the things of God from afar, by the 'principles of reason'. Yet when vision is strengthened by the light of faith it ceases to tremble. (Adapted from *Albert & Thomas: Selected Writings*, trans. and ed. Simon Tugwell [Paulist Press, 1988], 65)

Doctor universalis's theology followed Saint Paul's and was close also to Dürer's implicit faith in the loving study of God's will and works as revealed by nature. Though "we now see through a glass, darkly," by coming close to creation we near the Creator, preparing us "to see Him face to face." In human love, so Albertus observed, men are aroused to physical passion by seeing the beloved when they use the "eyes of the heart." Dürer's animals are so remarkable because they too were first seen by the eyes of his heart.

Twice Trained—The Early Years

Where did young Dürer first learn how to draw the animals enlivening his career? In his father's goldsmith shop. There he first worked around 1481, mastering the graphic arts, including engraving, that printmaker's art a byproduct of the goldsmith's techniques. His father had pattern books [1.7–1.12]—albums filled with all sorts of designs of birds and beasts, flowers, and exotic peoples. These were ready for adaptation to the many projects that a court goldsmith had to produce, such as table fountains [1.20; 8.16], fancy clock cases,

1.7

1.8

1.9

1.10

1.11

1.12

lavish covered cups, sword and knife handles, chains and pendants, whistles [11.32], brooches [4.24; 9.33], and rings [12.38], as well as designs for fancy saddles and bridles for the well-dressed horse. These wares were incised, engraved, enameled [1.18; 1.19], or modeled in the round—often embellished with birds in flight, monkeys at play, hunters lost in the woods.

Playing cards were printed from engraved suites of birds of all sorts [3.3; 3.4], lions [6.12] and deer [4.1], dogs and cats; these too were much copied. Young Dürer found many of his first themes in such games on paper, imported from Italy [3.43; 7.10; 11.10] or engraved nearby.

The best image we have of a goldsmith's shop like the one Dürer's father first worked in is found in a midfifteenth century Netherlandish engraving of Eligius [1.13], the artisan who later became a bishop and patron saint of goldsmiths. While Eligius hammers out the cup for a chalice, his helpers work on its base and on the plate or paten that go with it for the church service. At the left a younger, less experienced

The Artist as *Animalier*

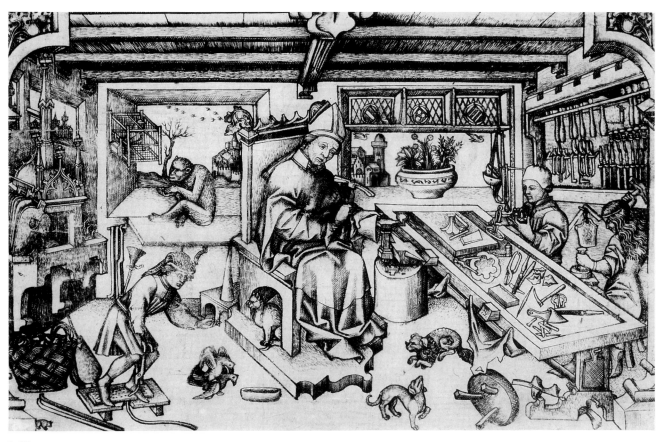

1.13

apprentice makes wire, which will probably be applied decoratively to the two objects central to the Mass.

Though the printmaker wants to show just what the bishop saint's life as a metalworker was all about, he was equally fascinated by the animal life inside and outside Eligius's shop. Seen through the window, nine birds fly in V-shaped formation, watched enviously by a caged bird hanging on the window wall. Chained to the sill is a large monkey, whose presence suggests that the four metalworkers are themselves the apes of nature, copying in precious metals and enamels the loveliest of plant and animal forms. Two wild geese are seen in flight, just below the stained-glass roundels bearing the coats of arms of the goldsmiths' and painters' guilds, whose allied skills were to mean so much in Dürer's career as printmaker and publisher. Fighting dogs are so lost in fury that they knock over a stool. Dignified, a cat sits proudly under Eligius's throne, unaware of a tiny, piglike mouse in the far left foreground. Two pet turtledoves make passionate love dangerously near the cat's saucer; their procreation parallels the surrounding creativity, or is it the other way around?

Why is the artisan saint surrounded by such an abundance of animal life inside and outside his studio walls? Because the engraver of this print believed that there was no such thing as art without nature or nature without divine art—Eligius, the sainted artisan, was their link. The serious son of extremely pious parents, Dürer learned this difficult lesson of ties between art and faith early and well, as seen in his self-portrait [1.14] in silverpoint, aged thirteen. Later he noted: "Here I portrayed myself from a mirror in 1484, when I was still a child."

His first surviving animal drawing is of a hawk held by a courtly lady [1.15], recalling

1.14

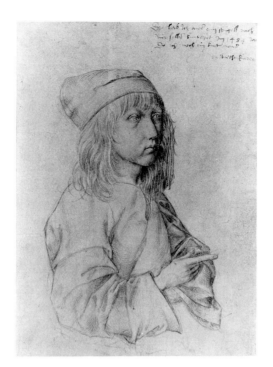

1.15

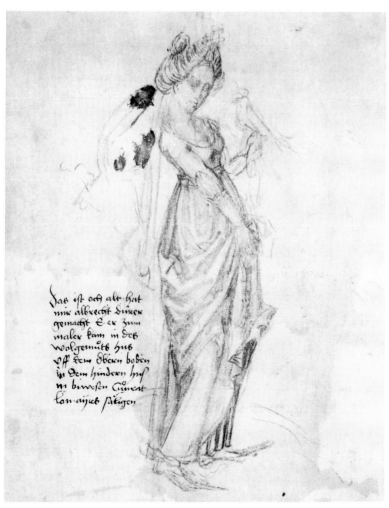

the pictorial alphabets of people and their pets engraved by the Master E.S. in the 1460s [1.16]. Then as now, the moral was "you're nobody unless somebody loves you"—preferably a costly pet as well as a generous person.

For every decorative art—tapestry weaving, embroidery, metalwork of all sorts, embellishment of gun butts and bone saddles [1.17], knives and leather boxes—craftsmen almost invariably drew upon the animal or the vegetable to attract purchasers. Snails or stags, bears or bugs slithered or ran around the borders of covered cups, prayerbooks, cutlery, or other objects of sacred or profane use. Animals' presence on or in these costly yet useful objects gave them a magical role in their owners' lives. Typical of the precious objects that the artist's father was trained to make is an enameled cup [1.18; 1.19] covered with roosters, stags, unicorns, and other beasts shown in two or three dimensions. A drawing for a similar work, from Dürer's studio, shows a pecking bird perched on the lid to serve as its handle. The artist depicted similar cups as gifts of the Magi—one of these has a lid whose ringed handle is formed by a serpent swallowing its tail [Plate 1], symbolizing Christ's eternal life.

During his three-year apprenticeship in painting in Wolgemut's studio, Dürer's fellow students bullied the sensitive, withdrawn, and, worst of all, immensely talented newcomer. His *Cavalcade* [9.7], drawn at this time, shows how quickly Dürer adapted his skills to broad narrative, away from the confines of a goldsmith's design. Here Nuremberg's young gallants take to the hills, riders and steeds alike still somewhat stiff in the joints as their young artist first studies the complex arts of motion. He may be including himself in this aristocratic company. His is probably an act of graphic wishful thinking, as Dürer was welcomed a decade later by the local aristocracy, excepting his early friendship with Pirckheimer.

By far the richest variety of animal life in Dürer's early work was drawn for one of the

13 The Artist as *Animalier*

1.16

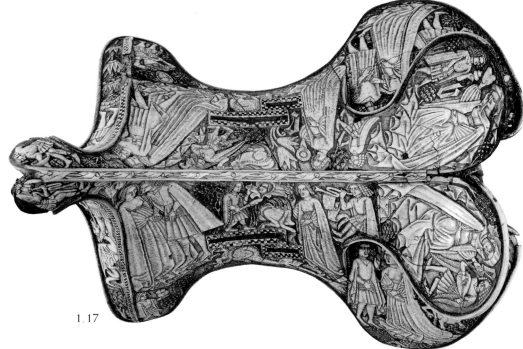

1.17

most animated art forms of the period, costly table fountains. These featured the spouting of red and white wines, whose jets rang little bells and moved miniature animals and men wrought of gold and silver. The artist's father-in-law was famous for manufacturing such centerpieces and his own father may also have made them. One of these projects [1.20] includes at least thirty-seven figures on the base alone—harvesters, duelers, brigands, hunters, fifers, drummers, shepherds, and soldiers. Diminutive lizards, a flock of sheep and goats, and a sheepdog and four hounds are also on the base, where three pairs of entwined serpents and a frog or toad all jet streams of wine. More sprays come from the fountain's upper section, from the mouths of archers and swordsmen, and from pets held by figures standing in the basin. Designing these tiny figure groups (including such miniature marvels as the lizards just above the head of the hounds at the far right) paved the way for Dürer's working out a microcosm, a miniature world that he was to bring to its greatest graphic perfection about three years later in his watercolor *Our Lady of the Animals* [Plate 2] and in such engravings as *Saint Eustace* [1.30] and

1.18 1.19

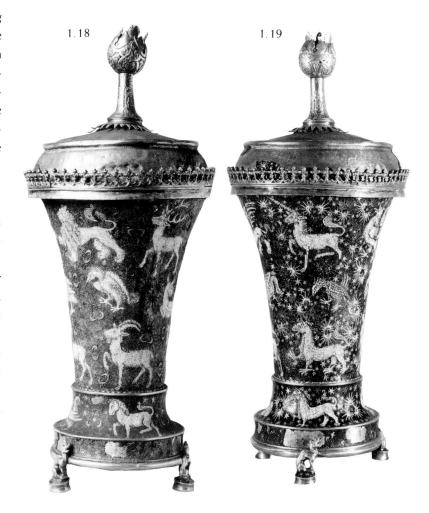

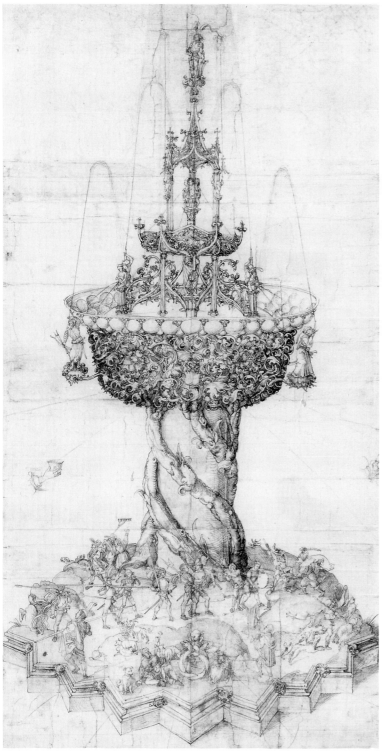

1.20

Knight, Death and Devil [9.47]. A Christlike figure supports the whole upper section of the fountain, bringing a startling sense of moral values to what otherwise would be an extravagantly uncritical presentation of the way of the world.

Such fabulous centerpieces are in the Burgundian ducal tradition, one kept alive by the Holy Roman emperor Maximilian, Dürer's later employer, whose wife Mary was the last of the Burgundian line. Gilded and enameled metal sheep jumping up and wagging their tails, lions roaring, birds flapping their wings —all these were moved by metal springs or water, part of the ancient art of the automata, combining the skills of goldsmith and clockmaker. Made in antiquity and preserved in Islam, the crafts of the automaton maker were revived by the Holy Roman emperors in their Sicilian courts and popularized in the windup toys and cuckoo clocks of the recent past. Leonardo da Vinci, Dürer, and many other painters steeped themselves in these works' designs, a vital extension of the illusionist's skills.

Journeyman's Travels

The artistic equivalent to the junior year abroad or Peace Corps—legitimate and economical ways of learning by working abroad—came by following artisanal travel routes without further inroads on the parental purse. This was the established way for those who had completed their apprenticeships to practice their skills away from home, employed by established masters in other centers, who would provide room, board, and spending money. Such travel was of special importance to Dürer because his native Nuremberg was not a strong center for painting or the other fine arts, far more like Silicon Valley than the School of Paris. As local painters like Wolgemut were mostly dry and provincial, the chance to get away, to work with innovative masters far from home, was an invaluable part

of Dürer's training during these *Wanderjahre* and lasted about four years. One of the greatest artists of this period, Martin Schongauer of Colmar, had died the year before Dürer arrived there in 1492, but Schongauer's brothers gave Dürer a cordial welcome and must have shown him the splendors still in Martin's studio.

Dürer went to other parts of Germany, Switzerland, and possibly to the Netherlands, to cities such as Bruges, which had been home to Jan Van Eyck [9.3], where he acquired a more fluid, naturalistic approach. Just how the young artist went about preparing drawings for woodcut illustrations during these journeyman years can be seen in those made for the Latin comedies of Terence, drawn in Basel in 1492–3. Fish, hare, and poultry facing a cook at a market stall are all traced with such animation that they seem still alive [1.21].

As a teenager, Dürer may well have designed some of the hundreds of woodcuts in Wolgemut's studio that were prepared for such massive compendiums as the *Nuremberg Chronicles*, whose lively roundels, like that showing the creation of the birds [1.22], suggest his hand. But the first documented evidence for such work is a full-page woodblock for the frontispiece of the second Basel printing of *The*

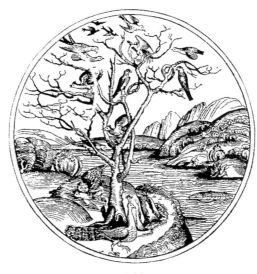

1.22

Letters of Saint Jerome [6.7] of 1492. The young artist or his publisher chose the popular northern subject of the Church Father removing a thorn from the lion's paw, setting the scene in Jerome's well-furnished study. Clearly not drawn from life, the exotic beast has the stiff, mannered profile of lions found on banners or coats of arms. The minute, fly-sized group of horse and rider seen through the window, drafted with brilliant economy, is a clue to the

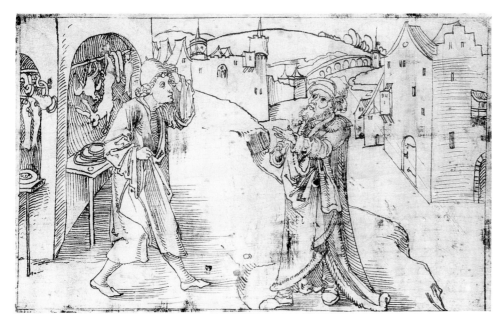

1.21

1.23

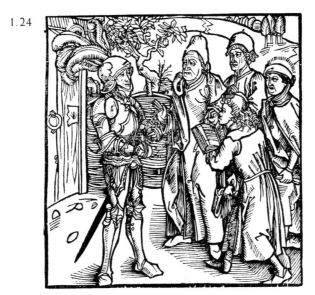

1.24

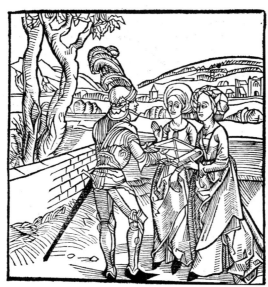

1.25

artist's future genius as *animalier*—a French term for a painter or sculptor skilled in portraying animal life.

Dürer doubtless cut some of his finest early woodblocks himself [4.32; 9.35], but one of his greatest skills was the ability to draw in such a way that his lines were readily followed by the accomplished reproductive woodblock cutter's tools—with little if anything lost in translation from the draughtsman's hand to the *Formschneider*'s chisel.

It was in Basel that Dürer also designed many of the woodcuts for a popular, late-fourteenth-century moralizing text by the Chevalier de La Tour Landry, written for the spiritual guidance of his two motherless daughters. Known in English as "*Examples of the Fear of God and of Respectability* by the Knight of Turn," his book opens with the knight dreaming of his book's genesis [1.23]. He instructs priests, a scholar, and a scribe to prepare the manuscript [1.24], soon scanned by his amazingly eager girls [1.25]. Teeming with biblical and classical references and a courtly context, this strict yet venturesome text opened new vistas for young Dürer, who worked on the 1493 edition.

His many references to animal life make the chevalier's morality tales more palatable, easier on the eye and ear. "Be not like the crane or tortoise in saying your prayers at mass, ever turning your head and face backwards and looking over your shoulder." Instead, he urges his daughters to "hold your head as firm as the beast that is called a lymer [bloodhound] which looks straight ahead, without turning his head hither or thither, but looks ever to the right."

Another early book to be illustrated by Dürer—*The Ship of Fools*—was even more important for the variety of its contents. Printed in Basel in 1494, it was written by a professor of law and philosophy, Sebastian Brant, who may have had Dürer draw his portrait for a later publication [1.26; 1.27; 1.28]. Amazingly popular, Brant's relentlessly sour, satirical text con-

17 The Artist as *Animalier*

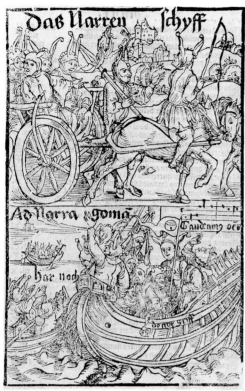

1.26

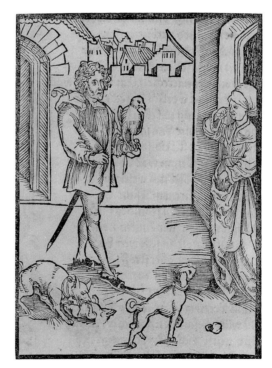

1.27

1.28

demned all human pursuits excepting the very purest piety—even priests did not escape his acid pen. Realizing how illustrations were needed to sweeten the bitter pill of his text, to help persuade the ignorant, Brant noted that "I've pictured every dolt, Should reading prove too difficult." And it was young Dürer who did the picturing, his lively animals following the imagery used so skillfully by Brant to keep his reader awake. To design these hundreds of woodcuts, young Dürer must have already drawn innumerable sketches, filling notebooks with quick renderings of life in the barnyard and stable, field and forest, many of them drawn as he went from town to town in these journeyman years. Perhaps that little woolly white dog [Plate 25], who turns up repeatedly in the young artist's works, accompanied him. This pet is first seen with another wanderer, the great theologian Jean Gerson, shown as a pilgrim in a woodcut designed by Dürer when he was in Strasbourg in 1494 [7.17]. These woodcuts for Brant show a new sense of light

and space, a fresh, almost lyrical feeling for life and for the way human and beast work and play together [3.24]. This novel freedom anticipates the finest of Dürer's later images and comes close to the later woodcuts of northern Italy that were inspired by the Nuremberger's sense of spontaneity.

Repeatedly the ass appears as the symbol of folly in Brant's book, yet Dürer never fails to give the animal individuality. His studies of all creatures are based upon compassionate observation, never condescension. The artist's hand, mind, and eye do not succumb to anthropomorphism—that too easy, dubious compliment of crediting animals with human ways and deeds. Dürer sees the serious stork [Plate 10], captive bison [4.15], or caged lions [Plate 24], along with starved nags [9.25] or dead stags [Plate 11], as sharing or being victims of our lives, but never (unless deliberately caricatural [10.23]) aping them. As artist and man, he recognized and delineated animals' special natures because of, or despite, our existance. That rare capacity, combining talent and perception, leads to the young master's distinctions as *animalier*.

Brant's sense of folly—that mean, fatal mix of vanity and stupidity—uses the ways of animals, of ape [10.22] and goose [8.47], crow [3.34] and lobster [Plate 18], for his moral zoo of "the beast in me and other animals." Such sermons were preached far more kindly by the equally popular, genial Johannes Geiler von Kaisersberg. Cautioning against false friends he noted that while "they love you, their love is often no different than that of a wolf for a chicken; a fox for eggs; a mouse for wheat; a mosquito for honey; a bird for its prey. They do not love you but only what you own." As for the value of the price of peace, in answer to his own question "Is peace a costly fruit?", the preacher replied, "The eagle nests on the highest cliff. Why? For peace. The worm crawls deep in the earth. For peace. Why does the hedgehog only come out at night? For peace. What does the fish seek in the water and the lobster below the rock? Peace." The sense of animals' caring and sharing in our lives is found in an early woodcut series known as the Albertina Passion, which Dürer planned around 1494. Here dogs in different guises [7.20; 7.21], snarling, cavorting, or cosseted, clue the viewer into the mood of the moment.

Nearness to nature is at its most telling and touching in one of Dürer's very earliest engravings, *The Holy Family with the Mayfly* [2.3]. Datable ca. 1495, the small print includes a minuscule insect, one that lives but a single day—the mayfly—as the only creature allowed to share the foreground with the mother and her baby. Northern Italian paintings already placed this insect on Christ's tomb, to indicate the brevity of his life on earth. But Dürer gives the mayfly the lion's share of this sad message from the very start.

By about the age of twenty-five, Dürer is close to achieving complete mastery of animal life. Equilibrium between human and beast is realized in his most moving engravings, the many versions of Saint Jerome and the lion and in *The Prodigal Son* [8.4]. Here a powerful young man, possibly the artist himself, kneels in misery in a typical Nuremberg farmyard, one rendered so accurately that its site can still be identified after almost five hundred years. Near a trough, the Prodigal is among the pigs, cattle, and chickens. Only his fancy curls and absurdly grand drapery, now looped above the barnyard's filth, suggest the son's wasted wealth. But now those swoops of costly goods seem like the bedraggled feathers of some grand bird caught in the mud.

Italian artists and critics of Dürer's day, generally so patronizing about contemporary northern art, usually exempted him from their contempt. Where other transalpine works were condemned because they lacked idealism and classical beauty, Dürer was often excused for almost the same reason—his prints were so close to the truth, so far beyond conventional ideas of beauty, that they were accepted as nature rather than art. It was his animals, at least

as much as his people, that won the artist such popularity. They were seen as a mirror and used as a pattern book, ready for admiration, amusement, or adaptation.

Italy and the Renaissance

On his initial southern journey, made in the mid 1490s, Dürer learned at first hand of two distant yet closely connected traditions, those of classical antiquity and the Italian Renaissance. Travels to Venice and to its nearby university center of Padua gave the young artist new knowledge of the rediscovery of the ancient past, seeing how the literary and visual arts of Greece and Rome inspired new subjects and styles. Two monumental bronze horses, so like the ancient quadriga stolen by the Venetians from Constantinople and installed on the porch of San Marco [9.16], were cast by Florentines active in Venice and Padua. Dürer made close notes of these statues, seen from below, following Verrocchio [9.15] and Donatello [9.14], using them for his own equestrian projects [9.46; 9.47] his life long. Though he could not read Greek and knew little Latin, Dürer responded to the spirit of the ancient poetry that saturated the Veneto where wealthy Venetians were building villas on the mainland, near the birthplace of Virgil in Mantua. New songs, celebrating the joys of rusticity like the Latin poet's *Georgics* and *Eclogues*, came to Dürer's ears, ancient texts reprinted in pocketbook size by the great Venetian publisher Aldus Manutius. Dürer's friends asked him to buy such works for them, but before sending the books homeward the artist often embellished the borders or the title pages with scenes from ancient mythology, showing battling *putti* astride their dolphins [Plate 33].

Ancient astrological poetry was widely read in Italy, often seen as a corroboration of folklore in its scrutiny of animal ways, Greek authors relating how the behavior of mice and birds, dogs and cats, predict whether sun or storm will follow.

The Psalms, like Virgil's verses, sang of the beauty of the farmer's life, but all these poems were far from the German peasant's harsh fate, especially those poor farmers dependent upon the crafty folk of Nuremberg. Dürer's art recalls both attitudes, showing compassion [2.16] and derision [8.16; 8.17], the latter a strong element in his merciless view of the Peasants' War of 1525. He painted scenes of the good life in green pastures on the backs of wedding portraits of his dearest friends [8.5; 11.30], wishing them too a fertile union.

Renaissance attitudes toward nature came along with new views of men and women, with novel pride in human beauty found in the cult of the nude, alien to Christianity and to the North. In Italy Dürer could see both ancient and contemporary art of the nude and hear and read some of the literature in praise of the form divine, still innocent of the serpent's wiles. This love of the nude went with a belief in the ancient harmony of man and beast in paradise—a biblical golden age—one leading the young artist into a world light-years away from the cramped, rigorously devout, class- and guilt-ridden climate of his native Nuremberg. Some of Dürer's happiest works were made in Italy, in his brief phase of born-again pagan, free to see us as just another species, completely comfortable in our own skins, with no need to take cover [2.20; 2.21; 2.24; 2.25].

One painter in particular, Andrea Mantegna, who had long worked for a patron from Munich—Barbara of Hohenzollern, the hugely wealthy bride of the marquis of Mantua—had special appeal for Dürer. Unlike most of his Italian contemporaries, Mantegna designed prints as well. He could work on a miniature scale, recalling the early Netherlandish masters, as well as on a heroic one. Much of Mantegna's art was shaped by the same classical sources as those studied by Pirckheimer, who had spent time in Padua and Venice [11.4]. So, in Mantegna, Dürer found an artist who brought together most of his interests—close realism, classicism, animal life,

printmaking, and a special sense of illusionism and precision.

Tiny rabbits take refuge in their warrens as the gods and goddesses cavort in a Mantegna panel for a Ferrarese palace (now in the Louvre). Mice, falcons, and turtles are found among the crags and forests of the hunting parties and diplomatic forays frescoed by the same painter for the Gonzaga castle in Mantua; there also, a favorite ducal dog is painted sitting under his master's chair. Bees buzz in and out of their hives in his *Agony in the Garden*, at Tours. The presence of all these creatures in the Paduan painter's work bespeaks nature studies as intense as Dürer's, although only one survives—a page after a Roman bird relief.

It was in northern Italy, not far from the Alps, that the first great early European nature studies were made in the first quarter of the fifteenth century, those of Giovanni de' Grassi and Michellino da Besozzo followed by Pisanello in Verona and Uccello in Florence. This Italian heritage, still strongly felt by Dürer, had been a stimulus to earlier northern artists. Venice, like Verona and Mantua, Padua, Florence, and Pavia, was always close to visitors and traders from Germany, France, and the Lowlands. So young Dürer, in visiting northern Italy twice, came close to many cultures old and new.

In Venice, center of the antique trade and that of wild animals, both mostly brought from the Near East and North Africa, Dürer could study wildlife as it was shown in the ancient past and as found in living models. He also learned from local masters like Giovanni Bellini how to use blue paper and work with new graphic media for the most lifelike techniques [7.7] and vibrant surfaces and colorings.

German students in Padua would send home bronze medals and plaquettes as well as life casts of animals and shells as scholarly souvenirs of the new classical learning and natural science their fathers were paying for. Bronzed like old baby booties but distinctly cold-blooded in nature (like that of most of their scholarly owners), these casts of crabs [5.15] and crayfish, frogs and toads [5.16; 5.17; 5.18], scarab beetles, and seashells were martyrs to literature, supporting inkwells, seal boxes, sand shakers, and all the other costly trinkets cast and bought for the relief of desktop tedium. Any wealthy author, dipping his quill into some metal frog's mouth, perpetually open for flights of literary fancy penned with a feather, must have felt that the forces of nature as well as those of art were at their command. Dürer may already have seen some of the Paduan life casts in Nuremberg, but it is far more likely that he was himself the major "missing link" between the art of North and South, learning so much from his Italian travels near the century's end and again in 1505–6.

Northerners were keen pet fanciers and *animaliers* but never to quite such an extravagant effect as those of classical antiquity and Renaissance Italy. Devoted to perspectival studies, Dürer must have known of Uccello, his great Italian forerunner in that field, and of that Florentine's passion for animals, true too for Piero di Cosimo. Marco Zoppo, painting in Bologna and Venice, was infamous for his terrifying menagerie of fierce mastiffs.

Italians received a double indulgence for their love of highly bred dogs and racehorses and birds of prey, also importing ocelots, monkeys, jaguars, exotic birds, and even massive beasts like elephants and rhinoceroses. This dual reinforcement came from the new trade routes established by the Portuguese, Spanish, and Venetian navigators who brought these exotic creatures back alive. It was strengthened by the newly rediscovered literary license that came with the publication of little-known Greek and Roman literature so often printed in Rome, Florence, Ferrara, and Venice. Texts like *The Epigrams* of Martial satirizing ancient Romans' love for pets were first typeset in Venice in the mid 1490s, at just about the time of Dürer's first visit. Making fun of his patrons' passion for exotic creatures, Martial asked a long, withering question:

If my Flaccus delights in a long-eared lynx, if Canius appreciates a grim Ethiopian, if Publius is con-

sumed with love for a tiny lapdog, if Cronius loves a long-tailed monkey as ugly as himself, if a mischievous mongoose is a joy to Marius, if you, Lausus, a talking magpie attracts; if Glaucilla winds a clammy snake around her neck, if Telesilla has set up a monument over her nightingale; why should not he who sees such monsters as these please their masters not love the winning face of Labycas, Cupid's boy?

In Italy, where Dürer strutted about in elegant clothing and wrote home of how Venetians treated artists as gentlemen, not as servants or parasites, as they were in his homeland, he also acquired some of the learning, the liberal arts explored in the universities and academies. Bologna and Padua taught the natural sciences, following the Aristotelian method, with perspective and other mathematical studies. Florence was steeped in the fashionable neo-Platonic approach, reinterpreting classical literature along complex, allegorical lines as in the text source for Dürer's *Rape of Europa* [8.36]. One of the books that the artist bought in Venice was the *Hypnerotomachia Poliphili*, printed in 1499. It came from the city's Aldine Press, and Dürer's copy is still in the Nuremberg City Library. Filled with simple yet uniquely evocative woodcuts of unknown design, this archaeological, arcane romance provided the painter with many themes, including unicorns and many other mysterious beasts and hieroglyphs in its classical zoo.

By the end of 1498, Dürer had completed a dazzling print series of unprecedented self-assurance. His fifteen large woodcuts for *The Apocalypse* were not illustrations in the conventional sense, even though he was to issue them as such. They *are* the Apocalypse, standing independently of text as the turbulent visions of Saint John the Apostle. These prints won him his greatest fame and were by far the best known of Nuremberg's many exports. Many more impressions could be made from a woodblock than from a finely engraved copperplate, the latter cracking and wearing out after a few hundred prints at most. Europe, anxiously awaiting the Last Judgment in 1500, was unusually receptive to any images close to that fearsome subject, one most eloquently envisioned in the Revelation. Shrewdly, Dürer later published his edition of that terrifying text in German and Latin versions. Now, for the first time, a visual equivalent to the horrors recited by Saint John appeared in completely persuasive, accessible fashion [12.16; 12.18–12.21; 12.28; 12.29].

These images synthesized the artist's medieval heritage of fantasy with his new realism and scrutiny, made possible by the naturalism that had come Dürer's way by Netherlandish as well as Italian travels. It was the artist's studies of Verrocchio and possibly of Leonardo's new zoos that gave Saint John's angels the gift of flight and his dragons [12.23] that special sense of reptilian monstrosity. Never were the Four Horseman [9.22] shown with such plausibility or Satan with quite so forceful (if artfully disguised) Mantegnesque skill.

These woodcuts were copied worldwide, in Peruvian frescoes and those of farthest India, in Iranian manuscript illuminations and Spanish stained-glass windows. Like many of the artist's finest works, *The Apocalypse* owes much of its great force and appeal to the animal imagery, which rivets the reader-viewer's attention.

In the 1490s Dürer worked toward his mastery of watercolor and that medium's opaque equivalent, gouache. These difficult, rapid, largely uncorrectable media made possible some of the most marvelous nature studies ever made. Richly colored plumage [Plate 5] or the varied textures of a hare's glossy eye, furred coat, or damply twitching pink nose [Plate 13], all were caught in the spontaneous, freely brushed look of watercolor on paper and sometimes on vellum. Panel painting too could provide a good background for such subjects,

the white gesso ground enlivening the thin layers of transparent oil pigments that Dürer painted one above the other, not far from the way of the Early Netherlandish School but with a new addition of Italianate freedom of touch [Plate 20].

In the year 1500, Dürer, now nearly thirty, was almost unrivaled in his mirroring of the look of life. A self-portrait of the same year [1.29] presents the painter in a strikingly Christlike pose, as if aspiring to divine creativity. That he felt himself heir to the artists of classical antiquity is evident in the lengthy Latin inscription alongside the artist's image, which uses the same formula as those for a Zeuxis or Apelles, both celebrated illusionists and master *animaliers*.

By 1503, Dürer had engraved his two masterworks of Christian faith, his most exhaustively encyclopedic explorations. First of these is his largest and most varied plate, *Saint Eustace* [1.30], with its countless animals. Another world of creation is presented in two preparatory drawings [2.9; 2.10] and a pen and watercolor [Plate 2] of Our Lady of the Animals, a rich zoological theme, a Christian bestiary and flower garden, that union largely of his own invention. This intricate composition may also have been destined for an engraving. Seldom again would Dürer pay such extensive tribute to his medieval heritage. From then on, when complex images were called for, as in *Adam and Eve* of 1504 [2.18], or *Knight, Death and Devil* of 1513 [9.47], his own earlier art, along with that of antiquity and Renaissance Italy, often provides his major models, rather than life itself.

In 1505, Dürer, now internationally famous, returned to Venice to protest local engravers' copying his prints. Though these practices could not be stopped, the city, according to Dürer's account, offered him its highest honor, the position of city painter, which he rejected. But he stayed there for almost two years. The local German merchants' society ordered a massive, now ruined altarpiece (Prague) for their altar. Like the Greek painter Apelles, Dürer added a fly close to the Virgin's knee, painted near Maximilian's head, reminding the viewer of the legend of that ancient artist, who painted a fly with such brilliant illusionism that all tried to brush it away. That story's revival flattered Maximilian, making him into an Alexanderlike figure, matching his imperial ambitions.

Back home, Dürer was ready to take on complex classical subjects, hoping that they might prove as popular there as in Italy; such elegant profundities helped one forget or obscure the cruel moneylending practices that won major mercantile centers like Florence and Nuremberg their great wealth. Dürer brought intricate allegories like the engraved *Melencolia I* [3.16] to life by making such symbolic elements as her sleeping dog [7.40] and the bat above so unusually compelling, stressing natural elements to soften the rigidly reasoned, forbiddingly erudite theme. Whereas

1.29

23 The Artist as *Animalier*

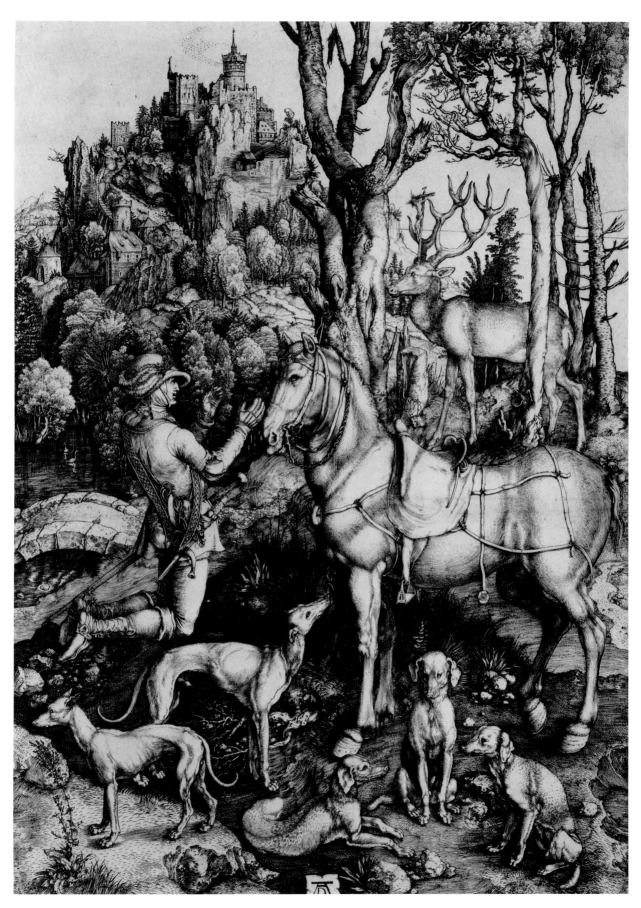

the woman symbolizing the black despond of Melancholy is so powerfully masculine and Michelangelesque that she commands little if any compassion, the dog asleep at her feet proclaims her humanity by "personifying" her fitful torpor. It takes a bat, that night-flying, frightening fusion of bird and beast, to tell us what the print is all about, quite literally bearing the caption across its wings [4.9].

Two other prints, *Saint Jerome in His Study* [6.10] and *Knight, Death and Devil* [9.47], along with *Melencolia I*, are known as the Master Prints. The three were engraved between 1513 and 1514. Dürer's most profound and still enigmatic works, this trio grapples with questions of, and conflicts between, faith, thought, and action. Each dark scene, illuminated by sudden shafts of light, stages the challenges of mortality and redemption. We are not alone but accompanied by animals that often symbolize aspects of life and death, confidence and failure, good and evil. All three prints, completed less than a decade after his second Italian journey, recall the artist's Renaissance-inspired studies as well as those after nature and antiquity.

For more than a decade, Dürer's commissions centered upon the pageantry and complexity of the Holy Roman emperor's itinerant court, which moved from his native Austria to his leading German imperial cities of Augsburg and Nuremberg. Maximilian's inflated ambitions and shriveled purse limited his commissions largely to works on paper, to the full pictorial panoply of classical triumph, a great arch of victory [1.31], and several parades [1.32]. So Dürer helped design hundreds of woodcuts for the arch and for the prancing steeds drawing weighty pageant wagons. These imaginary chariots and arches were painted and carved with hundreds of panthers, tigers, and hosts of other real and mythological beasts, many of them on shields and banners. Self-appointed heir to the gods and pharaohs of ancient Egypt, the emperor, with Pirckheimer's aid, had Dürer illustrate the ancient manuscript of Horus Apollo explaining the hieroglyphs. To further Maximilian's dreams of world conquest, Dürer devised star charts [10.3; 10.4] and world maps. These helped realize a vast empire to the east and west, one that actually came to be in the reign of his grandson Charles V. During the years he worked for Maximilian, the artist's work was pulled in two different directions—expended upon pageantry in the traditional manner, in well-paid, repetitive drudgery, and to the exploration of many of the new sciences on his own.

Upon the emperor's death in 1519, Dürer followed his Spanish-born grandson Charles V to the Lowlands to ensure the pension of one hundred florins that Maximilian had promised him. It was then, if not before, that the painter had a chance to explore the artistic wonders of that incomparably rich region, studying great paintings by the van Eycks and Roger van der Weyden and of the new school of Antwerp. Traveling with Agnes and her maid, Dürer kept a careful account of every penny spent. His father had worked in the same area, and some of Dürer's nature studies may have been determined by those of such earlier painters as Gerard David, the Bruges master whose approach to flower painting was so like his own. Dürer drew the animals in Charles V's Brussels zoo [10.14], lions in the moat of the magnificent old Ghent castle [6.40; 6.41], and dogs [7.38; 7.39] and horses seen all over the Netherlands. These were sketched rapidly in little pocket-sized notebooks that were instantly available for a quick draw. In his diary, Dürer described the small green tropical birds [Plate 30] given him by Rodrigo, the Portuguese agent in Antwerp, the Aztec gold animals and feather mantles laid out in the same city, the exotic little turtles, rare seashells, and horns, many of which he added to his own *Wunderkammer*, for his chamber of natural wonders, or bought for Pirckheimer.

When Dürer visited Margaret, governess of the Netherlands, daughter of Maximilian,

25 The Artist as *Animalier*

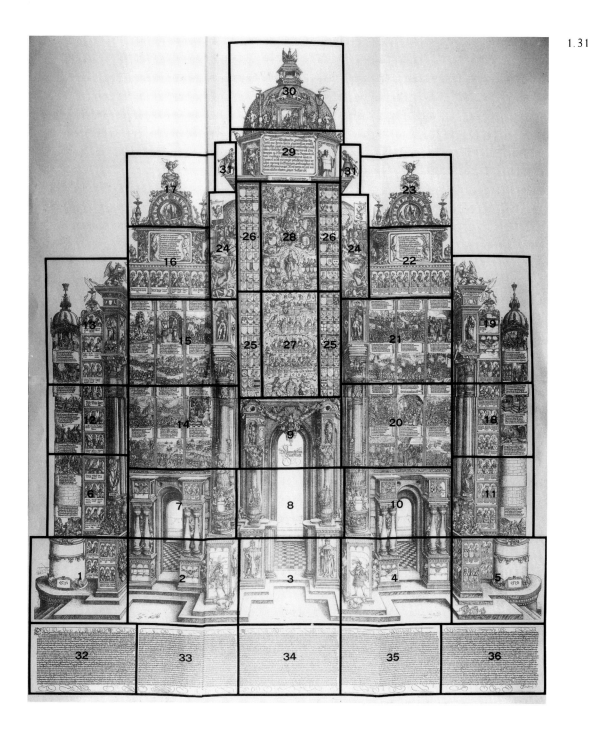

1.31

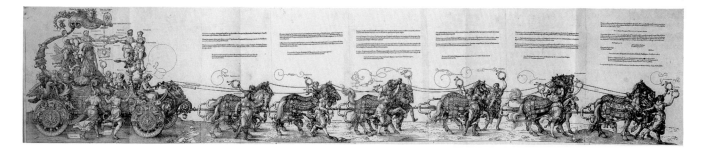

1.32

he received a cool greeting at her lovely small court in Malines. The lady was far fonder of her parrot, which stayed on her shoulder throughout their interview, than of Dürer's work. In Antwerp he saw massive bones and fossils and sketched living wonders as well, exotic birds, parrots, and snails from faraway places.

In 1521, on that same journey to the Netherlands, Dürer met the great Erasmus of Rotterdam, drawing and later engraving his portrait [1.33]. Thousands of that scholar's pages of Latin correspondence and literature are enlivened by references to animals, from the sacred to the profane, the tragic to the comic. Long self-supporting as a tutor—including Charles V among his pupils—Erasmus knew how important it was to have his young students learn for pleasure rather than from fear. His appreciation for the gifts of the animal as teacher came from the literature of classical antiquity. Erasmus enjoyed such passages as that of the ancient Greek philosopher Democritus: "In the most important things men are taught by animals. The spider in weaving and darning, the swallow in domestic architecture, and songbirds, the swan and nightingale, in songs and even in the ways of imitation." Imitation—at the heart of all the arts—was found in nature in the parrot's speech and in the ape's ways, both creatures seen as copying man, who, in turn, was made in God's image. These animals were also believed to be among nature's greatest artists, providing the models for our own attempts to copy God's creation in drawing and painting, sculpture, and music.

For Erasmus, animals occupied a unique role as models in the educational process. New private schools independent of the Church were just being founded all over northern Europe for rich or gifted students. So the scholar proposed that "from all that varied mass of material which the curiosity of antiquity has handed down to us," what students should first learn was "the natural history of birds, quadrupeds, wild animals, serpents, insects, fishes; this will principally derive from ancient writers. . . . Next we shall prize the accounts of singular adventures handed down to us by trustworthy authorities." Among these examples, "as vouched for by Pliny," are the stories of Arion and the dolphin, which Dürer drew [Plate 32], and that "of the lion who returned [Androcles's] kindness for kindness," another of the artist's possible subjects [6.19].

Animals preparing their young for life provided Erasmus with proof for his thesis that parents needed to take their children's future into early and serious consideration, the subject of his treatise "That Children Should Straightaway from Their Earliest Years Be Trained in Virtues and Sound Learning." He condemned parents for spending more care in choosing a dog than a tutor for their children and censured them for imprisoning their offspring in fancy clothes, telling them to buy trained monkeys and so dress them instead. Again using Pliny, along with Plato, as his undisclosed sources, Erasmus wrote of the ways in which animals raise their young, birds teaching fledglings the art of flight, cats taking their kittens on the prowl, stags warning their young to escape the human hunter. He wound

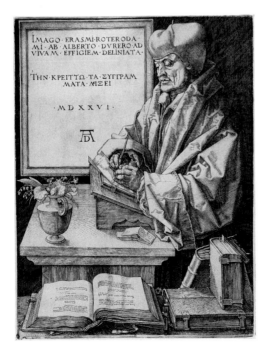

1.33

up this lesson with an all-important, optimistic punch line:

And I affirm that, as the instinct of the dog is to hunt, of the bird to fly, of the horse to gallop, so the natural bent of man is to philosophy and right conduct. As every creature must readily learn what it is created for, so will man, with but slight effort, be brought to follow what Nature has given him so strong an instinct for—the pursuit of excellence, but on one condition: that Nature be reinforced by the wise energy of the Educator.

Erasmus wrote that the teacher should "show a picture of an elephant in combat with a dragon. . . . the class is interested at once"; and with pictures of hunting scenes, "a wealth of information about trees, plants, birds, and animals may be imparted in most delightful yet instructive manner." Dürer's animal prints may have been used by teachers following Erasmian progressive ideals to make dead languages and learning come to life. Working as a study aid, it is easy to imagine *The Rhinoceros* [10.40] employed to so lively an end.

Dürer's wisdom and artistic energy also cast him in the role of Erasmian educator. Supreme imitator of the way animals look and live, he also became teacher of human ways along with those of the squirrel or hare, lion or stag beetle. Unlike so much medieval scrutiny of nature, designed only to fill the spectator with awe for the Lord's work, this new, humanistic approach leads to self-understanding by exploration of the surrounding world.

At the same time that Erasmus was "restoring" Saint Jerome's Latin writings (protesting that the Church Father's poor prose style had ruined his own), Martin Luther was preparing a new German translation of the Bible. Each, in very different and largely opposed ways, contributed to the Reformation. Disliking Jerome even more than he did Erasmus, Luther noted, "Surely there is more learning in Aesop than in all of Jerome."

Many of Luther's strongest sermons were supplemented by animal cartoons, some of them brutal caricatures that circulated throughout Europe openly as well as underground. His happier animal images provided lively links between theology and the everyday, making Luther's Christianity remarkably direct and clear, qualities to which Dürer, an unusually sensitive, anxious man, always responded. Like the fathers of the early church, Luther also broke with contemporary Rome. He used the Parables, those humble ties to rustic experience, and the still-tangible wonders of Genesis to draw close to those who heard or read his sermons. Luther had a keen appreciation for animal life, loving domestic pets and those of the farm alike with a benevolence less evident in his dealings with mere mortals.

Like Erasmus, Luther was a great teacher. He employed the visual arts in many of his publications. Appreciative of painting, print, and sculpture, he was responsive to their power for good, the German Reformer no friend to Calvin's resolute iconoclasm.

Many artists caught in the conflicts of the Reformation, including Dürer, responded to Luther's message and joined his cause. The painter's interest in science and experimentation, along with his natural anxiety and ever-present stress, also made him welcome a new faith that seemed more rational and protective, closer to the climate of modern knowledge and the spirits of nationalism and commerce. His own publications of illustrated cycles of the Life of the Virgin and the Passion shared Luther's goals of a clear, less mystical approach to Christianity. The Reformer owned several of the artist's works, and the artist owned several of the Reformer's. In 1525, Nuremberg officially joined Luther's side.

<center>AD</center>

Dürer's zoological, perspectival, and other arts were important for a new world of scientific discovery. Close to Italy's modern artists, who saw themselves as heroes—virtuosi as well as geniuses and scientists, their academies close

to the universities—Dürer identified himself with Hercules, that legendary strongman, sole mortal elevated to divinity. He used himself as that hero's model in a poorly preserved canvas of 1500, depicting Hercules's victory over the beastly Stymphalian birds. This was painted for the Elector of Saxony, who, like most men of power, also believed himself to be Hercules Reborn. Working once again for a ruler, for the Holy Roman emperor Maximilian, Dürer may have wanted to remind his patron of his own lofty status by repeating this scene, once again his own model, so drawn in the margins of the emperor's prayer book.

<div align="center">🇦🇩</div>

Dürer made few etchings, a technique he only used around 1512, near the time of its invention, possibly in Italy. Because it involved the use of acid or *aqua fortis*, the method was associated with black magic. Not all etchings were redolent of those dubious arts. They could be unusually light filled and impressionist in effect, like Dürer's *Saint Jerome by the Pollard Willow* [6.15], which allowed for a unique fusion of the mass-produced image with subtle gradations in illumination unrivaled until the etchings of Rembrandt. The Nuremberg artist's prints could convey gradations of intimacy, a new sense of subtlety and informality, qualities seldom found in northern art of the period.

Among the most dramatic of Dürer's etchings is *Rape on a Unicorn* [11.43], in which a hefty nude is carried off by a muscular, bearded man astride a shaggy unicorn. Naked, he hangs on to his mount by grabbing the unicorn's mane with one hand, encircling the victim with the other arm. For all their agitated fray, the couple's swirl of arms and legs recalls a pinwheel, oddly irrelevant in the face of the monumental unicorn as that unbridled force of nature sweeps them both away. Possibly showing the rape of Prosperpina by Pluto, god of the Underworld, this print is among Dürer's most expressive later works. Even though classical in reference, there is something about the beast as well as its burdens that recalls the dark forces of northern mythology, of wild ways to deepest perdition, lost in the *Urwald*, that impenetrable forest primeval.

Enticed by the concept of mathematically determined, perfect form, seduced by the ideal of divinely prescribed visual order, Dürer followed Mantegna, Piero della Francesca, and Leonardo da Vinci in their pursuit of the sacred mystery of measure. These magisterial concerns slowly drew artists away from the fascination of fact, from motion and emotion, from the challenges of immediacy, toward the cold, dry pursuit of the absolute.

Why did Dürer, like other, earlier Renaissance masters, veer away from the accessible world of nature, one he knew so well, and one that he, better than anyone else, could recreate with such force and conviction? A letter of 1523, sent to a group of Swiss Protestant ministers, provides the clue to this change. Written on the back of a savage caricature of the Mass, in which a round dance of cavorting monkeys satirizes the gestures of the priest and acolytes [10.23], Dürer apologized for his feeble rendering of the animals, saying he had not seen any for a long time. This drawing merits an apology, if not for its content, then for the way in which the monkeys resemble stuffed toys or baggy costumes hiding human wearers. Dürer's excuse was as weak as his sketch—just two years before he may even have bought some of these monkeys during his Antwerp days. What his note really meant was that the aging artist no longer cared about the outer world, that of appearances. He was becoming impatient with the accidents and irregularities of surface, with the individual that diverges from the ideal. Feeling his life shorten, Dürer wanted to get back to basics. He was searching for the keys to fundamental, eternal knowledge, for keys to the universal, not the particular, for those opening the doors to the laws for understanding the "how" and the "what" if not the "why."

Ever more learned in astronomy, cartog-

raphy, and mathematics, where his art and vast intelligence had lead him almost effortlessly by way of perspective's geometry and other sciences, Dürer felt less need to study the comfortable surfaces of the known, disdaining the needless reassurance of the familiar. Pursuit of imitation, the role of illusionist—these probably struck the painter as increasingly unworthy pursuits. A devoted reader of Plato, Dürer may have followed the philosopher's dim views of art as "deception", naming his own painter's guide after Plato's *Banquet*.

Leonardo da Vinci may also have moved Dürer away from the particular to the universal. The concept and mystery of perfection and the pursuit of the divinely ordered ideal, one that could be captured by mathematical keys and codes, were central to Leonardo's art [9.38]. Dürer followed him in his obsession with measure, retracing the rules of proportion over and over again in endless tedious publications. This concern with the abstract, with the beauty of number, came to blind the German master to the fascination of fact, to the study of texture and motion, of flight and feather, of anatomy and ecology, which had all so profoundly enlivened his art. "When I was young," he wrote in Latin to Luther's friend, the scholar Melanchthon, "I craved variety and novelty; now, in my old age, I have begun to see the native countenance of nature and come to understand that this simplicity is the ultimate goal of art." Even if Dürer saw most of Leonardo's works only in copies, prints, and small bronzes, so seductive was their still-powerful shadow, their echo of the original's power, that they drew him away from his own greatest strength—seizing nature—to redrawing and tracing her idealized outlines ad nauseum.

Dürer dedicated his book on proportion and measurement to Pirckheimer, whose sister, a nun, wrote him that one of her sister nuns, a painter, had said of this book "She does not need it because she can paint just as well without it." The same holds true for Dürer himself, whose work was far better before preparing these studies, before the deadening obsession for the ideal rested ever heavier on his hand and over his eye.

<p style="text-align:center">AD</p>

If Dürer was inching ever further away from the minutely descriptive to a grander, more formal view, the desire for the first never quite lost its grip on the artist's life, and it even caused his death. On the artist's journey to the Lowlands in 1521, he learned of a great whale, washed ashore at Zierikzee [5.20]. Dürer vowed to see and draw this greatest of beasts, the one nearest biblical descriptions of God's monsters of the deep. After a hazardous journey through the mosquito-ridden Netherlandish mud flats, he just missed the chance to draw that vast animal, which had vanished. Soon the painter was subject to wracking fevers, probably due to a malaria-bearing mosquito, their torments plaguing him on and off until his death seven years later. So the animals' most faithful artist was killed in the pursuit of drawing the very largest, by a bite from one of the very smallest.

Almost four hundred years after Dürer's death, another German artist, Frans Marc, drew upon his lines. He wrote to a friend, "I am trying to create pictures with a new sense of motion and with colors that will mock the easel paintings of the past. . . . I can see no more successful means toward an 'animalization' of art, as I like to call it, than by painting animals. That is why I am doing this."

The poet and painter Elsa Lasker-Schuler, lamenting Marc's death in the First World War, wrote, "He was the one who could hear the animals speak, and he transfigured their uncomprehending souls." But to transfigure—to show the being beyond physical limits and constraints—is not what Dürer did. He was the more modern, the less mystical of the two men. As re-created by art, Dürer's animals seem, if anything, more their physical selves than ever.

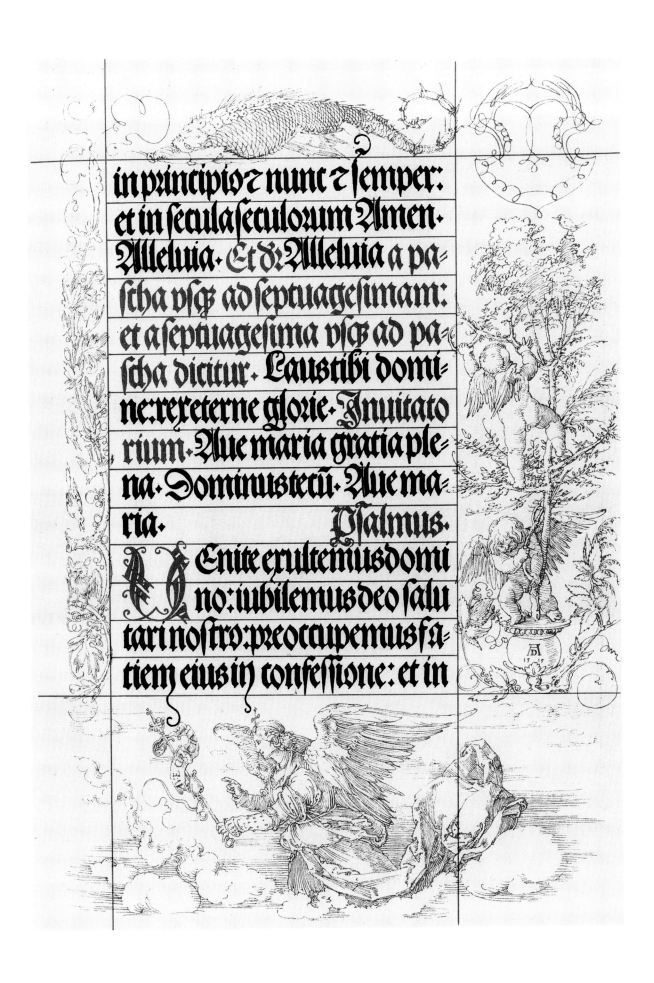

in principio z nunc z semper:
et in secula seculorum Amen·
Alleluia· Et dr Alleluia a pa
scha vsq; ad septuagesimam:
et a septuagesima vsq; ad pa
scha dicitur· Laus tibi domi
ne: rex eterne glorie· Inuitato
rium· Aue maria gratia ple
na· Dominus tecu· Aue ma
ria. Psalmus.
Enite exultemus domi
no: iubilemus deo salu
tari nostro: preoccupemus fa
ciem eius in confessione: et in

Chapter Two

Our Lady of the Animals

Annus mirabilis—the year of wonders—is a term used to describe a productive period in the life of an artist of genius; 1503–4 was one of Dürer's. His works from this time encompass the worlds of faith and science, from the extremes of Gothic mystical devotion to the closest scrutiny of surface reality, a range that can be best seen in two much-loved watercolors: *The Great Piece of Turf* [2.1], in which every blade and bloom of hundreds of wild grasses, assembled from studies made in different seasons, are recorded with uncanny sharpness of focus and precise observation; and *Our Lady of the Animals*, which depicts the Virgin and Child surrounded by a touching variety of God's creatures. In the engraved *Adam and Eve* of 1504 [2.18], innocence and immortality alike are about to be lost, but innocence and paradise regained is the message of *Our Lady of the Animals*. Just as expulsion follows the Fall, so salvation through Christ's sacrifice follows the scene of motherly love set in the midst of adoring nature.

Few of Dürer's botanical studies are preserved, but those that survive are as novel and beautiful as his animal studies. Like the latter, their roots are in the realistic art of the Netherlands and Italy, from the late fourteenth and first half of the fifteenth centuries. Most of his watercolors and gouaches of herbs, plants, and flowers are of those with healing qualities, reflecting the true meaning of the word *salvation*. In the months when Dürer was working on *Our Lady of the Animals*, he was also painting *The Great Piece of Turf*. Both studies are equally encyclopedic, each a gathering of the infinite variety of divine invention. Random and almost accidental though the leaves may look, three have special healing qualities, recognized by Albertus Magnus. One of these, beneficial for eye troubles, would have been of interest to any artist.

Just as *Our Lady of the Animals* refers clearly to God's creativity, so may *The Great Piece of Turf* reflect that of the human artist. Marsilio Ficino, the Florentine philosopher whose works were well known in Nuremberg, described how the great Greek painter Apelles, after seeing a field, painted blades of grass to express his creative soul. Often compared to Apelles, Dürer may have taken such a symbolic account to heart. Both of these studies, one so openly a mirror of faith, the other so obviously a mirror of nature, are complementary.

2.1

Had Dürer not been the consummate master of drawing from life that he was, animals would still have figured in his work because they and their symbolism surround many subjects from the Bible, the center of his art. The Holy Spirit is traditionally shown as a dove present at the Annunciation and at Pentecost. The Magi are often accompanied by wild beasts from Africa, India, and Asia, a sign of their earthly dominions. A train of camels, cheetahs, leopards, exotic birds, and cavorting apes follows the kings, scattered among their splendid horses, tended by African and Oriental grooms and gamekeepers wearing twisted turbans and fantastic armor.

Dürer showed Jesus holding a bird or playing with a finch on a string [2.17]. Flying skyward, such birds symbolized the soul and its release; the Infant's finch also suggested the brevity and tragedy of his life on earth. Animals were even understood as portents of Christ's coming. Saint Jerome, in his Christmas Day homily explaining Jesus' presence in a manger, said, "That the prophecy of Isaiah might be fulfilled: 'An ox knows his owner, and an ass its master's manger!'"

Dürer's way to the living landscape, to plants and animals, like that of his patron saint, Albertus Magnus, is found in the intimate tie linking his faith to the visible world: Nature, like Dürer's art, reflects creation in its primal, pristine beauty; nature's infinite variety represents God's inventiveness as seen in his works. Early in the sixteenth century, before he turned obsessively to the Renaissance concern with ideal proportions, Dürer examined the surface, texture, and fiber of life, down to its smallest creatures, and found in it the first Garden of Eden and the promise of the second.

Dürer's intensive use of animals as messengers and as symbols of his faith may have been influenced by Saint Jerome's belief that animals stood for constancy: Still just as God made them, they had never changed. Man, though molded in God's image, was never the same after the Fall, awaiting Christ, the new Adam, for salvation. When Dürer devised *Our Lady of the Animals* he may well have thought of Jerome's *Homily on the 148th Psalm*, "Wild beasts, creeping things, fruit trees, winged birds, all these give praise to God by the very fact that they do not change their nature . . . it is through God that they serve and obey." Here Dürer's is a theologian's zoo, collected in creation for the saving presence of Mother and Son.

In many ways *Our Lady of the Animals* draws on medieval depictions such as the fourteenth-century English *Queen Mary Psalter* [2.2]. Dürer's enchanted garden is a sanctuary of hope and peace, a land of perpetual promise. Gathering the creatures from Eden's garden and Noah's ark, *Our Lady of the Animals* moves back and forth in time—from the Fall, when para-

dise was lost, to the Son's sacrifice, by which it was regained. (The late fifteenth century was the time when the idea of the Immaculate Conception was first made popular, though it only became Catholic dogma three hundred fifty years later; it meant that Mary was conceived without the stain of original sin; later, she would conceive without the sexual act—superhuman genesis that empowered her as the new Eve, with her Son as new Adam, to redeem us.)

One of the best-known books in Dürer's youth was a text proving Mary's purity by the behavior of the birds and the beasts. Francis of Retz's *Defensorum virginitatis Mariae*, an almost Darwinian "defense" of his subject, showed how the ways of oyster and clam, bull and bear, phoenix and lion, dragon and fish, heralded the Virgin's Immaculate Conception and the miraculous birth of her Son. As evidenced by the inclusion of such fabulous beasts as the phoenix and unicorn [Plate 26], Francis went back to the bestiaries and other medieval accounts of mythical animals to support his argument. Dürer may well have owned a copy of Retz's book. It was reprinted many times in his boyhood, and when he worked in Basel, about ten years before drawing *Our Lady of the Animals*, new editions of the *Defensorum* were printed there. He would certainly have seen if not read Retz's message several times over, before preparing his three richly zoological pages.

Formal subjects, such as the Virgin and Child enthroned, seldom allowed Renaissance masters the chance to display their nature lore. But Antonio Negroponte, a midfifteenth-century painter who belonged to the Order of Saint Francis, broke from tradition by laying nature's variety at Mary's feet, in an altarpiece for the Church of Saint Francis of the Vineyard, which Dürer might have seen on his first visit to Venice. Birds and cold-blooded beasts stand just below the ancient steps of her throne. Mother and Child are enthroned on a rustic bench in *Our Lady of the Animals*, bringing together the tradition of the garden of para-

2.2

dise and the new world opened up by the Venetian artists' voyage into nature.

The theme of the courtly little cloistered garden of paradise where Mother and Child are surrounded by birds and flowers ended with the early death of Mary of Burgundy, bride of the emperor Maximilian. Many of Dürer's works for him were cast in a richly romantic mold, in keeping with the splendor-loving ducal house. Dürer's goldsmith father must have seen many works in precious metals, fairy-tale tableaux of enameled unicorns and other bejeweled birds and beasts surrounding images of the Virgin and Child, tiny, precious worlds made to dazzle and delight. Small gardens of paradise were also painted, with an opulent display of flowering shrubs and fruit trees, banks of roses, beds of strawberries, and choirs of birds and angels, singing and flying

around Mary and her baby. Such scenes were also inspired by the new nature-loving poetry of the northern troubadours. In these small heavens, Mother and Son sit close to the ground, abandoning jeweled thrones for humility's sake. Medieval writers believed that the Latin word for earth—*humus*—provided the root for the virtue of humility. So, by presenting the Virgin and Jesus informally, seated on a cushion or raised bank of grasses, artists also showed the humble humanity of Mother and Son, ready to save the world on which they sat. Dürer followed such ideas in *Our Lady of the Animals* and in other early works such as his *Holy Family with the Mayfly* [2.3]. He often made reference to the enclosed garden, a common symbol of the purity of the Virgin. By placing the Mother and Child in an islandlike setting, cut off by winding stream or walls from the rest of the composition, they were safely removed from the evils of this earth.

Love, filling these diminutive paradise gardens, also had its earthly equivalent at the precious courts of chivalry, where knights jousted in the name of love. Dreams of lovers enjoying one another in a state of endless grace were shared in all the arts and by those who could afford to buy them. This earthly paradise was filled with songbirds and plentiful supplies of game—as seen in one of the most popular prints of the midfifteenth century [2.4], its engraver known only as the Master of the Garden of Love. Ordinary chores are tended by invisible hands so that the courtly couples may devote themselves to love alone, surrounded by about thirty creatures. Most important of these is the little unicorn quietly dipping his horn in the stream at the far right. This act tells us that we see an earthly paradise as the legendary beast purifies the water by making the sign of the cross with his horn, creating a new Eden, a peaceable kingdom, saved by love.

A falconer, his predatory bird tied to a nearby fence, kneels before his lady. She holds his hunter's hat in her lap, toying with a love offering of flowers. Their dog, dozing, may represent fidelity. In the center foreground a jester makes signs of love, accompanied by a long-curled lutenist. His monkey is chained to a fence, chattering with a trained bear, as another couple, also shown with their dog, play cards. (Early playing cards, either handpainted or engraved, showed instead of hearts, clubs, diamonds, and spades, all sorts of animals [3.3; 3.4; 4.1; 4.2; 6.12] and flowers—so that the players were gambling with nature. By Dürer's time, such images were replaced by classical gods and goddesses. As a young artist, Dürer copied both versions, so learning of pagan faith, Renaissance art, and a variety of flora and fauna, all at the same time.) Birds fly overhead and animals abound in the woods surrounding

2.3

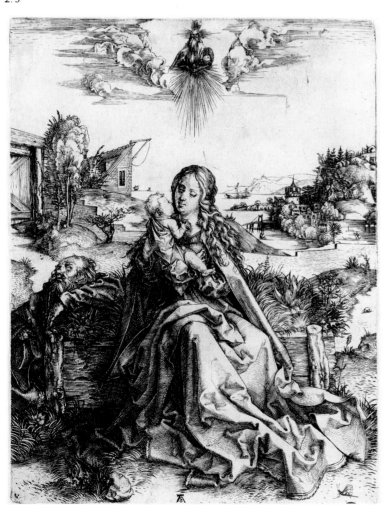

35 Our Lady of the Animals

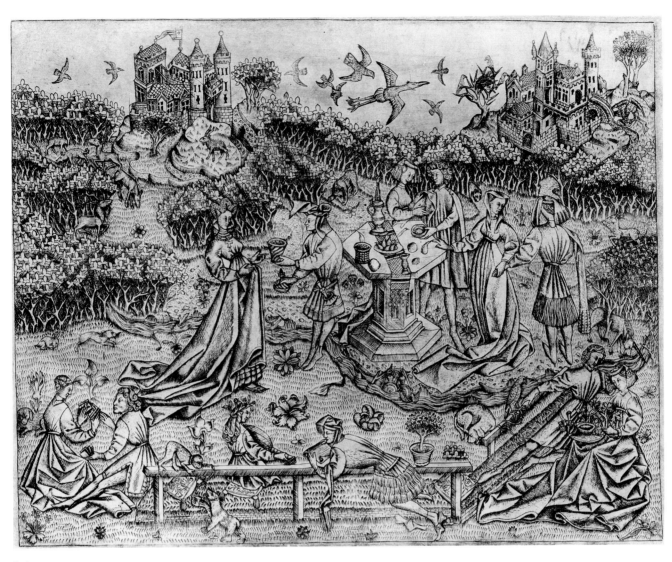

2.4

two great castles in the background, this garden also a game preserve that feeds the game of love. But for a single predatory bird in the sky, and the falconer's, this is an enchanted world where human and beast live in harmony.

Tapestrylike, in the same tradition as the printed *Garden of Love*, is an early Dürer sketch that shows the pursuit of the courtly pleasures at a palatial garden party. Dazzling for its speedy rendering of almost innumerable details, *The Pleasures of the World* [2.5; 7.48] is also steeped in the lore of the love garden. Probably made before his first Italian journey, the sketch draws on the same sources he used for the setting of *Our Lady of the Animals*. Here he celebrates this life by presenting those who can best afford to do so, while dropping a hint of the party's fatal ending.

Couples strip for mixed bathing in the pavilion at the far right, while others eat, drink, and gamble. A bold young man is about to be debreeched by two girls as he hangs on to a fellow picnicker for protection. Eight leaping dogs cavort among the couples. A great tournament takes place shadowed by the vast castle in the distance, as horses water in the grove at the upper left. Death steals in at the lower right, a coffin borne jauntily on a bony shoulder, jaws parted in an ironic grin, but the partygoers are too in love with them-

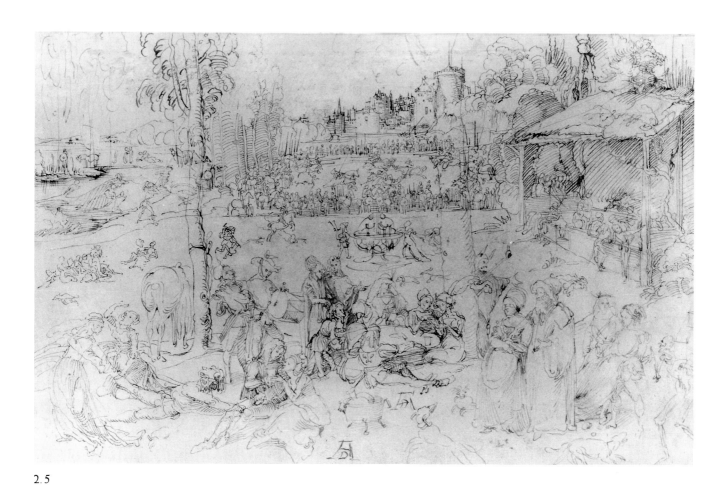

2.5

selves or each other to note his coming. Only a dog, smart enough to smell out Death, rushes at the party's last arrival.

The Holy Family with the Mayfly is Dürer's first engraving to be signed with his monogram, given in a wiggly Gothic shape. This print also draws on the rich soil of the love garden, again stressing the humanity of Mary, Jesus, and Joseph. Fast asleep at the left, Joseph may already be wearied by the strains of the flight into Egypt, his age and feebleness underlined to make it clear that he could never have been the baby's real father. Bareheaded, Mary is shown not as future Queen of Heaven but simply as a doting mother, holding her homely son's face close to her own. This Holy Family is a devotional exercise in humility, seated close to the earth.

Just as Dürer is trying out his recently developed printmaker's skills, so is he first venturing upon a close study of nature. Such observation, in the early 1490s, is still very tentative. The insect at the lower right, placed parallel to the artist's initials, has lent itself to a whole list of names—dragonfly, cricket, butterfly, locust, grasshopper, and recently and most implausibly of all, praying mantis! Perhaps it is a mayfly, known in German as a "one-day fly," humble yet eloquent prophet of Christ's crucially short life on earth, proof of earth's salvation. Its presence calls to mind Keats's "On the Grasshopper and Cricket," whose tiny, noisy subject "rests at ease beneath some pleasant weed, its living presence proof of earth's poetry." Like the sculpture by Tony Smith, *Gracehopper* (a name borrowed from James Joyce to signify the great gifts of imagination and creativity), Dürer's mayfly, too, bridges the gap between God and mortal, between the momentary and the eternal.

Other small creatures appear in the foregrounds of several Dürer woodcuts devoted to the Virgin and Child. In the earliest of these, *The Holy Family with the Three Hares* [2.6], Joseph looks worried, hat and stick in hand, as he leads his family to safety in Egypt. Once again the Mother and Son are humbly seated on a grassy bank in a brick enclosure. The Infant plays at reading a book of prophecy foretelling his tragic and glorious fate, which will end happily with Christ's coronation of Mary in Heaven, as anticipated in this woodcut by the two angels who fly a cross-topped crown over her head. Just to the left of the artist's monogram, a hare runs to shelter while two others, like a vaudeville team, suggest the monkeys who neither see nor speak evil. The hares, like the often erotic and eccentric drawings squeezed in the margins of sacred medieval texts, provide comic relief from the scene of high seriousness above.

In *The Glorification of the Virgin* [2.7], a woodcut close in date to *Our Lady of the Animals*, a rabbit dashes along a ledge, dodging little vases filled with Mary's flowers, lilies of the valley and peonies, in order to escape a cherub. Other cherubs hold small blank shields to be handcolored with the coats of arms of the print's newly wed purchasers. The cherub chasing the rabbit grabs its foot for good luck, meant as a guarantee of the couple's fertility. As if they were messages on a greeting card, Dürer delivers at least four separate sentiments on one page: "Wishes for Loving Marriage," "Many Happy Birthdays," "Good luck," and "May the Holy Mother and Child, Saints and Angels, Always be with You."

Dürer's engraving of the *Madonna and Child with Monkey* [2.8] also dates from the early 1500s. The monkey is chained to a wooden fence below Jesus, who feeds a thrush from a little sack. The fettered beast refers to Christ's conquest of the devil; the thrush, to the Resurrection. Once again Mother and Child are humbly placed, on a little island.

The three full-page studies Dürer devoted to the subject of Our Lady of the Animals in 1503 may come just before or after *Madonna and Child with Monkey*. Earliest of these is in the Berlin Museum; the next, more finished but less rich in content, is in the Louvre; and the final rendering is in the Albertina. As each version is successively smaller in size, Dürer may have been working toward a print's design, one that was never engraved. Many of the animals, along with their richly varied settings, are taken from the gentle heritage of late Gothic art. Only Mary and her Son are new in their dynamic, spiraling poses: The torsion of her body and the intricacy of his outreach show how Dürer now turned to Italy, especially to Leonardo, for new insight into the mystery of movement.

All three drawings place Mary and Jesus in an enclosed setting, with Joseph just beyond the pale. Both the annunciation to the shepherds and the Magi's arrival are shown in much smaller scale above. Kings and shepherds are far apart in the Berlin drawing [2.9]. Though few, those squiggly lines at the upper left let one tell the sheep from the goats and spot the herders' seated dog among them. A single boat bearing the Magi is on the horizon at the left, in dramatic isolation. Camels with the three kings' treasure-laden retinue are above Mary's head on the left. (Dürer never could do camels—their heads and necks look like the Loch Ness monster's.) Even in this first hasty sketch, minute animals are clearly drawn, Calderlike in the wiry economy and wit of their outlines.

A leashed fox at the lower right stands for the devil, to be caught by Christ's sacrifice. Jesus was to speak of the fox, comparing Herod to that shrewd beast. Of his own homelessness he noted that "even foxes have holes, and birds have nests; but the Son of Man hath nowhere to lay his head." In the Song of Songs there is a line reading, "Catch us the foxes, the little foxes that spoil the vineyards," which the church fathers understood as a reference to

38 Dürer's Animals

2.6

 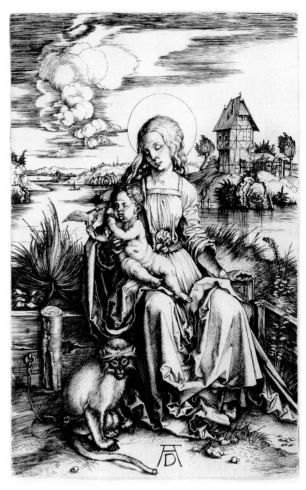

2.7 2.8

the devil. But here is a fox happy in captivity, saved from himself. Were it otherwise, the wily beast could easily jump over the stump; but he prefers to approach the Mother and Child, tightening his bond with each step.

Two owls, one in a tree stump, the other in the little wooden shelter that is part of Mary's enclosure, keep well out of the way, as if they know of their reputed evil nature. The Bible links owls to wailing, to sacrifice and the night. Northern folklore sees the bird of darkness as a demonic trapper of small winged creatures too young and innocent to know better. Tiny wrenlike birds hop around in the foreground. Described by Aristotle as the eagle's rival, the wren is called *Regulus*, or "little king," by Pliny and here may refer to the young King of Kings. A dog—symbol of faith—lies near the Virgin's mantle. A lizard, birds, butterfly, and parrot are at her feet, with a stag beetle at the far left.

The talkative bird, close to Mary in all three drawings for *Our Lady of the Animals*, is elevated to the place of honor at her side in the final version, as the parrot was believed to have been a prophet of the Virgin's coming. Dürer may also have had more personal reason for giving the parrot such prominence. He loved these birds and acquired one as a pet in Antwerp. Among his most vivid works are bird studies that show inspired specificity. Closely observed, these ornithological drawings were made just before planning *Our Lady of the Animals*, such as the *Parrot* [Plate 30], which Dürer must have had in view when he worked on the final rendering.

In the Louvre sheet [2.10], dated 1503, the annunciation to the shepherds is at the up-

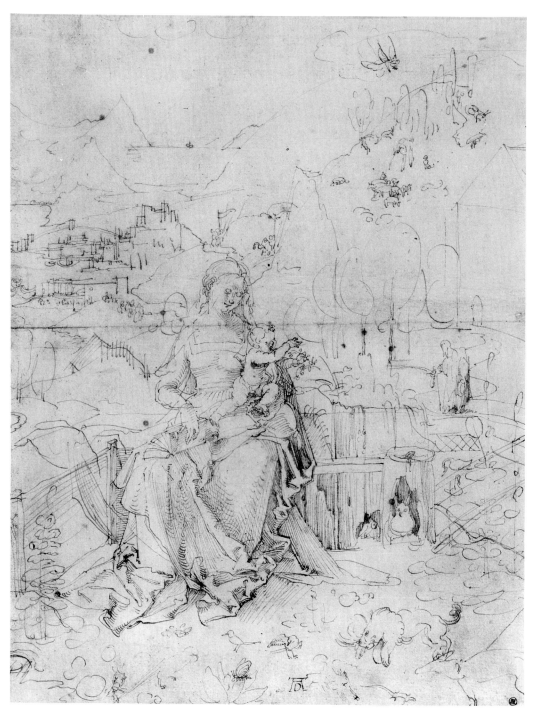

2.9

per left, angels holding the scroll of the Gloria just above them, as a wild goat stares down stubbornly from his rocky perch at such noisy goings-on. A winding procession in the middle distance is led by the three Magi. Seen near the center of the composition, they ask one another the way to Bethlehem. Joseph, holding his rosary, stands near a young ox, symbol of Saint Luke, whose Gospel gives the most detailed account of Mary's life and Jesus' infancy. (Because of his uniquely graphic Gospel, Luke was long believed to have been an artist, becoming the patron saint of painters.)

The ass nearby may refer to the Holy

41 Our Lady of the Animals

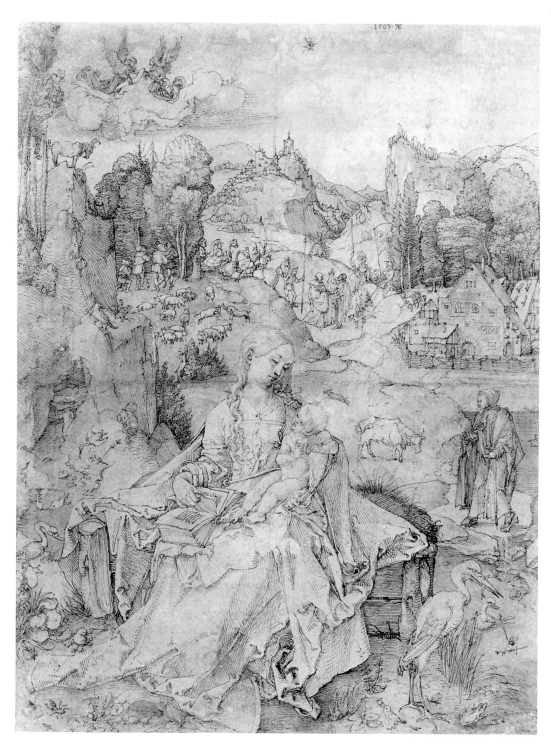

2.10

Family's flight into Egypt [Plate 26] or to that beast at the manger [Plate 1]. Water, at the lower left and right, from the same source as the mill stream, might signify the waters of salvation. Christ was viewed as the new Moses, so the rocky pool to the left—enjoyed by birds, a snake, and two lizards—recalls the waters rising when Moses struck the rock. This water divining was believed to be a preview of the Crucifixion, when water and blood sprang from the Savior's side where the lance pierced him. The two little lizards may also represent

the serpents that Moses and Aaron turned to brass, which were often shown in lizardlike form in medieval art. Their nailing to a cross also anticipates the Crucifixion. The lizards are signs of Christ's immortality and his Resurrection, as salamanders were believed to be immune to fire and able to live on air, miraculous qualities close to the Savior's.

Birds chase one another as they bathe, and one snake wiggles after a second whose tail emerges from the water. Freshly washed, a swan waddles toward the Virgin and Child, seen just above the peonies. A partridge, ever faithful to its mate, is among the birds at Mary's feet, which include a redtail pecking at a strawberry, the same fruit of Heaven held by the Babe. Without a thorn or stone, his strawberry can be eaten in its entirety, so symbolizing the virtues of the righteous and the paradise that is theirs. Blooming in spring, the berry's white flowers stand for the Incarnation, the purity of God made mortal. Now the parrot is perched on a solitary promontory at the left, a frog and butterfly at his feet. A heron in the right corner holds a fish in his beak as insects buzz about. With all its aqueous references, the Louvre drawing's touches of green and yellow watercolor give it an appropriately cool tonality.

In some ways, the composition in the Louvre, though smaller than Berlin's, suggests a larger final format, moving toward the design of *The Adoration of the Magi* painted in the following year [Plate 1]. Simpler, sadder, and in some ways grander than the final version, it intimates the mood of a rest on the flight into Egypt rather than the happy moment of the "Gloria in Excelsis Deo" sung by paired angels flying in the corner.

On the Albertina page [Plate 2], the Magi's ships have landed at the upper left, and their cavalcade winds its way toward Mother and Child. A single, miraculously bright star shines above. The shepherds' annunciation takes place at the right, with an angel flying down to the astonished peasants, telling them the good news, letting them be the first to see the infant Savior. (The shepherds represent the Jews; the Magi stand for the Gentiles.) Near the heads of Mary and Jesus is a flock of sheep, safely grazing. Their presence points to Christ as the Good Shepherd, who will sort out and look after the saved souls at the Last Judgment, and to his earlier role as sacrificial lamb. Goats, who represent the damned at the Last Judgment, butt one another in evil vexation at Christ's coming. Calm amidst the excitement, the faithful dog watches over his herds and flocks.

This composition seems to draw on the account in the popular fourteenth-century text by John of Hildesheim, *The Story of the Three Kings*, printed in Cologne in 1477, which Dürer surely would have known. His landscape suggests the one in the text: "The land about Bethlehem . . . is wonderfully planned and set with mountains with many fat pastures, hotter than in other places, insomuch as at Christmas time barley beginneth to wax ripe, and that time we call Christmas is called there the time of herbs. It was full convenient that the shepherds were awake that night about their sheep, for He was born that night that said 'I am the Good Shepherd. A good shepherd giveth his life for his sheep'" (translated by Margaret B. Freeman [New York, 1955 ed.], p. 8). (Shepherds are stressed frequently in Dürer's work at this time—notably in those prints in the Life of the Virgin woodcut series that he made close to the time of *Our Lady of the Animals*, where the shepherds and the annunciation are included in the *Nativity*. They appear once again, although without their annunciation, in the woodcut *Adoration of the Magi*.)

Studying plants as closely as animals, Dürer consulted his finest botanical watercolors for the Albertina version of *Our Lady of the Animals*. Urban Nuremberg abounded in flowers. Conrad Celtes, Emperor Maximilian's poet laureate, whose books Dürer illustrated, called the city a veritable garden, where "the variety

of flowers and plants outside the windows of her houses present an eternal spring. Their scent pervades the air and the faintest breeze carries their aromas into the bedchambers and the interiors of the homes." But flowers mean far more than that. In the last version of *Our Lady of the Animals*, hollyhocks rise to the right of the owl, to counter that sinister bird's evil effects. The hollyhock was believed to heal the bites of poisonous snakes, scorpions, and spiders and thus, like Christ, to save humankind from the serpent—Satan. Its presence here reinforces Mary's role as the new Eve, immune to the snake's wiles and poisons.

Iris, rising at the far left, was known as "king's lily" in Dürer's time. Sword-shaped, the petals' covering was linked to Mary's Seven Sorrows. Its presence here points to her first two sorrows, the earliest shedding of Jesus' blood, in the circumcision, and the flight into Egypt. Peonies, growing at the Virgin's side, were called "roses of the Pentecost" and signified an event in the future—the descent of the Holy Spirit. Among the frail spring flowers growing at Mary's feet is the lungwort, which, like other plants in *Our Lady of the Animals*, has medicinal properties. Appropriately for the herds above, lungwort was used as a cure for sheep's ills.

Creatures of the water also pay tribute to the Virgin and Child. A great sea crab, of the sort that Dürer saw on his Venetian journey, fills the lower-right corner, replacing the heron and frog of the Parisian page. Stag beetles, believed to be lightning conductors, deflecting danger from the Mother and Son, scrabble about in the foreground among the dragonflies and larger creatures. One of them teases Dürer's little dog, a griffon too relaxed to bark back, at least for the moment, as a snail slides alongside. It symbolizes the slow but steady faith and action found in the animated borders of medieval manuscripts as well as in Dürer's *Hours* for Maximilian [5.53].

These snails bear the message of the Virgin Birth, as explained by Francis of Retz: "If the dew of the clear air can make the sea snail pregnant, then God in his virtue can make [Jesus'] mother pregnant." Just below the parrot at Mary's side is a green woodpecker, ready to hammer out a percussive song of praise on the wood post of the Virgin's rustic throne as he finds his meal within. Other small birds, robin and waterwagtail, hop about.

Both scriptwriter and cartoonist, Dürer invented and recorded exchanges between many creatures of different species, conveying such often unspoken dialogue in graphic and funny fashion. Such lovely harmony and gentle humor is closer to the divine illogic of the Gothic than to the relentlessly rational perspective of the Renaissance. These meetings of very different minds, hides, and feathers present a shared experience and concern that goes beyond the limits of reason or science to stress the unity of man and beast as God's creatures all. The baby Jesus points to the happiest of these heavenly discourses, taking place between Joseph and the stork to the upper right of *Our Lady of the Animals*. Here man and bird are deeply engaged, sharing joy and sorrow, confusion and enlightenment.

Could Joseph be asking whether the stork (described by Aristotle as a pious bird) had just delivered a baby or was it otherwise engaged in the mysterious circumstances surrounding the Son's arrival—long linked with filial piety and gratitude?

Surrounded by the animal kingdom as he is held in his mother's lap, Jesus recalls the lines for the prayers of matins. The first nocturn of these includes the Eighth Psalm of the young shepherd David, who asked: "What is man that you should be mindful of him, or the son of man that you should care for him?"—words understood as a prophecy of Christ's coming. Then come the lines so close to Dürer's in *Our Lady of the Animals*:

You have made him little less than the angels, and crowned him with glory and honor. You have given

him rule over the works of your hands, putting all things under his feet:

All sheep and oxen, yes, and the beasts of the field, the birds of the air, the fishes of the sea, and whatever swims the paths of the seas.

Our Lady of the Animals is Dürer's swan song to the Gothic tradition, his most richly evocative and touching tribute to the lyrical world of Christian romance that his later art was to destroy. Profoundly emblematic and poetic, the three lovely renderings of Mother and Child surrounded by plants and animals are a last echo of the Bestiary, that sacred zoo of medieval symbolism. Dürer probably abandoned the final development of *Our Lady of the Animals*, perhaps at the time of his second Italian journey of 1505. Was this theme's sensibility one he could no longer share? The artist may now have found the late Gothic sentiments and sources for his drawing naive, out of touch with the more formal, rigorous views of the world of God, man, and measure with which, increasingly, he identified his art and himself.

Painted and engraved copies of *Our Lady of the Animals* were made during the Dürer revival at the end of the sixteenth century. Clumsy watercolor additions to the Albertina sheet may have been made for a later dealer to dress up a pen drawing for sale, not Dürer's own creative guides to its development in another medium. Brueghel's intricately painted copy [2.11] loses rather than gains in interest, "finishing" the composition in the worst sense of that word. But the same is not true for the print made by Giles Sadeler [2.12]. That Flemish artist was a bright star in the Dürer renaissance at the Prague court of Rudolph II, who owned the Vienna *Our Lady of the Animals* and who probably commissioned the engraving, which was as highly valued as those from Dürer's hand and suggests the direction in which Dürer was moving. Sadeler so identified with Dürer that he Latinized his first name to Aegidius in order to copy the German's monogram almost as closely as many of his prints followed those of his idol.) Remarkably successful in transposing Dürer's myriad details into engraved line, Sadeler's print is faithful not only to the spirit but to the actual size of the original drawing. (His plate is engraved in reverse so that the print made from it would be seen in the same direction as Dürer's design, a very difficult achievement indeed.)

2.11

From the minute to the massive, crabs and kings are equal before the Virgin and Child: this message of humility often encountered in Dürer's art. In *The Adoration of the Magi* [2.13] [Plate 1], possibly painted in 1504, within a year or so of *Our Lady of the Animals*, the Infant is recognized as their Lord by the rulers of this

world and by the great stag beetle lumbering near the steps to the right. Here the contrast between and community of weak and strong is stressed by their ruinous setting. Ox and ass appear just behind the Mother and Child, while doves—birds of divine love, peace, and promise—flutter overhead. The ox stares ahead, patiently, possibly lovingly, but the ass bares its teeth in the grinning gesture that precedes a hearty meal, fulfilling Isaiah's prophecy. Like those old-time movie makers who made "cameo appearances" in their own films, Dürer often made one of his characters resemble himself as a most personal and dramatic signature. In this painting, it is the western king Casper, seen at the center, who looks a little like the painter. He holds one of those elaborate footed and covered cups the young artist often designed.

Long abandoned, a great millstone at the Virgin's side sprouts weeds and flowers. Insects gather on its curved surface and on the carnation above, which, due to the naillike shape of its buds, was known as the nailflower, a poignant sign of the Crucifixion to come. In full bloom, the same flower stood for love, another message both secular and religious. Combined with butterflies, the carnation refers to Christian love and salvation: The soul will rise, just as grubby pupae change to heaven-borne creatures.

Only those insects whose presence bespeaks the death, Resurrection, and Ascension remain close to the Virgin and Son. Butterfly and moth share this rich reference because in Greek the same word is used for the soul and for the winged insect—*psyche*. Both butterfly and moth, ready to rise skyward, proclaim Christ's spirit, death, and Resurrection; the great millstone just below (shaped like the circular covering of his tomb) promises his enduring earthly presence in the wheat to be ground into the sacred Host. And so the very littlest creatures in *The Adoration of the Magi* convey the beginning and the end of Christ's mortal life.

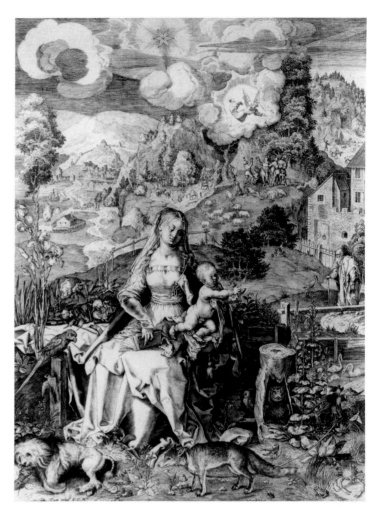

2.12

Some of the same thoughts Dürer assembled for *Our Lady of the Animals* followed the Mother and Child into a regal interior setting, known from several drawn copies and a woodcut frontispiece. In these the parrot of prophecy is perched overhead on a classical garland. A wistful monster with a ring in its nose lets this docile devil support the cloth of honor hanging behind the Mother and Child. Flanking the music-making *putti* in the foreground are two hares; one dashes to the left, and the other places his paws in a reverential pose on the platform where angelic harmony unites heaven and earth in song.

Dürer never wholly abandoned these loving, largely medieval scenes, which remained popular even after his own faith moved toward Luther's less mystical one. But he turned to a

46 Dürer's Animals

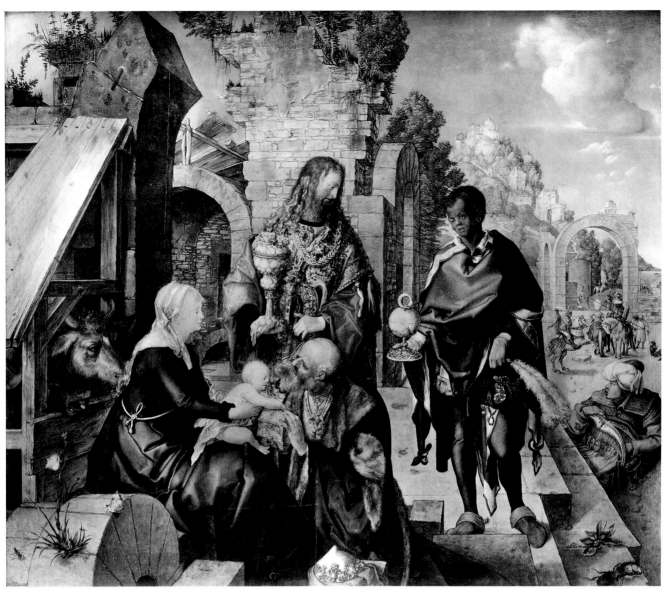

2.13

more scientific and documentary approach, a more closely historical account of the stories of Mary and Jesus, in a chapter-by-chapter visual narrative. This was told and sold in the form of series of engravings and woodcuts, made to be bound into separate books or family Bibles. These printed "film strips" were very profitable—Dürer employed special salesmen to take care of their distribution—their publication took the artist away from his painting, which paid far less.

Beginning in 1500, when he first learned of the new analyses of classical proportion, Dürer studied the rediscovered scientific research of the Renaissance. He bought the works of Aristotle, Pliny, and Theophrastus, printed in Venice by Aldus, and often illuminated their title pages for his learned friend Pirckheimer, who may have reciprocated by translating some of these texts into a simplified Latin or German. (Pirckheimer later dedicated a translation of Theophrastus to Dürer). Such new knowledge weakened the hold of the artist's first, Catholic faith, represented so movingly by the inspired zoo and its holy keepers in *Our Lady of the Animals*. Yet even here the

language of nature crawls in. The German of Dürer's day had no elaborate Greek- or Latin-based scientific terminology. So the artist-scientist used the traditional craftsman's descriptive terms whenever he could, calling the figures derived by intersecting circles "fish-bladders." Angles made by circular arcs were "boar's teeth," and the coiled curves on a snail's shell gave the name of "snail line" to the spiral.

Many of the same creatures that surround Mother and Child in *Our Lady of the Animals* creep into the woodcut *Life of the Virgin*, which Dürer began two years later—the little captive fox reappears, chained below stairs in the scene of the Annunciation, signifying that at the very moment of Christ made flesh the devil was captured. Also, as in *The Holy Family with the Mayfly*, the Holy Spirit is shown as a dove. In this cycle, a special text was prepared to accompany the series of large woodcuts, written by a scholarly priest called Chelidonius, a Latin version of his real name—the German word for "swallow." The cycle opens with the rejection of Joachim's offering of a sacrificial lamb, followed by the *Angel Appearing to Joachim* [8.62], in which he is surrounded by shepherds, flocks, and dog. Mary's *Presentation in the Temple* includes sacrificial sheep in the foreground, near the little figure of the Virgin climbing the temple steps. Dürer stressed the Roman corruption of Solomon's sacred building by giving it classical architectural details, with animal combats and a grotesque triumphal arch featuring a frieze of animal-headed combatants, one winged and twisting a pig by the leg, the other astride a porcine steed, all seen below a Roman soldier and his guard dog.

The Marriage of the Virgin [2.14] is framed by the temple's great arch, an evil owl at the middle, perhaps standing for Jews' future official opposition to Christ. (A study for this bird [3.67] is found on the back of the artist's great drawing, *King Death Riding a Horse* [9.24].) Just above *The Circumcision* is a decorative relief with the Lion of Judah, from whose tribe the nude Infant was descended. Dürer's favorite animal,

2.14

his shaggy little dog, which lies at Mary's feet in *Our Lady of the Animals*, reappears at the Virgin's side in *The Visitation* [7.25], when Jesus first stirs in Mary's womb as she and her cousin Elizabeth embrace.

For the engraved Madonna of 1503 [2.15], the nursing Mother and her Child are seated on a grassy bank, a single bird perched on the enclosing fence. In a woodcut made the next year, *The Flight into Egypt* [2.16], a similar little bird is close to the artist's monogram at the far left. Does one sparrow now stand for the wonders of earthly creation? The same seems true for a great, late woodcut, where an-

2.15

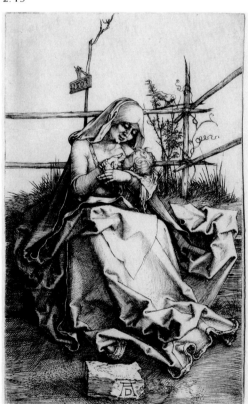

2.16

gels at the left bring a great cluster of grapes signifying Christ's Passion. Mary's apple shows that she and her Son shall save the earth, as the new Eve and the new Adam. All the heavenly pomp and circumstance of her future coronation are proclaimed by the massively winged angels flying a heavy bridal crown overhead. The celebration is accompanied by an angelic choir and band. Deaf to their fanfares, a little bird, at the lower right, pops a berry in his beak, observed only by the Holy Infant, who looks down, pointing toward the earth as if to say, "My eye is on the sparrow." This is Dürer's message, for he has placed his monogram almost parallel to the bird, to identify his own being and sharing of God's grace with his littlest creature. Such small birds symbolize "those whose spirits are in harmony with God," often singled out in religious literature as the victims of the owl and the ape, who went hunting together. Here this small bird may stand for all the best of nature, its spirit in harmony with Heaven.

In a drawing owned by Queen Elizabeth II [2.17], Jesus holds a flying bird by a long string, a fruit or flower in the other hand, and Mary is shown as the new Eve, holding an apple in her hand. As so often happened to Dürer's drawings, the monogram and erroneous date are later additions in another hand. Of his surviving painted Madonnas, only one includes a bird—a siskin, a finchlike bird beloved for supposedly sharing Christ's Passion by a bitter diet of thistles and thorns [Plate 3]. Probably painted close to Dürer's second Venetian visit of 1505, Mother and Son are in dramatic close-up, following Dürer's favorite Venetian master, Giovanni Bellini, another great *animalier*. As angels hold a crown over Mary's head, the infant Saint John the Baptist gives her lilies of the valley, once again curative flowers. Jesus holds a little sack, perhaps for comforting his own teething or for feeding the bird perched on his other arm. In a prophetic pose—like that of the Last Judgment—his right hand is raised toward the blessed destination of the saved, and the left, lowered to that of the damned.

Dürer turned from the lyrical mood of late medieval mysticism to the Scholastic concept of the four humors, in which the behavior of several animals made them symbols of the four basic temperaments. He first applied this medieval psychology, developed by twelfth-century scholars, to an Adam and Eve [2.18] engraved within a year of *Our Lady of the Animals*, in 1504. The idea of the four humors, or the temperaments determined by them, posited that a happy being was based upon the perfect balance of the basic fluids, or humors—blood, choler (yellow bile), melancholy (black bile), and phlegm. This rare state, leading to immortality, was enjoyed by Adam

and Eve in paradise until one bite of the fatal apple upset their body chemistry, which then tilted too far in one of the four directions. Each of these temperaments is symbolized by the surrounding beasts: the cat at Eve's feet standing for the choleric or cruel type; the ox, stolid and phlegmatic; the elk, as well as the goat, depressive melancholy; and the almost impossibly fertile rabbit, overwhelmingly sanguine and loving.

Made by God but not in his image, all animals were affected by the humors from the start and could not change the roles in which they first were cast. Only the once-upright serpent, as agent of corruption, was condemned to wriggle along the ground, bruised under Eve's heel. Dürer intimated this fate by the placement of the cat's tail, curling close to Eve's feet. (Traditionally tied to death and the devil, cats are rare in Dürer's art). The mouse under Adam's feet is another harbinger of death and disease, as described in northern proverbs.

To Renaissance eyes, classical antiquity gave evidence of man's divinely harmonic proportions before the Fall. So Dürer's casting of Apollo as Adam and Venus as Eve is a drive toward anthropological accuracy, a scientific reconstruction of primeval glory. Rendered in black and white, the first couple have a quality of severe realism close to that of photography. Yet, like classical marble statues lost in the northern woods, Adam and Eve look oddly artificial in contrast to the surrounding animals. The beautiful body of the first man is based upon an antiquity treasured at the Vatican— the Apollo Belvedere; Eve's torso follows that of a Venus but she is given the head of a Nuremberg matron. Just as the animals at their feet should be the essence of catness and mouseness, so Dürer believed that the first couple, caught just before the Fall, should be shown as the quintessential man and woman, never to look or be so good after losing the beauty of their innocence, in this last moment for heroic human nudity. Secure in their being, the eight animals, including the sleekly coroneted serpent, are comfortable in their skins, furs, and feathers. Nature remains unchanged as fatal self-awareness is about to undermine humanity. Rare, very early impressions taken from *Adam and Eve* [2.19], printed by Dürer long before his plate was completed, show just how the artist's engravings began, as reversed drawings. Outlined by his burin, the first man and woman, cat, rabbit, cow, and goat are spun onto the surface as clear, free, Matisselike profiles. Even more idea than fact in the proof state of the engraving than in the drawing, the forms wait to be filled in, defined by thousands of tiny lines and dots. These lend a subtle sense of modeling in light and dark, moving Dürer's zoo from the beginning of creation to the end of illusion.

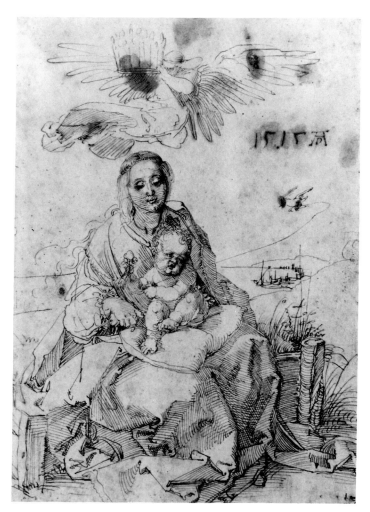

2.17

50 Dürer's Animals

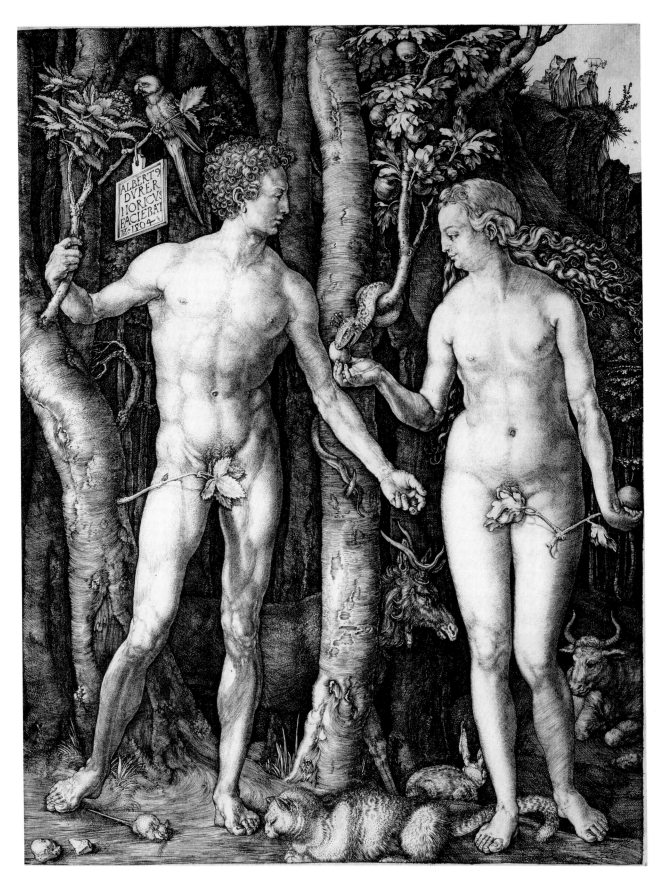

2.18

51 Our Lady of the Animals

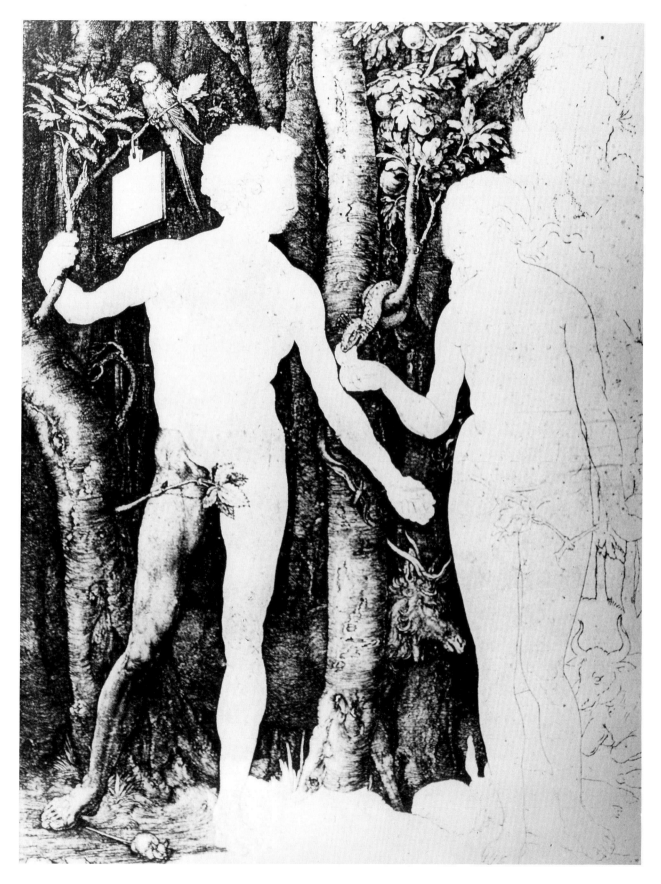

2.19

52 Dürer's Animals

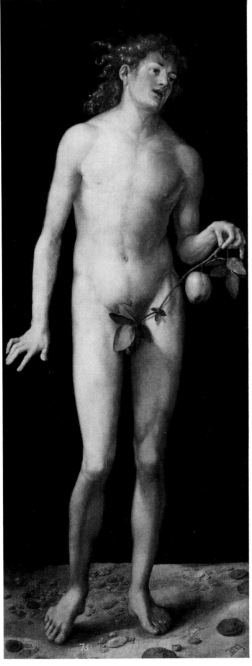 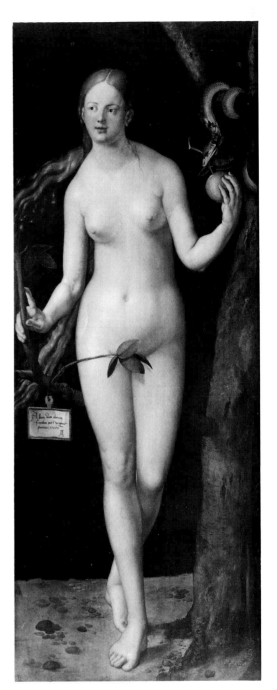

2.20

Adam and Eve boasts a large inscribed tablet, where, for the first time, Dürer places his full name and birthplace, in Latin, as well as his monogram and the date. With his art, he claims descent from the depicted couple, Adam holding the branch and its tablet. Dürer's name faces the parrot, whose words, like his own art, imitate and sometimes even prophesy God's works.

2.21

In the only paintings Dürer made of Adam and Eve [2.20; 2.21], all animals but the serpent are absent. But so accustomed were the artist's admirers to his inspired zoo that an early copyist faked in a handsome range of creatures on demand [2.22; 2.23].

Later, Dürer again depicted Adam and Eve with animals [2.24]—as a graphic introduction to his print series, The Small Woodcut

53 Our Lady of the Animals

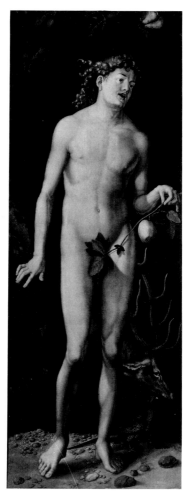
2.22

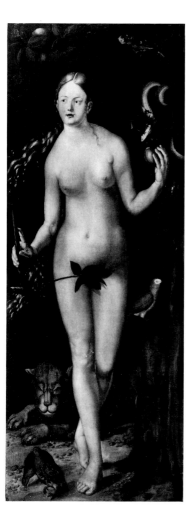
2.23

Passion, an explanatory preface showing why the coming suffering of Jesus and Mary was needed. Look at it closely, Dürer suggests, to appreciate the meaning of the following prints. In the drawing [2.25] for this initial image, Dürer showed the serpent as seductively Evelike, nude from the waist up, speaking as woman to woman rather than just hissing in Eve's ear. Mystery plays, always staged by artists, presented the snake in this way and may have suggested the formula to Dürer. In the fourteenth-century text of Piers Plowman, "The serpent is y-like a lusard, with a lady visage." But when Dürer had his woodblock cut, he returned to a more conventional snake. Caught in an unusually close, intimate manner in the preparatory drawing, Adam and Eve are seen from the back, both holding the apple as they embrace. Far more human than in the engraving of 1504, they have been overtaken by an excessively sanguine—sexual—humor, causing their downfall.

In the woodcut itself the couple have been turned to face the viewer as well as the tree in a more daring pose. Eve takes the apple from the serpent's mouth as Adam's free hand wavers indecisively. Symbols of the other three humors surround the tempted couple: A great badger lumbers in from the left; notoriously lazy, he stands for phlegmatic sloth. Awkwardly squeezed between the trees, the lion represents the choleric, angry humor. At the far right a European bison symbolizes melancholic gloom.

54 Dürer's Animals

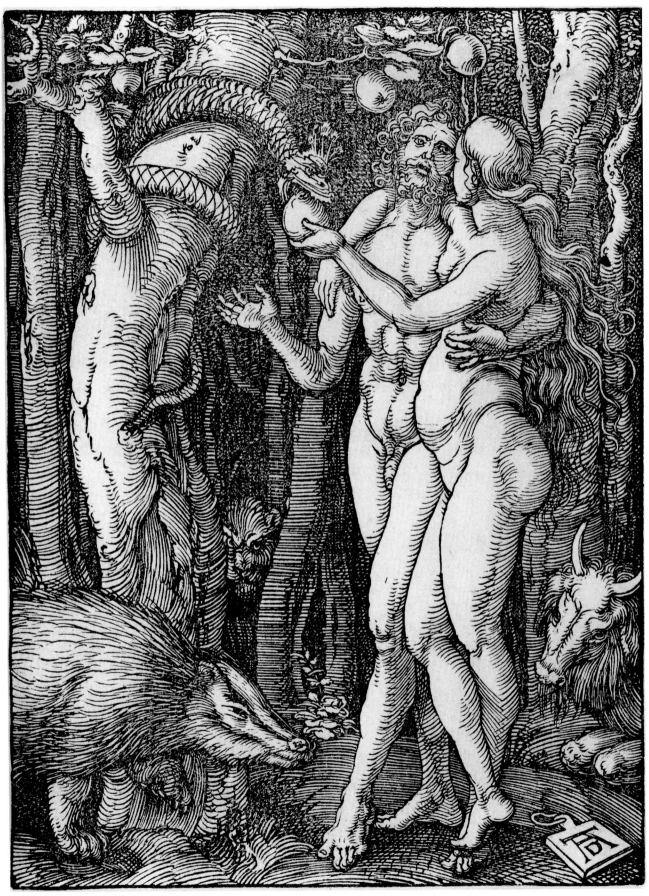

2.24

55 Our Lady of the Animals

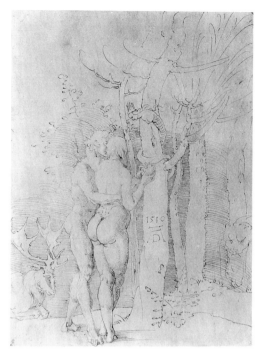

2.25

2.26

After the triumph of Luther's Reformation, Dürer ceased devising themes like *Our Lady of the Animals*. Protestant Nuremberg was lost to the cult of the Virgin; from now on, it had to be our Lord rather than our Lady of Creation. When a student of Dürer's, Hans Baldung, planned the title page [2.26] for Luther's *Thirteen Sermons* in 1523, he included a great congregation of animals—a unicorn, two lions, two stags, two cherubs holding rabbits with a cross, and an ass. God's name is inscribed in Hebrew lettering at the very top, with flying birds on both sides, and Luther's title appears on a tablet suspended in the skies, with two dolphins upon it and a bird perched above, showing that all these animals, symbols of Christ and paradise, are now the Lord's alone.

Near the end of his life, discouraged by the search for mathematical solutions to ideal forms in art, Dürer wrote in the preface to his *Theory of Proportion*, "I believe that there is no man living who can contemplate to the end what is most beautiful even in a small creature, much less in man.... It does not enter into man's soul. But God knows such things, and if He wishes to reveal it to someone, that person knows it too.... But I do not know how to show and measure what approximates to the greatest beauty." Dürer's last contemplation centers on the beauty of even the smallest creature. In a sense, this is where his art began, with the mayfly.

te deus in eternum. Pater noster. Et ne nos. Bñdictio. Precibus et meritis. vt sequitur post Iste psalmus: et alij duo sequentes cum suis antiphonis dicuntur diebus mercurij et sabbati. Antiphona. Gaude. Psalmus

Cantate domino canticum nouū: cantate dño omnis terra. Cantate domio et benedicite nomini eius: annuncciate de die in diem salutare eius. Annuncciate inter

Chapter Three

Birds by His Hand

Birds are messengers and celestial escape artists. Singing or soaring, they take us above all that is here and now. The psalmist David knew this, singing, "Who will give me wings like a dove, and I shall fly away and rest?" Harbingers of the changing seasons, birds were believed the first to hear God's timetable and make their travel plans accordingly. Their flight suggests freedom and spontaneity, a shared journey toward hope, to that leap of faith known as love. Poetry without birds would be hard to imagine, let alone to write, for these winged creatures are flying metaphors. Long before Emily Dickinson, Dürer knew that

> *Hope is a thing with feathers*
> *That perches in the soul—*
> *And sings the tune without the words—*
> *And never stops—at all.*

The painter showed how the death-defying phoenix is the symbol of hope—so drawn by Dürer after an Italian engraving of that virtue, with the bird rising from flames at its side.

In his *Commentary on the Sixth Day of Creation*, Saint Ambrose observed, "Man is kin to the winged flock—with his vision he aims at what is most high. He flies on the oarage of wings by the wisdom of his sublime senses. Hence it was said of him: 'Your youth is renewed like the eagle's,' because he is near what is celestial and is higher than the eagle, as one who can say: 'But our citizenship is in heaven.'" Combining images from the Old and New Testaments and from Virgil ('on the oarage of wings'), Ambrose showed how, in both the classical and biblical traditions, faith is borne in flight.

Two very different men—one a saint, the other an emperor, both born in the late twelfth century—Francis of Assisi and the Sicilian-born Frederick II pioneered a fresh, new view of nature that was central to Dürer's art and most particularly to his interest in bird life. Troubadours' songs came from their novel approach to the beauty of creation, and both king and saint were close to this music and to the poetic language of chivalry. The saint's followers remembered how, in moments of happiness, Francis would "burst out into a French song of joy." Bird sounds at their loveliest suggested a hymn to creation, whose trills and cadence brought a fresh feeling of the wonder of life and its living.

Walking in the Italian countryside, close

to his native Assisi where he had been brought up in a rich, conventional family, Francis turned to the bird-filled trees and preached the following sermon [3.1]: "Brother birds, you ought to praise and love your Creator very much. He has given you feathers for clothing, wings for flying and all that is needed for you. He has made you the noblest of his creatures; he permits you to live in the pure air; you have neither to sow nor reap, and yet he takes care of you, watches over you and guides you." A friar with him recalled, "As Francis spoke the birds began, all of them, to open their bills and stretch out their necks and spread their wings and reverently they bent their heads to the ground and by these acts and by their song they showed the joy their Father gave them."

Like Francis, Frederick, known as *Stupor Mundi* ("Wonder of the World"), was also a poet. The emperor was a linguist, mathematician, amateur architect, philosopher, founder of the University of Naples, and benefactor of the medical school at Salerno. A passionate huntsman, in 1244 he started a vast treatise, *On the Art of Hunting with Birds, an Analytical Inquiry into the Natural Phenomena Manifest in Hawking*, which was unfinished at his death six years later. The manuscript was more than two hundred chapters long with a sixty-three-chapter introduction, concerned with the feeding, mating, and nesting habits of the main classes of water, land, and "neutral" birds. Frederick also studied migration and anatomy of birds. Not content to read and repeat what earlier scholars had written, he went into the field to study ornithology at first hand. The original manuscript of *An Analytical Inquiry* was lost, but his son Manfred painstakingly recreated it, arranging for 1,915 colored drawings to accompany the text. The illustration of geese in flight [3.2] shows the new concern with motion inspired by Frederick's bird studies, with the energy of the flying wedge of birds in passage stressed by the flowing waters below.

Frederick's interest in falconry was inherited by a distant descendant, Maximilian, whose manuals on hunting and natural lore emulated his ancestor's. Albertus Magnus was another keen ornithologist. Like Frederick, Albertus as a young nobleman had been passionately interested in hawking and studied birds of prey with special fascination. But it is hard to choose any single source from whom the young Dürer may have drawn his models. Certainly a prominent influence was the Master of the Playing Cards, with his wonderfully animated, witty prints of plants and animals of all kinds. Expert in avian psychology, this great engraver spent many hours watching his feathered models and recorded them louse picking, feather ruffling, preening, and mating [3.3; 3.4]. Of equal importance to his studies of single birds was his knowledge of how birds behave together. Significantly, all his creatures are shown grounded, just before or after flight. He chose their clumsy, often ridiculous earthbound aspect because his models were to be birds in hand, quite literally, placed on playing

3.1

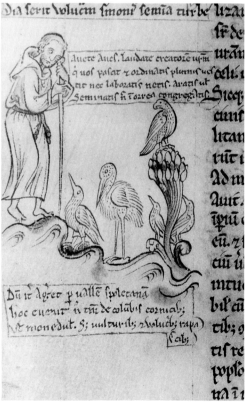

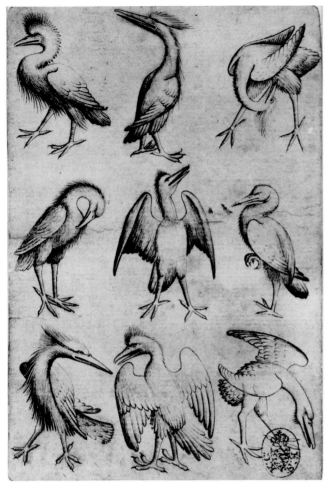
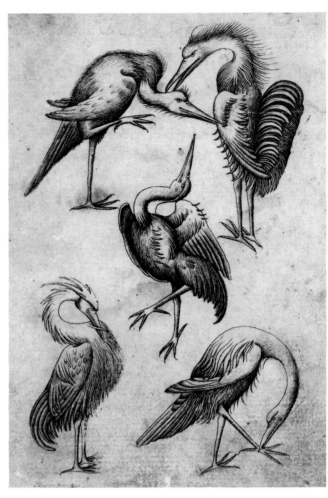

3.3

3.4

cards held close to the chest. The free motion of flight might suggest escape—the player's loss.

According to an ancient Greek legend, birds one day flew into the studio of Zeuxis the painter and pecked at his freshly painted canvas of a grapevine, mistaking his picture for reality, the highest possible tribute to the power of his art. This legend became popular again in Dürer's day, when Pliny and other classic writers were printed for the first time and studied by the humanists. Most skilled masters were compared with those of the past and described as "Zeuxis reborn," and Dürer was no exception.

The freedom of movement that birds enjoy makes them ideal for ornamental use, carved fluttering around a stone capital, in enamel or silver, stained-glass, or tooled leather bindings. Schongauer, young Dürer's favorite master, engraved many birds for adaptation by workers in the applied arts; in one, spiraling leaves surround an owl attacked by richly feathered day birds [3.5], and his roundels with shieldbearers often include little birds [3.6; 3.7; 3.8]. Robins and wrens seem to rejoice in their freedom from the clutter of heraldic devices that people needed to tell one another who they were. Two tiny plump birds chat, as if intrigued by the huge wings on the shield leaned upon by a weary country bumpkin. This contrast between the carefree natural being and the burden of heraldry provides one of Schongauer's happiest series.

The birds of heraldry—roosters, parakeets, and such fantastic flying creatures as

3.5

3.6

3.7

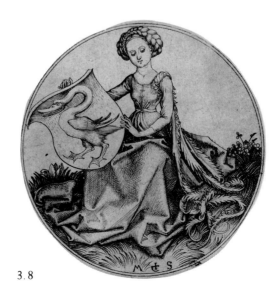

3.8

two-headed eagles—can proclaim the folly, trade, and lineage of the person so fortunate, or unfortunate, as to have his fate tied to the character of the birds in question. On the back of his father's portrait, the young Dürer painted his parental coat of arms with a winged helmet and a blackamoor—symbol of Nuremberg as a center of international trade, including that of slaves. The same symbol rises above a shield decorated with an open door, Dürer's own arms because the German word for *door* sounded like his Hungarian name.

Many early Netherlandish and German painters were masters of avian subjects. Hans Memling, a German working in Bruges, painted a gathering of cranes, four to each of a pair of panels, in a little altarpiece done around the time that Dürer was an artist's apprentice in Nuremberg. Dürer may have seen Memling's and other paintings done in a livelier, more naturalistic style than those commonly found in Germany at that time. The crane in the left foreground holds a stone in his raised foot as a symbol of watchfulness [3.9]. Vigilance was

62 Dürer's Animals

3.9

3.10

3.11

the quality that made the bird such a good choice for the outside of an altarpiece— guarding the owner's property and portraits within.

Most important for the young Dürer were the wonderful books, teeming with woodcuts, published in his boyhood throughout Germany and the Netherlands. Only the brightest birds were allowed to fly down for illustration in the pages of Conrad von Megenberg's *Bidpai: The Book of Nature* [3.10], printed in 1478 and

based upon the writings of Albertus Magnus. The woodcuts are made with such fresh genius that they speak directly to us five centuries later; what they lack in accuracy they make up for in vivacity. This work was probably in the Dürer family's possession. Another popular publication, issued in Haarlem in 1485, was the medieval text of Bartholomew the Englishman, *The Book of the Nature of Things* [3.11], translated from Latin into Dutch and French. Fourteen when this lively book came out, Dürer would have found the illustrations, and certainly their text, of interest.

Even before leaving for Italy in the mid-1490s, Dürer may well have seen the medals made in the midfifteenth century by Vittore Pisanello. This brilliant portrait and battle painter was also a telling master of animal life, continuing the great Gothic tradition of nature studies in his reliefs and in hundreds of drawings. Only Pisanello could convey the fierce majesty of an eagle on so small a scale, on the back of a royal portrait relief, shown with other birds of prey surrounding the dead game [3.12]. Winged victory provides a forceful parallel to the power of King Alfonso of Aragon, whose profile fills the medal's other side. Similarly close identification of human and beast is one of the most powerful weapons in Dürer's arsenal of artistic gifts.

Dürer's brilliant bird studies coincided with those of Renaissance Venice. One of the finest and earliest illusionistic renderings of a bird is *The Dead Partridge*. Though this sheet has the AD monogram and carries the date 1511 at the top, it was drawn by the fine painter and engraver Jacopo de' Barbari (so named because his fellow Venetians thought he spent too much time in northern Europe); its amazingly subtle and lifelike image is close in style to a painting by Jacopo signed and dated 1504 [3.13], where the same bird is shown hanging alongside falconer's gauntlets. On Dürer's first Venetian journey, he was attracted to Jacopo's jealously guarded mastery of art theory and perspective, and his *Study of a Dead Duck* [3.40]

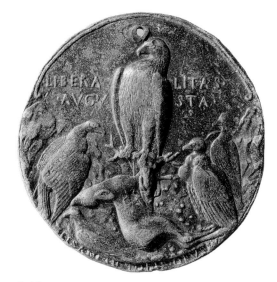

3.12

3.13

64 Dürer's Animals

3.14

follows the Italian's art. Appropriately, Jacopo's greatest work was a bird's-eye view of Venice [11.6], a huge woodcut published by Anton Kolb, a Nuremberg merchant residing there who, like both Jacopo and Dürer, was later employed by the emperor Maximilian. Jacopo and Dürer shared another patron, Frederick the Wise of Saxony, who may have asked both of them to paint these convincing images. Like many rulers, Frederick was a passionate huntsman, who ordered works like these of dead game to fool the viewer into taking them for reality. Since Dürer is known to have copied Leonardo's studies of horses, brought to Nuremberg not long after their completion [9.38; 9.39], he may also have seen some of Leonardo's equally revolutionary graphic explorations of bird flight [3.14].

Some of Dürer's exotic creatures were inspired by art rather than nature and were taken from Oriental ceramics and from Italian silks, in turn based on designs seen in textiles, showing Chinese pheasant and phoenixlike birds rising from formal patterns of swirling flames and clouds. With their opulent plumage, half dragon and half peacock, such birds sometimes clutch great pearls in their claws, in flight from an aviary never seen by Western eyes. But wings could also fall to lowly uses; in a sketch ascribed to the young Dürer, a servant fans a fire or sweeps a floor with one [3.15].

The freedom of birds, their uncaged, airborne adventures, inspired artists and patrons alike to add wings to their works. Painters of Dürer's day sought this liberation and independence and left the old-fashioned, protective craftsman's societies to make their own way. Nuremberg's artists were among the first in western Europe to do away with such guilds, dispensing with their benefits to work on their own without restrictions. This willingness to give up the advantages of the professional fraternity for the risks and rewards of free creative and commercial enterprise was typical of Nuremberg as an international trade center, known for manufacturing the most advanced

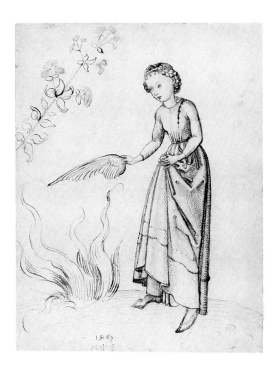

3.15

instruments for the twin studies of navigation and astronomy. Now artists shared the speculative, intellectual world of the university and the seminary. Painters wanted their genius to be included among the liberal arts, and themselves to be accepted as educated men in pursuit of knowledge, their spirits moving heavenward by free thought. Some scholars believe that Dürer's heavily winged *Melencolia I* [3.16] may represent the occasional failure of the liberal arts; the figure's inability to fly might suggest how these studies disappointed those who had hoped to benefit from their pursuit. In this most enigmatic engraving, poor Melancholy, gloomiest of the four humors, stares blindly ahead. Mistress of all the arts and sciences and master of none, she is lost in black despair, surrounded by the unused tools and instruments of knowledge, of craft and creativity. Huge wings springing from her shoulders cannot lift her from indecision and inaction as she sits, idly twiddling her compass. A cherub nods over his writing tablet, hoping in vain for dictation, one tiny wing barely grazing the huge one at his side. Only a dog-faced bat

65 Birds by His Hand

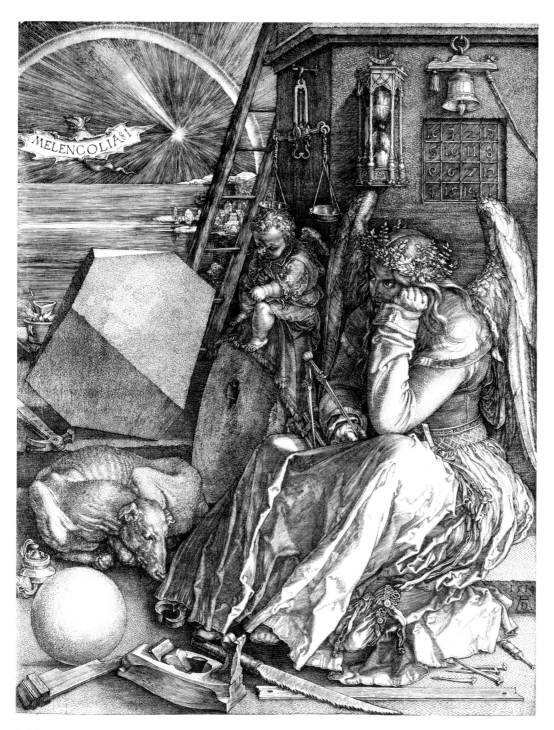

3.16

flies, in the distance, bearing Melancholy's name and number [4.9]. The black side of genius, Melancholy stands for the "wait-and-see" attitude, sapping the spirits of those who live by their wits as they expect inspiration without working to meet it halfway.

Dürer loved birds not only for their beauty and variety but also for what they could tell him of the winds and clouds. Their presence as tiny woodcut or engraved specks in an otherwise vacant sky provided a sense of space and

depth, where they might release or reflect emotions locked within the earthbound figures below. Swooping down toward the dramatic action, birds fly in formation in the skies of Dürer's dramatic early woodcuts—*Samson and the Lion* [3.17], *Hercules Conquering Cacus* [3.18], *The Apocalypse,* and *The Martyrdom of the Ten Thousand* [3.19].

These flights of birds express the major thematic moods of many of Dürer's prints. Old Joachim's excitement, as he learns that he and Anna are to be parents of the Virgin, is indicated by the birds diving just overhead, above the flocks of sheep and goats. In *Joachim and Anna at the Golden Gate* [3.20], Joachim and Anna embrace in joy and surprise, overcome by the good news. The elderly couple is seen as one, just as the bird flights overhead, like skywriting, draw that space into a single, lyrical line.

Impossible to reprint, Dürer's most amaz-

3.17

3.18

3.19

ing flight of birds encircles the fortified tower at the top of the engraved *Saint Eustace* [1.30]. The birds are so small that their bodies are almost microscopic dots of ink, filling pinlike indentations on the copper plate; engraving them must have required the most highly developed technical control and the help of a magnifying glass. Only in the best impressions, printed under the artist's direction, do these dots come to life. They seem to swirl through the air, boomerang into the distance, and come back again as a single, almost bird-shaped mass, flying as one.

Though Dürer dismissed a series of his lesser print designs, crudely crafted by assistants, as *Modest Woodcuts,* these included some surprisingly beautiful passages. Among the loveliest of these is a flight of birds high above Saint Christopher [3.21]. Their formation

67 Birds by His Hand

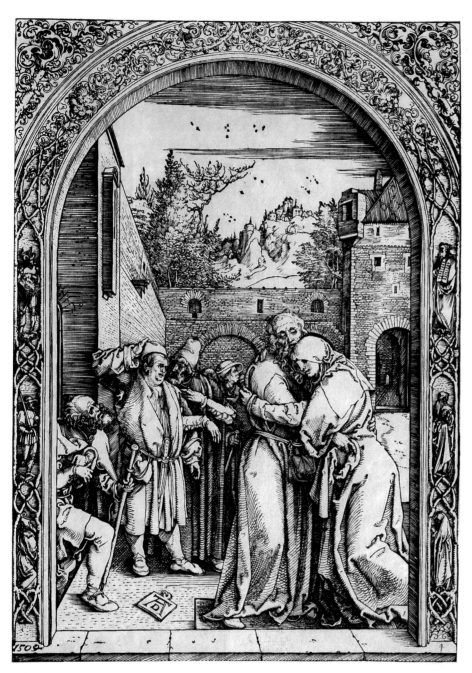

3.20

3.21

3.22

3.23

3.24

sweeps from left to right and back again, paralleling the directions in which the giant Christopher carried his passengers to and fro, fording the river. This birds' passage is one of the master's finest, cut with the same compelling force and vitality first shown in a woodcut for Brant's *The Ship of Fools*, where the satirist condemns the practice of ornithomancy, an ancient form of prophecy based upon special meanings found in bird formations. (The way in which birds lost their feathers as well as found their wings was another source of magical revelation.) Dürer too was an ornithomancer; his graphic mastery of such flights gave the viewer special insights into the scene below.

In another woodcut from *The Ship of Fools*, the Fool is a bird's nest robber [3.22]. Brant's motto for this scene reads:

Who would on self-willed pinions fly
Will aim at birds' nests very high
Hence oft upon the grounds will lie.

Those "self-willed pinions" also refer to the fatal wings Daedalus designed for his son Icarus, shown falling in a crude woodcut attributed to the young Dürer [3.23]. Flying through Brant's verses, birds stand for the freest will. Never again did Dürer equal the airy exuberance of these early birds, irrepressibly buoyant and scintillating, too wise for the Fool's trap, rejoicing in their freedom [3.24].

Wings in Dürer's art keep both angels and devils aloft, guiding them to and from earth. In the medieval tradition, angels are sometimes shown with only a head and well-feathered wings, but Dürer adds a new sense of conviction to their image, a novel feeling for the quality of motion. His earliest rendering of effective, inventive wings is found in the woodcut *Apocalypse*, where angels and devils [12.19] whirl and swoop through Saint John's action-charged Revelations. The Woman of the

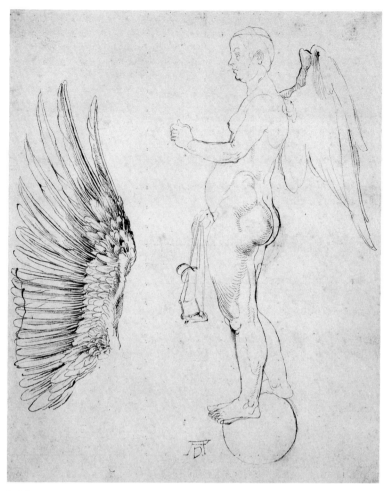 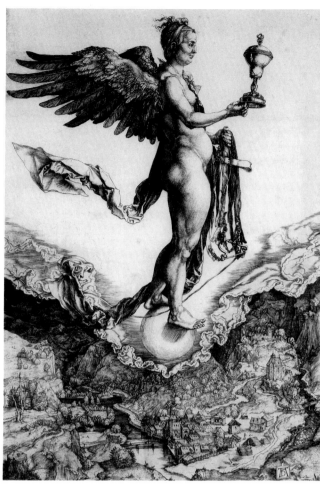

3.25 3.26

Apocalypse flies on classical rather than jagged Gothic wings, she and her son escaping Satan's traps with Grecian grace [12.21].

Dürer's great page of a single wing, perhaps a pigeon's, shows the intense scrutiny he gave to the means of flight (the black background was painted in by another hand at a later date) [Plate 4]. He treasured these magnificent sketches and used them as the point of departure for the wings of Nemesis [3.25], in a print based on a Latin poem by the Medici court poet Angelo Poliziano. The engraving *The Great Fortune* or *Nemesis* [3.26] brings the figures together with a study for her wings—fickle Fortune, astride a globe, has splendid wings worthy of the Victory of Samothrace. A clumsy yet convincingly airborne woman, she draws back a harness—reward restrained—and holds out a trophy—reward bestowed. Below her is a stunning Alpine scene based on a drawing made by Dürer on his way north from Venice.

Like Nemesis, Dürer too seems to have possessed the gift of flight. The real winner in this dazzling yet unbalanced work is the vista of mountains and valleys: Never before, or after, were the experiences of flight and sight, of the bird's-eye view and the way to its attainment, engraved with such skill. (Fortune's unfortunate proportions, however, show Dürer slavishly following the then-current Italian studies of ideal measurement. Only when he follows his independent eye in creating her magnificent wings is the artist at his best.)

His nature studies were used again for the winged helmet in *Coat of Arms with a Skull*

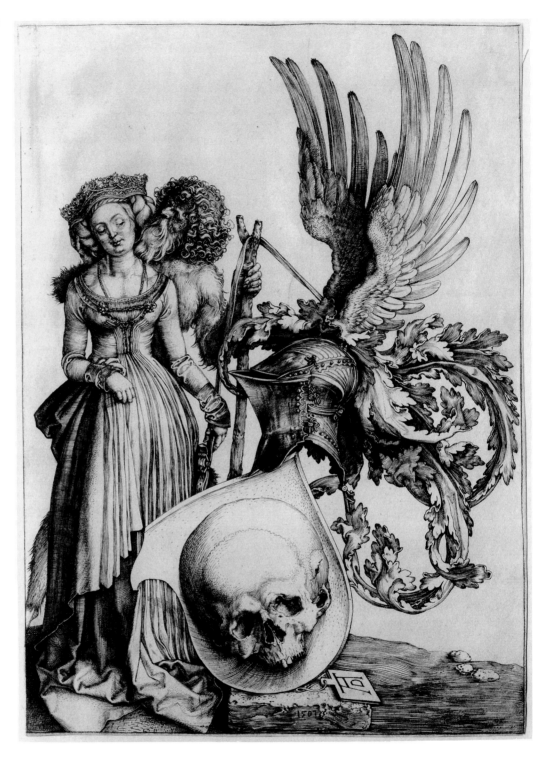

3.27

[3.27], engraved in 1503. Here the helmet and skull-bearing shield are supported by a Wild Man who seems blind to the fatal message on his shield. Survivors of the ancient northern fertility gods, Wild Men—known in England as the Green Men—were said to live in the woods, where they rescued lost children, returning them to their parents, and also delivered babies. Calmest of the Wild Man's many roles is that of bearing coats-of-arms on shields [11.46]; he does this in many engagement portraits, as if to guarantee a couple's fu-

ture fertility. But in *Coat of Arms with a Skull*, the Wild Man becomes an ironic commentary on the brevity of earthly passion. Wearing bridal dress and crown, the Nuremberg maiden is embraced by her shaggy, wintry lover. Such coupling of a northern beauty and the beast should suggest ecstatic abandon, but death, not birth, results from their union. This curious contrast of love and fate, of sprouting wings and grimly jaunty steel, exemplifies life's extremes.

For their immense variety and animation, of all Dürer's animal studies his birds are among the finest and most deeply felt, often as daringly independent and far seeing as the loneliest gull on the high seas. Flying from above, inspiration leads artists to ever greater creative heights according to classical and Christian belief, so the concept of flight was central to their life and work. Birds, so seemingly boundless in their spatial conquests, came close to artists' keen sense of self, to their winged victory over copperplate or marble, canvas or paper, realizing flights of fantasy.

Bittern

Nocturnal marsh dwellers, bitterns are members of the heron family. Chances are that *Both Sides of a Bittern's Wing* [3.28] was sketched from a dead bird brought to Dürer's studio. Though painted in watercolor on vellum, the study is rendered in a free-flowing, almost Oriental way, similar in technique to the dead heron [3.53] and probably dates close to 1500. Although few scholars feel that this wing, seen from above and below, is by Dürer, it has some of the brilliance and freshness of the other sheet. Both share the identical form of added inscription.

Blue Roller

The most copied of Dürer's ornithological studies are those of the blue roller [Plate 5], native to northern Europe and found around

3.28

Nuremberg in Dürer's time. Vibrant, shimmering, many-hued blue, green, white, and brown plumage gave the bird's wings unusual sculptural definition. Dürer's angels sometimes borrowed their brilliantly colored plumage from this glorious bird. In his early thirties, Dürer made his freshest, most closely observed nature studies in watercolor, studying his animal models from many different viewpoints, an idea he may have gotten from Leonardo.

Like most of Dürer's highly finished, richly colored renderings, the Blue Roller wing studies are painted on vellum, with a mastery of microscopic detail that recalls the Netherlandish work of Jan van Eyck almost a century earlier, as close to their source as a fingerprint or a footstep in the snow, more a fact of life than art. His finest study of the blue roller's outstretched wing is at the Albertina, painted on vellum [Plate 6]. Most of Dürer's highly finished animal studies date from the first years of the sixteenth century, but the date 1512 and his monogram, both drawn in the same crimson as the blue roller's blood spots, suggest that these great pages do indeed date from the second decade.

Crane

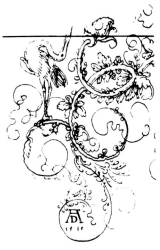

3.29

3.30

3.31

Dürer's first drawing of this watchful bird was based on an Italian engraved playing card, copied by him before his first journey to the south. Cranes and cranelike birds appear frequently in the margins of Maximilian's *Book of Hours* [3.29; 3.30; 3.31], drawn with great rapidity, looking down from the top of one page and up from the bottom of another. Symbols of vigilance, they may have been drawn to remind the imperial leader to stay awake and attend to his prayers. (The birds were also believed to keep a stone in their raised foot, ready to drop in case of alarm.)

In his *Commentary on the Sixth Day of Creation*, Saint Ambrose chose cranes as a good example for all: "These birds have a natural social and military organization, whereas with us this service is compulsory and servile.... Ever vigilant they provide complete protection. When the watcher has completed his period of guard duty, he prepares for slumber, first giving a warning cry to arouse the sleeper who is to take his place at the next sentry." Unlike most of us, he "willingly accepts his duty... performs his duty and repays with equal care and courtesy the favors he has received."

For the hieroglyphs of Horus Apollo, *The Hieroglyphica*, Dürer drew cranes to go with two different symbols: "A Man Guarding Himself against the Plots of His Enemies" and "A Man Who Knows the Higher Things." ("For the crane flies extremely high that it may see the clouds in order not to be storm-tossed, and to remain in the calm.") Its strength as a sentinel may explain why Dürer included a crane on the visor of Maximilian's helmet [3.32], placed near the bagpiper who is found on the opening page of the emperor's *Book of Hours*. Cranes also inhabit Maximilian's massive *Triumphal Arch* [6.32; 6.33], their vigilance a key element in the many victories claimed as the emperor's. Dead cranes or herons [3.53] hang from hooks at the sides of the arch's central portal, as if punished for sleeping on the job.

When Dürer was in Venice, Pirckheimer wrote to ask him to buy some crane feathers for him. Though these birds flew all over northern Europe, Pirckheimer may have wanted feathers from the North African crane, found in the Venetian markets where exotic wildlife from the south and the Near East was bought and sold.

Crow and Raven

These large, dark birds are hard to tell apart in much of Dürer's art. Sometimes they act for good and at other times for evil. In one of his *Ship of Fools* illustrations, Dürer showed the Fool with three birds, all crowing. Printed just above the woodcut [3.33] was its moral:

> *Who sings Cras Cras like any crow*
> *Will stay a fool till death, and so*
> *His dunce's cap will wax and grow.*

This vigorous, coarsely effective woodcut is one of the first specific bird illustrations to come from Dürer's hand.

Tales were told of blackbirds coming to the aid of holy men, once by bringing them bread, and once by taking it away. A handsome woodcut of 1504, *Saint Anthony and Saint Paul in the Wilderness* [3.34], shows the saints being

3.32

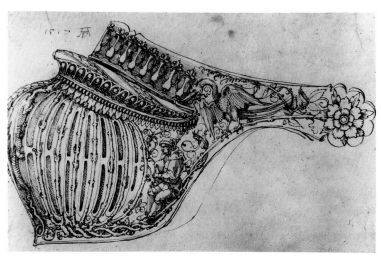

3.33

brought bread by a black raven. Dürer's assistant probably cut the woodblock; his own preparatory drawing is a livelier rendering, with a loaf about to split in midair, each half within ready reach of the hungry hermit saints below.

A black bird, struggling to remove a poisoned loaf [3.35], is seen in one of a series of twelve line drawings prepared by Dürer and his studio around 1501 to guide glass painters, who were decorating a local Benedictine abbey's windows with scenes from its patron saint's life: He is offered a poisoned loaf by an evil priest, Florentinus, who stands at the left. According to Voragine's *Golden Legend*, Benedict thanked the wicked donor of the poisoned bread "and gave it to his pet crow, a bird used to eating from his hand, saying: 'In the name of Jesus Christ, take this bread and hide it where no man can ever find it.' Then the bird opened his beak and spread his wings and hopped around the bread and crowed, as if he wanted to say, 'I would like to be obedient but I cannot follow your order.'" The saint commanded him a second and a third time, and finally the crow obeyed. When he returned after three days "he took his food from the saint's hand once again, as he was used to do."

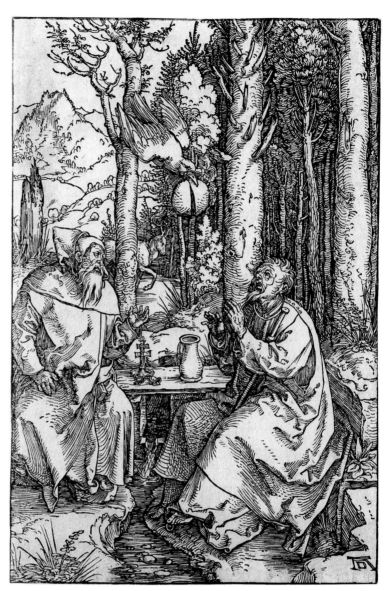

3.34

Ravens, known in German as "coal ravens," once abounded around Nuremberg but are there no more. Dürer put a raven at Apollo's side on a Nuremberg star chart [3.36], drawn ca. 1503. The artist went back to this map in 1515 when he prepared an impressive woodcut of the northern celestial hemisphere [3.37]; the crow appears further down, perching on a serpent, about to peck its scaly skin.

Crows come up several times in Horus Apollo's hieroglyphs. For example, "A Man Passing His Time in Constant Motion and Irascibility" is depicted by "young crows. For

3.35

3.36

the crow feeds her young on the wing." And "A Man Mating with His Wife" is also related to crows, for "crows mate with each other as man does, according to nature." Greek and Roman writings on animal life and behavior, such as Aelian's and the *Physiologus*, also stressed the crow's fidelity to its mate. According to Horus Apollo's eighth sign, Ares, Greek god of war, and his beloved Aphrodite were shown as crows in Egyptian hieroglyphs.

Cuckoo

Cuckoos supposedly lay their eggs in other birds' nests, tricking them into hatching and feeding their young. This had radically different meanings in antiquity and in the Renaissance. According to Horus Apollo's hieroglyphs [3.38], the cuckoo stood for gratitude, but in the literature of Dürer's time, the crafty bird symbolized people with social pretensions. Brant's *The Ship of Fools* equates the cuckoo with the peasant who wants to buy his way into the aristocracy, after profiteering from food hoarding and price gouging. By changing their garb—their "feathers"—such peasants dressed their way to social superiority. Brant wrote that despite such fancy attire, which came from the Netherlands—

> *Clothes cut away and slit and short,*
> *With colors weird and quite absurd,*
> *Upon the sleeve a cuckoo bird*

—the peasant could never hope to escape his humble origins, betrayed by the bird worn on the sleeve.

Birds may also be a match for brass bands—or such is the message of Dürer's works for Maximilian's *Hours*. Like many of the other marginal drawings in the *Book of Hours*, Dürer's is a scene of fun, not faith. A mean-looking, cuckoolike bird with a kingfisherlike beak is perched above six trumpeters and a drummer. These military musicians play along

with the opening of the Ninety-eighth Psalm, written above them, "O sing unto the Lord a new song; for he hath done marvelous things; his right hand, and his holy arm, hath gotten him the victory. . . . Sing unto the Lord with the harp; with the harp, and the voice of a psalm. With trumpets and sound of cornets make a joyful noise before the Lord, the King. . . ." Some scholars believe that this ornery bird and the grotesque elephant opposite refer to the many voices of nature cited in this psalm, but the scurvy crew of martial musicians are clearly not of the caliber the psalmist had in mind. Nor does the resolutely songless bird, identified by some as a woodpecker and others as the cuckoo, share the exultant spirit of David's songs. Neither bird nor band is meant to equal David's far livelier lines. Here satire is the name of Dürer's graphic game, a hollow, irreverent echo of the holy song within.

Dove and Pigeon

The odd, bug-eyed look of Dürer's only fullpage drawing devoted to the dove has been explained by one scholar as caused by hypnosis: The bird was spellbound so it could be laid back and drawn from above. Be that as it may, these big white birds, known as *Columba tabellaris*, are still kept in European farms and manor houses, prized for their beauty and their acrobatic, tumbling flight.

The story of Noah's dove and its peaceful message of happy landing and of God's forgiveness is well known. As a symbol of divine love, the dove was also found in classical faith, belonging to Venus. Turtledoves were the only birds used in Hebrew sacrifices, caged in Dürer's scene of *Joachim's Offering Rejected*, *The Marriage of the Virgin*, and *The Presentation in the Temple*.

A very different message, that of the Holy Spirit, is the one borne in Christian art by doves and pigeons. The white bird's immaculate plumage conveys virginal purity, and its silent, gliding flight often represents the passage of the Holy Spirit at the Annunciation. The dove's symmetry in the large drawing suggests that it was meant for a baptism, Pentecost, or a coronation of the Virgin, three of many sacred subjects in which the white bird was often centrally placed, seen from below.

The Holy Spirit was described by Matthew as appearing at the baptism of Jesus, when "the heavens opened unto him, and he saw the Spirit of God descending like a dove, and lighting upon him; And lo a voice from heaven, saying 'This is my beloved Son, in whom I am well pleased'." Dürer felt the force of this account and showed the Holy Spirit and God the Father appearing to his Son in *The Holy Family with the Mayfly* [2.3].

He drew doves for two of Horus Apollo's hieroglyphs, one for "A Man Who Loves Dancing" [3.39]; but "Ingratitude for Kindness to Oneself" is also a dove, because it was believed that when the male bird "grows somewhat strong, he drives away his father from his mother and then mates with her." According to Horus Apollo, the bird's flesh is unusually pure and can be safely eaten during a plague when all other living things are diseased.

Duck

One of Dürer's most highly finished drawings, *Study of a Dead Duck* [3.40], is painted in watercolor and gouache with touches of gold. Vellum provides a rich, glossy surface and iridescence to match the hanging bird's plumage against the white wall. Although dated 1515, the page was probably illuminated much earlier, when Dürer prepared many studies in this time-consuming technique. Perhaps he drew this study a few years before the *Hare* [Plate 16], close to 1500, when he was much influenced by Jacopo de' Barbari [3.13].

Completely different in style is the quickly penned, calligraphic dead duck hanging head first in the margin of Maximilian's *Hours* [3.41], just above a quack doctor, doubtless with the graphic pun intended.

3.37

3.38

3.39

76 Dürer's Animals

3.41

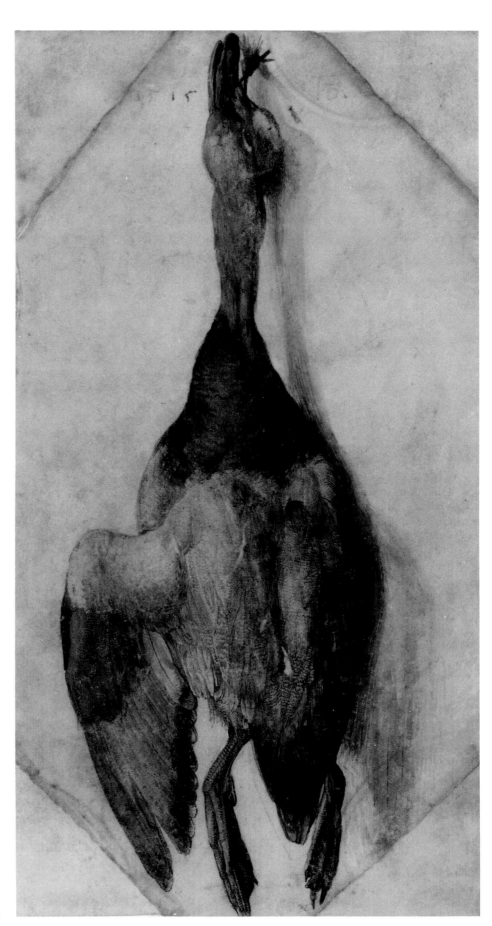

3.40

Eagle

Large and strong, gifted with brilliant vision, a solitary flyer and merciless hunter, the eagle has always been linked to power. In the Old Testament, God caring for Israel is compared to a mother "eagle who stirreth up her nest, fluttereth over her young, spreadeth abroad her wings, taketh them, beareth them on her wings." Rulers of Egypt and Rome took the eagle as their emblem; and the bird was the sign of Zeus, most powerful of the Greek gods, ruler of the heavens, protector of the state, and judge of men.

The great bird is present in Dürer's art in all of these classical and Christian connections. One of his earliest drawings in the Renaissance style [3.42], copied from a northern Italian engraved playing card [3.43], shows Zeus with his eagle. Here the god, with his Roman name of Jupiter, holds the arrow of mortality above the dead and dying below. Dürer included an eagle on an earlier star chart [3.44] to complete the god's attributes.

Only emperors and kings were allowed to use eagles and vultures for the hunt in classical and medieval times. Medals that Dürer must have seen, such as Pisanello's for Alfonso V of Aragon, king of Naples and Castile [3.12], places the king of birds in profile on one side. Portraits of great rulers, such as Maximilian, often included a bird of prey in the sky, pounc-

3.42

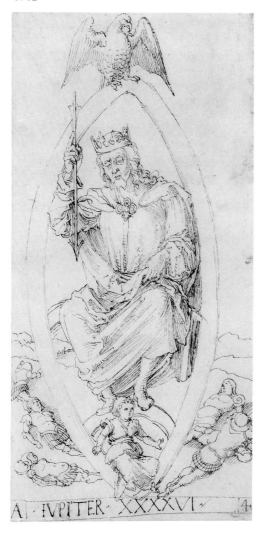

3.43

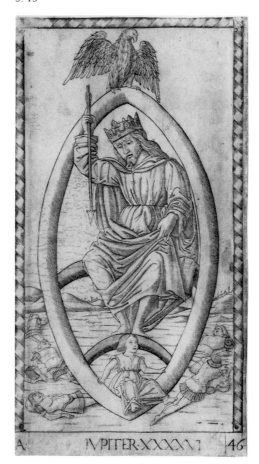

3.44

3.46

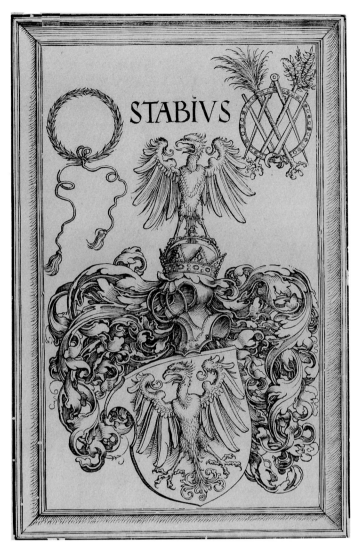

3.45

ing upon some weaker flyer, an obvious sign of imperial omnipotence, and the eagle also is found in the border of his *Hours*. Though the two-headed eagle of the Holy Roman Empire formed part of the arms of Nuremberg, when Dürer designed a coin for his native city (one that was never struck), his is a naturalistic eagle with the letter N on its breast. The regal bird is shown twice on the coat of arms of the Holy Roman emperor's court astronomer, Johannes Stabius [3.45]. He helped Dürer prepare his *Celestial Map: The Northern Celestial Hemisphere*, which includes the eagle-shaped constellation Aquilae [3.46].

This predatory bird became a popular emblem partly because of its tremendous strength, believed capable of carrying men's bodies to heaven. In ancient times, mortals joining the gods became divine, their wing-borne rise known as *apotheosis*. Saint John's symbol was the eagle, sign of his visionary journey heavenward to witness his Revelations, shown with the bird on the frontispiece of Dürer's woodcut *Apocalypse* added in 1511. John describes an angel "flying through the midst of heaven, saying with a loud voice, 'Woe, woe, woe,' to the inhabitants of the earth." But the angel was translated as "eagle" in Dürer's text and shown as such. In an unusually tame pose, the eagle is sometimes perched at John's side, a

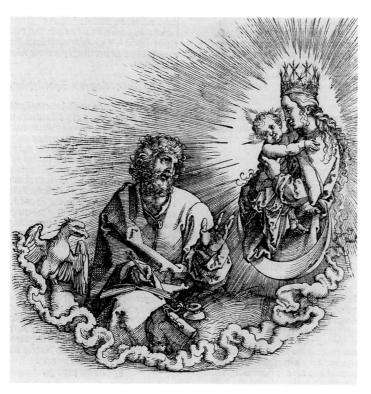

3.47

pencase in his beak, as the saint records his Revelations on Patmos [3.47]. Here the lofty bird indicates the divine source of John's visions seen on that island.

Two of Horus Apollo's hieroglyphs deal with eagles. "An Old Man Dying of Hunger" is depicted by "an eagle with a twisted beak. For when the eagle grows old, he twists his beak and dies of hunger." When the Egyptians "wish to indicate a king living in retirement and giving no pity to those at fault, they draw an eagle. For the eagle has his nest in high places and flies higher than all other birds."

Falcon and Hawk

These swift birds of prey, with their keen sight and fierce beaks and claws, have been trained for the chase since ancient times. Falcons are long-winged raptors; hawks' wings have a shorter, more rounded form. Like the eagle and vulture, these hunters are linked with power, to the king and his court. In England and parts of Germany, only the king and his brothers and sons—the royal dukes—were allowed to own gryfalcons; earls and counts were permitted the peregrine; yeomen and priests were limited to the short-winged sparrow-hawk; the servants could keep kestrel.

Dürer's early drawing of the lady in courtly dress, a hawk upon her wrist [1.15], was followed about seven years later, in 1492, by a woodcut for Brant's *The Ship of Fools*, showing an elegant gentleman with his hunting bird perched on his left arm [1.28]. Devoted to the subject of noise in church, the moral of the accompanying verse is that

> *Who takes to church dog, hawk or jay,*
> *Disturbing others who would pray,*
> *The fool's role he with zeal doth play.*

Fittingly, Dürer drew birds of prey almost exclusively for his most powerful patron, Maximilian, who is shown with them on his *Arch*. A hawk pounces on a heron in the *Hours*. Fal-

3.48

3.49

3.50

3.51

conry was among the emperor's favorite sports, and one of Dürer's first hawks for him was an illustration for *The Hieroglyphica*. Horus Apollo wrote that when the Egyptians wanted to refer to Venus, "they drew a hawk . . . because the hawk is fecund or long-lived" [3.48]. He then notes that the hawk also stands for superiority and victory, and for blood, which it was believed to drink instead of water [3.49]. The soul is also represented by the hawk, and Mars and Venus are both shown as hawks—the first because of the bird's fierce spirit [3.50] and the second because the Egyptians believed the female hawk to be unusually capable of love [3.51].

3.52

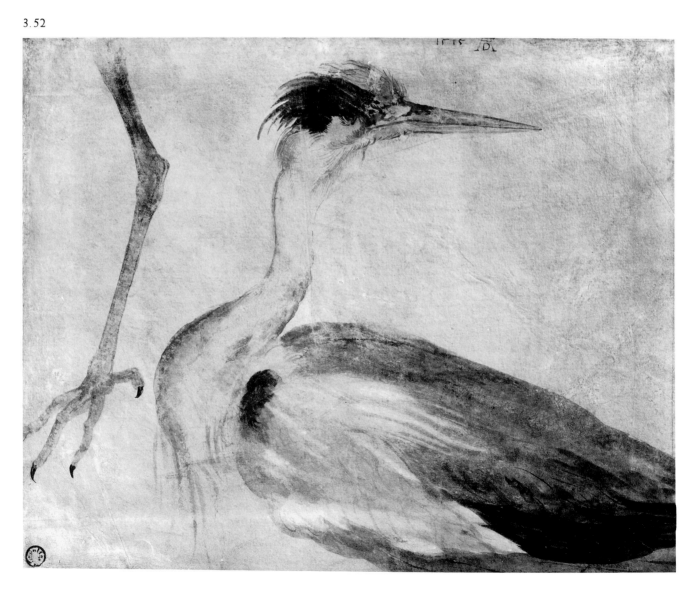

Finch

Keeping Saint Jerome company in the well-watered wildness, a tiny goldfinch and bullfinch hop near a stream to the lower right of the penitent saint [Plates 7, 21], representing the waters of baptism and purification made possible by Christ's sacrifice. In medieval art, finches were associated with Christ and the suffering saints because the thistles and thorns the birds supposedly ate were believed to show their sharing of the Passion, the holy torment, and the crowning of thorns, a bitter diet for man's salvation. Any small bird with a spot of red plumage was also linked by northern folklore to early legends of the Passion. As Christ bore the cross on the way to Calvary, a bird was said to have flown down to lighten his burden, plucking a thorn from the crown pressed so painfully upon his head.

Heron

Like the wing of the blue roller, Dürer's watercolor study of a gray fisher heron [3.52] is one of his liveliest bird drawings—all the more remarkable since he may have been working from a dead model with a broken neck. The vellum page was probably sketched around 1502, when Dürer is known to have made his finest nature studies; neither the 1515 date nor the AD monogram was made by the artist himself. The same dead bird hangs from the side of Maximilian's Arch [3.53] and is seen again in the border of the emperor's *Hours* [3.54].

Jay

Irrepressible chatterboxes, jays were viewed as mischievous if not downright evil in Dürer's day. For this reason he showed the jay with pheasant and magpie at the top of the Wheel of Fortune [3.55], a place it does not deserve. Showing how unfairly the Wheel of Fortune turns, all six birds on the upper half of the wheel are evil, with the good birds at their

3.53

3.54

3.55

3.56

mercy below. The impertinent jay pops up twice in Maximilian's *Hours* [3.56; 3.57], where its plump, irreverent presence wittily contrasts with the psalmist's humble, worshipful words.

Lapwing

Fritz Koreny, the scholar who so recently and rightly took away many of the highly finished nature studies long attributed to Dürer and gave most of them to later artists, suggested that a fine page of a lapwing may be by the master [Plate 8]. Drawn with pen and brush, the severed wing is shown in watercolor and ink, heightened with gold and touches of white on vellum. Both the monogram and the date 1500 agree with what is known of the artist's style and interests at that time. Though ownership long after its completion cannot document the *Lapwing*'s autograph quality, the

3.57

fact that this study may have been owned by Crozat and Mariette, two of the greatest drawing collectors of all time, confirms its brilliance. This page's vigorous response to the source of flight makes it fundamental to such winged beings as Dürer's angels and *Nemesis*.

Magpie

Magpies' linguistic gifts intrigued scholars as long ago as Pliny, who wrote, "These birds get fond of uttering particular words, and not only learn them but love them. . . . It is an established fact that if the difficulty of a word beats them, this causes their death . . . when they are at a loss for a word they cheer up wonderfully when they hear it spoken." This clever bird occupies the place of honor atop the Wheel of Fortune [3.58], where he wears a crown and lords it over the others sharing his circular perch.

Dürer added a lifelike drawing of a little magpie, symbol of speedy message, at Mercury's feet for the Map of the Northern Sky [3.59], dated 1503.

Nowhere in Dürer's prints does a bird play a more eloquent if not downright gabby part than the magpie in his early engraving of a well-known French story taken from the book of the Chevalier de La Tour Landry, which Dürer may first have heard at his mother's knee. He had designed woodcut illustrations for twenty-one other stories from the same text in 1493 [1.23; 1.24; 1.25], but it was another five years before he engraved this moralizing tale [3.60]. Looking startled, a plump

3.58

3.59

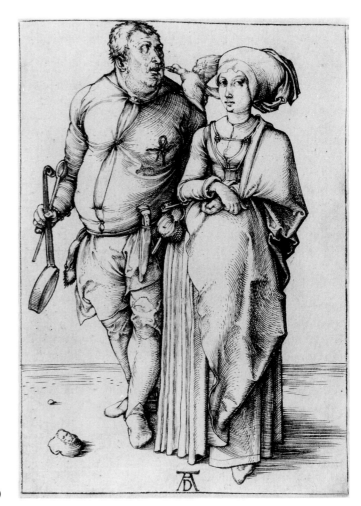

3.60

cook, spoon in hand, is listening to a magpie while his wife looks sourly ahead, her arms crossed in restrained revenge. The magpie has tattled on the wife for having eaten an eel kept in reserve for unexpected guests; when she tried to blame its loss on an otter, the garrulous magpie told the true story. Later, the wife and her friend who shared the eel plucked every feather from the magpie's head. Ever after, when the bird saw a bald man, he would call out: "So you must have been telling about the eel!" (In the more polite French version, the wife shares the fish with her maid, but in the German the friend is male and may have shared the cook's wife as well as his eel.)

Owl

The little screech or barn owl has long been one of Dürer's most beloved animal studies [Plate 9], but many recent scholars have questioned whether the drawing is in fact his. Perhaps, as its curator at the Albertina has suggested, the bird may look somewhat stiff because the artist worked from a stuffed specimen, not a living model. Possibly this drawing was retouched by another hand, thus losing some of its freshness; vellum tends to stiffen, causing the original coloring to flake away, which might explain a certain lifelessness. The monogram and date, 1508, are certainly not Dürer's own. If it is the artist's, then this sheet was probably made shortly before *Our Lady of the Animals* [3.61] [Plate 2], in which the bird appears once again.

An owl can be good or evil. The Greeks considered this bird, which was able to see in the dark, the wisest of all and gave it to their most intelligent deity—Athena—as her emblem. In medieval times, it was believed that birds planned attacks on owls, "mobbing" them [3.62]. The theme is found several times in Dürer's works. In a minute devotional painting, the owl and its enemies are placed just above Christ, the Man of Sorrows [3.63], in an odd setting suggesting both a cave and a tomb.

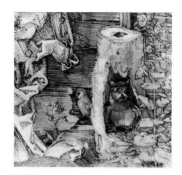
3.61

3.62

84 Dürer's Animals

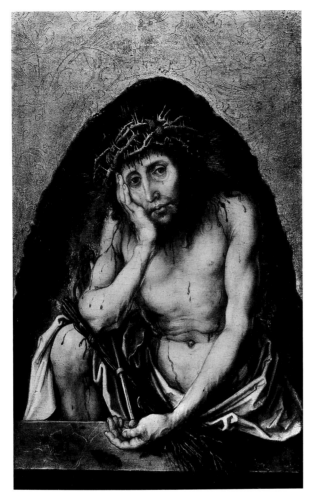

3.63

3.64

(His features are those of the young artist.) Unlike the tragic figure painted below, the mobbing of the owl is shown against a gold background and not painted at all [3.64]. Using a goldsmith's technique learned from his father, Dürer brings the birds and sprays of leaves to life by delineating them with hundreds of needle jabs; the punctures catch the light and define the forms against the gilded, mirrorlike ground.

Wildly excited, threatened from every side, the beleaguered bird flaps his wings in furious self-defense, in striking contrast to Christ's melancholy resignation. This mobbing of the owl refers to one of David's saddest psalms, which seemed to prophecy Christ's death on the cross and his cry, "My God, my God, why has thou forsaken me?" David sang: "I am like the pelican of the wilderness: I am like an owl of the desert. I watch and am as a sparrow alone on a housetop. Mine enemies reproach me all the day: and they that are against me are sworn against me." The psalm was understood to refer to the mystical Pelican of Piety, the bird who brought her chicks back to life by nurturing them with her own blood, a popular allegory of Christ's suffering. In the painting Christ himself is shown as the Pelican of Piety, sacrificed for man's salvation. Covered with blood, rivulets streaming all over his body, he displays the hideous instruments of the Flagellation and the wounds of the Passion. The medieval theologian Hrabanus Maurus argued that the first bird, the pelican, long linked with Christ, gave special sacred significance to the second bird, the owl. The "owl in its abode" predicted Christ in his burial place. (The *Greek Bestiary* or *Physiologus* also related Christ to the owl, for the wise bird's love of dark over light was like Christ's choice in man's behalf, made when he was in the darkness and in the shadow of death, the eclipse at the Crucifixion.) The owl will share the same fate as the wisest of men, besieged by jealous birds just as Christ was killed by men deaf to his words. Dürer's designs show that the suffering

will stop only when everyone hears the message.

A later woodcut of the mobbing of an owl [3.65], perhaps designed by Dürer's studio and accompanying a poem possibly written by Dürer himself, illuminates his far earlier painting of the Man of Sorrows. The wise owl is attacked by predators flying from all four corners of the print. The poem, "All Birds Envy and Begrudge the Owl," may have been written in 1515, when Dürer won his coveted pension from Maximilian [3.66]; perhaps he felt the envy of his rivals or, as a virtuous man, guarded against falling victim to false pride. The first verse exclaims:

3.65

Oh, hate and envy the world over,
Oh, false faith, oh wicked wealth,
Ever quarreling, always strife,
Though you may be defamed or cursed,
Deceitful nature is ever at your call
And has never failed you yet.

In northern Europe, the owl was also linked to evil, however, for it was believed to be night loving because it feared the light of truth and faith. "A real owl's nest" meant any place that was mean and squalid, a den of iniquity where the dark obscured a multitude of sins.

Dürer drew a belligerent owl [3.67] on the verso of *King Death Riding a Horse* in 1505 [9.24]. Just above the archway of the temple where Mary and Joseph are betrothed, the same cross bird is shown [11.41], perhaps as a sign of the stubbornness of the old law, soon to be eclipsed by the brilliance of the new. Here the owl is in a central place, over the entrance to the sanctuary, with its carved archway of fighting lions and unicorns.

3.67

Pelican

A small study of a pelicanlike bird drawn on vellum [3.68] may relate to the illustrations Dürer made for the fifty-fourth symbol in Horus Apollo's hieroglyphs, known only from this work [3.69]. Horus Apollo claimed that Egyptians "draw a pelican to indicate foolishness or imprudence. Though, like other birds, it can lay its eggs in the highest places, it does not. But rather it hollows out a place in the ground, and there places its young. When men observe this, they surround the spot with dry cowdung to which they set fire. When the pelican sees the smoke, it wishes to put out the fire with its wings, but on the contrary only fans the flames with its motion. When its wings are burned, it is very easily caught by hunters. From this reason, priests are not supposed to

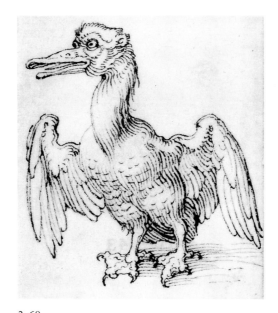

3.68

3.69

3.71

3.70

3.72

3.73

eat of it, since it died solely to save its children. But the other Egyptians eat it, saying that the pelican does not do this because of intelligence, as does the vulpanser, but from heedlessness." Another rendering of the same subject, probably meant for the decoration of a bookbinding, shows the agitated bird drawing blood as her chicks are hatched below. This is the Pelican of Piety, sacrificing her life to maintain her young [3.70; 3.71], often painted above Christ's head in early Crucifixions.

Pheasant

On the first page decorated by Dürer for Maximilian's *Book of Hours*, two handsome pheasants perch on a branch beneath a piping peasant [3.72]. The rendering of these graceful birds could have been freely adapted from those found in Europe or taken from Oriental textiles or metalwork. They may have been placed in the margin of a prayer to Christ and Mary because, according to Horus Apollo, pheasants gave up their lives to save those of their young.

Another pheasant pecks its way along the crowded edges of Dürer's *Triumphal Arch* woodcut for Maximilian [3.73].

Siskin

Among Dürer's most carefully painted birds is the siskin in *Madonna with Siskin* [Plate 10], a panel prepared in 1506. Perched on Jesus' arm, the little bird seems to have just landed, wings outstretched, waiting to be fed from the sugar tit held in the Infant's other hand. Dürer also showed Jesus feeding a little bird in *Madonna and Child with Monkey* [2.8]. (Both scenes may go back to *The Apocryphal Gospel of Pseudo Matthew*, which describes the infant playing with a clay bird that sprang to life in a sudden, miraculous foretelling of the Resurrection.) The same theme may relate to Dürer's 1515 drawing *Virgin and Child with Bird on String* [2.17; 3.74], in which Jesus plays with a bird on a

string. As in the 1506 picture, angels fly a crown over Mary's head, sign of her future coronation in Heaven. Although probably painted in Venice, Dürer's 1506 panel is close to a theme found farther south. For example, Michelangelo's tondo, a circular marble relief, made for the Taddei family, shows Jesus with a goldfinch or a siskin, and such a work may have led Dürer to the subject.

Sparrow

Two pairs of sparrows, the original drawing of which was made ca. 1513, illustrate Horus Apollo's hieroglyphs [3.75; 3.76]. About four years later, a tiny, single sparrowlike bird appears at the bottom of the master's woodcut of *The Glorification of the Virgin* [2.7].

Spoonbill

European spoonbills, which winter in central Africa, are still found in Holland, but in Germany they are usually seen only as they migrate and even today are sighted over Nuremberg, where they occasionally stop to rest.

Drawn in the lower margin of Maximilian's *Book of Hours* [3.77], this gooselike, awkward bird, symbol of stupidity, runs forward to attack a shabby, sprawling drunkard who leans back to drain the last drops from his flask. The drinker and bird are contrasted with the powerful, virtuous figure of Hercules, shown with his vanquished enemy, the lion.

Folk legends, which so often saw animal features as signs of good and evil, explained those of the spoonbill as resulting from the bird's attempt to free Christ from his cross, the bill twisted while trying to pull out the nails.

Starling

In Hungary, land of Dürer's ancestors, starlings abounded. Traveling with cattle, which tolerated them because they peck at the flies, the birds also dined on seeds and other edibles re-

cycled in cattle droppings. In the *Book of Hours* a red starling flies just above a European bison, his beak wide open [3.78]. The bird looks as though he is trying to tell the beast important news, but the bison does not care. A baby boy holds the same bird by the wing, running away from the combat in Dürer's engraved *Hercules* [3.79].

Stork

The Romans thought storks represented loyalty, piety, and wisdom. Saint Ambrose noted that the Greek word for *thankfulness* came from the word for *stork*. According to Horus Apollo, when the scribes of the Nile wanted "to express gratitude, they drew a stork," so doing "because, alone of all dumb animals, the bird, when it has been reared by its parents, returns to thank them in their old age." (The ancient text actually referred to the hoopoe, but very early on, it was translated as *stork*, as it was known in Dürer's time.) Later, storks were believed to bring good fortune and babies.

All the finest portraits, animal or human, suggest a dialogue, a deep if silent communication between model and artist. Few works make this clearer than Dürer's *Stork* [Plate 11], rendered with quick strokes of pen and dark brown ink, in which the bird seems to be eyeing him every bit as closely as he observes his model. This is one of Dürer's most impressive ornithological studies. Despite the date 1517, written by a later hand at the upper left, his drawing must predate *Our Lady of the Animals* [Plate 2], where the bird reappears in a spirited confrontation with Joseph. In another version of the same composition, a different stork is found at the lower right with a small fish in its bill [3.80].

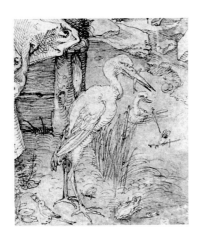

3.80

Swallow

In European folklore, swallows were believed to wall themselves up in their mud nests and hibernate through the long winter. Their sudden return to life in the spring made them seem like signs of the Resurrection, of Christ's awakening. They were known as "birds of the Virgin" in Dürer's youth.

In his *Commentary on Genesis*, Martin Luther had his own theories on swallow behavior. He did not believe that these birds "go to regions lying more toward the south, inasmuch as from experience it has been learned that the swallows lie dead in the waters throughout the winter and return to life at springtime. This is truly a weighty proof of our resurrection. Therefore I think that birds are preserved either in trees or in waters. These works of Divine Majesty are plainly miraculous. So we see them, and yet we do not understand them. I think that even if someday a species should perish (but I doubt that this can happen), it would nevertheless be replaced by God." Sadly, Luther's prediction of divine providence in the face of extinction has not come to be.

These lovely, light-colored birds were included in Dürer's *Nativity* (Munich) and *Adoration of the Magi* [3.81] [Plate 1] (Florence). Like the heralding angels, swallows were seen as a promise not only of Christ's rebirth but of our own as well. With his birth, a new time of hope came into being in the humblest of settings, the home of the ox, the ass, and the swallow. And, in *The Prodigal Son* [8.4], the bird roosts atop the barn in the upper left of the yard where the son comes to his senses.

3.81

Swan

Dürer copied his first swan [3.82] from a northern Italian print engraved for use as a playing card [3.83]. The graceful white bird was shown with Apollo, god of the sun and the arts. Swans could also belong to Aphrodite, goddess of love, drawing her chariot across the waters. When Dürer's friend, the poet Conrad Celtes, asked him to design a woodcut for one of his works, it showed Celtes in 1503 as a plump, boyish man, writing his *Four Books of Love* under the inspiration of Aphrodite's swan and wise Athena's clever crow [3.84]. Celebrated for its beautiful song, sung only as it died, the swan was the traditional emblem of the Muses, especially that of the art of poetry. Dürer later added a swan, drawn with a new Renaissance assurance, to a star map Celtes ordered for the new college of poetry and mathematics founded by Maximilian in 1502 for his poet laureate. The swan was included as part of the new poetic symbolism of scholarship under the emperor's protection.

Swans swim in a rock pool to the left of the Virgin and Child in *Our Lady of the Animals* [2.10]; one waddles out of the water toward the creatures gathering at Mary's feet. Long linked with royalty and noble orders (all of England's are owned by the queen), the birds may be a special emblem of the Queen of Heaven.

Two beautiful swans in the left margins of Maximilian's *Book of Hours* are very much out of place; the first appears between an ape and an Oriental leading a dromedary [3.85]. Almost equally incongruous is the swan on top of a peasant woman who, marketbound, clutches a cheese to her side and grasps a well-filled egg basket [3.86]. In 1515 Dürer designed the con-

3.82

3.83

90 Dürer's Animals

3.84

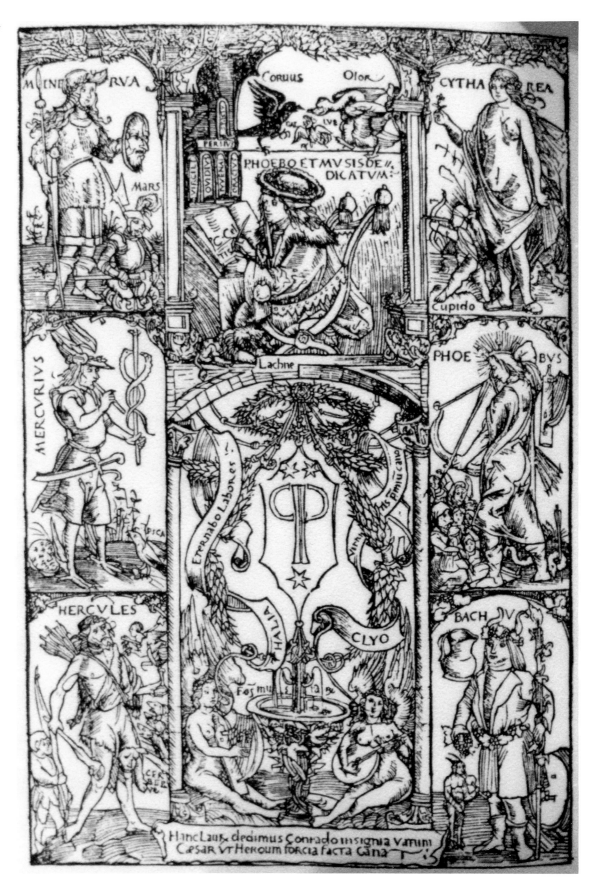

stellation of the swan for the great woodcut *Celestial Map: The Northern Celestial Hemisphere* [3.87].

Magnificent swanlike wings rising from the helmet's mantling suggest that in the engraved *Coat of Arms with a Skull* [3.27] it may belong to the Swan Knight—Lohengrin—a messenger of love and death whose bird, like Plato's, sings best with his last breath. Similar wings are found on Dürer's own coat of arms in 1523, where they may also refer to the bird of Apollo, god of the arts.

Woodpecker

A cross bird perched above a ragged seven-man band has been identified with this noisy avian [3.88]. But the same creature has also been thought to be a kukupa, symbolizing gratitude.

3.85

3.86

3.87

3.88

neratione et generationem.
Deus qui beatum Mathiam
tuoꝝ apostolorum collegio so
ciasti: tribue quesumus: vt ei
us interuentióe tue circa nos
pietatis: semper viscera sentia
mus. Per christum dominū
nostrum Amen.

De sancto Andrea.

Andreas christi famulᵒ
dignus dei apostolus
germanus petri: et in passio
ne socius. Ver. Dilexit andre
am dūs: iŋ odorē suauitatis.

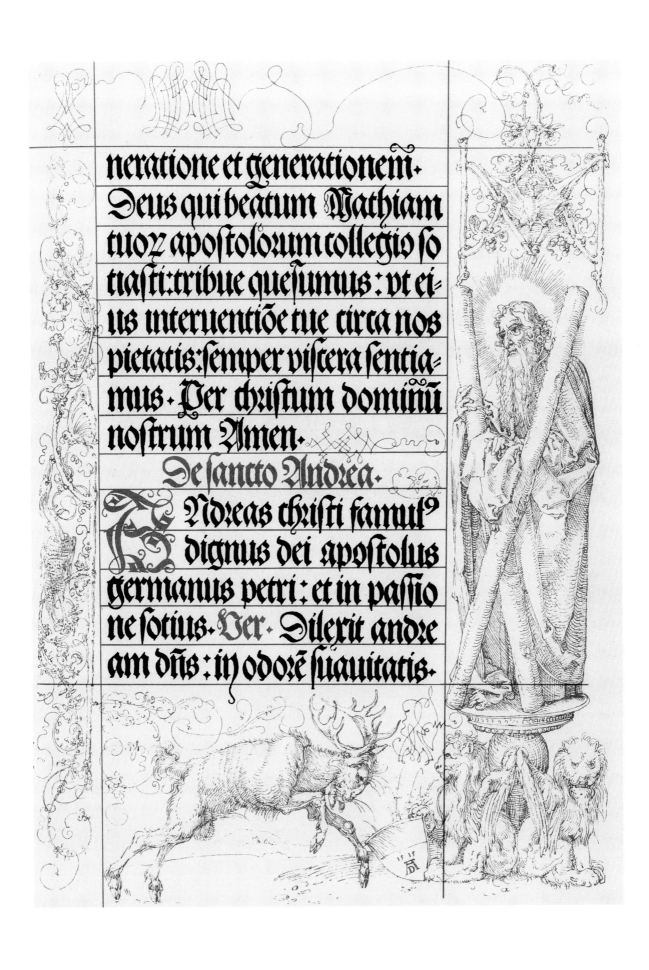

Chapter Four

Wild in the Woods

Despite Dürer's lyrical watercolors of landscapes, the first and still the loveliest ever painted, he was a city boy. Indeed, his urban life may have helped to make him more responsive to animals, as if they brought the outdoors along with them. Though descended from a long line of horse and cattle breeders, the artist's father and grandfather could work their goldsmith's craft only near a court and marketplace. Not until Dürer's travels—his first and second Venetian visits and the trip to the Netherlands in 1520–21—did he see much new wildlife, though he may have found many woodland animals during his early years when he rode from market to market to sell his prints (this work was soon taken over by his wife and by the traveling salesmen he hired to distribute his woodcuts, etchings, and engravings).

Dürer's chief sources for animal studies when he was an apprentice probably were painters' pattern books. Very few of them survive, but extant examples show poses of a large variety of wildlife. Dürer may also have looked at the engraved suits of cards from the midfifteenth century, such as the stags designed by the Master of the Playing Cards [4.1] or the rabbits designed by the Master of the Berlin Passion [4.2]. Among the prints that Dürer studied closely were those of Israhel van Meckenem, an engraver working at the end of the fifteenth century. In one of these, as part of a popular late medieval humor called *The World Upside Down*, the hare has his day and victim becomes victor, turning the tables on the hunter, who is being roasted on a spit, patiently rotated by hares. Barely visible, a third hare pumps the bellows to fan the flames. At the ends of this long, narrow print, hares bring in their archenemies, two hounds, readied for cooking, to join two smaller dogs, already boiling. They are attended by their four-footed chefs, one of whom opens a spice box to season the gravy. This print may have been the pattern for the decoration of a crossbow handle or a gun butt, enlivening those heavy, all-too-businesslike surfaces with some comic relief.

Young Dürer undoubtedly loved to ride, whether or not he could afford to own his own horse. Many of his early works show youthful horsemen [9.11] or lovers blissfully cantering through the woods [9.9]; cavalcades of dandies take the country air on horseback [9.7], as interested in their own plumage as in that of the birds flying overhead. Such scenes were probably drawn more from fancy than fact. An am-

4.1

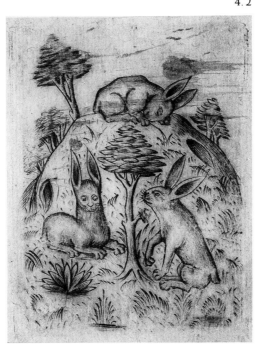

4.2

bitious, hardworking teenager, Dürer had little time for leisurely nature studies, to follow animals through fields and thickets. That he managed to draw and paint as many scenes of forest life as he did is something to celebrate.

Dürer pursued his trophy with zeal and studied its ways with care and concentration. Unlike most other great artists of the forest, such as John James Audubon, Gustave Courbet, or Winslow Homer, he seldom if ever killed his sources so as to study them. Rarely caged, stuffed, or freshly slaughtered, these woodland models were caught on the hoof or wing, their wild presence shared in art rather than robbed of life. In some cases the wilds came to Dürer—he may have bought or had brought dead game to draw in his studio, such as the great severed head of a stricken deer [Plate 11]. These were usually given as a reward to the chief hound who had tracked down the prey. But first the horns were removed, as fine specimens were highly prized. Some of the deer living within Nuremberg's dry moats may have been relatively tame and proved patient models; other animals, like the hare, could have been pets before ending up on the dinner table.

Among Dürer's early drawings of wild animals were designs for elaborate silver centerpieces made by his father [1.20]. Similar works in base metal helped the prosperous craftsman Hans Frey provide a substantial dowry for his daughter Agnes when she became engaged to Dürer. Just what Frey made can be seen in a rendering for a table fountain from his workshop; the base has hunters pursuing the wily, agile chamois with a long pole or a pike [4.3]. This scene, like the animal itself, is something of a cliff-hanger—will the goat get away or end up as a trophy? Such suspense is soon relieved by quaffing wine that bubbles from the fountain's top.

Those who could afford such finely worked objects were also likely to have the time and title to indulge in such costly pleasures as the chase. Gleaming platters and beak-

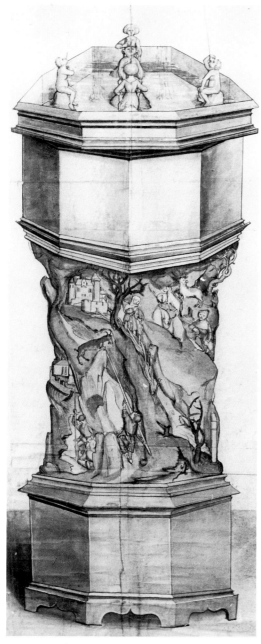

4.3

virtue. Though their presence could always be justified by some carefully reasoned explanation, the hares and rabbits that run around before *The Holy Family with the Three Hares* of ca. 1498 [2.6] and *The Glorification of the Virgin* [2.7] were undoubtedly meant as much for amusement as for some heavy article of faith. Rabbits and squirrels were unwilling but popular household pets, especially in Italy. There ladies were painted cradling beloved bunnies in their arms, and squirrels on long, red leashes can be seen escaping along curtain rods as Mary receives the Annunciation. These little beasts were cast in the frames for Lorenzo Ghiberti's bronze baptistery doors by the sculptor's son Vittorio and were doubtless admired by Dürer when in Florence, on his way to Rome. Gothic as well as Renaissance works of art abounded with such small furry animals; they pop up between the leaves in tapestries and spring from carved stone capitals.

Just as Dürer's dogs managed to provide moments of respite from even the most tragic scenes, so do his creatures of field and forest. Untamable and therefore incorruptible, woodland animals are at a safe remove from man's possessive love, only knowing him at his worst when out for their blood.

Wildlife came closest to hand in the chase. That royal sport required armies of gamekeepers, beaters, masters of the hounds, trumpeters, grooms, men to look after the crossbows and other hunting equipment, and trackers of the wild goat, bear, deer, elk, fox, and boar. Special skill was needed to flush the target animal. Like bullfights, though less formally staged, these great pursuits turned the countryside into vast theater, with the ruler cast in the lead. The chase was an odd mixture of butchery and ceremony, of brutality and courtesy. Serving as both entertainment and allegory, it was also a form of dynamic education and exercise in the saddle. Developing a hardy royal body and mind alike, the hunt supposedly prepared the prince for the arts of war and the ways of power. He learned about

ers were often engraved with hunting scenes of artistocrats pursuing real or imaginary beasts. Sometimes the inner as well as the outer sides of tableware would be richly ornamented with birds and stags in motley profusion. The more you drained your cup or emptied your dish, the more game would fill your eyes.

Woodland scenes must have provided welcome escape for Dürer, taking him away from images of saintly sacrifice and relentless

4.4

himself—his strengths and weaknesses—and about the lay of his land.

In densely populated Europe, wildlife had been protected since Roman times by the formation of game preserves, consisting of hundreds of square miles of forestland. All the animals within were royal property, regardless of the actual owners of the land where they lived, fled, or died. This possession of woodland life went back to the most distant past, when the king's power was absolute. Aside from commoners who worked for the hunt, the only one of less than noble blood who could come along was the painter, to record the beast's glorious pursuit and its ceremonial slaughter. He alone perpetuated the moment when king or queen proved his or her magical strength by administering the deer's final death stroke or directing the fatal deed from a safe distance.

All the game in the territory surrounding Nuremberg belonged to the imperial city, which was highly selective as to who could be accorded the privilege of its pursuit. Members of the local aristocracy, such as Willibald Pirckheimer, often went hunting, renting the privilege from the city, but they usually relinquished their rights at the age of thirty or so. This was very different from the nobles of Saxony [4.4] or the kings of France, who kept at it all their lives, surrounding the sport with all possible ceremony and opulence.

Hunting on horseback was divided into two main types—the chase and falconry. For the first, deer, bear, and wild boar were the chief trophies. Packs of hunting dogs trained for their sense of scent as well as speed and endurance, such as greyhounds and heavy mastiffs, were used to chase down the big game, which was then killed by the hunters with spear or knife. Dogs and ferrets also pursued fox, hare, otter, squirrel, and fowl, including the partridge and the crane. Duck, egret, and other game birds were captured by falcon.

Frederick the Wise of Saxony undoubt-

edly wanted the young Dürer to be court painter, to record his victories in forest and battlefield. But this was an opportunity that the artist did not take, leaving it to his friend Lucas Cranach, who worked with him on Maximilian's *Hours*, to add scenes of deer in the woods. Little in Dürer's work suggests a taste for such violence.

Condemning all forms of human pleasure as vanity and evil, Sebastian Brant's *Ship of Fools* did not let the hunter escape a tongue lashing:

This sport is not without folly, because it involves great expense. Hounds must be fed and hawks are expensive, so that every hare or grouse costs a pound. And what a waste of time and labour in driving the game and seeking it among mountains and forests. More game is scared away than shot, and many a sportsman brings home a hare which he has bought in the market! Many others want to show their courage and go hunting lions and bears and wild boar or else chase the chamois but they find only danger. -And now farmers are encroaching upon the nobility. They go out in the snow and have already secretly sold the game while the nobleman is still searching for it. Nemrod, the first hunter, was abandoned by Heaven, and Esau became a huntsman because he was a sinner. There are few such hunters as St. Hubert was and St. Eustace [1.30], who left their hunting to serve God. (See Aurelius Pompen, *The English Versions of the Ship of Fools*, 288)

Only one major hunting scene painted by Dürer survives, and significantly the subject is a mythological one, a scene of justice, not sport. Painted in 1500 for Frederick the Wise, the now much-damaged canvas *Hercules Shooting the Stymphalian Birds* [11.2] was kept in a sort of steam room in the lower depths of his castle. Fifteen years later, Dürer repeated the classical theme for one of the whirling line drawings that enliven the margins of Maximilian's *Book of Hours*. In another sketch, a hunter blows his horn as he and his hounds approach a stag, and there is a playfulness, almost a camaraderie, uniting the dogs and the deer, as if in merry, not mortal, pursuit, sharing the adventure of a bloodless chase [4.5]. This witty little scene is in the same capricious mood of the other marginal decorations for Maximilian's *Hours* and some of the emperor's other good-humored commissions.

Beyond the city walls, animals of the woodlands—except deer—were not pets, but rather reminders of another world, free from the twin thralls of farm or domesticity. Dürer came close to their independent nature, studying them both dead and alive, with sympathy yet without projecting human qualities upon them. He preserved the wild character of his reluctant models, never losing their "otherness" despite sudden proximity.

4.5

Badger

A long-snouted badger waddles to the left in an early sketch drawn in the mid-1490s [4.6], sharing the space with a male nude, a saint with a book, and some drapery. About fifteen years later Dürer sketched another badger, perhaps based on the earlier one, with a she-serpent, a European bison, and a lion. All are present in a woodcut entitled *The Fall of Man* [2.24], which the artist made around 1510 as an introduction to his *Small Passion* cycle. The badger [4.7] was included because he stood for sloth, understood as the source of all sins.

Chained below a stairwell in the woodcut *The Life of the Virgin* is a demonic creature with a badgerlike head. Almost out of sight, it is present at the moment of the Annunciation [4.8], again signifying the first sin, its capture symbolizing the salvation that will come with Christ.

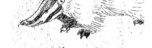

4.6

4.7

4.8

Bat

Bats, like most nocturnal animals and other lovers of the dark, tend to carry connotations of evil. The fifteenth-century scientist and theologian Nicholas of Cusa wrote, "Just as the eye of a bat hides itself from the light of day, so does our soul's eye hide from an understanding of what is clearest in nature." Certainly the best-known bat in all art before Goya's flies in *Melencolia I* of 1514 [3.16; 4.9]. Though its fearful head resembles that of the European brown bat, the creature's widespread wings and curly tail are nearer Gothic fancy than zoological fact. A German scholar has suggested that Melancholy's bat announces not only the subject of this print but also its cure: Boiled bats were prescribed in antiquity for ailments of the spleen, where excessive black bile, the melancholy fluid, was secreted.

Dürer drew two more bats in 1515. One spread its wings at the top of a grotesque column supported by a wounded peasant [4.10], once again a sign of melancholy. The other appears above the apostle Andrew in Maximilian's *Hours* [4.11], where it probably represents the forces of darkness, overcome by light shining from the saint's halo below. A lock of a hope chest in a drawing for *The Temptation of Saint Anthony* [4.12] is bat shaped, indicating the evil that lies in the accumulation of worldly goods. Dürer himself was a melan-

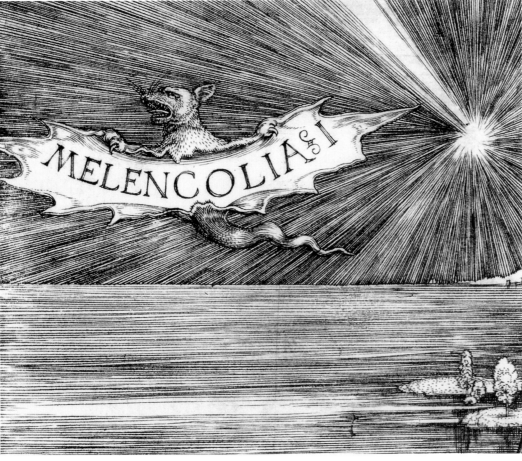

4.9

4.10

choly man, certainly a night owl, a keen amateur astronomer and astrologer. Was he drawn to the bat because of its virtuosity as the only mammal able to fly, providing a zoological parallel to the wide range of his own artistic skills?

4.11

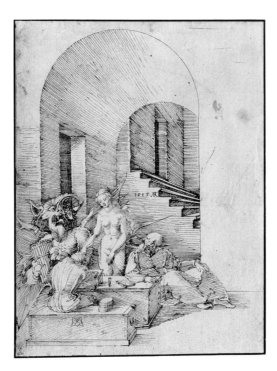

4.12

Bear

Dürer's first known bear was for a woodcut illustrating the seventieth poem in Brant's *The Ship of Fools* [5.22]. Crouching at the lower right, the bear licks his handlike paws to illustrate the moral of "Not Providing in Time." Hibernation was not understood in Dürer's day; bears were believed to subsist in winter by licking their paws. Here, a lazy, bedraggled fool is about to beg for food in winter, in contrast to nature's busiest, most providential creatures, the ants at the right and the bear below.

Far more naturalistic, but still inaccurate, are the bears that Dürer drew for the northern sky chart of 1515. The shapes of the constellations required that Big and Little Bears both be shown with long tails [4.13], even though real bears don't have any!

Artists could be compared to bears, because it was once believed that mother bears quite literally licked their cubs into shape. So Titian (who admired and adapted Dürer's prints) placed the bear on his coat of arms for its legendary creativity. Dürer drew another bear, ridden by a cupid into combat with a unicorn. An assistant painted this scene on the first page of Pirckheimer's Greek edition of *Aristotle and Theophrastes*, printed in Venice in 1497 and illuminated before 1504. Later, when Dürer and the gifted Augsburg master Hans von Kulmbach designed Maximilian's *Triumphal Procession*, they included bears accompanied by their gamekeepers and huntsmen.

European Bison (Wisent)

These magnificent beasts, awesome survivors from prehistoric times, were already rare in Europe by the early sixteenth century. Although found in preserves in Poland and Hungary established in the seventeenth century, European bison became virtually extinct in the wild (they were artificially reestablished by selective breeding only in recent times). Surviving drawings suggest that Dürer first studied bison in 1501, noting in his diary that for Maximilian's visit to Nuremberg, "Five bison were presented to the King, they looked very strange [4.14]." (They were so rare he used the wrong German word to describe them: *aurochs* instead of *wisent*.) This great wild animal is shown in profile, stressing the unique curvature of the upper back and the beardlike hair on the chest and under the jaw. Dürer included the wisent in his ca. 1509–10 woodcut *The Fall of Man* [2.24; 4.15], quietly kneeling at the far right.

Abundant in ancient times, the European bison was included in *The Hieroglyphica* of Horus Apollo, where it stood for military valor and discretion. Maximilian probably valued these qualities above all others, being both a fearless soldier and a hugely successful and discreet matchmaker. The bison may be seen in *The Book of Hours* grazing near the emperor's patron saint, Bishop Maximilian, but this beast is something called a "domesticated European buffalo" and is grouped with farm animals.

Wild Goat (Chamois)

The reckless antics of goats have contributed to a special kind of art form—the *capriccio*, a word derived from the Spanish for goat, *cabra*, or the Italian, *capra*. Typical of the *capriccio* are many of the marginal decorations made for Maximilian's *Hours*, lighthearted or grotesquely funny moments of fanciful exploration. Imaginative, irrational, closer to comedy than tragedy, the *capriccio*, like the goat, is a cliff-hanger, usually with a happy, if bizarre, ending. Goats and satyrs, both close to Bacchus and comedy, appear in much of the classical literature first printed in the Renaissance. Dürer placed goats on columns, part of the decorative framework for such texts, following the Italian designs of frontispieces. These title pages turn up in unlikely places, even prefacing Luther's sermons.

Of all four-footed northern beasts, the chamois is the swiftest and most elusive of the hunter's prey, and it provided Maximilian with his favorite pursuit in the Tyrolean mountains.

4.13

101 Wild in the Woods

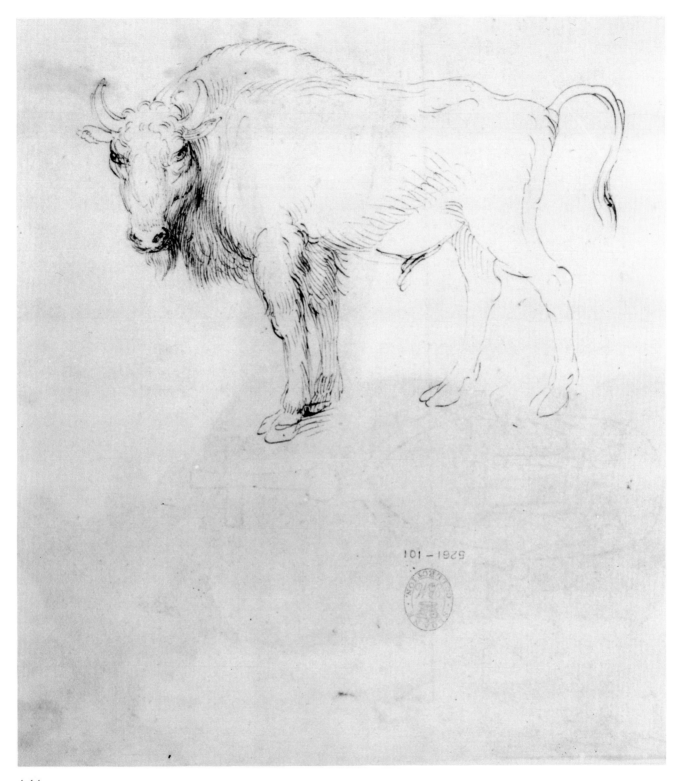

4.14

4.15

4.16

4.17

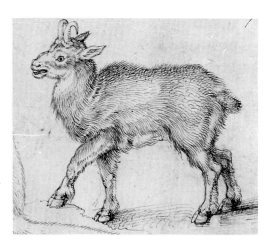

4.18

Leaping in rugged Alpine vistas, the surefooted climber is found in the Louvre's *Our Lady of the Animals* of 1503 [2.10; 4.16], and in *Adam and Eve* [4.17] of the following year, where a goat peers down from the rocks at the moment of the Fall. Feisty if not actually badtempered, the goat sometimes stood for the melancholic humor and may for this reason be included here, for it was during the Fall that the balance between the humors was disrupted.

Though Dürer may have seen the chamois [4.18] on his journeys to Switzerland or Italy, his first chance to examine this beast at close range may have come in Brussels, where he visited the zoo of Charles V, drawing several of these animals in 1521.

Deer

Dürer's first and perhaps most powerful depiction of a deer is of a dead one [Plate 11], drawn during his return from the first Italian journey. Shot with an arrow from a crossbow, the red deer may have somehow managed to escape the hunters and their hounds, dying far from his pursuers on a mountain path. This very large drawing is worked in watercolor and gouache, with some details done in pen. (The watermark, identical to those found on paper that Dürer used in Venice in 1495, helps to date it.)

Although much of Dürer's work is devoted to suffering, to Christian torments in often repetitive detail, few of these come close to the sense of loss and shocked witness provided by the stricken deer. It is as if he wanted to come to graphic terms with wanton destruction. A whole world seems to have died with this deer, whose massive, tragic head suggests some remote planetary surface, with mountains and rivers, crags, and elevations seen close up, yet its monumentality makes the head appear to have been observed from a great distance.

Some years later, Dürer may have remembered this study when he engraved *Apollo and Diana* [4.19], where the goddess of the hunt has in her lap a stag whose hidden eye and strangely open mouth suggest a certain lifelessness. Although the goddess is meant to be feeding her pet, holding grasses in one hand as she pats him on the muzzle, her deer may be dead.

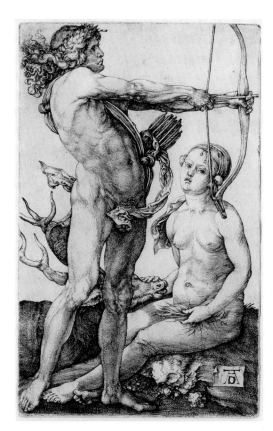

4.19

Rarely can one "see" a master of the past at work or have the experience of looking over his shoulder as he transforms the first outline into a fully rounded form. But by comparing two of Dürer's drawings, just such an extraordinary feeling of participation is possible. The first is the *Head of a Roebuck* [4.20], done with a pale gray wash alone, which is how Dürer prepared his preliminary underdrawing. The second is a highly finished rendering of the same head in watercolor and opaque color [4.21], with the same sort of underdrawing just below the surface, close in date to the *Hare*. Even in the first drawing, Dürer provided a rich sense of texture with short, hairlike strokes for the furry areas and long, unbroken ones for the stag horns. Dürer may have found the model for one of his liveliest studies, *The Roe Deer*, among the herd that grazed in the dry moat of Nuremberg's old castle. This was the city's first and long-outdated fortification, located between the river and one of the great towers in the city walls.

Psalms abound with beautiful images of deer—"As the Hart panteth after the water brooks, So panteth my soul after thee, O God"—and the Bible is filled with references to the hind and the roe. But neither Dürer nor Cranach made these inferences in their drawings for *The Book of Hours* of Maximilian. Cranach does include marvelous scenes of stags, designed to delight that imperial huntsman but never coinciding with the text. For the opening page of the 1510 woodcut *Small Passion*, Dürer sketched an Italianate Adam and Eve seen from the back in loving embrace [4.22]. A fallow deer with palmate horns is at the amorous couple's side, while a lion, more moody than menacing, sulks at the right. In Dürer's design for a chandelier [4.23], similar horns reappear as wings, keeping a cupid aloft as he beams the light of love. To support a delicately poised stag within a circular pendant [4.24], Dürer devised a latticework of horns and a branch of oak leaves. Hunters' hats of the period were often adorned with just such brooches, and this design may have been made for execution by Dürer's goldsmith brother.

The artist and his friend Pirckheimer shared a passion for collecting the horns of stags, cattle, elk, and European buffalo. These were valued for themselves alone, hung proudly on walls or mounted in precious metals. And when Dürer traveled he was always on the lookout for fine or rare specimens; some he kept for himself, others were gifts for his friends. Agnes Dürer, who detested Pirckheimer, inherited many such natural wonders upon her husband's death. "Albrecht had some horns, and among them a very fine pair which I should have liked to have had," Pirckheimer noted bitterly, "but *she* secretly gave them away for a mere trifle along with many beautiful things."

Stag horns were also worked into oddly shaped chandeliers, where their intricate, nat-

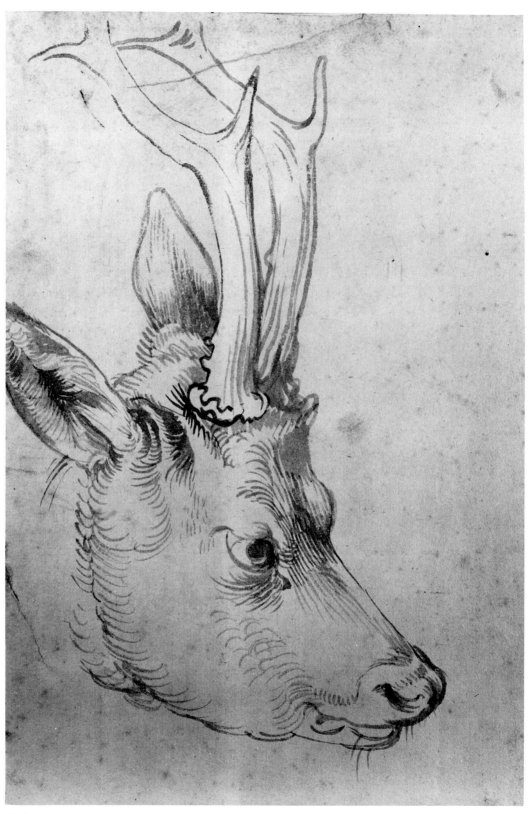

4.20

105 Wild in the Woods

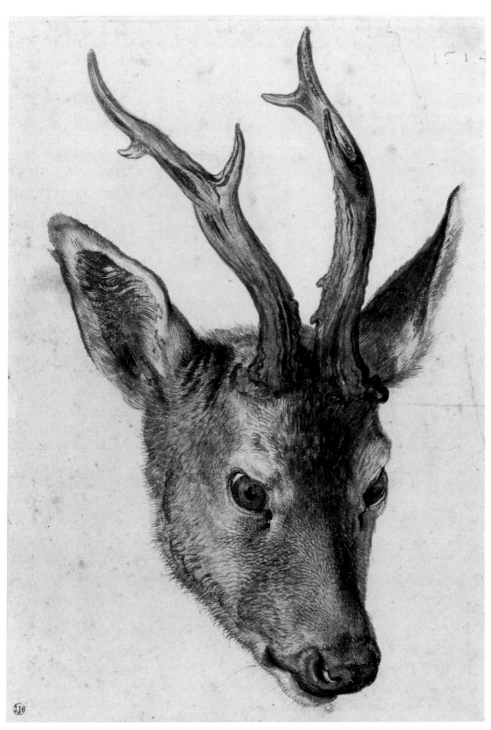

4.21

106 Dürer's Animals

4.22

4.24

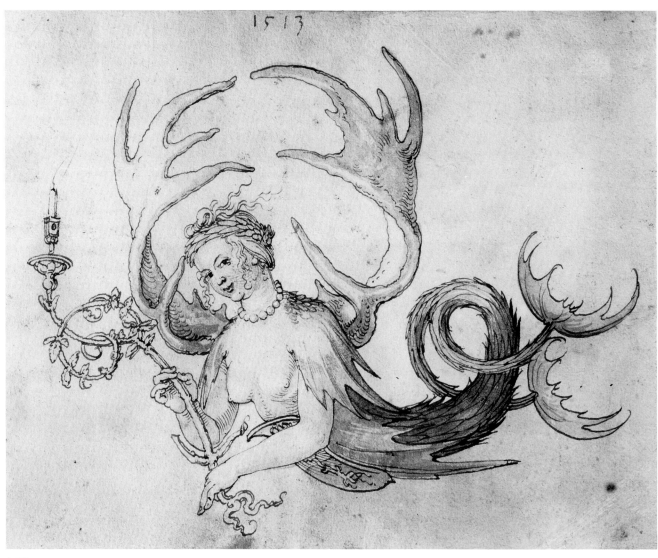

4.23

urally decorative form lent itself to the fabrication of fantastic mermaids or flying creatures, whose wings or bodies sprouted candle-bearing horns [12.35]. Preparatory drawings for these bizarre lighting fixtures are found among Dürer's designs. One shows a siren to illuminate Pirckheimer's house [Plate 34]. Frederick the Wise also sent Dürer antlers for conversion into such a grotesque light.

Not all Dürer's deer were chosen for their beauty. We know from a copy [12.27] that one of his pages records a freak, its grotesquely misshapen head drawn with as much care as he devoted to the finest specimens.

Symbol of longevity, a stag's hide appears near the top of the Portal of Nobility, which the artist designed to trace the lines of Maximilian's forebears on his *Triumphal Arch* of 1515 [4.25]. And life-sized stags with real horns, painted on the walls of a fifty-yard-long hall, are still found in Maximilian's Tyrolean hunting lodge, each placed between a portrait of the 147 members of the emperor's family, forebears and descendants, ending with his son Philip.

Elk

Only one complete drawing of an elk by Dürer is known—a powerful study in brush and pen, using black ink and watercolor heightened with white [Plate 12]. For such a highly finished sheet, the artist began by lightly sketching the outlines with pen and ink and building up the form within using brush and watercolor. Some of the hairs are drawn with a solid white, which provides a remarkable sense of texture and a lifelike effect. Another animal, the European bison on the back of this page, helps to date it near 1501, when five of these rare beasts were presented to Maximilian. (As often happened, a false date was added to the study later in the century.) Later, the artist reused this study for the older-looking, melancholic elk that looms in the background of *Adam and Eve* of 1504 [2.18; 4.26]. And a strange, somewhat elklike creature appears in the borders of Maximilian's *Hours*, but it does not fall into any strictly defined zoological category.

4.26

4.25

Elk were killed for their medicinal properties. When Dürer contracted the malarial fever that may have led to his death, the artist purchased an elk's foot in Antwerp. He may have bought it in powdered form, as this was believed to bring down fever and take away the chills. He sent another "great elk's foot" from the Netherlands to a friend back home.

Fox

Strange as it may seem for an artist who drew thousands of animals, not one of Dürer's surviving scenes of wild or domesticated creatures is associated with the most popular fables of his time. If it were otherwise, he would certainly have produced many more foxes, since a fox was Aesop's major informant as to the ways of the animal world, and the same wily beast was the antihero of a widely read late medieval French poem about Renard the Fox, which when translated into German became almost as beloved as the Greek fables. Long linked to the devil, the fox was seen as an agent of evil, far too smart for his own or anyone else's good. Most of the foxes that Dürer drew were chained, demonstrating the triumph of good over evil, as in *Our Lady of the Animals* [Plate 2].

In Aesop's spirit is a drawing for the bottom of a page in Maximilian's *Hours* [8.45], where a sly fox, with typical savoir faire, plays a recorder, hoping to seduce the chickens across the way.

A woodcut of an elaborate allegory of life's changing fortunes, *The Wheel of Fortune* [4.27], was designed by Dürer after a late medieval model, an early fifteenth-century tapestry discovered at Michelfeld. He modernized the woven Gothic figures but kept their complicated message—that of fickle fate. Standing on his hind legs, a fox turns a wheel on which six birds go round and round, his labor shared by a long-haired maiden at the right whose label identifies her as Fortune. In a southern star chart, the constellation Fera—the fox—is shown with a sword thrust through its open mouth by the neighboring Centaur [4.28]. The fox was also included with a wild cat in the intricate design Dürer devised for the neck guard of a splendid suit of armor ordered by Maximilian [4.29]. His presence amidst grape vines may refer to the Song of Songs: "Catch us the foxes, the little foxes that spoil the vineyards, for our vines have tender grapes." About six years later, in 1523, Dürer included a fox in a project for a massively elaborate altarpiece [4.30]. He stands, patiently wearing a collar, just below the Mother and Son, placed over the artist's monogram.

4.27

4.28

4.29

4.30

Hare and Rabbit

Most famous artists of the past are renowned for carefully composed paintings, in which the viewer can become lost in the beauty, mystery, or drama of the maker's vision. But Dürer is far better known for his works on paper, his prints and drawings. Of all these, the best known and loved are his *Praying Hands* and the *Hare* [Plate 13]. Their huge popularity seems strangely linked, as if the lively realization of the earlier work could not have been made possible without the promise and massive appeal of the second. Equally compelling, both images are those of love. Where praying hands bespeak the love of God, hares and rabbits are traditional symbols of classical and Christian love, devoted to both Venus and the Virgin. The venerable Bede wrote that hares were sacred to Germans; they also symbolize speed, the passage of life, protection, and fertility.

Two of Dürer's favorite Italian painters, Mantegna and Giovanni Bellini, included a sprinkling of rabbits in their scenes of Heaven and Olympus, found among the strawberries and the flowers, chasing and mating in the little rocky outcroppings. Renaissance rabbits may have caught Dürer's eye even before his first Italian journey: A northern Italian illuminated manuscript shows rabbits on Mount Parnassus keeping Apollo company as he plays the lyre. This was copied by Dürer's assistant Hans von Kulmbach in 1501 and may have been in Nuremberg for many years before that date. Hares and rabbits divert saints in the wilderness, providing moments of mirth between hermetic rounds of harsh self-punishment. Northern Italian masters often placed black and white rabbits near the scene of the Nativity, as if giving the Infant live instead of stuffed toys. Renaissance portraitists showed women holding rabbits, as these made popular pets. When they died, they were given funerary odes and tombs to help console their grief-stricken mistresses.

Dürer's first hare is very different from these poetic, romantic images of love and faith. Dead, it hangs from a market stall in a lively cartoonlike illustration he provided in the early 1490s for Terence's play *Andria* [1.21]. For another classical subject—the arrival of the sea-born goddess of love, who floats to shore on a dolphin—Dürer drew cupids in the foreground, one of whom chases a rabbit (Windsor Castle). This scene, with complicated references to ancient texts, was doubtless suggested to Dürer by Pirckheimer, who knew Greek works in which the land of Venus is identified as one where cherubs chase rabbits.

Within a year or so of this drawing, prepared in reverse for a print that was never engraved, the artist made the woodcut *The Holy Family with the Three Hares* [2.6; 4.31]. Like the rabbit in the drawing, the animal on the left plans to vanish down the hole. Another is eating a quick snack as his watchful companion keeps a protective paw on his shoulder. The powerful woodblock for this print [4.32], which still survives, was carved with masterful confidence and clarity, possibly by Dürer himself; it shows how the force of outline was transferred from inked wood to paper.

Another woodcut, also dating from the late 1490s, *The Glorification of the Virgin* [2.7; 4.33], presents the holy family behind a low ledge. Five cherubs race around the foreground; two hold blank shields to be handcolored with the coats of arms of the print's purchasers, usually an engaged or newly married couple. Another angel tries to grab a rabbit by its lucky foot as a companion plays a tiny flute. This may be a spoof of the hunter's horn, played at the moment of capture and kill; the captured hare suggests the capture of love and luck alike.

Shy yet surprisingly poised, the hare drawn by Dürer in 1502 seems almost to have been rendered in the artist's absence. In fact, a sense of the artist's anonymity and invisibility seems essential for the elusive animal's presence on paper. The "vanishing artist" is one of

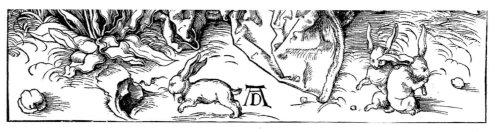

4.31

4.32

4.33

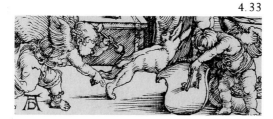

the central tricks of the Renaissance, which so enjoyed exploring the new world of illusion. Now the viewer can forget that the image is description rather than fact, filtered through a mind and realized by a hand. Everything the artist depicts is explored as though never seen before, with an intense scrutiny that makes the familiar novel and the novel familiar. Such close observation of the natural world is the beginning of the new theology of natural science.

The knowledge of God's works is achieved by their re-creation in art as the painter, godlike in his illusionistic powers, establishes a sense of life, even of breath and potential motion. If you look closely into the hare's gleaming eye, there is a revealing reflection: Not painted in Nuremberg's sandy stretches, it posed on a table in Dürer's house, as indicated by a studio window's crossbars mirrored in the animal's pupil. The artist may well have raised this hare from infancy so that it took him for granted and was not afraid. Dürer doubtless used dead hares as models before painting this remarkable live one, exploring the texture of fur as well as the bones and muscles below; but such studies after death could not have prepared him for the life found on this page, for the way the fur rises and falls with the hare's breath, for the damply curious twitching nose and the sharp yet vacant gaze of the liquid eye.

Working in gouache and watercolor, Dürer began by drawing the outline in broad brushstrokes. Using a far finer brush, he then made the thousands of little strokes to give the hare its fur. At the end, white highlights provided additional modeling. Dürer pictured the hare head-on yet unaware, in a startling fusion of the abstract and the realistic that is almost Oriental in its austerity. Life is suggested by the nine eloquent whiskers bristling to the left, the twin projections of the ears, the delicately paired paws, and the looming shadow.

Thanks to a copy by Hans Hoffman signed and dated in 1582, we know that Dürer made at least one other drawing of the famous hare in highly finished form, this time seen from above, and even more daring in its dramatic yet naturalistic viewpoint [4.34]. Though Hoffman or a later hand chose 1528, the year of Dürer's death, as the date to inscribe on this copy, the lost original must have been painted within a short time of the beloved *Hare* of 1502.

The same qualities found in the *Hare* are

111 Wild in the Woods

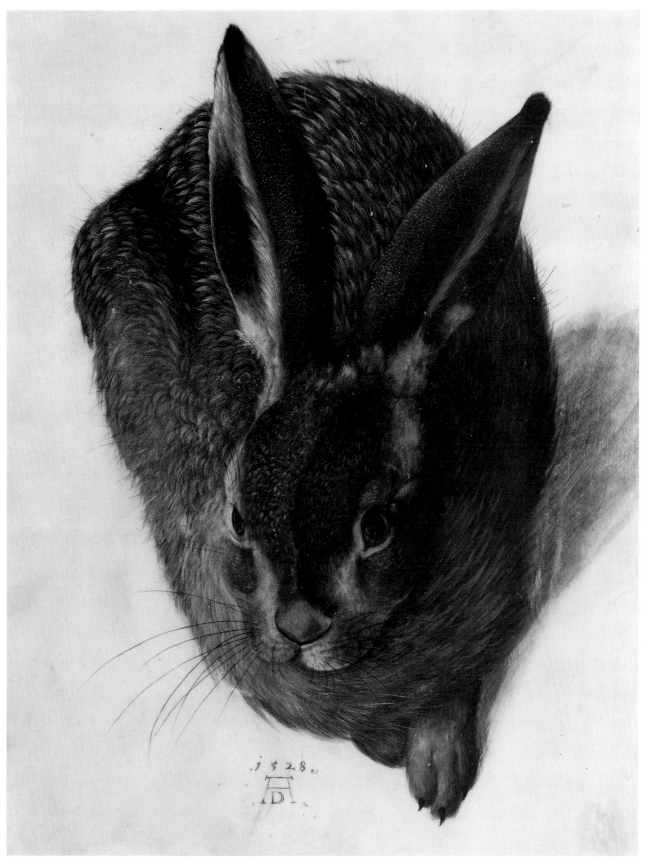

4.34

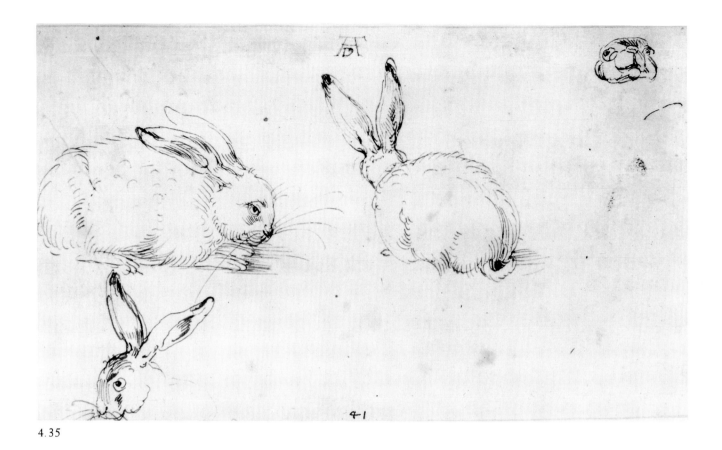

4.35

4.36

4.37

4.38

seen once again in a page Dürer prepared about a year later with four studies, all drawn after one rabbit model [4.35]. (In the *Adam and Eve* of 1504 [2.18; 4.36], the rabbit is printed in reverse following Dürer's engraving of the second drawing from the right, placed close to Eve.) Before Leonardo da Vinci and Dürer, more artists contented themselves with a single view or two. But now, with the multiple projections of the *Hare* and *The Blue Roller*, the painter shows his concern with exploring an animal almost as if his living model were a continent or a constellation whose richly independent structure was to be perceived in its entirety, understood as a world in itself.

Two rabbits were drawn by Dürer flanking a roundel with a classical profile, all placed on a curved architectural form [4.37]. He saw Roman funerary reliefs somewhat like this in northern Italy and in Venetian book illustrations from the late 1490s, but Pirckheimer could have suggested the theme, possibly for the decoration of a text. Fanciful and witty in style and sentiment, the drawing resembles those found in Maximilian's *Hours*, on one of whose pages, almost hidden in an intricate swirl of calligraphy, are two other rabbits [4.38], placed back to back. Another rabbit has leapt into the skies, forming the constellation Lepus, just below Orion in Dürer's southern star chart of 1515 [4.39].

On his design for Maximilian's *Triumphal Arch* [4.40], paired councilors, one wearing robes with the two-headed eagle of the Holy Roman Empire, the other in prophetic garb, point with slender staffs toward two rabbits perched in profile on the cornice above. They may be featured so prominently to call attention to Venus's nearby presence, or because rabbits, like cranes, also represent Vigilance, as they do in the hieroglyphs of Horus Apollo [4.41]. Triumph is, after all, not a permanent state; if one does not keep a lookout, victory may be short lived.

Wild in the Woods

4.39

4.41

4.40

4.42

Lynx

A fierce fighter, the lynx [4.42] is capable of taking on animals larger than itself, such as the deer, but most of its meals come from far smaller creatures, like fieldmice.

Drawn in 1521 on the same large sheet with the chamois, this is the handsome European lynx, whose beautifully spotted fur was highly prized. To depict predators and prey in such proximity on one sheet suggests Edward Hicks's many paintings of the Peaceable Kingdom. In fact, Dürer probably sketched from a safe distance at the imperial zoo in Brussels. Entries in his diary and a drawing of the zoo itself [10.14] record his visit there in 1520.

Late medieval legend credited the lynx with X-ray vision; "able to penetrate with their eyes things that are otherwise not transparent, such as walls, wood, and the like. On the other hand, if any reflecting thing is held before them they hide their faces and die of it." This belief was restated by the late Renaissance zoologist Conrad Gessner, who took so many of the illustrations for his book from Dürer's art.

Squirrel

"The squirrel," according to Albertus Magnus, "is an extremely lively little animal; it nests in the tops of trees, has a long bushy tail, and swings from tree to tree, doing so using its tail as a rudder. When on the move it drags its tail behind, but when sitting erect it carries it erect, upon its back. When taking food, he holds it, as do the other rodents, in his hands, so to speak, and places it in his mouth. His food consists of nuts and such like things. His flesh is sweet and palatable. In Germany his color is black when young, and later reddish, in old age even partly gray." Pliny's *Natural History* remarked on how the clever squirrel used his tail as both weather vane and blanket, how it stored food for the winter, and how Roman women liked to keep them as pets. In medieval times, Germans found many medicinal purposes for squirrel fur and flesh, especially as a cure for gout. Another of Dürer's sources, Conrad von Megenberg, claimed that the ingenious animal loved to go to sea, using his tail as a sail to catch the breeze. Such delightful myths led to the squirrel's becoming a symbol for inventiveness, as shown in an emblem book [4.43] written by a friend of Dürer's, sailing away under his own fur. Most early pictures of squirrels show them eating, as this is a sign of both their industriousness—having stored the fall's harvest for nourishment in the long, lean months ahead—and of their greed.

Several of the best-loved Dürer animal studies are ones that scholars now suspect he may never have made, such as the watercolor on vellum, *The Two Squirrels*, perhaps of the same pet from two angles. Most experts believe this is a copy after Dürer by his faithful imitator Hans Hoffman, who drew a squirrel similar to the one on the right in watercolor on parchment [Plate 14], signed and dated 1578. He probably worked from a Dürer owned by the Imhoff family of Nuremberg. Pirckheimer's heirs, they owned many of the artist's works and made them available to Hoffman.

If *The Two Squirrels* is a sixteenth-century copy, its source is close in date to the *Hare* of 1502. The wonderfully felt textures, the sense of fur and gleaming eye, of suddenly arrested movement, of total absorption, are much the same in both. The squirrel on the left, seen from the rear, seems rather boneless, so much so that those who argue for Dürer's drawing the one on the right often regard this one as added by a later hand. But that seems unlikely: Dürer was so revered a figure that to tamper with an original work by placing another image on the same page, risking damage or suspicion by so doing, is implausible.

Artists in the seventeenth century did not hesitate to "improve" earlier works by great masters, bringing them "up-to-date" by adding more dramatic shading or coloring, but such radical steps were seldom taken earlier. So in the case of the two squirrels, Dürer made either both or none. Recently Fritz Koreny, an Austrian scholar, made a strong argument for giving this page to Dürer's copyist Hans Hoffman. Compositionally the squirrel to the left has its uses, for the mate is not so well balanced and looks almost as if he might tip over with-

4.43

115 Wild in the Woods

out his partner's support. Moreover, the way in which one animal is shown eating hazelnuts behind the other's back is in keeping with the folkloric wisdom about the squirrel's greed. Traces of their meal, scattered in the foreground, create a sense of space. This is an illusionistic device never found in Dürer's drawings but common later in the sixteenth century, when Tobias Stimmer prepared his *Squirrel* in 1564 [4.44].

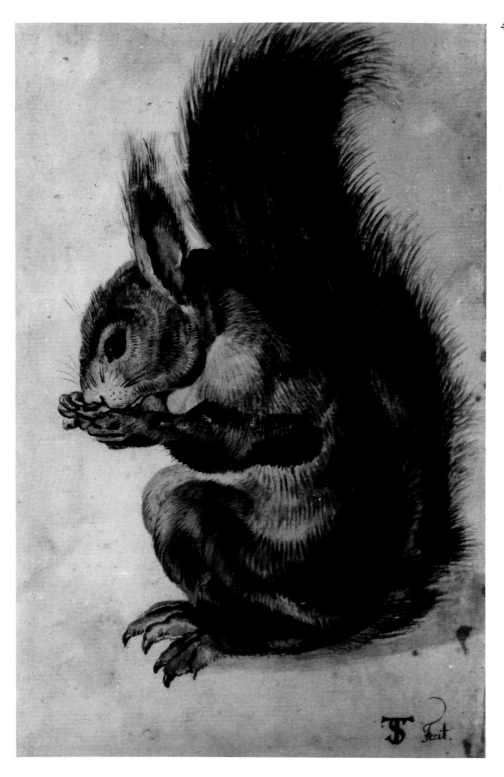

4.44

Stoat

A study of two stoats [4.45]—possibly the same model seen from two sides—was done in pen and brush with brown and gray ink on paper. These elegant brown animals often turn a protective snow white in winter, when the pelt becomes known as ermine, the fur of kings. Not all scholars agree that this sheet was drawn by Dürer, but the style and technique are close to those of *The Dead Heron*; the page may be a copy by Franz Buch, whose name is on the back with the date 18 June 1573. A dead animal might have been the model; something about the way the head is poised suggests that the painter saw this laid out on a tabletop and tried to bring it back to life in his art.

Wild Cat

A small but fierce ring-tailed wild cat [4.46] keeps company with a fox on the neck guard for the silver-plated suit of armor ordered for the emperor Maximilian in 1517. Both predatory beasts contrast sharply with the two birds that they approach: the Pelican of Piety, reviving her young with her own blood, and the phoenix, another sign of spiritual rebirth. Nuremberg was a center for the international fur trade, especially for precious pelts from Russia. The model for this wild cat may have been caged, carried from the wintry wastes of Siberia or northernmost Scandinavia.

4.45

Wild in the Woods

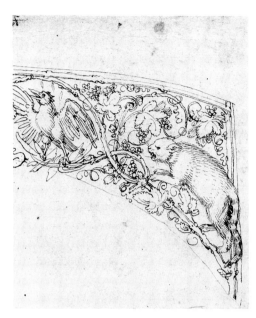

4.46

Ever the dandy, Dürer loved lavish clothing, confirming his lofty status as the prince of painters. In his *Self-Portrait* of 1500 [1.29] (Munich), he is shown at the midpoint of his life, just as one century turned to the next. The artist's left hand fingers the rich fur lining of his robe as Nuremberg's Narcissus stares, self-entranced, at his mirrored image. Such wild pelts, mostly trapped in Russia, were part of Nuremberg's wealth in trade, usually adorning the clothing of men of power and breeding. But here nature's sumptuary honors cover Dürer, self-earned, generated by the power of his art, from images of his own breeding.

Chapter Five

Creatures Hard-Shelled and Cold-Blooded

Soft- and hard-shelled and cold-blooded creatures, reptiles, fish, and insects—hovering between dry and wet, sea and sky—offer special challenges and peculiar delights to the artist as well as the scientist. Few such animals inspire the sort of sympathy or affection so readily won by the more appealing and companionable species. In Dürer's day, only intrepid painters with natural curiosity would wade into the waters or mudflats or explore the fish markets in pursuit of these creatures to bring them back alive—on paper. But far from being viewed as repugnant, most insects and cold-blooded animals were seen by philosophers and artists as illustrations of divine ingenuity, of brilliantly inspired engineering. The idea of microcosm, the very small, as a key to the working of the universe, a miraculous reduction of the mystery and magic of the grand divine design, made these often tiny creatures of special appeal. Only dangerous creatures were detested. In myth and faith as well as in fact, many insects were connected with death, plague, sudden affliction, and relentless terror. Because the locusts that rained down on the Egyptians were individually so small and vulnerable yet collectively so unassailable and destructive, there was a fearful paradox in the insect world between miniature cause and monstrous effect.

Long before Dürer's first journey to Venice in the mid-1490s, German artists had already shown a special interest in cold-blooded creatures. Snails, lizards, beetles, flies, and crabs fly or crawl through many paintings by Dürer's teacher [5.1]. Manuscript illumination had included amazing flights of painted dragonflies, slithering snails, and other insect life. Early Gothic architects such as Villard de Honnecourt explored the ingenious construction of lobsters' movable fortifications [5.2]. This medieval delight continued into the Renaissance, when Ghiberti's son sculpted a miniature zoo, including snails and salamanders, on the jambs of his father's doors for the Florentine Baptistery. And an unknown illuminator, the Master of Mary of Burgundy, accompanied a Coronation of the Virgin with snails, frogs, crickets, and other crawling creatures [5.3]; their highly social meeting takes place at the bottom of the page, a fly just above; at the top, gliding toward the initial, is a large snail, symbol of virginity, its slow patience rewarded by a glimpse of the heavenly scene. Made for a monk rather than a monarch, this page shows that rich members of holy orders were as entitled to witty asides as their rulers. Though

120 Dürer's Animals

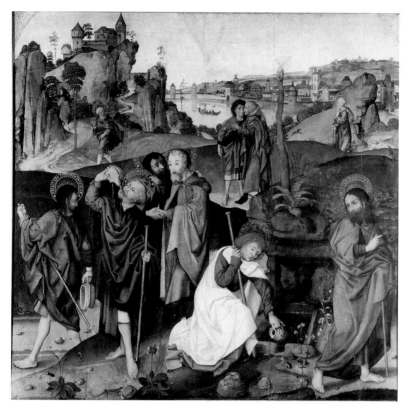

5.1

5.2

5.3

the humor may seem irreverent, it is quite the reverse; this page's pictorial message is, "All is sacred." Such animal life abounded in Dürer's boyhood reading in the *Bidpai: The Book of Nature* [5.4–5.8], and other books [5.9; 5.10].

In Nuremberg, the major Renaissance bronze—a great reliquary in honor of the leading local saint, Sebaldus—features a squad of snails supporting the saint's tomb on their backs [5.11]. (This motif, which is related to astrology, goes back to ancient Egypt, where bronze crabs, symbols of the solstices, were tucked under massive stone obelisks.) Similar surprises abound in the massively illustrated *Nuremberg Chronicles* [5.12]. Scholars have searched for Dürer's hand in the design of some of this large book's monumental woodcuts, but it might be wiser to find his touch in smaller scenes, such as the woodcut showing a plague of hungry insects, which have the same delicate yet convincing sense of life found elsewhere in Dürer's oeuvre.

Just as artists explored the miniature workings of nature, moralists also derived large messages from the deeds of these small creatures. The famous preacher Johannes Geiler von Kaisersberg, who was in Strasbourg when Dürer worked there in 1493, frequently invoked images of spiders, bugs, and other insects to make his points.

Christian attitudes to nature were also reinforced by classical thought rediscovered in the Renaissance. Pliny, in the eleventh book of his *Natural History*, wrote "There remain some creatures of immeasurably minute structure—

5.5

5.4

5.6

5.7

122 Dürer's Animals

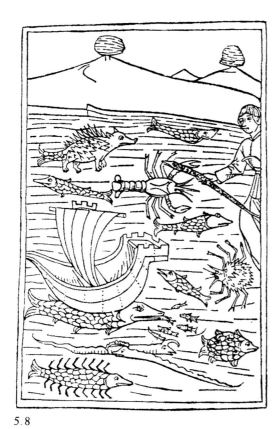
5.8

5.9

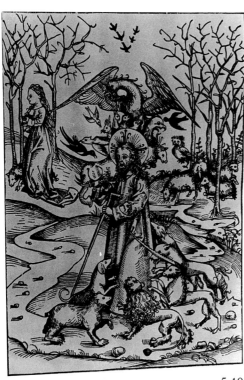
5.10

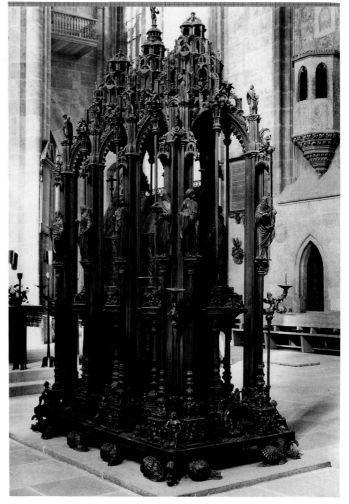
5.11

in fact some authorities have stated that they do not breathe and also that they are actually devoid of blood—insects... with flexible vertebrae shaped like [roof] gutter-tiles show a craftsmanship on the part of Nature that is more remarkable than in any other case. In these minute nothings, what method, what power, what labyrinthine perfection is displayed!... Nature is to be found in her entirety nowhere more than in her smallest creations."

Late fifteenth-century scholars returned to this classical scientific literature and combined it with their own direct investigation of the natural world, for which they required the aid of the artist in depiction, description, and explanation. Understanding could now spring from observation and not from preconceived ideas. No one more than the artist knew the uses of sight, of the responsive eye and the recording hand.

Leonardo da Vinci pioneered a new study of animal life at just about the time that Dürer visited northern Italy. Padua's many-leveled animal arts ranged from the scientific spirit of the descriptive catalog to the grotesque whimsy of small bronze beasts cast from life. Leonardo's *Dragonfly* [5.13] almost takes flight, wings shimmering into life and light; crabs scramble over another page where time and line become one [5.14]. Like the northern sermons, Leonardo's fables abound in tales of spiders and ants, bats and weasels, snakes, oysters, and toads. The caterpillar was especially meaningful, for it "can weave around itself a new dwelling place with marvelous artifice and fine workmanship. Afterwards it emerges from this housing with lovely painted wings on which it rises heavenward." (See Jean Paul Richter, *The Notebooks of Leonardo da Vinci*, 2 vols., 1883 [reprint, New York: Dover, 1970].) The Florentine saw such examples of natural ingenuity as an affirmation and prophecy of his own. The German's *Adoration of the Magi* [Plate 1], with all its insect details, shows an approach to their meaning that is close to Leonardo's.

5.12

5.13

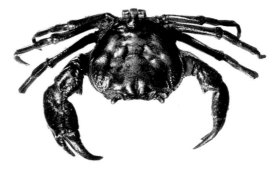

5.14

5.15

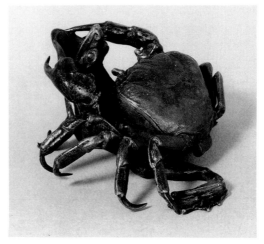

5.16

Dürer felt a powerful affinity for the miniature world of insects, and his role as printmaker may also have given him a sense of kinship with the littlest creatures, finding their being close to that of his art. His sense of wonder for all animal life is often keenest on an intimate scale, where the drawing's actual size comes close to its model's.

"Self-portraits" of crabs [5.15; 5.16] were being cast from their shells by sculptors in Padua when Dürer went there in the mid-1490s. Frogs [5.17], toads [5.18], snakes, and beetles [5.19] met the same bronzed fate. These hardened pond dwellers now found themselves abused as inkwells, eternally open-mouthed, forever awaiting pen or brush. Such gruesome yet comical works, contriving to be both less and more than either art or nature, signify a critical moment in Western art and thought, a breaking down of the barriers between creation and re-creation, fact and fancy, art and nature, invention and facsimile; this moment marks the beginning of modern times. Weird harbingers of mass production and movie cartoons, forerunners of hand-painted turtles and color photography, these cast frogs, stag beetles, and toads have a visible message—themselves—that may well be more meaningful than any written by their proud Renaissance owners.

The new Quattrocento drive toward realism lead to strikingly lifelike images, such as the eight varieties of freshwater fish in Maximilian's *Fishing Code* of 1506 [Plate 15]. Laws controlling the catching and selling of river fish had been formulated by the emperor's father, but he was the one to find artists able to illustrate the code so vividly.

Dürer's fondness for marine life, for seashells and coral, for exotic marine specimens, emerges most strongly in the diary he kept during his Netherlandish journey of 1520–21, when he was happy to receive a branch of white coral in exchange for drawing a portrait. "I paid three *stuivers* for two little veined shells," Dürer noted in September,

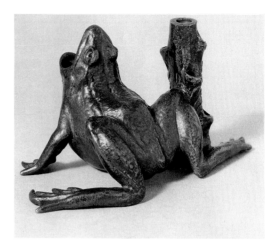

5.17

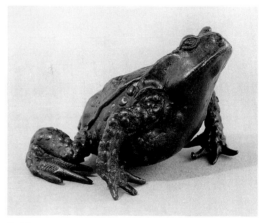

5.18

5.19

when he was in Antwerp. "Felix [a "splendid and extraordinary luteplayer," whose portrait Dürer drew twice] has given my wife two [shells] like them; and Master Jacob, the painter from Luebeck, has also given my wife another."

In Brussels he saw "a fish bone as vast as if it had been built up of squared stones. It was a fathom long and very thick and weighed some fifteen hundred weight." Dürer drew it in his diary and noted that this huge bone—probably from a whale—"stood at the back of the fish's head." When the artist wrote, "I paid four *stuivers* for a little tortoise," was this one brought back from overseas or simply an appealing regional one found in an Antwerp marketplace? The same section of his diary de-

scribes him being given a little shield from "Calicut" (India) made of fishskin, and the tortoise, too, may have come from faraway, though the animal's low price would suggest otherwise.

Several times Dürer mentions presents of snail shells, presumably from overseas or at any rate unusual. Typical of a more complicated exchange is one made in Antwerp toward the end of 1520 or in early 1521: "In return for three books [his religious print series] which I gave him, Lazarus von Ravensburg had given me a great fish-scale, five snail shells, four medals of silver, five of copper, two little dried fish, a white coral, four cane-arrows, and another white coral." Dürer also describes buying "fish-fins" (shark fins?), which he may also have kept in a chamber of natural curiosities. And so impressed was he by a local fish called a sea-rod (*meeruthe*) that he bought one—no doubt for display in dried form—for five *stuivers* and noted that a Nuremberg acquaintance gave him another that cost one *stuiver* more. He kept as sharp an eye on the price as he did on the appearance of nature's wonders.

By the time of this Netherlandish journey, Dürer was moving toward Protestantism, reading Luther's works. Puzzled as to why "the Scripture rarely makes mention of any but the larger fish," Luther had written, "I believe the reason for this is that we should know that such large bodies are the works of God, lest we be frightened by their size and believe they are apparitions. Then it is easy to conclude that since such large bodies were created by God, the smaller fish (such as herring, trout, carp, and others) were also created by God."

It was while Dürer and his wife were living in Antwerp, in 1520, that he heard of the great whale beached on the seashore [5.20]. Excited by the news, he wrote in his diary, "At Zierikzee in Zeeland a whale has been stranded by a high tide and a gale of wind. It is much more than 400 fathoms [600 feet] long, and no man living in Zeeland has seen one even a third as long as this. The fish cannot get off the shore; the people would gladly see it gone, as they fear the great stench, for it's so large that they say it could not be cut in pieces and the blubber boiled down in half a year." He decided to set sail northward to see it for himself.

5.20

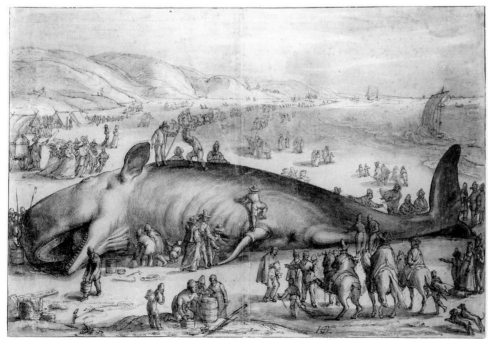

Dürer nearly died before he even came close to finding the beached whale: "At Arnemuiden, where I landed before, a great misfortune befell me. As we were pushing ashore and getting out our rope, a great ship bumped hard against us, as we were in the act of landing, and in the crush I had let every one get out before me, so that only I, George Kotzler, two old wives, and the skipper with a small boy were left in the ship. . . . Thereupon, in the same moment, a storm of wind arose. . . . And the wind carried us away out to sea. Thereupon the skipper tore his hair and cried aloud, for all his men had landed and the ship was unmanned. Then were we in fear and danger, for the wind was strong and only six persons in the ship. So I spoke to the skipper that he should take courage and have hope in God, and that he should consider what was to be done. So he said that if he could haul up the small sail he would try again to land. So we toiled all together and got it feebly about half-way up, and went on again towards the land."

In late April 1521, when Dürer had returned to Antwerp, he described how "In the third week after Easter a violent fever seized me, with great weakness. And before, when I was in Zeeland, a wondrous sickness overcame me, such as I never heard of from any man, and this sickness remains with me." The malaria was never to leave. For the next seven years, until his death in 1528, he records in his diary payments to surgeons, barbers (for bloodletting), and apothecaries for drugs to bring his fever down.

Ant and Bee

In most societies the ant and bee exemplify industry, the ultimate organization insects. Solomon's Proverbs cite the ant as a model to the lazy man: "Go to the ant, O sluggard; consider her ways and be wise. Which having no guide, overseer or ruler, provideth her meat in the summer and gathereth her food in the harvest." Wherever they go, these insects offer living evidence of the way of providence. And Horus Apollo's *Hieroglyphica* [5.21] claimed, "To represent knowledge Egyptians draw an ant. For if a man would hide something safely, this animal would know of it. And not only this, but also beyond all other animals, the ant provides food for itself against the winter. Never straying from its home the ant, unhesitatingly, returns to it." Ants are among the assembly in Dürer's garden of *Our Lady of the Animals*; they also accompany the hibernating bear in Brant's *Ship of Fools* [5.22].

5.22

As for bees, they rarely get much credit in the Bible for their part in providing honey. But Christian literature followed the model provided by Saint Ambrose in his *Commentary on the Six Days of Creation*, where the society of bees is singled out as the ideal state in miniature, because all bees but the king (Ambrose did not know this was really the queen) live in a perfect commune.

Among the artist's most highly finished classical subjects is a drawing of Eros, the little god of love, running to his mother Aphrodite,

vainly trying to escape a swarm of bees whose honey he has stolen [Plate 16]. This 1514 watercolor illustrates Theocritus's poem "The Honey Thief." When Eros snatches the honeycomb from a hive, his mother laughs, asking "Are you not just like the bee—so little yet able to inflict such painful wounds?" Horus Apollo calls bees "the king's submissive subjects" [5.23].

Butterfly and Moth

Butterflies and moths wing their way through many of Dürer's works—including *The Adoration of the Magi* [5.24] [Plate 1], where they perch on the great, dry millwheel to the left of the Mother and Child. Symbols of the soul rising from the body's earthly prison—the chrysalis or cocoon—to Heaven, the butterfly and moth almost always refer to death and to spiritual ascent. The truest beauty of the soul is "visible" only when it has left the world of the flesh and the devil far behind.

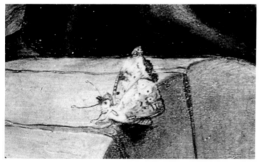

5.24

The butterfly is placed parallel to the nursing Christ Child in *The Madonna of the Iris* [5.25], one of Dürer's handsomest paintings, now known only from copies. Here the graceful insect flutters against a flourish of the Madonna's bright red dress, its color symbolizing Mary's future suffering as does the iris alongside. Freedom from grief is the butterfly's message, for, according to Catholic doctrine, Mary's body as well as her spirit was carried heavenward, to be reunited with her Son forever.

On a study sheet [5.26], Dürer (or a studio assistant) seems to have delighted in the lively contrast between these most decorative insects, so well dressed for flight, and the squat forms of toad and lizard. Butterflies turn up again in the borders of Maximilian's *Hours*, decorated by Dürer and his friends, where Altdorfer included a dragonfly and two butterflies on a page where all the other drawings are of Christian subjects.

Crab

Astrology assigns the sign of the Crab, or Cancer, to the northernmost point of the sun's passage, formed by the star cluster known as the Manger or Beehive, and there it appears as a lobster in Dürer's woodcut northern sky chart [5.27]. During the two annual solstices, the sun seems to stand still and then hover and move away: ancients called the sign the "Crab" because the sun then appeared to move sideways, as crabs do. Astrology may explain why a crab is found among the animals at Mary's feet in Dürer's watercolor drawing *Our Lady of the Animals* [Plate 2], for Cancer is feminine, maternal and fertile—those born under the constellation of the crab are said to be responsive and sympathetic. (The sign looks more like a crayfish or lobster than a crab.) Very precise in its rendering, a crab long thought to be by Dürer may be by a later sixteenth-century Italian naturalist [5.28] [Plate 17].

Fish

As the fish is a symbol for Christ, Dürer must have been surprised to find that the Egyptians used the same animal as a sign for injustice, for the godless man. "To show the lawless or the abominable, [the Egyptians] draw a fish, because its flesh is hated and is an object of disgust in the temples. For every fish is a purgative, and they eat each other." His Horus Apollo drawing is known from a copy [5.29], and other fish abound in Dürer's extant work. A fantastic example with a scorpionlike tail

5.23

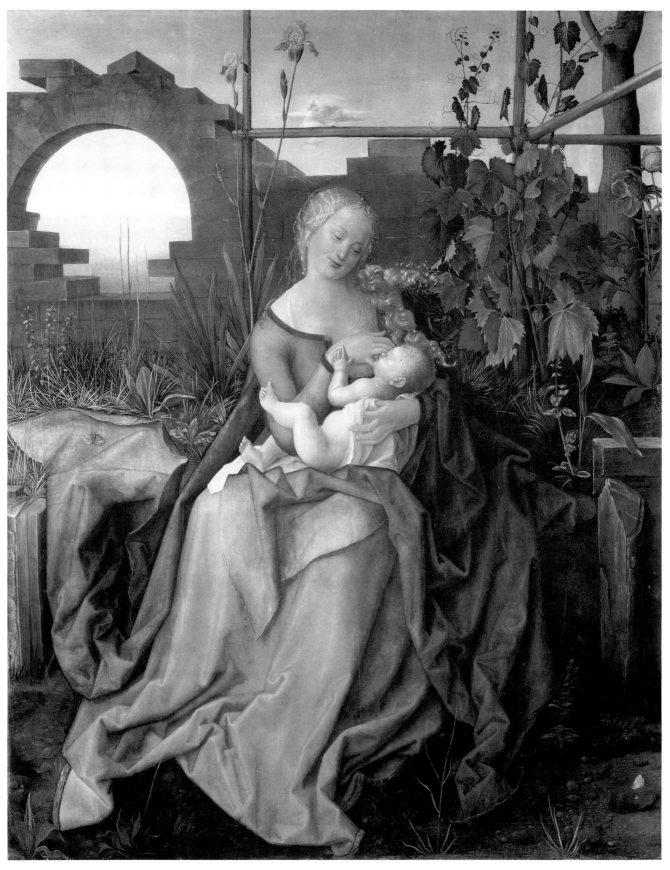

5.25

129 Creatures Hard-Shelled and Cold-Blooded

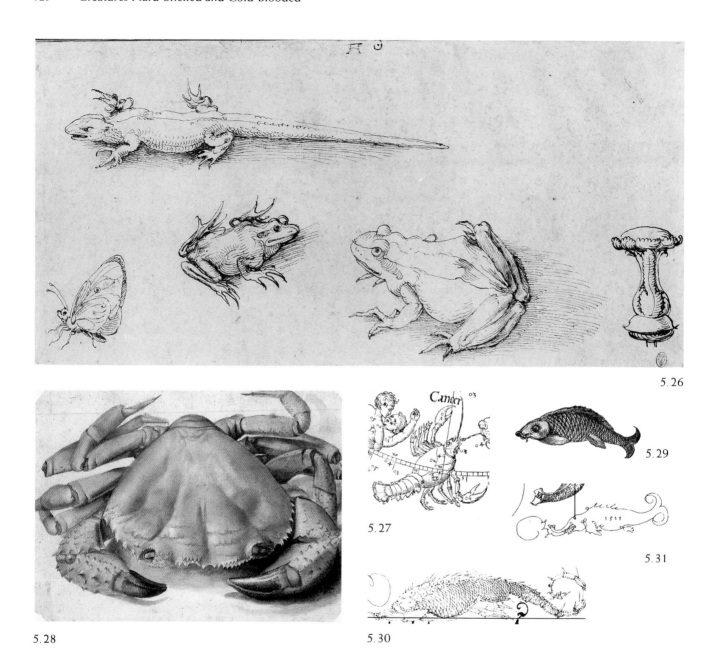

5.26

5.28 5.27 5.29

5.30 5.31

swims along the top of a page in Maximilian's *Hours* [5.30], following the line in the Ninety-fifth Psalm, "The sea is His." Another page catches a fish in a single swirl of calligraphy [5.31] with the date of its drawing—1515—shown like so many swallowed worms. And Dürer's Map of the Southern Sky [5.32–5.36] includes five fish belonging to the constellation Pisces. Hard to see in the sky, the chain of stars that forms Pisces is below Pegasus's Great Square. As they did for Capricorn, the Goat, the Greeks used the myth of the monster Typho (who so frightened the gods that they hid from him in animal guise) to explain the presence of Pisces in the heavens. Turned into fishes, Aphrodite and her son Eros fled the huge beast by diving into the river Euphrates, chained together by the tail so that they might never be separated. The twin-fish-shaped constellation commemorates their miraculous escape.

In Maximilian's armor the fish is shown once again, possibly as a sign of Maximilian's would-be mastery over sea as well as land.

5.32
5.33
5.34
5.35
5.36

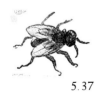

5.37

Fly

According to Horus Apollo [5.37], the fly was the most ancient symbol for impudence, because these persistent little pests, "when driven off, will nonetheless fly right back."

Why did the great masters of early Netherlandish realism, and later of the Italian Renaissance, devote loving care to such an unlovable creature as the fly? In a positive way, these painters earned the same title as the Bible's Evil One, Beelzebub, Lord of the Flies. By adding these tiny insects to their pictures, using brilliant illusionism, a painter could fool the viewer into accepting his artifice for the work of God, and so take on almost magical powers. These insects' presence proves that their artists had read Pliny, whose *Natural History* describes how Apelles painted a fly so skillfully that all who saw it sought to brush it off. While Dürer was still an apprentice in Wolgemut's studio, he was said to have painted a very realistic fly on the brow of the archangel in his master's picture of the Annunciation. Unable to whisk the insect away, Wolgemut caught on that Dürer was the real pest.

On his first visit to Venice, Dürer was certain to have seen Cima da Conegliano's recently completed *Annunciation* (1495) for the Church of the Crusaders, where a fly looks as though it has just landed on the canvas. It was placed there to call attention to the artist's name, inscribed on a little piece of paper which, like the fly, seems also to have happened upon the surface by accident.

In 1504 Dürer included a large, mean-looking horsefly in his *Adoration of the Magi* [Plate 1]; two years later, back in Venice, he painted another one resting on the white cloth of Mary's dress in his great altarpiece *The Feast of the Rosegarlands*, known today from a copy [5.38]. There, the fly is a sign of death as well as art. After all, the fly was known in Latin as *Sarcophaga canaria*, or meat eater, and described in von Megenberg's *Bidpai: The Book of Nature* as a harbinger of Christ's death and sacrifice.

Dürer had a personal reason for giving this fly such prominence. Of the many portraits he included in the painting, mostly of members of the German traders' company in Venice, those placed closest to the Virgin and the fly are the two most powerful—the pope and the emperor, whom Dürer hoped to impress. Just under Maximilian's Habsburgian beak, the fly is shown in actual size, while all other figures are reduced by half; we can be sure it was meant to be seen as a living, breathing work of life, not art. Doubtless Dürer wanted to identify himself with Apelles, court painter to Alexander the Great, and be given the same role by Maximilian.

Mayfly

First in the extended family of Dürer's insects is the one perched on the earth to the lower right in *The Holy Family with the Mayfly* [2.3; 5.39]. Joseph, asleep at the left, may not know that at this moment God the Father and the Holy Spirit appear to the Mother and Son. Only the mayfly, close to the humbly placed, embracing Virgin and Child, is at one with them, awake to this sacred, uniquely happy moment. Living so short a time, known as the One-Day Fly, this insect points to the tragic brevity of Jesus's life. Insects like this stand for the first of God's works, a world before sin, and they surround the Mother and Son in Dürer's three versions of *Our Lady of the Animals* [2.9; 2.10] [Plate 2].

Toad and Frog

Toads—clumsy, dull-colored, strangely sluggish creatures—were seen as signs of sin in the Middle Ages. In one of the many moralizing tales told by the Chevalier de La Tour Landry and illustrated by Dürer [5.40], this cold-blooded creature delivers a spine-chilling message: "My fair daughters, beware and keep you well ever more that ye be not overcome with the sin of ire or wrath," the chevalier warned

them in his 104th story. "I shall tell you an example of a rich woman, seemingly a charitable woman, full of examples of good living, Till it befell that she took sick and died.... [Her parson dreamed that] the devil bore away the soul of this rich woman, and that he saw a great foul toad sitting upon her heart; and upon the morrow, when the day is come, it was told unto him that she was dead."

Her kin and friends sent for the parson, who refused her Christian burial, "for she died in deadly sin of wrath and ire, and moreover he said unto them that there should be found within her body, upon her heart, a foul toad." The disbelieving friends "at the last opened her dead body, and found what the parson told them was true . . . whereof they were hugely amarvelled." The parson questioned the toad, who answered "that he was a devil from hell, that over twenty winters he had tempted that woman unto many sins, but in special in the sin of ire, or wrath. . . . That other day when thou heardest her confession, I was upon her heart, and grasped it so sore with my four paws, and held it so strait and empoisoned, that she might have no will to give forgiveness. . . . Now I have the victory in such wise as she is mine, and shall be damned in hell for evermore."

A moralized inquest, Dürer's early woodcut shows the toad as if it were part of the dead woman, living on and in her body, feasting on her flesh. Still beautiful, she lies on the coroner's table like an effigy.

Dapper, agile, and well tailored, frogs have an endearingly witty way about them. And frogs, unlike toads, were described in medieval manuscripts as being like good people; favorably compared with Christians, land frogs could bear trial and torment. This may be why a frog is placed near Mary in *Our Lady of the Animals*. Those living in the water were thought to resemble monks, according to the *Physiologus* and the bestiaries. Such odd favorable comparisons may still have been made in Dürer's youth, and he included frogs on a

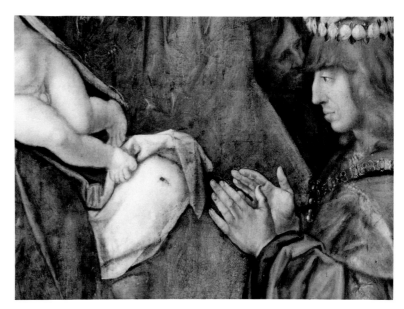

5.38

page with a butterfly. On the other hand, *frog* was a term of loathing in Italy. Boccaccio called the Florentines "frogs," and Donatello used the same term for Paduans, whose city he lived in for more than a decade and where the first bronze portraits of those clammy little beasts were cast. One of Dürer's few surviving original drawings for *The Hieroglyphica* shows a toad [5.41], described in that ancient text as a symbol of a slovenly, ugly person.

5.39

Grasshopper and Locust

Showers of frogs and locusts rain down on the bearded Fool in Dürer's woodcut illustration for the eighty-eighth chapter of Brant's *The Ship of Fools* [5.42]. Moses and Aaron appear in the skies above, recalling their role in the plagues sent down upon the Egyptians. More grasshoppers are found in the woodcut for Brant's thirty-second verse [5.43], on the folly and futility of guarding wives.

> *The grasshoppers 'neath the sun,*
> *Pour water into wells for fun,*
> *Who guards a wife as 'twere a nun.*

Brant's foolish antihero keeps a close watch on

5.40

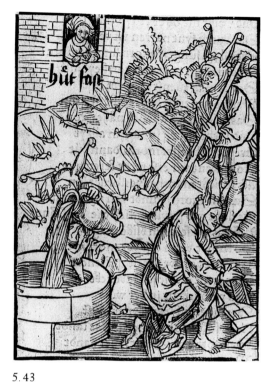

5.43

his flock of giant grasshoppers as if they were incapable of taking off on their own (other fools undertake similar exercises in futility).

Lizard

A lively lizard wriggles along at Hercules's feet in the drawing Dürer prepared for a painting of that hero shooting the Stymphalian birds [5.44]. Placed just below Hercules's club, the lizard points to the wild marshes infested by the loathsome creatures, which combine the worst features of birds and women.

Another study of a fierce lizard placed among butterflies and frogs resembles a miniature dragon or crocodile. It is very like the one Dürer engraved in *Knight, Death and Devil* in 1513 [5.45; 9.47]. Here, as in the *Hercules*, the lizard proves an effective messenger of the evil surrounding the man of action.

Two lizards creeping close to a date palm in *The Flight into Egypt* [2.16; 5.46] refer to the name of the exotic tree on the right, known as the dragon tree. Red resin—"dragon's blood"—seeps from the trunk. First found in

5.41

5.44

5.45

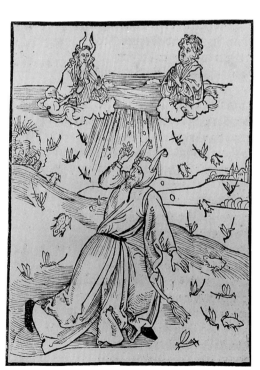

5.42

the Canary Islands, by the late fifteenth century the tree was cultivated in Portugal. Its resin was sent to German printers, for use as a base for printer's ink. It was also believed to stop the flow of blood. Dürer's source for the tree and lizards was Schongauer's *Flight into Egypt* [5.47; 8.6]; for his own woodcut of the subject he moved the tree to the right, but the lizards are about where Schongauer first showed them.

The sand lizard (*Lacerta agilis*) on the right of the woodcut is one of central Europe's most common species, found in gardens and sandy regions. As Dürer had a large garden of his own in sandy Nuremberg, such lizards were doubtless easily available for drawing.

Lobster

One of the artist's greatest animal studies shows a lobster freshly caught in the Adriatic in 1495 [Plate 18], when Dürer first went to Venice. Drawn on an outsized sheet of blue paper, then popular in Italy, in pen and brown ink, using black and brown washes, the animal's form is rounded by using touches of white, in a northern Italian manner. Every stroke of this still-menacing crustacean moves it into action. Almost life-sized, the lobster's pugnacity survives its now faded state. As a boy, the artist may have first seen a lobster on the *Bidpai*'s woodcut pages.

Dürer devised heraldic subjects throughout his life. For Katherine Heller's shield of 1508–9 [5.48] the lobster reveals that his kneeling lady was born a von Melem, that crustacean on their coat of arms, painted, as he wrote his patron, "in the best colors I could obtain." Dürer's great drawing of 1495 may have inspired this armorial beast, which looks unusually lively.

More cartoonlike than the fierce lobster from Dürer's Italian journey is the one in a woodcut designed about two years before, for Brant's *The Ship of Fools* [5.49]. Simple though this scene of a fool riding a lobster may look, it deals with one of Christianity's most complex and controversial issues, predestination: Is our life divinely determined from the start, or can our actions influence our fate? What does a lobster have to do with this? Folklore had it that the crustacean could only go in reverse, scuttling backward wherever it went. Those who only hope for the best but do no good will be dragged back, lobsterwise.

Scorpion

A magnificent constellation, Scorpio is a southern phenomenon; its most brilliant star, Antares, readily visible in Europe in the summer, is noticeable for its red coloring. In Hesiod's astronomical poem, the handsome hunter Orion is killed by a scorpion's bite, and this is the tale illuminated by the stars. Dürer showed Orion in his southern star chart at the upper left [10.4], a short sword at his side, with club in hand. When hunting with Artemis, Orion boasted that he could kill all wild animals. Countering his claim, the goddess Earth sent a scorpion to slay Orion with a single bite. Dürer chose a lobsterlike creature for that venomous beast. Seemingly headless and brandishing its lethal tail, a scorpion is also found at the bottom of Dürer's *Celestial Map: The Northern Celestial Hemisphere* [5.50].

Snail

In the margins of Maximilian's *Hours* [5.51], Dürer had a land snail slither down the page devoted to "The earth is the Lord's and the fullness thereof; the world and they that dwell therein." In a place of honor just above the emperor's arms, a snail is found also on his *Arch* [5.52], where another great land snail slugs its way around the base.

Elsewhere in Maximilian's prayerbook [5.53], a lute-playing *putto* uses a snail as a footrest, both seen below the Virgin who is crowned by an angel. Musician and snail alike celebrate her purity. (As air alone was believed

5.46

5.47

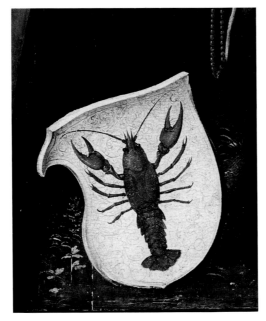

5.48

5.51

5.50

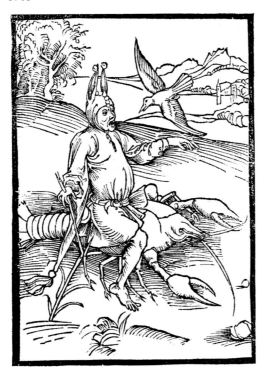

5.49

to impregnate the sea snail, so reasoned Francis of Retz, "God can make his mother pregnant.") Brought so closely together, the cherub and snail suggest a special emblematic message, like that of the dolphin-entwined anchor of the Venetian printer Aldus, which symbolized the best way to make haste—slowly. Perhaps the winged messenger of sacred song with his sluggish companion also argue for the slowest, surest way to eternal truth.

Snake

Snakes, apples, and sin have gone hand in hand ever since Genesis. Dürer combined all three in his brilliantly engraved *Adam and Eve* of 1504 [2.18; 5.54]. Though the two great nudes, seen against Eden's dark woods, are the main subjects, the snake enjoys her central placement. She is even furnished with a tiny crown, almost as if in reward for beginning the cycle of temptation, sin, death, and redemption, the story of Christian life and death and life everlasting. As an attribute of the all-powerful ruler, the snake is also crowned in the hieroglyphs of Horus Apollo.

Function and imagination were combined by Dürer in his design for a *pokal* [5.55], an ornate, apple-shaped, covered cup on

which a serpent forms the handle. Dürer probably drew the cup for his friend Pirckheimer, who is known to have owned one like it in silver gilt. A delightful fusion of animal, vegetable, and mineral—this cup is the essence of the late Middle Ages' free associations, the fatal fruit and its tempter joined forever. Dürer's suggestion that we all fell with Adam is made clear by the apple's globular shape—the world, as well as the fruit, consumed in that paradisical snack.

Another serpent is found on a fruit-shaped *pokal* held by a king in Dürer's *Adoration of the Magi*, but here the serpent swallows his own tail to form a ringlike handle. This endless circle symbolizes eternity, the salvation beyond time brought about by the sacrifice of the King of Kings, prophecied by the Infant's gift.

According to the text of Horus Apollo [5.56; 5.57], "When they [the Egyptians] wish to symbolize Eternity, they draw the sun and the moon, because they are eternal elements. But when they wish to represent Eternity differently, they draw a serpent with its tail concealed by the rest of its body." And "When they wish to depict the Universe, they draw a serpent devouring its own tail, marked with variegated scales. By the scales they suggest the stars in the heavens. This beast is the heaviest of all animals, as the earth is heaviest [of elements]. It is the smoothest, like water. . . .

"When they wish to show a very powerful king, they draw a serpent represented as the cosmos, with its tail in its mouth and the name of the king written in the middle of the coils. . . . To show the king as guardian in another way, they draw the serpent in a state of watchfulness. And instead of the name of the king, they draw a guard. For he is the guardian of the whole world. And in both ways is the king watchful.

"Again, when they consider the king to be a cosmic ruler and wish to intimate this, they draw the serpent and in the middle they represent a great palace. And reasonably, for the place of the king's palace is the cosmos." Ven-

5.52

5.53

5.54

ice, Europe's greatest city, provided the artist with his architectural source.

For his northern star chart [5.58], Dürer drew the snake-shaped constellation Hydra, the great serpent strangled by Hercules. A similar snake wriggles down the left margin of

5.55

5.56

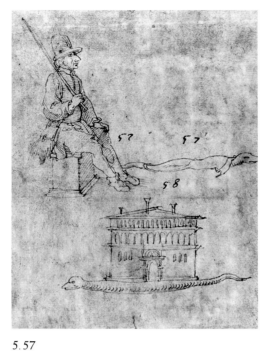

5.57

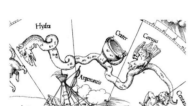

5.58

5.59

the forty-seventh folio of the emperor's *Book of Hours* [5.59], enlivening the page by its presence. In spite of a bulging middle, attesting to a recent dinner, this snake is about to pounce upon a calligraphic wiggle for dessert.

Squid

At the center of European trade routes, Nuremberg was not on any great river and far from the sea, so creatures of the deep were more a matter of fancy than fact, subjects of speculation and wonder. Dürer's whimsical, squidlike animal in the margins of Maximilian's *Hours* [5.60] may have been drawn from memories of Venetian life. Oddly demure, with a face like a smiley-button, this squid seems entangled in its own tentacles, a menace only to itself.

Stag Beetle and Scarab

Without the condescension of a cartoon, Dürer's *Stag Beetle* [Plate 19], in gouache and watercolor, conveys character and personality, using a forceful, deliberate, individual approach. Not just any beetle, it is *the* beetle that has just crossed the artist's page. A few skillfully cast shadows help provide a sense of space and tension, as if this awesome insect, found in the woods of southern Germany, lumbered across the blank paper. Suggesting some great monster from Mesozoic times, there is nothing miniature about the beetle. Perhaps the page was originally much larger, with the monogram and date placed at the center of the sheet before it was cut down. The upper-left corner, including the tip of the stag beetle's tentacle-like leg, is a replacement. Dürer's *Beetle* was much copied later in the sixteenth century and his authorship of this famous page has recently been questioned. Like many of Dürer's most striking animal sketches, this one was copied by Hans Hoffman and other artists in the later sixteenth century. Until recently it was owned by the actor Alain Delon, who enjoyed sharing the artist's initials.

The same mighty insect is found in the left foreground of *Our Lady of the Animals* of 1503 and is included in *The Adoration of the Magi*, painted a year later. Why did Dürer want to include this tank of a beetle with the more delicately dressed insects and magi surrounding the future King of Kings? What was there about this armored miniature monster that proved worthy of such distinguished company? In the late Middle Ages the stag beetle was believed to be a zoological lightning rod, diverting or absorbing God's wrath; so, like Christ, the insect could save man, a symbol of divine grace despite a surprisingly graceless casing.

Artists before Dürer added such eloquent yet mute witnesses to Christ's role in scenes of the Adoration. On the Peringsdörfer Altar (1485–88) [5.1], Michael Wolgemut, Dürer's teacher, places the stag beetle in a similarly strategic location, just below the feet of the Apostles as they separate to preach the Gospel. Paduan bronzes could have given Dürer the ability to see these menacing-looking beetles beyond faith, not as symbols but for themselves alone. Life casts of these creatures were made for the curio cabinets assembled by Italian scholars and other lovers of such odd Renaissance "collectibles." Dürer may have brought one back from northern Italy in his pocket.

Small yet powerful, the stag beetle was seen as the Lord's messenger, one whose size in no way lessened the strength of its good tidings. When the Flemish master of animal art Georg Hoefnagel painted a stag beetle for the greatest collector of Dürer's art, the emperor Rudolph II, he took care to make the insect's sacred role clear. This was done by inscribing a line from David's Psalms immediately above the beetle: "He has sent deliverance to his people, he has ratified his covenant forever; holy and awesome is his name." So, when placed on a step all its own in Dürer's *Adoration of the Magi*, this holy and awesomely armed beetle is no less than a living promise of the Lord's coming, fulfilled by the Infant's presence. Beetles, in ancient Egyptian symbolism, stood for God as he came into being. Here, in the *Adoration*, the stag beetle, having announced the Lord's coming, leaves.

Almost a decade after his great study of the stag beetle, Dürer took another long look at hard-shelled insects when he illustrated a scarab for the hieroglyphs of Horus Apollo [5.61], who says: "To signify the only begotten, or birth, or a father, or the world, or man, they [Egyptians] draw a scarab. The only begotten, because this animal is self-begotten, unborn of the female."

Turtle

Margins are more often used for illustrating fancy than fact; Dürer's creatures in the borders for Maximilian's *Hours* [5.62] often defy strict zoological classification. One scholar who studied many of them says that his turtle, an almost armadillolike creature caught in conversation with a spoonbill, is a European swamp turtle, more commonly found in Italy than Germany. Perhaps Dürer bought the shell without its dweller and then had to invent a head and tail to go with it.

Shells of great sea turtles—unlike this little one—were highly prized, brought back by sailors from faraway places, to be worked into precious objects by European craftsmen. One of their huge shells is used as a shield by the merman in *Sea Monster* [10.50]. Dürer sent such a large specimen back to Nuremberg from Antwerp long after engraving that print and treasured a tortoiseshell given him in Antwerp. He wrote lovingly of a little live tortoise he bought there six or so years after drawing this one for his imperial patron's *Hours*.

Appropriately, the artist who was so responsive to the special qualities of the hare could care just as much for the slow but sure tortoise who, in Aesop's fable, proved the winner in the contest between both beasts.

5.60

5.61

5.62

cuntur diebus dominicis lu=
ne et iouis· Antiphona· Be=
nedicta· Psalmus·
Omine dominus no=
ster: quam admirabile
est nomen tuum in vniuersa
terra· Quoniã eleuata ē: ma
gnificẽtia tua super celos· Ex
ore infantium: et lactentium
perfecisti laudem propter ini=
micos tuos: vt destruas ini=
micum τ vltorem· Quoniam
videbo celos tuos opera digi
torum tuorum: lunam et stel

Chapter Six

The Lion, the Saint, and the Artist

In the many centuries when kings enjoyed godlike powers on earth, the lion, king of beasts, received equal awe and deference. These noble animals were considered signs of divine kingship, symbol of Mark the Evangelist and of that scholarly church father, Saint Jerome. The lamb stood for Jesus at his most meek and sacrificial, but the lion's roar and imperial presence proclaimed the Lord's force, his supreme authority. Small wonder that Heaven would be wherever the lion and the lamb lay down together, when weak and strong complement one another in an eternal state of grace.

The behavior of lions was closely studied with a view to analyzing their regal ways. Fussy about meals, the lion proved his kingship, according to Saint Ambrose, by his refusal to eat leftovers. Further proof of a noble nature was his fierce power and utter disregard for all other animals. "Like a king, he has only disdain for their association," Ambrose noted.

Monarchical hauteur was matched by regal magnanimity and noblesse oblige without equal in the animal kingdom. "Only the lion," Pliny observed, "of all wild creatures, shows mercy to supplicants; he spares persons prostrated before him." And when it came to eating people, he said, lions consumed them in the following order: men first, then women, and lastly, reluctantly if at all, children.

Among the earliest Western drawings of lions is a midthirteenth-century one, inscribed proudly by its maker, French architect Villard de Honnecourt, "Know well that this lion was drawn from life" [6.1]. But if the draftsman had not written this information alongside his lion, it would seem closer to caricature than to nature. More realistic is the pride of lions carved by Niccolò de Bartolommeo da Foggia a few years later to support the columns holding up a handsome pulpit in the Italian cathedral of Ravello [6.2].

Even in fifteenth-century painting and sculpture, many lions look more like well-fed kings than beasts of the jungle. And vice versa. Renaissance sculptors gave their generals' portraits lionlike features, such expressions conforming with the ancient study of physiognomy, according to which your behavior was believed to follow that of the beast most closely resembling you; military leaders absolutely required leonine features, like those of Donatello's Erasmo de Narni at Padua [9.14], better known as the "honeyed cat," Gattamelata. Verrocchio's Colleoni [9.15] in Venice also had lions—*leoni*—hidden in his name, as well as on his face. As lions stood for so many

6.1

6.2

qualities—leadership, courage, strength, nobility, sound judgment, pride—they inevitably started resembling those who were supposed to share their special gifts, powerful men in the prime of life. So, though many northern European and Italian cities and courts had lions as symbols of civic or regal strength, in art they looked more imaginary than real. Roman circuses, where lions fought other animals at great public spectacles, were revived in the Renaissance to entertain distinguished visitors. In a drawing [6.3] after a mid-fifteenth century Florentine source [6.4], Dürer showed one of these bloody festivities. Here jungle beasts fight deer, cattle, and horses, with dogs in their midst.

Dürer may not have seen a lion until his first Venetian journey in the mid-1490s when he could have drawn lions from life—they were kept at the Doge's Palace—and found them in Jacopo Bellini's sketchbooks [6.5], for he was a friend of his son Giovanni. The artist may also have seen the lion padding restlessly in paintings of Saint Jerome's study and certainly saw some of Vittore Pisanello's marvelous animal paintings, drawings, and medals. One of these [6.6], cast in 1444 for the marquis of Ferrara, Lionello d'Este, showed Cupid teaching a lion how to read music so that he could sing instead of roar, a vocal and visual tribute to the power of love as well as an elaborate pun on Lionello's name and passions.

A lion, possibly painted during Dürer's first Italian journey and dated 1494 [Plate 20], with his monogram, is his first finished independent animal subject, though not his first lion. He made it in the same manner he sometimes used for New Year's cards sent to friends during his travels. Done in gouache with touches of gold, this vellum page shows much the same richly detailed technique found a few years later in *The Blue Roller*, though that study reflects the intervening years of practice. Motionless, the dead bird made a better model than the restless lion, whose "portrait" may be based more on works of art copied in Venice

141　The Lion, the Saint, and the Artist

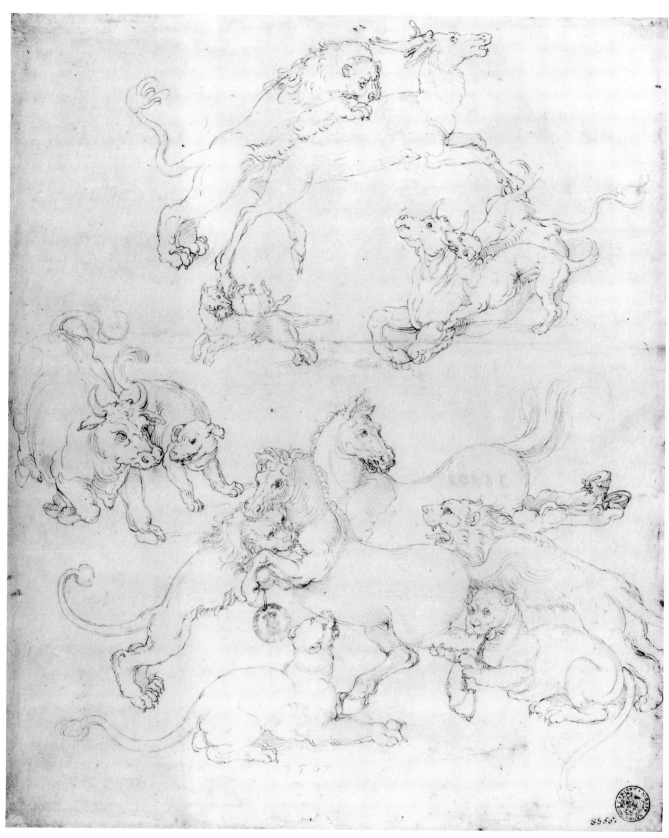

6.3

6.4

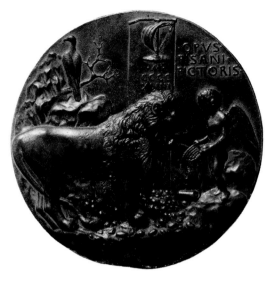

6.6

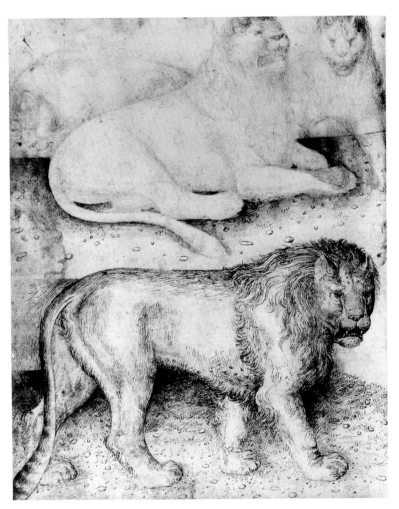

6.5

than on a living animal; the lion has a stiff, stuffed quality. Perhaps the awkwardly large paw at the upper right replaced the Gospel book usually found there in Venetian images of Mark, the republic's patron saint. More lifelike than Dürer's earlier Leos, the highly finished watercolor may have benefited from the study of three lions' heads probably made shortly before.

Jerome was a saint close to Dürer. Both men possessed great gifts and performed immense labors; both loved classical and Christian traditions alike. Caring for large issues, they never lost sight of the small.

Church father as well as Bible translator, Jerome was no ordinary saint, nor was the great beast who became his watchdog a commonplace lion. First told in the ninth century, the story of the patron saint of scholarly thought who healed a lion was circulated by Giovanni d'Andrea, a law professor in fourteenth-century Bologna. He wrote that a lion with a thorn in its paw came to the saint's monastery in the Holy Land for help. After convincing Jerome that all he wanted was to have the thorn extracted, the grateful lion became the saint's lifelong companion. But in truth the saint hated lions and often described

them in his *Letters* as devils in disguise. At the time of his writing, lions were still found on the prowl in the desert of the Holy Land and were far from mere figures of speech. The lion's roar heard echoing across the plain was a familiar and terrifying sound. In David's words: "The young lions roar after their prey, and seek their meat from God."

Nothing could have suited the Renaissance cult of Saint Jerome better than to have the myth of the saint's encounter with a lion based upon an ancient work of art as well as a classical source. Like other medieval animal lore, Jerome's lion may have been drawn from a line in Pliny's *Natural History*, perhaps his description of an ancient painting showing a philosopher who "met a lion that rolled on the ground in suppliant wise and struck such terror in him that he was running away . . . [T]he lion blocked his path at every turn and licked his footprints as if fawning on him"; finally the wise man "saw a swelling and a wound in the lion's paw. By pulling out a thorn he freed the creature from his torment."

The saint and his beast became a popular religious story—with a theme that combined love and force, scholarship and adventure, healing and danger, man and nature. It appealed to artists from the early fifteenth century onward, when the veneration of this scholarly saint became widespread with new interests in education, philology, and classical scholarship, concerns all close to Jerome's own.

Jerome bridged the best of old and new, representing the universality of wisdom advocated by Europe's new schools and universities. His lion was the mascot for all scholars dedicated to the reconciliation of the classical and the Christian. The story of Jerome's lion, like the saint's writings, is filled with a keen sense of the beauty of creation and the wonder of life. Jerome knew that real humility is meaningless in the absence of true pride, penitence a sham without evil within. How can one show these dynamic drives, these urgent calls upon

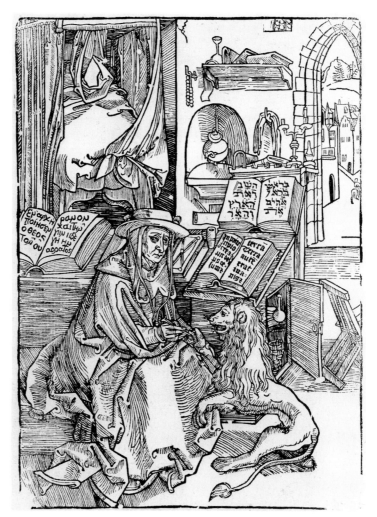

6.7

the Christian spirit? By the lion. Jerome *is* the lion, tamed by love but ever vigilant.

Dürer devoted at least three engravings, a drypoint, several woodcuts, many drawings, and two paintings to Saint Jerome. Unsigned, the original woodcut of the earliest version of Jerome and the lion [6.7] was made in 1492, when the artist was twenty-one; it shows Saint Jerome in his combined study-bedroom. He turns away from three Bibles, all open to the first words of Genesis in Greek, Hebrew, and Latin. Nearest to his worried gaze is his own project, the new Latin Bible, prepared with the help of Jewish scholars. The woodcut appeared opposite the title page of Jerome's *Letters*, a huge, two-volume publication issued in Basel by a printer well known to Koberger, Dürer's publisher godfather, in the same year

that Columbus discovered America. This lion, Dürer's first, is one of his least convincing. Probably based upon a crude, late fifteenth-century print, it looks like a fugitive from a coat of arms.

A preparatory drawing [6.8] for Dürer's 1511 woodcut, *Saint Jerome in His Cell* [6.9], is tougher and harder than the printed version, lacking the gentle curves in the print's architecture and the more endearing characterization of the lion. In the woodcut, Jerome and his protective pet are at work in similar ways: As the saint holds pens in hand, the lion holds his tail between his paws for a few neatening licks. "Lions indicate their state of mind by means of their tail, as horses do by their ears," Pliny had observed, because "nature has assigned even these means of expression to all the noblest animals."

In 1514, Dürer engraved his most famous version, *Saint Jerome in His Study* [6.10]. Just as an incisive, all-inclusive work is called a *summa*, assembling wisdom on the highest level, so may this intricately devised, profound print be seen as a graphic summa. Without any interest whatever in historical accuracy, Dürer's engraving shows a thoroughly modern saint, in a contemporary setting, Jerome *now*. His study is that of a rich Nuremberger, possibly Dürer's own studio, which was furnished with a special star-gazing balcony. The divine light, the animals, and the gourd suspended from a beam over the study entrance clearly stress symbolism, but even here there is a sense of the actual—as if the lion were a big stuffed toy that could be safely picked up and moved out of the way. Jerome's gourd is a sign of divine forgiveness—so described in the Book of Jonah—assurance that God may change his mind if people change their ways.

This print goes back to the magically detailed art and rich illumination of early Netherlandish art, possibly modeled on a now-lost painting by Jan van Eyck. It exemplifies the ideal of the scholarly, spiritual life (the *vita contemplativa*), which complements the bold, dynamic life (the *vita activa*) shown in Dürer's *Knight, Death and Devil* of 1513 [9.47]. In medieval times, these extremes of thought and action were believed to be the two halves of the human soul. These two prints, differing only by a small fraction of an inch in width, may be thought of as a single "soul portrait" when placed side by side. Where Jerome's study is radiant, the knight traverses a dark, dismal valley, accompanied by Death and the devil. Where the contemplative saint is busy writing, the active knight looks straight ahead, almost unseeing, leaving the direction to his horse; stone-faced, he ignores the messenger of Death at his side. Another harbinger of mortality is the skull on the tree stump, recognized only by Death's old horse, while the one on Jerome's window is sunlit, reminding the old saint of his imminent fate, of the brevity and vanity of life. The knight's dog is so fleet footed that he bounds past poisonous lizards, skull and bones unseen in his haste. Jerome's dog is the ultimate in contemplation, dreaming in the sunshine, curled up next to his master's slippers. His lion is also on the verge of

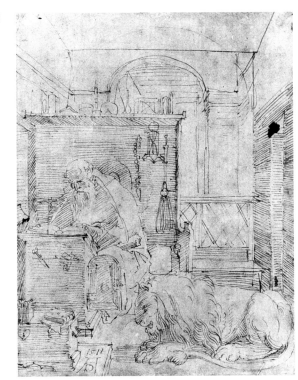

6.8

nodding off, smiling benignly as he attempts to hold his head up in the warm light.

Another aspect of contemplation, the personification of morbid thought, was the subject of a second engraving of 1514, *Melencolia I* [3.16]. The personification of that morbid temperament broods as a bat flies through the skies, proclaiming the print's sad subject and tragic mood, one of knowledge without light, suspended between creativity and inaction, lost in black thought.

"I was tortured more severely still by the fires of conscience" wrote Jerome in his thirty-second letter, and this is the subject of two works showing the penitent saint in the wilderness made by Dürer in the mid-1490s. The earlier and smaller of the two is a painting [Plate 21], the second an engraving [6.11]. So minute that it suggests a manuscript illumination, the painting is a radiant microcosm of varied skies and tumbling waters, whose songbirds, butterfly, mayfly, and lion all keep the saint company. Exciting yellow, grey, and pink skies bathe the scene in a golden, harmonious glow, as if to reassure Jerome that for all his sense of sin, Heaven is his destination, indicated too by the saint's sky-blue garb and rich cardinal's robe and hat, which lie on the ground before him. A watchful lion lies at his side as two finchlike birds drink at the rushing stream below. The waters allude to salvation and baptism, the little birds to the Resurrection and Passion. Poised near the water's edge, a butterfly is a reassuring emblem of the soul's ascent. Painted on the reverse is an amazing rendering of an eclipse, probably following a text of Albertus Magnus.

Dürer's engraving of Jerome in the desert is very close in date to *The Prodigal Son* of 1496 [8.4] and almost as powerful. Both works deal with the same issues—of man in nature, regretting and condemning his own as he seeks forgiveness, subjects demanding a rich reinforcement between body, setting, and accompanying beast. Little rises from the rocky landscape, which serves only to provide Jerome with ever more stones for mortification. Abandoning the mystical reassurance of the minute painting, the print does away with birds, butterfly, and book. Man and lion almost form a single letter L, so great is the sense of continuity and harmony between them. Divided between love of God and hatred of self, Jerome gazes yearningly toward the image of Christ on the tiny cross, rising from the rocks before him as he is about to mortify the flesh made in God's image. The composition follows Italian models. Another cross is placed high above Jerome's bald pate, on the bell tower of the little pilgrimage chapel in the background. Similar proximity of man to divinity in *The Prodigal Son* is indicated by directing the son's gaze toward a chapel at the upper right. No status symbols surround old Jerome, no indication of time, class, or rank. His listless lion looks like a bald, beleaguered accountant.

The five hundred or so buyers of the engraved *Jerome* sought a very different image from that of the festive little picture. A fairytale glimpse of celestial penitence, the paint-

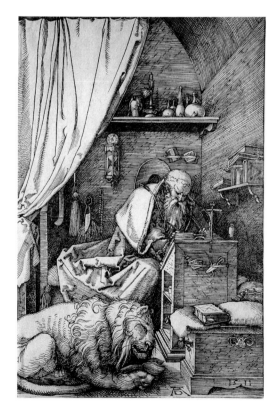

6.9

146 Dürer's Animals

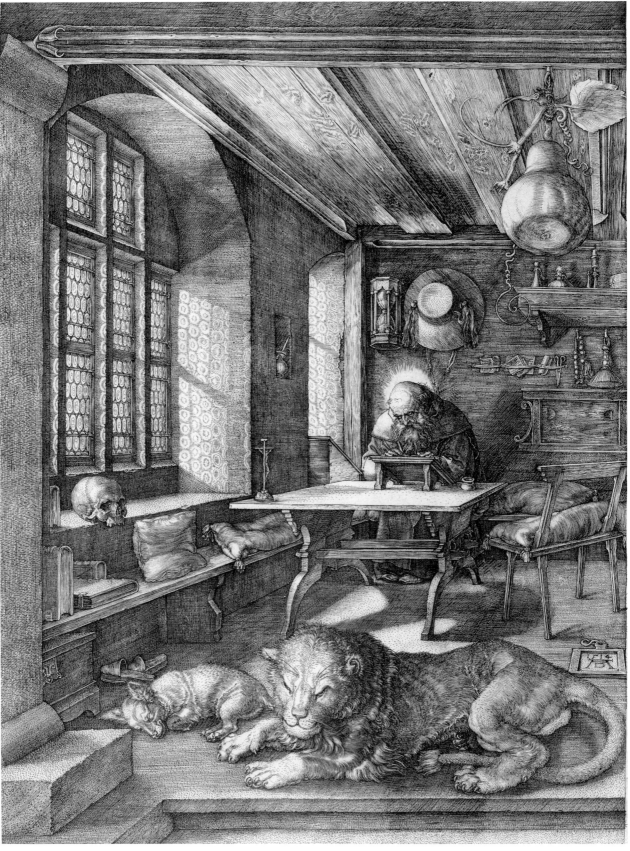

6.10

147 The Lion, the Saint, and the Artist

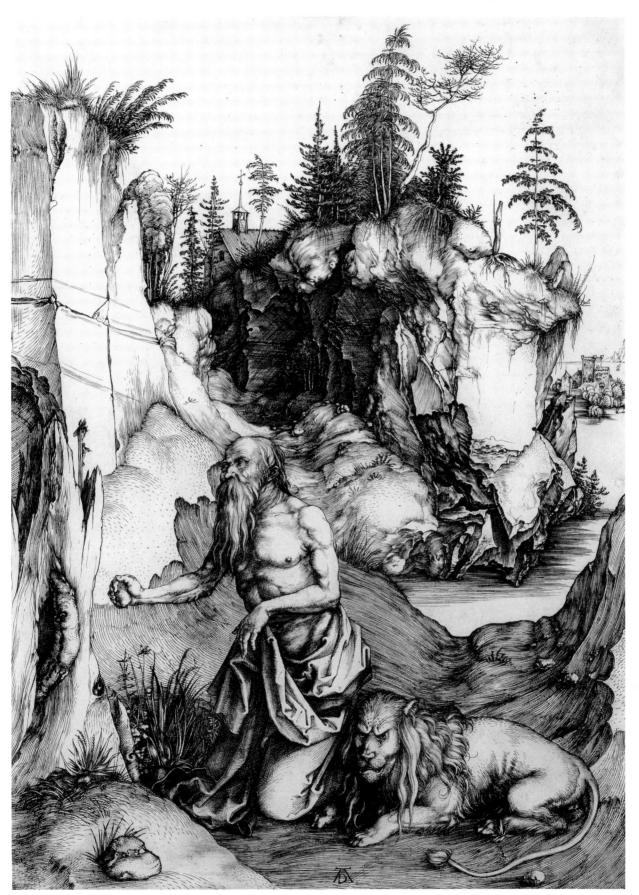

6.11

6.12

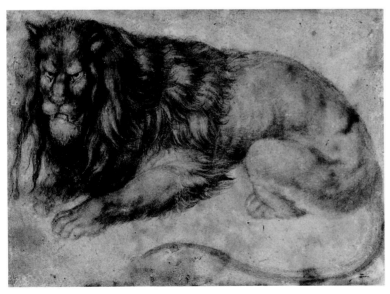

6.13

ing remains a medieval treasure, a constant source of wonder and miraculous intricacy, one made to be admired. The engraving was for sharing, its uncompromising message as hard as its technique: "Repent." No saint to pray for his purchaser, Jerome's rigor may inspire the print's owners to follow suit.

The printed and the engraved lions show some kinship with those by the Master of the Playing Cards [6.12], which Dürer probably saw when he was a boy. And his study in brown and rose wash [6.13], brushed over a preparatory black chalk sketch, is close to the eponymous artist's, as is still another lion in a woodcut made a few years later. Dürer drew upon the same sources over and over again, consulting notebooks in order to produce new designs.

Even five years later, in 1512, when his art was far more sophisticated, Dürer returned to that sulky and unconvincing lion for still another print, now a woodcut [6.14], once again of the penitent Saint Jerome in the wilderness. Seated in a cave, under a natural rocky bridge, Jerome leaves the life of the city and even the monastery far behind, for devotional writing in much-needed isolation. This romantic setting is very like those favored in Renaissance Venice and Mantua, found in works by Giovanni Bellini and his brother-in-law Andrea Mantegna and first used by Dürer in the engraving of the mid-1490s. Jerome seems to be writing with his eyes shut, guided by divine inspiration as he faces the crucifix on his rock desk. Divided between indulgence and impatience, the lion's gaze looks cross-eyed as he shifts from tolerance to jealousy and back again. Living with a saint may be good for the soul, but it is hard on the heart.

This woodcut was the frontispiece for a life of Saint Jerome, translated by Dürer's friend Lazarus Spengler from the ancient Latin text of Eusebius. In the same year, 1512, Dürer made a much more personal, profound print, *Saint Jerome by the Pollard Willow* [6.15], in drypoint. Delicate needling of the metal surface

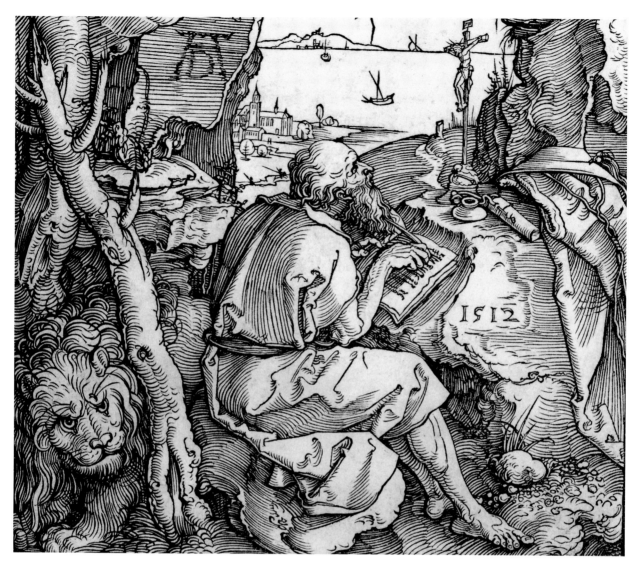

6.14

allowed for only a few prints to be made. Less protected by nature than in the woodcut's cave, Jerome, looking like a Michelangelo prophet, turns from his rough-hewn masonry desk to pray. A great rocky outcropping behind him echoes his spiritual strength and resolution. Pliny wrote that lions could see through closed eyes, but such power seems beyond Jerome's sleeping beast. (As is true for Dürer's most direct, heartfelt religious works, such as *The Prodigal Son*, this print held special appeal for Rembrandt, who translated all its elements into his own etched version, *Saint Jerome Writing below a Pollard Willow*.)

When the Nuremberg artist went to the Lowlands in 1520, he met the most accomplished of Netherlandish painters and printmakers, the prodigy Lucas van Leyden. No one appraised Dürer's art more intelligently or adapted it more skillfully. When Lucas engraved his idea of Jerome, he showed the saint in a melancholic pose, almost as if he were referring to Dürer's print devoted to that black mood, an occupational disease of art and scholarship. Humbly seated on the floor, the saint clutches a book so close to his chest that he cannot even read it, reassured by the physical promixity of God's word. Lucas's penitent, poorly dressed Jerome is sadder than any of Dürer's. But two sources of comfort warm him—a great halo glows around his bald head while a catlike lion consolingly licks his toes.

150 Dürer's Animals

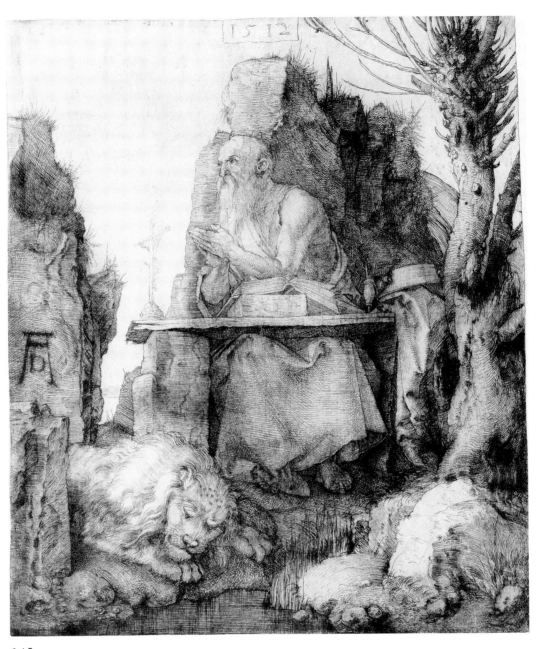

6.15

Lions figured prominently in the classical images of strength that northern Europe was just beginning to absorb. According to ancient Greek mythology, Leo originated on the moon and was brought to earth by Hera to bedevil her old enemy, the legendary strongman Hercules, whose twelve labors Dürer drew in a series of roundels dating from 1511. So fierce was this king of beasts that no one dared to enter the Nemean plain to sow crops, rapidly reducing that terrain to a desert. First of Hercules's deeds was the killing of the lion, whose tough hide was impervious to his arrows. Hercules followed the lion to his lair, where he throttled him to death with bare hands; sensibly, he wore the beast's protective pelt ever after. In 1491, young Maximilian declared himself to be the German Hercules and had crude woodcuts printed showing him wearing the lionskin to make this identification clear. By far the smallest and one of the

151 The Lion, the Saint, and the Artist

6.17

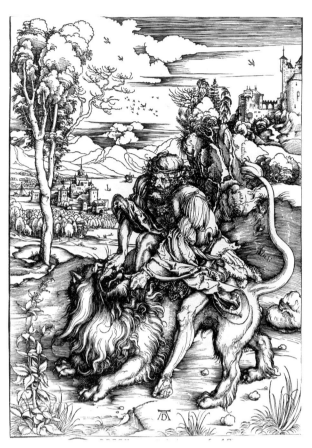

6.18

earliest of Dürer's many lions stalks along the woodcut horizon of *Hercules Conquering Cacus* ("Ercules") of 1496 [6.16].

Just as Italian artists inspired some of Dürer's early lions, particularly those in the Saint Jerome works, northern artists too provided Dürer with animal models. At midcentury, that most powerful of Rhenish engravers, Master E.S., showed Samson wrestling with the lion. In 1497–98, Dürer may have used that work or a copy by Israhel van Meckenem [6.17] for his vigorous woodcut [6.18] of the same subject, where each vibrantly carved line crackles with activity and combat. Samson's wrestler's pose, treading down on the young lion's shoulder as he forces the beast's jaw open with his powerful hands and arms, has some of the strength of ancient sculpture. When Samson first heard the proud beast's roar in the Philistine vineyards, "the Spirit of the Lord came mightily upon him, and he rent him as he would have rent a kid, and he had nothing in his hand." Proving God's power, Samson's bare-handed victory over the young lion was a popular subject, and it brought him close to the sun-linked gods of classical mythology. A great judge, Samson was also seen as the forerunner of Christ, the ultimate judge. Dürer used a massive Roman statue of Hercules as the model for this nude Hebrew superman, whom he decided to show seizing a grimacing lion's mane in a study made around 1500, at the time of his first measured studies of ideal proportion.

Drawn within a short time of the Samson woodcut is a minute version of the same subject, found in the background of a Samson with the jawbone of an ass. Dürer's scene of the mass murder—"With the jawbone of an ass I have slain a thousand men"—includes the tiny figures of Samson and the lion wrestling in the vineyard as a precedent for the great battle be-

6.16

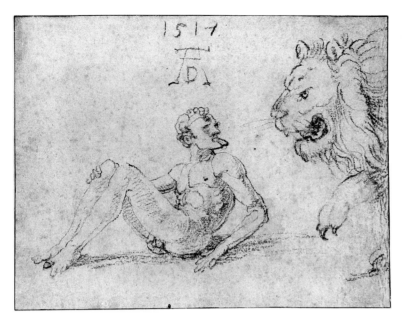

6.19

6.20

6.21

6.22

6.23

6.24

low. Barely visible on the horizon, the victory of man over beast presages new triumphs to come.

In a late, ludicrous drawing [6.19], speedily rendered in charcoal, is a classical figure, so indicated by his nudity and the band of the victorious athlete above his brow. He seems strangely relaxed under what would seem to be very trying circumstances, facing a very large angry lion. Could this odd hero be Androcles?

Other lions appear in Horus Apollo's interpretation of Egyptian hieroglyphics [6.20–23]. Of the four lions designed by Dürer, only one is by the artist himself; the others are early copies known from the manuscript, which is now in Vienna. First of these lions was the one that went with "The Rising of the Nile." According to the Greek text, Egyptians referred to this as *noun*, "which . . . means 'new,' sometimes they draw a lion . . . since when the sun enters Leo, it produces a great rise in the Nile. As the sun remains in this sign, the water is frequently twice its normal height at flood tide. Wherefore the ancient engineers of the sacred works made the pipes and inlets of the fountains in the shape of lions." Elsewhere the text claims that the Egyptians showed lions as symbols of Anger because its rounded brow, fiery eyes, and radiating mane imitate the sun. As in Dürer's *Sol Iustitiae* (Sun of Righteousness) [6.25], the lion was supposedly placed under the throne of Horus, the sun god, ruler over the hours. "They draw the forequarters of a lion to indicate strength," *The Hieroglyphica* claimed, "because these parts of the lion are the strongest." "To indicate that one is wide awake, and on guard, they draw the head of a lion. For the lion while on guard closes his eyes; but when sleeping keeps them open." "If they wish to show measurable anger, as if the spirits were in a fever from it, they draw a lion tearing its cubs to pieces . . . since their bones when struck emit fire."

A student of astronomy and astrology, Dürer knew how the ancients read the stars and would have studied their astrological guides. According to a poem by the Greek poet Aratus—portrayed by Dürer at the upper left of his *Celestial Map: The Northern Celestial Hemisphere*—the lion is a creature of the Greek sun god, Helios, for the sun burns brightest in July, when in the house of Leo [6.24]. The early church fathers linked Christ to Helios and his lions, especially as he would appear at the Last Judgment, as the Sun of Justice. The medieval encyclopedist Berchorius, whose work was reprinted by Anton Koberger, interpreted a biblical passage in Malachi to mean: "The sun of righteousness shall appear ablaze when he will judge mankind on the day of doom, and he shall be burning and grim. For, as the sun burns the flowers and its herbs in summertime when he is in the lion, so shall Christ appear as fierce and lionlike man in the heat of judgment, and shall wither the sinners." Dürer returned to his early Samson studies for an engraving of this subject made around 1500 [6.25], when many believed that the Last Judgment would take place.

For a lionlike man, Dürer used the same blazing image of the Son of God as in *The Vision of the Seven Candlesticks* from the woodcut *Apocalypse*, carved ca. 1500. Never were images of equity or righteousness more welcome than at this anxious time. Saint John's Apocalypse—his vision of the end of the earth and the coming of the heavenly Jerusalem—offered hope as well as fear; Jesus is called "the lion of the tribe of Judah," but the symbol that the saint sees, and Dürer shows, is of the Lamb of God.

𝄞

Royalty is expressed in the symbolic language of heraldry. Not surprisingly, the lion is one of the most popular armorial beasts. (Still surviving is the seal of the biblical King Jeroboam's steward, Shema, who chose the lion as sign of his royal service.) The rich, visual code of shields, arms, and devices was one that Dürer

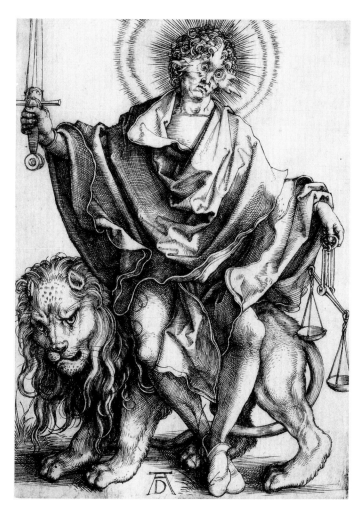

6.25

must have learned at an early age. Unlike other countries, where coats of arms were limited to the bluest blood, heraldry was shared by all free men in Germany, and much of Dürer's later work was taken up with designing these intricate devices for family names, trades, and fortunes. Since it does not allow for any sign of individual variation, heraldry would seem ill suited to artistic expression, but Dürer's early armorial woodcuts bristle with vitality.

Dürer prepared one such coat of arms [6.26] when in the Netherlands for Maximilian's secretary, Bannissis. The shield's three lions may refer to his eastern European origins; a fourth is poised belligerently on top of the jousting helmet cresting the arms. All four are crowned—and lick their chops menacingly. Soon after, Dürer prepared an even more dramatic coat of arms [6.27] for the rich Austrian

154 Dürer's Animals

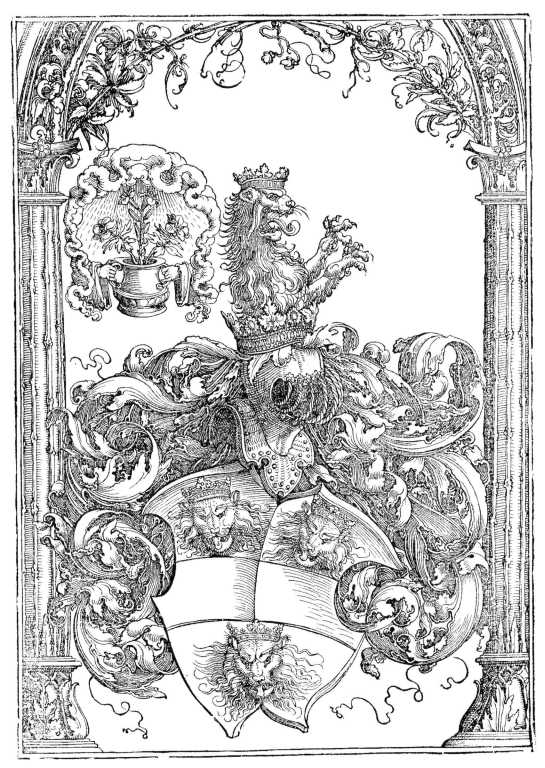

6.26

155 The Lion, the Saint, and the Artist

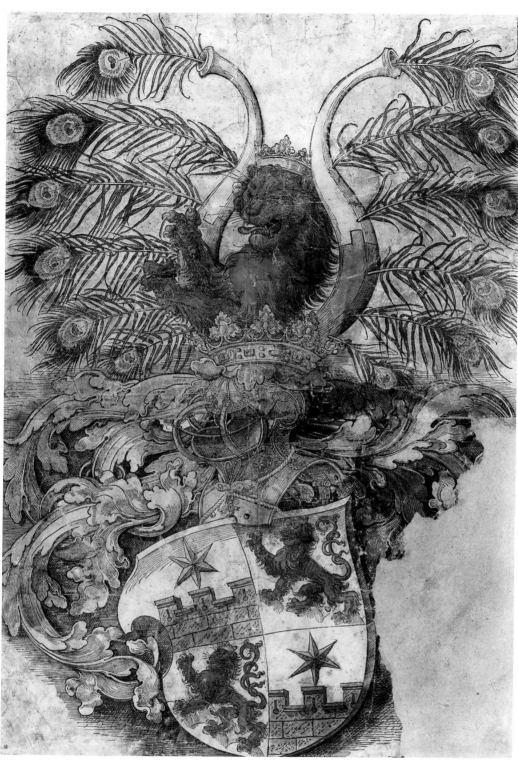

6.27

156 Dürer's Animals

6.28

6.29

to the popular medieval text of the Bestiary is found in such a heraldic fantasy, an engraved coat of arms with a lion below and a rooster above. This odd combination goes back to a Greek belief that a lion fears a cock, especially a white one. The artist revels in the contrast between the formal, heraldic rendering of the lion on the shield and the extremely lifelike, naturalistic rooster crest, perched on the closed helmet, which is a typical Nuremberg design. Proud of this unusually fine print, Dürer took impressions along to the Lowlands and presented one to King Christian of Denmark in Antwerp in 1521.

Many kings and nobles retained alchemists to help balance their books by the transmutation of metals—the impossible dream of creating gold from base metals. Gold was known as the "lion" of metals, and in alchemy that beast was related to the "fixed" element, sulfur. First trained as a goldsmith, Dürer, like so many artists of the Renaissance, was concerned with alchemy. His three views of a lion's head [6.28] are seen above an alchemist pondering a skull with a three-footed, egglike vessel boiling at his feet, inscribed LVTVS, an alchemical abbreviation for the phrase LVTVS SAPIENSE—the sealing wax of wisdom. Another sun symbol, Helios, stands at his side. A lion-legged base is found in the borders of Maximilian's *Hours*, supporting another globe with three little dots in the sides like those in the drawing, suggesting another alchemical reference.

One of Dürer's most puzzling lions, drawn in 1513 [Plate 22], possibly for a bookplate, straddles a golden, bejeweled coronet placed upon a winged, egg-shaped cup on webbed bird feet; this may also be an alchemical image of "the philosopher's egg," that egg-shaped vessel for thought and matter. Ringed around the lion is a handsome scroll inscribed with the Latin motto: "Luck Helps the Strong." This design goes along with another of a heron or a cranelike bird [Plate 36], similarly placed on a roughly shaped section of earth.

Roggendorf brothers, nobles at Maximilian's court and active in the Netherlands and Spain. Their jousting helmet is embellished with a great pair of buffalo horns; twelve magnificent peacock feathers shoot from these like fireworks. Perhaps such prints were presents, in exchange for hospitality or help extended to Dürer in his application to Emperor Charles V to continue paying the pension he had received from Maximilian.

Heraldry captured the mind and art of Dürer's times. When he chose to devise imaginary coats of arms even they found a ready market. One of his surprisingly rare references

157 The Lion, the Saint, and the Artist

Like the lion's inscription, the bird refers to good fortune. Close in style to these strange pages is a plan for a pendant [6.29]. Curved into the form of a jewel, a lion is shown open mouthed, his head and paws converging upon a round gem—possibly a pearl—gleaming against the gold.

Maximilian, who identified closely with the lion, included about 150 of them in all shapes and sizes climbing over his *Triumphal Arch* [1.31], most of the small ones upon the shields [6.30] of his ancestors and allies. Never have so many of these noble beasts [6.31–6.34] been caged within a single structure. A great lionskin [6.35] is stretched out on top of its left Portal of Praise, bearing a long message of imperial strength.

6.30

6.31

6.32

6.33

Lions also abound in Maximilian's *Book of Hours*, where ornery ones, their shield possibly representing Venice, repel an odd-looking stag. That republic, symbolized by Saint Mark's lion, successfully blocked Maximilian's plans to go to Rome for investiture as Holy Roman emperor in 1508.

Caricatures are best when they show the silly side of power or the absurdity of evil, their ridicule most effective when their target is easily understood. Several comic lions are brought together on a single page in the *Hours*. Was their presence to remind Maximilian that he, like the lions themselves, was no more than mortal? One anxious, worried beast peers through a loop in the droll decoration that fills the margin of a page of prayers [6.36], trapped in a ringed trellis of Dürer's calligraphy. Another lion [6.37], crouching, recalls those old-fashioned exercises in penmanship, coming to life in a single unbroken, springing line of heraldic power. More man than beast and wearing an imperial crown of oak leaves, a third lion's head [6.38], seen frontally, shows bared teeth and bristling whiskers, the whole idea of triumphal power seen here as a joke.

Largest of the lions in Maximilian's *Hours* [6.39] is one that cowers beneath a maddening fly, infuriated by his failure to destroy this little

6.36

6.37

pest. As his tail winds up the right margin, the lion digs into the ground, clawing the earth, preparing to spring at the fly. On the same page, David's Eighth Psalm asks, "What is man, that thou art mindful of him? . . . Thou madest him a little lower than the angels." Dürer shows man very much lower than the angels here, noisy and ignorant, like the peasants at the left, or foolish victim of blind faith, like the hermit about to tumble into the lion's open mouth.

6.34

6.35

The Lion, the Saint, and the Artist

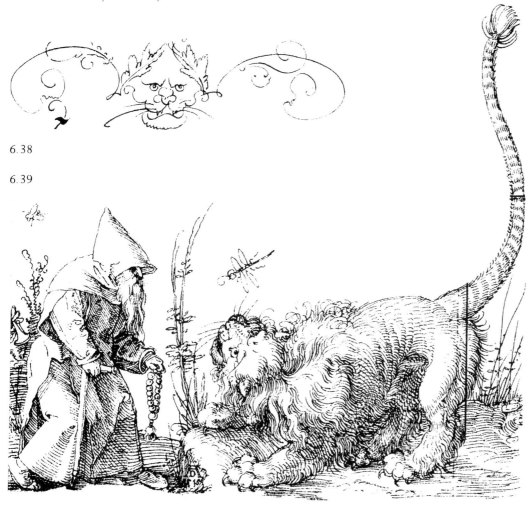

6.38

6.39

Dürer, whose own birth sign was Leo, is certainly leonine in his *Self-Portrait* of 1500 [1.29], completed when he was at the height of his powers as nature's painter and as a man. With a massively drooping mustache, his hair and beard teased and twisted into a great lionlike mane, physically as well as artistically Dürer proclaims himself heir apparent to majestic strength, such abundant hair signifying the creative force of nature. Inscribed in Latin, this picture identifies him as a great master in the tradition of the major artists of antiquity. Twenty-one years later, when he drew the imperial lions at Ghent, Dürer gave them the identical swirl of curls above the brow.

On 11 April 1521, the artist wrote in his travel diary that he went to the fortresslike castle of the counts of Flanders in Ghent and drew the lions kept in the moat as living symbols of princely power. Appropriately, it was here that Maximilian's grandson, Charles V, was born, the West's most powerful ruler since Charlemagne.

Three lion studies [6.40; 6.41] survive that Dürer worked in the same silverpoint technique used with such skill by Jan van Eyck. That Netherlandish master was very much on Dürer's mind, and he made a special pilgrimage to the church where van Eyck's greatest work, the Ghent Altarpiece [9.3], was kept. He recorded paying an entrance fee and described the painting as "more than excellent, painted with the greatest understanding. Thereafter, I saw the lions and sketched one in silverpoint."

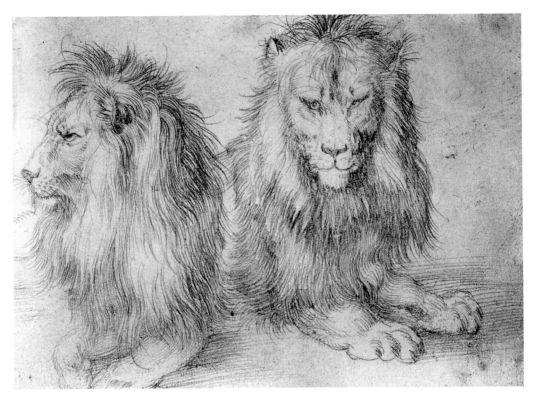

6.40

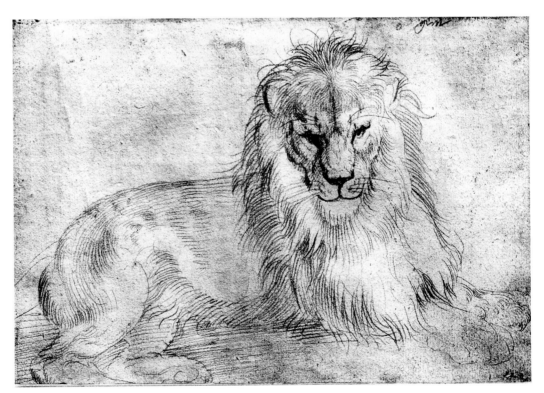

6.41

The Lion, the Saint, and the Artist

Seen from the side, the same lion may be shown again, with eyes lowered, on a page inscribed in the artist's hand "at Ghent." Later, in July, Dürer went to Brussels, where he drew in the zoo in the royal gardens of Charles V. He had been there before and had penned a map-like view of the gardens in their entirety. This time he drew his most ambitious surviving record of a lion and lionesses, on the same page with a lynx, a chamois, and a dog-faced baboon [Plate 23]. Stretched out, the sleeping lionesses may actually both show the same beast in different poses. Cut off in the original sheet, the one at the bottom can be seen in her entirety in an early copy kept in Warsaw [6.42].

This most varied of all Dürer's animal studies was discovered in 1917; it had been used as a backing for an Italian engraving after Raphael. Each animal is given its separate ground plane, clearly sketched on its own, but the overall effect of this suggests a breaking down of barriers, as if the artist had shattered the bars between the cages, bringing together the separate wonders he witnessed in such paradisical profusion.

Just as lions had loomed large among Dürer's earliest highly finished animal studies, they are found once again in his last decade. Concluding his works in watercolor and gouache on vellum are two renderings of 1521, of a lion (Vienna, Albertina) and a lioness (Paris, Louvre, Edmond de Rothschild Collection) [Plate 24], both based upon those seen in the Brussels zoo. Now shown in splendid isolation, the lion pads crossly along the page, tail twitching nervously in the air. His mate, first seen snoozing along the bottom of the Clark Institute page, now stands in stiffly canine fashion, her head raised, sniffing the air suspiciously. Though neither the dates nor the monograms on the two studies are by Dürer, the drawings are his, copied by Hoffman in 1577 (Nuremberg, Germanisches Nationalmuseum).

When he first visited the royal palace in Brussels, Dürer wrote, "I saw . . . the fountains, labyrinth and animal garden, which is a beautiful thing, like a garden of paradise, and more delightful than anything I have seen." The Williamstown sheet [Plate 23] shows how, on his own page, the artist created a new Eden.

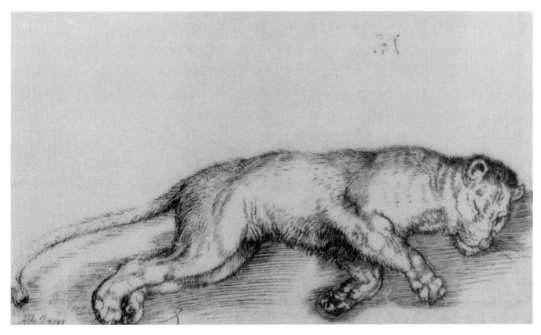

6.42

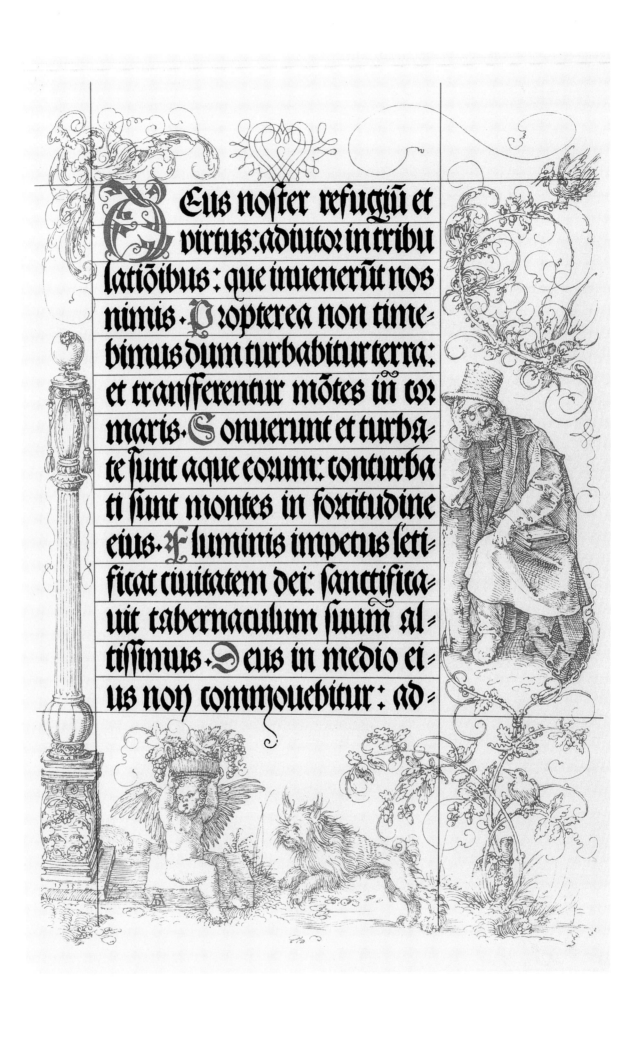

Eus noster refugiũ et
virtus: adiutor in tribu
latiõibus: que inuenerũt nos
nimis. Propterea non time=
bimus dum turbabitur terra:
et transferentur mõtes in cor
maris. Sonuerunt et turba=
te sunt aque eorum: conturba
ti sunt montes in fortitudine
eius. Fluminis impetus leti=
ficat ciuitatem dei: sanctifica=
uit tabernaculum suum al=
tissimus. Deus in medio ei
us non commouebitur: ad=

Chapter Seven

An Artist's Best Friend

Dogs did not have a good reputation in biblical days. Considered our enemies, not friends, they are described in the Old Testament as mean and dirty, ravenous and diseased. Not pets or shepherds, dogs were foul scavengers roaming the desert in search of prey, and hounds were never linked to any biblical leaders. David and Jesus, both the best of shepherds, had no kind words for dogs. Indeed, the threatening, ravening beast David described was seen by Christians as a prophecy of the Passion. His psalm describing the evil-tempered ways of hounds—"They scoffed at me with scorn; they gnashed at me with their teeth"—was read during Holy Week to foretell the sufferings of Christ on the way to the cross. European painters and printmakers kept this vile canine image in mind when they showed Christ's tormentors wearing the heavy, metal-studded collars customarily worn by hounds in the hunt.

But in the verdant lands of classical antiquity, the dog was a faithful, loving companion, a watchful yet reflective guide to his master as well as to his flocks, protecting both from harm. Great philosophers believed that human souls entered animal bodies at death, so Pythagoras held a dog close to the head of a dying disciple so that the hound could inhale his last breath—in no other creature could the virtues of the deceased live on quite so well. Roman hounds like the little bitch Helen were given handsome tombstones [7.1], with touching inscriptions extolling their virtues and beauties and proclaiming the inconsolable grief of those they left behind. On Dürer's two journeys to Italy he may have come upon such monuments, or those made for beloved dogs of recent times, together with the brilliantly realistic ancient canine portraiture rediscovered in the Renaissance.

Seen so often in Dürer's works—asleep, awake, or somewhere in between—dogs are also in many of the prints by Martin Schongauer, with whom Dürer had first hoped to study. Many of Schongauer's works include marvelously lifelike dogs that seem almost like their master's monogram—found in *The Adoration of the Magi* [7.2], *Christ before Pilate* [7.3], *Pilate Washing His Hands*, *Ecce Homo* [7.4], and *Christ Carrying the Cross* [7.5]. Dogs frisk about the foreground, sniffing the earth and each other; they sprawl indolently before the master's throne or trot alongside the bearing of the cross. Living symbol of power and prestige, petted darling of tyrant or judge, following at

7.1

7.2

7.3

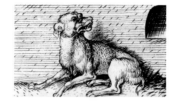

7.4

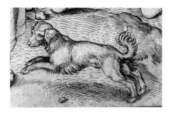

7.5

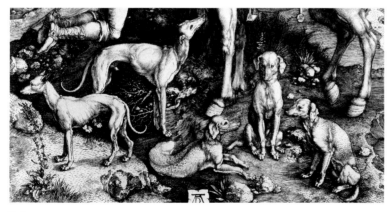

7.6

a master's heel or his mount's hoof, the dog probably appeared for the sake of sales appeal as much as for other reasons. Whoever could afford an engraving usually owned a dog, whether as luxury or necessity, as a source of pleasure or gain, protection or aid in the chase. So prints with dogs sold better than those without.

Based on the ancient legend of the three-headed hound, Cerberus, who guarded the gates of the Underworld, dogs in medieval times were carved at the feet of their masters' effigies—portraits in death—to watch over them as they left this world for the next. Dürer drew at least one tomb project where an endearingly homely pug nestles faithfully at his mistress's feet, shoulder to shoulder with her husband's whimsical lion. Her dog stands for *fides*, or faith; "Fido" was a popular name for dogs.

Five costly hunting dogs are placed in the foreground of Dürer's largest engraving, *Saint Eustace* [1.30; 7.6], in which Saint Eustace kneels before the miraculous stag. The triangular group of almost identical dogs seem to have been drawn from a single model, seen from different angles, in much the same way that Dürer studied the blue roller and the hare. Eustace's dogs were to "pose" for centuries of artists who used them as a source for their own images. The only preparatory drawing for this project to survive shows a lean hound looking up toward his master's horse, rendered in reverse [7.7]. Dürer worked with a brush and gray ink, a technique that shows a possible Venetian influence, for Italian masters liked the soft, richly luminous effect of such brushwork. He carried over the richly variegated tonality of the drawing into the highly finished engraving, adding still greater brilliance and gloss.

Doubtless inspired by Aristotle, Pliny wrote, "Of all the domestic animals, the one most worth studying, and before all the one most faithful to man is the dog." He tells of the dog that fought against brigands in defense of his master and although covered with wounds

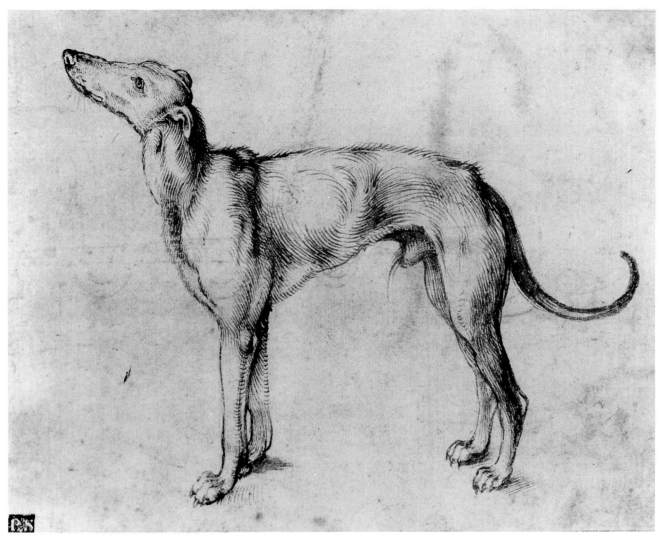

7.7

would not leave the corpse, driving away birds and beasts of prey; and of another dog in Epirus who recognized his master's murderer in a crowd and made him confess the crime. Aristotle also linked dogs to *sacras literes*—holy writing—a tie that never died. The medieval encyclopedia of Hrabanus Maurus stated that dogs represent a good sermon—a view that may have inspired the preaching order of the Dominicans to welcome the popular reading of their saint's name as the "Lord's dogs"—*domini cane*.

The Greeks and Romans had probably taken their cue from the beliefs of ancient Egypt, primary source of earthly wisdom. Dogs were worshiped as gods in Egypt, where tradition first linked them to the pursuit of knowledge. Horus Apollo, in *The Hieroglyphica*, stated that the Egyptian symbol for the scribe, the master of the written word, was the dog.

Dogs were also believed to have been the Egyptians' hieroglyph for the magistrate or judge. The ancients, Horus Apollo wrote, placed "the royal stole beside the dog, who is naked. Just as the dog . . . gazes intently upon the images of the gods, so the judge of ancient times contemplated the king in his nakedness. Wherefore they add the royal stole to this figure." Dürer drew these "hieroglyphs" [7.8; 7.9]—an inkwell and pen with a dog below representing divine literature, followed by another wearing a stole.

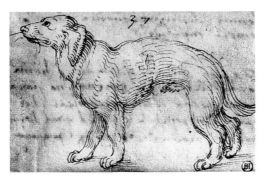

7.8

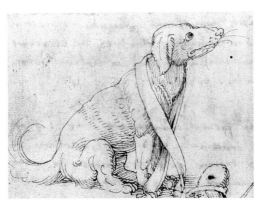

7.9

Scholars—ever hunting truth, pursuing the good word—were long symbolized by dogs, who eventually also stood for the dedicated studies of the church fathers and their followers, as well as for poets and humanists. Scenes of writers at work were seldom complete without dogs at their side.

As a young artist, Dürer knew that dogs stood for faith. This can be seen from an early drawing he made after an Italian-engraved playing card that showed the figure of Faith holding a chalice, wafer, and cross, with a little, rather wooden-looking dog seated at her side [7.10]. Dissatisfied with the animal, Dürer drew a much livelier one in his copy [7.11]. In a richly detailed woodcut, Dürer shows the poet Conrad Celtes as a chubby, boyish writer signing his name at the end of his book, while a drowsy little long-haired dog at his feet is identified as Lachne, the Latin word for *woolly* [3.84]. (This name was given to one of Actaeon's hounds in Ovid's *Metamorphoses*, which rests among the books shown on the poet's desk. Ovid recorded no less than thirty-two of Actaeon's dogs by name and trait, noting that there were "many more, whose names must pass unsung.")

Whether or not Celtes really owned a dog like Lachne, he believed he should be shown with that faithful friend at his feet, as great writers and poets of the past had been so depicted. Celtes's three short Latin verses celebrated Dürer as the finest of artists, comparing him favorably with the greatest masters of classical antiquity. Borrowing from a story first told by Pliny of the Greek painter Zeuxis, he said, "So great is Albrecht's pen, that he is endowed with marvelous talent. He painted his own features with such skill that his dog came running and reckoned the self-portrait to be his living master and licked it affectionately."

Dürer may have had Lachne in mind when he designed a bookplate for Celtes's pupil Christoph Scheurl around 1512. Here too the same pet is seen snoozing between the humanist's coats of arms [7.12]. Scheurl, who had met Dürer in July 1506, retold Pliny's old story once again. In his version, the self-portrait, not yet dry, was lovingly licked by the artist's dog "whose marks are still on it." Recalling how "it was not only Zeuxis in ancient times who played tricks by fooling birds with painted grapes, or Parrhasius, who made Zeuxis himself believe a painted curtain was real. My Albrecht deceived a dog in the same manner. When he painted his self-portrait and set the new work out in the sun to dry, his little dog happened upon it and began to caress the portrait, thinking it was his master. I can testify to that, because the marks are still on that portrait."

No less a master than Leonardo da Vinci used Pliny's story of the artist and his dog to prove the superiority of painting over sculpture. When Dürer first came to Italy in 1494, this comparison between the two media merited endless academic debate. Leonardo defended his favorite medium on these grounds: "Painting even deceives animals, for I have seen

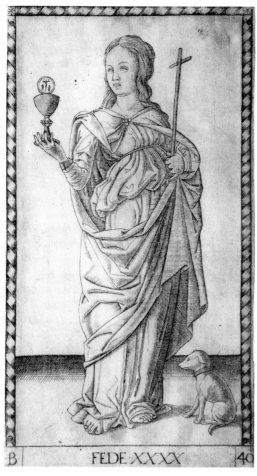

7.10

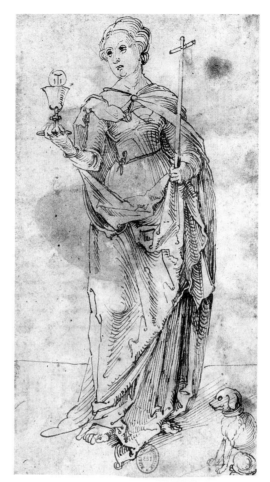

7.11

a picture that deceived a dog because of the likeness to its master; likewise I have seen dogs bark and try to bite painted dogs, and a monkey that did an infinite number of foolish things with another painted monkey. I have seen flying swallows light on painted iron bars before the windows of buildings."

During his second Italian journey, Dürer sent a letter from Venice to his friend Willibald Pirckheimer in Nuremberg. Dated 7 February 1506, it includes drawings of a flower, a leaping dog, and a brush [7.13]. These could stand for the names of Willibald's various loves or may suggest that Pirckheimer was an old dog still pursuing Nuremberg's young beauties though they gave him the brush-off. Dürer warned his friend, "It does not escape me that, when you wrote your last letter you were full of amorous

7.12

thoughts. You ought to be ashamed of yourself, an old fellow like you pretending to be so good looking. Flirting pleases you in the same way a shaggy old dog likes to play with a kitten." He then added, "But I'm glad for your virtue and good temper. Your dogs will be the better for it, for you will no longer strike them lame."

7.13

7.14

Perhaps the most extravagant claim ever made by a dog-lover was that of Jacob Locher, a Nuremberg scholar whose birth and death came in the same years as Dürer's. Both men went to Italy and were closely associated with German humanists—Locher was a student of Celtes and translated Brant's *The Ship of Fools* into German. Locher devoted the final facing pages of his *Little Works* of 1506 to his dog Scaramella [7.14]. A woodcut shows her protecting his writings from being eaten by mice and burnt by a fool. Vigilant, she stands beneath a Greek inscription, which her doting master claimed she could read. It states "All things will turn out beautifully," but then with a bitch like Scaramella how could it prove otherwise? Opposite are Latin lines ascribed to Scaramella's authorship, a verbal self-portrait by that brilliant, faithful bitch. Locher must have translated these, since he claimed Greek to have been her favorite tongue! Like so many of Dürer's humanist conceits, Locher's canine text came from an Italian source—the German scholar went back to Leon Battista Alberti's *Canis* of 1441, a mock panegyric of the many splendors of his hound, eulogized as worthy of his progenitor Megastomo (Big Mouth). The earlier scholar's dog was even more exemplary than Locher's—past master of all the liberal arts and virtues, brave and talented too, this was truly a hound of heaven, blessed with no less searching a sense than that of moral wisdom!

In 1509 Scheurl praised a painting that Dürer had recently made for Frederick the Wise of *The Martyrdom of the Ten Thousand* [7.15] (the massacre of soldiers by the troops of King Saper of Persia in A.D. 303; Frederick was the proud possessor of many relics from this mass murder—bones, nails, hair, teeth, and skin—preserved in his treasury and worshiped for their miraculous properties). In this, Dürer's most gruesome work, some of the tortured early Christian soldiers are impaled on the bare trees like meat upon a skewer, bleeding like stuck pigs; the artist stresses this beastly aspect of the mass martyrdom by showing a little dog savoring the warm blood's scent, sniffing it appreciatively as he would that of freshly killed game. The pet's animal innocence makes the scene all the more horrifying.

At the lower right foreground, a little white dog is petted by a pagan prince, oblivious to the carnage. Standing amidst the butchery, Dürer portrays himself holding a sign reading "Albrecht Dürer the German made this in the year of our Lord 1508." So in this terrible painting he takes on the role of a martyr, in the

169 An Artist's Best Friend

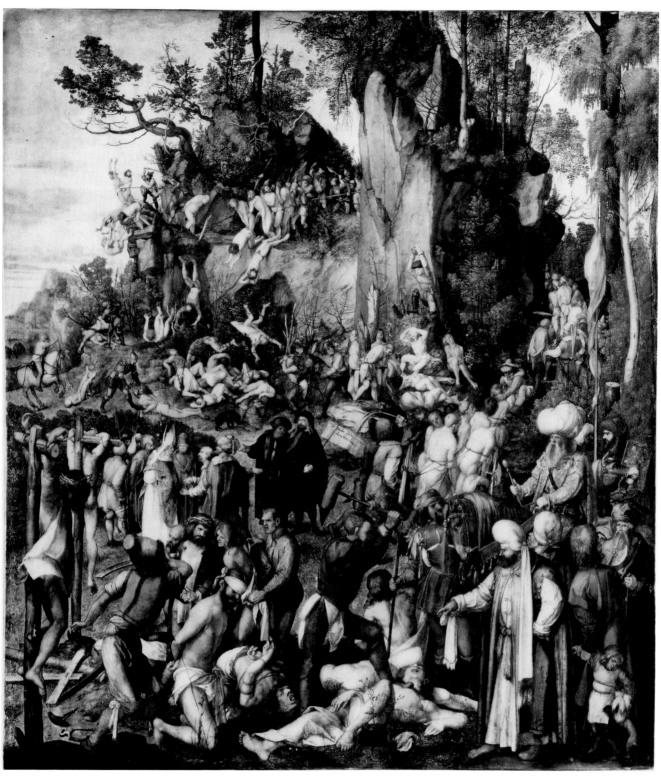

7.15

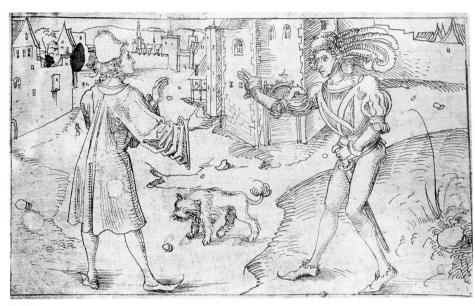

7.16

7.17

true Greek meaning of that word, "witness." (Some writers suggest that the man standing at Dürer's side near the center of the composition may be Conrad Celtes.)

Bounding and woolly, with a devil-may-care gleam in his eye, the same small white dog wanders in and out of Dürer's art for fifteen years or so. We do not know if he actually owned this canine, but it is tempting to see the little animal as belonging to the artist's life as well as to his work. It is first seen in Dürer's earliest known series, the 147 illustrations for Terence's comedies, which he drew in 1492 directly on the woodblocks (the scenes were not cut or printed until almost five hundred years later). With a poodlelike trim and a waving, rakish tail, the dog [7.16] steals the stage when a dandy, Pamphilus, standing at the right, is horrified to learn of the intrigues of the slave Davus, whose unsolicited advice always proves disastrous. The young gallant tugs at his sword, while his little dog trots toward the trouble-making servant, its jaunty good humor in marked contrast to his master's indignation.

This dog is next seen accompanying the great early-fifteenth-century theologian Jean Gerson on his pilgrimage to Compostela in a woodcut designed by young Dürer in his journeyman years in Strasbourg [7.17]. Such dogs, traveling with their masters, were often shown in Italian paintings depicting the apocryphal tale of the young Tobias, protecting the youth as he wandered far and wide in search of the fish that would cure his father's blindness. Altarpieces devoted to Tobias and his guardian angel were painted to help safeguard the commercial travels of young Florentines: Worried parents found comfort in these images of a boy, journeying like their own, provided with both a faithful watchdog and a guardian angel.

On Dürer's first Italian journey, he traveled south on horseback, probably with a group of merchants and pilgrims from Augsburg and Nuremberg. It is unlikely that he took a dog along, but the pet may have accompanied him on the return, for only then, around 1495, does the dog first appear in his art. It has been identified as a Brussels griffon, bred close to the land of the duc de Berri; or it could be a Seidenpinscher (silk terrier); a half-shorn poodle; an Affenpinscher (monkey terrier), or, most likely correct, a Löwenpinscher (lion terrier), very like the Bolognese griffon. That the dog should be linked to the duc de Berri is hardly surprising, for he was among the greatest dog-lovers of the North. When banqueting in the early fifteenth century, he was accompanied by a pack of the dainty canines,

7.18

7.19

7.20

which he had been first to breed. All too clearly they were given carte blanche to trot up and down his splendidly set table, taking their pick of morsels from the ducal gold plate (*Trés riches heures*, Chantilly). No less than fifteen hundred dogs filled Berri's kennels, ranging in size from great mastiffs to his pampered little white terriers, solely status symbols.

In a powerful early woodcut, *Knight on Horseback and the Lansquenet* [7.18], the dog seems to imitate the pace and pose of his master's mount—a device that appears elsewhere in Dürer's work. This "echoing" of a major figure by a minor one is also found in the shaggy dog at the emperor Domitian's feet as Saint John crouches in a footed cauldron of boiling oil, in *Martyrdom of Saint John* of 1498 [7.19] (from the Apocalypse series). Lying close to the ground, his features as lionlike as possible, Dürer's dog does his best, or worst, to resemble his grimly bearded, scowling, imperial master, recalling Pilate's pet in Schongauer's *Christ before Pilate*. In *The Flagellation* (*Large Passion*) of 1497, Dürer places the dog at Christ's feet, by his monogram [7.20], as though the dog were an extension of the artist's gift and faith. Only the dog's left eye is seen, looking out sadly at the spectator, the sole living being in the woodcut to do so. In the woodcut *Christ Carrying the Cross* [7.21], Christ is followed by the same dog as he stops to place his features on Veronica's veil. Here Dürer may have worked after Schongauer's print of the same subject, where little dogs abound.

Christ among the Doctors [Plate 25] is the first painting in which Dürer's signature dog appears. It is also one of his earliest and most delightful pictures, belonging to a series of the Seven Sorrows of the Virgin ordered by Frederick the Wise, probably in 1496, when Dürer was twenty-five. The elector of Saxony was a passionate huntsman [4.4], and his commissions often included animal subjects. Knowing Frederick's taste so well, Dürer may have been encouraged to include not only the engaging dog seen at the center of the painting but also the ill-tempered ape, to symbolize evil. As if knowing his presence was not approved of by

7.21

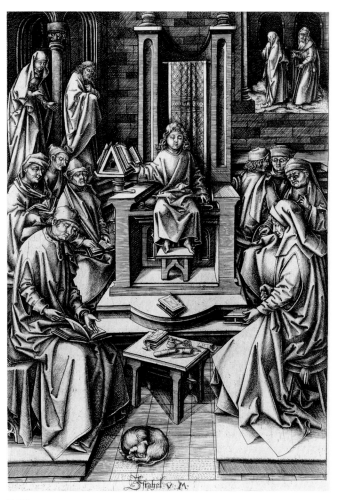

7.22

the defeated doctors surrounding him, the dog seems to be in good spirits.

The dog's most specific sacred association, as given in medieval encyclopedias, is that he represents the good sermon. Here among the doctors is a dog who not only knows what is going on, but, as his smile makes clear, has known it all along. In this way, he also represents prophecy, the other gift that medieval writers gave him.

For all its humorous, almost caricatural depiction of the frustrated doctors, cheeky dog, and brooding ape of evil, the painting is meant to be a sad one. Not only does it show the first separation of Mother and Son, Mary's Third Sorrow, but also the future sufferings he will have on earth, begun by his preaching.

Just before Dürer began to paint this panel, he saw a series of engravings devoted to the life of Christ by Israhel van Meckenem. Meckenem's major strength was also his major weakness—lack of originality—and the older artist was the busiest of printmakers, basing many of his own prints on those by stronger, often earlier masters. Dürer's *Christ among the Doctors* in turn is freely modeled on van Meckenem's treatment of the subject [7.22], adding new humor and insight. Dozing at center stage of van Meckenem's print, the sleeping dog represents the blindness of the old law, ignorant of the new law as preached by Jesus. Dürer wakes up the dog and gives him to the Holy Family. He substitutes the ape for the sleeping hound as a symbol of stubbornness and sin, the vices that led to the Fall. In van Meckenem's print, Joseph and Mary are shown in two symmetrically placed flashbacks, looking for Jesus at the upper right and finding him at the upper left. As if zooming in on van Meckenem's static presentation, Dürer changes this from one of balanced, boring formality to a scene filled with excitement, of human interest.

Dürer's richest zoological works, two of the three drawings of *Our Lady of the Animals*, understandably included his beloved dog. In the first sheet [2.9; 7.23], he wanted to show

173 An Artist's Best Friend

7.23

7.24

7.25

the dog lying down near the Virgin, but his lively model seems to recline reluctantly, ready to spring off at any second. Mary's little poodlelike pet is quite different from the hardworking sheepdogs in the hills above. In the smaller, highly finished watercolor version of the composition [7.24] [Plate 2], Dürer shifts the pup to the left and seems to explain its restless behavior by inserting an inquisitive stag beetle. Lying at Mary's feet, with a strawberry—the fruit of Heaven—just above him, this is a lucky dog, the emblem of happy faith. In the last, most serious version of *Our Lady of the Animals* [2.10], Dürer omits his dog, perhaps because Mary is shown as a simpler woman who would never have possessed such a modish, costly pet. Even the shepherds have fewer hounds, only one in sight, leaping across the fields just above the Infant's head; another dog belongs to the Magi.

At the Visitation, a happy moment depicted in a woodcut belonging to the *Life of the Virgin* series [7.25], Mary and Elizabeth first feel their babies stir as they embrace. Mary's little dog stands at her side. In Dürer's preparatory drawing of about 1504 [7.26], where, of course, the dog is shown in reverse, it looks very much like the one in his first sketch for Terence's comedies. At about the same time, an artist in Dürer's studio prepared a woodcut for Pinder's *The Closed Garden of Mary's Rosary*, printed in 1505 [7.27]. As a heroine whose triumph prefigures that of the Virgin, Judith is

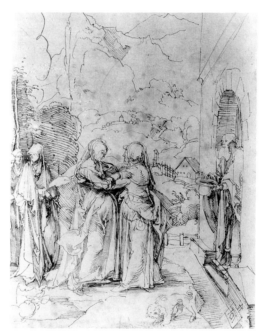

7.26

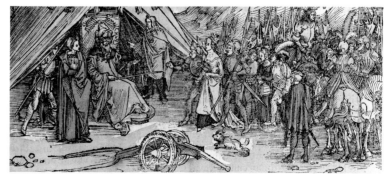

7.27

shown entering Holofernes's camp. The dog at her side could be hers or Holofernes's, but probably the latter, since Holofernes resembles Domitian who, as we have seen, had a similar dog at his feet. The grouping of an evil, powerful man with a dog as a sign of his power is repeated in Dürer's small woodcut *Christ before Caiaphas* of 1509–10 [7.28], where Caiaphas, enthroned as judge, has a shaggy creature by his throne.

As Dürer grew older he found less to laugh about, but his dog, or memories of it, provided a steady source of mirth, never more so than in his appearances in the margins of Maximilian's *Hours*. Striding masterfully across the upper border [7.29], trying to be a lion

7.28

7.29

7.30

rather than a dog, Dürer's pet is the source of some of the *Hours'* most memorable laughs, given a long, plumelike tail terminating in gothic tracery. The dog's mock-heroic expression suggests that Dürer, like the duc de Berri a century before, may have called his favorite pup "Lion." Farther on, the dog reappears, for the last time in his master's works, as more fearful than fearsome, curled up in a whirl of penmanship at the upper-left corner of a page [7.30] with a similarly spiraling fish far below [5.31].

7.31

Dürer's "dog of a thousand faces" appears throughout his master's art as variously haughty, threatening, humorous, or companionable and may have led to the late-sixteenth-century belief of a "mimicke dogge . . . apt to imitate alle things it seeth." Illustrated in Edward Topsell's *Historie of Foure-Footed Beastes* [7.31], a huge zoological compendium printed in 1607, this strangest of dogs seems caught in the middle of a costume change, switching from lamb to lion, or lion to lamb. The book, which drew heavily upon Dürer's art, explained the infinite variety of the dog's roles due to its being "conceived by an Ape," that traditional symbol of the imitative arts.

Three different kinds of little dogs appear on Maximilian's *Triumphal Arch*; a pair is seen with a massively attendant groom leaning over each like a solicitous giant [7.32; 7.33]. Dürer saw to it that many sections did double duty; his dog appears four times, flanking the bottom corners of both sides of two great inscribed hides, those of a deer [4.25] and a lion [6.35]. The scenes were printed from left to right and then traced in reverse upon a new woodblock to be reproduced again. A bored or clumsy woodcutter did not do justice to Dürer's drawings, and the prints look more like the product of cookie cutters, lacking the lighthearted lines needed to bring the prancing pup and playful *putto* to life as they disport themselves under a cornucopia [7.34].

Dogs like Dürer's remained symbols of scholarly attributes until the end of the sixteenth century. In 1599, two such pets are the only living animals in a woodcut of a chamber of natural wonders in Antwerp [10.13]; they wait, more or less patiently, as their masters take a guided tour given by the young man at the far left. He tips his hat deferentially as he points to the fierce stuffed creatures hanging from the ceiling and placed on the walls, calling their features to the cavaliers' attention.

Dürer may have visited this room too on his journey to the Netherlands in 1520, when he drew a stuffed walrus [Plate 31] suspiciously like the one hanging on the end wall at the upper left. Both the quick and the dead, model dogs and model seal alike, seem to have stayed the same for the next eighty years, preserved by the woodcutter's art or that of taxidermy. Brief canine barks may have helped make up for the long silence of that sadly stuffed, professorial walrus, now so far from the frozen northern waters where Albertus Magnus first saw these beasts and wrote of them for Dürer's eager boyhood reading.

<p style="text-align:center">𝔸𝔻</p>

A dog is included in each of Dürer's Master Prints and enhances the meaning of each engraving. In *Saint Jerome in His Study* [6.10; 7.35], while the saint works on his letters or translations, his dog, sleeping so securely in the sun-warmed study, is one more sign of the good sermon, or fidelity to God's word, which permeates this scene. Of the living beings in this print, the dog is closest to the three books at the far left and the little treasure chest below, both of which he guards. Far from the strident life of action, Jerome's sleeping pet is present as a living symbol of the contemplative life. Inkpot and pen are just like those shown by Dürer for the hieroglyph of "Divine Literature" [7.9]. Since this engraving of Jerome was made in the same year that Dürer was illustrating Maximilian's Egyptian series, he obviously had their meaning freshly in mind.

7.32

7.33

7.34

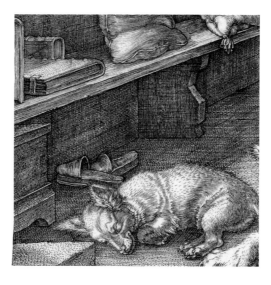
7.35

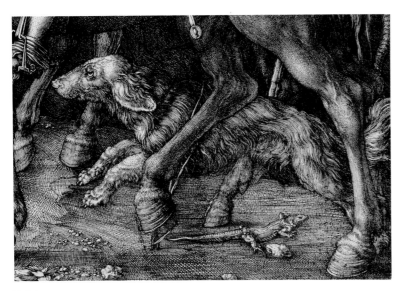

7.36

7.37

Bounding alongside the soldier's horse in *Knight, Death and Devil* [9.47] is a hound, the kind known as a talbot [7.36], with long legs, ears, and muzzle, which is often found in heraldry [7.37]. Dürer made several studies of this dog [7.38; 7.39], and he is the liveliest figure in the engraving. At this moment the dog looks worried, as well he might be: A dragonlike lizard runs along just below him, while a demonic, three-horned monster trots along to the rear.

Knight, Death and Devil and *Saint Jerome in His Study* show different ways of dealing with death; in each the animals are closer to the subject than their masters. The saint's back is to his hourglass, and the soldier stolidly ignores the one Death waved in his face as the devil scratches at the knight's armor. Burdened by this skeletal, serpent-infested rider, the sadly beautiful horse bends down to snuffle a skull on the earth below. (This symbol also appears in Jerome's sun-warmed study, very like the bald saint's head bowed over his desk. The slumber of his dog, comfortable under the skull on the sill, may also refer to the just sleep of the faithful.) The knight's hound, by his very next leap, is about to come upon the same symbol, which blocks his way in the Valley of Death and the Devil. By propping a tablet with his monogram and the year 1513 against the skull-supporting stump, Dürer tells his viewers to "think upon death," engraved in that unlucky year when he lost his much-loved mother and godfather; "Me[m]ento Mei" is the same message he inscribed on *King Death Riding a Horse* [9.24]. Both that rapidly drawn charcoal nag and the one in the engraving have bells around their necks, as though warning of their coming, perhaps tolling the call to "Bring out your dead."

Leaping hound and armored rider, sleeping pet and writing saint—each team of man and beast represents both halves of the medieval portrait of man's soul, a delicate balance of the active and the contemplative. Seen together, this pair of prints represents what man can do, within and without; two dogs help tell the story.

Bleakest of the three dogs that dwell in the Master Prints is the one who accompanies his gloomy mistress in *Melencolia I* [3.16; 7.40]. Melancholy and her dog are in a studious setting resembling a cross between a craftsman's workshop and a cabalist's alchemical courtyard, filled with all the tools and instruments that she is kept from using by her black humor. In *Adam and Eve* of 1504 [2.18], Melancholy was depicted as a sad elk, looming in the background of paradise, but here the dog takes over that temperament. Believed to be supremely intelligent of all beasts, the dog was deemed necessarily the most melancholy. A writer of Dürer's time noted how "the most sagacious of dogs are those who carry a melancholy face before themselves," and in his *Anatomy of Melancholy*, Richard Burton observed that dogs were of all animals most often subject to that

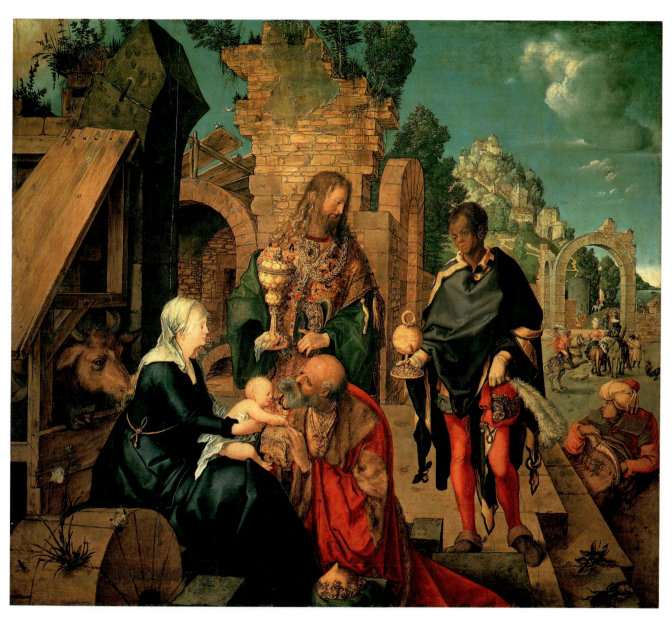

Plate 1

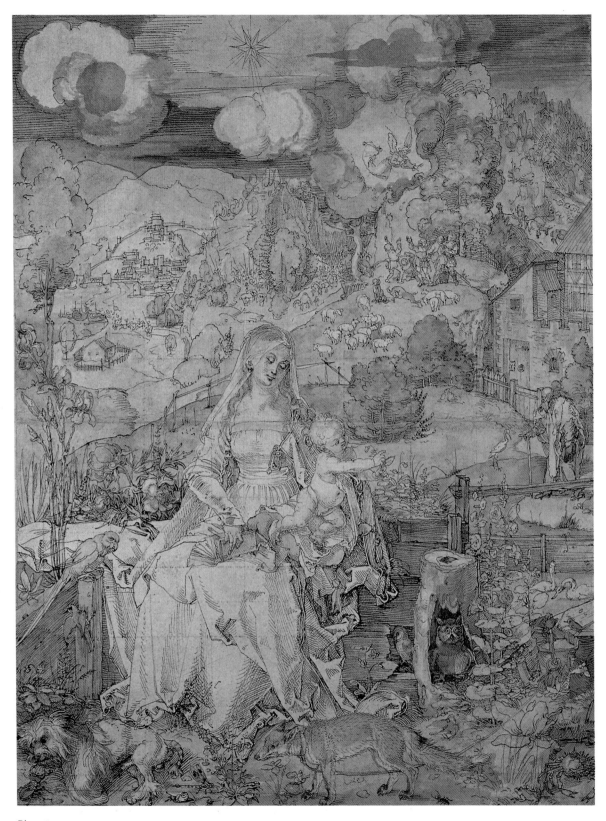

Plate 2

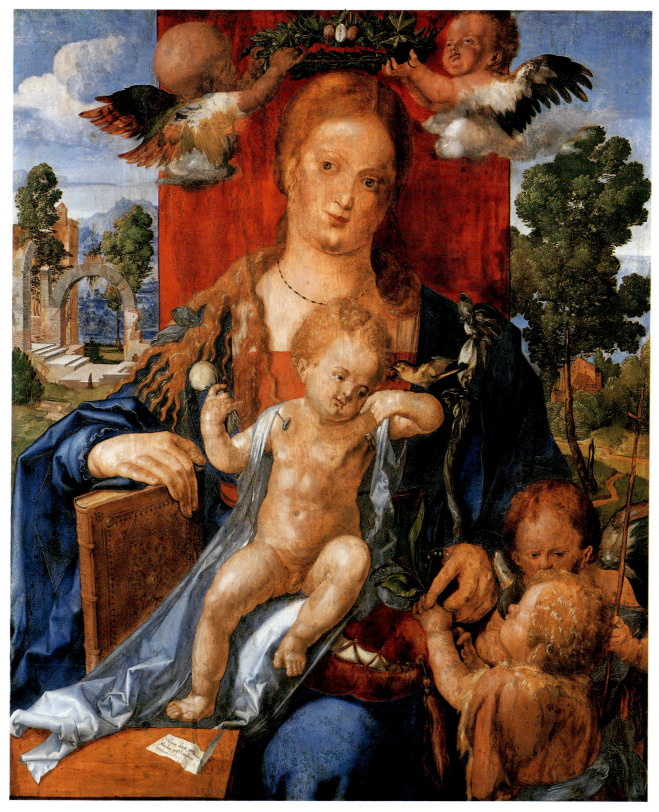

Plate 3

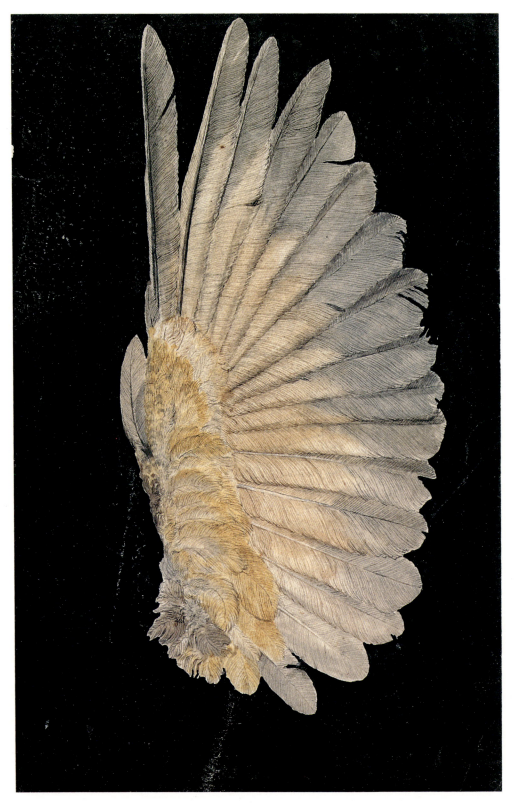

Plate 4

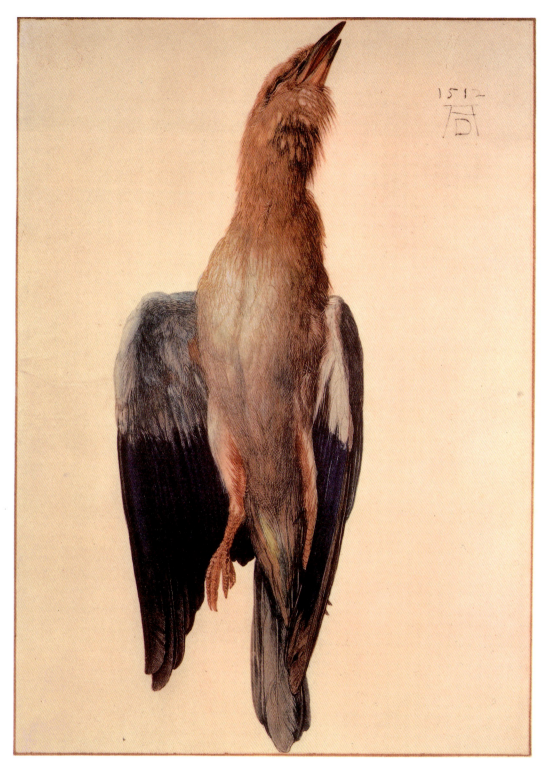

Plate 5

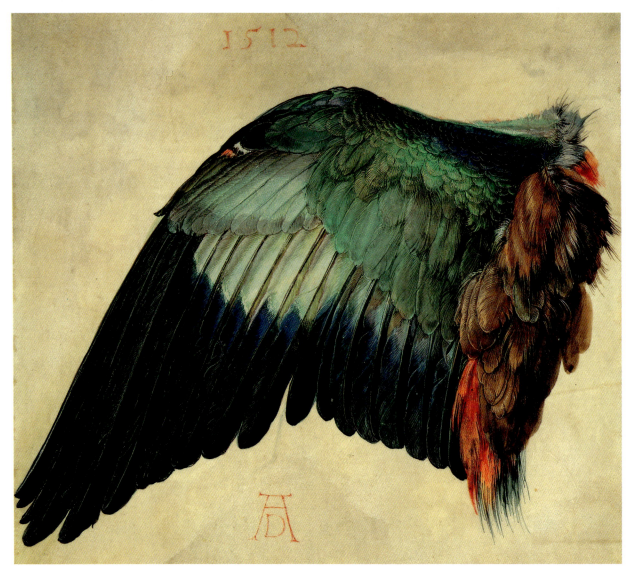

Plate 6

Plate 7

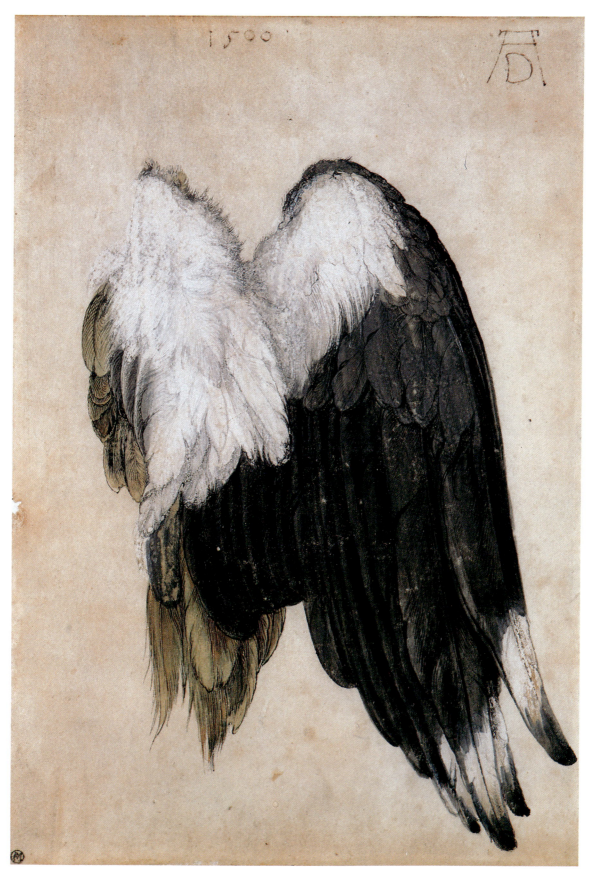

Plate 8

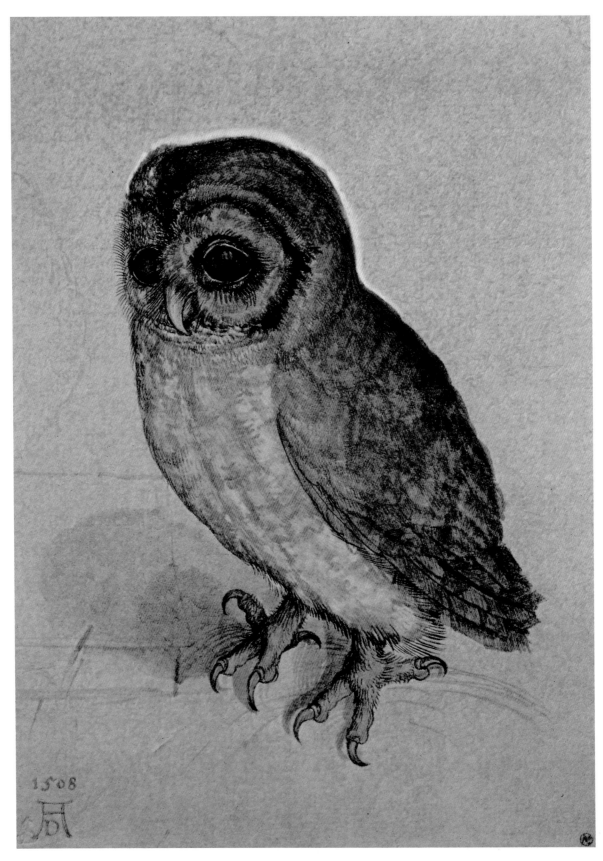

Plate 9

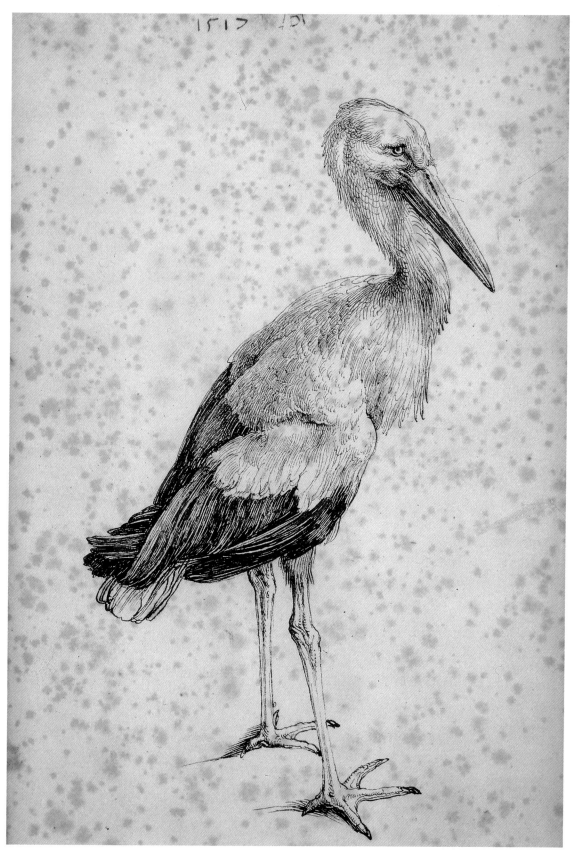

Plate 10

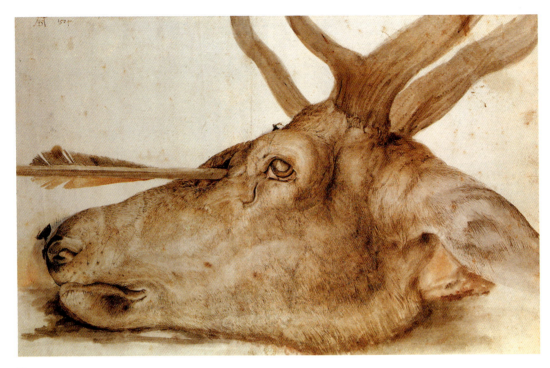

Plate 11

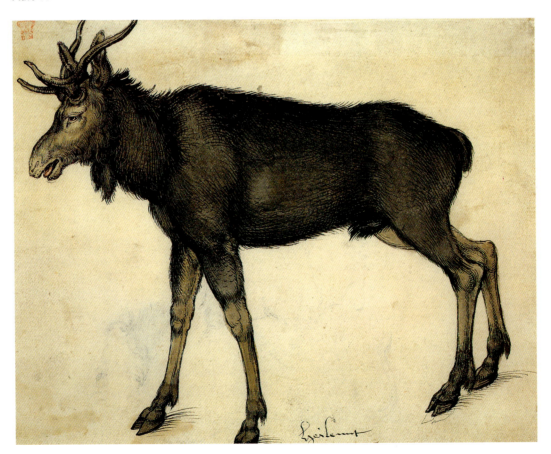

Plate 12

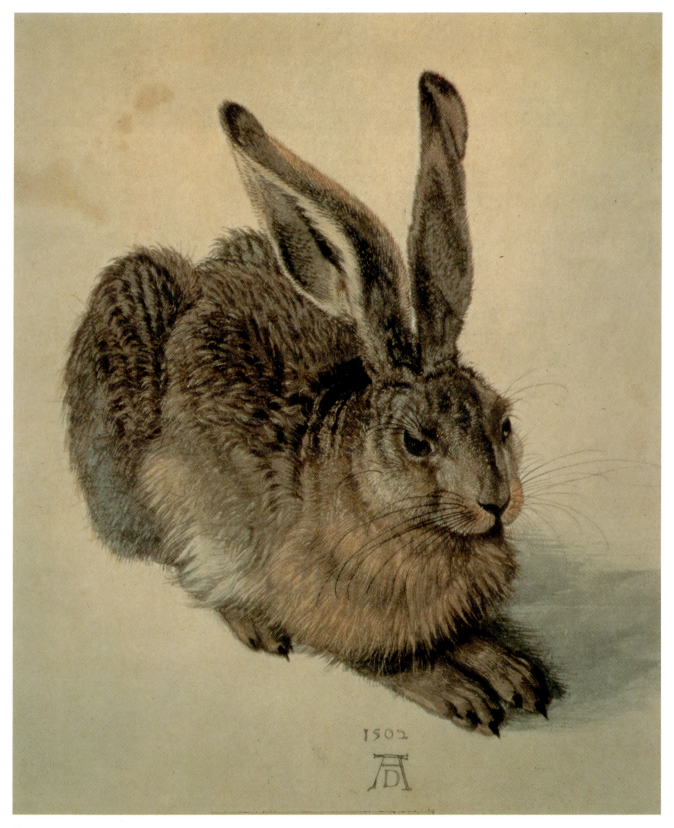

Plate 13

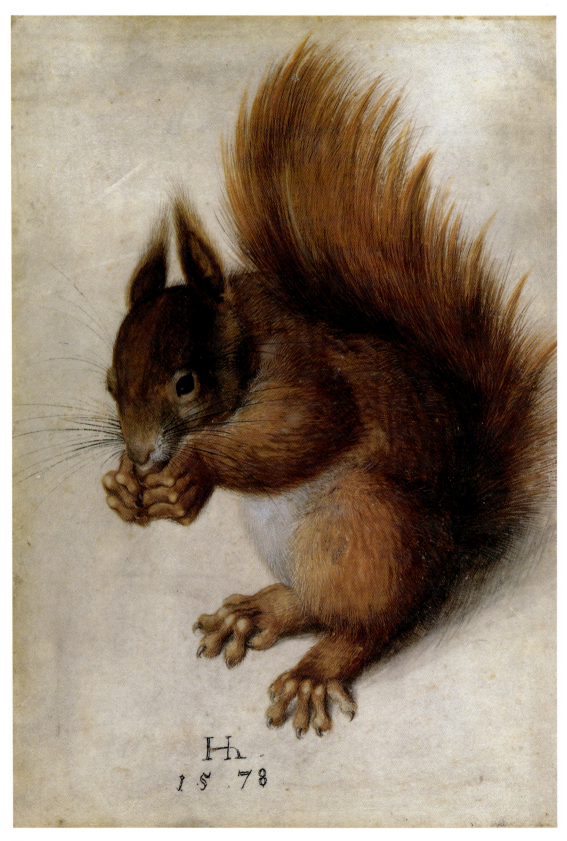

Plate 14

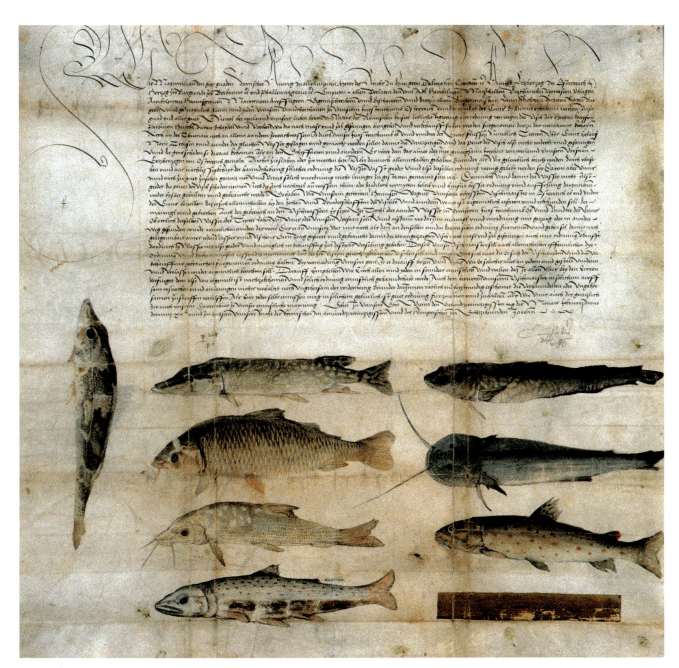

Plate 15

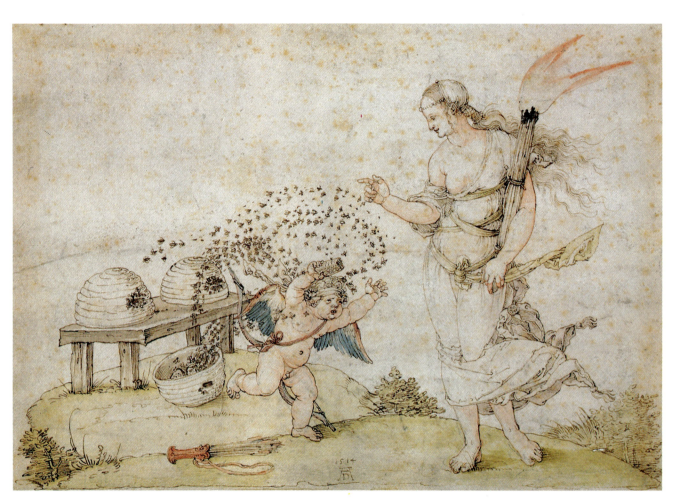

Plate 16

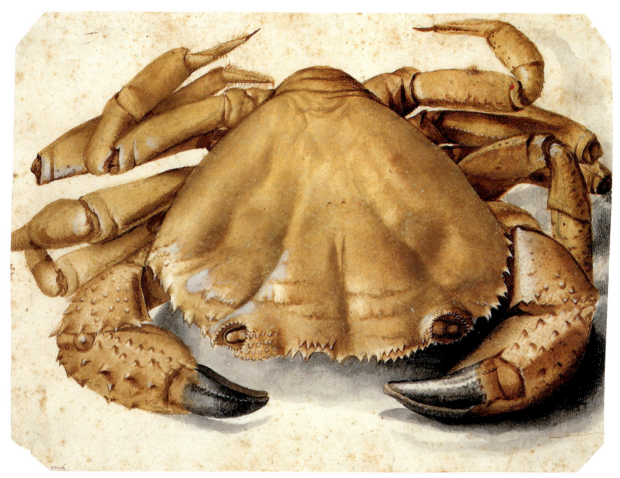

Plate 17

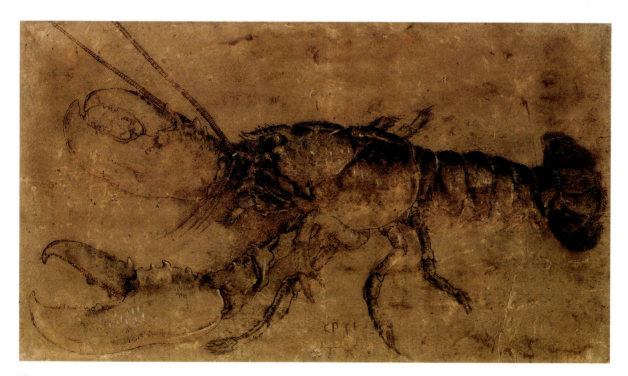

Plate 18

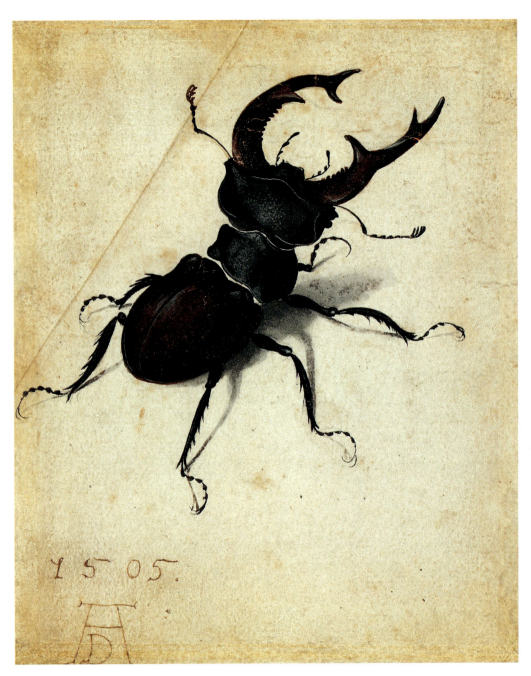
Plate 19

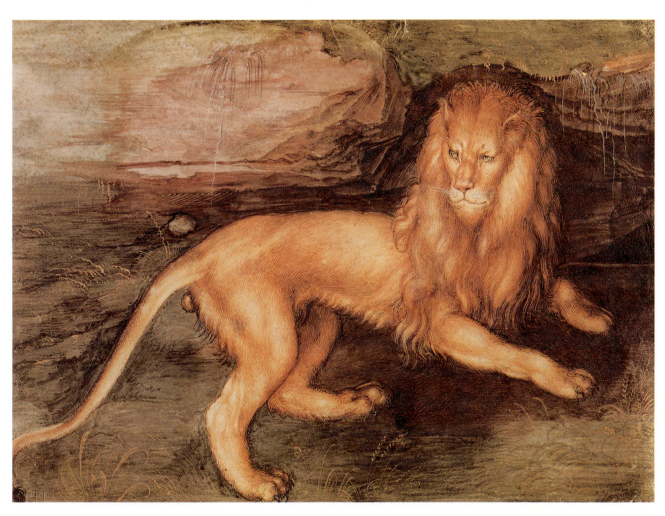

Plate 20

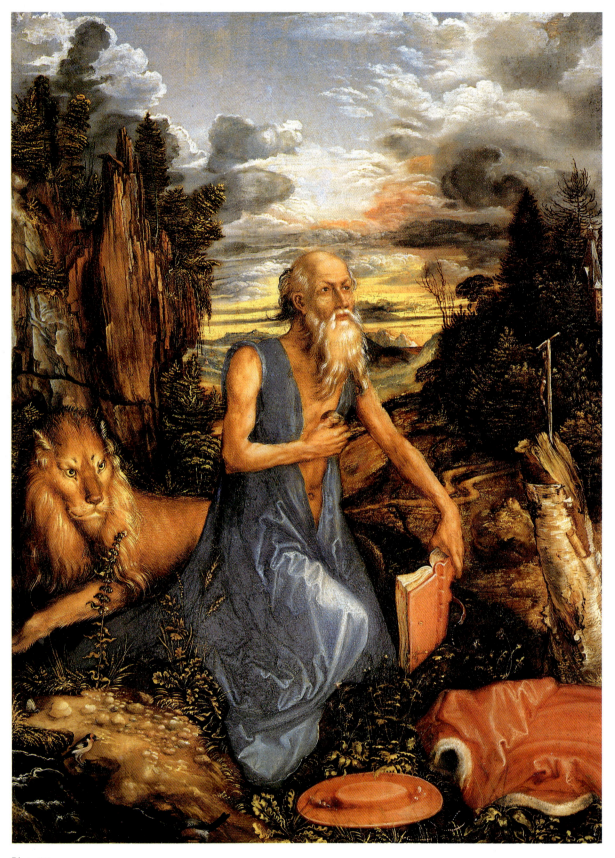

Plate 21

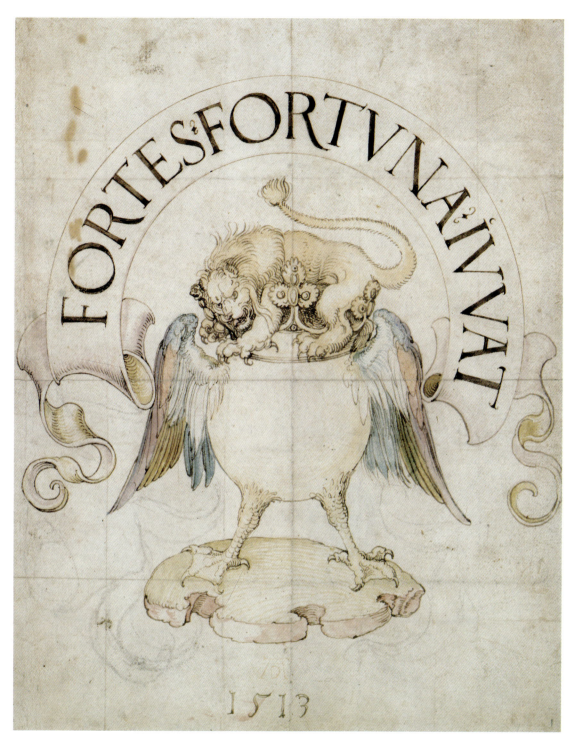

Plate 22

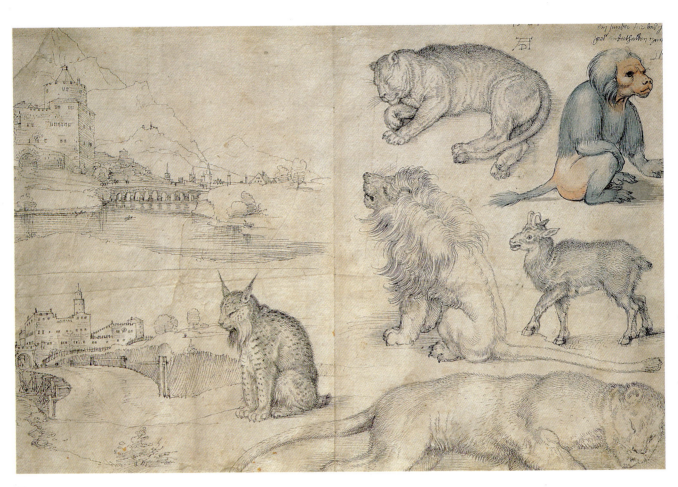

Plate 23

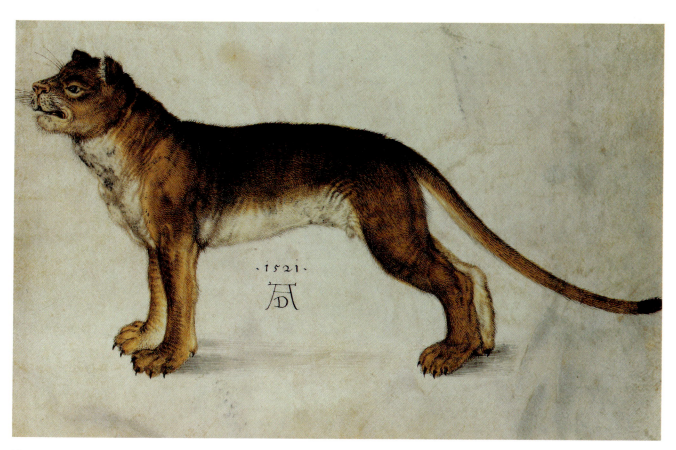
Plate 24

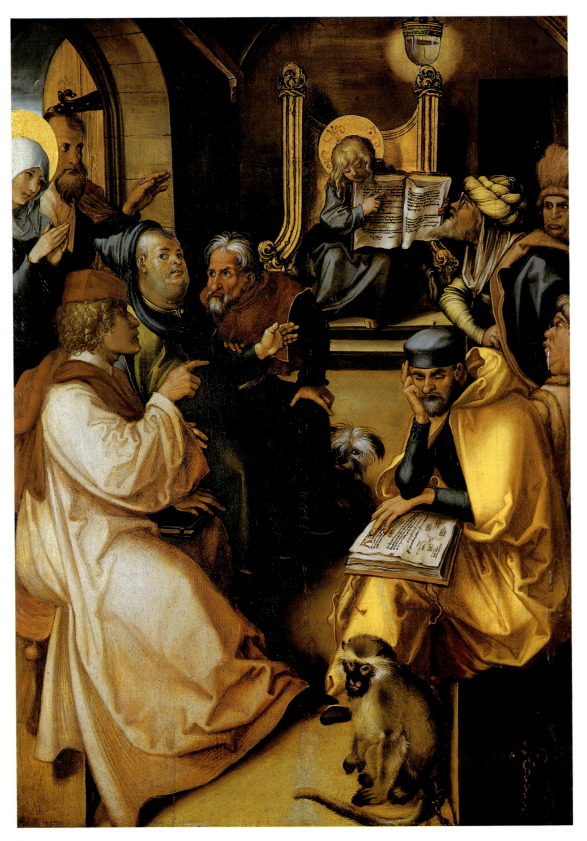

Plate 25

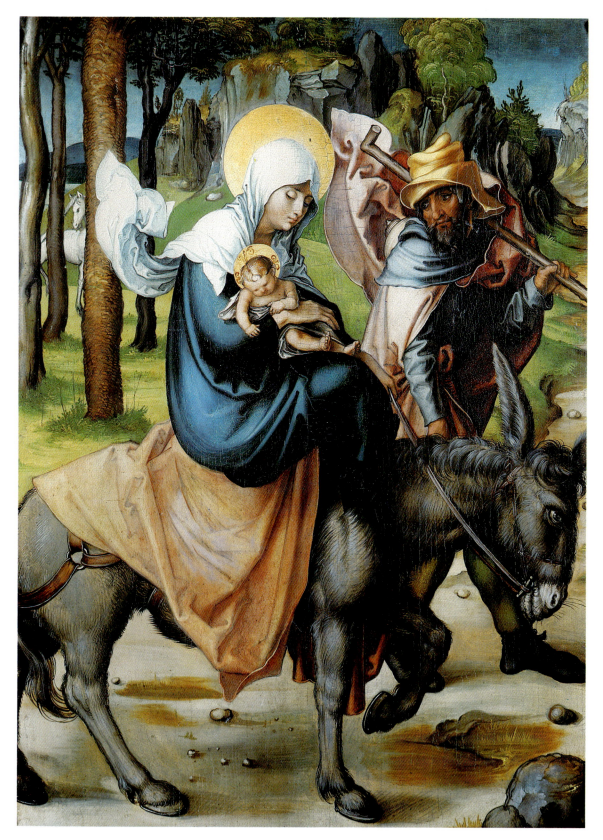

Plate 26

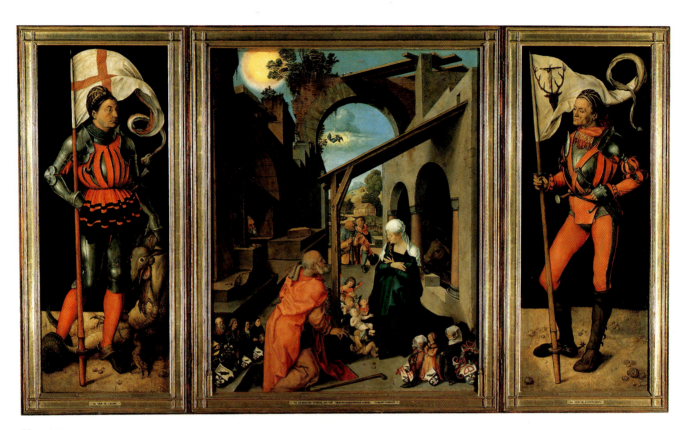

Plate 27

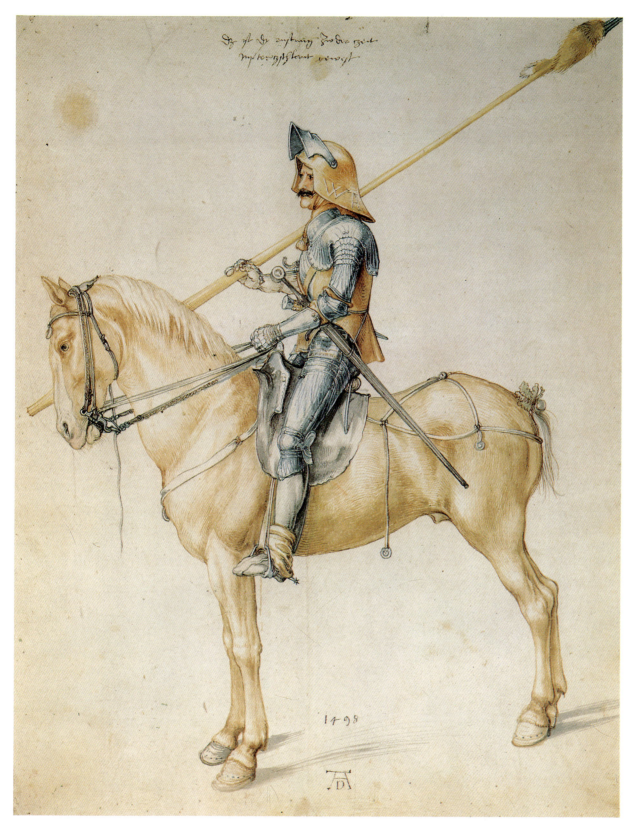

Plate 28

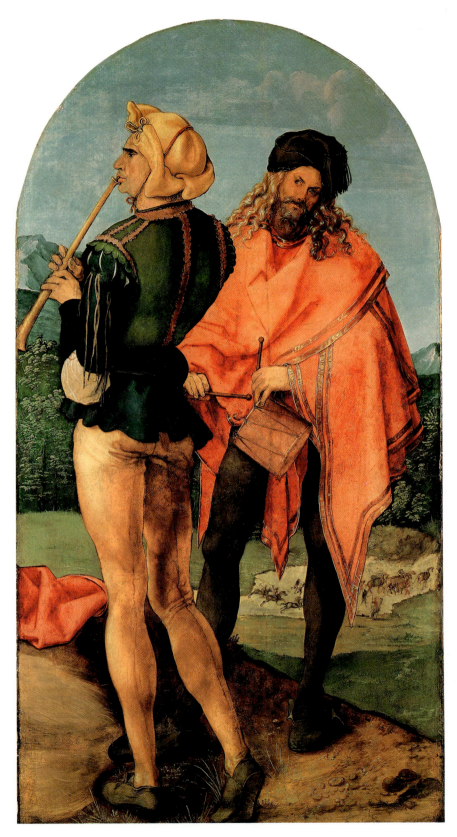

Plate 29

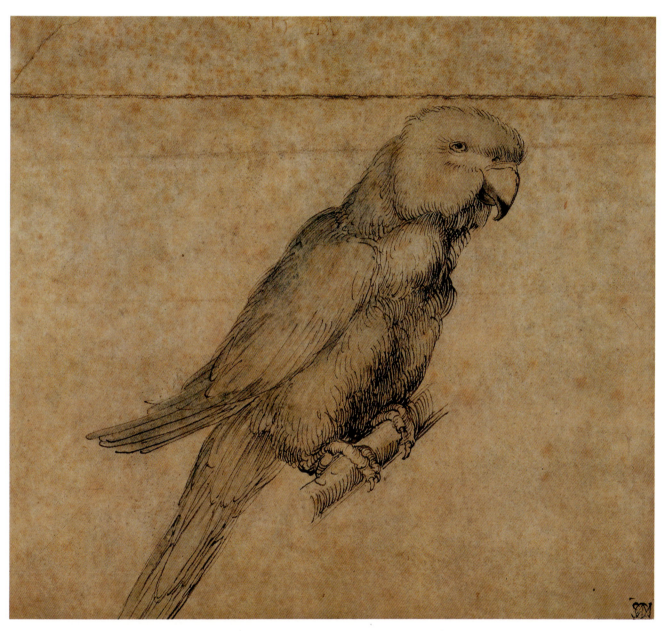

Plate 30

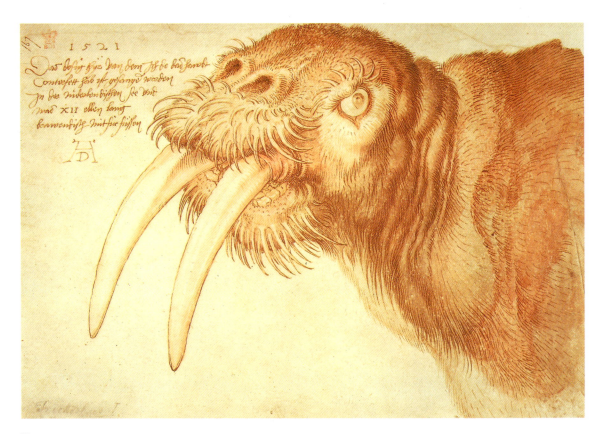

Plate 31

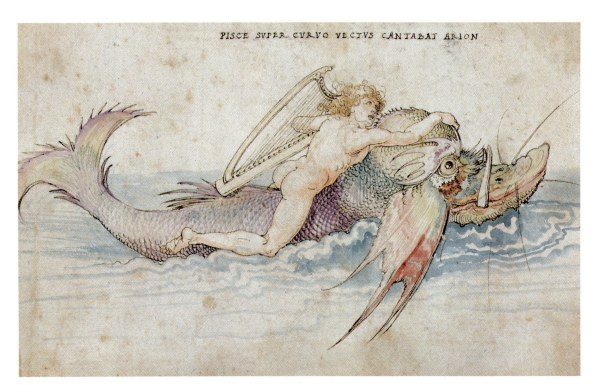

Plate 32

ΠΟΡΦΥΡΙΟΥ ΕΙΣΑΓΩΓΗ.

Ὄντος ἀναγκαίου Χρυσαόριε εἰς τὴν τῶν παρὰ Ἀριστοτέλει κατηγοριῶν διδασκαλίαν, τοῦ γνῶναι τί γένος, καὶ τί διαφορά, τί τε εἶδος, καὶ τί ἴδιον, καὶ τί συμβεβηκός, εἴς τε τῶν ὁρισμῶν ἀπόδοσιν, καὶ ὅλως εἰς τὰ περὶ διαιρέσεως καὶ ἀποδείξεως χρησίμης οὔσης τῆς τούτων θεωρίας, σύντομόν σοι παράδοσιν ποιούμενος, πειράσομαι διὰ βραχέων ὥσπερ ἐν εἰσαγωγῆς τρόπῳ, τὰ παρὰ τοῖς πρεσβυτέροις ἐπελθεῖν· τῶν μὲν βαθυτέρων ἀπεχόμενος ζητημάτων, τῶν δὲ ἁπλουστέρων συμμέτρως στοχαζόμενος. Αὐτίκα περὶ γενῶν τε καὶ εἰδῶν, τὸ μὲν εἴτε ὑφέστηκεν, εἴτε καὶ ἐν μόναις ψιλαῖς ἐπινοίαις κεῖται, εἴτε καὶ ὑφεστηκότα σώματά ἐστιν, ἢ ἀσώματα, καὶ πότερον χωριστά, ἢ ἐν τοῖς αἰσθητοῖς καὶ περὶ ταῦτα ὑφεστῶτα, παραιτήσομαι λέγειν· βαθυτάτης οὔσης τῆς τοιαύτης πραγματείας, καὶ ἄλλης μείζονος δεομένης ἐξετάσεως. Τὸ δ' ὅπως περὶ αὐτῶν τε καὶ τῶν προκειμένων λογικώτερον οἱ παλαιοὶ διέλαβον, καὶ τούτων μάλιστα οἱ ἐκ τοῦ περιπάτου, νῦν σοι πειράσομαι δεικνύναι.

ΠΕΡΙ ΓΕΝΟΥΣ.

Ἔοικε δὲ μήτε τὸ γένος, μήτε τὸ εἶδος ἁπλῶς λέγεσθαι. Γένος γὰρ λέγεται καὶ ἡ τινῶν ἐχόντων πως πρὸς ἕν τι καὶ πρὸς ἀλλήλους ἄθροισις, καθ' ὃ σημαινόμενον, τὸ Ἡρακλειδῶν λέγεται γένος, ἐκ τῆς ἀφ' ἑνός σχέσεως, λέγω δὴ τοῦ Ἡρακλέους, ⁊

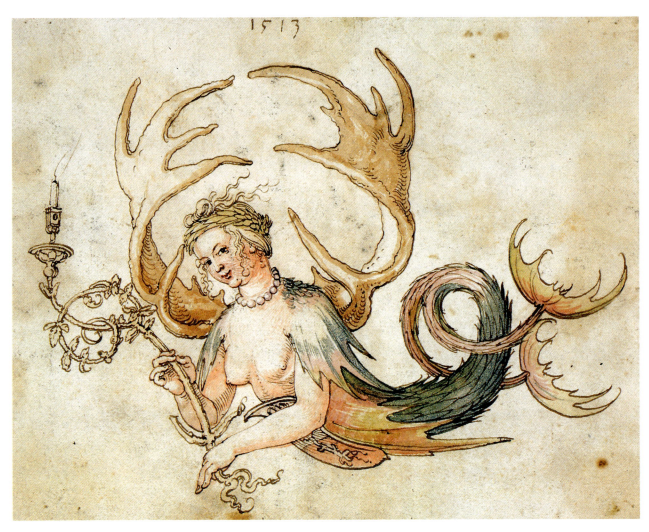

Plate 34

ἈΡΙΣΤΟΤΈΛΟΥΣ ΠΕΡῚ ΖΩ͂ΩΝ ἹΣΤΟΡΊΑΣ ΤῸ Αʹ.

Plate 35

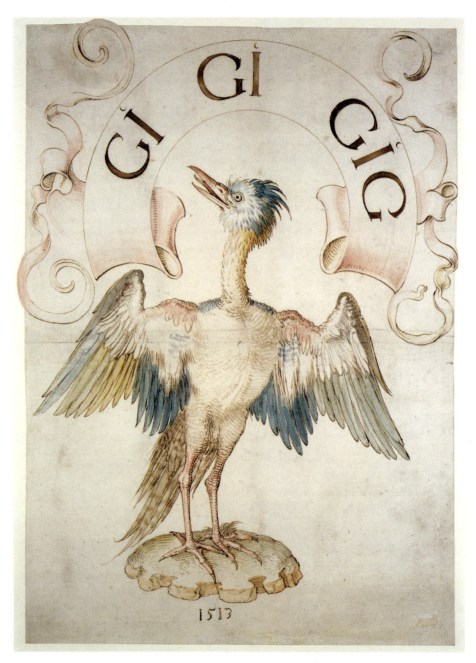

Plate 36

177 An Artist's Best Friend

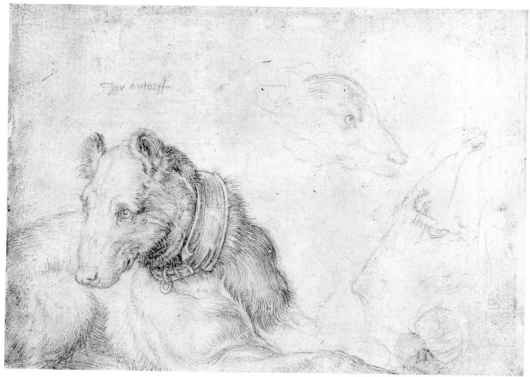

7.38

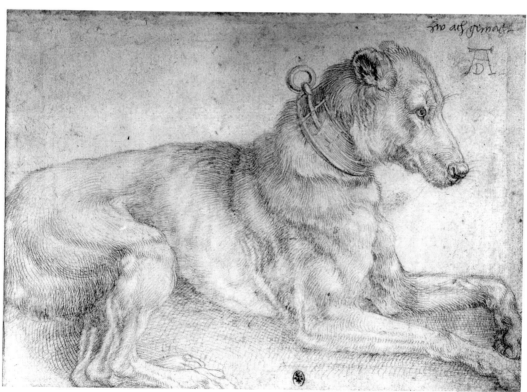

7.39

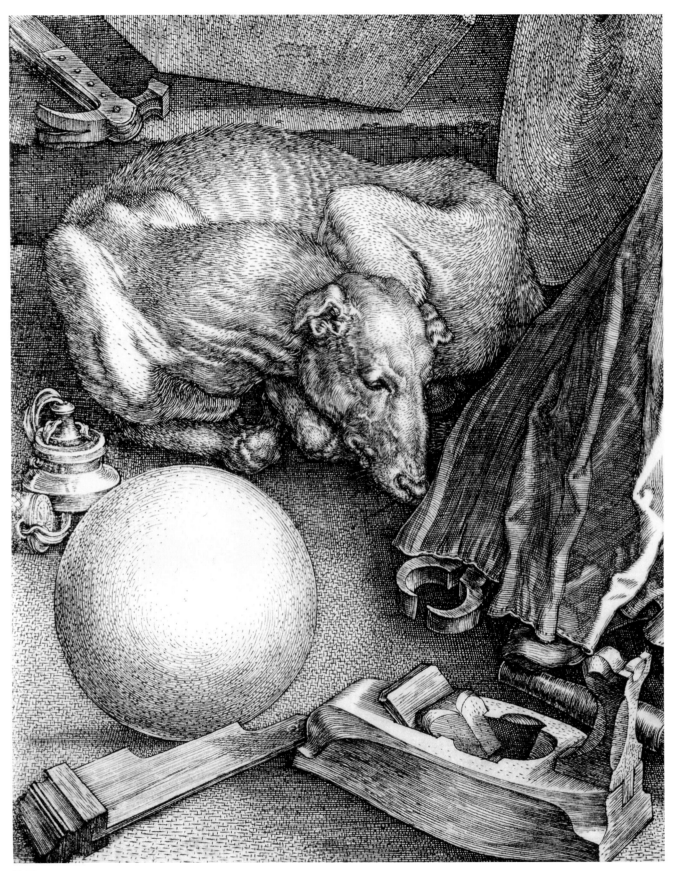

7.40

7.41

7.42

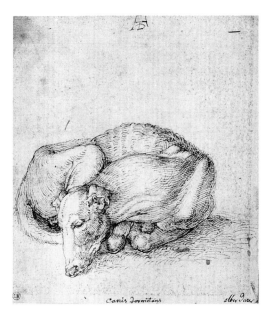

malady: "They dream as men do, and, through violence of melancholy, run mad." Under Sirius [7.41], an evil star, the dog days of summer start, those of wildest, blackest despair.

Squeezed between a tetrahedron and a globe, *Melencolia I*'s greyhound [7.42] seems to be forcing his lean form into a compact pretzel. He dozes fitfully, his eyes almost closed, as if the active life, streaking through the woods and fields, were but a dream; in Dürer's original drawing, known only from a copy, the hound's eyelids seem to flicker. Even asleep, the dog shares his mistress's restlessness.

One year after this engraving, Dürer drew another brooding, melancholic woman. Unable to turn to her spinning, she hides her miserable head in her lap, placed in the margins of Maximilian's *Hours*, with a floppy-eared dog padding sadly overhead, sniffing the ground. Both he and the crane, who stands for vigilance, are on guard, as is the nearby soldier. All three watch out for virtue, relating to the Last Judgment, the subject of this page's prayers. Whether on the track, on guard, or on the defensive, bird, beast, and man are very different from the poor woman lost in oblivion, a sinful state that will probably have her in Hell on Judgment Day.

In his commentary on "a certain proverb . . . told by the vulgar—'Who loves me loves my dog'," Saint Bernard of Clairvaux explained to his readers in the twelfth century that this meant, "Truly we are dogs of that master, whom you blessed angels esteem with such passion; dogs, I say, desirous of satisfaction from the crumbs which fall from the tables of our masters, who you angels are." But that "vulgar" proverb may not always have had such divine meaning. Like doting parents, dog owners see their pets as part of their life and love. And the dog's presence, painted alongside the owner, tells the world that this person, though shown alone, is lovable.

Little pugs, with round or piggy eyes and clipped or floppy ears, turn up quite often in Dürer's prints and drawings. These ugly creatures must have been rare and therefore highly prized. The pup Dürer has assigned to guard Faith's side is cut along such lines, as is a somewhat fatter pooch, of the kind known in Germany by the marvelously descriptive name of *mops*, lying at his mistress's feet in Dürer's design for the funerary relief [7.43]. Another pug keeps the great scholar Gerson company on

180 Dürer's Animals

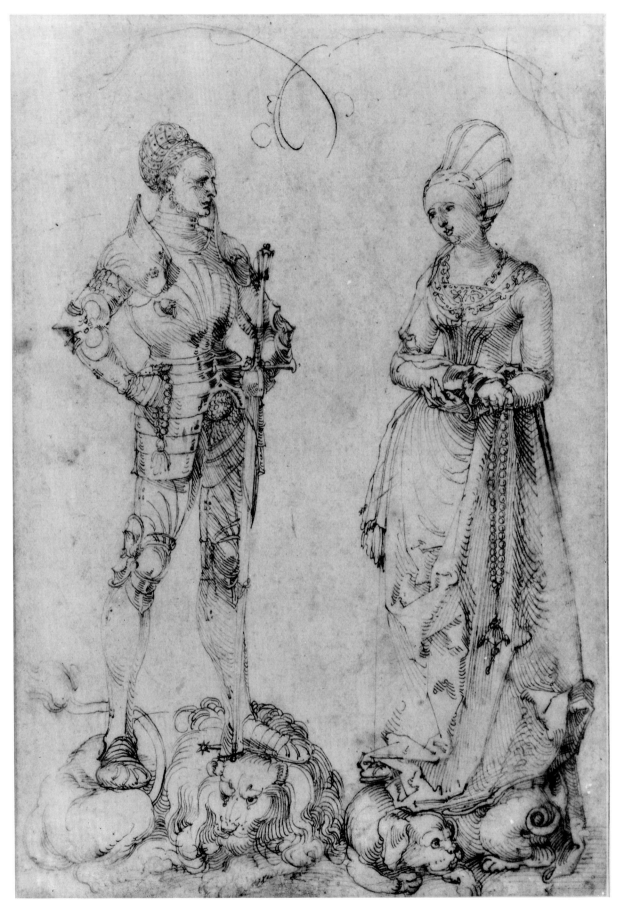

7.43

his pilgrimage. A similar dog takes refuge behind Herod's boots in the *Small Woodcut Passion* of 1507 [7.44].

Among young Dürer's early projects as a book illustrator were the woodcuts that embellished the Basel edition of the "Book of the Knight of Turn," by the Chevalier de La Tour Landry [7.45]. Writing of the foolish, heartless extravagances of the rich, the chevalier begins his moral tale: "Dear daughters, I will give you an example of how those who love pleasure go to the dogs. . . . Once there was a noble woman. She had two little dogs she was very fond of." A hermit came to her and said that as long as people went hungry she should not fatten her pets and would be punished for her indulgence. Soon the lady died and two little black dogs leaped upon her deathbed and licked her body, turning it the same demonic color as their coats, to show the world that the devil had claimed her evil being. Dürer does not seem to have read the story carefully, or, confirmed dog-lover that he was, he redrew it in a happier light. In his woodcut the cosseted canines are white and look as if they are trying to lick their mistress back to life, rather than revealing her black character; he has made the scene more dramatic by showing the woman as young, with a man holding his head in grief at the foot of the death bed; still smiling, the lady reaches out for the candle of her penitence and last communion. Black dogs could be messengers of death without coming from the devil. The great preacher Johannes Geiler von Kaisersberg wrote in his own *Book of the Good Death* that our "precursor is death, that little black dog who runs ahead of his master. Fear therefore not death, my Christian brother, because he foretells the Lord your God, so be a wise and ever good man of the house."

But no writer, hermit, or preacher could keep sitters from insisting on having their pets included in their portraits, pampered in their laps like reluctant, petulant babes. In Dürer's 1525 drawing of Maximilian's niece Susanna, duchess of Brandenburg-Ansbach [7.46], her little dog is held securely in her hands. She turns away, but the pup looks straight out at the spectator as if to make up for his mistress's disinterested restraint. His self-confident stare is one of loyalty and protection; he is literally *watching out*. Four years earlier, Dürer drew a similar dog that looks up balefully with one

7.44

7.45

182 Dürer's Animals

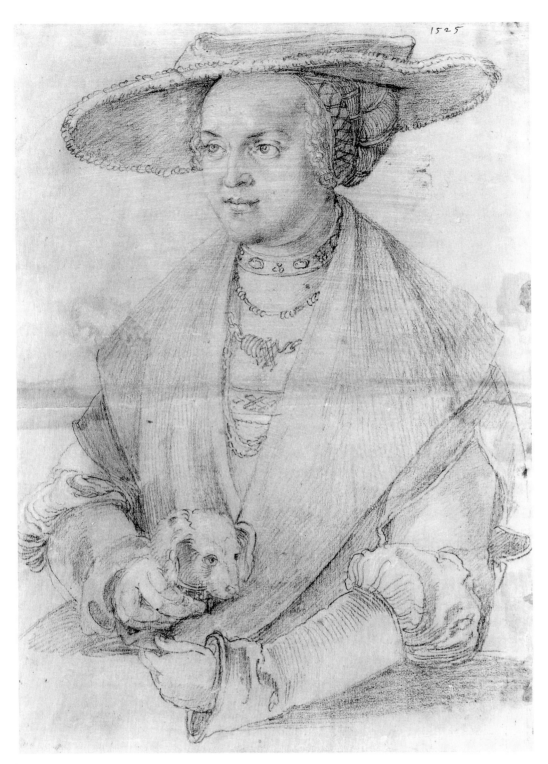

7.46

7.47

7.48

eye closed [7.47]; he may have been part of a study for a portrait like the duchess's. This silverpoint drawing was made on the artist's trip to the Lowlands in 1521 and kept in a notebook with many others. Another notebook included two pages of studies of the same dog, perhaps one accompanying him. In what can only be described as a portrait, the large hound wearing a heavy collar is seen from the right on a sheet with the inscription "Made in Aachen"; his head turned to the left and wearing a different collar, the dog is shown on a page inscribed "At Antwerp." A more fleeting sketch of his head is to the upper right, with a lion's head, also rapidly, faintly indicated in left profile at the right, drawn in Ghent.

Recently the fine American actor Al Pacino felt a pair of penetrating, luminous eyes following his every move throughout a Shakespearean performance. So impressed was he by this understanding, intense look constantly directed his way, that the actor decided to perform solely for that perceptive source. When the house lights went on and he could identify his most faithful viewer, Pacino found that it was a Seeing Eye dog, doing the viewing for two. Dogs, too, could be the first to see Death's presence, trying to ward off his fatal arrow [7.48], seeking to save a master or mistress from loss of life [2.5].

All creative performance, whether Pacino's or Dürer's, comes from the self, first and last a very lonely labor, the reason why artists so value canine company in the studio.

credibilia facta sunt nimis: domum tuam domine decet sanctitudo: in longitudine dierū. Gloria patri et · Antiphona · Assumpta ē maria in celum gaudent angeli laudantes benedicūt dominū · Antiphona Maria · Psalmus · Jubilate deo omīs terra: seruite domino in letitia · Introite in cōspectu eius: in exultatiōe · Scitote quoniam dominus ipse est deus: ipse fecit nos: et non ipsi nos ·

Chapter Eight

Down on the Farm

Dürer's understanding of the rustic world was a deep and natural one. His *Family Journal* recalled that his family was descended from a long line of Hungarian horse and cattle breeders, before his grandfather left the farm for the city. A paternal uncle was a saddler, and several of Dürer's designs were for fancy trappings. Though most of his work was meant for a prosperous or citified audience, one of its many strengths was a strong sense of what farm life was all about, the sound and smell of the barnyard, the heavy, egg-filled market basket, the hungry ox in the fields, the crate of squawking chickens.

A century before the artist was born, hundreds of thousands had died in the Black Death, the plague that almost destroyed western Europe. But by 1500 the cities were prospering once again, and it paid the farmer to grow his crops and flocks, bringing produce to the marketplace, where eager city folk bought all he could sell. After thousands of years of dumb toil, agronomy became a popular science. In the year of Dürer's birth, 1471, the first edition of a great guide to agriculture was printed in Augsburg. Like so many of the publications made possible by recently invented movable type, the text was in Latin and far from new. Written by a thirteenth-century Italian scholar and Dominican jurist, Pietro de Crescenzi, the *Liber ruralium commodorum* was a "farm-it-yourself" encyclopedia. Crescenzi's guide was soon printed in many languages and editions, bought by the same readers who would soon purchase Dürer's prints. (Its rarity today reflects the book's great utility in the past; few copies were left intact.)

For city dwellers, the farm provided not only their food but also the rustic themes that decorated their possessions. Schongauer engraved an early masterpiece of rustic realism, his *Peasant Family Going to Market* [8.1]. The farmer's barefoot wife, astride a starved horse, slings a brace of scrawny chickens around the nag's neck. Their plump little son hangs on to his mother's belt for dear life. Leading the horse, the farmer has a sack of vegetables over one shoulder, an egg basket under his arm, and a stout sword to keep robbers at bay. (Dürer's design for a table fountain [1.20] showed such thieves preying upon a ragged, marketbound peasant couple near a well at the right.)

Prints of farm animals such as Schongauer's *Family of Pigs* [8.2] were really made for adaptation, to be kept in a craftsman's notebook or drawer. Engraved, the pigs prolifer-

ated, to be seen again and again in the decorative arts of Dürer's time, on silver beakers or inlaid tables. Draftsmen enjoyed using these greedy pigs to poke sly and skillful fun at their patrons' ways and means.

Everyday farm life was shown in Italy as well as the North. By far the finest of all the frank, almost journalistic insights into the lives of animals herded into enforced community are those of Leonardo da Vinci. His mother was a peasant, and he spent his early years in the Florentine countryside. But there is a big difference between the best of the closely observed works by Leonardo and Dürer's. When Leonardo came to painting, his fresh perceptions, such as his drawing of farm animals

8.1

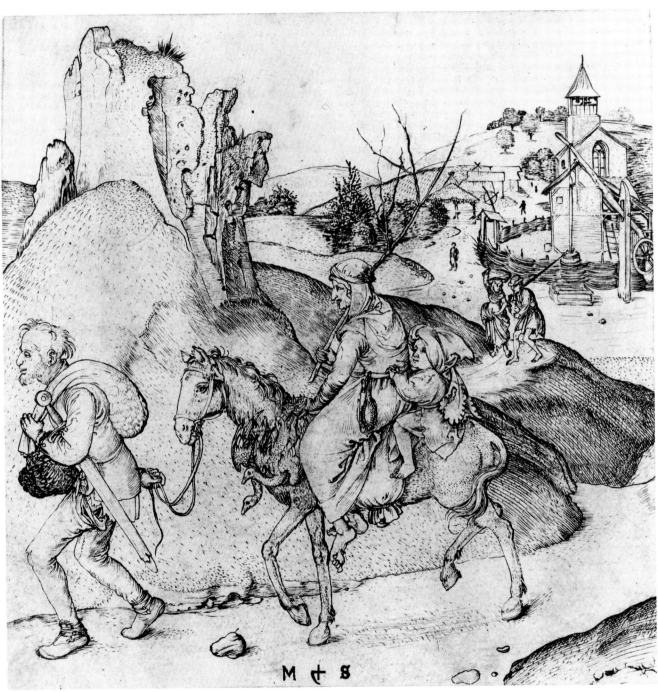

[8.3], were often pushed into the background, becoming little more than telling footnotes. Dürer's prints—not limited to the often snobbish taste of a patron's self-serving needs or the formality of a work in the church's service—allowed him far greater commercial and creative freedom. If his engraved *The Prodigal Son* [8.4] had been painted, it would never have appeared on an altar or in the dining or living room of the rich collector. No picture could have allowed those compelling pigs such prominent roles and large-scale bad manners. Professional gluttons all, they hog center stage, stuffing without ever fluffing their one line, so tellingly engraved by Dürer's burin, "Pigs is pigs."

Seldom since the days of the Dutch masters or Rosa Bonheur have cows been found serious subjects for painters and sculptors. Jean Dubuffet and Alexander Calder saw Bessie as a creature of sweet ridicule, a walking milk shake, an absurd essay in abundant maternity. But in classical times a beautiful heifer repaid the greatest artists' attention; in antiquity, all animals were considered worthy subjects of artistic record, and Myron's marble cow was agreed to be one of the marvels of his age.

As the creators of this infinite animal variety, the gods often saw fit to cast themselves as a cow or bull or goose, if such transformation helped speed passion's goals. In the Renaissance, Ovid's Latin poems of the gods' metamorphoses became popular and encouraged the artists of northern Italy to make wonderfully lifelike little bronzes of farm life. Dürer's peasants and their flocks could never have been quite so fully or movingly portrayed without this new spirit of rustic realism. He also knew of a poem by Angelo Poliziano (who inspired many Italian artists), which prompted his drawing the *Rape of Europa* [8.36].

At Padua, where professors taught Aristotle's sciences, including zoology, many local artists dealt with the subject of farm life. Studies there by generations of wealthy Nurembergers such as the Pirckheimers helped make

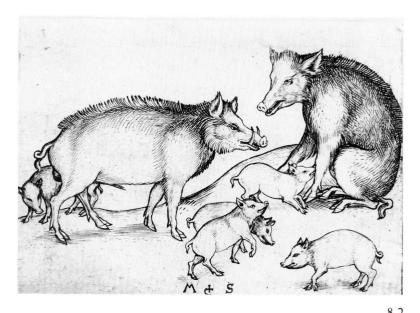
8.2

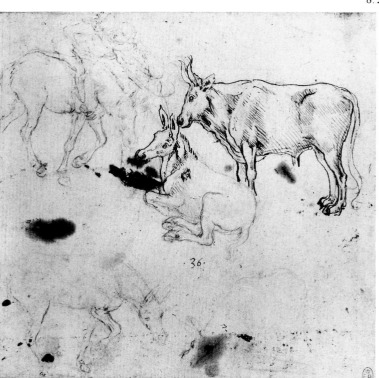
8.3

classical agricultural topics known to their northern artists.

Farm life, for all its rigors, provided a powerful link between Dürer's times and their favorite classical reading—Virgil's *Georgics*. Celtes's crowded desk top includes these noble verses among his clutter of books. The Latin poet's lines are a celebration of the world of

188 Dürer's Animals

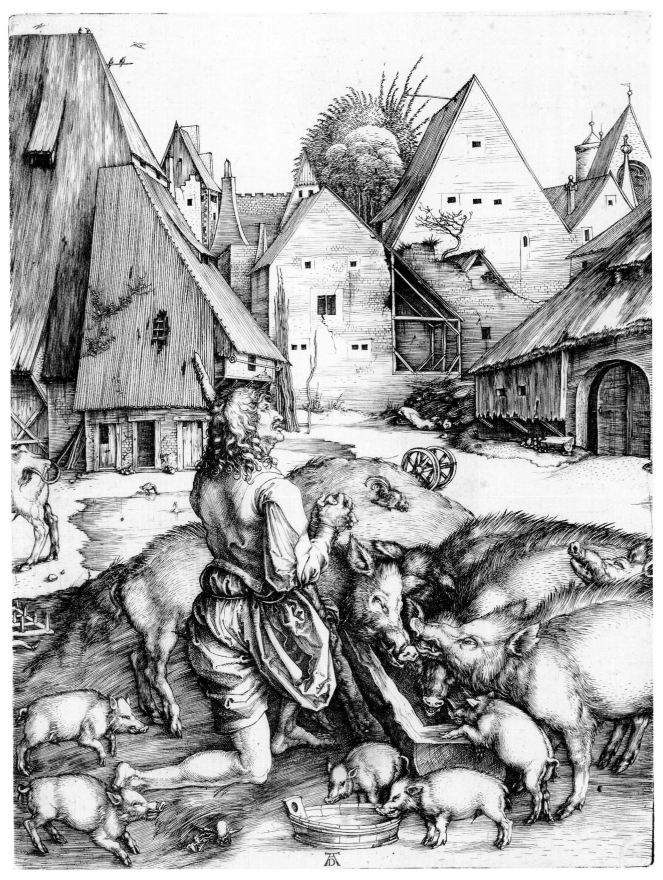

8.4

nature and its cultivation, the straightforward ways of farm and field. Son of a farmer, the Roman writer sang of the simple yet eternal glories of country life. Virgil was always widely read as many of his lines, like those of the Old Testament, were seen as prophecies of Christ's coming.

Dürer's first trip to Venice in 1494 coincided with a rediscovery of rural beauty there. Many newly prosperous Venetians were building country retreats on the mainland, where they played the role of rich, gentlemen farmers. Seen from a safe distance, their peasants looked picturesque, as they tended the cattle, olive trees, and vines. The rediscovered romantic literature of Arcadia, that peaceful Greek region ringed by protective mountains, was now printed for the first time by the presses of the Venetian scholar Aldus Manutius, who persuaded scholars such as Dürer's friend Erasmus to study at his New Academy. Dürer bought Aldus's cheap, small paperbacks in Italy, adding handpainted decorations of piping shepherds to make them worthy of Pirckheimer's splendid library.

Dürer's most detailed farm scene [8.5] was painted for a bridal couple who had little if any interest in country life. It is one of a pair, now lost but known through careful copies, painted on the backs of portraits made to celebrate Willibald Pirckheimer's marriage to another Nuremberg aristocrat, Crescentia Rieter. Her first name, meaning "growth," is the subject of the rustic pictorial message painted on the reverse sides of their likenesses, where Dürer assembled images of dairy maids and shepherds working at their rural labors. He contrasted that domesticated abundance in the upper half of the painting with the wild world of woodland nymphs and satyrs just below, who bear the coats of arms of husband and wife—a bay tree and a siren. These symbols of land and water work well with the picture's subject, Nature's twin fertility, the tamed and free, the local and classical, commemorating the couple's entry into marriage, that honor-

8.5

able estate with its own tame and wild pleasures.

As if Dürer's painted wishes for the newlyweds' fertility had worked too well, Willibald and Crescentia had eight children in almost as many years. Then, tragically, the learned lady died in childbirth, as did the baby—a far cry from that Arcadian world of nymphs and shepherds, piping and singing, envisioned less than a decade earlier.

𐆄

Farm life mirrored the sacred world; it reflected many of the Bible's holiest images and concerns. David was a shepherd, his psalms comparing the ties between man and God to those between the lambs and their shepherd or, to

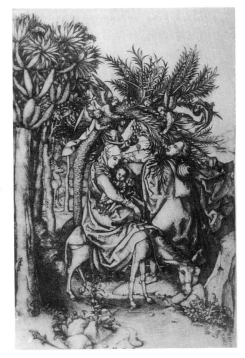

8.6

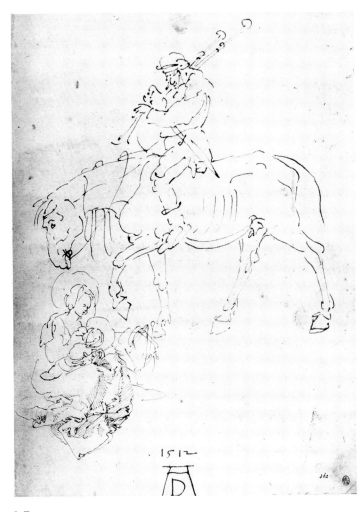

8.7

use the Latin, *pastor*. Christ's parables abound in rustic reference; both the Last Judgment and salvation are seen in terms of farm life—the separation of the sheep from the goats and Jesus' role as Good Shepherd as well as sacrificial lamb. Christ said, "I am the good shepherd. The good shepherd lays down his life for the sheep" (John 10:11). Before the wise kings of the world, shepherds were the first to come to the Nativity, and medieval legend had poor peasants guide the Magi to Bethlehem. So, however much the squalid, ignorant life of rustics might be reviled and ridiculed by city folk, holy writ and image could never let them forget the pastoral life's potential for loving goodness. Dürer presented the Holy Family as peasants, modeling the setting of his woodcut *The Flight into Egypt* [2.16] on Schongauer's engraving of the same subject [8.6]. To show Egypt as a tropical country, he also followed Schongauer by including a large date palm and a dragon's blood tree. Lizards seen below relate to that tree's legend and refer to the Brazen Serpent—the prophecy of the Crucifixion. Centrally placed, the grapevine may also point to Christ's sacrifice.

Remarkable for its freely rendered calligraphic quality is a page that shows a peasant piping as he rides on a scrawny nag [8.7]. Though the Madonna seen below may be a slightly later addition, the sacred theme of the Mother and Child, humbly placed close to the cold ground, is very much in the same spirit as that of the rider.

In *The Golden Legend*, a popular, late medieval retelling of the life of Christ, the writer stresses the Holy Family's saintly poverty. Describing the Nativity, the Dominican reports, "The ox and ass knelt with their mouths above the manger and breathed on the infant as though they possessed reason and knew that the Child was so poorly wrapped he needed to be warmed, in that cold season." Lines like those, in the loving tradition of Saint Francis, show how animals were credited with uncommon as well as common sense, here acting more wisely than Mary herself.

Isaiah's words, "The ox knoweth his owner and the ass his master's crib; but Israel doth not know, my people doth not consider" (Isa. 1:3) were taken as a prophecy of the Nativity. The lines also foretold the division among the prophet's people, between those who did and did not recognize Christ's divinity; in scenes of the Nativity, the ox was often shown looking toward the baby reverently, while the ignorant ass concentrated on the meal before him, with neither eye nor ear for the special presence so close by.

Dürer made this message clear in two Adorations of the Magi. For the 1504 painting [Plate 1], the ass brays derisively, in the only case where that animal is placed nearer the viewer than the ox. For the woodcut of the same subject in his *Life of the Virgin* series, the artist may have read of a pilgrimage to Bethlehem around 1481, many of which described the holy site [8.8].

Shortly before engraving *The Prodigal Son*, Dürer completed a woodcut farm scene, one of his first for Brant's *The Ship of Fools* [8.9]. This illustration, like *The Prodigal Son*, deals with sin and forgiveness and is set in a barnyard where man and beast are seen side by side. Brant's shabby Fool faces a trough where swine and geese swill away. The accompanying poem cautions man not to count on God's condoning a deliberate wrong. True justice consists of mercy as well as punishment, a fact only a fool could misunderstand, or ignore at his peril.

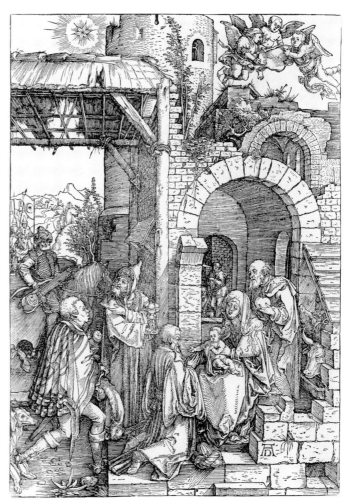

8.8

Who says: No pity God avows
And that no justice He doth house,
Is ignorant as geese and sows.

One of the angry birds eyes the poor Fool quizzically, as though expressing this moral. The Fool's heedlessness in counting on salvation has reduced him to a beast of burden, indicated by the horse collar around his neck; this eloquent detail is Dürer's own. Another sign of the Fool's asinine character is the can hanging around his neck from which

He smears himself with donkey's fat
And has the grease-pot 'neath his hat.

Dürer's woodcut follows Brant's lines faithfully, but it also shows a beauty and com-

192 Dürer's Animals

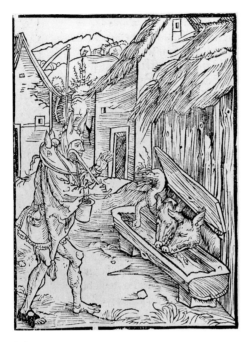

8.9

8.10

passion not found in the nagging verses. The Fool's wretched clothing makes him more tragic than comic. The animals, their trough and shed, the house and landscape, all so beautifully recorded, provide a scene more loving than disapproving.

While in Basel working on *The Ship of Fools*, the artist saw a Latin edition of *The Mirror of Human Salvation* that included an arresting woodcut of the Prodigal Son [8.10]. With a large, awkward peasant's club, the son's left leg is extended in clumsy but intriguing fashion. The same figure in Dürer's print follows this coarsely effective rendering of the despairing young man and the greedy swine. Just after Dürer's time in Basel as a journeyman, Franciscan Lenten sermons on the rare theme of the Prodigal Son were printed there, the accompanying woodcuts prepared by a designer who had worked with Dürer on *The Ship of Fools*. (Brant wrote another poem to go with these sermons, the *Quadragesimale de filio prodigale* of 1495.)

To these models Dürer brought new technical refinements, learned from Schongauer's engravings, such as his insouciant *Family of Pigs*, and a monumental approach to form that came from Italian prints. Now Dürer controlled the resources to produce his own early yet definitive masterpiece of man and beast—*The Prodigal Son*.

Only one or two years may separate the artist's woodcut of Brant's Fool tending grasshoppers [5.43] from his engraved personification of remorse and divine forgiveness, the son among the swine, but a lifetime of experience in art and emotion lies between these prints. Was it Dürer's sudden exposure to the tragic

authority of Renaissance art that made the difference? Or did some personal pilgrimage carry him from the vivid wit of *The Ship of Fools* to the Prodigal's ultimate, redeeming insight? The son's homesickness and despair, his yearning and humiliation, must have come very close to Dürer's feelings.

The sense of impending doom on Judgment Day, which so many people felt as the year 1500 approached, called for setting one's house in order and for hoping and trusting in divine forgiveness; this is the theme of Christ's parable of the Prodigal Son. Never before Dürer's engraving had his suffering been treated with such care. King James's Protestant version of the Bible stresses "the Prodigal," the parable's extravagant, wasteful son, but in German, he is more compassionately called the "lost son." Neither translation describes the son's kneeling when he reflects, "How many hired servants of my father's have bread enough and to spare, and I perish here with hunger." But Dürer understood this critical moment as one of prayer as the son, kneeling awkwardly near the trough of the uncaring swine, twists his hands in agonized appeal. The humble placement of Dürer's still-medieval monogram, below the interlocked fingers and just under a bucket of water or swill, may express the engraver's own penitential feelings. He sets the scene in a local barnyard, the Himpelshof, surprisingly near Nuremberg's center. Only the architecture reveals that the son is searching for his Heavenly Father as he looks away from the pigs to face a small chapel tucked away at the upper right. Unlike Brant's insolent Fool, who counts on God's forgiveness, the barefoot Prodigal begs for it, placed, Joblike, near a dung hill where a rooster pecks grain from manure. The son's useless, opulent garb is looped up and around his waist, out of the muck. Crouching at the lower left, a piglet is about to spring forward, to kick or devour a fresh turnip. The thickly bristled brown or black pigs at the trough are close kin to rampaging wild boars. Typical of this atypical print is Dürer's audacity, shown by the way the ox walks right out of the picture at the left, leaving only his rear behind.

Not only did the artist incorporate many earlier studies of animals into this engraving, but he probably also prepared a series of views of the Himpelshof. Happily, one major preliminary drawing survives [8.11]. Here the son is farther from the trough, so the club does not rest against it. Perhaps the ox moved away while Dürer was making another study, leading to the engraving's remarkably contemporary, cropped look. He added the pig at the left, running to the trough, drawing it over the harrow that was there in the first place.

Difference and indifference, penitence and gluttony, the son and the swine are side by side, one taking no more room than the other in the mind or on the page. As the son, the beasts, and their setting are without precedence over one another, so too is this a work without precedent, a unique affirmation of

8.11

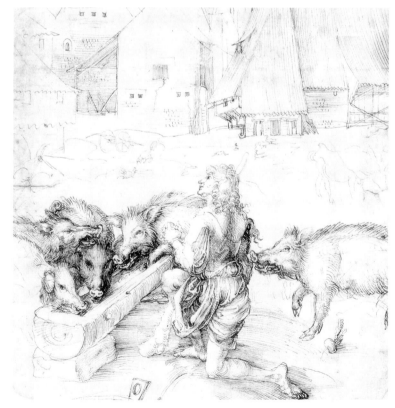

8.12

lovable folk. Later in his oeuvre, they become coarse, gross, and ever less comprehending—with heavy, slack jaws and dull, glazed looks gladdened only by greed or lust. Living with and caring for animals has made the peasants bestial. One farmer, looking slightly brain damaged, stands weirdly knock-kneed, a stance stressed by the stone below incised with the artist's monogram [8.13]. He seems scarcely able to hold out a hand to his prematurely aged wife. She, though heavily burdened, is clearly in command of her wits and resources—poultry in hand, an egg basket and cream jug at her feet.

faith and realism—man and beast defined by one another. Dürer's print never lost its impact and was used by the greatest painters of the High Renaissance, Raphael and Titian, as a model for animal studies. *The Prodigal Son* is centuries ahead of itself, a prophecy of paintings to come by Rubens, Constable, Courbet, Millet, and Puvis de Chavannes.

The Prodigal's humanity was a recurrent theme in Rembrandt's art; he presented it in prints, drawings, and a painting. His images show familiarity with Dürer's engraving, a print he may well have possessed and, even more, with its preparatory drawing, which is surprisingly close to one of Rembrandt's own compositions [8.12]. For both masters, the parable of the Prodigal Son inspired the most powerful art, conveying as it does the strongest sense of such essentials as salvation, parental love, and eternal forgiveness. Man's fate hangs in the balance between the dumb animal and divine compassion, all three the work of God.

8.13

Of the many creatures in Dürer's later barns and fields, peasants are shown with the least sympathy and understanding. Only in his early works or where farmers stood for figures from the Bible or classical literature are they presented as humble and simple if not always

Dürer almost denies rustics their humanity as they stomp around in dismal folk dances or carry hoes or flower pots. Such poor peasants certainly were not buying his works, so he had little to lose by these mean-spirited prints. But why did the artist change from the gentle images of his youth to these cruel cartoons?

195 Down on the Farm

8.14

Happier farmfolk dance in the borders of Maximilian's *Hours* drawn in 1515 [8.14]. Such merrymaking may reflect the lines of the Ninety-third and One-hundredth Psalms quoted on the same sheet, "Make a joyful noise unto the Lord, all ye lands. Serve the Lord with gladness: come before his presence with singing." On another page [8.15], a peasant woman on her way to market holds a wheel of cheese and carries a basket of eggs. She stands upon a pomegranate with glistening, jewellike seeds. This was a device of Maximilian's, who was fond of comparing his homely self to the luscious fruit—tough and ugly on the outside but beautiful within.

The mean, hard life led by most peasants in sixteenth-century Germany was understood by others, especially urbanites, to be their just deserts, brought on by ignorant, shiftless ways. This vicious circle, a self-fulfilling prophecy, was seen in all the farmer's actions, and Dürer's art was not immune to this smug cruelty. Mocking the peasant's pretensions, Brant made sure to include them in *The Ship of Fools*. In his poem, "Of Great Boasting," his farmer "hero" had fled from the battlefield:

Shield and helmet he bore away
to prove he was of knightly clay.
A hawk is like a heron dressed,
And on the helmet eggs in nest,
And on the nest a moulting cock,
he is brooding out the little flock.

Brant uses all these ridiculous, confused heraldic devices to make fun of the peasant's claims to chivalrous distinction:

His coat-of-arms a peasant draws
with decorative lion's paws,
A helmet crowned on gold shield
and he's a knight of Bennefield.

Grand through "Bennefield" may sound, *benne* is merely old German for a farm wagon. The peasant shall never escape his humble origins if Brant can help it. The lion's paws and the peasant's cart are seen as the greatest extremes—the beast of kings with the lowliest carriage. The peasant-knight's helmet is a brooder for newborn chicks, crested not with some magnificently intimidating bird of prey but a molting cock. Dürer drew several satirical coats of arms, close to Brant's biting lines, such as the one with a drowsy rustic below a great bird [12.10].

One of Dürer's fountain designs has a seated farmer grabbing his goose with one arm, holding onto the branch of a tree with

8.15

the other [8.16]. Shabbily dressed, this grubby peasant personifies the benign neglect accorded him by Nuremberg cityfolk and landed gentry alike. Wine squirts from the goose's beak and from the tree stump as the farmer

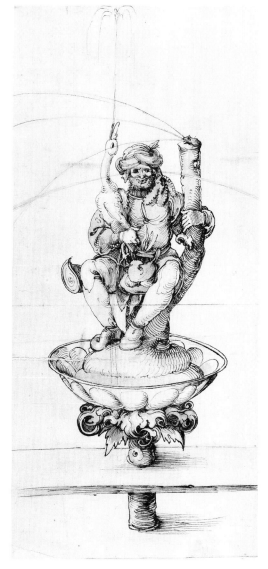

8.17 8.16

grins, oblivious to the sprays that douse his ragged clothing from every side. For all his rags and tatters, a fat purse rests between the peasant's patched and bare knees. That swollen purse voices a familiar complaint about peasants, their greed.

About a decade later, Dürer's studio carved his design of a gardener embracing a great potted vine as a dragonfly buzzes on the left and a chattering jay is about to peck at the fruit [8.17]. He seems like a gnarled outgrowth of the vines, which dwarf him as they grow from his body, recalling the Tree of Jesse.

Maximilian's *Triumphal Arch* shows villages burned down and the country squires of Gelders beheaded in the background, while the emperor's soldiers seize the fleeing livestock from peasants escaping the flames [8.18]. Unashamed to show such plunder and arson, Maximilian saw to it that Dürer and his assisting artists include this vengeful scene as a warning to all future enemies.

Tension and skirmishes between farmers, local governments, and large landowners had long marked German life. By the 1520s a new level of hatred was reached that came close to civil war. In one of the odder couplings of all time, the peasants teamed up with the knights, their oldest enemies and social superiors. But both were rooted to the land, to a way of living outside the new worlds of trade with the East and West Indies. Suddenly peasant and knight could find no one to support them but each other. Burdened by oppressive taxation and local legislation, both were robbed of former royal protection. Townfolk and the larger landholders ganged up on the peasantry just when they faced their worst troubles, forcing them to divide and subdivide their lands to pay their debts. Finally farmers could not even support their own needs, let alone raise enough produce to take to market. So, side by side, peasant and knight fought for their threatened way of life.

Under these circumstances, countryfolk took comfort in the fact that it was a miner's son, the rebellious Martin Luther, who became the spiritual and national leader of the new Germany. Knights and peasants alike expected the former monk to be on their side, for he had listed so many of the causes of their discontent with such admirable understanding in his *Nobility of the German Nation*.

But by 1525, Luther had married and wanted only to settle down to a comfortable world of peace and quiet, to an orderly Germany. In a modest way, he had become a country squire himself, supported by the great managerial gifts of his bride, the former nun Katharina von Bora. A perfect country wife, she kept the Luther family finances afloat by ably managing a guesthouse, keeping a houseful of lodgers happy with her excellent cooking, skillfully supervising a well-stocked fish pond, a thriving piggery, an abundant poultry yard, and no doubt some beehives to boot. The last thing Luther wanted was to see his countrymen at war with each other. Horrified when the peasants' leader urged the armed farmers not to "let the blood cool on their swords" in fighting for their rights, he retaliated with a savage pamphlet, *Against the Murdering, Thieving Gangs of Peasants*. Right-thinking Germans were urged "to strike down, choke and stab the farmers openly or in secret." Luther's slashing pen rallied the peasantry's princely, conservative opponents and lead to the farmers' remarkably cruel defeat. Against this violent background, Dürer created that strangest of satirical trophies, *Peasants' Defeat* [8.19]. The woodblock was cut in 1525, at the time of the farmers' downfall. Like so many of the print projects made earlier for Maximilian, this mock monument was never meant to go beyond paper. In the form of a triumphal Roman column, the print shows a dirt-poor figure of rustic dejection as chief captive among the victor's spoils. Head on hand, this human trophy sits at the top, resting on an overturned pot. His melancholy pose recalls the figure of Christ, as Dürer had shown him in the role of the Man of Sorrows [3.63], suffering for the world's sins, but the peasant is pierced not with a thorn but by a great sword thrust in his back. The crate of chickens just below him may point to betrayal, recalling the cock on the column during Peter's denial of Christ.

Once read as a cruel mockery of the peasants' dismal defeat, the woodcut more recently

8.18

has been interpreted as a sympathetic portrayal, stressing the defenselessness of the rustic victim, whose only weapons were those of his good works on the farm. As usual, the truth probably lies in between. Dürer certainly delineates the peasant as victim but also as fool, who, armed only with a pitchfork, should have known better than to take on a swordsman. For his folly the farmer has lost everything, including his life. Trussed swine, sheep, and cattle lie like sacrificial beasts on the platform far below, with baskets of cheese and eggs above. A hope chest, ironically inscribed "In the Year of Our Lord 1525," provides the base, with an upside-down milk pan above, supporting a smaller bowl and a great wooden jug or churn. Resting on the jug is another, with two handles, the sort peasants took to the fields at haying time or used for milk. This is below a fat sheaf of wheat surrounded by shovel, hoe, scythe, and pitchfork. No longer the Theocritean idyll of shepherds piping and harping in Arcadian shade, or a rustic Prodigal Son seized in a moment of poignant revelation, the peasants in this and Dürer's later works are defeated from without and within, twice lost.

8.19

Ass and Donkey

The ass was frequently drawn by young Dürer because it was a major character in Brant's *The Ship of Fools*. A fool shown with an ass jumping on his back [8.20] makes Brant's view of mankind burdened by folly abundantly clear. To prove Brant's point that only fools believe in luck over Christian faith, Dürer shows a fool—the ass—and two half-asses tied to Fortune's Wheel, which rotates at dizzying speed, turned by the hand of Fate [8.21]. The ass, riding high, grabs the golden ring as the half-asses satirize the classical idea of the centaur.

Ridden by a skeletal figure of Death, another ass is shod by a fool who lives in the false hope of becoming an heir [8.22]. As is true for so many of the woodcuts the twenty-one-year-old Dürer designed for *The Ship of Fools*, this one is more important for where it is headed than for what is shows. Here Dürer took his first steps toward that marvelous messenger of mortality—the Pale Horse of *The Apocalypse* [9.22]. In a graphic commentary rather like that of the placement of the horse for "Old Woman with Young Man" [8.23], the ass is seen from behind in Dürer's woodcut for the verse describing an old woman buying a young man.

The detailed rendering of ox and ass bearing the Holy Family to safety in the woodcut Flight into Egypt recalls the attention paid to farm animals in *The Prodigal Son* and Brant's book. This is one of nine large prints dedicated to the life of Mary. With this Flight he took up, once again, the theme of the second of the Virgin's Seven Sorrows, painted for the elector of Saxony a few years before [Plate 26]. In that panel, placed near the feet of the Madonna standing in the large vertical central panel, the

8.20

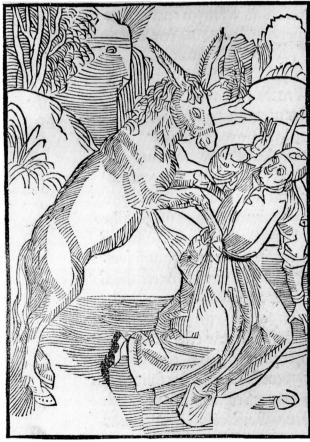

8.21

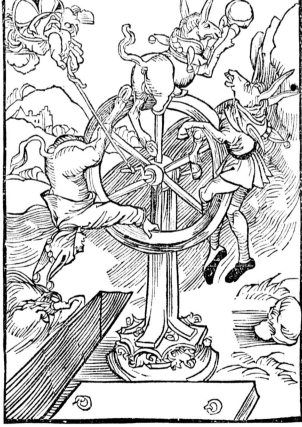

humble ass, agent of the Holy Family's escape from the Massacre of the Innocents, takes up almost half the composition. Dürer contrasts the shaggy beast with the wild unicorn hiding in the woods at the upper left, symbol of Christ's power.

Jesus rides an ass in the scene of his entry into Jerusalem from the woodcut Passion [8.24]: Just as that beast helped the Holy Infant flee to safety, it now bears Christ toward the end of his brief life. The Entry was celebrated in German Easter services as a mystery play: A young man riding a wooden ass set on wheels was pulled down the church aisle as part of the Palm Sunday observance. Dürer may have designed such life-sized "pull toys," which were an important part of popular devotion. Suitably, when it came to providing a drawing for the Egyptian hieroglyph symbolizing "A Stranger" [8.25]—an ass's head—Dürer went back to the animals he had drawn for the Entry into Jerusalem and the Flight into Egypt.

In Maximilian's *Book of Hours* [8.26], Dürer combines the two themes, the Flight into Egypt and the Entry into Jerusalem, but now depicting Christ on a donkey. Wearing priest-like attire, the Infant is already invested with the regal attributes of the King of Heaven; a crossed orb signifies his Crucifixion for the world's salvation. A naked cherub casts his robe before the sacred rider—a gesture recalling how the faithful of Jerusalem greeted Christ in tribute to his royalty and divinity. In this seemingly lighthearted vignette, the patient little donkey trots through some thirty years, from a first ride to safety to a last ride of sacrifice.

8.22

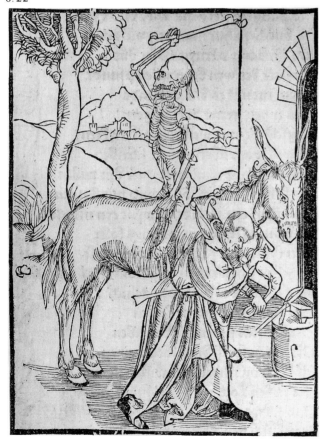

8.23

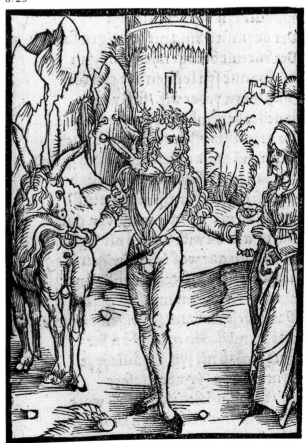

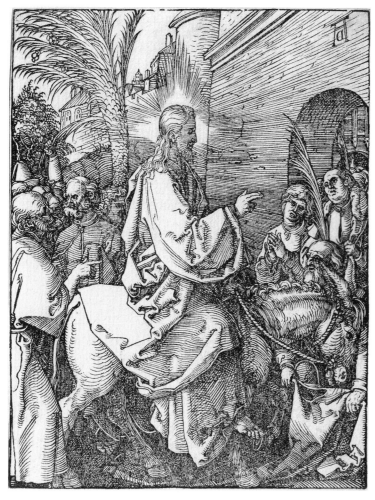

8.24

8.25

8.26

Buffalo

An angry-looking beast, crossing a meadow as a butterfly and red star fly overhead, has been variously identified as a bison, wisent, wild ox, and several other creatures [8.27]. But his handlebarlike horns suggest that this animal is a domesticated European buffalo. Dürer listed two buffalo horns and a ring of the same material among his many purchases in Brussels in 1520. When he went to Antwerp on the same journey, he designed woodcut arms for the wealthy Roggendorf brothers [6.27], where two great perforated buffalo horns rise from a crowned helmet; splendid peacock feathers spring from all twelve holes. (Pirckheimer was not forgotten on this journey: Dürer saw to it that his learned friend was sent "a costly inkstand of buffalo horn," buying himself a much cheaper horn on his way home, in Aachen.)

Cat and Mouse

Useful as mousers rather than loved as pets, cats were decidedly unpopular in Dürer's time. Black cats were linked to witchcraft and often had their tails cut off to prevent their use in witches' sabbaths. Villagers hung cats over fires on the Eve of Saint John the Baptist to protect themselves and their farm animals from disease. Girls would sends cats to unwelcome suitors as a sign of discouragement. Popular belief held that if a cat died a natural death, someone living in the same house was sure to die soon, and a cat seen at the beginning of a journey meant a bad trip. Because birds were popular pets, beloved for their welcome song, cats were belled to warn their winged prey of the enemy's approach.

Despite their poor reputation, Albertus Magnus had a passion for cats that was as great as his knowledge. He wrote that they were discreet, even crediting them with being lovers of beauty. He most admired grey ones, who resembled ice in a heavy frost, and remarked that

cats are close to the king of beasts, their teeth and claws being distinctly leonine. Baldung Grien, working with Dürer on Maximilian's *Hours*, had a similar text in mind when he showed lions and cats together.

Dürer's only detailed rendering of a feline is placed at the foot of the tree of knowledge, taking up the center foreground of his *Adam and Eve* of 1504 [2.18; 8.28]. Though dozing, this beautifully furred beast seems aware of the mouse's presence to the left [8.29]. The cat may be included in this scene as a representative of the cruel, choleric humor, which like the other temperaments is thrown into fatal imbalance after the Fall. Once the harmony of paradise is shattered, the cat will pounce upon its prey. Mice were symbols of death, disease, and decay. Their furtive ways and sharp teeth suggest the sneaky passage of time and its constant if scarcely visible wear and tear, what Germans call "the tooth of time." Lowest of the low, the mouse is seen in dramatic contrast with Adam's parrot. The mouse is a messenger of mortality, whereas the bird imitates the Word of God as attribute and prophet of the Virgin. Dürer placed the mouse where it might be crushed underfoot should Adam move toward Eve.

Luther discussed the creation of mice and flies in quite a different tone in his *Commentary on Genesis*. Wondering how and why the Lord came to produce such unpopular creatures, the art-loving Reformer concluded that the mouse "has a very beautiful form—such pretty feet and such delicate hair that it is clear that it was created by the Word of God with a definite plan in view. Therefore here, too, we admire God's creation and workmanship. The same may be said about flies."

Dürer's other depiction of the mouse was for Horus Apollo's *Hieroglyphica* [8.30], according to which the Egyptians, "to denote disappearance, drew a mouse, since it eats all things, defiles them, and renders them useless. And they use the same sign when they wish to indicate discrimination. For if many pieces of bread are lying about, the mouse selects and eats the purest of them. Wherefore the judgment of the baker lies in the mouse."

8.27

8.28

8.29

8.30

Cattle

The artist's first known sketch of an ox [8.31] shows a young animal grazing on invisible grasses, bony haunches rising above a twisted tail, each rib sticking out. Drawn in pen and black ink in the early 1490s, possibly during his journeyman years (date and monogram were added later by an unknown collector), this lively study was kept close at hand throughout Dürer's career. He consulted it for *The Prodigal Son*'s beast in the barnyard and again for the rustic scene on the backs of the Pirckheimer marriage portraits. A similar bul-

lock is found in the meadows of *Our Lady of the Animals* [2.10; 8.32]. Close scrutiny of the outlines reveals that Dürer changed the placement of hind legs, back, horns, and muzzle, following his model's changing stance. At one point the mouth was open, but then the artist or, more likely, the ox decided to close it. Almost sculptural in form, the sense of weight and mass that this drawing conveys is partly due to marvelously adroit hatching. Such finely worked lines are the common property of sculptor and engraver alike, to be found in similar form but on very dissimilar objects in the drawings of Dürer's contemporary, Michelangelo. The Florentine was an admirer of the Nuremberger's art.

8.31

8.32

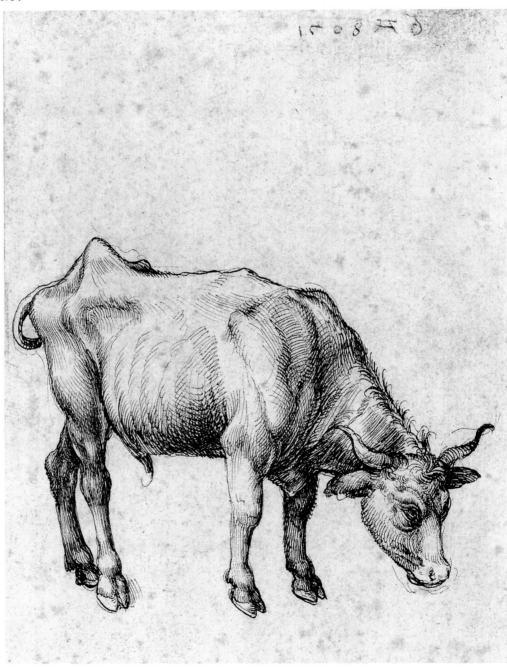

The ox was a symbol of the divine labors and patience of the Evangelist Luke, who was especially dear to artists as their guild's patron saint. That the Evangelists were shown in animal form stems from a vision of Ezekiel, so seen again by Saint John in the Apocalypse when he ascends to heaven and finds Luke's ox to the upper right of Lord as Lamb [8.33].

Dürer's earliest print of a bull is a woodcut illustrating the poem "Of Sensual Pleasure" in *The Ship of Fools* [8.34], where a fool twists an ox and a ram by the tail. The accompanying lines are adapted from Proverbs, where the man goes after the harlot "as an ox goeth to the slaughter, or as a fool to the correction of the stocks." For another of Brant's verses, the biblical story of the worship of the golden calf [8.35] illustrates the evils of dancing.

8.33

8.34

8.35

Classical mythology provided other opportunities to depict cattle. Drawn on his first Italian journey of 1494, the *Rape of Europa* [8.36] has Dürer turning not only to such classical subject matter but also to the art of the Renaissance. For all the borrowings from ancient art, this page is still Gothic in its vigorous calligraphy and briskly imaginative landscape setting. Zeus, in the form of a bull, has come to carry his beloved Europa away to Crete. Kneeling on the animal's back like a circus rider, the princess Europa grasps the bull's horn and haunch for support. Her hair and drapery flutter in the breeze as the beast-god gallops into the water for a quick escape, leaving Europa's desperately worried companions on the

8.36

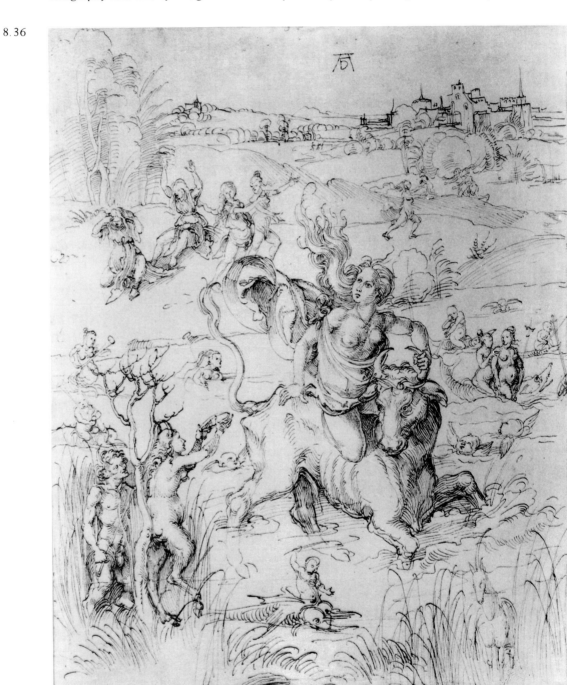

beach. A satyr couple at the left holds out a wreath to Europa, mermaids, cupids, dolphin riders, and other seafolk surround the exultant, prancing bull, like tugboats about a great ocean liner, as they celebrate his triumphal carrying away of his beautiful prize. Strong but stiff, as though combining several beasts from an ancient merry-go-round, part griffon, part lion, bull-Zeus shows Dürer's early artistry as *animalier*. This is the work of a brilliant, exciting young artist concerned more with feeling than with fact. In 1511, Dürer returned to a mythological subject using the same beast. For one of his twelve labors, Hercules overcomes the bull Geryon [8.37]. The vitality found in the young ox is still in evidence for this more formal, circular composition, which joined similarly shaped renderings of the hero's other labors.

So lifelike that it seems to snuffle, low, and drool right on the page, an ox muzzle is the subject of two great studies [8.38; 8.39]. These frontal and profile views are rendered in brush and watercolor using brown, grey, and pink gouache. They date from the period of Dürer's closest scrutiny of nature; his fascination with texture places the ox drawings close in date to the *Hare* [Plate 13] of 1502 and probably belonged with others used for the ox in the *Adam and Eve* of 1504.

8.37

8.38

8.39

8.40

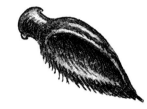

8.41

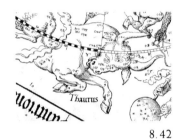

8.42

In illustrating Horus Apollo's *Hieroglyphica*, Dürer drew upon his earlier barnyard studies, producing a bull [8.40] and a bull's ear [8.41], among others. "To show courage with temperance," wrote Horus Apollo, "[Egyptians] draw a bull with his member erect. For this animal is the hottest of all in his genital organ.... When they wish to show a woman who has borne female children first, they draw a bull facing the left. But if she has borne male children, they draw a bull ... facing the right.... To denote hearing, they draw the ear of a bull. For when the female is in heat ... then she lows loudly. Understanding that she is in heat, [the bull] comes running to unite with her."

With the glittering star Aldebaran shining as its eye, the constellation Taurus [8.42] is shown in Dürer's northern sky chart of 1515. The bull's body is partly composed of the seven-starred Pleiades, with a star of the third magnitude—Alcyone—at the center. Often Taurus is identified with the bull that bore Europa to Crete.

In Dürer's time cattle horn was highly prized, as well as meat and hide. When he came to Cologne in 1521, the artist described giving his "great ox horn" to Leonard Groland. This must be the one Dürer bought in Aachen for a gold florin—a high price possibly due to the horn's having been purchased in a handsome mounting. If of a smooth, ivorylike texture, horns were engraved with fine lines that were then filled in with a black pigment, giving a richly decorative effect. Craftsmen adapted cattle horns for use as containers to keep the huntsman's or soldier's powder dry, and they sometimes selected Dürer's prints to provide designs for their embellishment. Fortuna, that magnificently winged woman sailing through the skies in one of Dürer's largest engravings, is carved on one of these powder horns now in the Dresden Treasury, her image meant to bring good luck to the hunter.

Chicken

Dürer's most elaborate rendering of a rooster is in an armorial engraving of about 1500 [8.43]. Here the bird, a symbol of vigilance because he crows at dawn, stands on the mantling atop a helmet. (Almost as large as the rooster, but less arresting, is a lion, shown as if painted on the shield below. Lions were believed to be afraid of roosters.)

Rooster studies prepared for *The Prodigal Son* were probably used for the cock perched on top of the cross among the Signs of the Passion in the woodcut *The Mass of Saint Gregory* of 1511 [8.44].

In Dürer's rare references to folktales, he shows the fox and his favorite victim, the chicken, face to face in the borders of Maximilian's *Hours* or the bird perched above a piping peasant [8.45]. In varying stages of seduction, curiosity, irritation, or indifference, seven cocks and hens are serenaded by a craftily piping fox. His mild, timorous air has deceived the nearest pair, and they come closer. As Dürer so often does, he separates his drama by a stream or dry river bed, a natural barrier that increases the excitement. Will the first step be a flurry of birds' steps or a silent, lethal leap on swiftly padded paws? This cartoonlike scene appears directly below the Lord's Prayer: The suave fox is none other than the devil, leading us, chickens all, into temptation.

Crowing roosters were adapted by Dürer for hunters' whistle designs [8.46]; these would sound close to the belligerent-looking bird's beak, as if he were making the shrill sound all alone. Yellow watercolor additions suggest that the whistles would have been gilded, perhaps by the artist's goldsmith brother, Endres.

Old hens, no longer able to lay eggs, were sold for meat; such birds make their last, sad appearance in *Peasants' Defeat*, kept in a crate, just below the murdered farmer.

207 Down on the Farm

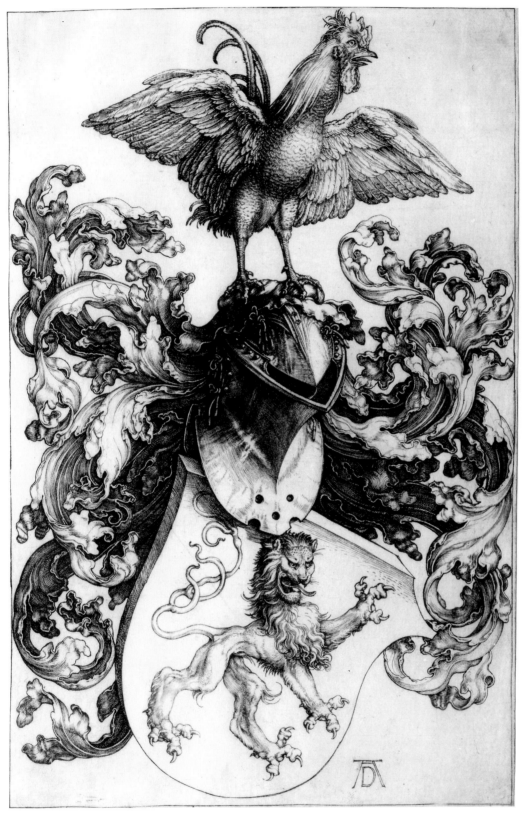

8.43

8.44

8.45

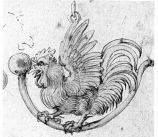

8.46

Geese

Geese have always been popular in Europe, prized for their succulent flesh, soft feathers, large eggs, and fine fat. No prosperous farm was complete without them. Brant used migratory geese in *The Ship of Fools* to satirize fifteenth-century wanderers:

> *Fools often travel very far*
> *Yet never learn just where they are*
> *For every goose when once let loose*
> *Returns and still remains a goose.*

Dürer's unusually beautiful early woodcut [8.47] shows a sense of balance and motion like those found in Dancing Shiva bronzes. He gives this page special animation and variety by showing the geese taking off, nesting on the ground, and perched on the Fool's outstretched hand.

8.47

Goat

Goats and sheep often graze together in Dürer's biblical and classical scenes. Feisty and evil smelling, goats in Christian symbolism stood for those of the flock that went to Hell. Their docile fellow grazers, the sheep, were Heaven bound.

The artist's first major study of a goat is found in an engraving made around 1500 [8.48]. The beast leaps through the air, a naked witch on his back, as four cherubs cavort in the foreground. Holding a distaff and spindle, the witch is clearly up to no good as she rides backward, grasping her mount's horn with her other arm.

Seen by themselves, goats tended to represent obstinacy and/or virility. According to Horus Apollo, the hieroglyph for the sexual organ of a fecund man was a goat, not a bull; Dürer drew a ramlike animal for this beast [8.49], both of these copied after his lost drawings. An original page for the same project shows a goat trotting to the left [8.50].

The goat also signifies sharpness of hearing. The Egyptians, "when they desire to represent a man of sharp hearing, draw a goat. For the goat breathes through its nostrils and ears." On Maximilian's *Triumphal Arch*, alert goats face one another in a "positive" and "negative" repeat of white on black and black on white, a labor-saving reversal [8.51; 8.52]. Dürer also placed them on columns as pagan idols [8.53]. And in the *Celestial Map: The Southern Celestial Hemisphere* of 1515 a goat forms the constellation of Capricorn [8.54] and another little one is perched on Erichthonius's shoulder.

8.49

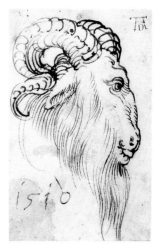

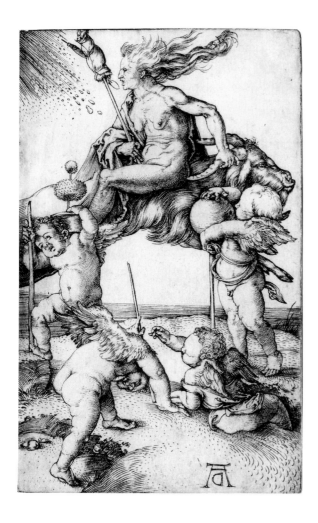

8.48

8.50

Pig

Dürer's first known design of a pig, very like the one to the right in the preparatory drawing for *The Prodigal Son*, was made for *The Ship of Fools* [8.55]. This is an insouciant swine, wearing her crown with a jaunty grin and an upturned tail, one foreleg raised in greeting as the Fool approaches. The pig's crown means the triumph of filthy speech, of dirty jokes:

> Sir Decency is doubtless dead,
> Fool holds the sow's ear, wags her head,
> And makes the sow-bell loudly ring
> So that the sow her ditty sing.

More than a quarter of *The Prodigal Son*'s space belongs to the pigs.

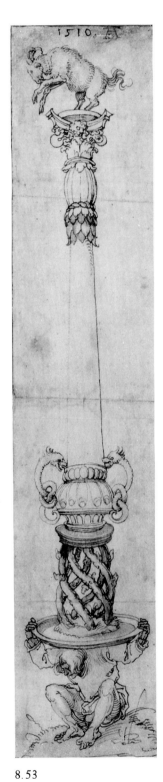

8.53

8.51

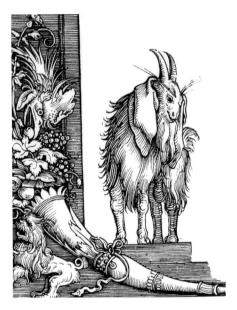

8.52

8.54

8.55

The artist returned to the belled pig as a symbol of obscenity and included it in a scene of witchcraft and demonology, where a happy pig witnesses a couple caught in the lusty embrace of the devil [8.56]. Another page includes a very small pig-headed flying devil [8.57] who tempts priests and nuns gathered at mass [12.8].

8.56

8.57

Sheep (and Their Shepherds)

Shepherds, the first to learn of Christ's birth, adore Jesus before the Magi get to Bethlehem and are placed in the background of the three pages showing *Our Lady of the Animals* [8.58; 8.59] and in the Nativity of the Paumgartner Altar [Plate 27]. Such scenes of heavenly messages sent to the hilltops, among cavorting rams and goats, silently nibbling lambs, and a dog or two, bring together much that is best in Dürer's art: closely watched, wisely drawn, informed and informing, with an eye for all that is and is not understood between angel and mortal. Less visionary than observer, Dürer understands the shepherd's charge.

Loving care for his flock made the good shepherd of both Old and New Testaments the perfect description of God's role. Saint Jerome summarizes all key biblical references to sheep in his eighty-ninth homily. "Let us bring to the Lord the children of God, let us bring to the Lord the offspring of rams. . . . let us imitate our Savior who is Himself called Shepherd and Ram and Lamb," says Jerome, "who was immolated for us in Egypt, who was caught by the horns in the bush for the sake of Isaac; and let us say, 'The Lord is my Shepherd; I shall not want, in verdant pastures he gives me repose; beside restful waters he leads me' to whom are given glory and dominion forever."

In a sense Dürer was the offspring of a ram; it was the emblem of his mother's family, the Holpers of Nuremberg. When he painted his parents' portraits he placed their coats of arms on the back of each; the maternal Holper ram can be seen on Barbara Dürer's shield [8.60], horns and hooves ready for defensive if not hostile action. The artist's wife was named after Saint Agnes—*agnus*, Latin for "lamb"—whose feast day was celebrated by blessing lambs and weaving sacred vestments from their shearing. She is shown with her lamb in an altar project of 1522 [10.51]; the Baptist holds his sheep at the upper left. Margaret, with her walruslike dragon, is just to the left of Agnes.

8.58

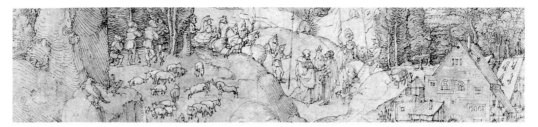

8.59

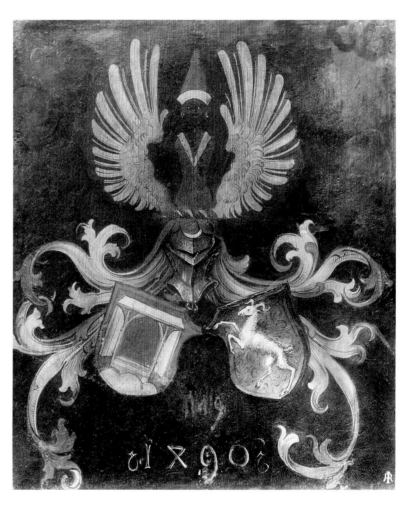

8.60

Blessed though the meek may be, the lamb takes on a different mien in Saint John's turbulent text. Sacrificial yet victorious, weak but strong, the Lamb of God as described with such force in the Apocalypse was to become a central image of Christian art and faith. But not until Dürer's woodcut of this woolly creature of divine contradictions did all the puzzlement of John's impassioned, mystical zoology ever blend into a completely convincing representation of that sacred hybrid.

Completed in 1510, Dürer's woodcut *Life of the Virgin* series appealed to a new documentary interest in Mary's biography and that of her parents, Joachim and Anna, and again the lamb is significant. Basing many of his early scenes on the apocryphal gospel of Saint James, Dürer chose subjects in the life of Joachim and Anna that paralleled events in the lives of Mary and Joseph. Joachim, because of his barren marriage, has his offering of a sacrificial lamb rejected [8.61]; Anna wrings her

8.61

8.62

8.63

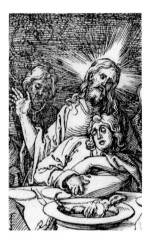

8.64

hands in sorrow, seeing her husband's humiliation; a lamb held by the man to the left is accepted for sacrifice, as the donor has his son stand proudly at the altar.

In the next scene, Joachim learns from an angel that he is to become the Virgin's father [8.62]. Sheep and goats abound in the background as birds dive downward, sharing the heavenly messenger's dramatic flight. Joachim is provided with a heavily sealed document "proving" its divine source. A herder just below, bagpipes over his shoulder, raises his arms in terror and amazement. All nature—air, water, birds, trees, and animals—share in this mystery, the sudden revelation of the Virgin's birth. Sheep and their guard dogs, symbols of sacrifice and faith, by their presence suggest the saving of the world.

In Dürer's *Christ Expelling the Moneylenders from the Temple* [8.63], one of the money changers grabs his fattest lamb on the run as he flees from an irate Christ. Next to be sacrificed will be Christ himself. This is made clear in the following scene of the Last Supper, when Christ tells his disciples that one of them will betray him. Only Judas and the viewer know who that will be, as his bag of thirty pieces of silver is invisible to the rest [8.64]. At the center of the round Passover table is the paschal lamb, its bare bones the sign of Christ's suffering to come. And in the woodcut *The Glorification of the Virgin* [2.7], John the Baptist holds his attribute, the lamb, in one hand and the victorious banner cross in the other: Both refer to Christ, first as sacrificially self-offered and then triumphantly resurrected.

Dürer's final *Last Supper*, a woodcut of 1523, is lambless. Now, under the new view of Luther, communion rather than betrayal and sacrifice is the subject's chief concern. By stressing the wine-filled chalice and the bread nearby, Dürer takes his cues from the Reformer, who wanted the Mass to be understood as a testament and sacrament. The body of the lamb on the table was too poignant a reminder of Christ's sacrifice to come; Luther played down this clue so that the Last Supper would be read not as the sacrifice itself, but rather as the initiation of an enduring ceremony.

In *Peasants' Defeat*, the artist returns to the symbols of the sacrificial lamb. Two pairs of trussed sheep, those gentlest of animals, are placed at the center of the base supporting their slain master. Though meant ironically, as the spoils of war and of the victor's conquests, Dürer knew well how closely these defenseless animals were linked to peace. Just as effectively as the sword thrust in their farmer's back, the sheep's fate brings home the cruelty of his own.

Isaiah's lines about the lamb, seen as a prophecy of Christ's coming and suffering, were selected as the legend inscribed below in *Christ Carrying the Cross* (ex Cook Collection), his last religious painting or that of his studio: "He was oppressed, and he was afflicted, yet he opened not his mouth: he is brought as a lamb to the slaughter, and as a sheep before her shearers is dumb, so he openeth not his mouth" (Isa. 53:7). Just as Isaiah describes the source of salvation as lamblike, so are the sinners, "All we like sheep have gone astray; we have turned every one to his own way."

Mythology and fifteenth-century commerce included further references to sheep. Europe's wealth was largely founded on the wool trade—raising, shearing, spinning, dying, weaving, and processing woolen cloths of various qualities. The Lowlands, belonging to Burgundy, played a key part in this valuable trade, and there, the Order of the Golden Fleece, a fancy and exclusive club, was founded by its dukes in a shrewd merger of commerce and chivalry. The order's fleece looms large in Maximilian's portraits and on his *Arch* [8.65]. Flames and *putti*, children of Venus, at the top and the sides celebrate Maximilian's worthy deeds as the fleece is guarded from below by the great dragon from whose ferocious care it will be stolen by Jason. Sheep above and dragon below suited Maximilian's heraldic ancestry: His in-laws founded the Order of the Golden Fleece, his forefathers that of the Dragon.

In late Greek times, Aries the ram was designated the first sign of the zodiac. Egyptian astrologers also came to give Aries first place because he resembled their ram-headed god Amon, whom the Greeks identified with Zeus. His rising is the sign of spring's advent. Aries's symbol, a simplified ram's head and horns, appears on Dürer's Map of the Northern Sky [8.66].

215　Down on the Farm

8.65

8.66

dei quod gloriose honorifica-
tū est in secula seculoꝛ Amen
De sancto Georgio.

O Georgi miles Christi:
palestinā deuicisti ma-
nu tua valida. Ortus tuus ge
nerosus: actus tuus bellicosus
fides erat feruida: per lanceā
in vibrantem et draconem vul
nerantē: viuit regis filia. Sic
in sancta trinitate: de Silena
ciuitate: credunt multa milia:
princeps ferox et insanus: cui⁹
nomē Datianus: corpus tuū

Chapter Nine

Horse and Rider

The winged creatures of myth, folklore, and Bible may swoop earthward and lift mortals to the heavens, but one beautiful though everyday animal can carry men and women closer to the sky, raising them above their fellows—the horse. Cherished alike by king and knight, rich townsman and peasant, this costly, skittish, handsome beast, so long essential for war and peace, has been a favorite subject of painter and sculptor since art began.

According to the Greeks, the horse was sculpted by the sea god Poseidon from the living rock. Athena, divinely wise, devised the bridle so that horses could be controlled and ridden in the great Athenian procession held annually in her honor. Ancient art abounds with images of horse-drawn chariots of sun and sea gods, and steeds bring victorious heroes to their eternal reward. Paired horses, according to Plato, represented man's divided soul, guided by his charioteer—the mind; the wise, good one gallops heavenward as the foolish, evil partner races down, Hell bound. Our horses, ourselves. Tacitus noted that white horses were revered as prophets in Germany: "Never soiled by mortal use, these are yoked to a sacred chariot and accompanied by the priest and king . . . who then observe their neighing or snorting. On no other divination is more reliance placed. . . . The priests they regard as the servants of the gods, but the horses are their confidants." Similar reverence for the magical force and beauty of the horse returned in the Renaissance, and it is keenly felt in Dürer's steeds, many of them not meant for mere mortals' use, but destined for divinity.

In the Bible, the stallion is among the most splendid images of sacred strength, but he is tied to the making of war, not peace. Liveliest of all biblical lines describing the horse are the Lord's in the Book of Job: "Hast thou given the horse strength? Hast thou clothed his neck with thunder? Canst thou make him afraid as a grasshopper? The glory of his nostrils is terrible. He paweth in the valley, and rejoiceth in his strength: he goeth on to meet the armed men. He mocketh at fear, and is not affrighted; neither turneth he back from the sword. . . . He saith among the trumpets, Ha, ha; and he smelleth the battle afar off, the thunder of the captains, and the shouting." Long-suffering Job, unswerving in his faith in God, was to see his flocks of camel, sheep, and asses carried off by enemy riders. Dürer painted this subject in the background of an altar [Plate 29]; he cast himself as the holy

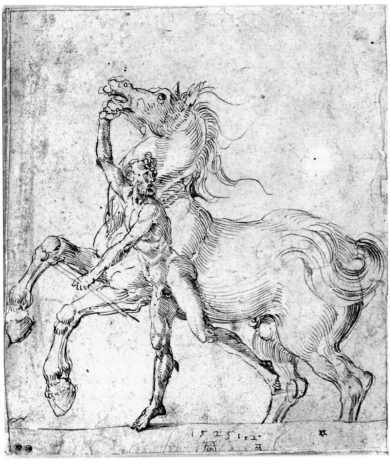

9.1

man's friend, comforting Job with music. (The great columnlike form in the detail is part of Dürer's leg, dwarfing the minute scene of the raid in the distance.)

Ancient Romans so loved their horses that sometimes they buried them with specially inscribed marble tablets. Their epitaphs kept the memory of the beautiful animals as green as the fields where once they grazed. Such Latin lines were known to Dürer's learned friends, who collected these inscriptions and shared their knowledge with him.

Two huge marble horse trainers, standing by their rampant steeds, are the largest equestrian groups that survive from ancient times. Long believed to be by Praxiteles, their site in Rome is still known as the Mount of the Horse—Dürer must have seen this famous twin monument on his second Italian visit, when he worked in Rome. Long after his return, in 1525, he drew the statuary group from memory or after an earlier, now-lost study, casting himself as the horse trainer, as if he had tamed antiquity [9.1].

9.2

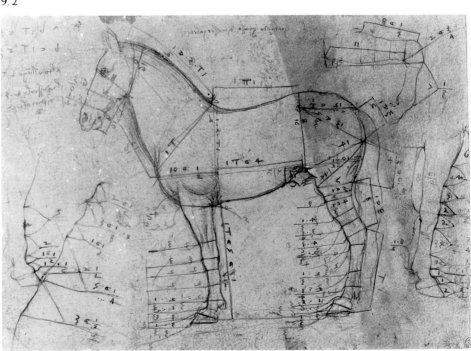

Leonardo da Vinci, whose comparative proportion studies of man and horse [9.2] Dürer copied, was fascinated by the links between the human and the stallion. He noted how "the walking of man follows that of all four-legged animals, for, just as they move their feet crosswise after the manner of a horse in trotting, so man moves his four limbs crosswise; that is, if he puts forward his right foot in walking he puts forward his left arm."

Classical art, dependent as it was upon the nude, was hard for artists of Dürer's generation to follow closely, as they seldom had a chance to draw from the living model and even more rarely, if ever, from a naked one. So it was often their study of the horse that led them close to the source that had inspired so many of the most beautiful images of ancient art. The Greek and Roman horse was equally at home on land or sea or in the skies, flying as the symbol of artistic genius and inspiration [11.23]. By copying images of these magnificent steeds from coins, monuments, reliefs, and other works, artists had an inside track to antique ideas of beauty, freedom, and motion. Greek and Roman statues of leaders on horseback, meant as tributes to triumph and as funerary monuments, were used as models in the late Middle Ages for similar equestrian groups all over Europe. Royal splendor was realized on a smaller scale with the making of massively golden roundels, in a series of the first Christian emperors on horseback, probably produced in northern Italy around 1400 for the great art collectors of France. This glittering series brought equestrian portraiture and the ancient practice of medal making back into view among the richest patrons of the arts, ancestors of Dürer's major patrons. These medals led to the greatest painting of horses since classical times: the inner left wing of the Ghent Altarpiece, completed by Jan van Eyck in 1432 [9.3]. Dürer perhaps saw the altarpiece and its brilliant cavalcade in his youth and certainly in 1521.

Most useful to the young artist was an-

9.3

other equestrian scene, which he must have studied near the beginning of his travel years. An unusually large print by Schongauer, it shows the Battle of Clavijo, where Saint James triumphed over the Moors [9.4]. Caught in ac-

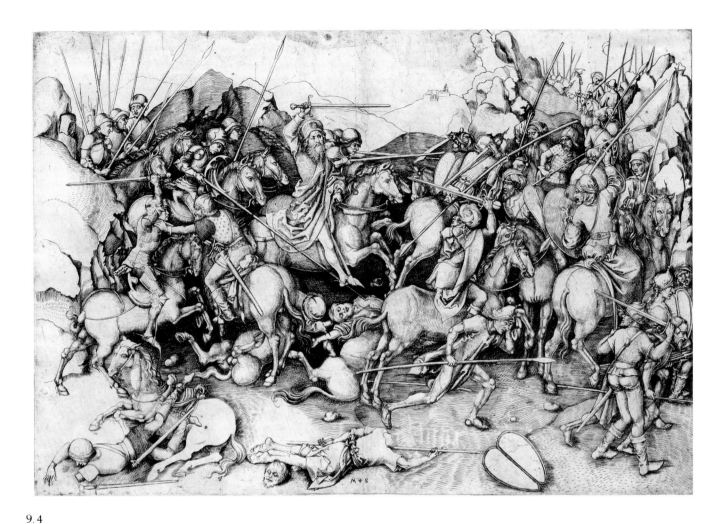

9.4

tion, Schongauer's cavalry presents a major graphic resource of the horse at war, ever a popular and profitable subject. Because the engraving was never finished, it was ideal for study purposes. Each of the more than eighteen Spanish horses is seen from a different angle, with a blank area all around, leaving it clearly defined and ready for copying. Artists young and old used this work just as photographs of the horse in motion were followed in more recent eras.

Since Roman times, the idea of the horseman went with that of the gentleman who enjoyed the same claims to fine breeding as his mount. The word for a knightly rider—*cavalier*, in Latin *eques*, *chevalier* in French, and *Ritter* in Dürer's German—is a clear statement of class. Adventure and romance, travels for war, profit, and love—all the challenges of change and passion depended upon getting there on horseback. For the young Dürer, horses must have signified liberty and license, escape from the devout, demanding parental eye. As a boy, he was doubtless horseless, but he drew steeds from the start and seemed to be a keen judge of horseflesh. Living at home during his apprentice years, he had no need or money for a mount of his own; only at the time of his first Italian journey, and possibly for his earlier travels in the Lowlands, he may have had a horse.

Never was the myth of knighthood more zealously tended than during these early years of Dürer's life, when chivalric life was already obsolete. Soon new government, new Protestant faith, and new military tactics were to make the old ways almost extinct. But this only lent the cavalier greater fascination than ever [9.5] [Plate 28]. Many Dürer prints of horse

and rider were made for those who wanted to preserve the memory of a chivalrous world. Tournaments, with their pageantry and excitement, fine horses, and shining armor, deeply appealed to Dürer. Once, when watching these semitheatrical contests staged in front of the house of his friend Pirckheimer, he fell into a deep sleep during which, so he told his friend, he dreamed dreams inspired by the knights in mock combat, which, were they to come true, would make him the happiest man in the world.

What may be Dürer's first jousting scene (not all agree that this woodcut is his) was designed for the moralizing book of the Chevalier de La Tour Landry [9.6], which urges wives to be ever humble, obedient, and loving; should husbands prove pigs or worse, God would see to their punishment in the next world, if not sooner. The chevalier told of a little-loved, nasty Roman senator who fell while jousting; when his substitute was unable to carry on the fight, none could be found to take his place. "The good lady his wife considered the great shame that should thus befall her lord; she went into her chamber and made her to be armed and mounted a good courser, and rode into the field and had her visage disguised in such a wise that she was unknown unto every creature. As God saw her bounty and truth, and that she did it in the salvation, love and worship of the lord and husband, He sent the victory and the honor unto her husband by her hands, for she conquered his enemy." Wearing a closed helmet made by Nuremberg's armorers, the senator's wife's face is hidden from view. Has she already delivered the decisive blow, or is she doing so as her opponent holds his sword to parry it?

Most elaborate of the young Dürer's equestrian pages is a cavalcade; seven Nuremberg dandies canter through a hilly landscape on awkward, cross, little horses [9.7]. Understandably vexed, the steed at the center has to put up with two riders rather than one. All the riders are fashionably dressed fops, soon to

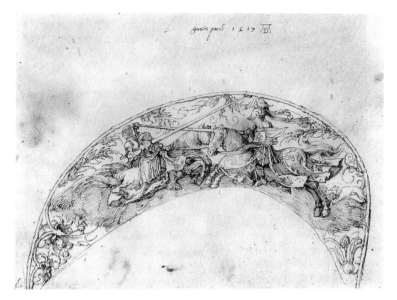

9.5

9.6

earn Sebastian Brant's stinging disapproval in *The Ship of Fools*. They may typify the circles in which Dürer's friend Pirckheimer moved. (His handwriting appears on the back of the drawing with the notation "Dürer painted this in

224 Dürer's Animals

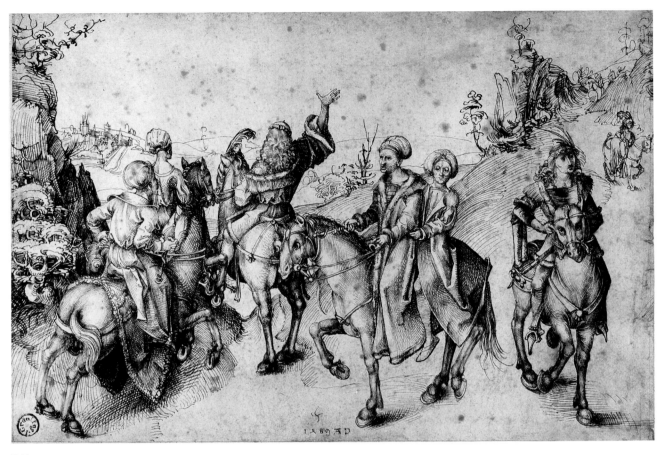

9.7

9.8

the year 1489.") Some of the riders' appearances suggest women's wear and ways, but all are men, presented in the dandified fashion Dürer used for his self-portrait a few years later. That the *Cavalcade* is an early work is clear from the wooden, merry-go-round manner of the steeds and the halting poses of their riders, but the wonderfully free landscape, with its sense of panorama, and the white area above the thinly penned horizon, suggesting the life of the skies, tell of Dürer's infinite promise.

Though taking up very little space, one of the artist's most powerful early horses is seen in the background of an engraving dating before his Italian journey, the *Ill-Assorted Couple* [9.8]. That subject, condemning old men or women for buying the love of the young, was a popular one, and scenes like these sold well. Here the horse has brought his old master and a young woman wearing the costume of a Nuremberg matron safely away to the country,

where she is shown taking money before making love. (A scholar has suggested that, in a reference from Jeremiah, her wifely dress explains why Dürer also included the horse: "They were as fed horses in the morning: every one neighed after his neighbor's wife.") Far better drawn than the seated couple, the horse turns his back on them to scratch his flanks against a tree. Such Venetian masters as Titian so admired this horse that it can be found in the background of many of their canvases, leaving the lovers far behind. More happily paired, young lovers ride through the woods, Dürer's dog bounding alongside [9.9].

First of Dürer's sleek mounts to be shown riderless is a fallow, or pale golden-brown, horse so described in the poem that goes with the woodcut for Brant's *The Ship of Fools* [9.10], with its moralistic disapproval of Nuremberg high life. Here the phrase "stroking the fallow stallion" signifies the courtiers' flattering the

owner of so splendid a steed. Dating from around 1493 is a dashing huntsman or messenger, baton in hand, wearing a sweeping, plumed headdress [9.11]. Though his galloping horse is impossibly long and thin, it shows the brisk spirit found in many of Dürer's early equestrian studies. He seems to have sketched this hurriedly from life, changing the placement of the fore and hind legs as he went, leaving ghost lines still visible on the page.

An amazing change took place between the clumsy steeds of the *Cavalcade* and Dürer's powerful horses of the later 1490s. This difference is traceable to his trip to Italy in 1495. Now Dürer's lively mounts seem to reflect their master's rapturous mood—and perhaps also his sense of his own thoroughbred good looks. With his prominent cheekbones, long, high-bridged nose, slightly bulging eyes, and long legs, Dürer suggested the coltish in youth and the nobly equine in maturity. Physiognomical theory, so popular in the Renaissance, in which character was read and understood by the correspondence between human features and those of the animal most like them, must have encouraged his identification with the horse.

The courts of Italy were wild about horses. Their connections with Islam and northern Europe encouraged them in this enthusiasm. Italian rulers spent enormous sums on the world's finest steeds, which of course were Arabian, brought from Spain. Princely riders in Lombardy, Ferrara, and Mantua saw themselves personifying two different traditions: Heirs to both antiquity and the recent Gothic past, they claimed descent from both Alexander and King Arthur, riding the fleet horses of Greece and also those of the Round Table. Venice, a city between East and West, kept magnificent stables, providing marvelous live models for Dürer, as well as those from classical and contemporary European art. Surprisingly, many of the horses the artist saw there came from the city of his birth or from Hungary, the land of his ancestors. Chief supplier of cavalry to the Venetian army was Her-

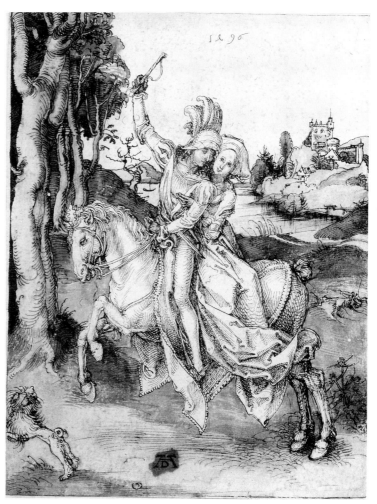

9.9

9.10

226 Dürer's Animals

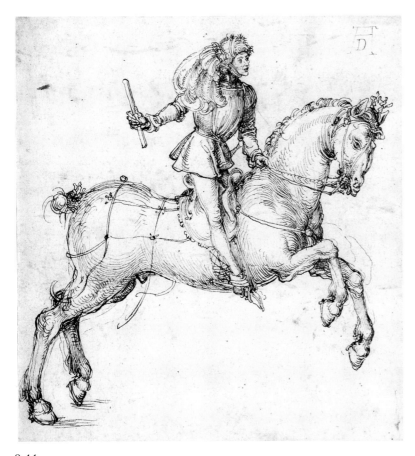

9.11

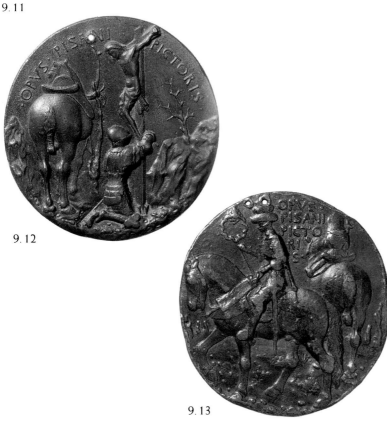

9.12

9.13

man of Nuremberg and Company, who would often bring as many as a hundred horses at a time. Medals by Pisanello, made in the 1440s for the rulers of Ferrara, Mantua, Rimini, Pesaro, and Milan [9.12; 9.13], could have given Dürer his first taste of Renaissance art—even before this trip to Italy. These may have inspired his new angles and perspectives upon the horse in motion.

In 1495, when Dürer set out on horseback for Venice, his travels took him to Padua, where he saw Donatello's splendid statue of Gattamelata [9.14], a *condottiere* or mercenary, erected in 1453, the greatest equestrian bronze made since antiquity. Even more vivid than Donatello's monument was the one made by Verrocchio, installed in Venice in 1496. Far more menacing in appearance is Verrocchio's statue of the equally mercenary Colleoni [9.15], who was trained by Gattamelata. Denying the safe, the predictable, the balanced, Verrocchio's tense, threatening horse and rider show muscles rippling beneath the skin, each with flashing eyes.

But four monumental bronze horses without riders proved the most impressive monument of all [9.16]. Proudly independent, the gilded, ancient Greek steeds prancing on the porch in front of Saint Mark's (stolen by Venice at the Sack of Constantinople in 1204) provided a dazzling inspiration. Taken from a Greek quadriga, a four-horse chariot, these beautifully preserved, larger than life-size bronzes had already been used by many artists as a point of departure for their own works.

Befriended by the Bellinis, Dürer probably saw their drawing books, filled with animal studies, from which he copied a series of Oriental riders [9.17–9.19]. These may have been made by Gentile Bellini when he worked in Constantinople for Sultan Mohammed II, and which he probably copied in turn from manuscripts Mohammed owned. He kept these drawings of equestrian figures in his notebooks and included them in many later works. But the first of the many Eastern horse-

227 Horse and Rider

9.14

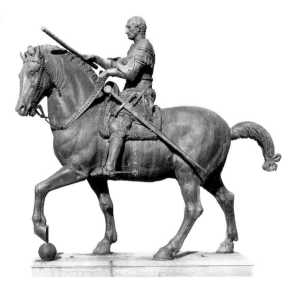

9.17

9.15

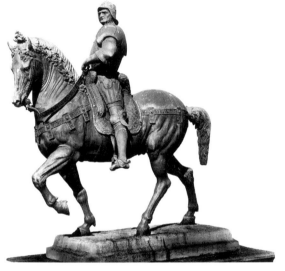

9.18

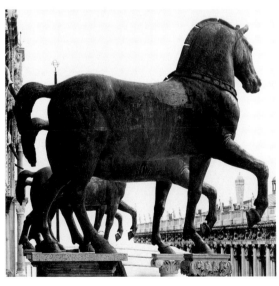

9.16

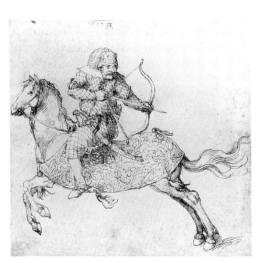

9.19

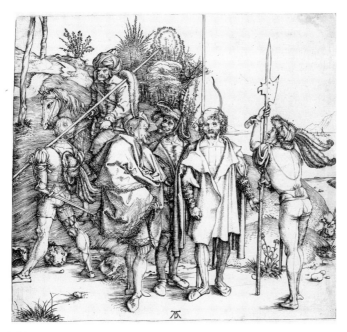

9.20

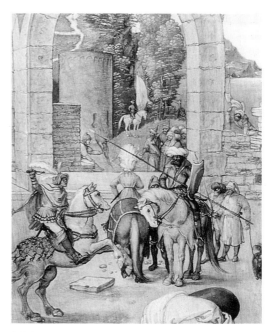

9.21

men Dürer engraved is found in a richly worked small print [9.20] that he may have made just before coming to Italy, where a turbaned rider is at the left, behind a casual group of standing European soldiers. His handsome mount, with a fine, delicate head, flowing mane, and great sparkling eye, is the first of Dürer's engraved horses to show Italian influence.

By 1504 the artist had painted his most intricately composed group of horsemen [9.21], placed by an open arch in the background of the *Adoration of the Magi* [Plate 1], ordered by Frederick the Wise of Saxony. Three horsemen with exotic armor and massively plumed headdresses, and a fourth holding a huge yellow banner in the background, represent the three kings' retinue. Approaching the black magus Melchior is a rider with a white turban; he opens a saddlebag that may have protected the great golden covered cup Melchior holds out to the baby Jesus. Another precious object, the golden coffer offered by the kneeling magus, shows a rider on its embossed side, who fells a foot soldier with his lance. The fatal message of this gift is countered by the cup held by the standing magus;

its top—a serpent swallowing its tail—symbolizes eternal life. Years later, having welcomed the Infant as the King of Kings, the same riders reappear in Dürer's art, crowding around the base of his cross, to kill him.

The strongest of Dürer's steeds belong to *The Four Horsemen* from *The Apocalypse* [9.22], ca. 1496–98. Part of a print series that swept the world, it has been copied by artists everywhere up to the present as the most telling vision of war, death, and destruction. Many of Saint John's images in the Revelation are given life by his vibrant use of animal symbolism, and none more so than the Four Horsemen: The first rides a white steed of conquest, the second a red roan horse of war, the third a black horse of hunger, and the fourth, the pale horse of death. According to Saint John, each horseman is prophecied by one of the first four of the seven wax seals hanging from the Lord's book, whose opening would lead to Judgment Day; all four seals are combined in this single page of equestrian dynamite. Dürer's distant model for these rampaging riders is the same subject in the Cologne Bible of 1480 [9.23], where the horsemen are confined to a single, narrow strip. Earthbound, they ride across the

229 Horse and Rider

9.22

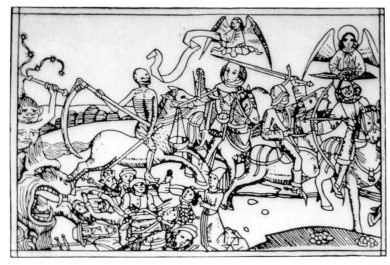

9.23

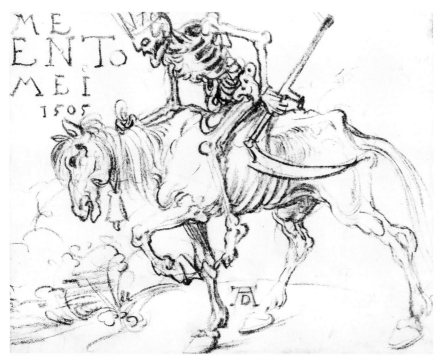

9.24

field like ordinary men of war, soldiers of evil fortune, taken from scenes of everyday combat. Opening up and expanding this horizontal strip, Dürer's woodcut takes up a full page; no mere illustration, the woodcut *is* the subject itself, just what John saw, replacing his words with his images. Now the riders conquer the skies; the stallions' thunderous passage is echoed by turbulent trailing clouds. These horses' classical spirit also suggests the new force of such Renaissance masters as Mantegna, whose prints traveled to Nuremberg and were copied by Dürer. The first rider, victor of the world, is farthest to the right and from the viewer, having already passed us by. Only Death's pale horse has all four hooves close to the ground, where the bodies have fallen. Scenes like these make it easy to understand why terrifying dreams have long been called "nightmares."

Tragic, not triumphant, the starved, bone-weary nags Dürer drew with such compassion have a sad, forgotten beauty all their own. Few artists cared as much for the long-suffering, faithful, broken-down horse, and it is just this concern for the whole range of life that makes him a great master. Earliest of these hungry horses is the white one ridden by Death in *The Four Horsemen* of 1498. More lifelike is a charcoal study of 1505, where Death and his starved horse form a cadaverous equestrian monument of skin and bones [9.24]. Scythe in hand, Death pitches forward, hanging on to the shaggy, unkempt mane to keep his balance, urging his horse onward to help reap a fatal harvest. These quickly drawn, dramatic charcoal strokes were guided by still earlier preparatory ones, which are almost invisible in their light-colored chalk. Writing of this page, the great Dürer scholar Erwin Panofsky has noted, "It shows Death as a king, or, to speak more exactly, as the King of the Plague. Crowned with a royal crown, he rides on an emaciated horse . . . a cowbell strung around its neck—a weird reminder of the death knell." Its gait is a ghastly caricature of what Dürer had admired in the horses by Leonardo da Vinci; Panofsky observed, "The Jade of Death lifts its near foreleg and simultaneously puts forward its off hind leg; but the rhythmic beauty of its movement is distorted into a crawl as slow and deadly as the advance of a lava stream." (See Erwin Panofsky, *Albrecht Dürer* [Princeton University Press, 1945], 106.)

Dürer's grimmest messenger is another rider, rendered by a workshop assistant, with raised bow and arrow and a wooden cage for bearing away bodies [9.25]. Designed for a painted glass window, a Latin message is written around the sides: "Watch out, Wretch, lest I plug you with my arrow and place you in the gloomy confines of this coffin carrier."

All work and no play, a heavy-set horse turns up over and over again in Dürer's works whenever he wants to show the quality of endurance. Similarly forceful horses are seen in the woodcut *Knight on Horseback and the Lansquenet* [9.26], in which the latter runs to keep up with his squire, whose stallion gallops through the woods. That horse, like the ones still found on northern European farms, is heavily built, bred for endurance. Those fancy feathers on his brow—a panache—look almost as misplaced as the ermine collar over his grim-looking squire's shoulders. Even the footsoldier sports plumes on the side of his hat. The only playful member of this serious group is Dürer's shaggy dog, bounding along in the foreground. Seldom is this powerful horse allowed an easy time of it, once ridden sidesaddle by a richly dressed woman whose debonair style is in striking contrast to the matter-of-fact mount [9.27]. On her high horse, the lady is about to leave her lover and social inferior, a footsoldier. Many early prints were devoted to the theme of the power of women, and Dürer's engraving continues to explore that popular subject.

Saint George, so often assigned a more dashing steed, is given a weighty stallion in an engraving Dürer began in 1505 and completed three years later [9.28]. Here the oak leaves braided into the tail and decorating the horse's head look out of place, even though compatible with the successful trappings of the hunt. The knight grasps a great lance, converted into a banner with the cross of Saint George on it. A slighter form of the same horse is shown in *Saint Eustace* [1.30]; still earlier may be its "portrait" in the background of the *Ill-Assorted*

9.25

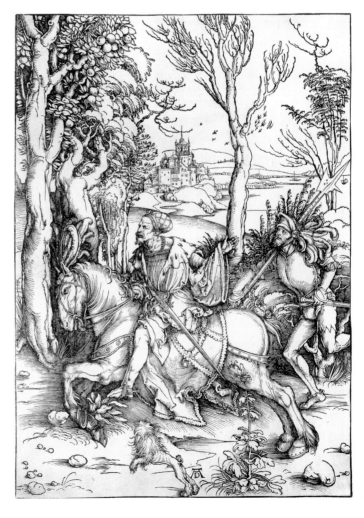
9.26

232 Dürer's Animals

9.27

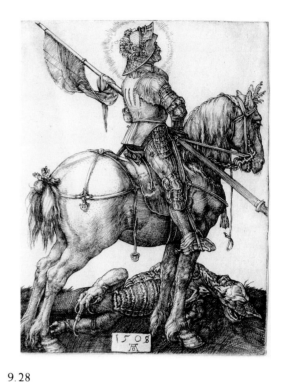

9.28

9.29

Couple. Updated but drawn close to 1500 is a silverpoint study of a horse, in profile, facing right [9.29]. This may be the same horse, with its luxuriant tail now braided, seen from the rear in the *Large Horse*, engraved in 1505.

Saint George also charges along the margins of Maximilian's *Book of Hours* [9.30], mounted on an armored steed and holding down a mortally wounded dragon with his lance. In German armor, his face hidden by a pointed Nuremberg visor, the saint bears a great banner and shield with the encircled cross of his order. He rides an equally well-protected horse, which is covered by steel plate, innumerable bells hanging from the harness. A peacock feather, placed rakishly on the horse's head, parallels three plumes rising from the rider's conical helmet. Far less fortunate is a warrior on another *Hours* page [9.31], pursued by the devil as Death (with a scythe) brings up the rear, running like a footsoldier after his knight. The warrior raises a mailed fist to ward him off, but escape is only momentary as a great devil, sliding down the left border, is sure to kill him with a claw-hammer. A yin-yang matching of beasts is found in the woodcut *Saint George and the Dragon* [9.32], where the horse and dragon fit together in the monster's final moment, just when his head is about to be

233 Horse and Rider

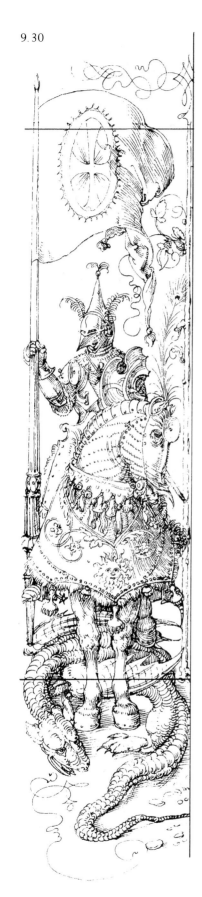

9.30

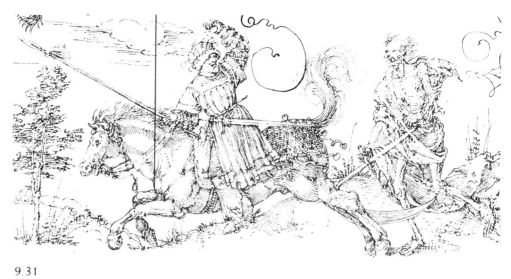

9.31

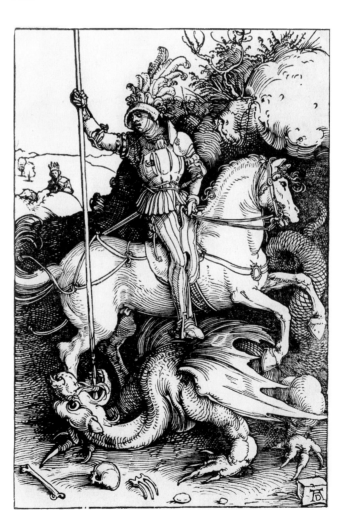

9.32

9.33

9.34

9.35

skewered upon the knight's lance, as the fearful princess peeks timidly from behind a hillock.

Smallest of Dürer's many Saint Georges is one that he may have designed for his goldsmith brother to make as a pendant [9.33]. The artist's own training in that craft stood him in good stead in this design: The equestrian group is cleverly held in by the dragon's tail, the horse's tail, and the plumage sprouting from the heads of horse and rider.

Martyr, which in Greek means no more than "witness," defines some of the horses as well as the saints in Dürer's prints of Christian revelation, all creatures sensing the sudden presence of God. In a scene of angelic vengeance from *The Apocalypse*, a horse tosses his rider like a rag doll [9.34]. This image of the toppling rider is a symbol of fallen pride. But Dürer's group is much more significant than usual because his horse kneels, as if aware of the angel's divine mission. In *The Martyrdom of Saint Catherine* [9.35], the Oriental ruler who ordered her death falls from his mount as the wheel of torture is destroyed by a shower of flaming stones. Once again the horse goes down on one leg in obeisance to God's will. Dürer loved this theme and repeated it on a minute scale for a narrow band of Catherine's

9.36

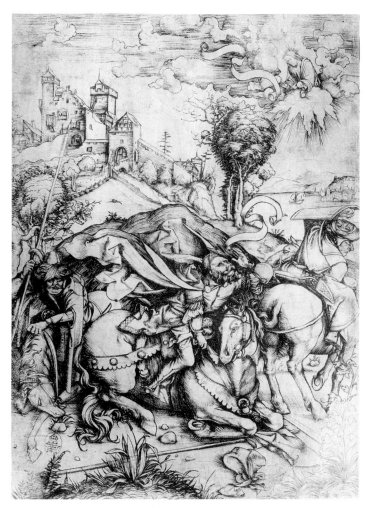

9.37

martyrdom [9.36], probably meant to decorate a metal object. (He cut most of his early prints into the wood himself, as few craftsmen's knives could follow the speed and dash of his fluid, expressive draftsmanship. Luckily, the original woodblock for *The Martyrdom of Saint Catherine* survives, and it gives us an idea of Dürer the sculptor as well as the draftsman at the peak of his first burst of graphic vitality.)

Most crucial of all the saints' equestrian subjects is the dramatic conversion of Paul. Only one puzzling print, in Dürer's early style but not from his hand, presents this scene. A large engraving, known from its unique impression [9.37], shows the militant persecutor of early Christians falling from his horse, blinded, as he hears Christ say, "Saul, Saul, why persecutest thou me?"

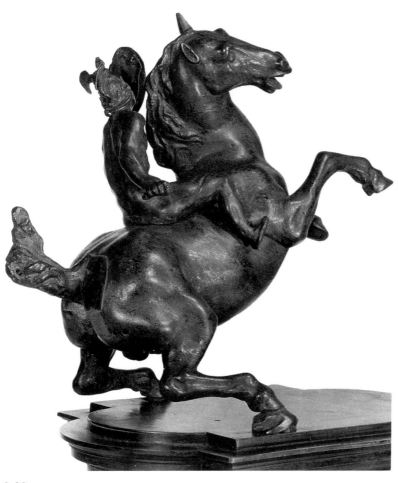

9.38

🅐

When Willibald Pirckheimer went to college in Pavia, he was a fellow student with Galeazzo de San Severino, the son-in-law and favorite of Lodovico Sforza, ruler of Lombardy. Galeazzo's magnificent stables in Milan had provided Leonardo da Vinci with the models for his beautiful equine studies [9.38]. Knowing Luca Pacioli, a specialist in proportion and perspective, as well as Leonardo, Galeazzo might well have told Pirckheimer of their discoveries. By the time Galeazzo came to Nuremberg in 1502 to spend some summer months with the Pirckheimers, Leonardo's and perhaps also Pacioli's studies of the proportions of the horse were already known there, present in Dürer's art.

Pirckheimer also saw at least one of Leonardo's models for a great equestrian monument to Sforza [9.39], displayed at the time of the French king Charles VIII's triumphant entry into Milan in 1494. At first Leonardo conceived of a huge horse rearing skyward, with both forelegs raised, but after years of experimentation this challenging plan was abandoned, and artist and patron settled for a simpler design that was never executed.

Opulent processions and hugely expensive theatrical performances with victorious pageantry were also designed by Leonardo, who brought all the splendor of ancient imperial art together with the most up-to-date grandeur in honor of the French king. When Pirckheimer's humanist circle had to plan similar print processions of chariots and riders for Emperor Maximilian, these scholars may have turned to descriptions if not to drawings of the festivities Leonardo had prepared. It was Pirckheimer who gave Dürer the commission for this massive imperial project, which included a Hungarian rider [9.40].

Leonardo's model for the great equestrian monument to Trivulzio showed the influence of Aristotle, who had, in noting that "birds are lightly built but can stand on two feet because their weight is at the back," remarked that this distribution of weight is "just like bronze horses, which are made by sculptors with their forelegs raised in the air." Such passages must have fascinated Leonardo, since they related closely to two of his most compelling concerns—the creation of an equestrian statue with the horse rearing, and the way in which birds move. Of all creatures, horses and birds offered Leonardo the richest variety of motion, so Dürer, by copying his measured manuscripts, engravings, and small bronzes, was able to follow many of the Florentine's discoveries. Like Leonardo, he saw motion as a key to the kingdom of nature, a clue to the mysterious ways in which the cosmos works. A first study for one of these horse-drawn triumphal wagons [9.41] is itself a triumph of spontaneous energy and flow, a graphic essay in perpetual motion.

237 Horse and Rider

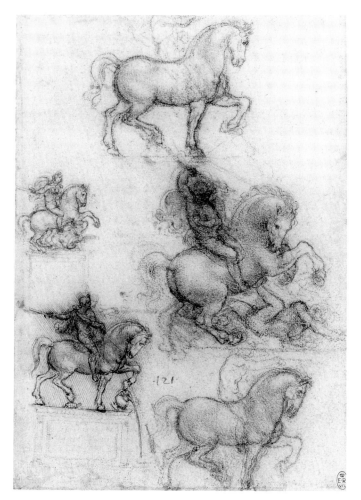

9.39

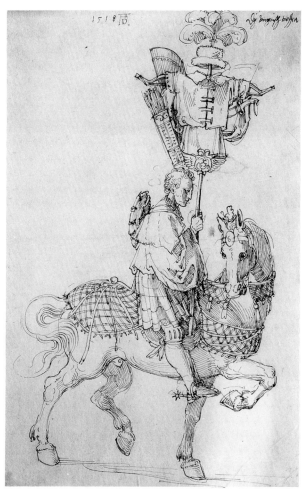

9.40

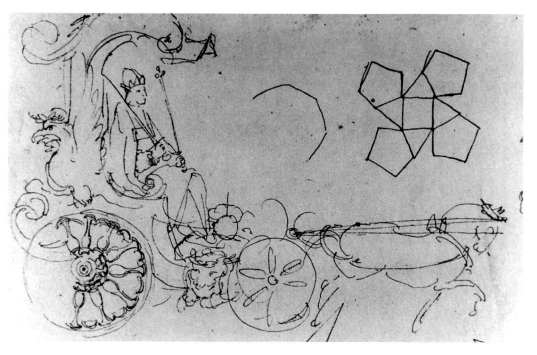

9.41

Dürer delighted in creating scenes of falconers riding through the fields; he seemed to share the infectious sense of excitement and expectation with which a young, lithe trainer turns to release his bird of prey. *The Falconer* of about 1503–5 [9.42], a seemingly spontaneous, freely drawn work and one of Dürer's finest equestrian studies, is actually based on a grid and a series of painstaking measurements following the new proportions devised by Leonardo. Reined in, the horse's proud head, with its fine long muzzle, is close to those often shown in da Vinci's drawings. Drawn in profile in 1503 [9.43], a magnificent horse shows the same influence of Italian art; displayed like a small, precious bronze against a black ground, it is inscribed within a grid of sixteen squares.

Head length also determines the proportions of the *Small Horse* [9.44], an engraving of 1505. The body is three heads long, the rump is three heads high, and the measure of the

9.42

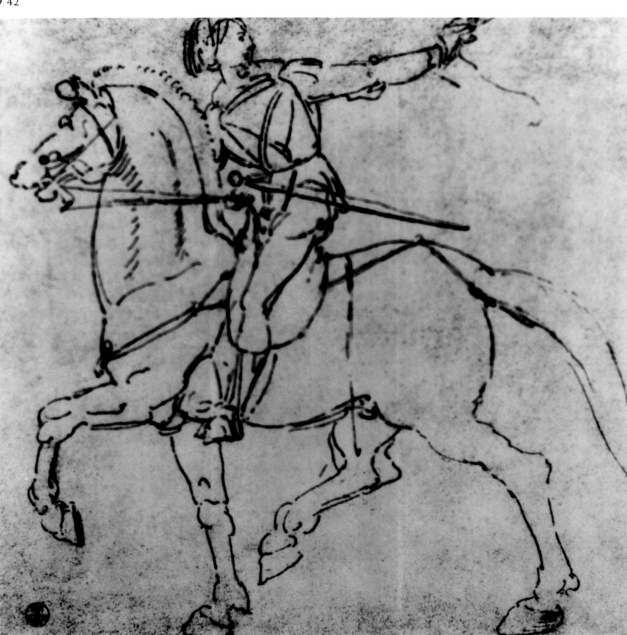

distance between the belly line and the rump is one-third of the head length; body and legs alone fill a square, each side of which measures three horse-head lengths that can be subdivided into nine smaller squares. Circles as well as squares determine the horse's shape, for Dürer used a compass to trace some of the animal's curves. Once again his model for these proportions, as for the horse's fine head, with its almost snoutlike muzzle, is Leonardo's work, though working with a grid and constructing animals along abstract, mathematical principles goes back to medieval and even to ancient times. But when Dürer turned to geometry to draw his ideal horse, these abstract forms yielded a sense of tension, of taut magic, suspending the life of the beast between the two perfect forms of circle and square, defined by the measure of the mind, the horse's head.

When Dürer had first learned of the new Italian mathematical rules for perfect proportion, he wanted to study with Jacopo de' Barbari, the Venetian master working in Nuremberg in 1500 at Maximilian's request. But Jacopo kept his secrets to himself, and Dürer went to Italy to learn of these matters at first hand. Ever generous with his own wisdom, Dürer shared his knowledge in *Nourishment for Painters' Apprentices*, the first draft for a guide he began in 1512. Its title is probably based on Plato's *Banquet*. Only horses among all the animals were allowed entry; of the ten planned chapters, the first was to deal with the proportions of a young child; the second, a grown man's; the third, a woman's; the fourth, those of the horse. A Dürer manuscript in Nuremberg and the preparatory drawings for the great print of *Knight, Death and Devil*, along with copies the artist made after Leonardo in 1507 [9.45] and studies in the Dresden sketchbook of 1517, all indicate what he projected "the measurement of the horse" to have been.

In the engraved *Small Horse* and its pendant—a heavy, resolutely unclassical beast, *Large Horse* [9.46]—Dürer couldn't resist a few tantalizing bits of arcane symbolism. The first

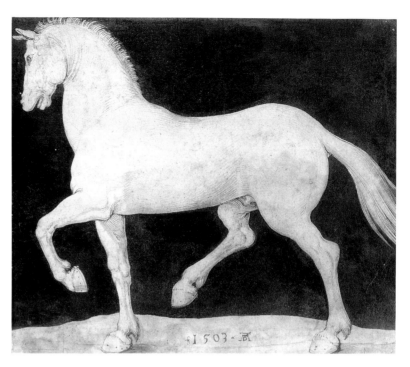

9.43

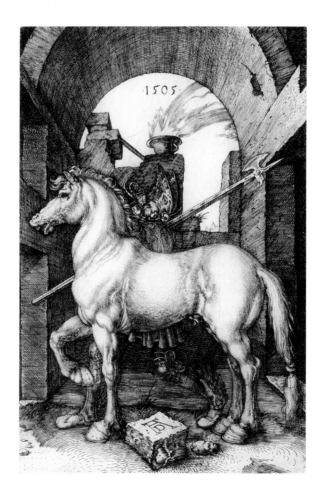

9.44

9.45

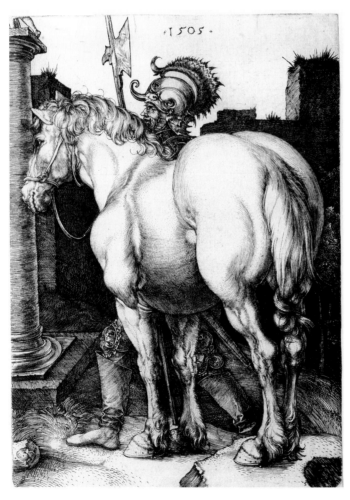

9.46

includes a strange warrior, an enchanted Mercurylike figure, with that god's wings on his heels. A haunting butterfly helmet is in striking contrast to his ugly face. He strides along, as if about to walk into the wall before him; the skittish white horse is frozen in its tracks, its right foreleg raised in the same pose as a bronze statue after Leonardo. Although the *Small Horse* refers to the elements of air and fire, with wings and flaming alchemical vessel, the *Large Horse* suggests the elements of water (the warrior's grotesquely fish-shaped helmet) and earth (the mount's four feet are planted on the ground, weight and mass stressed by the three-quarter rear view from which this stallion is seen). So uniquely forceful is this beast that Caravaggio included it in his most powerful image of a horse in *The Conversion of Saint Paul* (Rome, San Luigi dei Francesi), painted in the century's last decade.

An intricate masterprint like *Knight, Death and Devil* [9.47], with its great wealth of detail, is a whole world in itself, teeming with life on every level. But what kind of a warrior is the brutal rider? The beautiful horse is far more idealized than the man. Perhaps, as has often been suggested, Dürer had in mind Erasmus's *Manual of the Christian Knight* of 1504, where the northern humanist wrote that every Christian should see himself as the Lord's knight. The artist certainly knew Erasmus's popular text, for he quoted from it in his diary in 1521, when false rumor claimed that Luther was arrested and about to be killed. (Mistaking the ever-prudent Erasmus for a man of action, Dürer wrote "O listen, you Knight of Christ, ride forth in the company of Christ the Lord and defend the truth and be crowned a martyr.") But the print was engraved too soon to refer to Luther, whose break with the Church took place four years after it was made. If the knight is Christian, Dürer's imagery may stem from that most militant of saints—Paul—who delighted in the cry of sacred battle. Perhaps

241 Horse and Rider

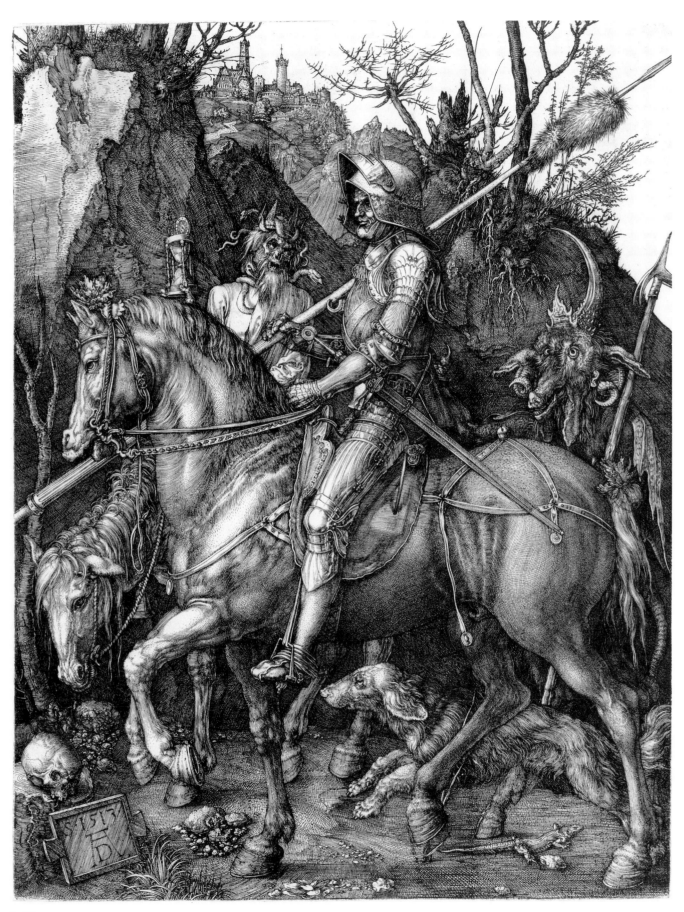

9.47

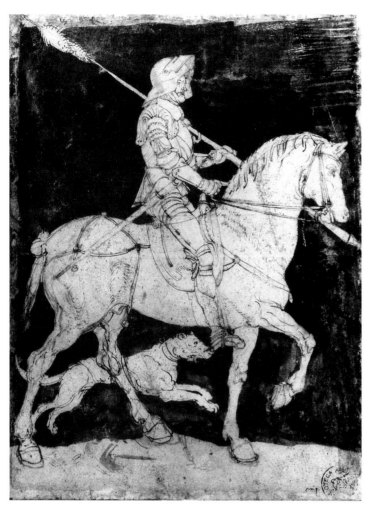

9.48

The knight, Death, and the devil make a gruesome masculine threesome that adds up to the very meaning of war. Trotting along at his master's side, the hound between the prancing stallion and Death's hungry horse is, like his master, unaware of the slithery lizard and the skull on the tree stump, emblems of death and decay.

Here, as is so often true in Dürer's works, animals, not humans, are the first to get the message. Death's fine old horse looks down at the skull with a pensive gaze, sole sign of understanding that this scene is a memento mori—a reminder of life's cruel brevity. Only the sad white nag suggests the quality of mercy, as if about to nuzzle the relic of human fate in this black valley. A bell around its scrawny neck tolls the beginning of the end, the coming of mortality, ringing to "Bring out your dead."

The armed rider was long known as the Knight Errant, one of those cavaliers who, having lost their lands and privileges, lived as highwaymen, terrorizing travelers. Without crusades or other wars to sustain them, these knights found their absence of mission intolerable; they, not damsels, were in distress. One of Dürer's traveling salesmen was waylaid by such a rider and stripped of his precious print portfolio in 1506. A wit as well as a poet, Ulrich von Hutten, who had praised Dürer as "Albertus Apelles," wrote that of the world's four categories of thieves, these poor knights were the best of the lot, much less harmful than merchants, priests, or lawyers, in that order!

Poorest of men at arms were the footsoldiers known as *Landsknechten*. Without protective covering or a horse at their command, they had nothing but themselves for sale. Active as mercenaries, such men were the chief cash crop of dirt poor German and Swiss farms. Dürer often showed these "hired guns" running along at their moneyed masters' sides, as they try to keep up with the squires' stallions. Though he left no caption to go along with his great knight, the artist did write a

the dramatic scene reflects such well-known lines of Paul's as, "Put on the whole armor of God, that ye may be able to stand against the wiles of the devil; for we wrestle not against flesh and blood, but against principalities, against powers, against the rulers of the darkness of this world."

Anything but Christian in appearance, without a cross or other sign of holiness, the knight in this bold, black print could also defend a world without faith. Riding through the dark Valley of Death, he can only fight, blind to death and deaf to the devil who scratches his armor with a long demonic claw. Snakes surround the crown of the king of death and wrap themselves affectionately around his neck, framing his ghastly head, with its rags and tatters of sunken flesh.

poem for a woodcut showing a footsoldier standing before Death who, as in the engraving, holds an hourglass with the message:

Nothing will prevent eventual death.
Therefore serve the Lord from morn to night
Only by fearing God
Can you escape eternal death.

The same lines may well have been in Dürer's mind when he engraved the *Knight, Death and Devil.*

Like a photographer's positive and negative images, the front [9.48] and back [9.49] of a single sheet present the major studies for the engraving of the warrior and his dreadful companions. Trotting to the right on the front side, his horse has the right foreleg raised. Dürer blacked out the background, placing the group in profile, to see it alone, more like a monument than a drawing, the way in which the group was engraved. He then held the drawing up to the light and traced the horse and rider through to the other side of the page. Now seen as they would appear in print form, in reverse on the other side of the page, the horse and rider face to the left, but with many changes in the horse's right hind leg. That same leg went on giving Dürer trouble in the engraving, where the ghostlike line of an earlier hoof can be detected. Some reedy lines crossing the dog just behind the horse's leg disguise earlier failed attempts to place the leg convincingly. Squared off, the page shows how Dürer kept the body of the horse within a series of rectangles so that it could conform to the ideal proportions developed in Italy. He went back to earlier works for this most sophisticated study, among these a drawing of almost twenty years before [11.39] for the knight's armor; he wrote on the page, "This was the armor that was worn in Germany at that time."

A "sculptor's digest" of all the major Italian equestrian monuments, the powerful stal-

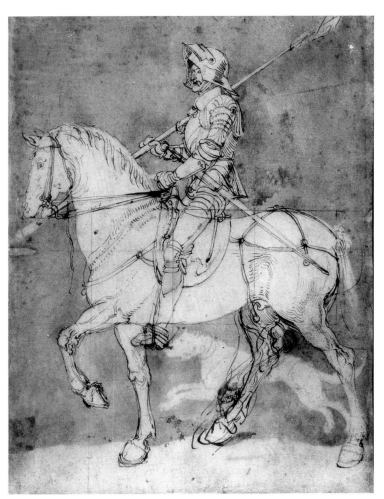

9.49

lion and rider in this great engraving combine those by Leonardo, Verrocchio, Pollaiuolo, and Donatello with the horses from Saint Mark's. That these statues are Dürer's sources explains why the engraved horse is seen from slightly below, since he had to look up at the bronze models mounted on tall bases in the squares of Padua and Venice. He may also have recalled groups seen in Jacopo Bellini's notebooks.

Proportion studies, using Leonardo's of 1506, were also essential for this print. Sketches for the leaping dog [9.50] and the lizard survive. Dürer had trouble squeezing Death's nag into an excessively small space. That poor beast, like Death and the devil, entered the scene almost as an afterthought—which, in a sense, all three were.

244 Dürer's Animals

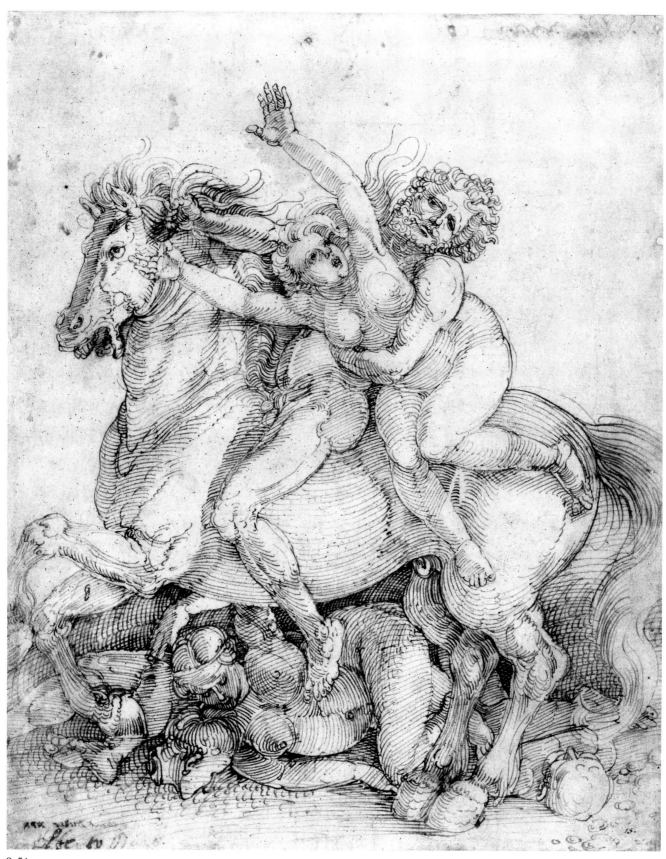

9.51

9.50

Dürer had worked out the knight and his steed almost fifteen years before. The devil's horselike trotters at the far right, with the four legs of Death's nag and those of the knight's steed, make for a crowded and confused section. The devil's right-most leg looks as though it may originally have been the right leg of the great stallion. Could the artist have added the devil to disguise and absorb this mistaken leg after he decided to change the splendid horse's gait? For a trotting horse, the legs' placement is all wrong. Despite its possible flaws, this horse remains *the* steed of its century. Only with the art of the baroque, when flowing movement was all, did the horses of another great northern artist, Peter Paul Rubens, surpass Dürer's.

Perhaps his most powerful use of the Renaissance horse—*Abduction on Horseback* [9.51]—came with a classical subject—a naked, fiercely bearded rider carrying off a protesting nude; he grabs her with one hand and his horse's mane with the other. For this wild scene, Dürer drew once again upon the equestrian statues planned by Leonardo and Pollaiuolo for Ludovico Sforza. Even the bodies below the steed and rider in *Abduction on Horseback* of 1516 relate to the defeated figures under Antonio Pollaiuolo's group. But Dürer's is a free, impulsive sketch. His rider is in the lusty spirit of the Wild Men [11.46], those shaggy forestfolk of the ancient northern woods. Perhaps this group is even distantly derived from the *Nuremberg Chronicles'* woodcut of the devil carrying off the Berkeley witch [11.44]. What is certain is that Dürer used his passionate drawing for the dark, fierce etching *Rape on a Unicorn* [11.43]. Indications made by his stylus are still found all around the drawn group when he transferred it for that stormy etching. All he added was a horn to the horse's brow.

Tiniest of Dürer's engraved horses is the one shown galloping uphill to the citadel in *Saint Eustace* [9.52], his largest engraving. Almost microscopic, this equestrian group is barely visible on the upper right fork of the road, above the great steed's head. Flea-sized, horse and rider are even smaller than those found above the lion's head in the Samson woodcut [9.53], and the little horse and wagon drawn in the background of an early Holy Family [9.54].

Only at the end of his life did Dürer return to such a diminutive scale, when a battle panorama, requiring two separate woodcuts,

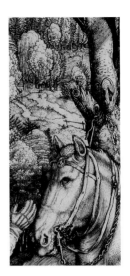

9.52

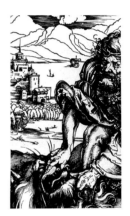

9.53

9.54

9.55

was prepared [9.55]. He must have drawn directly on the blocks, which were then carved by a craftsman in 1527. The vast scene was meant to be studied together with the text for the artist's final project, a treatise on military fortifications. Revolutionized by the use of heavy cannonfire, sixteenth-century warfare had far less use for cavalry than that of Dürer's youth. He made this clear when he drew a siege of the ducal fortress at Hohenasperg, which he witnessed in 1519. Here the tyrannical duke's citadel is ringed by heavy cannon. Only one knight on a well-protected horse is to be seen; all the rest are footsoldiers.

But in the woodcut are hundreds of less-than-ant-sized horses and riders, as well as many more sheep and cattle at the far right. On a hill in the right foreground is a small wooden sign dated 1527, with the artist's initials. A soldier kneeling at the right may be recording the great battle scene below. Defenses of the old town at the left have been redrawn according to Dürer's modern designs: A massively curved moat bellies out, with a great semicircular bastion behind. Invisible tunnels connect the moat's two gun turrets, which resemble tough cupcakes. Things look bad for the besieged city: Nearby villages are in flames, burned by the great approaching army; but with Dürer's newfangled fortifications and the well-ordered troops setting out at the lower left, all is not lost.

Like Leonardo and Michelangelo, Dürer often made designs for modern warfare. A striking contrast between martial arts in times of peace and war can be seen on a single page

divided between these themes. Heavily armed, two knights engage in a joust; on the other half of the sheet Dürer drew a horse's swimming gear, to be belted under the animal's belly [9.56]. He wrote above, "This is a girdle so that one can swim over the water. It is tied together over the shoulders. This is the way men fought on horseback in the year of our Lord 1372." On the reverse he drew a knight in heavy armor on an equally well-protected horse whose coat of mail is covered with sharp steel points. The knight wields an orb studded with the same steel points, hanging from a chain—a lethal device that went by the ironic name of "Morning Star." On the other half of the page [9.57] is a design for inflatable equine swimming gear, perhaps Dürer's invention, with the explanation, "This is a parchment bag for a horse. When it is blown up, a broad stream can be crossed."

After drawing the many splendid stallions needed to pull Maximilian's various triumphal chariots [1.32]—among Dürer's most time-consuming projects—he had the chance to see some of the fanciest horseflesh in Europe when he went to his old patron's grandson, Charles V, seeking the new emperor's renewal of his pension.

When the artist visited Aachen at the time of Charles V's triumphal entry in 1521, he saw fine steeds in the most festive caparison, with a plumed panache, rows of jingling bells, elegant saddles, and tasseled blankets [9.58]. More were admired in Brussels—where he witnessed another of these richly staged entries, this time for King Christian II of Den-

248 Dürer's Animals

9.56

9.57

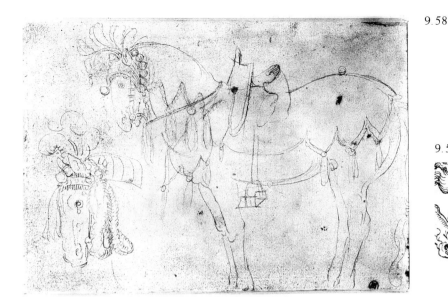

9.58

9.59

mark. Such horses were drawn in silverpoint, using a pocket-sized sketchbook. Dürer described these steeds and those owned by the Fuggers, the richest bankers of Germany, in a diary entry: "I was at the great horse-fair at Antwerp and I saw a great number of fine stallions ridden and two stallions in particular were sold for 700 florins." Right after that huge figure Dürer noted, "I have been paid one and three quarter florins for prints, the money I used for expenses; paid the doctor 4 stuivers." (That last pathetic sum was spent in the hope of curing the fatal malaria he had caught in the Lowlands' mosquito-infested marshes.)

In Ovid's *Book of Changes*, the Metamorphoses, those men and women beloved by the gods, are made immortal, and often turned into stars shining for eternity. In Dürer's *Celestial Map: The Northern Celestial Hemisphere*, the little horse's head, standing for the constellation Equus [9.59], might be construed as Dürer's genius, burning brightly alongside the great Pegasus, symbol of inspired soul and hand. One well-placed kick from winged Pegasus's hoof releases the well-springs of creative imagination, the inspiring waters of the Fount of Hippocrene. Dürer's lifelong passion for the beauty of horses inspired many of his best works. When Death came to the artist in 1528, was he riding the skeletal nag of the apocalyptic horseman, or did he come swooping down on that flying horse whose constellation glittered in Dürer's map of the northern stars?

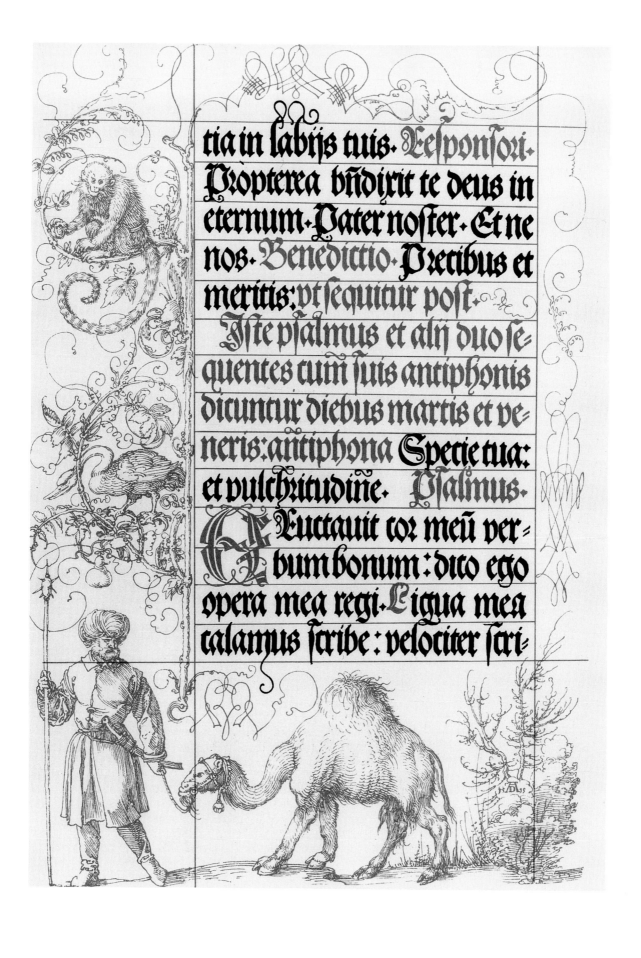

tia in labijs tuis. Responsori-
Propterea bñdixit te deus in
eternum. Pater noster. Et ne
nos. Benedictio. Precibus et
meritis: vt sequitur post.
Iste psalmus et alij duo se-
quentes cum suis antiphonis
dicuntur diebus martis et ve-
neris: antiphona Specie tua:
et pulchritudine. Psalmus.
Euctauit cor meũ ver=
bum bonum: dico ego
opera mea regi. Lingua mea
calamus scribe: velociter scri-

Chapter Ten

In the Stars and over the Seas

When Dürer was born, the world was on the brink of the great age of discovery. Explorers would soon reach the New World and find sea routes to the Orient and its treasures. Nuremberg, far from the western ports of Europe, was nevertheless at the center of things. "I have chosen Nuremberg for my place of residence," said Johann Müller, one of Europe's leading astronomers, "because I find without difficulty all the special instruments required by astronomy, and there it is easiest for me to keep in touch with the learned of all countries, for Nuremberg, thanks to the perpetual journeying of all her merchants, may be considered the center of Europe." Fine local craftsmen, such as Dürer's goldsmith father, made the precisely wrought astrolabes [10.1] and other equipment required for new navigation toward discovery. These intricate scientific instruments kept Nuremberg's economy humming.

Another Nuremberg astronomer, Bernhard Walther, built a house with a special balcony and windows for stargazing. He also bought whatever papers and instruments he could from Müller when that scholar left for Rome in the mid-1470s. Dürer, concerned with the heavens in so many of his works, bought Walther's house in 1509. The title page of a work by Ptolemy [10.2], found in Müller's translation from the Greek, first published in 1496, shows both astronomers seated to the left and right of an armillary sphere, where all twelve signs of the zodiac are seen on a narrow band—the ecliptic—wrapped about the earth. This was still the ancient geocentric view, soon to be challenged by Copernicus. Though crowned, Ptolemy is still doing his homework; Müller, gesturing in argument, need not crack a book. Far more modest in size is Dürer's first zodiac, printed in the same year, as part of a woodcut, *The Syphilitic Man*.

Müller's works helped lead Europeans to the unknown worlds lying to the east and west. His *Ephemerides*, publications that first came out in Nuremberg in 1472, were tables to measure latitude and longitude by using lunar distances, worked out through the year 1504. Müller's followers continued the astronomer's calculations after his death in 1476. With these findings, Italian, Portuguese, and Spanish navigators could chart their passages to the Indies.

Dürer's two woodcut star charts of 1515 [10.3; 10.4] are the first maps of the heavens ever printed. He worked on them with Maxi-

10.1

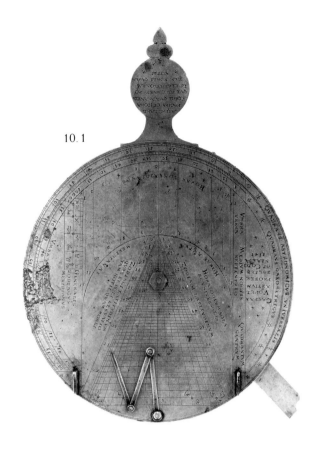

10.3

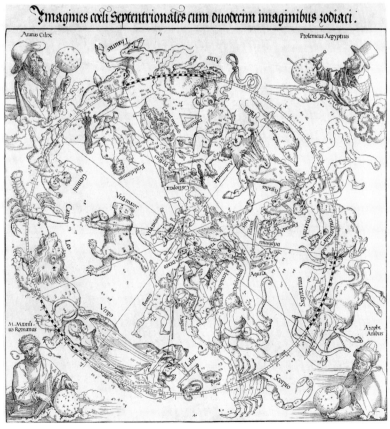

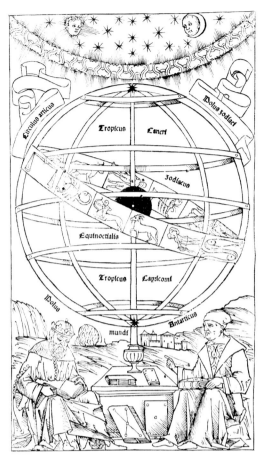

10.2

milian's astronomer, Johannes Stabius, a member of the emperor's college in Vienna, and Hainvogel, a Nuremberg astronomer, who drew in the coordinates. After designing the constellations in as classical or natural a form as possible, Dürer turned the drawings over to his woodblock cutters for printmaking. The sources for these prints were two very ornate parchment maps of the same subjects, illuminated in Vienna in 1503 [10.5; 10.6]. They bear inscriptions by Hainvogel and one Doctor Ulsenius, for whom Dürer designed *The Syphilitic Man*. To these maps of 1503, Dürer added two birds in black ink on the northern star chart—a raven and an eagle [3.36], representing Apollo and Jupiter, deities of Maximilian's Vienna College. Both parchment charts go back to a lost original, possibly owned by Müller, based on the position of the stars in 1424. Dürer's woodcut star charts are surpris-

ingly old fashioned, ignoring recent astronomical discoveries as they return to medieval and ancient sources.

At the upper left of the woodcut of the northern stars is an imaginary portrait of the Athenian poet Aratus, whose astrological poem *The Starry Sphere*, written in the third century B.C., told how to understand nature's signs. He provided beautiful, closely observed studies of animals' ways. As so many of the constellations form creatures, these heavenly beasts work with those on earth to provide a revealing dialogue, once man learns to see, hear, and understand their message.

Aratus's lovely lines, with those of Manilius (author of *Astronomica*, translated by Müller), who is portrayed by Dürer at the lower left, inspired Renaissance writers as well as painters. Those humanists who praised the natural wonders of Italy's painted and sculpted zoos stole many phrases from these ancient authors. At the lower right of Dürer's northern star chart is another imaginary portrait, of the astronomer al-Sufi, whose illustrations of the fixed stars were widely copied in the West. His manuscripts, based on Ptolemy, who is shown above him, presented a briskly animated series of zodiacal studies. The woodcut chart's fourth portrait is that of the Roman poet Maximus, also the author of astrological verse. By pairing two facing teams of astronomer-astrologers and writers, Stabius and Dürer suggested a relationship like their own, the essential collaboration of artist and scientist.

That astronomers and astrologers were linked was not unusual. Long after Dürer's time, astronomy was still inseparable from astrology—one, the study of the stars' nature, the other of their meaning. Horoscopes were cast in the same light as today's medical and psychological analyses, but they meant far more. The motion of the heavens shaped human life. Mere heredity or environment meant nothing compared with the cosmic drama of the moving, often animal-shaped constellations, whose position at the moment of birth

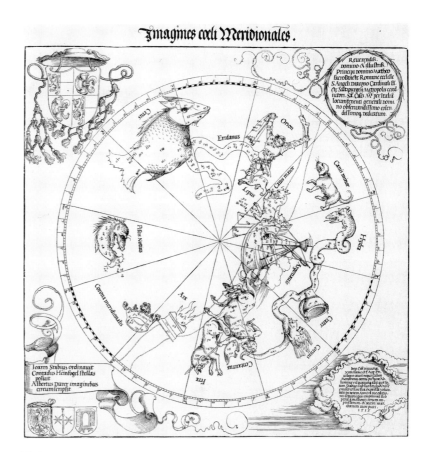

10.4

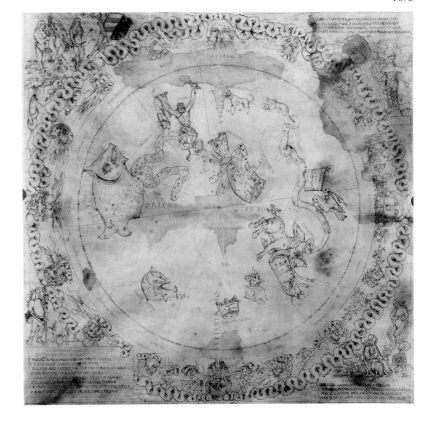

10.5

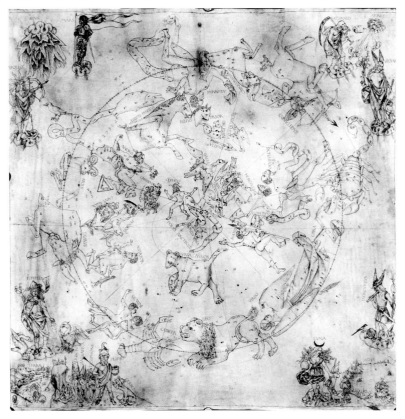

10.6

determined the total conduct, content, and passage of life to death and beyond.

Dürer's horoscope was prepared in 1507 by a priest, Canon Lorenz Behaim, who also drew up such charts for the entire Pirckheimer family. An astronomer and alchemist as well as a man of the cloth, Behaim was pleased with this work; in a letter to Pirckheimer, he stated:

Everything makes sense. Leo (the lion) being the ascendant, he is lean. Because the Wheel of Fortune is at the end, he will make money. Mercury in his natal house denotes genius in painting. And because Mercury is also in the house of Venus, his painting is elegant. Conversely, because Venus is in the house of Mercury, he is an avid lover. But Venus is separated from Saturn. This causes animosity, but is unimportant. The dual sign of Venus being inclined toward Luna makes him amorous. But Luna inclined toward the tail of the Serpent (Hydra) denotes decline. Because five planets are in a central position, his works and deeds are manifest to all. Because Mars is in Aries, he delights in weap-

ons. And because it is in the ninth house, he enjoys travel. Jupiter in the House of Substance means he will never be poor, but he will also have nothing left because Jupiter declines toward Virgo. And because the moon is not inclined toward any of the planets, he will, according to Ptolemy, have only one wife. Indeed, it is surprising that he is married at all. What else can I say? If he were here, I would tell him more. That is enough.

In *The Ship of Fools*, Sebastian Brant, the court humanist, opposed astrology, even though he earned most of his living by astrological predictions for Maximilian. Such a two-sided position is typical of the Renaissance, torn between love and fear of pagan knowledge. Brant's satire included the first literary reference to Columbus's discoveries. Just before writing it he had prepared the explorer's letters for German publication; Dürer had been in Basel near the time when they were first published there in 1494 and was in Venice when the explorer's more detailed account was printed there about ten years later. Animals as well as stars were used as guides; portents were found in "A Fly's Brain Lit by a Star" and in ornithomancy, prophecy based on birds' flight formations as shown in Dürer's illustration [10.7] and condemned by Brant's poem.

Dürer, Brant, and their patron Maximilian were all enormously involved with star lore. The important *Defense of Astrology* was published in Nuremberg in 1502, just after predictions that the world would end in 1500 had come to naught. However often condemned, astrology never lost its appeal. One might expect Luther to have opposed such arcane, pagan wisdom, but he did not, coming around to the compelling power of astrology in 1524, when the Reformer suspected that the frightening conjunction of planets in the sign of the fish, Pisces, should be seen as a heavenly alarm that the world would soon end. Luther cited the same freaks, including the Sow of Landser, which had frightened Germany twenty years before.

Even diseases were believed to come from the influence of the stars; our word *influenza* still bears witness to such thought. Dürer's earliest work showing the zodiac, *The Syphilitic Man* [10.8], is a vivid indication of the medical perspective of his times. This woodcut was made in 1496, the year of the first great European outbreak of the new disease, which was ascribed to an unfavorable conjunction of Jupiter and Saturn in Scorpio's sign in 1484, as indicated by the zodiac above the print's wretched subject. Covered with sores, the syphilitic holds out both arms imploringly, his fancy hat and richly draped cloak a sad contrast to his miserable state. The Ram and Bull, the first two signs, appear over the sick man's head, with the year of the evil star placement inscribed as if it were in the ring of the zodiac with Scorpio immediately above. The disease in fact may have been one of the earliest imports from the New World and was then known as the French or Spanish illness, after the countries where it first appeared. Scorpio's scourge may have had a personal meaning to Dürer, for he appears to have suffered from the same disease, which could account for his childless marriage.

When the future artist was six, perhaps the most exciting travel journal ever written, Marco Polo's, was first printed in Nuremberg. The frontispiece [10.9] shows the Venetian as a young man. A fine reporter, Polo's descriptions of elephants, rhinoceroses, tigers, and serpents sent shudders down many a reader's spine. His words about dogsleds, white bears, and reindeer-riding Tunguses brought remote regions to life. Both Columbus and Vasco de Gama concluded that if there were a land route to farthest Asia, surely there was a sea route too; each used Polo's book as the beginning of his campaign to reach the Indies—the Italian by sailing westward and the Portuguese eastward, down the African coast and around the Cape of Good Hope to India. With his own vast natural curiosity, Dürer must have shared the explorers' interest in learning of these exotic lands; much of his art was exploratory too,

10.7

10.8

256 Dürer's Animals

using skill, concentration, and innovation to bring a new sense of life, light, and space to the graphic arts. Some of his most brilliant works drew upon the explorers' findings—including the natives and the wildlife of newfound worlds.

Marco Polo's adventures led to the westward flow of Eastern goods, including silks, porcelains, and works in coral and precious metals. Exquisitely designed and highly finished Oriental decorative objects often included figures of dragons and flying storks, golden bears and fire-breathing monsters. Some of the dragons in Maximilian's *Book of Hours*, with their witty calligraphy, are distinctly Eastern in their design. This influence is also found in Dürer's ornamental motifs, where skinny blue and white Ming dynasty vases support wild rams and melancholic peasants, with bats resting on their gloomy heads [4.10; 8.53].

Exotic animals and people from Africa and India also found their way into Maximilian's *Book of Hours* [10.10; 10.11]; drawings of a

10.9

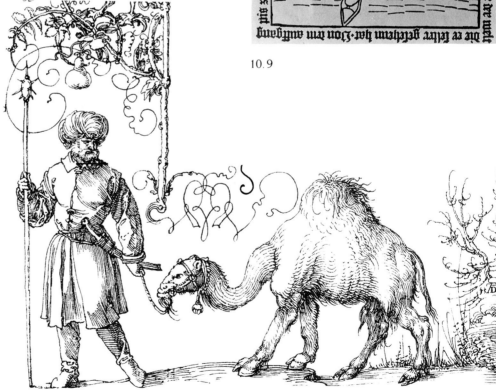

10.10 10.11

warrior from Calcutta and a ladle that was probably brought from the Far East by Portuguese navigators appear there. Dürer's friendly rival, the brilliant Augsburg artist Hans Burgkmair, added woodcuts of animals—an elephant [10.33], camel, and dromedary—and peoples from the Far East to the emperor's great woodcut, *Triumphal Procession*, that he and Dürer began in 1512 and worked on for many years. Only one brilliantly illustrated book could have given young Dürer the sense of being a pilgrim. This was a traveler's guide of 1486 to the Holy Land, described by one who had gone there, the dean of the cathedral of Mainz, where this work was printed. Various animals are assembled on a single woodcut page for Bernhard von Breydenbach's *Pilgrimage to the Holy Land* [10.12], where the draftsman and printmaker bring these images to life. This woodcut may be the work of the Housebook Master, among the most inventive and most acute of northern artists of the late fifteenth century, seemingly in Maximilian's employ, a decade or so before Dürer.

Printed in Nuremberg in 1505 was a book with the arresting title of *The Right Way to Travel from Lisbon to Calcutta Mile by Mile*, published by Weissenberger, who was the first to suggest that the New World be named after Amerigo Vespucci. A friend of Pirckheimer translated another text, also printed in Nuremberg, in 1508, *New, Unknown Lands and a New World Found in the Recent Past*. One more book came out in the same city two years later to describe the first German journey to the Portuguese East Indies and included richly decorated borders, with camel trains and other Near Eastern animal life. These were adapted by Dürer and his fellow artists for the borders they drew in Maximilian's *Hours* in 1515. Even more exotic woodcuts were provided by a book that came out in Augsburg in the same year: Vartoman's *The Knightly Voyage* included illustrations of Sumatran natives wearing the same sort of kiltlike skirts and feathers that Dürer's artists drew for the *Hours*.

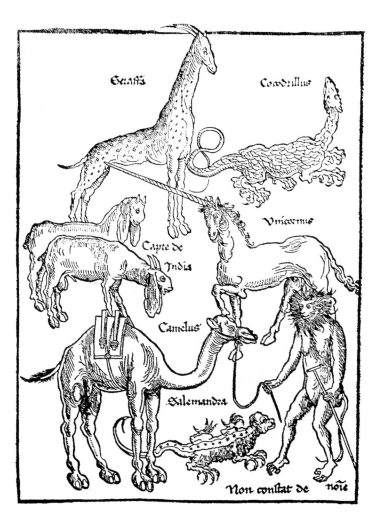

10.12

Lisbon soon eclipsed Venice as Europe's gateway to both the Orient and the New World. In 1519, a Portuguese, Chancelaria, wrote a poem in which he described "Lisbon, where all hasten to hunt," as teeming with gold, pearls, gems, gums, spices, and medicinal drugs, together with jaguars, lions, elephants, monkeys, talking birds, precious Oriental porcelains, and diamonds. A new Rome, Portugal, rising under the great leadership of its king Manuel, could rival the splendors of ancient empires, so the poet claimed.

Many Nuremberg trade representatives who were close to the Pirckheimers and Dürer moved to Lisbon and controlled much of the profitable spice trade from there to Germany. They wrote back of the natural wonders, like the rhinoceros, that were shipped to Portugal's

great harbor. That vast new seaport was competing with Venice for the arrival of new splendors.

And with the massive rise in foreign trade, many of the rarities from overseas came to be found in Dürer's art. Tropical, talkative birds were given him and his wife by Rodrigo, the Portuguese trade agent; images of elephants, lions, monkeys, and a rhinoceros worked their way into his prints, drawings, and travel journals. Other exotic beasts were seen, stuffed in the "chambers of wonders" [10.13] assembled by the wealthy Germans and Netherlanders or alive in the zoo of Charles V at Brussels [10.14].

Explorers to the New World were almost as taken with the beauty of the local wildlife as they were with abundant gold. Amerigo Vespucci, writing to the Medici of his second voyage, which left Cadiz in May 1499, noted at the end of his twenty-four-day journey that "We saw an immense number of birds, of varied forms and colors; a great number of parrots, and so many in variety that it caused us great astonishment. Some were crimson-colored, others of variegated green and lemon, others entirely green, and others again that were so sweet and melodious, as we heard it among the trees, that we often lingered, listening to their enchanting music. The trees, too, were so beautiful and smelled so sweetly, that we almost felt ourselves in a terrestrial paradise." Even Columbus, far less interested in animals, commented on the exotic bird life and wrote of seeing "mountains covered with monkeys."

Maximilian's grandson Charles V was the first of his descendants to benefit from the great wealth of the New World. In 1520 young Charles left Spain to be crowned Holy Roman emperor at Aachen. Dürer followed him there, for the renewal of the pension that had been granted him by the new emperor's grandfather. During his months in Germany and the Netherlands, Charles shipped on to Antwerp the letters and the splendors first sent by Cortés to Seville in 1519. Montezuma's marvels, the

10.13

feathered mantles and headdresses and finely wrought gold that had already astounded the Spanish people, were put on public view in Antwerp and described in Dürer's journal. His early training as a goldsmith, together with his love of nature, made his response to these treasures from overseas unusually strong and personal. "All the days of my life I have never seen anything that rejoiced my heart so much as these things," he wrote, "for I saw among them wonderful works of art, and I marveled at the subtle ingenuity of men in faraway lands. I cannot express the feeling that I had."

The artist saw more such exotica in 1521 when he went to Malines, at the court of Charles's aunt, Margaret of Austria, governess of the Netherlands. She owned Montezuma's stupendous headdress, with its gleaming blue-green fan of iridescent quetzal feathers, and kept a large collection of apes and parrots in her zoo. Margaret loved to walk around with strange pets on her arm or shoulder. Dürer noted of this visit, "She has given me no recompense for everything that I gave and did for her." Some of the Mexican treasures followed Dürer to Nuremberg, where Archduke Ferdinand's collection was exhibited in 1524.

Cortés's letters were printed in Nuremberg in 1524, translated from Spanish into Latin by a friend of Dürer and Pirckheimer. Dürer contributed a woodcut to this book, showing the Aztec capital of Tenochtitlán, the center of present-day Mexico City. He must have been fascinated by Cortes's description of the way animals were kept in Montezuma's palace. Birds—from kestrels and eagles to unknown species—were found in every room on their perches, or kept outside beneath latticework. Cortés wrote that they were fed only chickens. Lions, tigers, wolves, foxes, and cats of various kinds were housed in large cages and also given chickens. There were freshwater and saltwater pools for river birds; "above these pools were corridors and balconies, all very finely made, where Montezuma came to amuse himself by watching them." No sooner had he

10.14

finished describing the splendors of Cortés's treasures and the stirring effect that these marvels had upon him, than Dürer went on in his diary to tell about the wonderful things he saw in Antwerp, listing first and foremost "the great fish bone that seems to have been made of stone, a fathom long and very thick."

"Chambers of wonders," one-room museums of the masterpieces of nature and art, began to be popular at this time. Seashells, alligators, sea lions, exotic birds, and mineral specimens would be skillfully arranged to form a decorative and dazzling setting, a combination zoo, bank vault, freak show, museum of natural history, and art gallery. This is the sort of room Dürer saw in the Netherlands, where he had the chance to draw the stuffed walrus. At the upper left, that glass-eyed creature from the cold seas of the far north is so placed as to seem in combat with another beast from the deep. A sea lion, as if about to bark, is seen at the lower right, ready to sidle down the bookshelf, his animation a monument to the new art of taxidermy. A spoonbill, also shown in Maximilian's Hours [3.77], perches above a built-in combined desk and showcase, placed as if preening his feathers. Just to the left is an armadillo. Visitors to the chamber of wonders were especially impressed by a huge alligator, pointed out to them by a guide.

For all their knowledge of freshly chartered worlds, of birds and beasts never seen before, Dürer's generation wanted to place these new images in old frames, evident in the way the chamber exhibits the stuffed pelican perched on a cornice at the far right, next to the grinning blowfish. Here reality reinforces myth—the bird is displayed as she was believed to behave in the ancient bestiaries, pecking at her breast to provide blood to nurture the young, as Dürer had already portrayed her [3.70; 3.71]. A baby pelican is placed below, surviving by this fatal parental sacrifice and medieval symbol for Christian salvation. Tails held high, defying the dead yet menacing birds and beasts at every side, are two lively little griffons, the dog Dürer so much loved to draw, those faithful animals representing the life of study to which the chamber of wonders was also devoted.

Ready to return to Nuremberg in 1521, Dürer bought a big chest and filled it with purchases to be sent home. These included his greatest treasures—among them "the large tortoise-shell, the buckler of fish-skin, the long pipe, the long shield, the shark's fin and the two little vases with citronate and capers." He may have been the first northern artist with sufficient wealth to collect such a variety of curiosities, of animal specimens and craft examples, forerunner of the far more ambitious, encyclopedic gathering kept by Rembrandt in the next century. Among the Dutch master's marvels was a magnificent collection of Dürer's prints.

Ape and Monkey

Viewed as vain, imitative, clever, and thoroughly evil, monkeys in medieval lore were seen as signs of the devil, endowed with all those flaws that led to Adam's fall. Almost but not quite human, apes are like men without true understanding, lacking a sense of worth and faith. Too sexy, greedy, shiftless, and tricky, monkeys are nature's caricature of men's vices, living cartoons of folly. In German and English alike, the word *monkey* also means "fool."

"More fun than a barrel of monkeys" is one way of saying just how much mirth these animals can provide. In Renaissance Germany, such costly pets were kept for entertainment, chained to a windowsill in a craftsman's workroom [1.13]. Most of them were imported from Africa and often shown in art, as in the Eastern tales from *The Book of Wisdom*, printed in Germany when Dürer was twelve years old. Here six monkeys are catching birds [10.15]; those they cannot lure down from the tree they may trap or smoke out, using fire about to be lit in the hollow of the trunk. Less than a decade later, Dürer designed similar monkeys on an outing, in a woodcut for Brant's *The Ship of Fools* [10.16]. Objecting to business on the Sabbath, Brant wrote of seven monkeys (possibly representing the seven deadly sins) un-

10.15

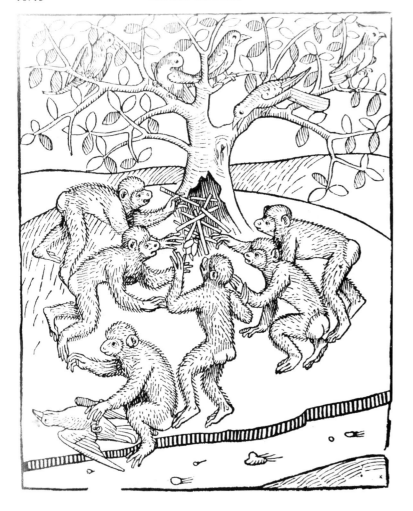

able to resist a peddler's sales pitch on a Sunday. Such folly makes apes of men; those who prefer buying to churchgoing are reduced to monkey business.

Writing of the endless profusion of recently printed books, of the confusion of new learning that would lead to the imminent coming of the Antichrist [12.16], Brant noted that holy men could not cope with this literature:

Men say: "these lazy apes, these beasts,
The devil's cursing us with priests!"

Another woodcut in the same work showed the power of love turning men into apes and asses, following an old proverb.

In an altarpiece where the standing Virgin is surrounded by panels showing her Seven Sorrows, the animal closest to the viewer is a monkey from Senegal, in the foreground of *Christ among the Doctors* [Plate 25], Mary's Third Sorrow. Among Dürer's most important early commissions, this altarpiece was ordered by Frederick the Wise in 1496 for the chapel of his castle at Wittenberg. Luther, who loved art and animals alike, must have known this image, kept near the church where he posted the Ninety-five Theses.

The ape's sorrowful pose echoes that of the melancholic, frustrated rabbi immediately above. The monkey's presence under a Hebrew book helps identify the setting as a synagogue, for Jews were sometimes equated with apes in the Middle Ages, stubborn in their refusal to recognize the divinity of Christ. Here the twelve-year-old Jesus is shown disputing with the doctors as his worried parents enter from the left. Seated under the temple's light, he points triumphantly to the text proving his argument, as the elders cower in frustration and dismay. The only note of cheer is Dürer's dog, peeking out from the side of a confounded rabbi.

Dürer's choice of ape may represent an in-joke on his part, for this species is known in German as "nun-monkey" and turns up again

10.16

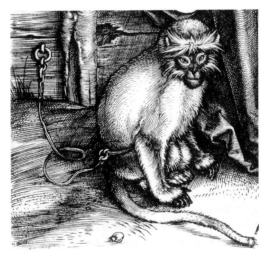

10.17

in an engraving, *Madonna and Child with Monkey* [2.8; 10.17], where it is chained to a retaining wall that seats the Virgin and Child. Like the chained fox in *Our Lady of the Animals*, the monkey stands for Jesus' and Mary's conquest over sin, as the new Adam and new Eve. Here the beast is contrasted with the bird on a string fed by Jesus. The first animal represents the Fall of Man, the second points to the Resurrection. Painting and print both go back to the same simian study (now lost), which, like so many of Dürer's images, was used over and over

10.18

10.19

10.20

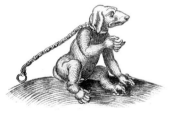

10.21

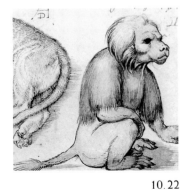

10.22

throughout his life and is found again in Maximilian's *Hours* and *Triumphal Arch* [10.18; 10.19].

Twelve or so years later, monkeys turn up once more as thoroughly pagan creatures in *The Hieroglyphica* of Horus Apollo. None of the apes and monkeys Dürer made for this text survive, but several copies show what these lost works looked like. He chose a baboon (known in German as a "dog-monkey") to show the hieroglyph for Moonrise, wearing a crown and standing, arms raised heavenward, praying to the moon goddess [10.20]. Seated and chained to a wall, the baboon symbolizes the two yearly equinoxes, during which it urinates twelve times a day as it cries on the hour [10.21]. Because these clever beasts knew of the coming of the equinox, they were kept in Egyptian temples. Their image, according to Horus Apollo, could also mean "the moon, inhabited earth, letters, a priest, anger, and a diver."

On his visit to Brussels in 1521, Dürer drew a dog-faced baboon from life, colored in gouache, with blue fur, rose-colored face and hindquarters, and gray paws [10.22]. His fragmentary inscription at the upper right reads, "an extraordinary animal which I . . . big, one and one half hundred weight." While in Antwerp he acquired a living souvenir—"I bought a little seacat [a long-tailed Indian monkey] for four gold florins and five fish for five *stuivers*."

The artist drew his largest page of monkeys in 1523, showing twelve of them in a circle, like a simian zodiac, dancing, tumbling, piping, and camping their way around [10.23]. But monkeys and circles are a bad combination, signs of endless folly. Seven years earlier, Dürer's printer Holtzel had published a satire on people's greedy ways with a title page showing animals seated around a table drinking themselves sodden. A monkey at the center cheered them on. As Dürer's monkeys were commissioned by a Swiss follower of Luther, they too must have been meant as moralizing, more than merely diverting.

Satire was a strong weapon for the Protestant reformers, who sought Dürer's help in designing a broadsheet against the power of the Catholic priests. By comparing the gestures made during the performance of the Mass to the monkeyshines of the popular morris dancers, Protestants hoped to attract followers to their churches. So a Zurich minister requested the drawing of such a subject that Dürer provided and sent with the following message written on the back: "But in regard to the dance of the monkeys which you asked me to draw, I am sending you an awkward sketch, for I have not been able to see monkeys in a long time. Please be understanding. Kindly convey my regards to Herr Zwingli"—the leader of the Reformation in German-speaking Switzerland.

Camel

Neither the camel nor its Arabian cousin, the one-humped dromedary, was drawn correctly by Dürer; their necks were much too long and thin, rising in sudden, snake-like fashion from the shoulder. Valued for transport, these animals are driven away when Job loses his flocks to his enemies, seen in the middle ground of an altar painted just before Dürer's second Italian journey [Plate 29]. Dressed as a dandy, he casts himself as one of Job's friends, trying to comfort and divert the plagued man by playing a drum.

More than a decade later, the artist drew a much larger dromedary in the margin of Maximilian's *Hours*, dwarfed by its heavily armed and turbaned keeper, an Oriental bell around its neck. This Eastern team may suggest the forces of Islam, enemies of Christianity, here equated with David's enemies, from his psalm printed on this and the facing page. A mischievous monkey clutches a ball as if ready to let fly. Evil, he makes the dromedary guilty by association. A few years later, Dürer or a studio assistant, still working in the decorative style developed for Maximilian, de-

263 In the Stars and over the Seas

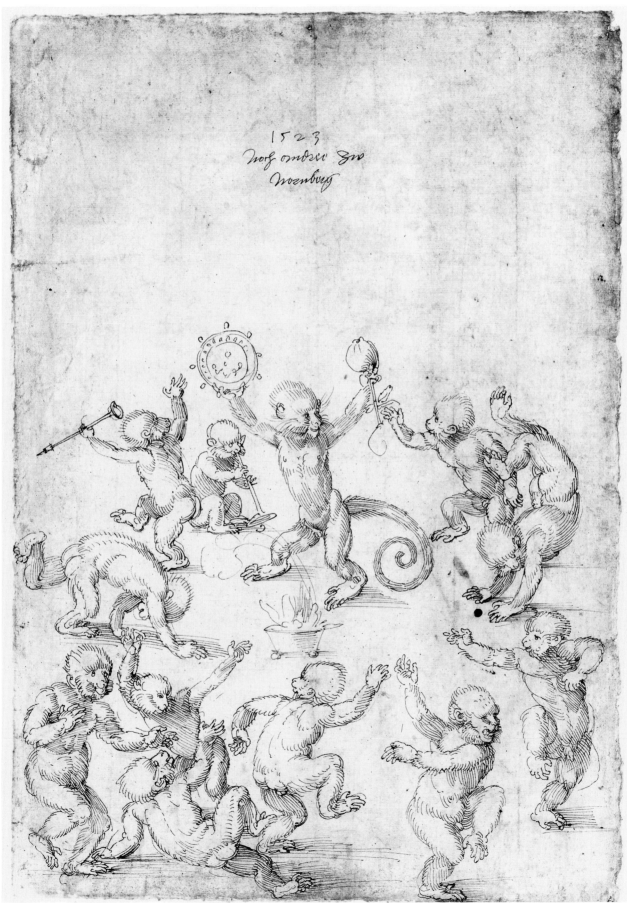

10.23

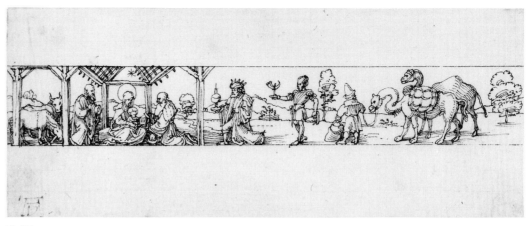

10.24

signed a very narrow frieze of *The Adoration of the Magi* [10.24] and *Christ Carrying the Cross,* probably for use as an engraving on a sword blade or handle. Here the camels at the far right, bearing the Magi's gifts as they did in *Our Lady of the Animals,* are in sharp contrast with the everyday ox and ass at the far left.

In 1520 if not before, Dürer certainly saw real camels, for he records having witnessed "the three holy kings riding on great camels and on other rare beasts, very well arranged, in Antwerp for a procession on the first Sunday after Assumption." Perhaps they were lent for the parade from Charles's zoo.

Crocodile

10.25

10.26

10.27

For better or worse, live crocodiles and alligators did not "travel well" and were seldom if ever found in northern Europe, although some may have been kept in southern zoos such as that of the king of Naples. "A curse on four legs" is the way Pliny described the crocodile, "equally pernicious on land and in the water." Egyptian gods were known to take the shape of crocodiles, so Horus Apollo had much to say on the subject of that fierce, crawling beast, and several copies survive of Dürer's neo-Egyptian crocodiles drawn for that text. Shown in its entirety [10.25] a crocodile is almost all bad, a symbol of a plunderer or madman, because this beast "is fecund, has many offspring and raves." According to the author, the Egyptians "to indicate a sunrise draw two crocodile's eyes because the eyes of the crocodile emerge from the depths first, before the rest of the body" [10.26]. Dusk was indicated by depicting the tail all alone [10.27] "since the crocodile does not produce disappearance and destruction except by striking its victim and reducing it to immobility with its tail. For in this part of it lies the crocodile's strength and courage."

That the crocodile was coming to the consciousness of the West, if slowly, is suggested by Erasmus's question: "What will it profit you to utter a syllogism on the crocodile if you do not know whether a crocodile is a kind of plant or animal?" He tried to remedy such ignorance by recommending the inclusion of animal pictures in the classroom, to teach Greek and Latin as well as zoology. Although Dürer could not furnish Erasmus with a print of this rare beast, such works as his *Rhinoceros* could easily have been used for instruction. A wall painting in Erasmus's imaginary, ideal classroom showed the Nile, where "a dolphin, that natural friend of man, is fighting with man's deadly animal, the crocodile."

By the later sixteenth century alligators came to Europe from the New World. Seemingly fierce, stuffed alligators were hung from ceilings in alchemical studios and chambers of wonders. Small alligators worked in gold also came from Mexico and South America and were much admired for their craftsmanship.

Nuremberg's artisans, too, fabricated fine little spice boxes shaped like alligators, their precious contents guarded by "curses on four legs."

By the time Dürer drew fiercely whimsical crocodiles up and down the borders of Maximilian's *Hours*, he had seen some of their skins and brought them back to life by his calligraphy. Here, the crocodile's tail [10.28] almost touches that of the furious lion below, shown beside himself with rage as a fly buzzes maddeningly overhead [6.39]. Clearly the insouciant crocodile could not care less as it heads up the margin, a wicked smile instead of crocodile tears on its dolphinlike head.

Dodo

Rarest of all creatures sketched by Dürer's circle is the dodo, the bird drawn on the left margin of Maximilian's *Hours* [10.29], if identified correctly as such here. Its name derived from the Portuguese for "fool," *doudo*, this bird became known with the European discovery of the island of Mauritius in 1507. Extinct since the late seventeenth century, the poor, hard-headed dodo, unable to fly, could escape neither hunters nor rats. Why hunters wanted dodos no one knows; as an early writer noted, "the flesh is very tough." The ugly bird's huge, black bill ended in a hook, its cheeks were unfeathered. The dodo's short, stout legs were yellow, like a chicken's. It had dark, ash-colored plumage, white at the breast and tail, with yellow, flightless wings. For all its odd appearance, the dodo had a very common relative—the pigeon.

Our knowledge of the bird comes from old drawings, like Savery's of 1599 [10.30], based on the two dodos kept in the zoo of Maximilian's great-great-grandson, Rudolph II of Prague, who collected rare beasts and Dürer's works with equal passion.

10.28

10.29

10.30

Elephant

Largest of land animals, the elephant has always been admired for qualities of character as well as for sheer size. Their wise nature was recorded in touching detail by Plutarch in his essay, "The Cleverness of Animals." He describes an elephant in a Roman circus, having trouble mastering a complicated series of dance steps and turns: "Slowest to learn [the elephant was] always being scolded and often punished; he was seen at night, alone by himself in the moonlight, voluntarily rehearsing his lessons and practicing them." Pliny found the elephant "nearest to man in intelligence: it . . . is pleased by affection and by marks of honor, nay more, it possesses virtues rare even in man, honesty, wisdom, justice, also respect for the earth and reverence for the sun and moon."

Elephants came Dürer's way via Maximilian's imperial concerns. Holy Roman emperors viewed these animals as their due and brought them northward from time to time.

Schongauer's popular engraving of an elephant [10.31] has it supporting a turret from which a warrior takes aim; the ears and trunk look armored, as if made of layers of ridged steel, like Dürer's *Rhinoceros*. This odd print must have been made when an African elephant was exhibited at the Frankfurt fair in 1480 and was probably the same creature that was shown in Cologne two years later, providing the model for the elephant in the *Hortus sanitatis*, which came out in 1485, when Dürer was fourteen. Used as tanks in Indian warfare, elephants were represented in that military function in Indian and Western manuscripts; the combination of the ivory-tusked beast of battle and the fortified turret rising from the saddle led to the expression "the ivory tower." Schongauer's squinty-eyed version, with its weirdly serpentine trunk, reappears in the margins Dürer drew for Maximilian's *Hours* [10.32] along with a naturalistic one by Burgkmair [10.33] for the same book, found also in the coats of arms on the emperor's *Triumphal Arch*.

Turning to Gothic elephants for the margins of the emperor's prayers was one thing, but using the same outdated images in a scientific publication that also included Dürer's beautifully devised armillary sphere was quite another. The artist protested when he saw such quaint cuts [10.34], furnished by the Strasbourg publisher who popularized Ptolemy in 1525. Pirckheimer reported: "I wish you could have heard what Dürer said about the decorations in the book. He had not found a single good line in them and made fun of me, saying we will reap great honors when the book reaches the knowledgeable painters of Italy. Then my translation will be put in those splen-

10.31

did decorations, and you and I will be considered grossly uneducated." Pygmy in size and dwarfed by the native family standing alongside, this elephant looks appropriately cross as a little boy plays with its trunk.

If Dürer illustrated every last one of the hieroglyphs given by Horus Apollo, many elephants must have come from his hand. Among the Egyptian messages conveyed by this beast according to the ancient text is one for "A Strong Man Sensitive to What is Expedient," because "the elephant smells with his trunk and is master of his fate." The same text claims that a hieroglyph showing an elephant burying his tusks signifies "A Man Who Has Prepared His Own Tomb." The greater part of the elephant's wisdom was always to know when to get going. As vulnerable as he is wise, threatened by the very small (the mouse) as well as by the large (the rhinoceros), the pachyderm saves his life by taking flight.

Hippopotamus

Because the Horus Apollo was meant to explain the picture-language of the Nile, Dürer was called upon to draw a hippopotamus, an animal of then-unknown appearance. Happily for him, the hieroglyph described by Horus Apollo is limited to "two hippopotamus claws, turned down"; Dürer's now-lost version is known from an early copy [10.35]. Pliny's well-known description gave the beast's hoofs "as cloven like those of the oxen." With this sign the Egyptians were supposed to "represent the unjust and the ungrateful."

Ibis

Like the hippopotamus and so many of Dürer's exotic drawings, the Egyptian ibis [10.36] was prepared as an illustration to the Horus Apollo, which said, "When [the Egyptians] wish to denote the heart, they draw an ibis. For this animal is sacred to Hermes, lord of every heart and reason, since the ibis is also like the

10.32 10.33

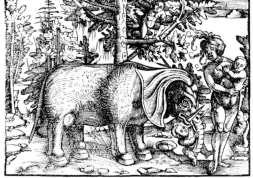

10.34

10.35 10.36

heart itself." Trying to make sense of this arcane text, Dürer decided that the heart symbolism was based on the shape of the bird's breast, stressing this in his rendering, now only known from this copy.

Parrot

Overdressed and garrulous, parrots make unlikely messengers of sacred tidings, but so were they seen in Christian symbolism. Virgil's account of the bird who hailed Caesar was understood in the Middle Ages as prophecy of the coming of the Virgin and the Ave Maria. The bird's bright green, waterproof feathers were also interpreted as signs of Marian virginity. Thus the clever bird came as close to an angelic messenger as most mere mortals could hope to see.

First found in the mountain forests and lowland jungles of India and Ceylon, parrots were brought to Europe long before Dürer's day and soon became surprisingly well acclimatized to the cold.

In 1500, at about the time Dürer made his watercolor of a parrot [Plate 30], a cardinal is said to have spent a hundred gold pieces for such a gay bird because he was capable of repeating with singular clarity and conviction the entire Apostles' Creed! Parrots were considered splendid presents even when their piety left something to be desired. The Pirckheimers ordered parrots in Antwerp in 1505, but their agents were robbed of a basketful of these birds on the way to Nuremberg. On the Dürers' visit to the harbor city, the artist's wife was presented with a little green parrot by their Portuguese friend Rodrigo; he also gave Dürer one or two parrots from Malaga. (The artist and his wife bought separate cages for their birds; hers appears on a shopping list including slippers and knee hose.)

Ornithologists differ as to just what sort of bird Dürer drew from; most call it a ring-necked parakeet, or a grey African parrot, which has a red tail. The drawing that Dürer prepared with pen and watercolor includes the crossbar the bird is perched on; it was probably drawn around 1502 (the date of 1513 on the watercolor itself was added later), before the final version of *Our Lady of the Animals*, where the same parrot is perched on the post at the Virgin's side. It is the only one of Dürer's

10.37

large watercolor studies to be seen in an engraving, reversed in *Adam and Eve* [10.37]. Here the parrot's rod becomes a branch from which the artist's signature is suspended, proudly inscribed on a hanging tablet.

Peacock

Such splendid plumage must have caught Dürer's eye, but no major study of the bird, prized as much for its expensive meat as for its fine feathers, is known. One stands below the woodcut *Wheel of Fortune* [10.38], clearly find-

10.38

ing this placement beneath his dignity and thus keeping his plumage to himself. Twelve peacock feathers are poked into the "buffalo's horns" rising from the Roggendorf crown in Dürer's armorial woodcut of 1520 [6.27], prepared in Antwerp, where such feathers were imported. They create a radiant fan from which the rampant, crowned Roggendorf lion emerges. By devising these sumptuous arms, Dürer, ever the dandy, could become a peacock himself; the wealthy brothers paid him in the form of seven ells—a little less than seven yards—of very costly silk velvet.

Rhinoceros

The single-horned creature, "one of the most fierce of animals," so medieval bestiaries said, "has between its eyes a terribly sharp horn which no armor in the world can withstand. Because of its ferocity, this animal can be captured by humans only through a ruse; a pure virgin approaches it, and drawn by the smell of her virginity, it lies down at her feet where it falls asleep, and is killed by a hunter."

This fierce creature "symbolizes savage people whom no human can withstand, but who may be overcome by the power of divinity, and reformed. As this power proved itself with Saul, so it affects the same upon many others."

Unlike the elephant, the rhinoceros seldom traveled in life or art. Too wild and unresponsive for taming, the beast was nevertheless famous for its single horn, which stood for two very different qualities. In Europe the animal was linked to David's Ninety-second Psalm: "But my horn thou shalt exalt like the horn of a unicorn," and in the Orient rhinoceros horn was a costly aphrodisiac. This belief has led to fewer rather than more rhinos, for hunters have been killing them and selling their horns to the Chinese in powdered form to the present day.

The first Westerner since antiquity known to have seen the Indian rhinoceros was Marco Polo in the thirteenth century. He stopped at Sumatra on his return from China to Venice, where he saw "lion-horns, which though they have feet like elephants, are much smaller than the latter, resemble the buffalo in the distribution of their hair and have two horns on their heads, with which, however, they harm no one." Marco reluctantly concluded the animal with the single horn to be the source for that dreaded yet sacred beast, the powerful unicorn. "All in all," he commented, "they are nasty creatures, they always carry their piglike heads to the ground, like to wallow in mud, and are not in the least like the unicorns of which our stories speak in Europe. Can an animal of their race feel at ease in the lap of a virgin? I will say only one thing: this creature is entirely different from what we fancied."

By 1483, as the canals of Bruges, the Netherlands' major port, were slowly being clogged by sediment, a new harbor was established on the shore at Antwerp. There, a book illustrator worked on modernizing the unicorn to make it conform with descriptions from the East. This strange creature, leaping forward in the *Animals' Dialogues Moralized* [10.39], moves toward a hermit who grasps his prayer beads as if these, with his stick, could fortify him against all dangers, including those of a rambunctious, but not necessarily mean-spirited, late Gothic rhinoceros. With its leonine physique, the animal may have been derived from Marco Polo's "lion-horns," as could the two horns on his brow, all of which, as the Venetian traveler had so mistakenly assured his readers, "harm no one."

10.39

Strangely, the only large print Dürer devoted to an exotic animal was the woodcut of 1515, which showed one he had never seen. This was the famous *Rhinoceros* [10.40], based on a drawing made by Valentine Ferdinand, a Moravian printer who was in Lisbon when the great beast was shipped there in May 1515, sent from the farthest reaches among Portuguese maritime conquests, Cambay in northwest India. The print also reproduces Ferdinand's text, which must have accompanied his lost rendering to Germany [10.41]:

They call it a rhinoceros. It is represented here in its complete form. It has the color of a speckled turtle. And in size it is like the elephant but lower on its legs, and almost invulnerable. It has a sharp strong horn on its nose, which it starts to sharpen whenever it is near stones. The stupid animal is the mortal enemy of the elephant. . . . Because that animal is so well armed, the elephant cannot do anything to it. They also say that the rhinoceros is fast, lively and clever. The animal is called "Rhinocero" in Greek and in Latin. In India it is called "Ganda."

270 Dürer's Animals

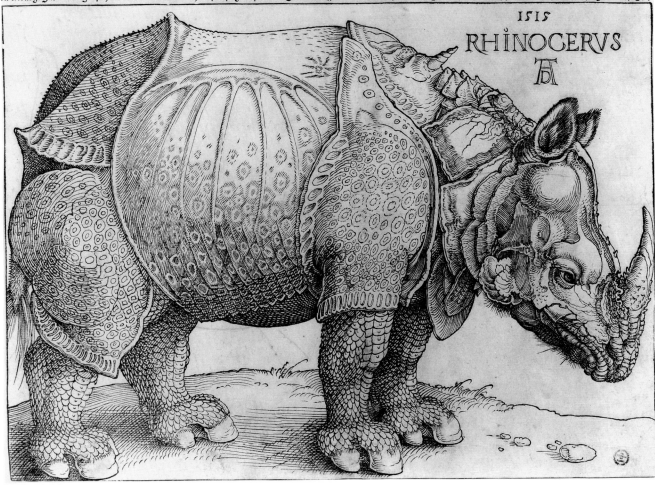

Nach Christus gepurt.1513.Jar.Adi.1.May. Hat man dem grosmechtigen Künig von Portugall Emanuell gen Lysabona pracht auß India/ein sollich lebendig Thier. Das nennen sie Rhinocerus. Das ist hye mit aller seiner gestalt Abconderfet. Es hat ein farb wie ein gesprecklete Schildkrot.Vnd ist vö dicken Schalen vberlegt fast fest. Vnd ist in der gröss als der Helfandt Aber nydertrechtiger von paynen/vnd fast weyhasstig. Es hat ein scharff starck Horn vorn auff der nasen/Das begyndt es alweg zu wetzen wo es bey staynen ist. Das dosig Thier ist des Helfantz todt feyndt. Der Helffandt furcht es fast vbel/dann wo es In ankumbt/so laufft Im das Thier mit dem kopff zwischen dye fordern payn/vnd reyst den Helffandt vnden am pauch auff vnd erwürgt In/des mag er sich nit erwern. Dann das Thier ist also gewapent/das Im der Helffandt nichts kan thün. Sie sagen auch das der Rhynocerus Schnell/Fraydig vnd Listig sey.

10.40

Dürer used a woodblock instead of a copperplate, so a maximum number of impressions could be made. His print is really a broadside, a journalistic scoop of a major event, like the engraving he had made of the Sow of Landser [12.15], another marvel he never saw.

A specialist in rhinoceros's dermatology has suggested that this poor animal may have acquired some funguslike ailment on his long, damp sea trip, which would account for the beast's strange scale pattern. The print was prepared when Dürer was at the peak of his labors for Maximilian; the complicated cut of the fierce beast's covering recalls those of courtly armor. The animal has a strangely "dressed" look, like some revolting pet lovingly clad by a proud owner. This personal quality is one of the many reasons why Dürer's print remained the definitive image of the rhinoceros centuries after its many inaccuracies and strange little additions—such as the spiral dorsal horn above the shoulders (pointing directly toward the R in the word *rhinoceros* just above)—had been noted.

The rhinoceros fought its way into Maximilian's *Hours* only to stand below a psalm asking for divine mercy and blessing (the decorations on this page made by an unknown associate of Dürer). The exotic animal is also included in the emperor's *Triumphal Arch*

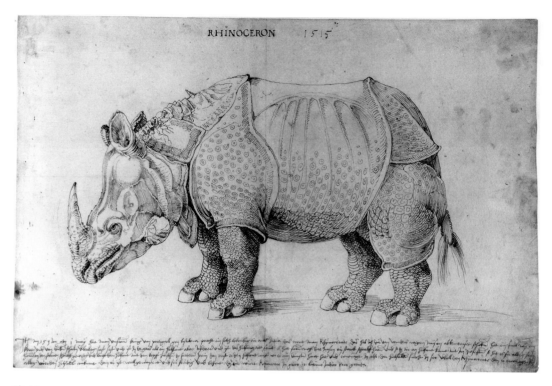

10.41

[10.42], on the coat of arms of the Moluccan Isles in the Indian Ocean, which the emperor claimed as his own.

Far less vulnerable in art than in nature, Dürer's *ganda* went into eight printings, seven of them posthumous. In the seventeenth century, the woodblock, by then beginning to show signs of wear and tear, came into the possession of a famous Dutch map printer, Hendrick Hondius, and his partner. Their skilled craftsman prepared an additional woodcut, inked in grey to be printed over the first one to create a chiaroscuro effect, lengthening the old block's life and enhancing the image's rich graphic quality to suit the new Baroque style. When Burgkmair made his own rhinoceros print in the year 1515 [10.43], he left out that little extra dorsal horn and the dramatic armor plate and pie-crust edging that make Dürer's beast so well dressed. But Burgkmair's more accurate rhino never caught on. People wanted to believe in the rhinoceros just as Dürer first showed it. If nature was demonstrably different, he was right and reality was wrong.

In 1547, the *ganda* was reborn as a great statue [10.44], part of the splendid pageantry celebrating the triumphal entry into Paris of the city's new king, Henri II, and his young Medici queen, Catherine. According to the festival book commemorating the event, the fierce beast connotes force and vigilance. Like the Egyptian monuments inscribed with hier-

10.43

10.42

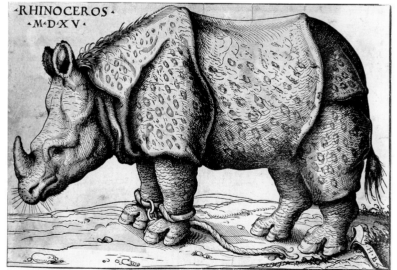

10.44

oglyphs that had so fascinated Maximilian, the obelisk strapped to the *ganda*'s back is covered with animal pictographs. Squeezed below the rhino are a lion, boar, and other beasts, symbols of nations defeated by France. The same victorious theme is carried to the top of the obelisk, where a triumphant warrior is about to sheathe his sword.

Henri's father had seen the *ganda* itself. More than thirty years earlier, François I had sailed from Marseilles to catch a glimpse of that "wonderful beast called Reynoceron" grazing on a little isle nearby, for a rest stop on the way from Portugal to Rome. There the animal was to be presented to the Medici pope Leo X as a gift from the king of Portugal, but it drowned in a shipwreck en route.

Tough customers, the Medici had a soft spot for the rhino, whose harsh and greedy ways resembled their own. Duke Alessandro de' Medici saw to it that Dürer's well-protected beast was engraved upon his armor as an emblem of invincibility, along with the canny Latin motto: "I war not but to win." When the Florentine family had wild animal groups sculpted for their grotto in the Boboli Gardens, the rhinoceros, once again, was modeled upon Dürer's.

Not until 1579 did another rhinoceros come to Lisbon, and seven years later, the Flemish engraver Phillip Galle published an accurate engraving of it, but nobody cared. Portuguese maps, often made by artists trained in the Netherlands or Germany, also included tiny but correct portraits of the beast, but, once more, Dürer's was It.

The woodcut rhinoceros even found its way into a book by a follower of Leonardo da Vinci, Giacomo della Porta, who continued that genius's study *Of Human Physiognomy*, where the rhino's head appears opposite a portrait of the Tuscan poet Angelo Poliziano, whose lines had inspired Dürer's art. Slightly cross-eyed, with a very large nose indeed, the writer was found to look *ganda*-like, an animal believed by della Porta to be "ingenious, astute, happy and skillful."

Later and still stranger is a sculpture based on Dürer's design [10.45], housed in the Schönborn castle not far from Nuremberg. Whoever crafted this relief followed Dürer's words as closely as his lines: Translating word into image for his punlike portrait, the artisan has composed the rhino of tortoise, coral, and seashells from all over the world. Playful works like these were made to suggest how art's nature could recreate nature's art, a sort of rustic photograph or fossil Polaroid, devising the rhinoceros's image from other hard-shelled creatures.

Though the relief was never designed to deceive, another plaque, of carved marble [10.46], was meant to be taken for a Roman antiquity. What this wily forger did not know

273　In the Stars and over the Seas

10.45

10.46

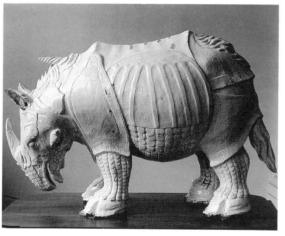

10.47

when he worked after an Italian copy of Dürer's woodcut made in 1548 was that the ancient Romans knew only the African rhinoceros, which has two horns!

Several centuries later, the king of Saxony ordered a great zoo of glistening white china to fill a vast gallery in his Porcelain Palace at Dresden. Working in 1731, the modeler Kirchner followed Dürer's *ganda*, except for the more horselike hoofs and a straight panel going down the front legs [10.47]. Augustus's jest in china contrasts the ponderous bulk of the toughest of beasts with the most fragile of media, pure white porcelain, glassy in its delicate perfection. With the death of Augustus the Strong, this china zoo, where many of the smaller specimens were shown life-size, was abandoned. Happily, enough of these creatures were completed to give an idea of the king's caprice.

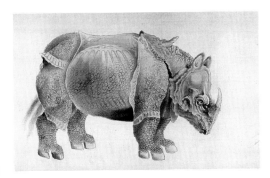

10.48

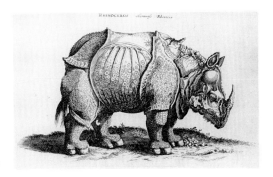

10.49

A Far Eastern copy of Dürer's *ganda*, a beautifully brushed beast, was painted on silk by Tani Buncho in 1790 [10.48]. The Japanese master did not go directly to the German source but used a version found in Jan Joesten's *Curious Descriptions of the Nature of Four-Footed Animals, Fish and Bloodless Water Animals, Birds, Crocodiles, Snakes, and Dragons*, printed in Amsterdam in 1660 [10.49]. Unlike so many copies, Joesten's is not reversed; his rhino lumbers along in the same direction as the original, and so does Tani Buncho's.

Sea Turtle

In Dürer's engraved *Sea Monster* [10.50] the shell of the great sea turtle is turned into a shield, protecting the chest of an old merman as he swims along, carrying off a beautiful woman. Strung on a cord around his neck, the turtle shell is also held up by the merman's weapon, a jawbone, probably that of a horse. In this print, Dürer delights in placing next to one another so many different organic textures, of bone, shell, fishskin, hair, horn, and flesh. Satyrs and sea centaurs were given bone weapons in northern Italian Renaissance engravings, and on his visit to that region, if not before, he could have seen such great turtle shells, imported to Venice, where they were made into precious objects, sometimes set in gold.

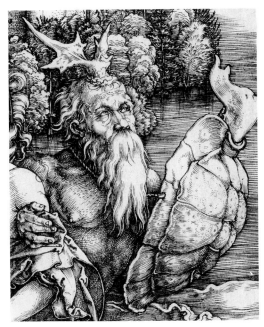

10.50

Walrus

Strangest of the animals drawn on Dürer's journey to the Lowlands in 1521 is a walrus [Plate 31], done in watercolor and pen and brown ink. "This sleepy animal," Dürer wrote on the page, "whose head I sketched here, was caught in the Netherlandish sea. It measured twelve ells in length and moves on four legs." Whether the German word *dosig* means "sleepy" or "this very" is the center of scholarly dispute, for if the latter reading is correct the animal may well have been a stuffed one, drawn by Dürer in some crowded chamber of wonders. Something about the beast's glassy-eyed stare suggests the taxidermist's rather than nature's art. These animals were great curiosities, and it seems unlikely that they could have lived in captivity for long. Two years before Dürer's drawing, the bishop of Trondheim cut off the head of a walrus and had it pickled in brine before shipment to Leo X, where it joined the stuffed Indian rhinoceros in the papal collections. Dürer probably drew after a similar model, seeing only a head, referring to the "four legs" on the basis of hearsay.

A few months after Dürer returned to Nuremberg, he drew plans for a very large altarpiece, *Madonna with Eight Saints and Musical Angels* [10.51], modeled on compositions he had seen recently in the Netherlands. One striking souvenir of his journey is included in the foreground—the artist used his study of the walrus for Saint Catherine's dragon [10.52]. This project came to naught with the Reformation, when complex works of Marian art became an endangered if not extinct species.

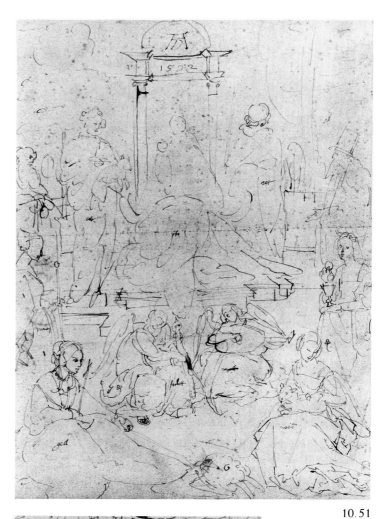

10.51

10.52

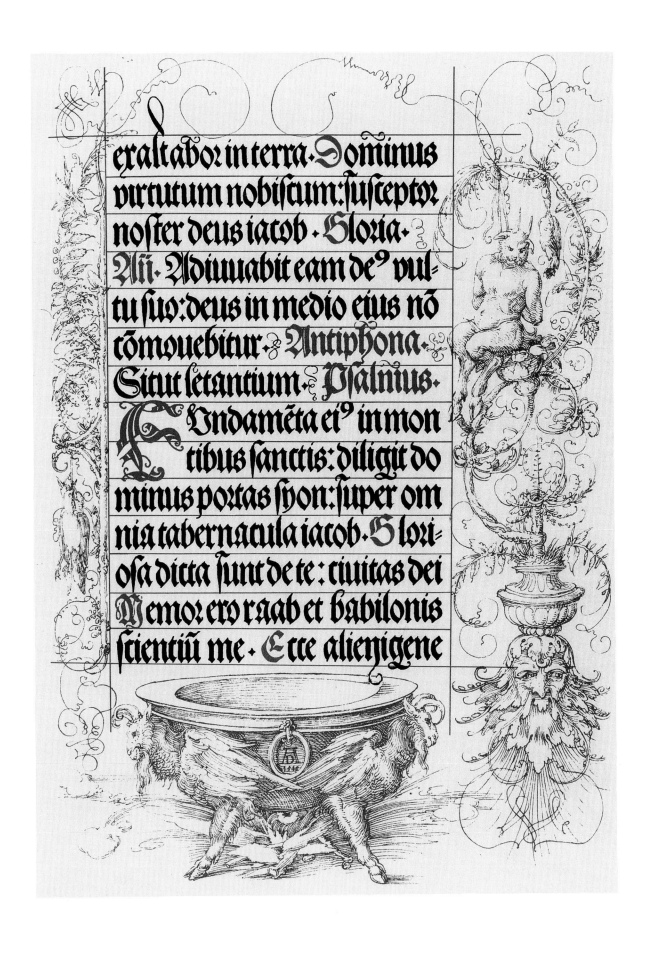

exaltabor in terra· Dominus
virtutum nobiscum: susceptor
noster deus iacob· Gloria·
Ali· Adiuuabit eam de⁹ vul-
tu suo: deus in medio eius nō
cōmouebitur· Antiphona·
Sicut letantium· Psalmus·
Fundamēta ei⁹ in mon-
tibus sanctis: diligit do-
minus portas syon: super om-
nia tabernacula iacob· Glori-
osa dicta sunt de te: ciuitas dei
Memor ero raab et babilonis
scientiū me· Ecce alienigene

Chapter Eleven

Classical Creatures

When Dürer visited Venice, it provided him with the twin stimuli of exotic creatures imported there from the Near East and Africa, and, even more important, the zoo of classical antiquity that abounded in Italian art and literature. Here all the strange beasts and birds of ancient literature and faith came to life. In Ovid's Latin verses and the abundant new love songs of Venice, legendary creatures—centaurs and satyrs, fauns and nymphs, sirens, mermaids, and tritons—flourished as nowhere else in the West. Their fantastic fusions of animal, human, and divine—unexpected, challenging, intriguing—came close to being a kind of history of evolution, where the fittest survivors combined the best qualities of man and beast.

The ancient zoo was revived in the art of the Renaissance not only because Greek and Latin texts were being printed and often translated for the first time, but also because Europe's rulers cast themselves in the same mold as those of antiquity. Just as the leaders of ancient Rome had no qualms about their own divinity and generously gave themselves immortal airs, so could rulers of the Renaissance, without disservice to their Lord, take on the attributes of eternity. Sphinxes, griffons, and sea horses, lending their magical powers to the godlike rulers of the past, were taken over by Dürer to support the divine claims of recent leaders.

Legends of all these gods and of the animals in their lives were first making a major comeback in Dürer's lifetime. His friends, like Celtes and Pirckheimer, and his own travels and studies brought the learning of antiquity into German art and literature. Dürer made a major contribution to this old/new learning. Conrad Celtes asked him and his studio to design several woodcuts for *Four Books of Love* of 1502. The concluding print shows Celtes as a plump young poet signing his finished work, described as dictated by Phoebus Apollo and the Muses [3.84]. These gods and many others surround the page, accompanied by their attributes, so often in the form of animals. Apollo's swan, with a rooster and crow, is just above the writer. The winged Muses of history and comedy are far below, separated by their inspiring Fount of Hippocrene. Apollo has the slain python at his side; Bacchus, a horned and goat-legged satyr. Hercules wears the Nemean lion's skin as he attacks a Stymphalian bird and the three-headed watchdog of Hades, Cer-

berus. Mercury, with his serpent-entwined, magical caduceus speeds along with winged feet and hat.

To be modern in the Renaissance was to show how much you knew about antiquity. The humanist, who specialized in the culture of classical times, praised new princes as "Hercules Reborn," that hero being the first man to become a god, winning immortality through his vast power, or virtue. Pollaiuolo, the vigorous Florentine painter, sculptor, and printmaker—who, like Dürer, began as a goldsmith—was the major artist to the Medici family's Neo-Platonic Academy. He depicted Hercules's life and labors in many media, and his virile images were copied by young Dürer for Maximilian and other royal patrons. Maximilian called himself "Hercules Germanicus" and was pictured as such in 1490. Twenty-five years later, Dürer drew Hercules in the margins of the same ruler's *Book of Hours* [11.1] shooting down the foul Stymphalian birds. (The same scene is the subject of one of Dürer's first noble commissions and his earliest mythological work, a drawing [11.2] and poorly preserved canvas painted for Frederick the Wise. Dürer gave his own face to Hercules, perhaps to tell the world that he, too, was a hero—of the pen, brush, and burin, a true virtuoso.)

Man's closest tie to the animals and monsters of classical mythology was the twelve-linked chain of Hercules's labors. His triumphs, seen as forerunners of Christian strength and justice, survived the Dark Ages and were built into the very fabric of later Western faith, illuminating the pages of prayerbooks and carved around church portals to show the victory of virtue over evil. When Dürer was young, these legends were well known in many forms, told and retold with new morals, so that the divinities and heroes of distant days could be understood in the light of a single god.

Hercules's sacred strength was already evident in the cradle, when he strangled two snakes sent to kill him. The boy-hero then

11.1

worked as a shepherd, learning patience, one of life's hardest lessons. The king of Mycenae assigned Hercules twelve labors (each drawn by Dürer), requiring great feats of strength, in which he often overcame brute force with his own. In the first, Hercules chased the fierce lion of the Nemean desert into a cave, where he strangled it to death and covered his head and body with the lion's skinned hide, which then protected him against all but that animal's claws.

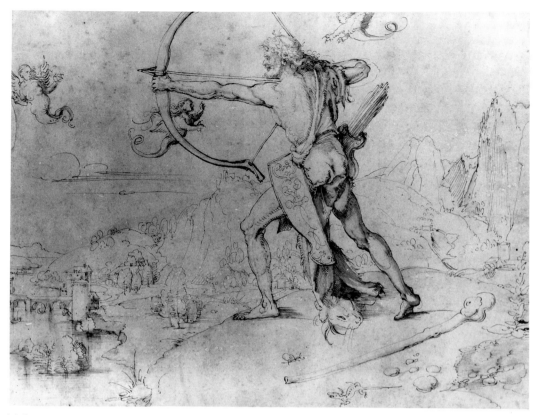

11.2

Hercules's second labor required him to kill another monster, the Lernean Hydra, a nine-headed poisonous serpent that lurked in the marshes [11.3]. For the third labor, he had to capture the fierce boar of Erymanthus, which had long terrorized Arcadia. He chased the beast into the snowy plains where the bone-weary boar finally gave up.

The Hind of Mount Ceryneia, running swiftly on brazen hoofs and holding its golden horns high, was Hercules's fourth conquest. The hero's fifth labor was that of exterminating the birds that infested Lake Stymphalus. After frightening the birds with a great brass rattle, Hercules shot several of them with his bow and arrow and drove the rest into the Black Sea.

His sixth feat involved slaying a sea monster near Troy, when the Trojan king was just about to feed it his daughter Hesione. The seventh labor required Hercules to clean up after all three thousand cattle belonging to Augeas, king of Elis, in a single day. He did so by

11.3

changing the course of the river Alphaeus so that it swept through the royal barn like a vast open sewer.

Another beast had to be brought back alive for Hercules's eighth labor—a mad, wild bull that was carried to Crete by Poseidon as punishment for that island's disobedient king

Minos. For his ninth labor, the hero caught the man-eating mares of Diomedes, king of Thrace, who was fond of throwing strangers to his carnivorous horses. Hercules fed them the king's body before bringing them back to Mycenae, where they were set free.

Zoologically, the richest of the twelve labors was the tenth. Hercules had to capture all the oxen of Geryon, a winged giant with three bodies. His eleventh labor was to slay a serpent guarding the apples of the Hesperides. Finally, for the twelfth, Hercules dealt with Cerberus, the fierce, three-headed hound that guarded the Greek underworld. Dürer's roundel shows Hercules using a club rather than wrestling the dog to the ground, a variant on the ancient texts.

Though Hercules was a hero who was elevated to divinity, classical art and faith also abound in examples of humans dragged down by beasts, representing the passions and primitive states of being, far from heroic reason and sacred insight. Centaurs and satyrs, playfully wise dolphins, seductive mermaids—these were links between man and nature, magical ties binding human understanding to the forces of field and stream, wind, water, and growth. Pagan gods, beasts, and men, in league with one another, made for a world where creation keeps right on going, ever an unfinished business, spurred by love and hate, without any single overarching divine design in evidence. Passion is the license and the passport for many a journey to Parnassus or Hades and to those hybrids of man and beast that so fascinated Renaissance artists and patrons.

With his wonderfully clear and poetic cause and effect, Ovid explained the origins of nature in terms of feelings—of fear, flight, and rejection, of revenge, seduction, and abduction, and most important of all, of exaltation. A fair maiden may find herself in the stars as a shining new constellation; a bold hunter becomes a bird of prey; a boastful weaver is turned into a lowly spider. A hunter who accidentally views the chaste goddess Diana nude in her sanctuary is converted by that furious deity into a deer, to be torn limb from limb by his own faithful dogs. Ovid's recounting of the ancient myths was pithy, gripping; his often sexy, pagan text zealously moralized by a late medieval scholar so that it could be read with impunity by good Christians. Dürer's knowledge of Ovid was deepened by retellings in the Renaissance by such poets as Angelo Poliziano, on whose work the artist based his drawing the *Rape of Europa* [8.36].

Mantegna, Dürer's favorite master, saw to it that the engravings made after his mythological scenes were distributed all over Europe. These prints, such as the splendid two-paneled *Battle of the Sea Gods* [11.4], which Dürer copied [11.5], gave the young artist his first modern lesson in classical marine biology.

Both Vittore Pisanello and Jacopi Bellini had depicted creatures from classical antiquity, and Dürer drew upon these forty years later when he saw the former's medals and the latter's notebooks on his first visit to Venice in the mid-1490s. Jacopo de' Barbari was Dürer's chief source of mythological wildlife. Typical of Jacopo's powers is a great merman, riding exultantly on his dolphin in the waters around Venice as part of Jacopo's greatest feat, a massive woodcut aerial view of Venice [11.6].

11.4

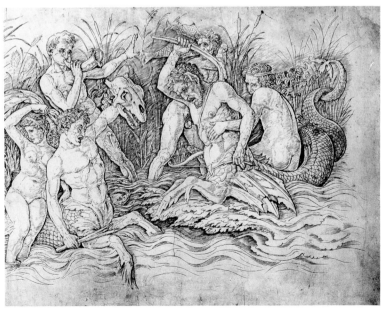

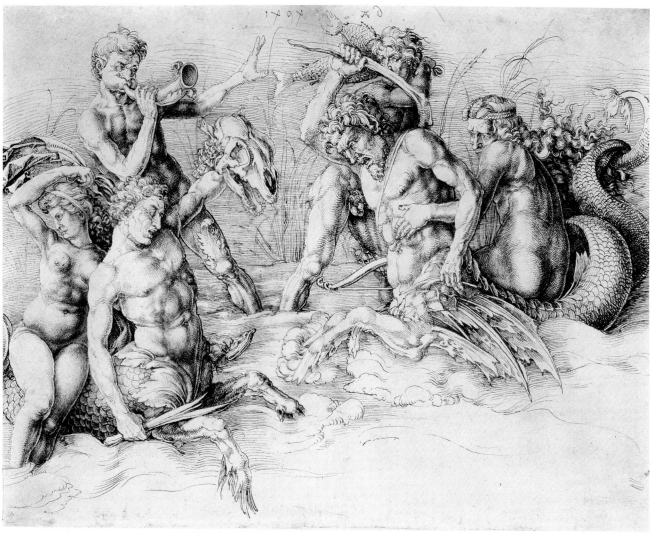

11.5

Many of Dürer's mythological subjects belong to his most "elitist" works, illuminations on the printed title pages of the Venetian books and paintings for Pirckheimer. Others relate to imperial commissions for Maximilian, devised by the court astronomer Stabius: complex astrological conceits with hidden, emblematic meanings and zoological secrets revealed to the chosen few. Mythological beasts allowed Dürer to enter the scholarly circle of Pirckheimer, Erasmus, and Celtes, who all explored the ancient wisdom of Greece and Rome.

One Venetian book, printed in 1499, made the ancient zoo available to artists all over Europe. Dürer's copy of this haunting story, the *Hypnerotomachia Poliphili* or *Strife of Love in Poliphilus's Dream*, is still preserved. The text is a gathering of Egyptian, Grecian, and Roman gods, assembled to advance a Gothic archaeological romance written by a Venetian monk. An anonymous illustrator and his equally gifted typographer designed the many beautiful woodcut pages. Exotic emblems, hieroglyphs, ciphers, inscriptions in Greek, Latin, and Hebrew, depictions of magical grottoes and gardens, ancient monuments with pyramids and sphinxes, winged horses, satyrs, and garden gods abound.

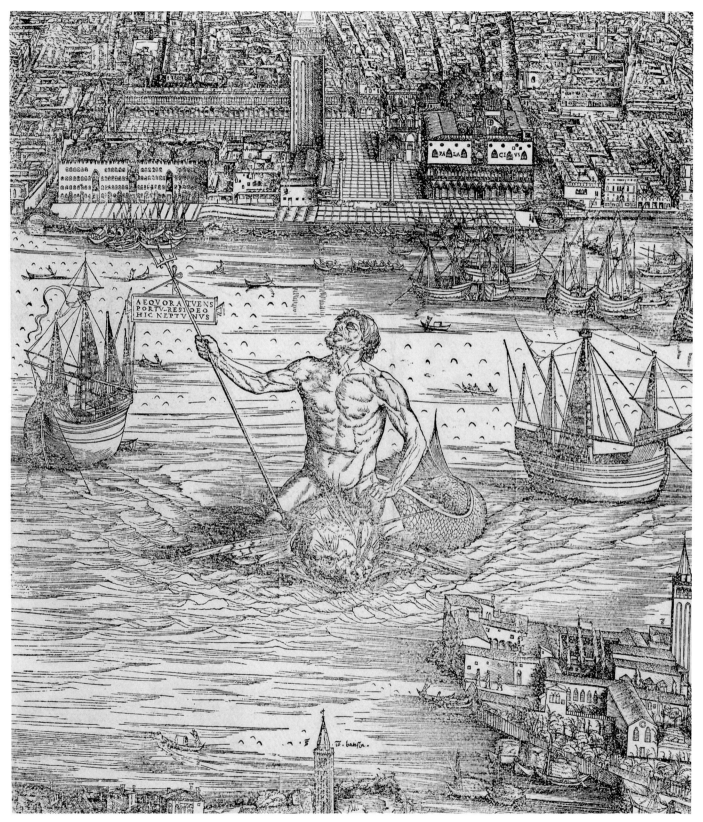

11.6

Artists love the Greek legend of Orpheus, whose song was so magical that he could charm birds from the trees and lure animals out of the woods, enchanting the wild beasts and the landscape itself. The beauty of his music suggests divine creation, like David's psalms. Painters, sculptors, and musicians find in this myth praise for the power of all the arts and hope that they, too, by re-creating nature's wonders, may become more her master than imitation's slave. Orpheus was included in a page of Maximilian's *Book of Hours* [11.7] drawn by Dürer's associate Jorg Breu.

Many pages of Maximilian's *Book of Hours* are bordered by *grotesques*—a word taken from the Italian for cave, *grotto*. When Dürer saw Rome in 1505, it was honeycombed with partly excavated caverns, many of which were lined with ancient wall decorations in wild combinations of male and female, animal and human figures combined in intricate, suggestive fashion [11.8]. He also copied weird ornamental themes from northern Italian engravings based on ancient sources, such as the great cauldron, supported by winged goats, in the margin of the emperor's prayer book. Perhaps this barbarous vessel is meant to illustrate the references to godless Babylon in the verse from the Eighty-seventh Psalm written on the same page. It may also be taken from *The Hieroglyphica* of Horus Apollo, in which this vast bowl signified "Ignorance." Perched in the vines, the bound satyr belongs to the same pagan imagery. Hanging at his side is a dead duck, another hieroglyph that symbolized the end of antiquity. Grotesque motifs also animate many of Dürer's finest decorative passages, his projects for ornamental metalwork.

Least known of all his work, Dürer's classical beasts include some of his most powerful and personal studies. Without sentimentality or self-consciousness, these mythological images show total freedom and self-assurance, as in his quick drawing *Centaur Family*, the etched *Rape on a Unicorn*, and his rapidly penned *Centaur Carrying Off Woman*, based on a great lost

11.7

Florentine source. These ancient themes brought out the artist Dürer might have become rather than the one he was: They present a spirit liberated from an often oppressive society and faith, an artist now suddenly and vitally pagan. Dürer's legendary beasts, their lovers and keepers, enemies and friends, seem powerfully contemporary. They live in a perpetual present, along with Matisse and his Fauves—the wild beasts—and that French master's German followers, members of the Blue Rider group, best known for the almost human horses of Franz Marc, heirs to Dürer's centaurs.

11.8

Basilisk/Cocatrice

This is the deadliest of mythological creatures, usually described as a small, poisonous reptile about 6 inches long. Pliny wrote that the white marking on its head resembled a diadem, making it the king of serpents. Though the basilisk is two-legged, its back and tail drag along the ground in slithery, snakelike fashion. Just a hiss from this dreaded beast will make all flee, for death is sure to come to those remaining in its lethal range. One glance from a basilisk's beady little eye can be fatal, as is inhaling its breath. Wise travelers in such basilisk-ridden territories as Libya included a mirror in their baggage: Show a basilisk its reflection and it gets the shock of its life and dies.

Dürer's first basilisk [11.9] is from an Italian model [11.10], after a series of engraved playing cards; sensibly, the figure of Logic keeps the evil creature veiled.

A page for the first book of *The Hieroglyphica* illustrates the opening symbol for "Eternity," represented by the sun and moon. Just below is the basilisk [11.11]. Because its breath could kill, Horus Apollo explained, "since it seems to have power over life and death, Egyptians put it on the heads of the gods." Maximilian's scholars included it in his crown, placed by Dürer in the emperor's portrait at the top of his *Triumphal Arch* [1.2].

11.9

11.10

Capricorn

Half goat, half fish, this constellation glitters in the southern sky, shown there in Dürer's woodcut star map [11.12]. First given the name of a fish by the Babylonians, the constellation was later linked to goats, to Aegipan, who was possibly the son of the goat-legged god Pan. Sign of the winter solstice, Capricorn's period includes the birthday of the unconquerable sun and the unconquerable Son on 25 December, a date whose dual significance in classical and Christian terms was important to the art of Dürer's day. An earthly sign, Capricorn is under Saturn's rule.

Centaur

Renaissance artists loved centaurs, whose handsome heads and torsos of powerful men or lovely women were united with the beautiful bodies of horses. Embodying both brute and human strength, the centaur provided the ultimate challenge to artists, that of joining man and beast in plausible, persuasive, and functional fashion, symbolizing fantasy or imagination. Young Dürer first saw these creatures in northern guise in the *Animals' Dialogues Moralized* of 1486 [11.13].

Centaurs combine the best of both human and animal spirits. Wise and hospitable, they could be great teachers, like Chiron, tutor of the young hero Achilles. Awesomely high-minded, they could also be very sensual. Too much wine and they rushed away with women, doing with them what they would. Dürer drew a remarkably lively study of a young centaur carrying off its kicking victim [11.14] during his first Italian journey of 1494, datable by its watermark. Marvelously vital from head to hoof, this centaur combines Dürer's knowledge of ancient sculpture with that of works by the great fifteenth-century Italians. The awkward raised leg of the woman—Hercules's wife Deanira—kicking the centaur Nessus in the stomach may have been Dürer's invention.

11.11

11.12

Similar use of Italian and ancient art with a new northern twist can be seen in his *Rape of Europa* from the same year.

Dürer's loveliest rendering of a mythological creature may be his page showing a mother centaur nursing her young [11.15]. Swiftly realized, suggesting writing as much as drawing, this scene is based upon Lucian's description of a painting by Zeuxis, who worked in the fourth century B.C. Writing in the second century A.D., Lucian recalled: "The mother centaur is shown on fresh greensward . . . her equine body lying on the ground with the human section slightly raised as she rests on her elbows, her forefeet not extended. . . . She holds one foal in her arms, nursing it in human fashion while the other draws at the mare's dugs like a foal."

Centaurs are also found in the sky. To the east of Scorpio's brightest star—Antares—is the centaur Sagittarius [11.16], southernmost of the zodiac's constellation. Another constellation, Centaurus [11.17], is in the southern sky.

11.13

286 Dürer's Animals

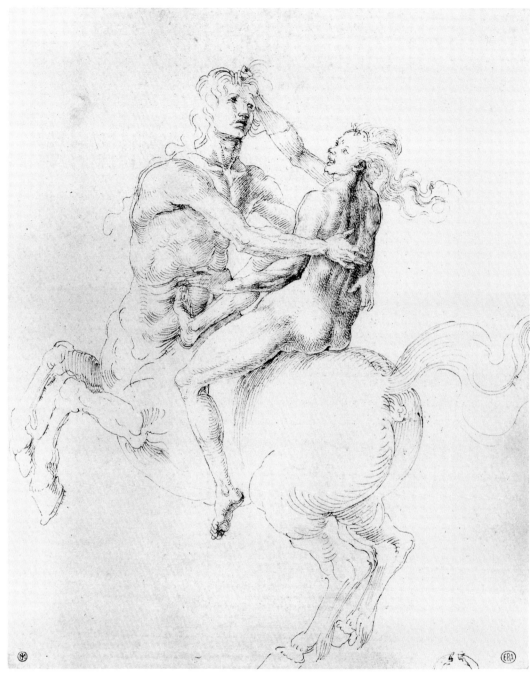

11.14

287 Classical Creatures

11.15

11.16 11.17

Dolphin

Dolphins, like whales, are warm-blooded, mammals breathing air but living in the water. A unique combination of friendliness and intelligence, dolphins were long believed to be music lovers, charmed by singing and the sound of the water organ. These wise, swift swimmers were often messengers of the gods, speeding divine tidings over the waters. The way they gamboled around ships, racing and passing even the speediest of them, made Pliny believe in the legend of Arion, the gifted young harpist whose tale was best told by Lucian: When far out at sea, sailors tried to drown their passenger Arion to steal the money he

won from them by his playing; they granted him one last wish—to sing and play his harp before dying—and a dolphin, attracted to the beauty of the music, rescued the youth and proudly bore him shoreward. A dolphin bearing Arion was drawn after an ancient relief, by Cyriaco d'Ancona, a Venetian traveler to Greece and the Near East. This page came to Nuremberg, where Dürer may have copied it. His own watercolor of the subject [Plate 32] was painted around 1514, recalling the work of Jacopo de' Barbari.

Another of the dolphin's passengers, drawn by Dürer a decade earlier, is a plump, Hausfrau-like Venus, holding a horn of endless love, with her blindfolded son Cupid perched on top of the cornucopia shooting arrows of passion [11.18]. Dolphins also pop up frequently in the margins of Maximilian's *Book of Hours* and *Triumphal Arch*, sometimes with cupids on their backs. Their welcome presence provides good spirits and loving harmony.

11.18

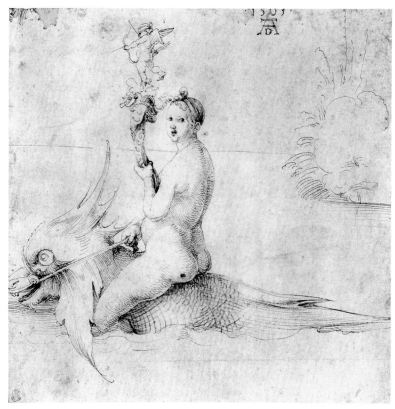

11.19

Making fun of tournaments, Dürer showed two dolphin-mounted helmeted babes in armor, tilting at one another, toy windmills their weapons [Plate 33]. Here they face the Pirckheimer arms in the border of an Aristotle of 1495 from Aldus Manutius's press. Like so many of Dürer's classical creatures, his dolphins were inspired by those he saw in Venice, as that maritime lagoon city, close to the East, loved these genial beasts. Aldus, whose books Dürer often bought and decorated, had an emblem combining the swift dolphin and the stable anchor [11.19], accompanied by the motto "Make haste slowly."

11.20

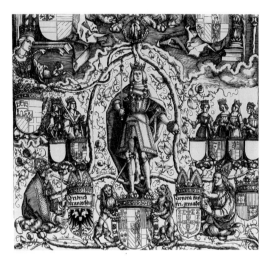

11.21

11.22

Griffon

Among Dürer's most splendid mythological beasts are the griffons he devised for the emperor Maximilian. This fierce creature linked the features of the lion and the imperial eagle, usually depicted on four lion legs with eagle claws. Like the unicorn, the griffon was believed able to prevent death from poison, for its claws changed color in the presence of any such evil substance. Largest of flying creatures, the griffon was supposedly so immense that when its massive wings were spread in flight, they obscured the sun's rays. Herodotus wrote that the griffons' native habitat was among the highest of the Indian mountains, where they dug for gold to build their nests. This legend explains their presence in Dürer's great woodcut *The Vision of the Seven Candlesticks* [11.20], where two tiny yet already fierce griffons nest on the base of one of the seven gold candlesticks. Because the griffon is linked with the sun, with gold, and with healing and is tied to the royal and imperial forces of lion and eagle, it is easy to see why Maximilian should have chosen so powerful a beast for his own. They flank his portrait, supporting the arms of the Holy Roman Empire and his Order of the Golden Fleece.

Finest of Maximilian's griffons are those that appear in the two great projects Dürer collaborated on to celebrate the emperor's powers—his *Triumphal Arch* and *Procession*. Griffons flank Maximilian's throne at the arch's center [11.21], lending their wings and clawing two sad lions crouching below. Perched like gargoyles above the side portals, two others display the emperor's pomegranate branch and a speech scroll with his motto of self-restraint. Biggest and boldest are the two great griffons, each with a panel to itself [11.22], proudly bearing the Cross of Saint Andrew and the flintlike strike plates that form the collar of the Order of the Golden Fleece, both referring to Maximilian's richest prize, Burgundy.

Pegasus

Perhaps the most beautiful of mythological beasts, Pegasus combines the graceful force of horse power with the freedom of winged flight. According to the Greeks, this airborne steed was the son of the sea god Poseidon. Pegasus was ridden by another son of Poseidon, Bellerophon, to slay the chimera, a fire-breathing monster. After many other triumphs, Bellerophon decided to gallop to heaven on Pegasus. Zeus sent a gadfly to enrage the flying horse, causing Bellerophon's fatal fall. But the winged horse remained in the stars, where his constellation is shown in Dürer's Map of the Northern Sky [11.23].

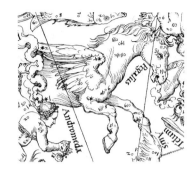

11.23

Artists and writers look to Pegasus as he leads them to the fountain of inspiration, Hippocrene, whose waters, released by a blow of his hoof, also nurture the Muses. Conrad Celtes took care to include this fountain on the crowded page showing all the classical creatures contributing to his art.

Phoenix

This bird's miraculous qualities were recounted in ancient art and Oriental literature. Dürer's first drawing of the death-defying avian, rising from the ashes of its own destruction, is a copy made in 1499 of an Italian engraved playing card, one of a series of the Virtues Dürer often drew from. The phoenix often symbolized Christ's immortality, flying safely above a nest of flames, winging from life to life. Dürer made two drawings of the bird [11.24; 11.25], known from copies for the Horus Apollo where its perpetual rebirth is understood as a symbol of the eternity of spiritual renewal, of long life, of someone returning from afar. This promise of renewal was also seen in the Nile's flooding its banks.

11.24

11.25

Satyr and Faun

Satyrs, those Greek sylvan deities who cavort with Pan the nature god, and the Roman fauns, who resemble them, are all followers of Dionysus or Bacchus, god of the vine and leader of the revels. They love wine, women, and the music of wind instruments. Sometimes given goat horns, ears, legs, and tails, satyrs and fauns can have any or all the above [11.26]. They are woodland spirits linked to fertility and to the rustic riches of the fields and forests; farmer's gods, they care for their cattle and their crops. Creatures of extremes, satyrs and fauns are either immensely pleased or tormented by their state, fused between man and goat.

Dürer may first have learned about them in Padua, where these beings fascinated scholars and artists alike. His satyrs, like those of Renaissance Italy, are sometimes plagued by a dim sense of the black fate they cannot quite follow. Though they walk upright, they are demonic, too different from God's image to share his message of salvation and redemption. For this reason, Dürer could show small, desperate satyrs abandoned in their grief near Christian funerary monuments, more than dumb witnesses but less than beneficiaries of the good word, knowing only enough to realize they are damned. According to legend, a great wail of grief was heard throughout Greece when the shepherds received angelic tidings of Christ's birth. Now Greece knew that the great god Pan was dead, pagan faith eclipsed by one still greater. With his passion for animal life, Dürer may have thought that only something partly human could prove a truly dumb brute. His drawing for a funerary monument [11.27], made for Germany's richest bankers, the Fuggers of Augsburg, is unique for its inclusion of satyrs, unprecedented in northern Europe. Cosmopolitan, Dürer's wealthiest patrons spent much time in Italy and were doubtless impressed by the Renaissance mixture of pagan and Christian imagery.

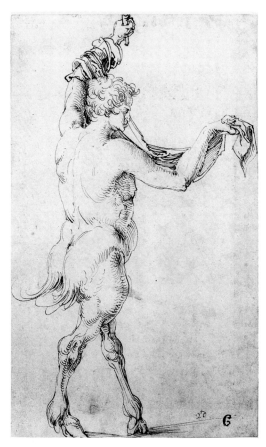

11.26

The artist's earliest and most powerful satyr, seated with a horse's jawbone in hand [11.28], is based on a Paduan bronze of a fighting satyr family. Peaceful Italian scenes of satyr life were also made. One of these, an engraving by Jacopo de' Barbari, shows a satyr playing a lyre as his mate and nursing baby satyr listen quietly. Dürer has the satyr play a trumpet; both mother and infant look completely human in this engraving of 1505 [11.29].

Fauns are found in two early Dürer paintings (known only from copies). One is an agricultural scene [8.5]; the other takes place in the wild woods [11.30]. The pan-piping satyr family in each picture bears the coats of arms of Willibald Pirckheimer and his bride. Dürer identified his art with the sound of nature; that is why he worked his monogram into the minute panpipes shown near the woodland god and invented by that spirit of nature [11.31].

291 Classical Creatures

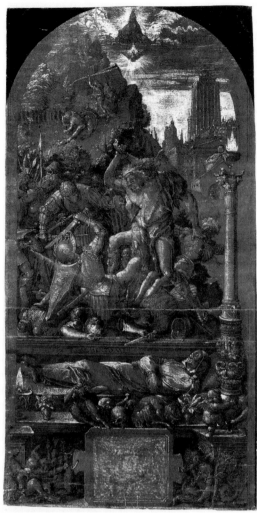

11.27

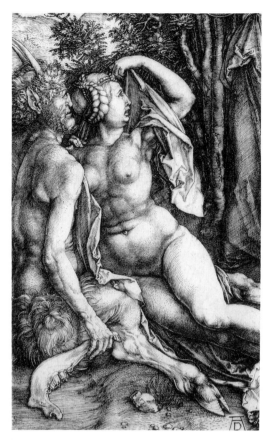

11.28

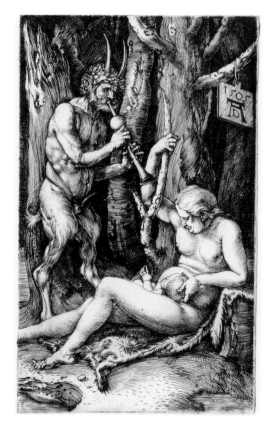

11.29

Sea Horse

Seaworthy horses, or hippocamps, half horse, half fish, with a twirling, dragonlike tail, were often shown in classical art bearing sea gods over the water's surface. Like Pegasus, the hippocamp is an especially graceful creature, in the decorative arts often winding elegantly around odd corners, filling awkward spaces with its sinuous, handsome form. Dürer used two such confronted beasts for a metal applique attached to a bookbinding or box. His sea horses sometimes come with wings, as in a design for a hunter's hanging whistle [11.32], probably made in gilded silver, possibly for execution by his goldsmith brother. Like so many of Dürer's most assured classical forms,

292 Dürer's Animals

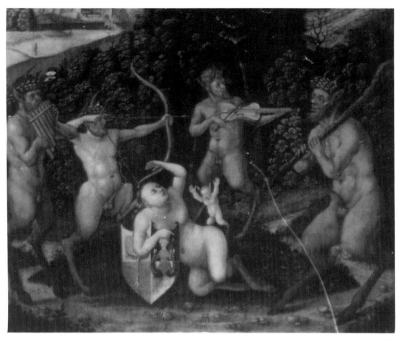

11.30

11.31

11.32

these figures are adapted from the art of Mantegna, taken from the left section of his famous two-part engraving, *The Battle of the Sea Gods* [11.4]; Dürer copied the right half.

Sphinx

Today this enigmatic creature is usually seen in terms of the colossal statue crouching near the Egyptian pyramids, but sphinxes came in many different shapes and sizes—mysterious fusions of woman, lion, bird, and dragon that were symbols of both evil and wisdom. In the Renaissance, sphinxes were considered more good than bad, signs of the special quality of knowledge. But the one Dürer drew, for the right half of Maximilian's jousting saddle [11.33], is probably meant to be evil, as she is placed parallel to a symbol of vanity. Though different from the harpies on Maximilian's *Triumphal Arch*, which resemble winged, lion-armed mermaids, this creature may also be seen as a harpy, an enemy menacing the emperor's riches, to be caught in the nick of time by the alert crane at the right.

Triton, Mermaid, Harpy, Siren, and Sea Monster

Of the many classical combinations of man and beast, the denizens of the deep were the most intricately devised. Tritons, seaworthy centaurs, were the attendants at Poseidon's court, with human heads and arms, horses' forelegs, and small wings rising from the hips; their human torsos terminated in massively twined, fish-scaled tails. Such fantastic creatures were often carved on ancient sarcophagi, guarding the bodies of the deceased within. In medieval times, mermen and mermaids found their way among the sculpture on church porches and capitals and swam along the borders of illuminated manuscripts. Dürer's first study of these sea creatures in the antique manner was based on Mantegna's engravings. Horns springing from the abductor's brow in

the engraved *Sea Monster* [11.34] are like those specimens soon to be collected by Dürer and Pirckheimer. Any work as exciting as this early print suggests a single convincing literary source, but so far none has been found. Dürer may have seen mosaics or sarcophagi of sea battles with fantastic half-human creatures of the deep. Or perhaps the sea monster represents the rape of Syme by Glaukos. A mortal transformed into a sea monster, Glaukos still had an eye for maidens rather than nymphs, and carried off Syme, the daughter of a Rhodian hero, to an island that he named after his beautiful captive. This subject was described among the paintings seen in classical antiquity by Philostratus, whose elaborate account of the works of Greek masters—the *Imagines*—must have been known to Dürer and was used for his *Centaur Family* and other scenes. Philostratus's text, which abounded in animal life, was popular among Venetian artists of the late fifteenth century, and, together with Pliny's descriptions of works by Greek painters and sculptors, it allowed Dürer to identify himself with the great artists of the ancient past and to reinvent from the written word the lost masterpieces of antiquity.

Or Dürer may have turned to some rich Renaissance account like Bracciolini's *Facetiae* for the sea monster. The fifteenth-century Florentine text tells of a triton with little horns and a flowing beard, who carried off young folk on the beach too careless to note his coming; finally five brave washerwomen caught the triton and killed him. His body, or a carving of it that the author claimed to have seen, was proudly exhibited in Ferrara. This may seem like a long shot as a source for Dürer's engraving, but surprisingly, it was printed in Nuremberg by Anton Koberger in 1472 and again by another German publisher six years later. Regardless of the source, this subject afforded Dürer the opportunity to show off a dazzling variety of textures—water, skin, fish scales, horn, shell, bone—as well as a rich land and skyscape, a magnificent pagan tour de force.

11.33

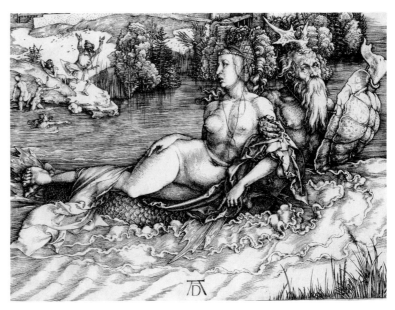

11.34

Two mermaids, tails and arms in ringed embrace [11.35], must have been drawn as a jewelry design close to the many decorative projects Dürer worked on for Maximilian. These seductive maidens of the sea were not always decorative, however. They hang from the columns of Maximilian's *Triumphal Arch* [11.36], dead or dying, alongside the central Portal of Honor and Might. Described as sirens, they are meant "to call to mind disaster at sea and secret, unpleasant incidents caused by their sweet songs reported by the ancient poets. Such incidental episodes cannot harm those traversing this noble Portal of Honor, and with God's help will never happen again."

11.35

11.36

11.37

Strange cross between woman and vulture, the dreaded harpy had the head, breast, and hair of a lovely maiden combined with the wings, legs, and feet of the carnivorous vulture. A harpy's claws and wings were of metal, making them both deadly and noisy. Ever hungry and evil smelling, the weird, pale creature never could find enough to feed its voracious appetite. Known in Germany as a *Jungfernadler* (virgin eagle), the harpy is found on the arms of Nuremberg's castle and on Maximilian's *Arch*, "on the great columns, adjacent to those with the Sirens." Stabius, the author of its program, cites Virgil as describing harpies as having "faces of young women, unclean bodies, misshapen limbs, and at all times being of pale, hungry and avaricious countenance. This indicates that the emperor Maximilian, because of his honorable bearing and his great goodness, was never tempted by lustful desire." But most of Dürer's harpies bear no resemblance to Stabius's quotation, nor do the scholar's words have any correspondence with the facts of Maximilian's lusty life. The mermaids holding shields and playing musical instruments [11.37] to the lower left and right of the central portal are taken from the decorative heritage of Maximilian's second wife, Bianca Maria Sforza, daughter of the duke of Milan, and are adapted from ornamental panels engraved from the illuminator Giovanni Pietro da Birago, whose manuscripts as well as prints came to Nuremberg.

Dürer's most seductive harpy is a water-colored design for a carved and polychromed chandelier [Plate 34], whose wings are formed by the palmated antlers of a European elk. The coat of arms, placed to be seen from below, is partly visible on the siren's stomach. As Mrs. Pirckheimer's arms, a tree, are drawn nearby, and the artist and his friend were both great collectors of horns, the page may have been made for his use. Both the city of Nuremberg and Pirckheimer's wife included the siren on their coats of arms. A cupid chandelier, also of Dürer's devising, flew on similar antler-wings [4.23]. Siren and cupid may have been planned to hang together, lighting up a room by their brilliant combination of art and nature. She holds out an offering, actually a candleholder disguised as an elegantly uprooted branch, probably of gilded wood or metal. A chain attached to the small of her back links this siren to the ceiling.

Stymphalian Birds

These horrible, man-eating monsters [11.38] are described in ancient texts as having beaks, claws, and wings of brass, killing their prey by releasing their hard feathers like porcupine's quills. Dürer increased the birds' menace by giving them human guile and beauty; like Adam and Eve's serpent, they have the heads of lovely women. He stressed their fierce strength by adding lion's forepaws to the bodies, which terminate in fiercely twisting tails.

11.38

Unicorn

Long one of the most popular of legendary beasts, the beautiful unicorn is a creature of contradictions. Both ferocious and pure, this powerful animal is so wild that he can be captured only by a virgin using the enchantment of music. Lulled by seductive harmony, the unicorn nears the sound's source and places his long horn in the maiden's lap. Then the beast is tied down by hunters lurking nearby and soon carried away in triumph. The horn is endowed with qualities of miraculous healing, able to detect and neutralize poison. By making the sign of the cross as he dipped his horn in a spring that was poisoned by an evil serpent, the unicorn purified the water. This story, from a medieval bestiary, is a popular retelling of Christian redemption in the form of a fable.

In *The Bestiary of Love*, written in the mid-thirteenth century, the unicorn's horn is described as "so sharp that one cannot resist it." It was reputed to pierce armor, so spiraling "unicorn horns" were worked in steel by Italian armorers and added to horses' helmets, making them offensive as well as protective. Dürer drew a warrior whose mount is encased in just such armor [11.39], making the horse both unicorn and rhinoceros, resembling the latter in the *Animals' Dialogues Moralized* [10.39]. That woodcut gives the beast one horn on the brow and another, meanly hooked, over the muzzle.

A rare sea mammal, the narwhal, belonging to the whale and dolphin family, has a long, twisted horn that grows just above the nose. Believed to spring from the unicorn's brow, these pointed, spiraling ivory rods were prized in the Middle Ages. They were kept in church and ducal treasuries and on dining tables, to guard the possessors from poison. Dürer's father probably made swords and cups with such "unicorn" horn inserts as gifts for royal presentation.

Almost invisible, hidden in the woods, Dürer's first unicorn is painted at the upper left of *The Flight into Egypt* [Plate 26], one of eight panels for an early altarpiece painted for Frederick the Wise in 1496. The beautiful, elusive beast is in striking contrast to the homely ass that carries the Mother and Child to refuge from Herod's wrath. Placed parallel to the peasantlike Holy Family, the noble unicorn signifies the Virgin Birth and Christ's heavenly rule.

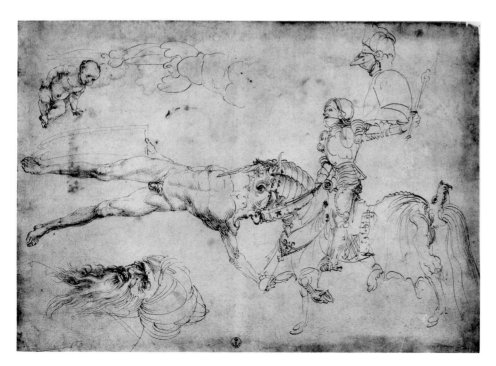

11.39

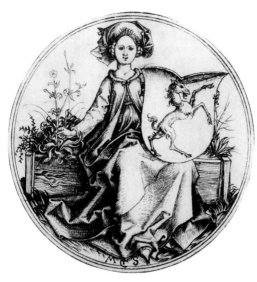

11.40

Dürer's early unicorns are like one engraved by Schongauer on a shield held by a demure maiden [11.40], where the horn slopes downward over the animal's brow. Such heraldic unicorns are carved around a great archway of Solomon's Temple [11.41] in Dürer's woodcut of 1504–5, where *The Marriage of the Virgin* takes place. He included these beasts in combat with lions, as the unicorn represents Mary's

11.41

11.42

purity and the lion stands for Israel and for Jesus, "lion of the tribe of Judah."

A different kind of unicorn, less Gothic and more goatlike, with a curved, almost sawtoothed horn, is shown in the margin of a Greek text [Plate 35] printed in Venice and decorated by Dürer for the learned Crescentia Pirckheimer. This strange beast, closer to classical art, was first painted in combat with a bear, both animals ridden by *putti* jousting with children's toys.

Lurking among the reeds in the foreground of the *Rape of Europa* [8.36] is a deerlike animal, who seems to be munching tender rushes. This too may be a unicorn, but the hornlike loop upon its brow could be but reed or grass.

Drawn just one year before the great etched unicorn of 1516, a small, young creature in the border of Maximilian's *Book of Hours* [11.42] is caught in a moment of spirited dialogue with a loquacious, cranelike bird. Appearing with the 130th Psalm, these engaging animals may have nothing whatever to do with the text, one of Maximilian's favorites. The unicorn could stand for strength, as Job described it, and the crane represents watchfulness. Squeezed into the book's margins, the unicorn turns up on top of a page where the Benediction reads: "Bless us Mary, Maiden mild, bless us Jesus, Mary's Child," probably included as a reference to her purity. This compact unicorn anticipates the seagoing version Dürer designed for Maximilian's armor two years later, confined within similarly close quarters. Shown with the same curved, sawtoothed horn, the beast turns into a sea horse from the back down: Even its front legs end in flippers, a faint echo of Mantegna's great sea beasts.

Consumed by passion, Wild Men were known to ride off on their unicorns, carrying away their victims. One of Maximilian's artists, the Housebook Master, showed such a scene, and Dürer classicized the subject in the unicorn etching of 1516 [11.43]. Among his most

powerful works, this smoldering, richly black print presents a naked, bearded, Herculean rider astride a galloping, shaggy unicorn. He embraces a struggling nude around her ample waist; her arms are raised skyward in protest.

Before Dürer etched this final version, he had a more classical image in mind, based on the equestrian monuments planned by Pollaiuolo and Leonardo for the dukes of Milan. He probably recalled a woodcut of the Berkeley witch [11.44] designed in the workshop where Dürer was apprenticed, which provided illustrations for the *Nuremberg Chronicles*, printed by his godfather in 1493. The devil abducts a long-haired nude sorceress, who rides bareback behind him, both arms thrust skyward, like the Wild Man's furious victim.

11.44

Vulpanser or Chenopolex

This odd bird, the fifty-third hieroglyph of the Horus Apollo [11.45], symbolizes the wish for a son. Believed to produce many male offspring, the vulpanser was also described as a self-sacrificing parent, ready to offer itself to the hunter's dogs, so as to keep them away from its young.

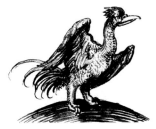

11.45

Wildfolk

What are wildfolk doing in a book on beasts? Much beloved in Dürer's times, they were valued as links between animal spirits and human passions. Satyrs and fauns of the northern heritage, wildfolk often support coats of arms in Dürer's portraits [11.46], promising his sitters fertility. Befurred but for their faces, these beastly people lived in and out of the woods. Mostly benevolent, they were known to return lost children to their parents. In England they were called Green Men or woodwoses and woodwives, color and fur alike proclaiming their close ties to nature.

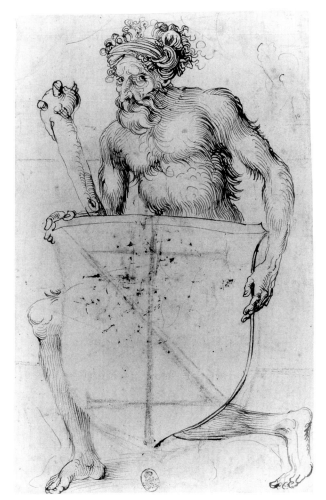

11.46

bonum quod agere debuerũt neglexerunt: et libera eas ab omnibus penis: et angustijs: et perduc eas ad requiem sempiternam. Qui venturus es iudicare vivos et mortuos et seculum per ignem Amen.

Versi. Ne tradas bestijs animas confitentes tibi. Et animas pauperum tuorũ ne obliuiscaris in finem.

Omnipotens sempiterne deus: qui humanũ corpus de limo terre formasti ex-

Chapter Twelve

Beastly Temptations, Monstrous Sins

In the depths of the Great Depression, President Roosevelt declared: "We have nothing to fear but fear itself." In Dürer's times the world, the flesh, and the devil were all held in dread. Before sleep, old and young knelt at their bedsides, beseeching protection from the monsters of the night.

<center>AD</center>

Much of Dürer's skill went into the creation of the beastly horrors that represented sin and depravity. Alternately terrorizing and amusing the viewer, such demons' shocking appearance is a credit to the draftsman's bonding of various animal forms—birds and snakes, toads and fish, apes and lizards. Without the remarkable zoological skills Dürer used to bring such hybrid forms to fearful life on paper, these devils would be far less effective. They tempt Christ, litter Hell, scramble over the borders of Limbo, pollute the Apocalypse, creep out of the woodwork, the stove, and the forest. Cold-blooded demonic beasts lurk in shadows or under rocks; lizards and toads creep and wriggle or swoop on bat's or owl's wings through black skies. Though phantoms, these monstrous figures are visible nonetheless. They represent hideous consequences, catastrophes to come, ghastly errors, lapses of judgment and of faith, an insidious world of vice and envy, nagging anxiety, creeping inadequacy, and sins of all sorts.

One way the good Lord helped reveal the presence of the Evil One was to seldom, if ever, let him look completely human. No matter how enticing Satan might seem, there would always be, by way of warning, a telltale claw or tail poking out from under the tempting skirt or tight breeches; his bestial nature was never entirely hidden. Fishtails or bird feet; a little horn here or there; the sudden flash of a cat's paw or a sharp incisor—these were the clues from the animal kingdom that revealed Satan's presence.

Dürer drew and engraved such unnatural wonders not only because they were popular subjects and sold well, but also because they fascinated him as aberrant and bizarre, as messages of the infinite variety, the danger and wonder, of this life and the next. He was inspired by the fierce animal imagery of medieval art, such as the line drawing of a half-human, half-monstrous creature representing the seven deadly sins, devised by a midfourteenth century Master of Allegory [12.1]. Her crowned head symbolizes Pride; she holds Wrath's bow and grasps the coin-filled sack of Avarice as she rests upon a single great bird's

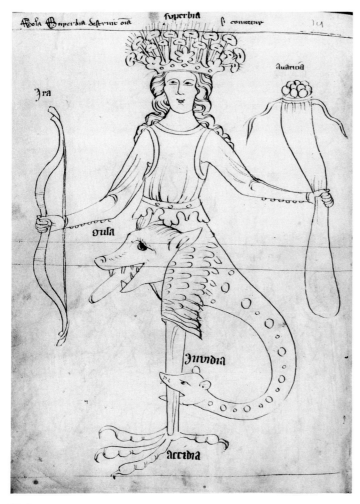

12.1

*Suppose a painter to a human head
Should join a horse's neck, and wildly spread
The various plumage of the feather's kind
O'er links of different beasts, absurdly join'd,
Or if he gave to view a beauteous maid
Above the waist with every charm array'd
Should a foul fish her lower parts unfold,
Would you not laugh such pictures to behold?*

But as Horace and Bernard both knew well, fear more than laughter resulted from these beastly fusions. The good, the true, and the beautiful long formed a trinity of divine art, opposed by the bad, the false, and the ugly. Sometimes seductive with borrowed beauty, devils, demons, and monsters remained, by definition, revolting. They repelled the gaze and chilled the spirit, their ugliness a sign of the absence of God, of love, and of truth. And the keener an artist's response to beauty, the livelier his reaction to the ugly. Dürer, the first German artist to be obsessed by the classical pursuit of ideal beauty, designed the "perfect" visual summation of all that was imperfect—the revolting monsters of his *Apocalypse*. For these demons he drew upon the monsters from Schongauer's *The Tribulations of Saint Anthony* [12.3] and devils and dragons found in stone, in manuscripts, and in paintings and prints. By fusing the qualities of fur and feather, scales and claws, fins and talons, elephant trunks and octopus tentacles, Schongauer eliminated the barriers between the very beastliest. Only a master *animalier* could create such convincing demonic images. Dürer's devils, like those of Schongauer, seem in a constant process of biological conversion, shifting from one form to another in a monstrous metamorphosis, as they bring together the foul features of God's ugliest designs—toads and alligators, long, cold bird's feet, wounding beaks, and horns, in a diabolical merging of all you do not want to be or see.

12.2

foot, which stands for Sloth. From the waist down she is like a mermaid, Lust, her tail terminating in a ferretlike head of Envy, which bites her own birdlike leg. This demon's winged body has another canine head sticking out its tongue as a sign of endless Greed. Another evil allegory is provided by the mid-fifteenth-century printmaker known only by his initials, E.S., whose five beasts, united by greed and hate, devour one another [12.2].

Saint Bernard objected to such composite monsters, so often found in medieval churches, as unworthy of their sacred setting, but he was far from the first to protest against these horrible creatures. Writing more than a thousand years before, Horace had observed in his *Ars poetica*:

Dürer's first rendering of a powerful devil,

combining brute force and human cunning, is found in his woodcut for the Chevalier de La Tour Landry's account of a battered boy whose parents turn him over to the devil for further hideous punishment [12.4]. Though Dürer's illustration spares the reader the worst of the chevalier's horror story, the demon is truly terrifying nonetheless, all the more so because the parents look too foolish and feeble to have unleashed such devastation, one more frightening element in a dreadful tale of fear and hate. This woodcut, prepared a few years before Dürer first went to Italy, shows the way in which he approached a vigorous fusion of human and inhuman though he had not yet experienced the new vitality of ancient and Renaissance art.

Tragic and comic at the same time, an immensely frustrated, howling old Satan is shown at the lower left corner of a two-page spread in Maximilian's *Hours* devoted to the Annunciation [12.5]. Hideously frustrated by foreknowledge of his defeat, he pulls out his hair, crouching in bitter wrath, with shriveled, pendulous breasts flapping. Just a hint of Herculean strength toughens his beastly thighs and arms. A burdened, ugly man squeezed in the corner of Mantegna's *Triumphs* provided Dürer's point of departure for this amazing devil. Less than three inches high, Dürer's hateful figure has monumental power, worthy of comparison with the devils Michelangelo painted in *The Last Judgment*, begun fifteen years later. His gargoyle of a head, with massively open mouth and demented, Hitlerlike stare, makes this evil beast among Dürer's most memorable monsters.

Two early prints with a small but effective demonic presence are the 1497 *Four Naked Women* [12.6] and *The Dream of the Doctor (Temptation of the Idler)* [12.7], engraved about a year later. In the first, Venus stands to the right with a wreathed Minerva and a matronly Juno; Discord, whose apple of conflict hangs overhead, scowls in the background. A demon at the far left anticipates the awful troubles to come, the

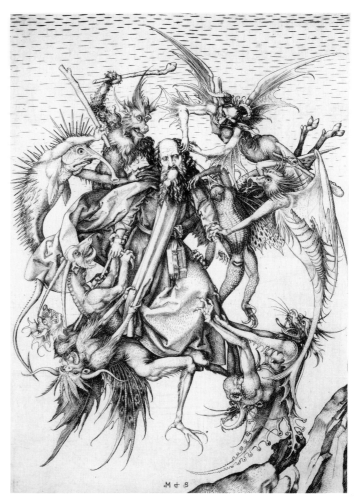

12.3

12.4

12.5

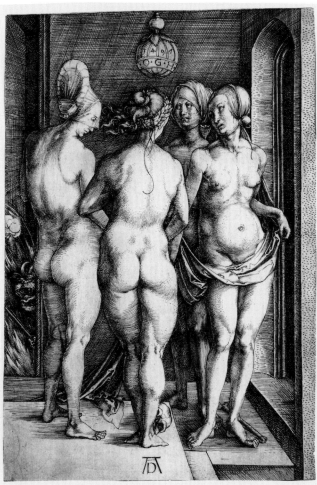

12.6

rape of Helen and the fall of Troy. The second print shows a lazy man dozing by a tile stove and dreaming of Venus, who stands at his side. A fiendish devil flies in from the left at the sleeper's ear.

After his dramatic *Apocalypse* woodcuts of the 1490s, teeming with demons, dragons, and battling angels, the master continued the images of that turbulent text in a drawing of nuns and monks at a mass celebrated by angels [12.8]. Saint John wrote of angels who recorded good deeds and devils who noted the bad; at the time of the Last Judgment they would battle over all human souls. It takes only one angel to keep track of the good in a very small book, but two devils are needed for the bad. One sits on the stoop of a little Gothic outhouse, writing on a large, parchment scroll, while an assistant devil dictates from a still longer list.

Dürer must have been reminded of the Chevalier de La Tour Landry's story of two devils recording the names of people gossiping during the church service, which he illustrated about ten years before. But now the entire congregation is the clergy, and a wonderfully drawn company of little devils tempts it with offerings that cover all seven deadly sins. Only three priests and a nun can resist. The latter, at the upper right, is rewarded by a glimpse of the cross, and a good priest below sees a soul—perhaps his own—snatched from Hell by a guardian angel. On the left another old priest is shown the Woman of the Apocalypse. A flying pig-headed devil [8.57] represents the sin of Pride with a cardinal's hat as a little dragon flies to the rear with an important, many-sealed document offering promotion or wealth. An evil insect below extends a glass of rum (toward Drunkenness and Wrath), while another little monster holds out a lovely little nude, Lust, toward a cherubic priest. Gluttony in the form of a chicken on a spit flies through the air at the upper right, followed by the sins of Vanity and Sloth, symbolized by the devil with the backgammon board. Another devil

offers a splendid residence, a glimpse of alluring Envy or Covetousness, probably Envy; a dog-headed demon peddles a whole hamper of vices, holding a stein of beer and bearing a nude and a barrel on his back. Some believe this design was meant for a church window, but that seems inappropriate for so transparently humorous and irreverent a treatment. Dürer may have made this to send to Caritas Pirckheimer, a friend who was a Poor Clare, which would explain the tablet in the foreground, where he noted: "Write here what you will." His correspondence with her abounded with lusty good humor; abbess of a Franciscan convent, she would have been the first to laugh at such a painted glass.

Dürer probably knew the monsters so ingeniously making the punishment fit the crime in the infernal recesses painted by Bosch. His own weirdly wonderful freaks with a thousand faces, like the devil in the engraved *Knight, Death and Devil* of 1513 [12.9], are the dying hiss of a rich heritage of medieval madness. Soon the Reformation and Counter-Reformation alike terminated this teeming diabolism.

Magic, sorcery, alchemy, astrology, the many varied arts and sciences of the occult, were popular all over Europe, forceful mysteries for bad as well as good, powers one would just as soon have under control. Incantations that could put the devil in your service were highly sought after. Canon Lorenz Behaim was not only a master astrologer (who cast Dürer's horoscope); he could also write out recipes for slow poison, requiring conjuration with the devil. One such gruesome paper of his was found among Pirckheimer's documents when he died. Behaim was probably an alchemist as well, working with explosives and other chemicals of holy war; he was in charge of artillery for Cardinal Cesare Borgia, son of Pope Alexander VI.

Indeed, witchcraft and magic were never more of an obsession than in the later Renaissance, just at the dawn of the Age of Reason.

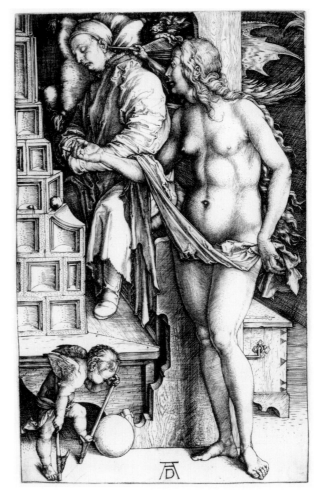

12.7

And artists, closely involved with medicine, chemistry, and experimentation of all sorts, were themselves victors and victims in this most ambiguous period. Arcane secrets of ancient knowledge were now available in print form. Science and superstition made for strangely inseparable bedfellows. Sophisticated urban centers were equally open to the extremes of demonology and rarified heights of neo-Platonism.

Devils, demons, and witches had been given a renewed lease on their infernal lives by the *Malleus maleficarum*, or *The Witches' Hammer*, first printed around 1486, when Dürer was fifteen. In his lifetime, fourteen editions appeared, making this horrifying text among the most popular of all books. A treatise on witchcraft, the *Hammer* was written by two German-speaking Dominican inquisitors. Their ac-

306 Dürer's Animals

12.8

count "of the manner whereby they [witches] change men into the shapes of beasts" begins by repeating Homer's account of how Circe turned Ulysses's companions into swine.

Rarely abandoning himself to a visual orgy of witches' sabbaths, Dürer completed only a few such scenes, for which there was an all-too-ready market. One of these showed a naked witch on a goat [8.48], grabbing her mount's horns, which symbolize rampant male sexuality. The harridan is on her way to a witches' sabbath, or black mass, where the sacred service is profaned by reading it in reverse. That she is headed for no good is made obvious by her backward position. Dürer probably based this print on a northern Italian work: Renaissance bronzes and prints of this kind abounded, especially in Padua.

𝔸

Being stupid is not necessarily evil, but ignorance of God is sin. That is why a virtually pea-brained bird-demon may look as witless as it does. Dürer had a certain fondness for this dumb devil of a bird, who appears all through his works. Not the master's invention, the ridiculous monster went by the name of *Schnerb*; winged and long necked, he is often shown pumping vain thoughts into lazy, sinful minds. More frightened than frightening, he is totally absorbed by the difficult task of being a monster, hanging onto his horrible role by the chicken skin of his teeth.

Big bird feet are symbols of sloth, which is why the rustic warming himself by the oven in another drawing has a massive bird on a jousting helmet, one foot raised heavenward in mock supplication [12.10]. Another winged demon flies in to fill a dreamer's cozy corner with sin—in the form of a beautiful nude woman. More demonic is the head of a bird with wattles and ugly, winglike crests, a fixed stare in its beady little eyes. In 1510 this bird appeared in Hell, craning its neck to get a glimpse of Jesus, who was in Limbo to rescue the Patriarchs [12.11]. Related to it is one that

12.9

Dürer drew, crunching a dragonfly in its beak [12.12]. That this bird is a devil can be seen on another page, where its long scaley tail is visible. This sheet is very close to those of Maximilian's *Book of Hours*, drawn in 1515.

A humorous drawing made in 1513 shows a winged creature, sometimes identified as the monk's crane [Plate 36], though the crane's cry of "kur, kri, kurr, kier" is not the "GI GI GIG" inscribed in the banderole arched around this specimen's ungainly head. Placed on a very large page and touched with remarkably bright watercolor, this festive rendering may have been meant for use as a heraldic device or a design for a stained-glass window. One of a pair, it goes with a page on which a cross little lion is squeezed within a coronet placed upon a bizarre, egg-shaped winged vessel supported on bird feet [Plate 22]. Since the lion's page has alchemical references, these may also be present in the bird's.

Late medieval literature lent itself to the horrors of the demonic world. Strange creatures on lost continents, half-animal, half-human, were described in ancient literature and again by stunned travelers who claimed to have been overwhelmed by mermen and mermaids, centaurs, and the rest. Thrilling, often fraudulent accounts of horrible creatures were devoured by readers as they pored over the often crude woodcuts and blood-chilling de-

12.10

12.11

12.12

scriptions that came out year after year in the best-sellers of Dürer's youth. One of the most popular of these was "Sir John Mandeville's" *Travels*, a fourteenth-century account printed in Basel by the same publisher for whom Dürer worked on his early woodcuts. Everyone with a press wanted to publish his own edition of this sure-fire hit, largely fiction posing as fact, with its descriptions of revolting killer-monsters in North Africa, India, and the Near and Far East.

Many strange man-beasts, misshapen harbingers of disaster and punishment for sin, were gathered together in a single page of the *Nuremberg Chronicles* of 1493 [12.13]. Some of these curious couplings, such as the semicen-

taur at the far right, are more human than their classical models and were probably based on the hoked-up *Travels* of "Sir John Mandeville"; on Marco Polo's accounts of many-armed divinities of the Far East; on the medieval encyclopedists and Conrad von Megenberg's *Bidpai: The Book of Nature* printed in 1475 [12.14].

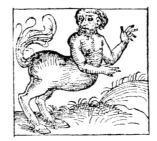

12.13

Unlike Marco Polo, who wrote to document what he saw, Mandeville brought together all the most sensational, horrifying rumors circulated by earlier travel writers. His pages teem with one-eyed cyclopses, sciapodes or "footshade men," hopping along on one foot so large it also works as a sunshade, and the hippopodes or anthropophagi, men with heads growing below the shoulders. His beasts reminded readers of the devils that already crowded church portals, columns, capitals, and prayer books and showed that beyond Europe lay a whole world where these signs of living evil were a visible reality.

At the time the *Nuremberg Chronicles* came out, the major surge of new global exploration was under way, with the Portuguese navigating along the African west coast and Columbus's first transatlantic voyage in 1492. Garbled accounts of the wonders of the New World merged with those of the distant past, giving new credence to some of the wildest nightmares of the medieval mind. Past and present, fused in sailors' stories of whales, sea lions, and narwhals, convinced Europeans that all the wildest creatures of myth and faith were fact, not fiction.

🅰

Just as the invention of movable type near the time of Dürer's birth lead to a boom in medieval thought—realized by reissuing Gothic manuscripts in cheaper published form—so too did the discovery of new worlds, with their novel flora and fauna, return readers to medieval encyclopedias for answers to the nature of these unprecedented natural marvels. Instead of sinking into oblivion, those early illustrated books of nature from Dürer's childhood, based

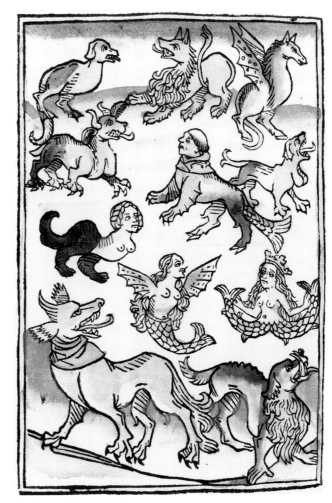

12.14

on Bartholomew the Englishman or Albertus Magnus, were examined more closely than ever. Never was the past more present—or more needed—than in Dürer's maturity when "Renaissance men and women" were those whose learning combined the immediacy of their medieval heritage, the rediscovered culture of antiquity, and the consciousness of new worlds to east and west.

Engravings, above all those by Dürer, be-

longed with the recently accessible, enlarged cosmology of the early sixteenth century. They drew upon and multiplied the intricate, magical worlds of Jan van Eyck and Leonardo da Vinci. Almost infinitely detailed, the three Master Prints and *Saint Eustace* seemed like monochromatic mirrors of and to new worlds of understanding. Their virtuosity transcended previous technical limitations in much the same way that their artist's *Fortuna* or *Nemesis*, with its bird's eye vista, lent the viewer the gift of flight. These prints carried their peruser away with them. Seeing *was* knowing.

Dürer's woodcut *Apocalypse* of 1497, issued with German and Latin texts the following year, breathed new life into the ancient visions of Saint John the Divine, lending his monsters fresh credibility. Although we may see Dürer's devils and dragons as the oldest-fashioned of his animals, he probably found them among his newest, novel because they were based on strange and wonderful creatures from long-lost lands known to Aristotle and Pliny. Just when the West was already shivering in anticipation of the world ending in the year 1500, texts like "Sir John Mandeville's" *Travels* and the Revelation reinforced one another, Saint John picturing an early Christian world of monstrous beings, agents of evil, Sir John describing unknown regions where these survived as zoological fact.

Close to the time that Dürer designed *The Apocalypse* and engraved *The Prodigal Son*, the qualities of fantasy found in the first and the naturalism of the second were brought together in one of his oddest prints, *The Monstrous Pig of Landser* [12.15]. Like the *Rhinoceros*, his only other print devoted to a single exotic creature, the sow was based on a work by another artist, which Dürer then improved upon for a readily saleable sheet of newsworthy interest. A Nuremberg chronicle recorded that "In the year 1496 a wondrous sow was born in the village of Landser with one head, four ears, eight feet, on six of which it stood, and two tongues." Dürer never saw the living freak, but he adapted it, with the landscape background, from a crude woodcut broadside with a text by Sebastian Brant. Brant's *Monstrous Pig of Landser* looks like two pigs doing the foxtrot; Dürer's is far more lifelike, standing on six legs, the other two rising from the freak's shoulders. This convincing pose may have been based on the stuffed sow, which Dürer saw when it (or one like it), was exhibited in Nuremberg around Eastertime, still in the year of the beast's birth. Dürer has done everything he can do to bring this monster to life, engraving the sow as she might have been seen in her short life by some lucky bystander. His print shows the same reverence and respect for life that fill the pages of his Netherlandish journal. Monstrous and marvelous are seen as one, the sow a wonderful working together of Heaven and earth. The stars above influenced biology below to prepare a special sign, a portent, foretelling the future.

A keen astrologer, Luther could never forget the Sow of Landser, whose appearance he

12.15

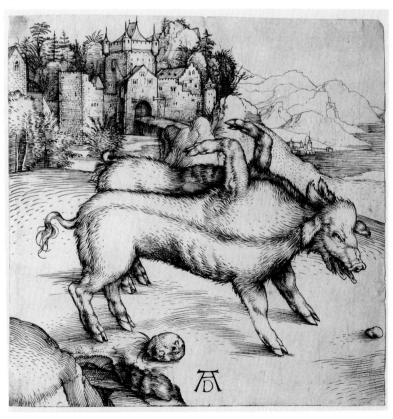

may have known through this engraving. As late as 1524 he said that this monster, together with another, believed to combine the body of a woman and an ass's head, washed up on the banks of the Tiber, augured the end of the world.

But the most stirring of all accounts of demonic threats, conquests, and defeats is the Revelation of Saint John. Before Dürer issued his own tempestuous edition, there had already been at least six woodcut publications of the text accompanied by illustrations whose raw power made up for their lack of suavity. Beset by plague and new diseases such as syphilis, oppressed by the venality of the church, Christians were plunged into doubt and fear. How could they reconcile themselves to collusion between the pope and the great moneylenders, like the Fuggers of Augsburg and the Medici of Florence, when usury was forbidden by canon law? The legend of the Antichrist, that seductive, evil figure who was to keep the earth in his vile grip just before the Second Coming of Christ, became ever more popular as the dreaded year 1500 neared. In 1494, Dürer had illustrated the Antichrist as a beamish boy perched on a rainbow [12.16], all too open to demonic inspiration. In Florence, Savonarola preached that his city would be ravaged, telling of a vengeful angel, sword in hand, who would slaughter the lion—the city's symbol. Ready for the unexpected, for the horrific, for the end of time, Italy like Germany was overwhelmed by a sense of impending catastrophe.

In this context, Dürer's series of fifteen woodcuts of the Apocalypse, telling the story of John's vision, confirmed everyone's gravest fears. Splendid angels, a vigorous Saint John [3.47], vibrant images of the heavenly host and the Four Horsemen of the Apocalypse [9.22]—all these enhanced the young artist's publication, whose graphic horror, not beauty, captured the European imagination. Dürer destroyed the world. Once he had shown how he believed falling stars and demons would look,

12.16

that was it. His many-headed dragons and hideous lion-faced beasts were soon copied all over the world, from colonial Mexico and Peru to Persia and India, found in frescoes in Yugoslavia, and used by biblical artists in the Far East. These images maintain much of their power even now.

The special force of Dürer's monstrous images comes from his adding reason to unreason. By using new Italian anatomical discoveries, applying the virile, muscular drama of that iron-pumping engraver of Florence, Antonio Pollaiuolo, and adapting Mantegna's authoritative recreation of the mythical monsters of Greece, the young German infused his late Gothic sources with new validity. The skeletal, shriveled little woodcuts in the Cologne and Strasbourg Bibles, reprinted by Anton Kober-

12.17

ger [12.17], were brought to terrifying life and refreshed by their transfusion of Renaissance dragon's blood.

A flying wedge of fearsome cavalry, "numbering twenty thousand times ten thousand," appears at the upper part of Dürer's woodcut for the ninth chapter of the Revelation, showing the Four Avenging Angels of the Euphrates [12.18]. "And thus I saw in my vision the horses and their riders, wearing breastplates colored red as fire, dark blue, and yellow as sulphur; and the heads of the horses were like the heads of lions, and out of their mouths issued fire, smoke and sulphur. By these three plagues . . . a third of mankind was killed. . . . Their tails are like serpents and have heads, and with them they do hurt (Rev. 9:17–19). This group is a forerunner of the Four Horsemen of the Apocalypse, who also bring pestilence, war, hunger, and death. So sure is Dürer's imagination that he did not follow every word of Saint John: He added two more riders and, in view of the small size of the horseman, omitted the heads on the serpent tails.

Of all the extraordinary beasts in Dürer's *Apocalypse*, perhaps the most significant and the fiercest is the dragon [12.19]. Germany, whose art has provided the best of these beasts, has a surprisingly colorless word to describe them: *Lindwurm*, which means little more than "worm"; *Drache*, the modern word for dragon, became popular long after the artist's lifetime. He took care to give his giant worms wings, bringing together two of the most frightening senses—the unknown terror lurking below the surface and the one darting down from above. By fusing feathers and fishskins, merging the air- and the water-borne, threats from the sky and sea, Dürer, like Saint John, preys on all our fears of the unknown. This synthesis of motion above and beyond human limitations makes the viewer aware more of what he lacks than of what he has and conveys the sense of inadequacy and loss that is the first and often the only message of terror needed to do this awful work of paralysis and dislocation of will.

Roman naturalists like Pliny and Aelian discussed dragons in great detail. They were believed to have come from the bottom of the sea, where they guarded vast treasures. Thunder and lightning came and went with the dragon's breath. Larger than life, these creatures combined all the infernal powers. No single species, dragons are a flying anthology of the worst of all animals, with a creepy, snaky, toadlike skin, a fishscaled covering to its cold flesh; sharp-clawed falcon's feet; great, batlike wings unfurling like fatal umbrellas. Nordic legends abound with dragons awaiting slaughter by the right hero, their heart and blood to be dished up to some lucky recipient for a magical, alchemical cure. These Norse sagas seemed reborn in Saint John's words, for there is a correspondence between the dragon's slaying at the conclusion of the myths and the destruction of the many-headed monster at the end of the world in the Revelation, with the coming of a new heaven and a new earth, Saint John's New Jerusalem.

Some of the strange creatures found by explorers to the New World seemed to substantiate the wildest imaginings of medieval writers and travelers to the east. Vespucci, on his second sailing to the New World, reported to the Medici, "As we visited many Indians'

12.18

Beastly Temptations, Monstrous Sins

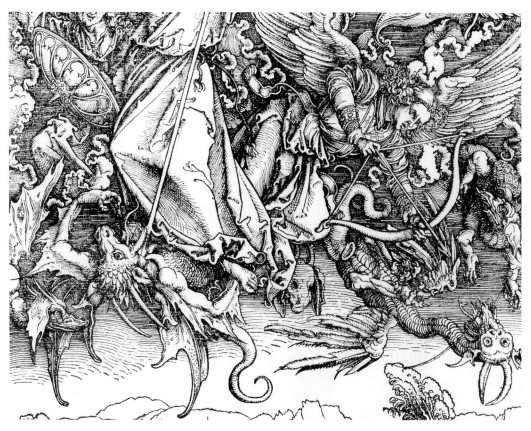

12.19

houses or tents, we saw many such serpents alive. Their feet were tied, and they had a cord around their snouts so they could not open their mouths. . . . These animals had such a savage appearance that none of us dared to turn one over, thinking they might be poisonous. They are about the size of a kid, about the length and a half of a man's arm, having long coarse feet with large nails. They have the snout and face of a serpent, and from the nose there runs a crest, passing over the middle of the back to the roots of the tail. We finally concluded that they were serpents and poisonous; nonetheless they were eaten." This awesome animal was probably an iguana. But dragons were believed to be alive and well as late as the seventeenth century, when a German scientist published the woodcut of one as *Dranunculus Monoceros* in his *Animalia Mexicana* of 1628. The terrifying zoological specimen later proved fraudulent, pieced together from different creatures.

Dragons were not confined to art and architecture, safely locked in limestone. On feast days and in religious processions, dragons roamed the streets and sometimes even belched fire and smoke. Dürer was especially admiring of one seen in the Saint Margaret's celebration in Antwerp. But his own dragons tended to be on the small side, reasonably sized so that the viewer could always relate them to his own experience, to the life of day rather than that of a dream.

Dürer's little dragons turn up in the most surprising places, almost undetectable, meaning more, perhaps, to the artist than to the viewer. As Christ, mocked and tormented, is shown to the people, his robe drawn back to reveal his beaten body, a small monster appears just to the left of Pilate's pillow [12.20]. Deliberately, Dürer makes it hard to tell whether this dragon is part of the carved, corrupt fabric of the Judgment Hall, or a living sign of the evil act of the *Ecce Homo*.

Dragons designed for Dürer's *Apocalypse* are central to that visionary text. In the twelfth chapter of the Revelation, Saint John tells of "a dragon, ruddy and great, with seven heads and ten horns, and seven crowns upon his heads [12.21]. And his tail swept a third of the stars from the sky and threw them down upon the earth. And the dragon stood before the woman who was about to give birth to devour her child as soon as it was born. And she bore a male child, who will rule all the nations with a rod of iron; and her child was snatched away to God and to his throne" (Rev. 12:3–5). Dürer showed how, "There were given to the woman the two great wings of an eagle, so that she might fly to her place in the desert, where far away from the serpent she might be nourished for an era. . . . Then the serpent cast from his mouth a stream of water after the woman, so that she might be swept away by the flood. But the earth came to the woman's aid; the earth opened her mouth and swallowed up the stream" (Rev. 12:17). The dramatic images of this mystical passage refer to the key events of the life of Christ and the Virgin.

Without Dürer's many wonderful studies of bird's wings [Plates 4, 5], the portrayal of Mary as the Woman of the Apocalypse, so plausibly endowed with the gift of flight, could never have been realized. Large yet stealthy, the seven-headed dragon clambering up the hill on a bearlike body is as persuasively real as the devils surrounding Schongauer's *The Tribulations of Saint Anthony*. The woodcut dragon's beautifully serpentine tail, placed as if to confine the borders of a manuscript, twitches stars from the skies.

Renaissance bronzes or engraved monsters that Dürer saw in Padua underly this dragon's convincingly organic qualities. One of its heads is close to the sea monster at the far left of Mantegna's *Battle of the Sea Gods* [11.4]. Compared with the tiny, ticket-shaped woodcut (the illustration in the Strasbourg Bible of 1485 that provided Dürer's point of departure), the large print is a majestic, full-bodied orchestration, informed by the art of ancient Rome and modern Padua, invigorated by the crisp, graphic landscape of his late Gothic heritage. Dürer's mastery of the animal world, added to his other resources, makes this great print soar. Saint John's imagery rises on eagle's wings and dragon's twisted tail, leaving that demonic monopoly of a dragon so near and yet so far behind.

Second of the monstrous ensembles that made Dürer's *Apocalypse* so thrilling is found in his woodcut for the twelfth chapter [12.22]; John tells his readers, "There was a battle in the sky: Michael and his angels fought with the dragon, and the dragon fought with his angels. But he did not prevail and their place in heaven was lost. Thus the ancient serpent, who is called the Devil and Satan, who leads astray

12.20

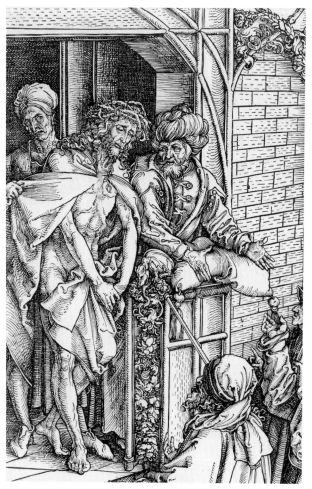

the entire inhabited world, was flung to the earth and his angels with him" (Rev. 12:7–9).

Satan's strangely oxlike head makes him look like an ancient minotaur, just about to have his throat slit by Michael. His fellow fallen angels are shown like somewhat anemic dragonettes, split away from those three great group portraits of evil, the seven-headed dragons. Some of these devils were first devised the right way around, then turned upside down to make them fall to earth. The angels are so large, or the monsters so small, that the contest seems robbed of suspense, almost unfair to disorganized devils.

These falling devils were followed by Dürer's assistant when he drew *The Fall of Simon Magus* [12.23]. Sorcerer and magician, Simon converted to Christianity and sought to buy its miraculous wonders, whereupon Saint Peter said to him, "Thy money perish with thee, because thou hast sought to purchase with money" (Acts 8:20). Simon's fall is all the more dramatic because he had just demonstrated his gifts of levitation to the emperor Nero. Caught in midair, the proud magician is dragged downward by both devils, as though at Saint Peter's command.

In the thirteenth chapter of the Revelation, Saint John recalls how he "saw a beast come up from the sea with ten horns and seven heads, and upon his horns ten crowns, and upon his heads the names of blasphemy. The beast I saw was like a leopard, and his feet as those of a bear, and his mouth like the mouth of a lion; and the dragon gave him his power, and his throne, and great authority. And one of his heads was as if stricken to death, and the death blow had been healed; and all the world followed the beast in amazement. . . . And then I saw another beast coming out of the ground, and he had two horns like a lamb and spoke like a dragon. . . . And he prompted great portents, even that fire pour down from the sky for all men to see" (Rev. 13:1–13). What makes these monsters so effective are just those forms that Dürer took from the two

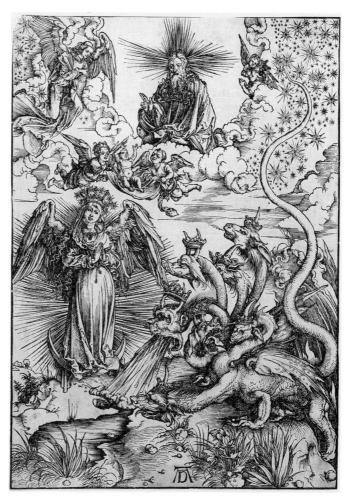

12.21

popular illustrated German Bibles of this subject and others based upon his experience of recent Italian art. Basically, the type and placement of the dragon and beast "coming from the ground" are those found in the Cologne Bible of 1480 [12.24] and the Strasbourg one printed five years later [12.25]. The latter is far closer to Dürer's graphic format, source for the excitement of his beast. Where the earlier monster has remarkable force and authority, it still belongs with the armorial world, his terror confined to the shieldlike wedge on which he appears to sit. Dürer built on that form, borrowing the beast's broad outlines but infusing it with the life of closely observed form, perhaps from the lions he had drawn on vellum in 1494. Leaving the language of heraldry far behind, this is a monster come into his own,

316 Dürer's Animals

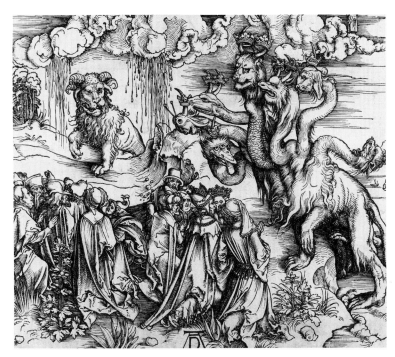

12.22

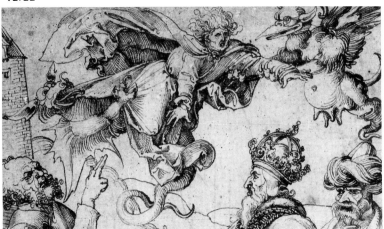

12.23

12.24

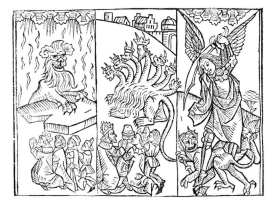

12.25

whose horrible horns are a biological freak, like the many zoological portents that loomed so large in European thought.

Some of the horrible horns rising from the brows of Dürer's monsters are not fantasies but facts, based upon misshapen forms that he and his friend Pirckheimer collected. A lost Dürer drawing of a stag's head with hideously convoluted horns, known from a copy by his follower Hoffman [12.26], probably recorded a stuffed specimen kept in a chamber of wonders; another study of a stag's head (close in style to Dürer's renderings) shows monstrously thick, corallike antlers [12.27]. The model may also have been kept in a curio collection.

A terrifying feature of *The Apocalypse* is the drops and rivulets of blood streaming down from the curtain of sky above, as they did in the nightmares that were to terrify Dürer in later life and like the rains of crosses that caused Luther to believe the world would end in the mid-1520s. At the lower right is the beast with seven heads, each of them far more sharply personalized than any done before. Perhaps these stand for the seven deadly sins, gloss to Saint John's text. The uppermost head, sole one of seven to be described, is shown "with the mouth of a lion" but modernized to make the entire head leonine but for the two horns that follow the text; this head stands for the sin of pride. A serpent, to the left, seems to slither for envy, and a snail head, farther left,

could portray covetousness. The comical bird head below might represent sloth, and the dog's head, second from the right, lust, leaving the one on either side to fend for the remaining sins of gluttony and wrath. Dürer did his best to give the dragon the bear feet and leopard body of John's text.

Among the most copied of Dürer's dragons is the one ridden by a very unlikely Whore of Babylon [12.28], who looks like a frightened girl overwhelmed by her fancy Venetian prostitute's dress and jeweled props. She is described in the seventeenth chapter as "sitting on a scarlet beast, full of names of blasphemies, with seven heads and ten horns. The woman was garbed in purple and scarlet, and gilded with gold, gems and pearls and bearing a golden goblet in her hand, full of abomination and the filth of her fornication (Rev. 17:3–4). The dragon as well as the young woman may be based on what the young artist saw on his first Italian journey: A German scholar found the monster very like one painted by a fourteenth-century Italian master, Giusto de' Menabuoi, in the baptistery at Padua. Though the dragon's broad outlines are like the Italian's, its different heads are designed by Dürer, who stressed a variety of textures and features. One of them recalls the fierce looking ox-skull held out in Mantegna's *Battle of the Sea Gods*.

Last of the Satans in *The Apocalypse* is that monster now shown as a muscular, hermaphroditic devil with wildly misshapen horns and wings that grow down from the shoulders, with a second pair flaring out at the hips; frog-like legs end in bird's feet, suggesting a menacingly amphibian creature, gifted with flight but equally suited to sea and land [12.29]. From now on, Satan will be limited to the latter: Saint John says that an angel holds a great chain in his hand with a key to the bottomless pit. "And he seized the dragon, that old serpent who is the Devil and Satan and bound him for a thousand years. And cast him into the bottomless pit, and shut him up, and placed a seal over him, so that he should deceive nations no

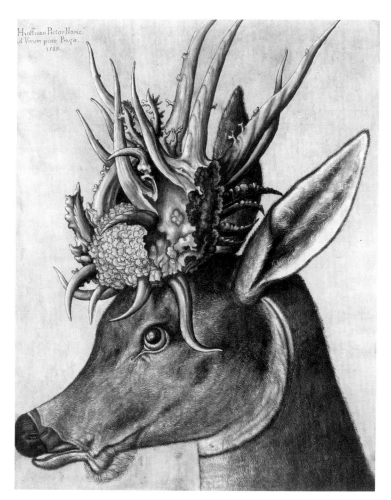

12.26

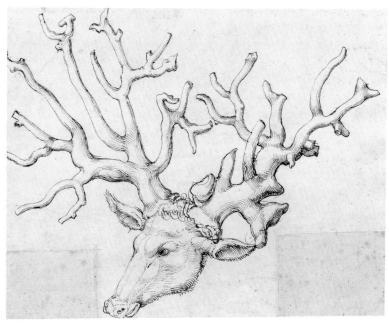

12.27

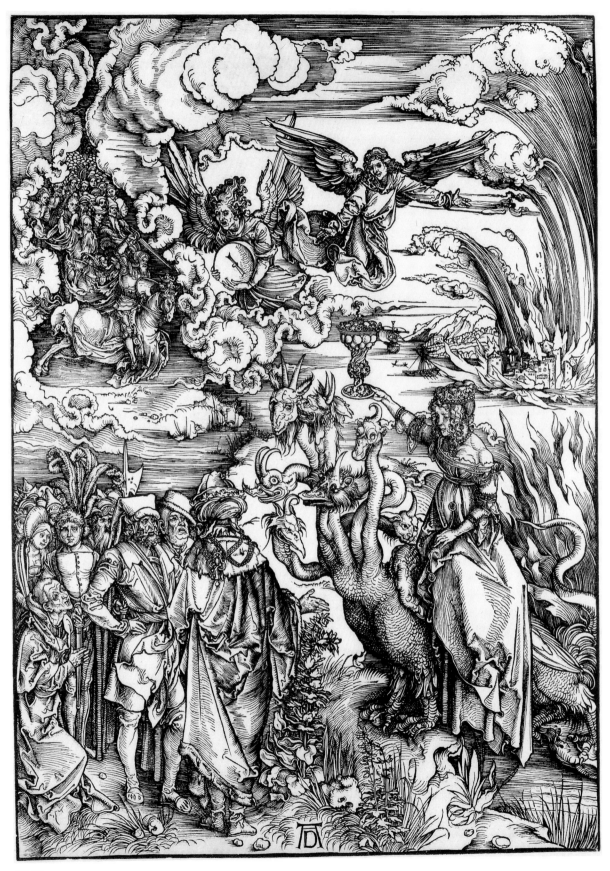

12.28

more until a thousand years have passed" (Rev. 20: 2). In this scene, Dürer combines the highest and the lowest references from the twenty-first chapter of Saint John's Revelation. At the upper right, the angel, his wings pointed skyward as a flurry of birds sweep down to the city below, shows "the great holy city of Jerusalem coming down out of heaven from God wearing the glory of God, and her radiance was that of a most precious stone, like stone of jasper that is clear as crystal" (Rev. 21: 10). Below is the terminal monster of the Apocalypse: Satan is in chains, arms tied behind his back, with a complicated Gothic strong-box lid about to be locked down on him.

Shortly after Dürer completed *The Apocalypse*, there is a very remote chance that he may even have come close to seeing a dragon. When his friend Pirckheimer went to Lake Constance in 1499 to help Maximilian's troops fight against the Swiss, Dürer went along. Three engravings from that time include landscapes suggesting those of the Swiss lakes. Could he have been there when, "on . . . the twenty-sixth day of May, there came a Dragon to the City of Lucerne, which came out of the lake through Rusa, down along the River, many people of all sorts beholding the same"? This apparition, like so many of Dürer's most terrifying images, was understood as a sign of the approaching doomsday.

In the late 1490s, Dürer first consulted Mantegna's creatures of the deep. He returned to the same master, using his engraved *Christ in Limbo* [12.30] for a magnificent woodcut of the same subject, part of "The Large Passion" series. Here the unisex demon flying at the top is modeled on Mantegna's; he blows a horn at Christ's crossed banner as another demon, a single horn rising from his head (like that of the evil unicorn), tries to harpoon Jesus with a pointed stick. Another demon who looks over his shoulder resembles the devil in the famous engraving of 1513 with the knight and Death. A third bird-headed demon, this one taken from the *Nuremberg Chronicles'* schnerb, strains

12.29

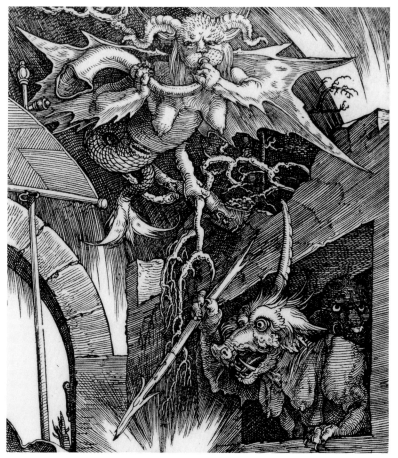

12.30

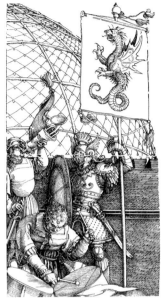

12.31

12.33

12.34

12.32

his neck to look at Christ and looks more perplexed than hateful. A second print of the same subject, made in 1512, part of Dürer's engraved Passion series, shows a wingless dragon climbing over the arch of the gateway to Limbo, his wickedly hooked stick grazing the top of old Adam's head. This cut-down version of the dragon in the Woman of the Apocalypse, shown with six heads, a shorter neck, a furry body, and fat scaley tail, is such a believable beast that Rembrandt copied it for his etched *Fall* more than a century later. Meanwhile, a snakelike dragon hisses at the Redeemer, who pulls Saint John the Baptist out of Limbo. By putting monsters on both sides of the gateway and placing the viewer in Hell, Dürer intensifies the dramatic power of this scene. The mouth of Hell is just exactly that in Dürer's art: With its jaw wide open, a monster's head lurks at the lower left of the Last Judgment, ready for an infernal bellyful of the damned as they stand, banded together, shoved by demons.

Fluttering to the upper right and left of Maximilian's *Triumphal Arch* [12.31], parallel with the great image of the emperor enthroned, are banners of a dragon and a double eagle, modeled on those of the Roman legions.

Dürer put them there, reflecting the belief that dragons were used in ancient times to strike terror into the hearts of the enemy—an early form of psychological warfare, when imperial armies marched under the dragon's or *draco*'s banner. Lucian alleged that Parthians kept live dragons to swallow their enemies. "They were alive and of enormous size . . . born in Persia . . . bound to long poles and raised high to create terror." As the army approached its enemy, the dragons were released and "swallowed many of our men and coiled themselves around others and suffocated and crushed them."

Dragons on Maximilian's *Arch* also act as guardians of the Golden Fleece. These handsome monsters are shown with their tails meeting the tip of the central pediment. Larger, plumper dragons are just below the precious fleece, one above each of the portal's side entrances [12.32]. Others are seen further left and right, perched defensively on cornices, tails wriggling up the wall [12.33]. All of these beasts watch over Maximilian's imperial treasure [12.34], but as he always spent far too much, by the time the *Arch* was printed he had more paper dragons than real gold for them to guard. Dragons had knightly societies dedicated to them and are found on most of the works of Dürer's collaborator, Lucas Cranach, who was so proud of this monster that he used its presence, with his monogram, instead of a signature, symbol of his lofty social status. Cranach's was a grand dragon, no matter how small, boasting bat wings, a crown poised nat-

tily on his head, and a ring of eternity in the flying monster's mouth. Perhaps Dürer's most original dragons are those spun in the borders of Maximilian's *Book of Hours*, where they dart around the pages, as if wished into form out of thin air, whirled onto the page with effortlessly inked lines, almost Oriental in their sleek, spontaneous calligraphy. Scintillating essays in changes of form—metamorphoses—it is hard to tell whether some of these speedy renderings are ferocious beasts or simply adroit, capricious patterns, which by purest chance momentarily have decided to be seen as such. These images, somewhere between filigree and calligraphy, show Dürer's goldsmith skills, with thin-spun, precious wires. Dürer loved the idea of lines changing from one fantastic form to the next but always remaining true to themselves.

Flying dragons could bring light as well as terror. Dürer adapted the palmate antlers of a stag for use as dragon's wings, grafting them to a shrewdly crafted three-headed dragon and bringing together art and nature in the form of an elaborate chandelier [12.35], where each of the beast's heads and both tails functioned as candle stands. He probably worked out this design for the son of Veit Stoss, Nuremberg's best sculptor, who prepared the hanging light [12.36] for installation in the city's guard room.

The ancient association of Saint George and the dragon exercised its perennial appeal upon Dürer, as it did upon so many other artists. But for his *Apocalypse*, most of Dürer's dragons either fight Saint George or lie dead at his feet. Drawn in the penultimate year of his life, Dürer's final dragons are a trio, tamed and twisted into a table fountain, spouting wine instead of breathing fire [12.37], and a duet, twinned to form a goldsmith's decoration [12.38]. Otherwise, Saint George and his dragon vanish from Dürer's art in the last decade. That holy knight and his monster were replaced by another active man of God, Martin Luther. Now shown in military guise, as a

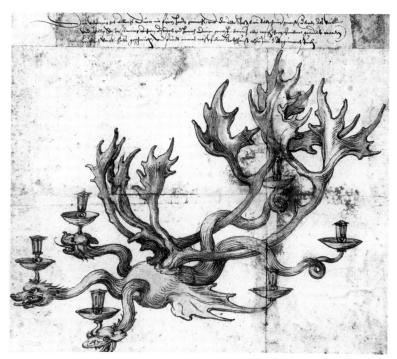

12.35

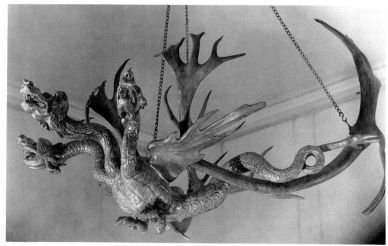

12.36

very different but still soldierly George, Luther was cast by Dürer as a knight in shining armor, "Junker Georg," ever ready to fight with his fellow Protestants against pope and peasant alike. Without dreams of crusade or the making of new saints and martyrs, the new northern Christianity stood fast, on its own matter-of-fact terms. Dragons were passé.

322 Dürer's Animals

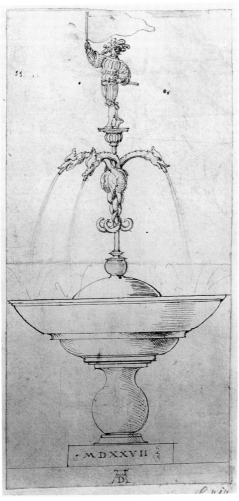

12.37

12.38

Monsters and devils received surprisingly documentary support from the accidental archaeology being done in Rome during Dürer's time. As the Eternal City was dug up to lay the foundations for the new, massive structures of the High Renaissance, a totally unexpected discovery was made of ancient, even subterranean architecture, and it reversed every idea of the orderly, sensible visual world of ancient Rome. This was a closeted area of whirlpool baths and steaming and drying chambers, their walls lined with underground art in every sense, and nonsense, too; grottoes whose bizarre decorations gave birth to the term *grotesque*. Lit by flickering lamplight, these frescoes and delicate, shallow plaster reliefs offered row upon row of haunting fusions of the abstract and the organic, the ornamental and the erotic; in an enveloping cave, the viewer was surrounded by an ominous world of changes, of architecture becoming monstrous, columns and recesses bulging with biomorphic forms of rampant sexuality. Horns and wings, bird legs and lion manes, fishtails and cattle skulls, feathers and fins—those eloquent bits and pieces of animal life were artfully merged with those of men and women, with wicked beards and sharp tongues, many breasts and lovely faces. Suddenly the monsters of the north met their match among these grotesque wonders of ancient Rome, which Dürer certainly saw on his second Italian journey or in the many prints from Italy that he used for his own works. Just when northern witches' sabbaths and scenes of hellfire began to look dated, the wildly, often obscenely decorative art of the Roman grottoes rushed in to take their place. The borders of Raphael's tapestries also abounded with the grottoes' new infernal zoology, and Dürer saw these on his trip to Brussels in 1520, where the Italian master's drawings were being woven into hangings. But by then, Dürer already knew the grotesque world of ancient art.

Thus did monsters from classical mythology creep into Hell's ecology; slowly the min-

otaur, the centaur, and other creatures from pagan faith came to populate the inferno, driving away some of the regular cast of Satan's beastly little helpers. This invasion from the classical realm became ever more commonplace. Even Luther helped send down the terrifying creatures so vividly delineated in Greek tragedy. The Reformer wrote, "The guilty conscience lights infernal fires and strikes anguish in the heart, with hellish imps, the Errinyes, as the poets call them." (These are the three Greek Furies, old crones with snakes for hair, dog heads, coal black bodies, bat wings, and bloodshot eyes, holding brass-studded scourges with which they killed their victims.)

But one of the very few doctrinal areas on which Reformation and Counter-Reformation agreed was that these beastly devils, with their monstrous ways, bare bottoms, obscene grins, and indecent exposures of all sorts, had no place in church, no matter how well intended their presence might have been. Caricatures of the worst of all physical aspects of human and beast, these old-fashioned depictions were seen more as a moral affront than as an effective sermon on the nature of evil.

Luther knew just where the devil was to be found: first of all in the great princely courts, then in other houses, fields, streets, in the water, in the woods. Whenever a house caught fire, the devil was to blame, for a little demon was sure to be found fanning the flames. Luther did not want to have the devil shown in art, preferring to preach against him instead, stressing the power of words over beastly images, which might give the devil more than his due. He sought a language strong enough "to overcome piggish life and devilish drinkers."

After Dürer's death, Protestants printed many series of "devil's books," where each vice was personified by a devil: the Clothes Horse Devil, the Dancing Devil, the Boozing Devil, and so on. Binding sins so closely to men, they were humanized, taken away from the world of beasts. All those winged, horned, scaly, forked-tongued, bird-footed, fish-tailed, lion-legged monsters became obsolete. You could be a devil just by being yourself, without any help from animals.

Yet new learning brought new devils to replace the old. Souls, taken for granted since time immemorial, became the subjects of serious scientific inquiry for the first time. Only then was it decided how a soul should look—like a baby—and when and where and how it left the body and the workings of immortality. Dr. Faust, who supposedly sold his soul to the devil, lived in Germany in Dürer's time. Who was such a man, who bartered away eternal life for damnation? Only one who wanted to learn the most he possibly could about this world and its mysterious ways was believed willing to sacrifice his heavenly reward. More than any other biography, whether true or imaginary, the story of Faust reveals the conflicted nature of the Renaissance artist—scientist, mystic, or visionary, caught between Heaven and Hell in the search for understanding.

The magical training of animals was a sign of Dr. Faust's infernal knowledge, ever accompanied by a performing horse and dog, both of them believed to be the devil in disguise. Melanchthon, whose portrait Dürer engraved, knew Faust "as a disgraceful beast and sewer of many devils." Luther also knew and wrote of Faust, finding him so appalling that he never wrote his name but described how "the doctor's" life was ended by the devil's wringing his neck.

What led to this awful new image of infernal man? The recent publication of ancient wisdom, the powerful mysticism of the Jewish Kabbalah, and ancient astrology and alchemy—all these meant much to Luther and his contemporaries. Compacts with the devil, such as those prescribed by Canon Lorenz Behaim, were described in this ancient literature. Legends of men selling their souls to the devil had been popular throughout the Middle Ages, and one of the most popular of these accounts, by the medieval German nun Hros-

witha of Gandersheim, was published with a frontispiece by Dürer.

The aging artist must have been divided between his concerns for the study of this world and the knowledge of the next. Luther offered him a way out of this dilemma between the world of the sciences—zoology, botany, astronomy, mathematics, optics, and hydraulics—and that of theology. A professor of law at the University of Wittenberg, Luther knew how to work together the terrifying knowledge of astrology and the haunting wisdom of the Kabbalah, by first making the Word of God available to every man in his own tongue. The Lord had to speak in German. Supposedly the devil himself blocked Luther at his task, but that fearless new leader of the Protestant church threw his inkpot at Satan, who fled in fear, leaving Luther to his sacred labors.

"Doctor" Dürer's early interests in animals, in medicine, in plants, freaks, constellations, and portents, all show him to be drawn to the secret of life. *Melencolia I* [3.16], steeped in references to many a black art, including that of printmaking itself, is filled with magical numerical clues and charts, malevolent, baleful stars and evil humors, with a dog-faced bat acting as label, bearing the engraving's title on its leathery, repulsive wings. The closer you get to the describable and the tangible, the keener an awareness of the elusive and the mystical becomes. Animals were among the most telling agents of the world and the universe. Ancient literature that Dürer knew well told of the beasts as prophets of change in the weather and health, as sign of Egyptian wisdom, Roman triumph, and pagan faith. Animals in the stars and overseas ruled the zodiac and the variety of earthly life. In their own compacts and fusions with the devil, animals were the infernal underbelly of zoology and theology; evil could only be seen with their beastly help.

Who freed the beasts from their ties to the deadly sins? Luther and Erasmus, those old enemies, who agreed on little but their love of the animal world. Luther stripped Satan of wings, horns, and claws when he declared his best image to be that of the impious man. It was the animals themselves, in the happy schoolrooms of the humanists, who were allowed to spread the good word about their own fine characters. That talking parrot in Erasmus's schoolroom, along with Dürer's woodcuts and descriptions of mosaics and wall paintings—the rhinoceros and the elephant, the ant and the bee—all showed a world of benign creatures as described by the early saints who so loved to dwell upon the creative wisdom of the Lord in his making of marvelous animals, in his creation of nature's pure ways, as contrasted with the human's unique capacity for corruption. Erasmus, long a tutor, brought this Latin literature back to life; it was read with pleasure by many a boy and girl, who could also enjoy Aesop's fables, among the most popular of early Latin publications and first printed in the original Greek in 1508. Sources of affection and amusement, animals were now seen as superior to humans. Nature was a mirror of virtue, not evil, and the wise child of the sixteenth century agreed with the writer Martial: "Beasts have not learned to lie."

Faith and fear, like love and hate, often lie close to one another, so near that they may be hard to tell apart. Dürer, among the most imaginative men who ever lived, was for that very reason unusually prone to anxiety, more open than most to the spiritual crises that gripped Europe at the time of the Reformation. Records of torment and suffering fill his diaries; troubled visions of tidal waves and hellfire cover their pages, giving ever greater anxiety in the years before Luther's clear, reassuring perspective did so much to calm his stress. The artist was assailed by irrational thoughts and nightmares (a term as well known in German as in English, referring to the wild white horses whose oppressive riders rob the sleeper of rest and breath). His prints and drawings of monsters are a complex cluster of fears expressed in animal form but worked together in "human-

oid" fashion; humans and beasts cloned to Hell and gone.

These portents, devils, and monsters, the visible and invisible afflictions and messengers of evil, tormenting mortals at every turn, seemed suddenly, forcefully, restrained by a new faith and a new messenger. With Martin Luther's firm sense, the Lord's mighty fortress, Dürer now felt freed from the doubts and terrors of the past, secure from the same ghouls and monsters, demons and dragons, brought to life and long animated by his own art.

In 1499, just when fear of the world's end rose to feverish heights, Nuremberg drove out its Jews, sending them away with only what could be borne on their backs. The city's pride, that great new square where Dürer was to witness Maximilian receiving those splendid wild bison, was the site of the ancient ghetto. Nuremberg's artists and scholars played ignominious roles in that expulsion, as Jane Hutchison noted (*Albrecht Dürer: A Biography* [Princeton University Press, 1990], 51). Willibald Pirckheimer had belonged to the city council in 1498, when that body petitioned to expel the Jews. This wish was fulfilled on the eve of his departure (possibly with Dürer) for the Swiss war of independence. The humanist-councilor provided an armed escort for the Jews, suggesting their protection but more likely enforcing departure. Dürer's godfather, Koberger, bought extensive Jewish property for resale, including the community buildings, and the great sculptor Veit Stoss acquired one of the very best houses.

More than four centuries later Hitler's triumphal rally was staged in this same square. There he was proclaimed Maximilian's heir, Caesar of the Third Empire, in 1934, and only then did diabolical happenings, beyond the scope of Saint John's wildest imaginings, take place in Germany. Luther was right—Satan could only be an impious man. Destruction, so needlessly feared in 1499, finally came in 1944, with apocalyptic fires of hell pouring down from sky-borne metal dragons. Dürer's home and the churches he so loved went up in flames, along with the whole medieval heart of Nuremberg in a massacre of innocent monuments, retribution for recent devilish crimes beyond hope of revenge.

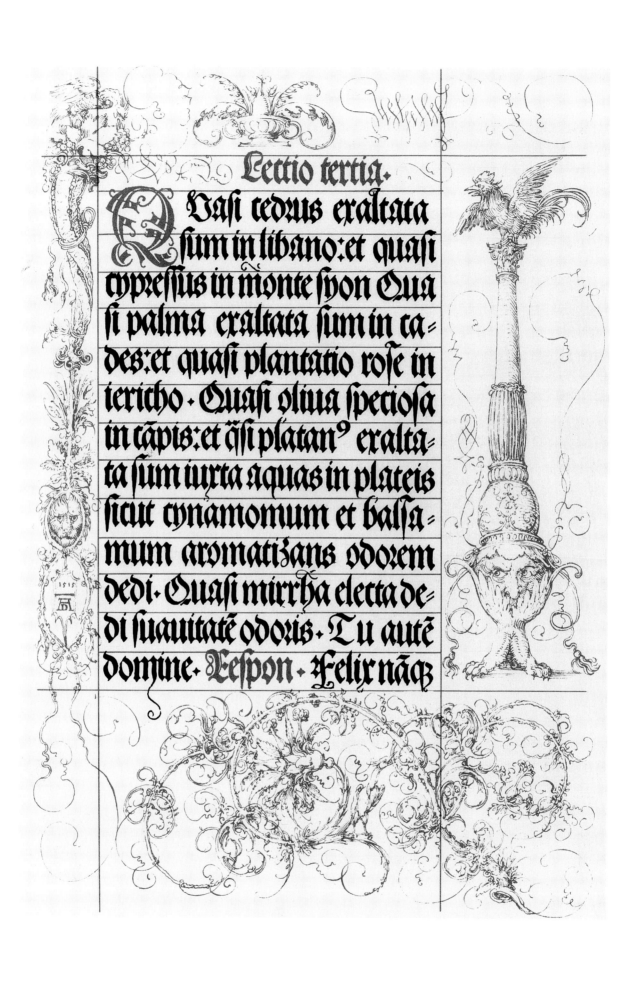

Lectio tertia.

Quasi cedrus exaltata sum in libano: et quasi cypressus in monte syon Quasi palma exaltata sum in cades: et quasi plantatio rose in iericho. Quasi oliua speciosa in campis: et q̃si platan⁹ exaltata sum iuxta aquas in plateis sicut cynamomum et balsamum aromatizans odorem dedi. Quasi mirrha electa dedi suauitatẽ odoris. Tu autẽ domine. Respon. Felix nã q̃

Chapter Thirteen

Poached Hares and Copy Cats

Dürer's zoo is one that never died. Many of his animals, whether those of everyday or from far away, became *the* animal forever remembered and recalled. That handsome horse in *Knight, Death and Devil* [9.47], itself based on Italian art, has been copied and recopied as the quintessential stallion for almost five hundred years. Rhinoceros and hare have lived through the centuries, created and re-created by generations of painters, printmakers, and craftspeople who used the master's animals in their own works. Almost as soon as they were first seen, Dürer's birds and beasts, both the real and the imaginary, were reflected in the art of his contemporaries. Beyond the borders of style and the confines of fashion or nation, only the creatures in Dürer's cages, unlike their keepers, proved truly universal. Renaissance Italy's greatest masters, such as the divine Raphael, found more beauty in the German's pigs than in his people and copied the prize porkers very carefully while omitting their masters, whose harshly foreign faces and bumpy Gothic bodies were too far from the newly rediscovered ideal beauty of Greece and Rome to pass muster.

On Dürer's first Italian journey, in the mid-1490s, he went to learn all he could from the Renaissance masters. By the time of his next southern journey, in 1506, the tables were turned, and the Italian masters had learned all too well from him. So he returned to Venice to protest the copying of his prints, such as *The Prodigal Son* [8.4]—now placed in a Venetian setting by an engraver who simply added the city's famous bell tower in the background to make this print his own. All Dürer could do was to have the forging of his initials forbidden on such copies.

Writing at the middle of the century, Georgio Vasari noted how well Dürer's fantastic imagination was suited to the subject of his woodcut *Apocalypse*. The Italian artist and historian singled out the variety of "animals and monsters that has been a great light to many of our artists who have copied them frequently." Similarly, in his discussion of the Nuremberger's great engravings, Vasari always selected the animals for special praise. What he most admired in *Saint Eustace* [1.30] was "some fine dogs in various attitudes, which could not be surpassed." Most copies of the Venetian prints Dürer objected to are fairly accurate. But Marcantonio Raimondi, in his version of the *Ma-*

donna and Child with Monkey, omitted that sinful beast. Another adaptation of the same print, by Giulio Campagnola, does away with the Madonna and Child as well as the ape. Only their setting survives as the landscape in which Ganymede rides heavenward on Jupiter, shown as a great eagle, the figures probably designed by Raphael.

When his prodigious Netherlandish rival Lucas van Leyden engraved the Prodigal Son, all he took from Dürer's early print was the tiny bull whose rear is shown at the upper left, repeating it faithfully in identical placement, as if to say, "I know that master's work down to the smallest detail but have no need of it." But even this brilliant Dutch master could not escape the authority of the great stallion in *Knight, Death and Devil*, giving it to Mordecai for his triumphant ride in the victorious conclusion to the story of Queen Esther.

A northern Italian printmaker, close to the art of Mantegna, decided to copy Dürer's *Large Horse* [9.46], but in so doing omitted all the German master's studiously classical trappings. Out went the architecture along with the warrior, creating a more monumental image, close to the horses of the earlier Quattrocento, like Uccello's. This copy proved more dramatic than the original and it, rather than Dürer's horse, may have been the one used by the master of magical realism, Caravaggio, for the sturdy beast in his *Conversion of Saint Paul*, painted near the end of the sixteenth century.

A fate just the reverse of the *Large Horse* in its Italian copy befell that of the *Small Horse* [9.44] in a northern adaptation. Dürer's German imitator, Ladenspelder, had no liking for the austere architectural background and decided to improve upon it by replacing the forceful masonry by the rich landscape of *Saint Eustace*. Oblivious to differences in placement and proportion, the *pasticheur* makes his poor *Small Horse* look like a fugitive from a merry-go-round, lost in the woods without rhyme or reason, let alone a calliope to keep him company!

An inventive, independent, ever-personal essay, the caprice is often gently humorous, readily conveyed through art or music. Originating in Venice, it is said to come from the Italian word for "goat"—*capra*. Perhaps that beast's stubbornness gave the caprice the courage of its convictions, the strength to forgo a conventional, readily identifiable subject or theme. Drawn from Dürer's art is one of the earliest of these *capricci*, the fancy of Agostino Veneziano, who may be saying that the German's finest features are animal, not human. The Venetian engraver makes his point in a zoological patchwork quilt, combining the woodland creatures and cat from the *Adam and Eve* [2.18] with *Saint Eustace*'s stag and dogs, applying these against a landscape background and classical building taken from two other artists working in Venice.

This engraving suggests a collage of scissored snippets from here and there, united by print rather than paste. Since Agostino's sources were well known, the artist never pretended to originality but expected his engraved jigsaw puzzle to be recognized for just what it was, a genial, witty gesture of homage to various masters from the North and South. Like Dürer's "animal dialogues" in the margins of Maximilian's *Book of Hours*, these kidnapped beasts, though often enemies in real life, dwell peacefully in their printed kingdom, liberated from carnivorous appetites and human pursuit. In Agostino's caprice, the joke is not on Dürer but rather on the way in which his animate art provides a genial paradise, blessedly free from the blundering first couple and from pursuit by their flawed descendants.

Every print is also an advertisement of its artist's skills, a form of publicity, or press release, usually seen by many more people than paintings are. Prints tend to be "read" like books; the eye is far more able to take in every detail than would be possible from a large painting. Many of Dürer's engravings and woodcuts were like a portable encyclopedia, filled with information, to be readily explored

and copied. Almost all of his religious series came out in a printed edition with text. Because these were the works most often seen, they were also among the most copied, a practice Dürer recommended in his own *Nourishment for Painter's Apprentices*. Writing in 1513, he observed, "Only after copying many works of good craftsmen is it possible to acquire a skilled hand."

Copying suggests not knowing the right answer or a failure to come up with the original model. But many capable artists based their animals on Dürer's not because they couldn't make their own but because his seemed, like nature itself, in the public domain, beyond art or style. As substitutes for living sources, Dürer's prints were used by Raphael and Rubens, and innumerable other artists, major, minor, and in-between. These pages often provided the definitive pose, so characteristic that looking to life itself seemed pointless. Models of convenience, the artist's animals were used in the manner of casts after ancient statuary. His animals, to use a contradiction in terms, provided the "ideal specificity" of nature, just as the statues brought classical perfection in plaster.

"Copying" sounds bad today—as if whoever does so lacks skill or originality. But sometimes using another artist's work is a form of tribute, and this imitative act can say something important about one's own work as well as its source. This is true for the fine Flemish painter Jan Gossaert, for example. The two artists met in the Lowlands, when Dürer drew Gossaert's portrait. Two brilliantly lifelike dogs in the foreground of Gossaert's *Adoration of the Magi* (National Gallery, London) are from separate sources. The elegant hound at the lower right, part of the Magi's retinue, is based upon a similarly situated dog in Dürer's *Saint Eustace*, his most spectacular and largest engraving. This always had a special fascination as it presents a world in miniature, including a horse, stag, five hounds, two swans, a minute horse and rider, and a flight of fifty or so birds encircling the turret at the very top. A shaggy little beast painted at the lower left is carefully copied, in reverse, from the one found in Schongauer's engraved *Adoration of the Magi* [7.2]. More than simply copies, both dogs signify the Fleming's faith in his own art as a worthy continuation of the two German masters he so much admired. When Dürer saw Gossaert's *Deposition* in the Netherlands, he made the same criticism of it that the Venetians had made of his own paintings many years before—better designed than painted! For all its vast appeal, the composition of *Saint Eustace* was criticized in the artist's lifetime for a certain clumsiness. It looks better reversed, in a 1579 copy by a printmaker known only by his initials, G. H., which flank Dürer's in the foreground. Saint, stag, and stallion work together in a better-balanced interchange because the print's largest element, the horse, now faces to the right, allowing the print, like the printed page, to be read from left to right.

Dürer's animals are lost and found throughout the art of five centuries. The seated hound in the *Saint Eustace* is seen once again in a French woodcut version of the same *Hieroglyphica* that Dürer had illustrated for the emperor Maximilian. A Parisian woodcut-maker, working in 1554, walked off with the engraved dog for his hieroglyph symbolizing "Good Judgment." Later woodcut compendiums of animal life use the dogs in *Saint Eustace* over and over again, in the collections of Gessner and his followers. Two printmakers engraved single plates exclusively devoted to Dürer's dogs. One of these, by Wierix, draws his kennel from those found in *Saint Eustace*. Another print, by a Nuremberg printmaker, Virgil Solis, goes Wierix one better by adding two more dogs, one taken from *Saint Jerome*. Topsell's *Historie of Foure-Footed Beastes* showed the three engraved dogs in a woodcut form, adding a fourth from the *Angel Appearing to Joachim* [8.62] belonging to *The Life of the Virgin* woodcut series. Near the end of the sixteenth century, especially in Nuremberg, copying Dürer amounted to a cot-

tage industry. In Antwerp, many artists' careful poaching from the master's animals kept their tables well supplied with meat, fish, and fowl!

By becoming the very nature of the past, Dürer's watercolors appealed to old Charles V and to his son Philip II of Spain. The former, though terrified of spiders and mice, is known to have loved animals, keeping many pets in the Brussels zoo Dürer so admired. Philip had a watercolor series of "Dürer" animals—cuckoo, magpie, falcon, mouse, dragonfly, bullfinch, and fish—enlivening the walls of his gloomy study in that chilly combination of castle, monastery, and underground burial site, the Escorial. Away from the demands of state, church, and greedy relatives, Philip II could gaze at his wall of "Dürer" watercolors, among which only a few of the landscape and flower studies may prove the master's but none of the animals. Reminders of a world beyond imperial regret and retreat, these natural subjects provided a sense of the marvels of Genesis and of the new age of discovery that had done so much to enlarge Philip's treasury and his vision. Charles' secretary, Cardinal Granvella, owned the *Book of Hours* that Dürer had illuminated for the emperor's great-grandfather Maximilian. When the cardinal ordered tapestries woven of the story of Noah, the emperor told his secretary to see to it that as many animals as possible be woven in the borders, to be shown in their native habitat. So the same passion for animal life that had so moved Maximilian carried on into the patronage of his imperial descendants at the century's close.

These Habsburg dukes, princes, and emperors, with their private zoos and passion for exotic nature and technical ingenuity, were much like their ancestor Maximilian. For such collectors, all those watercolors of bird wings and beetles meant not only the wondrous combination of art and nature by their favorite northern artist but also a link with the glories of late medieval life. If the wealthiest men settled for copies, owning them the way we do fine reproductions, then many others bought poorer imitations, often adding Dürer's monogram to "authenticate" them. Now, five hundred years later, it can be hard to tell whether a nature study is by the master from his workshop, made in the late-sixteenth-century renaissance of his style, or if the page in question is a recent, very careful forgery on old paper.

Brought up in Spain, Rudolph II had a passion for the artist's works and contributed more to the "Dürer renaissance" than any other patron. He ordered the completion of *Our Lady of the Animals* about a century after the master had set aside this liveliest of all his projects. The emperor owned the most elaborate of the three preparatory studies—the Vienna watercolor [Plate 2]—and turned to two Flemish artists, Jan Brueghel and Gilles Sadeler II, to show him how this work would have looked in finished form, fresh from Dürer's easel and printing press. Though the emperor never succeeded in luring Brueghel to Prague, the painter sent him many pictures, doubtless including one of those based on the watercolor [2.11]. Rudolph's painter and court engraver Sadeler used the same delicately tinted page to guide his fine engraving [2.12]. So thanks to this imperial collector's quest to own all Dürer's works, even those the master never made, we now know how this most celestial of his zoos—with the Holy Family as its keepers—might have looked had the artist followed his watercolor all the way to a painted or engraved conclusion.

Later in the sixteenth century, when the image wrecking of the Reformation and the wars had ceased, Dürer's works proved more popular than ever. Though rarely meant to deceive, sooner or later the many imitations of his paintings, prints, and drawings often did. Even the richest collectors, like Archduke Leopold Wilhelm, were so eager for Dürers that half of those in his ownership proved false. Careful copies, made in good faith, were long encouraged by the Imhoffs of Nuremberg, who had inherited the largest assemblage of Dürers from Willibald Pirckheimer.

Most skilled of Dürer imitators was Hans

Hoffman, who spent much time in the Imhoffs' storage room, probably making his copy of *Stag Beetle* [Plate 19] there in 1574 and the *Hare* [Plate 13] in 1582. A decade later, he joined the Prague court of Rudolph II, where a massive art assemblage was formed, including many Dürers, both true and false. Perhaps those of the master's drawings that Hoffman could not procure from Willibald Imhoff's estate for his imperial master may have been made by the gifted copyist. Maximilian of Bavaria, another fervent ducal Dürer collector, had no less than six such copyists in his employ, including Hoffman himself.

Interested in alchemy as well as art, Rudolph had the copperplate on which Dürer had engraved *Saint Eustace* dipped in gold, as if to show that Dürer's genius could transmute copper into precious metal. Though old catalogs and inventories may not make for the liveliest reading, some of these lists of works owned and sold can tell of missing paintings one would dearly love to see. These mysterious items need not always refer to originals; even if faithful copies, they can say much about the master's art. Among Rudolph's purchases from Willibald Imhoff was a silverpoint sketchbook, which also included three studies of birds pasted into it. Where did these birds fly? If the notebooks had been drawn during the artist's Netherlandish journey of 1520, were these birds like the beautiful double page of watercolored animals, *Sketches of Animals and Landscapes*, now in the Clark Art Institute [Plate 23].

Most dramatic of all stories concerning Dürer's recaptured animals concerns that great sheet. Long hidden, it had been used as backing for a print that was pasted over it and kept in an album since the eighteenth century. Luckily, whoever did the paste job was a very careful worker, using only the very edges of the double page so the study was scarcely damaged when the print was separated from its magnificent mount in 1917. But many other animals remain to be found. In the seventeenth century, the Imhoffs still had Dürers left for sale. Some of these were bought by an Amsterdam merchant in 1632, whose inventory records "a head of a rabbit with four ears, on vellum" and "a rabbit, on paper, supposedly by Dürer." "A beautiful wing, one foot in height, on vellum," which went for a very high price, is too large in size to be any of those known today. A leopard, on vellum, is also lost.

Let's look at some versions of Dürer's *Dead Blue Roller* to see how complicated questions concerning copies of the master's best animal studies can get. Almost all writers agree that the watercolor and gouache study on vellum in Vienna [Plate 6], showing the wing of this splendidly colored bird, is one of Dürer's finest works. This *Wing* has a flawless pedigree—it was acquired by the Habsburgs from its first owners, the Imhoffs of Nuremberg, whose ancestor Pirckheimer bought it directly from Dürer's family.

But another *Wing*, with the AD monogram and almost as brilliant in execution, is regarded by one of the finest Dürer scholars, Konrad Oberhuber, as the master's first study, made around 1500. He believes the Vienna version to be a copy, probably made by Dürer himself in 1512, the date that appears upon the page. The plot thickens once you know that at least five examples of the *Wing* are recorded, and it gets much more confusing when you realize that some of these references may be to the same work, seen at a later time in another collection. Two of these *Wings* were by Hoffman, probably ordered by the Imhoffs, who offered both for sale. One went to a Netherlandish painter in 1633; the other found no takers three years later, when it was offered for the high price of fifty florins. The four other *Wings* known today are clearly copies. One of these (Bamberg City Library), if the date it bears—1513—is authentic, could have been made in the master's studio by an assistant. More obviously recent copies are the two now to be found in private collections. Hans Hoffman was, expectedly, drawn to the master's studies of the Blue Roller. He copied the page that Dürer made of the bird in its entirety (Alber-

tina) at least twice. One of these is in the British Museum and the other, dated 1583, in the Cleveland Museum of Art. Both Hoffman and an anonymous copyist reproduced a now-lost Dürer study of *Dead Blue Roller* seen from above; these give an idea of the intensity and care the master brought to his examination of this bird, whose gorgeously tinted wings were the base for those of many of his angels. Most of the copies signed by Hoffman could never be taken for the works of Dürer. A hare by Hoffman, painted in gouache on vellum and surrounded by flowers, is dated 1582; three years later he painted another one in oils for Rudolph II. Nibbling leaves, surrounded by a lizard and butterflies with other insects, this rabbit, like most copied works signed by Hoffman, would not be accepted as by the original master. This is also true for *The Squirrel* (private collection, England), with Hoffman's monogram and the date 1578, based on one of the two in the famous watercolor. But there is ever the nagging possibility of better copies, ones so good that if the monogram were added, these might seem to be by Dürer himself. That famous *Hare* was the subject of several replicas, in which Hoffman often introduced insect and plant life quite different from Dürer's. One of these, now in the National Gallery of Rome, seems to have inspired J. J. Audubon's *Hare* (Detroit Institute of Arts)—minus the carnations and grasshopper! Thanks to Hoffman's copies, we know that Dürer drew his animal subjects from many angles so as best to understand their form. But it is Hoffman's repetition of the Dürer view of the hare, seen from above [4.34], that brings us closer to the way in which the master approached his animal subjects than any of his own surviving original works, since none of those show the same model seen from two such radically different angles. The same is true for the Hoffman copies after lost studies of *Dead Blue Roller*, which once again let us share the intricate perspectives that preceded the painter's finished works. Though such startlingly oblique, original viewpoints were used in his altarpieces or engravings, such experiments were essential precedents for these achievements.

One of the strangest birds to claim Dürer's draughtsmanship is a snipe or woodcock. Roosting among the finest of the Habsburgs' Dürer drawings in the Albertina, it may perhaps be a copy of a lost work by the master, possibly confected for the gullible Rudolph II. Nearer caricature than nature, this is no prize ornithological specimen, closer to the bird monster that is sometimes called the devil of Archduke Ernest, for which the page may have provided the point of departure. More frightened than frightening, the poor creature is ever totally absorbed in the burdensome task of being so barely monstrous, hanging onto his horrible role by the chicken skin of his teeth. What this perplexed, far-from-fine-feathered friend really looks like is a reject from *Sesame Street*, a design for Big Bird that never took wing from drawing board to TV screen. As if aware of a sadly unfulfilled future, the avian has a touchingly baleful, tentative manner, rendered in brightly colored and black chalks on watercolor.

A more complicated example of early baroque masters copying from the past can be found in *The Fall*, painted by Brueghel together with Rubens. As might be expected, the latter contributed the nude Adam and Eve, which he took from Titian. Brueghel added innumerable animals large and small, many based on Dürer's. A little dog at Eve's feet is none other than the little griffon that Dürer so loved to depict. Rubens, once again copying Titian's *Adam and Eve*, seen at the Spanish Court, couldn't resist adding Dürer's *Parrot* to make paradise complete. In his old age, Rubens included the same bird in his own earthly paradise, the Antwerp garden where he showed himself strolling so happily with his radiant young wife and beloved baby son (New York, Metropolitan Museum of Art).

Almost as great a collector as he was an artist, Rembrandt amassed a huge number of

prints and drawings, including many of Dürer's finest works. Like the Nuremberg master, he also kept a gathering of natural curiosities in the tradition of the chambers of wonders resembling those Dürer saw in Antwerp. The Dutch master drew upon Dürer's engraved monster from *Christ in Limbo* [12.11] for his own etching of the Fall. Long on art but short on fantasy, the Dutch master often depended upon the past for what he could not see before him. In this print, Rembrandt returned to the medieval view that the snake was really a monster and turned to Dürer to provide the one he needed. Many of Dürer's finest animal studies were once owned by a Dutch seventeenth-century collector, sometimes thought to have been Rembrandt himself. These were bound in large black morocco volumes labeled in Dutch, *Fish, Birds, Animals, and Fruit*, with the date 1637.

Dependence on Dürer's zoo was much in evidence in a four-volume publication by the Swiss doctor Conrad Gessner. His massive *Historia animalium* (1554–58) includes hundreds of woodcuts of all then-known birds and beasts. Many of these are crude copies of the German master's engravings and woodcuts. In 1607, Gessner's work was taken over by Edward Topsell. There the Prodigal's swine became boars; his bison come from Dürer too, as do the dogs. Leafing through this publication, one sees that many of Dürer's animals remained alive if not well reproduced. Both the Swiss and the English compendiums were used later in the seventeenth century by a Dutch zoological atlas, Jan Joesten's *Curious Descriptions of the Nature of Four-Footed Animals, Fish and Bloodless Water Animals, Birds, Crocodiles, Snakes and Dragons*, in metal plates polished in Amsterdam in 1660. Thus for over a century after Dürer's death, his prints continued to provide a major source for the way animals were seen.

Just as many early, finely detailed northern paintings were at one time attributed to Jan van Eyck, so have innumerable careful renderings of plants and animals been given Dürer's monogram or authorship. When the Nuremberg master first came to Italy, he was much impressed by animal studies of the masters of Florence, Venice, and Padua. Many of these centers were also university towns, which turned to the same ancient scientific texts that Willibald Pirckheimer read when he studied in Italy.

Now that we know more about the new scientific interests of the Renaissance, of research in biology, zoology, and anatomy, some of the pages that long seemed to stem from Dürer's hand are today assumed to have been made by Italians. The best known sheet for such relocation is the great watercolor of a crab (Boymans-van Beuningen Museum, Rotterdam). Scientists in Bologna, such as the encyclopedic Ulisse Aldovrandi, sought a new systematization and exploration of nature. In the north, Flemish masters such as Georg Hoefnagel continued to explore the hieroglyphs that so intrigued Dürer with a degree of magical realism still amazingly close to the Nuremberg master's.

Only in the seventeenth century, with the new freedom of the baroque age and the ever-widening exploration of east and west, did Dürer's animal studies depart the living world of nature and enter the exclusive purlieu of Art, locked sadly away from experience, use, and change.

Dürer put space as well as nature on the map. With his interest in mathematics, he helped teach the laws of proportion and perspective to generations of German artists, a lesson that the master had learned from Italian sources. Herbert Bayer's tribute—*Albrecht Dürer Adjusting the Vanishing Point to Future History*—refers to that pin-point on a surface where all lines perpendicular to the picture plane converge. This is the central principle of constructed space, of the illusion of depth within a scene. The largest element in Bayer's "portrait" of the science of Dürer's art is a fly, very like the one in *The Feast of the Rosegarlands*. Ignorant of that vibrant detail, which is known only

from an obscure copy [5.38], Bayer devised the fly as a sign of the encyclopedic extent of Dürer's knowledge. So this imagining of the Nuremberg master's timeless art re-creates, without even knowing it, a magical detail from one of the most prominent details of his celebrated Venetian altarpiece. Poised on the Virgin's drapery, this insect, near the heads of the kneeling emperor and pope, is meant to deceive the viewer into taking it for nature, not art.

When so many Victorian painters wanted to work their way back to the good old Gothic days before the High Renaissance and all its corrupt classicism, Dürer and his animals proved more popular than ever. Sir Edmund Burne-Jones, a leader of the Pre-Raphaelite School, revived the same silverpoint technique that Dürer had used with such skill when the English artist drew the dogs of Saint Eustace. He then placed these borrowed hounds close together, mourning before the tomb of Tristram and Iseult in a design for that most medieval of art forms—the stained-glass window. Emblematic, like the animals that Dürer had placed at the feet of a similar monument to a dead knight and his lady, these dogs reflect the fidelity and the love of their master and mistress, lasting beyond death.

A Note on Watermarks

Unseen beasts often lurk below the surface of Dürer's prints and drawings. Embedded in the papers' matrix, this zoo is not of his devising. These invisible lions and unicorns, bears, birds, and bulls' heads only come to life when paper is held against the light; then their beastly outlines emerge, clearly defined by strong white lines in contrast to the thicker, more light-resistant surrounding paper. This many-ringed circus is defined by wires twisted into animal shapes.

Rag pulp, from which such fine paper is made, was spread over mesh supported by wires as the sheet dried. Since the paper is thinner in those areas where the wires lie during the drying process, the pattern they make is known as the watermark. Calderlike, these twisted, calligraphic forms were made in many shapes, not limited to those of animals alone. Such watermarks can identify the region or name of the papermaker, present like a cattle brand hidden within the paper's "skin." More than a mere monogram or trademark, these signs, like tracks, can even help retrace Dürer's journeys to Italy or the Netherlands as the watermarks tell exactly where the paper was made.

Intrigued by the seemingly symbolic message of the many different watermarks, where mysterious beasts such as the unicorn are so often found, some scholars have tried to crack a secret code that never was. Many of the animals' heads support crowns, crosses, or flowers, which, way back in the mists of time, may have enjoyed some remote arcane significance. But, as is also true for the cattle brands found on today's ranches, only the vaguest sense of the protective power of such shapes survived, recalling the evocative strength of the animal in question. Better to have a bull, bear, or unicorn on your side than to ignore these creatures' mythic gifts by omission, wiser by far to weave them into the paper's very fabric, to help sustain the strength of the text or image upon the surface.

At least seven different bears stand or walk within the paper. Some extend their right fore and hind legs as if to get away from it all, others stand stock still. All are open mouthed; one sticks out a very long tongue—searching for honey? Most of these beasts wear collars, as much under human control as the wires that shape them. Sometimes animals are seen against shields, like coats of arms. One pudgy beast uses all four legs to climb up the right side of its escutcheon. An eaglelike bird is also found on a similar shield. Commonest of watermarks is a bull's head with a staff rising be-

tween the horns. This rod can end with a Maltese or Tau cross. Sometimes the staff is snake entwined, like Mercury's caduceus. Wiggling upward, without supporting staff, a crowned snake hisses out a slender tongue, making it seem just that much longer. With a jaunty tail stretched leftwards, a fox is sometimes shown running across the page. Fittingly, Dürer's work with the largest number of animals—the watercolor of *Our Lady of the Animals*—has a watermark with a small goose all its own, trapped in a double ring, complementing the ten wild birds drawn above.

A Note on Watermarks

Unseen beasts often lurk below the surface of Dürer's prints and drawings. Embedded in the papers' matrix, this zoo is not of his devising. These invisible lions and unicorns, bears, birds, and bulls' heads only come to life when paper is held against the light; then their beastly outlines emerge, clearly defined by strong white lines in contrast to the thicker, more light-resistant surrounding paper. This many-ringed circus is defined by wires twisted into animal shapes.

Rag pulp, from which such fine paper is made, was spread over mesh supported by wires as the sheet dried. Since the paper is thinner in those areas where the wires lie during the drying process, the pattern they make is known as the watermark. Calderlike, these twisted, calligraphic forms were made in many shapes, not limited to those of animals alone. Such watermarks can identify the region or name of the papermaker, present like a cattle brand hidden within the paper's "skin." More than a mere monogram or trademark, these signs, like tracks, can even help retrace Dürer's journeys to Italy or the Netherlands as the watermarks tell exactly where the paper was made.

Intrigued by the seemingly symbolic message of the many different watermarks, where mysterious beasts such as the unicorn are so often found, some scholars have tried to crack a secret code that never was. Many of the animals' heads support crowns, crosses, or flowers, which, way back in the mists of time, may have enjoyed some remote arcane significance. But, as is also true for the cattle brands found on today's ranches, only the vaguest sense of the protective power of such shapes survived, recalling the evocative strength of the animal in question. Better to have a bull, bear, or unicorn on your side than to ignore these creatures' mythic gifts by omission, wiser by far to weave them into the paper's very fabric, to help sustain the strength of the text or image upon the surface.

At least seven different bears stand or walk within the paper. Some extend their right fore and hind legs as if to get away from it all, others stand stock still. All are open mouthed; one sticks out a very long tongue—searching for honey? Most of these beasts wear collars, as much under human control as the wires that shape them. Sometimes animals are seen against shields, like coats of arms. One pudgy beast uses all four legs to climb up the right side of its escutcheon. An eaglelike bird is also found on a similar shield. Commonest of watermarks is a bull's head with a staff rising be-

tween the horns. This rod can end with a Maltese or Tau cross. Sometimes the staff is snake entwined, like Mercury's caduceus. Wiggling upward, without supporting staff, a crowned snake hisses out a slender tongue, making it seem just that much longer. With a jaunty tail stretched leftwards, a fox is sometimes shown running across the page. Fittingly, Dürer's work with the largest number of animals—the watercolor of *Our Lady of the Animals*—has a watermark with a small goose all its own, trapped in a double ring, complementing the ten wild birds drawn above.

Illustrations

The illustrations that face the chapter opening pages are from Maximilian's *Book of Hours*, 1515. Pen and Ink. Staatsbibliothek, Munich.

Chapter One: The Artist as Animalier

1.1. *Willibald Pirckheimer*, 1524. Engraving. Metropolitan Museum of Art, New York. Mr. and Mrs. Isaac D. Fletcher Fund.

1.2. Tabernacle, detail from Maximilian's *Triumphal Arch*, 1515. Woodcut. Photo: Courtesy of the National Gallery of Art, Washington, D.C.

1.3. Hans Burgkmair. *The Wise Young King in the Painter's Studio*, from *The Wise King*, ca. 1516, but not published until 1775. Woodcut. Trustees of the British Museum, London. Sloane Collection.

1.4. Philosophy, from Conrad Celtes's *Quattuor libri amorum*, 1502. Woodcut. National Gallery of Art, Washington, D.C. Rosenwald Collection. Photo: Courtesy of the National Gallery of Art.

1.5. Conrad von Megenberg. Quadrupeds, detail from *Bidpai: The Book of Nature*, Ulm, 1483. Woodcut. Library of Congress, Washington, D.C. Rare Book Division, Rosenwald Collection.

1.6. Conrad von Megenberg. Quadrupeds with bat, bird, and unicorn, detail from *Bidpai: The Book of Nature*, Ulm, 1483. Woodcut. Library of Congress, Washington, D.C. Rare Book Division, Rosenwald Collection.

1.7. English. Pepysian sketchbook, late fourteenth century. Pen and ink with wash. Magdalene College, Oxford.

1.8. English. Pepysian sketchbook, late fourteenth century. Pen and ink with wash. Magdalene College, Oxford.

1.9. English. Pepysian sketchbook, late fourteenth century. Pen and ink with wash. Magdalene College, Oxford.

1.10. English. Pepysian sketchbook, late fourteenth century. Pen and ink with wash. Magdalene College, Oxford.

1.11. English. Pepysian sketchbook, late fourteenth century. Pen and ink with wash. Magdalene College, Oxford.

1.12. English. Pepysian sketchbook, late fourteenth century. Pen and ink with wash. Magdalene College, Oxford.

1.13. Master of Bileam. *Saint Eligius in His Goldsmithshop*, midfifteenth century. Engraving. Rijksmuseum, Amsterdam.

1.14. *Self-Portrait at Thirteen*, 1484. Silverpoint. Albertina, Vienna.

1.15. *Lady with a Hawk*, 1484. Drawing. Trustees of the British Museum, London. Sloane Collection.

1.16. Master E.S. "B" from *Satirical Alphabet*, 1466–67. Engraving. Art Institute of Chicago. Clarence Buckingham Collection.

1.17. German. Saddle carved with scenes of fighting and ideal love, ca. 1400. Staghorn over wood, rawhide, and birch bark. Metropolitan Museum of Art, New York. Harris Brisbane Dick Fund.

1.18. Unknown artist. Enameled tankard, ca. 1440. Kunsthistorisches Museum, Vienna.

1.19. Unknown artist. Enameled tankard, ca. 1440. Kunsthistorisches Museum, Vienna.

1.20. *Table Fountain*, ca. 1499. Pen and ink with watercolor. Trustees of the British Museum, London. Sloane Collection.

1.21. Illustration for Terence, *Andria*, act 1, scene 1, 1492–93. Woodcut. Kunstmuseum, Basel.

1.22. Ascribed to Dürer, from the workshop of Michael Wolgemut. *Creation of Fish and Birds*, from the *Nuremberg Chronicles*, 1493. Woodcut. Library of Congress, Washington, D.C. Rare Book Division, Rosenwald Collection.

1.23. Illustration from *Der Ritter vom Turn*, Basel, 1493; also known as Chevalier de la Tour Landry, *Examples of the Fear of God and of Respectability*. Woodcut. Library of Congress, Washington, D.C. Rare Book Division, Rosenwald Collection. Photo: Hugh Talman.

1.24. Illustration from *Der Ritter vom Turn*, Basel, 1493; also known as Chevalier de la Tour Landry, *Examples of the Fear of God and of Respectability*. Woodcut. Library of Congress, Washington, D.C. Rare Book Division, Rosenwald Collection. Photo: Hugh Talman.

1.25. Illustration from *Der Ritter vom Turn*, Basel, 1493; also known as Chevalier de la Tour Landry, *Examples of the Fear of God and of Respectability*. Woodcut. Library of Congress, Washington, D.C. Rare Book Division, Rosenwald Collection. Photo: Hugh Talman.

1.26. Title page, from Sebastian Brant, *The Ship of Fools*, Basel, 1494. Woodcut. Library of Congress, Washington, D.C. Rare Book Division, Rosenwald Collection.

1.27. Illustration, from Sebastian Brant, *The Ship of Fools*, Basel, 1494. Woodcut. Library of Congress, Washington, D.C. Rare Book Division, Rosenwald Collection.

1.28. Illustration, from Sebastian Brant, *The Ship of Fools*, Basel, 1494. Woodcut. Library of Congress, Washington, D.C. Rare Book Division, Rosenwald Collection.

1.29. *Self-Portrait*, 1500. Oil on panel. Bavarian State Picture Collection, Munich.

1.30. *Saint Eustace*, ca. 1500–1501. Engraving. National Gallery of Art, Washington, D.C. Rosenwald Collection. Photo: Courtesy of the National Gallery of Art.

1.31. Maximilian's *Triumphal Arch*, 1515. Woodcut. Photo: Courtesy of the National Gallery of Art, Washington, D.C.

1.32. *The Triumphal Chariot of Maximilian I (The Great Triumphal Car)*, 1522. Woodcut (eight blocks). National Gallery of Art, Washington, D.C. Rosenwald Collection. Photo: Courtesy of the National Gallery of Art.

1.33. *Erasmus of Rotterdam*, 1526. Engraving. National Gallery of Art, Washington, D.C. Rosenwald Collection. Photo: Courtesy of the National Gallery of Art.

Chapter Two: Our Lady of the Animals

2.1. *The Great Piece of Turf*, 1503. Watercolor with gouache. Albertina, Vienna.

2.2. English. The creation of the birds and animals, from the *Queen Mary Psalter*, early fourteenth century. Trustees of the British Museum, London. Sloane Collection.

2.3. *The Holy Family with the Mayfly (One-Day Fly)*, 1495–96. Engraving with drypoint. National Gallery of Art, Washington, D.C. Rosenwald Collection. Photo: Courtesy of the National Gallery of Art.

2.4. Master of the Garden of Love. *The Garden of Love*, midfifteenth century. Engraving. Staatliche Museen, Berlin. Photo: Jörg P. Anders, Berlin.

2.5. *The Pleasures of the World*, ca. 1500. Pen and ink. Ashmolean Museum, Oxford.

2.6. *The Holy Family with the Three Hares*, 1497–98. Woodcut. National Gallery of Art, Washington, D.C. Rosenwald Collection. Photo: Courtesy of the National Gallery of Art.

2.7. *The Glorification of the Virgin*, from *The Life of the Virgin*, ca. 1504. Woodcut. National Gallery of Art, Washington, D.C. Rosenwald Collection. Photo: Courtesy of the National Gallery of Art.

2.8. *Madonna and Child with Monkey*, ca. 1500. Engraving. National Gallery of Art, Washington, D.C. R. Horace Gallatin Collection. Photo: Courtesy of the National Gallery of Art.

2.9. *Our Lady of the Animals*, ca. 1503. Pen and ink. Staatliche Museen, Berlin. Photo: Jörg P. Anders, Berlin.

2.10. *Our Lady of the Animals*, ca. 1503. Pen and ink with watercolor. Musée du Louvre, Paris. Cabinet des dessins. Photo: Réunion des Musées Nationaux, Paris.

2.11. Jan Brueghel the Elder. *Our Lady of the Animals*, ca. 1604. Oil on panel. Palazzo Doria, Rome.

2.12. Aegidius [Giles] Sadeler II. *Our Lady of the Animals*, end of sixteenth century. Engraving. Albertina, Vienna.

2.13. *The Adoration of the Magi*, 1504. Oil on panel. Uffizi, Florence. Photo: Editorial Photocolor Archives, Inc., New York.

2.14. Evil owl, detail from *The Marriage of the Virgin*, from *The Life of the Virgin*, ca. 1504–5. Woodcut. National Gallery of Art, Washington, D.C. Gift of W. G. Russell Allen. Photo: Courtesy of the National Gallery of Art.

2.15. *The Virgin and Child on a Grassy Bench*, 1503. Engraving. National Gallery of Art, Washington, D.C. Rosenwald Collection. Photo: Courtesy of the National Gallery of Art.

2.16. *The Flight into Egypt*, from *The Life of the Virgin*, ca. 1504. Woodcut. National Gallery of Art, Washington, D.C. Rosenwald Collection. Photo: Courtesy of the National Gallery of Art.

2.17. *Virgin and Child with Bird on String*, 1515. Pen and ink. Royal Library, Windsor Castle. Collection of Her Majesty Queen Elizabeth II.

2.18. *Adam and Eve*, 1504. Engraving. National Gallery of Art, Washington, D.C. Rosenwald Collection. Photo: Courtesy of the National Gallery of Art.

2.19. *Adam and Eve*, trial proof (Meder 1) of the 1504 engraving. Engraving.

2.20. *Adam*, 1507. Oil on panel. Museo del Prado, Madrid.

2.21. *Eve*, 1507. Oil on panel. Museo del Prado, Madrid.

2.22. Early copy after Dürer. *Adam*, early sixteenth century. Oil on panel. Uffizi, Florence. Photo: Editorial Photocolor Archives, Inc., New York.

2.23. Early copy after Dürer. *Eve*, early sixteenth century. Oil on panel. Uffizi, Florence. Photo: Editorial Photocolor Archives, Inc., New York.

2.24. *The Fall of Man*, from *The Small Woodcut Passion*, probably ca. 1509–10. Woodcut. National Gallery of Art, Washington, D.C. Rosenwald Collection. Photo: Courtesy of the National Gallery of Art.

2.25. *Adam and Eve*, 1510. Pen and ink. Albertina, Vienna.

2.26. Hans Baldung. Animals, from title page of Martin Luther, *Thirteen Sermons*, Augsburg 1523. Woodcut.

Chapter Three: Birds by His Hand

3.1. Unknown artist. *Saint Francis and the Birds*, from the *Chronicle of Matthew Paris*, midthirteenth century (ms. 16, fol. 66v). Corpus Christi College, Cambridge.

3.2. Unknown artist. Geese in flight, from Frederick II, *Treatise on Falconry*, ca. 1260 (Palet. Lat. 1071, fol. 15r). Vatican Library, Vatican City. Photographic Archive.

3.3. Master of the Playing Cards. *Three of Birds*, midfifteenth century. Engraving. Staatliche Kunstsammlungen, Dresden.

3.4. Master of the Playing Cards. *Five of Birds*, midfifteenth century. Engraving. Staatliche Graphische Sammlung, Munich.

3.5. Martin Schongauer. *Ornament with Owl Mocked by Day Birds*, ca. 1480. Engraving. National Gallery of Art, Washington, D.C. Rosenwald Collection. Photo: Courtesy of the National Gallery of Art.

3.6. Martin Schongauer. *Peasant with Shield with Two Wings*, ca. 1480–90. Engraving. National Gallery of Art, Washington, D.C. Rosenwald Collection. Photo: Courtesy of the National Gallery of Art.

3.7. Martin Schongauer. *Shield with Griffin's Foot, Held by Moor*, ca. 1480–90. Engraving.

3.8. Martin Schongauer. *Shield with Swan, Held by Woman*, from *Series of Coats of Arms*, ca. 1480–90. Engraving. National Gallery of Art, Washington, D.C. Rosenwald Collection. Photo: Courtesy of the National Gallery of Art.

3.9. Hans Memling. Storklike birds, detail from *Altar Shutters with Saints John the Baptist and Lawrence*, no date. Oil on panel. National Gallery, London.

3.10. Conrad von Megenberg. Birds, detail from *Bidpai: The Book of Nature*, Ulm, 1483. Woodcut. Library of Congress, Washington, D.C. Rare Book Division, Rosenwald Collection.

3.11. Bartholomew the Englishman. *The Book of the Nature of Things*, Haarlem, 1485. Hand-colored woodcut.

3.12. Vittore Pisanello. *Alfonso V of Aragon (1394–1458), King of Naples and Sicily (1442)*; reverse: *Eagle on Tree Stump above Dead Fawn, Surrounded by Lesser Birds of Prey*, 1449. Cast lead medal. National Gallery of Art, Washington, D.C. Samuel H. Kress Collection. Photo: Courtesy of the National Gallery of Art.

3.13. Jacopo de' Barbari. *Dead Partridge with Falconer's Gauntlets*, 1504. Oil on panel. Bavarian State Picture Collection, Munich.

3.14. Leonardo da Vinci. Birds in flight, no date, from Gustavo Uzielli's *Ricerche intorno a Leonardo da Vinci*, Turin, 1896. Pen and ink.

3.15. Attributed to Dürer. *Maidservant with Wingduster*, dated 1469. Pen and ink with wash. Trustees of the British Museum, London. Sloane Collection.

3.16. *Melencolia I*, 1514. Engraving. National Gallery of Art, Washington, D.C. Rosenwald Collection. Photo: Courtesy of the National Gallery of Art.

3.17. Flight formations, detail from *Samson and the Lion*, 1497–98. Woodcut. National Gallery of Art, Washington, D.C. Rosenwald Collection. Photo: Courtesy of the National Gallery of Art.

3.18. Flight formations, detail from *Hercules Conquering Cacus ("Ercules")*, 1496. Woodcut. National Gallery of Art, Washington, D.C. Rosenwald Collection. Photo: Courtesy of the National Gallery of Art.

3.19. *The Martyrdom of the Ten Thousand*, ca. 1496–97. Woodcut. National Gallery of Art, Washington, D.C. Rosenwald Collection. Photo: Courtesy of the National Gallery of Art.

3.20. *Joachim and Anna at the Golden Gate*, from *The Life of the Virgin*, 1504. Woodcut. National Gallery of Art, Washington, D.C. Rosenwald Collection. Photo: Courtesy of the National Gallery of Art.

3.21. Dürer's workshop. *Saint Christopher*, from *Modest Woodcuts*, ca. 1503–4. Woodcut. Bibliothèque Nationale, Paris.

3.22. "Fool as Bird's Nest Robber," from Sebastian Brant, *The Ship of Fools*, Basel, 1494. Woodcut. Library of Congress, Washington, D.C. Rare Book Division, Rosenwald Collection.

3.23. Attributed to Dürer. *Fall of Icarus*, 1493. Woodcut.

3.24. "Fool Netting Birds," from Sebastian Brant, *The Ship of Fools*, Basel, 1494. Woodcut. Library of Congress, Washington, D.C. Rare Book Division, Rosenwald Collection.

3.25. Preparatory drawing for *Nemesis*, ca. 1502. Pen and ink. Trustees of the British Museum, London. Sloane Collection.

3.26. *Nemesis (The Great Fortune)*, ca. 1501–2. Engraving. National Gallery of Art, Washington, D.C. Gift of R. Horace Gallatin. Photo: Courtesy of the National Gallery of Art.

3.27. *Coat of Arms with a Skull*, 1503. Engraving. National Gallery of Art, Washington, D.C. Rosenwald Collection. Photo: Courtesy of the National Gallery of Art.

3.28. Attributed to Dürer. *Both Sides of a Bittern's Wing*, 1515. Watercolor on vellum. Metropolitan Museum of Art, New York. Rogers Fund.

3.29. Crane, detail from Maximilian's *Book of Hours*, 1515. Pen and ink. Staatsbibliothek, Munich.

3.30. Crane, detail from Maximilian's *Book of Hours*, 1515. Pen and ink. Staatsbibliothek, Munich.

3.31. Crane, detail from Maximilian's *Book of Hours*, 1515. Pen and ink. Staatsbibliothek, Munich.

3.32. *Visor of Maximilian's Helmet*, 1517. Pen and ink. Albertina, Vienna.

3.33. "Fool with Crows," from Sebastian Brant, *The Ship of Fools*, Basel, 1494. Woodcut. Library of Congress, Washington, D.C. Rare Book Division, Rosenwald Collection.

3.34. *Saint Anthony and Saint Paul in the Wilderness*, 1504. Woodcut. National Gallery of Art, Washington, D.C. Rosenwald Collection. Photo: Courtesy of the National Gallery of Art.

3.35. Dürer's workshop. *Florentinus Attempting to Poison Saint Benedict*, ca. 1501. Pen and ink. Trustees of the British Museum, London. Sloane Collection.

3.36. Raven, detail from *Map of the Northern Sky*, ca. 1503. Pen and ink on vellum. Germanisches Nationalmuseum, Nuremberg.

3.37. Crow pecking serpent, detail from *Celestial Map: The Northern Celestial Hemisphere*, 1515. Woodcut. National Gallery of Art, Washington, D.C. Rosenwald Collection. Photo: Courtesy of the National Gallery of Art.

3.38. Cuckoo, from Horus Apollo, *The Hieroglyphica*, ca. 1513 (cod. 3255). Pen and ink with watercolor. Nationalbibliothek, Vienna.

3.39. Doves, from Horus Apollo, *The Hieroglyphica*, ca. 1512–13 (cod. 3255). Pen and ink with watercolor. Nationalbibliothek, Vienna.

3.40. *Study of a Dead Duck*, 1515. Watercolor and gouache with touches of gold. Fundaçao Calouste Gulbenkian Museu, Lisbon.

3.41. Dead duck, detail from Maximilian's *Book of Hours*, 1515. Pen and ink. Staatsbibliothek, Munich.

3.42. *Zeus (Jupiter)*, 1494. Pen and ink, after an engraved playing card. Trustees of the British Museum, London. Sloane Collection.

3.43. Tarocchi Master-E Series. *Jupiter*, ca. 1465. Engraved playing card. National Gallery of Art, Washington, D.C. Ailsa Mellon Bruce Fund. Photo: Courtesy of the National Gallery of Art.

3.44. Zeus (Jupiter) with eagle, detail from *Map of the Northern Sky*, 1503. Pen and ink on vellum. Germanisches Nationalmuseum, Nuremberg.

3.45. *Stabius Arms*, fifteenth–sixteenth century. Woodcut. Metropolitan Museum of Art, New York. Harris Brisbane Dick Fund.

3.46. Eagle (Aquilae), detail from *Celestial Map: The Northern Celestial Hemisphere*, 1515. Woodcut. National Gallery of Art, Washington, D.C. Rosenwald Collection. Photo: Courtesy of the National Gallery of Art.

3.47. Eagle perched at Saint John's side, detail from *The Virgin Appearing to Saint John*, from *The Apocalypse*, 1510–11. Woodcut. National Gallery of Art, Washington, D.C. Gift of Philip Hofer. Photo: Courtesy of the National Gallery of Art.

3.48. Two hawks, from Horus Apollo, *The Hieroglyphica*, ca. 1513 (cod. 3255). Pen and ink with watercolor. Nationalbibliothek, Vienna.

3.49. Single hawk, from Horus Apollo, *The Hieroglyphica*, ca. 1513 (cod. 3255). Pen and ink with watercolor. Nationalbibliothek, Vienna.

3.50. Swooping single hawk, from Horus Apollo, *The Hieroglyphica*, ca. 1513 (cod. 3255). Pen and ink with watercolor. Nationalbibliothek, Vienna.

3.51. Single hawk, from Horus Apollo, *The Hieroglyphica*, ca. 1513 (cod. 3255). Pen and ink with watercolor. Nationalbibliothek, Vienna.

3.52. *Gray Fisher Heron*, 1515. Watercolor on vellum. Staatliche Museen, Berlin. Photo: Jörg P. Anders, Berlin.

3.53. Dead heron, detail from Maximilian's *Triumphal Arch*, 1515. Woodcut. Photo: Courtesy of the National Gallery of Art, Washington, D.C.

3.54. Heron, detail from Maximilian's *Book of Hours*, 1515. Pen and ink. Staatsbibliothek, Munich.

3.55. Jay, detail from "Wheel of Fortune," from Sebastian Brant, *The Ship of Fools*, Basel, 1494. Woodcut. Library of Congress, Washington, D.C. Rare Book Division, Rosenwald Collection.

3.56. Jay, detail from Maximilian's *Book of Hours*, 1515. Pen and ink. Staatsbibliothek, Munich.

3.57. Jay, detail from Maximilian's *Book of Hours*, 1515. Pen and ink. Staatsbibliothek, Munich.

3.58. Magpie, detail from "Wheel of Fortune," from Sebastian Brant, *The Ship of Fools*, Basel, 1494. Woodcut. Library of Congress. Washington, D.C. Rare Book Division, Rosenwald Collection.

3.59. Magpie, detail from *Map of the Northern Sky*, 1503. Pen and ink on vellum. Germanisches Nationalmuseum, Nuremberg.

3.60. *The Cook and His Wife*, ca. 1496–97. Engraving. National Gallery of Art, Washington, D.C. Rosenwald Collection. Photo: Courtesy of the National Gallery of Art.

3.61. Owl in tree trunk, detail from *Our Lady of the Animals*, 1503. Pen and watercolor. Albertina, Vienna.

3.62. Unknown artist. Mobbing the owl, from East Anglican *Book of Hours*, ca. 1300. Pen and ink. Walters Art Gallery, Baltimore.

3.63. *Man of Sorrows*, ca. 1488–89. Oil on panel. Staatliche Kunsthalle, Karlsruhe.

3.64. Owl, detail from *Man of Sorrows*, ca. 1488–89. Oil on panel. Staatliche Kunsthalle, Karlsruhe.

3.65. *Mobbing the Owl*, ca. 1515. Woodcut. Staatliche Sammlung Veste Coburg, Coburg.

3.66. Owl, detail from Maximilian's *Book of Hours*, 1515. Pen and ink. Staatsbibliothek, Munich.

3.67. Belligerent owl, on verso of *King Death Riding a Horse*, ca. 1505. Charcoal. Trustees of the British Museum, London. Sloane Collection.

3.68. Pelican, for Horus Apollo, *The Hieroglyphica*, ca. 1513. Pen and ink on vellum. Trustees of the British Museum, London. Sloane Collection.

3.69. Pelican, from Horus Apollo, *The Hieroglyphica*, ca. 1513 (cod. 3255). Pen and ink with watercolor. Nationalbibliothek, Vienna.

3.70. *The Pelican in Her Piety*, ca. 1515–20. Pen and ink. Pierpont Morgan Library, New York.

3.71. *The Pelican of Piety*, 1515. Pen and ink. Trustees of the British Museum, London. Sloane Collection.

3.72. Two pheasants, detail from Maximilian's *Book of Hours*, 1515. Pen and ink. Staatsbibliothek, Munich.

3.73. Pheasant, detail from Maximilian's *Triumphal Arch*, 1515. Woodcut. Photo: Courtesy of the National Gallery of Art, Washington, D.C.

3.74. Bird on string, detail from *Virgin and Child with Bird on String*, 1515. Pen and ink. Royal Library, Windsor Castle. Collection of Her Royal Majesty Queen Elizabeth II.

3.75. Sparrows, from Horus Apollo, *The Hieroglyphica*, ca. 1513 (cod. 3255). Pen and ink with watercolor. Nationalbibliothek, Vienna.

3.76. Sparrows, from Horus Apollo, *The Hieroglyphica*, ca. 1513 (cod. 3255). Pen and ink with watercolor. Nationalbibliothek, Vienna.

3.77. Spoonbill, detail from Maximilian's *Book of Hours*, 1515. Pen and ink. Staatsbibliothek, Munich.

3.78. Red starling flying over bison, detail from Maximilian's *Book of Hours*, 1515. Pen and ink. Staatsbibliothek, Munich.

3.79. Boy with bird, detail from *Hercules*, 1498–99. Engraving. National Gallery of Art, Washington, D.C. Rosenwald Collection. Photo: Courtesy of the National Gallery of Art.

3.80. Stork with fish in bill, detail from *Our Lady of the Animals*, 1503. Pen and watercolor. Albertina, Vienna.

3.81. Swallows in sky, detail from *The Adoration of the Magi*, 1504. Oil on panel. Uffizi, Florence. Photo: Editorial Photocolor Archives, Inc., New York.

3.82. *Apollo, or the King of Clubs*, ca. 1495. Pen and ink. Formerly at Museum Boymans–van Beuningen, Rotterdam.

3.83. Tarocchi Master-E Series. *Apollo*, ca. 1465. Engraving. National Gallery of Art, Washington, D.C. Ailsa Mellon Bruce Fund. Photo: Courtesy of the National Gallery of Art.

3.84. *Conrad Celtes*, from *Quattuor libri amorum*, Augsburg, 1502. Woodcut.

3.85. Two swans, detail from Maximilian's *Book of Hours*, 1515. Pen and ink. Staatsbibliothek, Munich.

3.86. Swan on top of peasant woman, detail from Maximilian's *Book of Hours*, 1515. Pen and ink. Staatsbibliothek, Munich.

3.87. Constellation of the Swan, detail from *Celestial Map: The Northern Celestial Hemisphere*, 1515. Woodcut. National Gallery of Art, Washington, D.C. Rosenwald Collection. Photo: Courtesy of the National Gallery of Art.

3.88. Bird in tree, detail from Maximilian's *Book of Hours*, 1515. Pen and ink. Staatsbibliothek, Munich.

Chapter Four: Wild in the Woods

4.1. Master of the Playing Cards. *Nine of Deer*, ca. 1430–50. Engraving. Service Photographique Bibliothèque Nationale, Paris. Photo: Réunion des Musées Nationaux, Paris.

4.2. Master of the Berlin Passion. *Three of Rabbits*, ca. midfifteenth century. Engraving. Albertina, Vienna.

4.3. Workshop of Hans Frey. Design for table fountain, ca. 1500. Pen and ink. Staatsbibliothek, Nuremberg.

4.4. Lucas Cranach. *Saxon Staghunt*, ca. 1506. Woodcut. Albertina, Vienna.

4.5. *Hunter Blowing Horn*, ca. 1513. Pen and ink. Szépmüvészeti Múzeum, Budapest.

4.6. *Badger*, mid-1490s. Sketch. Staatliche Museen, Berlin. Photo: Jörg P. Anders, Berlin.

4.7. Badger, detail from *The Fall of Man*, from *The Small Woodcut Passion*, probably ca. 1509–10. Woodcut. National Gallery of Art, Washington, D.C. Rosenwald Collection. Photo: Courtesy of the National Gallery of Art.

4.8. Demonic creature (badger?), detail from *The Annunciation*, from *The Life of the Virgin*, ca. 1502–4. Woodcut. National Gallery of Art, Washington, D.C. Gift of W. G. Russell Allen. Photo: Courtesy of the National Gallery of Art.

4.9. Dog-faced bat, detail from *Melencolia I*, 1514. National Gallery of Art, Washington, D.C. Rosenwald Collection. Photo: Courtesy of the National Gallery of Art.

4.10. *Bat on Column*, 1515. Pen and watercolor. Trustees of the British Museum, London. Sloane Collection.

4.11. Bat, detail from Maximilian's *Book of Hours*, 1515. Pen and ink. Staatsbibliothek, Munich.

4.12. *The Temptation of Saint Anthony*, 1521. Silverpoint, heightened with white, on green-prepared paper. Albertina, Vienna.

4.13. Two bears (Ursa Major and Ursa Minor), detail from *Celestial Map: The Northern Celestial Hemisphere*, 1515. Woodcut. National Gallery of Art, Washington, D.C. Rosenwald Collection. Photo: Courtesy of the National Gallery of Art.

4.14. *European Bison (Wisent)*, 1501. Pen and ink. Trustees of the British Museum, London. Sloane Collection.

4.15. Bison, detail from *The Fall of Man*, from *The Small Woodcut Passion*, probably ca. 1509–10. Woodcut. National Gallery of Art, Washington, D.C. Rosenwald Collection. Photo: Courtesy of the National Gallery of Art.

4.16. Goat, detail from *Our Lady of the Animals*, ca. 1503. Pen and ink with watercolor. Musée de Louvre, Paris. Cabinet des dessins. Photo: Réunion des Musées Nationaux, Paris.

4.17. Goat, detail from *Adam and Eve*, 1504. Engraving. National Gallery of Art, Washington, D.C. Rosenwald Collection. Photo: Courtesy of the National Gallery of Art.

4.18. Wild goat (chamois or oryx), detail from *Sketch of Animals and Landscapes*, 1521. Pen and ink. Sterling and Francine Clark Art Institute, Wiliamstown, Massachusetts.

4.19. *Apollo and Diana*, ca. 1505. Engraving.

4.20. *Head of a Roebuck*, ca. 1503. Brush and ink on paper. Nelson Atkins Museum of Fine Arts, Kansas City. William Rockhill Nelson Gallery of Art.

4.21. *Head of a Roebuck*, 1514. Watercolor and opaque color. Musée Bonnat, Bayonne. Photo: Réunion des Musées Nationaux, Paris.

4.22. *Adam and Eve*, 1510. Pen and ink. Albertina, Vienna.

4.23. *Drawing for Siren-Shaped Antler Chandelier*, 1513. Pen and watercolor. Kunsthistorisches Museum, Vienna.

4.24. *Design for Hunter's Brooch*, ca. 1517. Pen and ink. Formerly at Musée du Louvre, Paris (destroyed by fire in 1871). Photo: Réunion des Musées Nationaux, Paris.

4.25. Deer, detail from Maximilian's *Triumphal Arch*, 1515. Woodcut. Photo: Courtesy of the National Gallery of Art, Washington, D.C.

4.26. Elk, detail from *Adam and Eve*, 1504. Engraving. National Gallery of Art, Washington, D.C. Rosenwald Collection. Photo: Courtesy of the National Gallery of Art.

4.27. "Wheel of Fortune," from Sebastian Brant, *The Ship of Fools*, Basel, 1494. Woodcut. Library of Congress, Washington, D.C. Rare Book Division, Rosenwald Collection.

4.28. Fox (Fera), detail from *Celestial Map: The Southern Celestial Hemisphere*, 1515. Woodcut. National Gallery of Art, Washington, D.C. Rosenwald Collection. Photo: Courtesy of the National Gallery of Art.

4.29. *Designs for Maximilian's Neck Guard*, 1517. Pen and ink. Staatliche Museen, Berlin. Photo: Jörg P. Anders, Berlin.

4.30. *Design for Altarpiece*, 1522. Pen and ink. Musée Bonnat, Bayonne. Photo: Réunion des Musées Nationaux, Paris.

4.31. Rabbits, detail from *The Holy Family with the Three Hares*, ca. 1497–98. Woodcut. National Gallery of Art, Washington, D.C. Rosenwald Collection. Photo: Courtesy of the National Gallery of Art.

4.32. *The Holy Family with the Three Hares*, ca. 1497. Fruitwood block for woodcut. Princeton University, Princeton. Art Museum, gift of Alexander P. Morgan.

4.33. Cherubs with rabbit, detail from *The Glorification of the Virgin*, from *The Life of the Virgin*, ca. 1504. Woodcut. National Gallery of Art, Washington, D.C. Rosenwald Collection. Photo: Courtesy of the National Gallery of Art.

4.34. Hans Hoffman after Dürer. *Hare Seen from Above*, 1528. Watercolor and gouache. Staatliche Museen, Berlin. Photo: Jörg P. Anders, Berlin.

4.35. *Four Studies of Rabbit*, ca. 1503. Pen and ink. Trustees of the British Museum, London. Sloane Collection.

4.36. Rabbit, detail from *Adam and Eve*, 1504. Engraving. National Gallery of Art, Washington, D.C. Rosenwald Collection. Photo: Courtesy of the National Gallery of Art.

4.37. *Hares Flanking Profile*, 1513. Pen and ink. Germanisches Nationalmuseum, Nuremberg.

4.38. Two rabbits, detail from Maximilian's *Book of Hours*, 1515. Pen and ink. Staatsbibliothek, Munich.

4.39. Rabbit (Lepus), detail from *Celestial Map: The Southern Celestial Hemisphere*, 1515. National Gallery of Art, Washington, D.C. Rosenwald Collection. Photo: Courtesy of the National Gallery of Art.

4.40. Rabbits, detail from Maximilian's *Triumphal Arch*, 1515. Woodcut. Photo: Courtesy of the National Gallery of Art, Washington, D.C.

4.41. Rabbit, detail from Horus Apollo, *The Hieroglyphica*, ca. 1513 (cod. 3255). Pen and ink with watercolor. Nationalbibliothek, Vienna.

4.42. Lynx, detail from *Sketch of Animals and Landscapes*, 1521. Pen and ink. Sterling and Francine Clark Art Institute, Williamstown, Massachusetts.

4.43. *Squirrel*. Woodcut from Gilles Corrozel, *Hecaton-graphie*, Paris, 1543.

4.44. Tobias Stimmer. *Squirrel*, 1564. Brush drawing. Kunsthaus, Zurich.

4.45. Possibly copy by Franz Buch, attributed to Dürer. *Study of Two Stoats*, no date. Pen, brush, and ink. Staatliche Museen, Berlin. Photo: Jörg P. Anders, Berlin.

4.46. Wild cat, detail from *Designs for Maximilian's Neck Guard*, 1517. Pen and ink. Staatliche Museen, Berlin. Photo: Jörg P. Anders, Berlin.

Chapter Five: Creatures Hard-Shelled and Cold-Blooded

5.1. Circle of Wolgemut. *Departure of the Apostles*, end of fifteenth century. Oil painting. Bavarian State Picture Collection, Munich

5.2. Villard de Honnecourt. *Crustacean*, ca. 1240. Pen and ink. Bibliothèque National, Paris. Photo: Réunion de Musées Nationaux, Paris.

5.3. Master of Mary of Burgundy. *Coronation of the Virgin*, late fifteenth century. Illuminated book of hours. Czartoryski Museum, Cracow. Photo: Stanislaw Lopatka, Cracow.

5.4. Conrad von Megenberg. Bird carrying lobster, detail from *Bidpai: The Book of Nature*, Ulm, 1483. Woodcut. Library of Congress, Washington, D.C. Rare Book Division, Rosenwald Collection.

5.5. Conrad von Megenberg. Bird, mouse, and turtle on bank, detail from *Bidpai: The Book of Nature*, Ulm, 1483. Woodcut. Library of Congress,

Washington, D.C. Rare Book Division, Rosenwald Collection.

5.6. Conrad von Megenberg. Fish, snake, birds, dog, lobster, etc., detail from *Bidpai: The Book of Nature*, Ulm, 1483. Library of Congress, Washington, D.C. Rare Book Division, Rosenwald Collection.

5.7. Conrad von Megenberg. Crickets, snails, bees, etc., detail from *Bidpai: The Book of Nature*, Ulm, 1483. Library of Congress, Washington, D.C. Rare Book Division, Rosenwald Collection.

5.8. Conrad von Megenberg. Fish, etc., detail from *Bidpai: The Book of Nature*, Ulm, 1483. Library of Congress, Washington, D.C. Rare Book Division, Rosenwald Collection.

5.9. Unknown artist. Animals, detail from Jacobus Publicius, *Artes orandi, epistolandi, memorandi*, Nuremberg, 1485. Woodcut. Pierpont Morgan Library, New York.

5.10. Unknown artist. Illustration from Stephan Fridolin, *Treasure or Shrine of True Riches of Health and Eternal Blessedness*, Nuremberg, 1491. Woodcut.

5.11. Peter Vischer the Elder. Base with snails, from the *Sebaldus Reliquary*, 1508–19. Saint Sebaldus Church, Nuremberg.

5.12. Michael Wolgemut and shop. Dragonfly, etc., detail from *Nuremberg Chronicles*, 1493. Woodcut. Library of Congress, Washington, D.C. Rare Book Division, Rosenwald Collection.

5.13. Leonardo da Vinci. *Dragonfly*, late fifteenth century. Pen and ink. Wallraf-Richartz Museum, Cologne. Photo: Rheinisches Bildung, Cologne.

5.14. Leonardo da Vinci. *Crabs*, late fifteenth century. Pen and ink. Wallraf-Richartz Museum, Cologne. Rheinisches Bildung, Cologne.

5.15. Andrea Riccio. *A Crab*, no date. Bronze. National Gallery of Art, Washington, D.C. Samuel H. Kress Collection. Photo: Courtesy of the National Gallery of Art.

5.16. Andrea Riccio. *Crab on a Toad*, early sixteenth century. Bronze. National Gallery of Art, Washington, D.C. Samuel H. Kress Collection. Photo: Courtesy of the National Gallery of Art.

5.17. Paduan. *A Frog*, early sixteenth century. Bronze. National Gallery of Art, Washington, D.C. Samuel H. Kress Collection. Photo: Courtesy of the National Gallery of Art.

5.18. Paduan. *Toad*, early sixteenth century. Bronze. National Gallery of Art, Washington, D.C. Samuel H. Kress Collection. Photo: Courtesy of the National Gallery of Art.

5.19. Attributed to Andrea Riccio. *Stag Beetle*, early sixteenth century. Bronze. Staatliche Museen, Berlin.

5.20. Hendrick Goltzius. *Beached Whale*, ca. 1598. Pen and wash, heightened with white, indented for transfer. Teylers Museum, Haarlem.

5.21. Ant, detail from Horus Apollo, *The Hieroglyphica*, ca. 1513 (cod. 3255). Pen and ink. Nationalbibliothek, Vienna.

5.22. Ant, detail from Sebastian Brant, *The Ship of Fools*, Basel, 1494. Woodcut. Library of Congress, Washington, D.C. Rare Book Division, Rosenwald Collection.

5.23. Bee, detail from Horus Apollo, *The Hieroglyphica*, ca. 1513 (cod. 3255). Pen and ink. Nationalbibliothek, Vienna.

5.24. Insect and butterflies on millwheel, detail from *The Adoration of the Magi*, 1504. Oil on panel. Uffizi, Florence. Photo: Editorial Photocolor Archives, Inc., New York.

5.25. Copy after Dürer. Butterfly, detail from *The Madonna of the Iris*, 1508. Oil on panel. National Gallery, London.

5.26. Dürer's workshop. Lizard, frogs, and butterfly, detail from study sheet, no date. Pen and ink. Fondation Custodia, Institut Neerlandais, Paris. F. Lugt Collection. Photo: Réunion des Musées Nationaux, Paris.

5.27. Lobster (Cancer), detail from *Celestial Map: The Northern Celestial Hemisphere*, 1515. Woodcut. National Gallery of Art, Washington, D.C. Rosenwald Collection. Photo: Courtesy of the National Gallery of Art.

5.28. *Crab*, ca. 1495. Watercolor and tempera, heightened with white. Museum Boymans–van Beuningen, Rotterdam.

5.29. Copy after Dürer. Fish, from Horus Apollo, *The Hieroglyphica*, ca. 1513 (cod. 3255). Pen and ink. Nationalbibliothek, Vienna.

5.30. Fish, detail from Maximilian's *Book of Hours*, 1515. Pen and ink. Staatsbibliothek, Munich.

5.31. Fish, detail from Maximilian's *Book of Hours*, 1515. Pen and ink. Staatsbibliothek, Munich.

5.32. Fish (Pisces), detail from *Map of the Southern Sky*, 1503. Pen and ink on vellum. Germanisches Nationalmuseum, Nuremberg.

5.33. Fish (Pisces), detail from *Map of the Southern Sky*, 1503. Pen and ink on vellum. Germanisches Nationalmuseum, Nuremberg.

5.34. Fish (Pisces), detail from *Map of the Southern Sky*, 1503. Pen and ink on vellum. Germanisches Nationalmuseum, Nuremberg.

5.35. Fish (Pisces), detail from *Map of the Southern Sky*, 1503. Pen and ink on vellum. Germanisches Nationalmuseum, Nuremberg.

5.36. Fish (Pisces), detail from *Map of the Southern Sky*, 1503. Pen and ink on vellum. Germanisches Nationalmuseum, Nuremberg.

5.37. Fly, detail from Horus Apollo, *The Hieroglyphica*, ca. 1513 (cod. 3255). Pen and ink with watercolor. Nationalbibliothek, Vienna.

5.38. Fly, detail from copy after *The Feast of the Rosegarlands*, 1506. Oil on panel. Kunsthistorisches Museum, Vienna.

5.39. Mayfly, detail from *The Holy Family with the Mayfly (One-Day Fly)*, ca. 1495–96. Engraving with drypoint. National Gallery of Art, Washington, D.C. Rosenwald Collection. Photo: Courtesy of the National Gallery of Art.

5.40. "Woman with Toad in Heart," from *Der Ritter vom Turn*, Basel, 1493; also known as Chevalier de la Tour Landry, *Examples of the Fear of God and of Respectability*. Woodcut. Library of Congress, Washington, D.C. Rare Book Division, Rosenwald Collection. Photo: Hugh Talman.

5.41. Toad, from Horus Apollo, *The Hieroglyphica*, ca. 1513 (cod. 3255). Pen and ink. Germanisches Nationalmuseum, Nuremberg.

5.42. Frogs, locusts, and the bearded fool, from Sebastian Brant, *The Ship of Fools*, Basel, 1494. Woodcut. Library of Congress, Washington, D.C. Rare Book Division, Rosenwald Collection.

5.43. "Fool Tending Grasshoppers," from Sebastian Brant, *The Ship of Fools*, Basel, 1494. Woodcut. Library of Congress, Washington, D.C. Rare Book Division, Rosenwald Collection.

5.44. Lizard, detail from *Hercules and Stymphalian Birds*, ca. 1500. Pen and ink. Hessisches Landesmuseum, Darmstadt.

5.45. Lizard, detail from *Knight, Death and Devil*, 1513. Engraving. National Gallery of Art, Washington, D.C. Gift of W. G. Russell Allen. Photo: Courtesy of the National Gallery of Art.

5.46. Two lizards, detail from *The Flight into Egypt*, from *The Life of the Virgin*, ca. 1504. Woodcut. National Gallery of Art, Washington, D.C. Rosenwald Collection. Photo: Courtesy of the National Gallery of Art.

5.47. Martin Schongauer. Detail from *The Flight into Egypt*, from *The Life of the Virgin*, ca. 1470–75. Engraving. National Gallery of Art, Washington, D.C. Rosenwald Collection. Photo: Courtesy of the National Gallery of Art.

5.48. Lobster, Von Melen arms, detail from *Portrait of Katherine Heller*, ca. 1508–9. Oil on panel. Historisches Museum, Frankfurt.

5.49. Lobster, detail from Sebastian Brant, *The Ship of Fools*, Basel, 1494. Woodcut. Library of Congress, Washington, D.C. Rare Book Division, Rosenwald Collection.

5.50. Scorpion (Scorpio), detail from *Celestial Map: The Northern Celestial Hemisphere*, 1515. Woodcut. National Gallery of Art, Washington, D.C. Rosenwald Collection. Photo: Courtesy of the National Gallery of Art.

5.51. Large land snail, detail from Maximilian's *Book of Hours*, 1515. Pen and ink. Staatsbibliothek, Munich.

5.52. Land snail, detail from Maximilian's *Triumphal Arch*, 1515. Woodcut. Photo: Courtesy of the National Gallery of Art, Washington, D.C.

5.53. Cherub with snail, detail from Maximilian's *Book of Hours*, 1515. Pen and ink. Staatsbibliothek, Munich.

5.54. Snake, detail from *Adam and Eve*, 1504. Engraving. National Gallery of Art, Washington, D.C. Rosenwald Collection. Photo: Courtesy of the National Gallery of Art.

5.55. *Pokal*, ca. 1514. Pen and ink. Sächsische Landesbibliothek, Dresden.

5.56. Snake swallowing tail, from Horus Apollo, *The Hieroglyphica*, ca. 1513 (cod. 3255). Pen and ink with watercolor. Nationalbibliothek, Vienna.

5.57. "King as Cosmic Ruler," from Horus Apollo, *The Hieroglyphica*, ca. 1513 (cod. 3255). Pen and watercolor. Nationalbibliothek, Vienna.

5.58. Snake (Hydra), detail from *Celestial Map: The Northern Celestial Hemisphere*, 1515. Woodcut. National Gallery of Art, Washington, D.C. Rosenwald Collection. Photo: Courtesy of the National Gallery of Art.

5.59. Snake, detail from Maximilian's *Book of Hours*, 1515. Pen and ink. Staatsbibliothek, Munich.

5.60. Squid, detail from Maximilian's *Book of Hours*, 1515. Pen and ink. Staatsbibliothek, Munich.

5.61. Scarab, from Horus Apollo, *The Hieroglyphica*, ca. 1513 (cod. 3255). Pen and ink with watercolor. Nationalbibliothek, Vienna.

5.62. Bird, turtle, and grotesque, from Maximilian's *Book of Hours*, 1515. Pen and ink. Staatsbibliothek, Munich.

Chapter Six: The Lion, the Saint, and the Artist

6.1. Villard de Honnecourt. *Lion*, ca. 1240. Pen and ink. Bibliothèque Nationale, Paris. Photo: Réunion des Musées Nationaux, Paris.

6.2. Niccolò Bartolommeo da Foggia. Pride of lions below pulpit, 1272. Carving. Cathedral of Ravello, Italy.

6.3. After Florentine print. *Study of Fighting Animals*, 1505. Pen and ink over silverpoint. Staatliche Graphische Sammlung, Munich.

6.4. Florentine. *Combat between Wild and Domestic Animals*, fifteenth century. Engraving. Musée du Louvre, Paris. Cabinet des dessins, Rothschild Collection. Photo: Réunion des Musées Nationaux, Paris.

6.5. Jacopo Bellini. *Lion Page*, ca. 1440. Graphite on rag paper. Trustees of the British Museum, London. Sloane Collection.

6.6. Vittore Pisanello, *Lionello D'Este*, Marquis of Ferrara, 1444. Medal. National Gallery of Art, Washington, D.C. Samuel H. Kress Collection. Photo: Courtesy of the National Gallery of Art.

6.7. Title page, *The Letters of Saint Jerome*, 1492. Woodcut. Metropolitan Museum of Art, New York. Bequest of James C. McGuire.

6.8. *Saint Jerome in His Cell*, 1511. Preparatory drawing. Biblioteca Ambrosiana, Milan.

6.9. *Saint Jerome in His Cell*, 1511. Woodcut. National Gallery of Art, Washington, D.C. Rosenwald Collection. Photo: Courtesy of the National Gallery of Art.

6.10. *Saint Jerome in His Study*, 1514. Engraving. National Gallery of Art, Washington, D.C. Gift of R. Horace Gallatin. Photo: Courtesy of the National Gallery of Art.

6.11. *Saint Jerome in Penance*, ca. 1496. Engraving. Metropolitan Museum of Art, New York. Mr. and Mrs. Isaac D. Fletcher Fund.

6.12. Master of the Playing Cards. *Five of Lions*, ca. 1430–50. Engraving. Staatliche Kunstsammlungen, Dresden.

6.13. *Lion*, ca. 1494. Brush and wash over black chalk. Detroit Institute of Arts, Detroit. Presented by E. & A. Silberman.

6.14. *Saint Jerome in a Cave*, 1512. Woodcut. Metropolitan Museum of Art, New York. Harris Brisbane Dick Fund.

6.15. *Saint Jerome by the Pollard Willow*, 1512. Drypoint. National Gallery of Art, Washington, D.C. Rosenwald Collection. Photo: Courtesy of the National Gallery of Art.

6.16. Lion, detail from *Hercules Conquering Cacus ("Ercules")*, 1496. Woodcut. National Gallery of Art, Washington, D.C. Rosenwald Collection. Photo: Courtesy of the National Gallery of Art.

6.17. Israhel van Meckenem. *Samson and the Lion*, ca. 1475. Engraving. National Gallery of Art, Washington, D.C. Rosenwald Collection. Photo: Courtesy of the National Gallery of Art.

6.18. *Samson and the Lion*, 1497–98. Woodcut. National Gallery of Art, Washington, D.C. Rosenwald Collection. Photo: Courtesy of the National Gallery of Art.

6.19. *Androcles*, 1517. Charcoal drawing. Städelsches Kunstinstitut, Frankfurt. Photo: Ursula Edelmann, Frankfurt.

6.20. Lion, from Horus Apollo, *The Hieroglyphica*, ca. 1513. Pen and ink. Germanisches Nationalmuseum, Nuremberg.

6.21. Lion, from Horus Apollo, *The Hieroglyphica*, ca. 1513 (cod. 3255). Pen and ink with watercolor. Nationalbibliothek, Vienna.

6.22. Lion, from Horus Apollo, *The Hieroglyphica*, ca. 1513 (cod. 3255). Pen and ink with watercolor. Nationalbibliothek, Vienna.

6.23. Lion, from Horus Apollo, *The Hieroglyphica*, ca. 1513 (cod. 3255). Pen and ink with watercolor. Nationalbibliothek, Vienna.

6.24. Aratus, detail from *Celestial Map: The Northern Celestial Hemisphere*, 1515. Woodcut. National Gallery of Art, Washington, D.C. Rosenwald Collection. Photo: Courtesy of the National Gallery of Art.

6.25. *Sol Iustitiae* ("Sun of Righteousness"), 1499–1500. Engraving. National Gallery of Art, Washington, D.C. Rosenwald Collection. Photo: Courtesy of the National Gallery of Art.

6.26. *Coat of Arms for Jacob Bannissis*, ca. 1520. Woodcut. Staatliche Museen, Berlin. Photo: Jörg P. Anders, Berlin.

6.27. *Coat of Arms for Roggendorf Brothers*, ca. 1520. Woodcut. Germanisches Nationalmuseum, Nuremberg.

6.28. *Three Views of a Lion's Head*, ca. 1494. Pen and ink. Albertina, Vienna.

6.29. *Pendant with Lion and Serpent*, ca. 1517. Pen and ink. Trustees of the British Museum, London. Sloane Collection.

6.30. Five Blocks of coats of arms, detail from Maximilian's *Triumphal Arch*, 1515. Woodcut. Photo: Courtesy of the National Gallery of Art, Washington, D.C.

6.31. Lion, detail from Maximilian's *Triumphal Arch*, 1515. Woodcut. Photo: Courtesy of the National Gallery of Art, Washington, D.C.

6.32. Lion, detail from Maximilian's *Triumphal Arch*, 1515. Woodcut. Photo: Courtesy of the National Gallery of Art, Washington, D.C.

6.33. Lion, detail from Maximilian's *Triumphal Arch*, 1515. Woodcut. Photo: Courtesy of the National Gallery of Art, Washington, D.C.

6.34. Lion, detail from Maximilian's *Triumphal Arch*, 1515. Woodcut. Photo: Courtesy of the National Gallery of Art, Washington, D.C.

6.35. Lionskin, detail from Maximilian's *Triumphal Arch*, 1515. Woodcut. Photo: Courtesy of the National Gallery of Art, Washington, D.C.

6.36. Lion, detail from Maximilian's *Book of Hours*, 1515. Pen and ink. Staatsbibliothek, Munich.

6.37. Lion, detail from Maximilian's *Book of Hours*, 1515. Pen and ink. Staatsbibliothek, Munich.

6.38. Lion head, detail from Maximilian's *Book of Hours*, 1515. Pen and ink. Staatsbibliothek, Munich.

6.39. Lion, detail from Maximilian's *Book of Hours*, 1515. Pen and Ink. Staatsbibliothek, Munich.

6.40. *Two Lions*, ca. 1521. Silverpoint on pink-prepared paper. Staatliche Museen, Berlin. Photo: Jörg P. Anders, Berlin.

6.41. *Lion*, 1521. Silverpoint on pink-prepared paper. Albertina, Vienna.

6.42. Copy after Dürer. *Lioness*, ca. 1521. Pen and ink. University Library, Warsaw.

Chapter Seven: An Artist's Best Friend

7.1. *Stele for the Bitch Helen*, late second century. Roman relief. J. Paul Getty Museum, Malibu.

7.2. Martin Schongauer. Dog, detail from *The Adoration of the Magi*, from *The Life of the Virgin*, ca. 1470–75. Engraving. National Gallery of Art, Washington, D.C. Rosenwald Collection. Photo: Courtesy of the National Gallery of Art.

7.3. Martin Schongauer. Dog, detail from *Christ before Pilate*, from *Twelve Scenes Illustrating Christ's Passion*, ca. 1480. Engraving. National Gallery of Art, Washington, D.C. Gift of W. G. Russell Allen. Photo: Courtesy of the National Gallery of Art.

7.4. Martin Schongauer. Dog, detail from *Ecce Homo*, ca. 1485. Engraving. National Gallery of Art, Washington, D.C. Gift of W. G. Russell Allen. Photo: Courtesy of the National Gallery of Art.

7.5. Martin Schongauer. Dog, detail from *Christ Carrying the Cross*, ca. 1485. Engraving. National Gallery of Art, Washington, D.C. Andrew W. Mellon Fund. Photo: Courtesy of the National Gallery of Art.

7.6. Dogs, detail from *Saint Eustace*, ca. 1500–1501. Engraving. National Gallery of Art, Washington, D.C. Rosenwald Collection. Photo: Courtesy of the National Gallery of Art.

7.7. Study for the hound, for *Saint Eustace*, ca. 1500. Brush and watercolor. Royal Library, Windsor Castle. Collection of Her Majesty Queen Elizabeth II.

7.8. Dog, from Horus Apollo, *The Hieroglyphica*, ca. 1513. Pen and ink. Germanisches Nationalmuseum, Nuremberg.

7.9. Dog with stole, from Horus Apollo, *The Hieroglyphica*, ca. 1513. Pen and ink. Staatliche Museen, Berlin. Photo: Jörg P. Anders, Berlin.

7.10. Tarocchi Master-E Series. *Faith*, ca. 1465. Engraving. National Gallery of Art, Washington, D.C. Ailsa Mellon Bruce Fund. Photo: Courtesy of the National Gallery of Art.

7.11. Dürer after Tarocchi. *Faith*, ca. 1495. Pen and ink. Bibliothèque Nationale, Paris. Photo: Réunion des Musées Nationaux, Paris.

7.12. Wolf Traut. Dog, detail from *Coat of Arms of Scheurl and Tucher Families*, 1512. Woodcut. National Gallery of Art, Washington, D.C. Rosenwald Collection. Photo: Courtesy of the National Gallery of Art.

7.13. A flower, a leaping dog, and a brush, detail from letter to Pirckheimer of 7 February 1506. Pen and ink. Institut Neerlandais, Paris.

7.14. Jacob Locher. Dedication to *Little Works*, 1506. Woodcut. Library of Congress, Washington, D.C. Reproduced from the Collections of the Library of Congress.

7.15. *The Martyrdom of the Ten Thousand*, 1508. Oil on panel. Kunsthistorisches Museum, Vienna.

7.16. Drawing for Terence, *Andria*, act 3, scene 5, 1492. Drawing on woodblock. Kunstmuseum, Basel.

7.17. Dog, detail from *Jean Gerson as Pilgrim*, 1494. Woodcut design. Germanisches Nationalmuseum, Nuremberg.

7.18. Dog, detail from *Knight on Horseback and Lansquenet*, ca. 1496. Woodcut. National Gallery of Art, Washington, D.C. Gift of W. G. Russell Allen. Photo: Courtesy of the National Gallery of Art.

7.19. Dog, detail from *Martyrdom of Saint John*, from *The Apocalypse*, 1496–98. Woodcut. National Gallery of Art, Washington, D.C. Ailsa Mellon Bruce Fund. Photo: Courtesy of the National Gallery of Art.

7.20. Dog, detail from *The Flagellation*, from *The Large Passion*, 1497. Woodcut. National Gallery of Art, Washington, D.C. Rosenwald Collection. Photo: Courtesy of the National Gallery of Art.

7.21. Dog, detail from *Christ Carrying the Cross*, from *The Large Passion*, ca. 1498–99. Woodcut. National Gallery of Art, Washington, D.C. Rosenwald Collection. Photo: Courtesy of the National Gallery of Art.

7.22. Israhel van Meckenem. *Christ among the Doctors*, from *The Life of the Virgin*, ca. 1490–1500. Engraving. National Gallery of Art, Washington, D.C. Rosenwald Collection. Photo: Courtesy of the National Gallery of Art.

7.23. Dog, detail from *Our Lady of the Animals*, ca. 1503. Pen and ink. Staatliche Museen, Berlin. Photo: Jörg P. Anders, Berlin.

7.24. Dog, detail from *Our Lady of the Animals*, ca. 1503. Pen and watercolor. Albertina, Vienna.

7.25. Dog, detail from *The Visitation*, from *The Life of the Virgin*, ca. 1504. Woodcut. National Gallery of Art, Washington, D.C. Rosenwald Collection. Photo: Courtesy of the National Gallery of Art.

7.26. Dog, detail from preparatory drawing for *The Visitation*, from *The Life of the Virgin*, ca. 1504. Pen and ink. Albertina, Vienna.

7.27. Dürer's workshop. Detail from illustration for Ulrich Pinder, *The Closed Garden of Mary's Rosary*, Nuremberg, 1505. Woodcut. Photo: New York Public Library, New York. Spencer Collection.

7.28. Dog, detail from *Christ before Caiaphas*, 1509–10. Woodcut. National Gallery of Art, Washington, D.C. Rosenwald Collection. Photo: Courtesy of the National Gallery of Art.

7.29. Dog, detail from Maximilian's *Book of Hours*, 1515. Pen and ink. Staatsbibliothek, Munich.

7.30. Dog, detail from Maximilian's *Book of Hours*, 1515. Pen and ink. Staatsbibliothek, Munich.

7.31. Edward Topsell. "Mimicke Dog," detail from *Historie of Foure-Footed Beastes*, London, 1607.

7.32. Left page of Maximilian's *Triumphal Arch*, 1515. Woodcut. Photo: Courtesy of the National Gallery of Art, Washington, D.C.

7.33. Right page of Maximilian's *Triumphal Arch*, 1515. Woodcut. Photo: Courtesy of the National Gallery of Art, Washington, D.C.

7.34. Putto with dog, detail from Maximilian's *Triumphal Arch*, 1515. Woodcut. Photo: Courtesy of the National Gallery of Art, Washington, D.C.

7.35. Dog, detail from *Saint Jerome in His Study*, 1514. Engraving. National Gallery of Art, Washington, D.C. Gift of R. Horace Gallatin. Photo: Courtesy of the National Gallery of Art.

7.36. Dog, detail from *Knight, Death and Devil*, 1513. Engraving. National Gallery of Art, Washington, D.C. Gift of W. G. Russell Allen. Photo: Courtesy of the National Gallery of Art.

7.37. Talbot, detail from *Coat of Arms of Lorenz Staiber*, 1520–21. Woodcut. National Gallery of Art, Washington, D.C. Rosenwald Collection. Photo: Courtesy of the National Gallery of Art.

7.38. *Talbot*, ca. 1521. Silverpoint on pink-prepared paper. Staatliche Museen, Berlin. Photo: Jörg P. Anders, Berlin.

7.39. *Talbot*, ca. 1520. Silverpoint on pink-prepared paper. Trustees of the British Museum, London. Sloane Collection.

7.40. Dog, detail from *Melencolia I*, 1514. Engraving. National Gallery of Art, Washington, D.C. Rosenwald Collection. Photo: Courtesy of the National Gallery of Art.

7.41. Dog (Canis minor), detail from *Celestial Map: The Southern Celestial Hemisphere*, 1515. Woodcut. National Gallery of Art, Washington, D.C. Rosenwald Collection. Photo: Courtesy of the National Gallery of Art.

7.42. Copy after Dürer. Greyhound, detail from *Melencolia I*, 1514. Pen and ink. Musée Bonnat, Bayonne. Photo: Réunion des Musées Nationaux, Paris.

7.43. *A Knight and His Lady*, 1510. Pen and ink. Design for funerary relief. Christ Church, Oxford.

7.44. Dog, detail from *Christ before Pilate*, 1509–10. Woodcut. National Gallery of Art, Washington, D.C. Rosenwald Collection. Photo: Courtesy of the National Gallery of Art.

7.45. Dog, detail from *Der Ritter vom Turn*, Basel, 1493; also known as Chevalier de la Tour Landry, *Examples of the Fear of God and of Respectability*. Woodcut. Library of Congress, Washington, D.C. Rare Book Division, Rosenwald Collection. Photo: Hugh Talman.

7.46. *Susanna von Brandenburg-Ansbach*, 1525. Black chalk, heightened with white, on green-papered paper. By permission of the Fogg Art Museum, Harvard University, Cambridge.

7.47. Dog, detail from *Hands Holding Puppy on Tile Floor*, 1521. Silverpoint on pink-prepared paper. Germanisches Nationalmuseum, Nuremberg.

7.48. Dog and Death, detail from *The Pleasures of the World*, ca. 1500. Pen and ink. Ashmolean Museum, Oxford.

Chapter Eight: Down on the Farm

8.1. Martin Schongauer. *Peasant Family Going to Market*, ca. 1470–75. Engraving. National Gallery of Art, Washington, D.C. Rosenwald Collection. Photo: Courtesy of the National Gallery of Art.

8.2. Martin Schongauer. *Family of Pigs*, ca. 1480–90. Engraving. National Gallery of Art, Washington, D.C. Rosenwald Collection. Photo: Courtesy of the National Gallery of Art.

8.3. Leonardo da Vinci. *Ox and Ass*, study for *The Adoration of the Shepherds*, ca. 1480–82. Pen drawing. Royal Library, Windsor Castle. Collection of Her Majesty Queen Elizabeth II.

8.4. *The Prodigal Son*, 1496. Engraving. National Gallery of Art, Washington, D.C. Rosenwald Collection. Photo: Courtesy of the National Gallery of Art.

8.5. Peter Corduër, copy after Dürer. Detail from *Farm Scene for the Pirckheimers* (on reverse of a portrait of Willibald Pirckheimer), late sixteenth century. Oil on panel.

8.6. Martin Schongauer. *The Flight into Egypt*, from *The Life of the Virgin*, ca. 1470–75. Engraving. National Gallery of Art, Washington, D.C. Rosenwald Collection. Photo: Courtesy of the National Gallery of Art.

8.7. *Peasant*, 1512. Pen and ink. Victoria and Albert Museum, London.

8.8. *The Adoration of the Magi*, from *The Life of the Virgin*, ca. 1501–3. Woodcut. National Gallery

of Art, Washington, D.C. Gift of W. G. Russell Allen. Photo: Courtesy of the National Gallery of Art.

8.9. "Narrenschiff," from Sebastian Brant, *The Ship of Fools*, Basel, 1494. Woodcut. Library of Congress, Washington, D.C. Rare Book Division, Rosenwald Collection.

8.10. Anonymous. *The Prodigal Son*, from *Speculum Humanae Salvations*, Basel, 1476 (PML 20681). Woodcut. Pierpont Morgan Library, New York.

8.11. *The Prodigal Son*, ca. 1496. Preparatory drawing, pen and ink. Trustees of the British Museum, London. Sloane Collection.

8.12. Rembrandt van Rijn. *The Prodigal Son*, ca. 1647–48. Pen and bistre. Trustees of the British Museum, London. Sloane Collection.

8.13. *Farmer Who Attends the Market and His Wife*, 1512. Engraving. National Gallery of Art, Washington, D.C. Rosenwald Collection. Photo: Courtesy of the National Gallery of Art.

8.14. Farmfolk dancing, detail from Maximilian's *Book of Hours*, 1515. Pen and ink. Staatsbibliothek, Munich.

8.15. Peasant woman to market, detail from Maximilian's *Book of Hours*, 1515. Pen and ink. Staatsbibliothek, Munich.

8.16. *Fountain with the Seated Peasant and Goose*, ca. 1499. Pen and watercolor. Kunsthistorisches Museum, Vienna.

8.17. *Gardner with a Vine*, 1515. Woodcut. Albertina, Vienna.

8.18. Plunder and arson, detail from Maximilian's *Triumphal Arch*, 1515. Woodcut. Photo: Courtesy of the National Gallery of Art, Washington, D.C.

8.19. *Design of a Monument to Peasants (Peasants' Defeat)*, 1525. Woodcut. Metropolitan Museum of Art. New York. Harris Brisbane Dick Fund.

8.20. "Fool with Ass on His Back," from Sebastian Brant, *The Ship of Fools*, Basel, 1494. Woodcut. Library of Congress, Washington, D.C. Rare Book Division, Rosenwald Collection.

8.21. "Wheel of Fortune," from Sebastian Brant, *The Ship of Fools*, Basel, 1494. Woodcut. Library of Congress, Washington, D.C. Rare Book Division, Rosenwald Collection.

8.22. Ass with skeleton, from Sebastian Brant, *The Ship of Fools*, Basel, 1494. Woodcut. Library of Congress, Washington, D.C. Rare Book Division, Rosenwald Collection.

8.23. "Old Woman with Young Man," from Sebastian Brant, *The Ship of Fools*, Basel, 1494. Woodcut. Library of Congress, Washington, D.C. Rare Book Division, Rosenwald Collection.

8.24. *Christ's Entry into Jerusalem*, 1509–10. Woodcut. National Gallery of Art, Washington, D.C. Rosenwald Collection. Photo: Courtesy of the National Gallery of Art.

8.25. Ass's head, from Horus Apollo, *The Hieroglyphica*, ca. 1513 (cod. 3255). Pen and ink with watercolor. Nationalbibliothek, Vienna.

8.26. Christ on a donkey, detail from Maximilian's *Book of Hours*, 1515. Pen and ink. Staatsbibliothek, Munich. Photo: Courtesy of the National Gallery of Art, Washington, D.C.

8.27. Domesticated European buffalo, detail from Maximilian's *Book of Hours*, 1515. Pen and ink. Staatsbibliothek, Munich. Photo: Courtesy of the National Gallery of Art, Washington, D.C.

8.28. Feline, detail from *Adam and Eve*, 1504. Engraving. National Gallery of Art, Washington, D.C. Rosenwald Collection. Photo: Courtesy of the National Gallery of Art.

8.29. Mouse, detail from *Adam and Eve*, 1504. Engraving. National Gallery of Art, Washington, D.C. Rosenwald Collection. Photo: Courtesy of the National Gallery of Art.

8.30. Mouse, detail from Horus Apollo, *The Hieroglyphica*, ca. 1513 (cod. 3255). Pen and ink with watercolor. Nationalbibliothek, Vienna.

8.31. *Young Steer*, ca. 1493. Pen and ink. Art Institute of Chicago. Clarence Buckingham Collection.

8.32. Bullock, detail from *Our Lady of the Animals*, 1503. Pen and ink with watercolor. Musée du Louvre, Paris. Cabinet des dessins. Photo: Réunion des Musées Nationaux, Paris.

8.33. *The Adoration of the Lamb*, from *The Apocalypse*, ca. 1496–98. Woodcut. National Gallery of Art, Washington, D.C. Gift of Philip Hofer. Photo: Courtesy of the National Gallery of Art.

8.34. Bull, detail from "Of Sensual Pleasure," from Sebastian Brant, *The Ship of Fools*, Basel, 1494. Woodcut. Library of Congress, Washington, D.C. Rare Book Division, Rosenwald Collection.

8.35. Golden Calf, detail from Sebastian Brant, *The Ship of Fools*, Basel, 1494. Library of Congress, Washington, D.C. Rare Book Division, Rosenwald Collection.

8.36. *Rape of Europa*, 1494. Pen and ink. Albertina, Vienna.

8.37. *Hercules and Geryon*, 1511. Pen and ink with wash. Amtlich Ausgabe der Kunsthalle, Bremen.

8.38. *Study of an Ox Muzzle (Frontal View)*, ca. 1501. Watercolor with gouache. Trustees of the British Museum, London. Sloane Collection.

8.39. *Study of an Ox Muzzle (Profile View)*, ca. 1501. Watercolor with gouache. Trustees of the British Museum, London. Sloane Collection.

8.40. Bull, from Horus Apollo, *The Hieroglyphica*, ca. 1513 (cod. 3255). Pen and ink with watercolor. Nationalbibliothek, Vienna.

8.41. Bull's ear, from Horus Apollo, *The Hieroglyphica*, ca. 1513 (cod. 3255). Pen and ink with watercolor. Nationalbibliothek, Vienna.

8.42. Bull (Taurus), detail from *Celestial Map: The Northern Celestial Hemisphere*, 1515. Woodcut. National Gallery of Art, Washington, D.C. Rosenwald Collection. Photo: Courtesy of the National Gallery of Art.

8.43. *Coat of Arms with a Cock*, ca. 1500. Engraving. National Gallery of Art, Washington, D.C. Rosenwald Collection. Photo: Courtesy of the National Gallery of Art.

8.44. Cock, detail from *The Mass of Saint Gregory*, 1511. Woodcut. National Gallery of Art, Washington, D.C. Rosenwald Collection. Photo: Courtesy of the National Gallery of Art.

8.45. Fox and chicken, detail from Maximilian's *Book of Hours*, 1515. Pen and ink. Staatsbibliothek, Munich.

8.46. Crowing rooster, for hunters' whistle design, ca. 1517. Drawing with yellow watercolor. Formerly at Kunsthalle, Bremen (lost in World War II).

8.47. Migratory geese, from Sebastian Brant, *The Ship of Fools*, Basel, 1494. Woodcut. Library of Congress, Washington, D.C. Rare Book Division, Rosenwald Collection.

8.48. *Witch Riding on a Goat*, 1500–1501. Engraving. National Gallery of Art, Washington, D.C. Rosenwald Collection. Photo: Courtesy of the National Gallery of Art.

8.49. Ram, for Horus Apollo, *The Hieroglyphica*, 1510. Pen and ink. Staatliche Museen, Berlin. Photo: Jörg P. Anders, Berlin.

8.50. Goat, for Horus Apollo, *The Hieroglyphica*, 1513. Pen and ink. Germanisches Nationalmuseum, Nuremberg.

8.51. Goat, detail from Maximilian's *Triumphal Arch*, 1515. Woodcut. Photo: Courtesy of the National Gallery of Art, Washington, D.C.

8.52. Goat, detail from Maximilian's *Triumphal Arch*, 1515. Woodcut. Photo: Courtesy of the National Gallery of Art, Washington, D.C.

8.53. *Goat on Column*, 1510. Pen and ink with watercolor. Trustees of the British Museum, London. Sloane Collection.

8.54. Goat (Capricorn), detail from *Celestial Map: The Southern Celestial Hemisphere*, 1515. Woodcut. National Gallery of Art, Washington, D.C. Rosenwald Collection. Photo: Courtesy of the National Gallery of Art.

8.55. Pig, from Sebastian Brant, *The Ship of Fools*, Basel, 1494. Woodcut. Library of Congress, Washington, D.C. Rare Book Division, Rosenwald Collection.

8.56. *Pig Witnessing Nude Couple and the Devil*, ca. 1505. Pen and ink. Formerly at Kunsthalle, Bremen (lost in World War II).

8.57. Pig-headed flying devil, detail from *The Mass Celebrated by Angels*, 1510. Pen and watercolor over silverpoint. Musée des Beaux-Arts, Rennes.

8.58. Shepherd, detail from *Our Lady of the Animals*, ca. 1503. Pen and ink. Staatliche Museen, Berlin. Photo: Jörg P. Anders, Berlin.

8.59. Shepherds, from *Our Lady of the Animals*, ca. 1503. Pen and ink with watercolor. Musée du Louvre, Paris. Cabinet des dessins. Photo: Réunion des Musées Nationaux, Paris.

8.60. Ram, detail from the coat of arms of the Holper family (Barbara Dürer), 1490 (on reverse of *Portrait of Dürer's Father*). Oil on panel. Uffizi,

Florence. Photo: Editorial Photocolor Archives, Inc., New York.

8.61. Lamb, detail from *Joachim's Offering Rejected*, from *The Life of the Virgin*, ca. 1504–5. Woodcut. National Gallery of Art, Washington, D.C. Gift of W. G. Russell Allen. Photo: Courtesy of the National Gallery of Art.

8.62. Fighting sheep, detail from *Angel Appearing to Joachim*, from *The Life of the Virgin*, ca. 1504–5. Woodcut. National Gallery of Art, Washington, D.C. Rosenwald Collection. Photo: Courtesy of the National Gallery of Art.

8.63. *Christ Expelling the Moneylenders from the Temple*, from *The Small Woodcut Passion*, 1509–10. Woodcut. National Gallery of Art, Washington, D.C. Rosenwald Collection. Photo: Courtesy of the National Gallery of Art.

8.64. *The Last Supper*, from *The Small Woodcut Passion*, 1509–10. Woodcut. National Gallery of Art, Washington, D.C. Rosenwald Collection. Photo: Courtesy of the National Gallery of Art.

8.65. Golden Fleece, detail from Maximilian's *Triumphal Arch*, 1515. Woodcut. Photo: Courtesy of the National Gallery of Art, Washington, D.C.

8.66. Ram's head and horns (Aries), detail from *Map of the Northern Sky*, 1503. Pen and ink on vellum. Germanisches Nationalmuseum, Nuremberg.

Chapter Nine: Horse and Rider

9.1. *Horse Tamer after Praxiteles*, 1525. Drawing. Musée Bonnat, Bayonne. Photo: Réunion des Musées Nationaux, Paris.

9.2. Leonardo da Vinci. *Study for the Sforza Horse*, late fifteenth century. Chalk. Royal Library, Windsor Castle. Collection of Her Majesty Queen Elizabeth II.

9.3. Jan van Eyck. *The Knights of Christ*, from the Ghent Altarpiece, 1432. Oil on panel. Saint Bavo Church, Ghent. Copyright A.C.L., Brussels.

9.4. Martin Schongauer. *The Battle of Saint James at Clavijo*, ca. 1485. Engraving. National Gallery of Art, Washington, D.C. Rosenwald Collection. Photo: Courtesy of the National Gallery of Art.

9.5. Knights jousting, detail from Maximilian's *Neck Guard*, 1517. Pen and ink. Albertina, Vienna.

9.6. Attributed to Dürer. Jousting scene, from *Der Ritter vom Turn*, Basel, 1493; also known as Chevalier de la Tour Landry, *Examples of the Fear of God and of Respectability*. Woodcut. Library of Congress, Washington, D.C. Rare Book Division, Rosenwald Collection. Photo: Hugh Talman.

9.7. *Cavalcade*, 1489. Pen and ink. Kunsthalle, Bremen. Photo: Stickelmann, Bremen.

9.8. Horse, detail from *Ill-Assorted Couple*, before 1496. Engraving. National Gallery of Art, Washington, D.C. Rosenwald Collection. Photo: Courtesy of the National Gallery of Art.

9.9. *Lovers on Horseback*, no date. Pen and ink over charcoal. Staatliche Museen, Berlin. Photo: Jörg P. Anders, Berlin.

9.10. "Stroking the Fallow Stallion," from Sebastian Brant, *The Ship of Fools*, Basel, 1494. Woodcut. Library of Congress, Washington, D.C. Rare Book Division, Rosenwald Collection.

9.11. *Galloping Rider*, 1493. Pen and ink. Trustees of the British Museum, London. Sloane Collection.

9.12. Vittore Pisanello. *Domenico Novello Malatesta Kneeling Before a Crucifix*, 1440s. Bronze medal. National Gallery of Art, Washington, D.C. Samuel H. Kress Collection. Photo: Courtesy of the National Gallery of Art.

9.13. Vittore Pisanello. *Gianfrancesco I Gonzaga Riding to Left*, 1440s. Bronze medal. National Gallery of Art, Washington, D.C. Samuel H. Kress Collection. Photo: Courtesy of the National Gallery of Art.

9.14. Donatello. *Gattamelata*, 1453. Equestrian bronze. Padua.

9.15. Andrea del Verrocchio. *Bartolommeo Colleoni*, 1496. Equestrian bronze. Venice.

9.16. Ancient Greek. *Horses of Saint Mark's*. Bronze. Venice.

9.17. After Gentile Bellini. *Oriental on Horseback*, 1495. Pen and watercolor. Albertina, Vienna.

9.18. After Gentile Bellini. *Oriental on Horseback*, 1495. Pen and watercolor. Biblioteca Ambrosiana, Milan.

9.19. After Gentile Bellini. *Oriental on Horseback*, 1495. Pen and watercolor. Biblioteca Ambrosiana, Milan.

9.20. *Five Soldiers and a Turk on Horseback*, 1495–96. Engraving. National Gallery of Art, Washington, D.C. Rosenwald Collection. Photo: Courtesy of the National Gallery of Art.

9.21. Group of horsemen, detail from *The Adoration of the Magi*, 1504. Oil on panel. Uffizi, Florence. Photo: Editorial Photocolor Archives, Inc., New York.

9.22. *The Four Horsemen*, from *The Apocalypse*, ca. 1496–98. Woodcut. National Gallery of Art, Washington, D.C. Rosenwald Collection. Photo: Courtesy of the National Gallery of Art.

9.23. Unknown artist. Woodcut from *Quentell Bible*, Anton Koberger, Cologne, 1480.

9.24. *King Death Riding a Horse*, ca. 1505. Charcoal. Trustees of the British Museum, London. Sloane Collection.

9.25. Dürer School. *Death on Horseback*, 1502. Design for painted glass, pen and ink. Kestner-Museum, Hannover. Photo: Niedersachsisches Landesmuseum, Landesgalerie, Hannover.

9.26. Dog, detail from *Knight on Horseback and the Lansquenet*, ca. 1496. Woodcut. National Gallery of Art, Washington, D.C. Gift of W. G. Russell Allen. Photo: Courtesy of the National Gallery of Art.

9.27. *Lady on Horseback and Lansquenet*, 1497. Engraving. National Gallery of Art, Washington, D.C. Rosenwald Collection. Photo: Courtesy of the National Gallery of Art.

9.28. *Saint George on Horseback*, 1508. Engraving. National Gallery of Art, Washington, D.C. Rosenwald Collection. Photo: Courtesy of the National Gallery of Art.

9.29. *Study of a Horse*, ca. 1500. Pen and ink over silverpoint on grey-blue prepared paper. Museum Boymans–van Beuningen, Rotterdam. Photo: Frequin-Photos, Voorburg.

9.30. Saint George, detail from Maximilian's *Book of Hours*, 1515. Pen and ink. Staatsbibliothek, Munich.

9.31. Warrior pursued by Death, detail from Maximilian's *Book of Hours*, 1515. Pen and ink. Staatsbibliothek, Munich.

9.32. *Saint George and the Dragon*, 1501–4. Woodcut. National Gallery of Art, Washington, D.C. Rosenwald Collection. Photo: Courtesy of the National Gallery of Art.

9.33. *Saint George and the Dragon*, design for pendant, ca. 1517. Pen and ink. Kunsthalle, Hamburg.

9.34. Toppling rider, detail from *The Apocalypse*, ca. 1496–98. Woodcut. National Gallery of Art, Washington, D.C. Ailsa Mellon Bruce Fund. Photo: Courtesy of the National Gallery of Art.

9.35. *The Martyrdom of Saint Catherine*, ca. 1517–18. Woodcut. National Gallery of Art, Washington, D.C. Rosenwald Collection. Photo: Courtesy of the National Gallery of Art.

9.36. Study for *The Martyrdom of Saint Catherine*, 1517. Pen and ink. Trustees of the British Museum, London. Sloane Collection.

9.37. *Conversion of Saint Paul*, no date. Engraving. Staatliche Kunstsammlungen, Dresden.

9.38. Unknown artist, after Leonardo de Vinci. *Warrior on Horseback*. Bronze. Szépművészeti Múzeum, Budapest.

9.39. Leonardo da Vinci. *Studies for the Sforza Monument*, late fifteenth century. Royal Library, Windsor Castle. Collection of Her Majesty Queen Elizabeth II.

9.40. *Hungarian Trophy*, 1518. Pen and ink. Albertina, Vienna.

9.41. *Study for Horse-Drawn Triumphal Wagon*, 1515. Pen and ink. Sächsische Landesbibliothek, Dresden.

9.42. *The Falconer*, ca. 1503–5. Pen and ink on yellowish paper. Uffizi, Florence. Photo: Editorial Photocolor Archives, Inc., New York.

9.43. *Horse in Profile*, 1503. Pen and grey wash on black and green ground. Wallraf-Richartz Museum, Cologne. Photo: Rheinisches Bildung, Cologne.

9.44. *Small Horse*, 1505. Engraving. National Gallery of Art, Washington, D.C. Rosenwald Collection. Photo: Courtesy of the National Gallery of Art.

9.45. Dürer after Leonardo da Vinci. *Studies of Men and Horses*, 1506 (Ms. Cent. V. App. 34, fol. 81). Pen and ink. Stadtbibliothek, Nuremberg.

9.46. *Large Horse*, 1505. Engraving. National Gallery of Art, Washington, D.C. Rosenwald Collection. Photo: Courtesy of the National Gallery of Art.

9.47. *Knight, Death and Devil*, 1513. Engraving. National Gallery of Art, Washington, D.C. Gift of W. G. Russell Allen. Photo: Courtesy of the National Gallery of Art.

9.48. Study for *Knight, Death and Devil*, 1513. Pen, brush, and ink. Biblioteca Ambrosiana, Milan.

9.49. Study for *Knight, Death and Devil*, 1513. Pen and ink. Biblioteca Ambrosiana, Milan.

9.50. Dürer after Leonardo da Vinci. *Leaping Dog*, 1513. Pen and ink. Trustees of the British Museum, London. Sloane Collection.

9.51. *Abduction on Horseback*, 1516. Pen and ink. Pierpont Morgan Library, New York.

9.52. Tiny horse, detail from *Saint Eustace*, ca. 1500–1501. Engraving. National Gallery of Art, Washington, D.C. Rosenwald Collection. Photo: Courtesy of the National Gallery of Art.

9.53. Horse and rider, detail from *Samson and the Lion*, 1497–98. Woodcut. National Gallery of Art, Washington, D.C. Rosenwald Collection. Photo: Courtesy of the National Gallery of Art.

9.54. *Holy Family under a Tree*, 1491. Pen and ink. Donington Priory, A. E. Gatharne-Hardy.

9.55. *Siege of a Fortress*, 1527. Woodcut (two blocks). National Gallery of Art, Washington, D.C. Rosenwald Collection. Photo: Courtesy of the National Gallery of Art.

9.56. *Horse's Swimming Gear*, ca. 1512. Pen and ink. Trustees of the British Museum, London. Sloane Collection.

9.57. *Equestrian Swinging a "Morning Star,"* 1512. Pen and ink. Trustees of the British Museum, London. Sloane Collection.

9.58. *Fine Steeds at Aachen at the Time of Charles V,* 1521. Silverpoint on pink-grounded paper. Germanisches Nationalmuseum, Nuremberg.

9.59. Horse's head (Equus), detail from *Celestial Map: The Northern Celestial Hemisphere*, 1515. Woodcut. National Gallery of Art, Washington, D.C. Rosenwald Collection. Photo: Courtesy of the National Gallery of Art.

Chapter Ten: In the Stars and over the Seas

10.1. Unknown craftsman. Astrolabe, no date. Photo: Courtesy of the Smithsonian Institution, Washington, D.C.

10.2. Unknown artist. Woodcut frontispiece for Ptolemy, *Geographica*, edition of 1513 by Martin Waldseemuller and Mathias Ringman, Strasbourg.

10.3. *Celestial Map: The Northern Celestial Hemisphere*, 1515. Woodcut. National Gallery of Art, Washington, D.C. Rosenwald Collection. Photo: Courtesy of the National Gallery of Art.

10.4. *Celestial Map: The Southern Celestial Hemisphere*, 1515. Woodcut. National Gallery of Art, Washington, D.C. Rosenwald Collection. Photo: Courtesy of the National Gallery of Art.

10.5. *Map of the Southern Sky*, 1503. Pen and ink on vellum. Germanisches Nationalmuseum, Nuremberg.

10.6. *Map of the Northern Sky*, 1503. Pen and ink on vellum. Germanisches Nationalmuseum, Nuremberg.

10.7. "A Fly's Brain Lit by a Star," from Sebastian Brant, *The Ship of Fools*, Basel, 1494. Woodcut. Library of Congress, Washington, D.C. Rare Book Division, Rosenwald Collection.

10.8. *The Syphilitic Man*, 1496. Woodcut. Staatliche Museen, Berlin. Photo: Jörg P. Anders, Berlin.

10.9. Unknown artist. Frontispiece, from Marco Polo, *Il Milione: Le Divisament dou monde*, Nuremberg, 1477 (PML 25134). Pierpont Morgan Library, New York.

10.10. Warrior, detail from Maximilian's *Book of Hours*, 1515. Pen and ink. Staatsbibliothek, Munich.

10.11. Ladle, detail from Maximilian's *Book of Hours*, 1515. Pen and ink. Staatsbibliothek, Munich.

10.12. Vrious animals, from Bernhard von Breydenbach, *Pilgrimage to the Holy Land*, Augsburg, 1488. Woodcut.

10.13. Unknown artist. *Chambers of Wonders*, 1519. Woodcut. By permission of the Houghton Library, Harvard University, Cambridge.

10.14. *View of Zoo in Brussels*, 1520. Pen and ink. Akademie der Künste, Vienna. Photo: Jörg P. Anders, Berlin.

10.15. Unknown artist. Monkeys, from Robertus Holkof, *Super sapientiam salomonis*, Basel, 1489. Woodcut.

10.16. Monkeys, from Sebastian Brant, *The Ship of Fools*, Basel, 1494. Woodcut. Library of Congress, Washington, D.C. Rare Book Division, Rosenwald Collection.

10.17. Ape, detail from *Madonna and Child with Monkey*, ca. 1500. Engraving. National Gallery of Art, Washington, D.C. R. Horace Gallatin Collection. Photo: Courtesy of the National Gallery of Art.

10.18. Nun-monkey, detail from Maximilian's *Book of Hours*, 1515. Pen and ink. Staatsbibliothek, Munich.

10.19. Monkey, detail from Maximilian's *Triumphal Arch*, 1515. Woodcut. Photo: Courtesy of the National Gallery of Art, Washington, D.C.

10.20. Copy after Dürer. Dog-faced baboon, from Horus Apollo, *The Hieroglyphica*, ca. 1513 (cod. 3255). Pen and ink with watercolor. Nationalbibliothek, Vienna.

10.21. Dog-faced baboon, from Horus Apollo, *The Hieroglyphica*, ca. 1513 (cod. 3255). Pen and ink with watercolor. Nationalbibliothek, Vienna.

10.22. Dog-faced baboon, detail from *Sketch of Animals and Landscapes*, 1521. Pen and ink with wash. Sterling and Francine Clark Art Institute, Williamstown, Massachusetts.

10.23. *Twelve Monkeys in a Circle*, 1523. Pen and ink. Kunstmuseum, Basel.

10.24. Narrow frieze of *Adoration of the Magi*, ca. 1517. Pen and ink. Trustees of the British Museum, London. Sloane Collection.

10.25. Egyptian crocodiles, from Horus Apollo, *The Hieroglyphica*, ca. 1513 (cod. 3255). Pen and ink with watercolor. Nationalbibliothek, Vienna.

10.26. Two Egyptian crocodiles, from Horus Apollo, *The Hieroglyphica*, ca. 1513 (cod. 3255). Pen and ink with watercolor. Nationalbibliothek, Vienna.

10.27. Egyptian crocodile tail, from Horus Apollo, *The Hieroglyphica*, ca. 1513 (cod. 3255). Pen and ink with watercolor. Nationalbibliothek, Vienna.

10.28. Egyptian crocodile tail and lion, detail from Maximilian's *Book of Hours*, 1515. Pen and ink. Staatsbibliothek, Munich.

10.29. Dodo, detail from Maximilian's *Book of Hours*, 1515. Pen and ink. Staatsbibliothek, Munich.

10.30. R. Savery. *Two Dodos*, 1599. Black chalk and umber chalk on white paper. Crocker Art Gallery, Sacramento. Photo: A. F. Madeira.

10.31. Martin Schongauer. *Elephant*, ca. 1480–90. Engraving. National Gallery of Art, Washington, D.C. Rosenwald Collection. Photo: Courtesy of the National Gallery of Art.

10.32. Elephant, detail from Maximilian's *Book of Hours*, 1515. Pen and ink. Staatsbibliothek, Munich.

10.33. Hans Burgkmair. Elephant, from Maximilian's *Book of Hours*, 1515. Woodcut. Staatsbibliothek, Munich.

10.34. Unknown artist. Elephant, from Pirckheimer's translation of Ptolemy, *Geographica*, 1525. Woodcut. Gruninger, Strasbourg.

10.35. Early copy after Dürer. Hippopotamus feet, from Horus Apollo, *The Hieroglyphica*, ca. 1513 (cod. 3255). Pen and ink with watercolor. Nationalbibliothek, Vienna.

10.36. Egyptian ibis, from Horus Apollo, *The Hieroglyphica*, ca. 1513 (cod. 3255). Pen and ink with watercolor. Nationalbibliothek, Vienna.

10.37. Parrot, detail from *Adam and Eve*, 1504. Engraving. National Gallery of Art, Washington, D.C. Rosenwald Collection. Photo: Courtesy of the National Gallery of Art.

10.38. Peacock, from "Wheel of Fortune," from Sebastian Brant, *The Ship of Fools*, Basel, 1494. Woodcut. Library of Congress, Washington, D.C. Rare Book Division, Rosenwald Collection.

10.39. Unknown artist. Unicorn, detail from *Animals's Dialogues Moralized*, Antwerp, 1486. Woodcut.

10.40. *The Rhinoceros*, 1515. Woodcut. National Gallery of Art, Washington, D.C. Rosenwald Collection. Photo: Courtesy of the National Gallery of Art.

10.41. *Rhinoceros*, 1515. Pen and ink. Trustees of the British Museum, London. Sloane Collection.

10.42. Rhinoceros, detail from Maximilian's *Triumphal Arch*, 1515. Woodcut. Photo: Courtesy of the National Gallery of Art, Washington, D.C.

10.43. Hans Burgkmair after Dürer. *Rhinoceros*, 1515. Woodcut. Albertina, Vienna.

10.44. Rhinoceros, detail from *Entry of Henri II*, 1547. Design for statue, pen and ink. By permission of the Houghton Library, Harvard University, Cambridge.

10.45. Schönborn castle artist after Dürer. *Rhinoceros*, no date. Sculpture in tortoise, coral, and seashells. Schönborn Castle, Germany. Photo: Foto Marburg.

10.46. After Dürer. *Rhinoceros*, no date. Carved fake marble relief. National Archaeological Museum, Naples.

10.47. Jon Kirchner. Rhinoceros, for the King of Saxony's Porcelain Palace, 1731. White china. Staatliche Kunstsammlungen, Dresden.

10.48. Tani Buncho after Jan Joesten van Kalkar. *Rhinoceros*, 1790. Ink on silk.

10.49. Jan Joesten. Rhinoceros, detail from *Curious Descriptions of the Nature of Four-Footed Animals, Fish, and Bloodless Water Animals, Birds, Crocodiles, Snakes, and Dragons*, 1660. Painted on silk. Tenri University Library, Amsterdam.

10.50. Turtle shell, detail from *Sea Monster*, 1498. Engraving. National Gallery of Art, Washington, D.C. Photo: Courtesy of the National Gallery of Art.

10.51. *Madonna with Eight Saints and Musical Angels*, 1522. Plans for altarpiece, pen and ink. Musée Bonnat, Bayonne. Photo: Réunion des Musées Nationaux, Paris.

10.52. Walrus, detail from *Madonna with Eight Saints and Musical Angels*, 1522. Plans for altarpiece, pen and ink. Musée Bonnat, Bayonne. Photo: Réunion des Musées Nationaux, Paris.

Chapter Eleven: Classical Creatures

11.1. Hercules, from Maximilian's *Book of Hours*, 1515. Pen and ink. Staatsbibliothek, Munich.

11.2. *Hercules Shooting the Stymphalian Birds*, 1500. Pen and ink. Hessisches Landesmuseum, Darmstadt.

11.3. *Hercules and the Lernean Hydra*, 1511. Pen and ink. Kunsthalle, Bremen. Photo: Stickelmann, Bremen.

11.4. Andrea Mantegna. *Battle of the Sea Gods*, ca. 1485–88. Engraving. Trustees of the British Museum, London. Sloane Collection.

11.5. Dürer after Mantegna. *Battle of the Sea Gods*, 1494. Engraving. Albertina, Vienna.

11.6. Detail from Jacopo de' Barbari. *View of Venice* (lower center block), 1500. Woodcut on two sheets. National Gallery of Art, Washington, D.C. Rosenwald Collection. Photo: Courtesy of the National Gallery of Art.

11.7. Jorg Breu. Orpheus, from Maximilian's *Book of Hours*, 1515. Pen and ink. Bibliothèk Municipal, Besançon.

11.8. Design for a scabbard, ca. 1515. Pen and ink with wash. Trustees of the British Museum, London. Sloane Collection.

11.9. Basilisk, detail from *Logic*, ca. 1495. Pen and ink. Formerly at Museum Boymans–van Beuningen, Rotterdam (lost in World War II).

11.10. Tarocchi Master-E Series. Basilisk, detail from *Logic*, ca. 1465. Engraving. National Gallery of Art, Washington, D.C. Ailsa Mellon Bruce Fund. Photo: Courtesy of the National Gallery of Art.

11.11. Basilisk, sun, and moon, from Horus Apollo, *The Hieroglyphica*, ca. 1513. Pen and ink. Trustees of the British Museum, London.

11.12. Half goat, half fish (Capricorn), detail from *Map of the Southern Sky*, 1503. Pen and ink on vellum. Germanisches Nationalmuseum, Nuremberg.

11.13. Unknown artist. Centaur, detail from *Animals' Dialogues Moralized*, Antwerp, 1486. Woodcut.

11.14. *Centaur Carrying off Woman*, 1494. Pen and ink. Musée de L'Ecole Supérieure des Beaux-Arts, Paris.

11.15. *Centaur Family*, 1505. Pen and ink. Staatliche Sammlung Veste Coburg, Coburg.

11.16. Centaur (Sagittarius), detail from *Map of the Southern Sky*, 1503. Pen and ink on vellum. Germanisches Nationalmuseum, Nuremberg.

11.17. Centaur (Centaurus), detail from *Map of the Southern Sky*, 1503. Pen and ink on vellum. Germanisches Nationalmuseum, Nuremberg.

11.18. *Venus Riding on a Dolphin*, 1503. Pen and ink. Albertina, Vienna.

11.19. Aldus Manutius Press. Dolphin, emblem for *The Aldine Anchor*. Woodcut.

11.20. Griffons, detail from *The Vision of the Seven Candlesticks*, from *The Apocalypse*, 1496–98. Woodcut. National Gallery of Art, Washington, D.C. Gift of Philip Hofer. Photo: Courtesy of the National Gallery of Art.

11.21. Griffons, detail from Maximilian's *Triumphal Arch*, 1515. Woodcut. Photo: Courtesy of the National Gallery of Art, Washington, D.C.

11.22. Griffons, detail from Maximilian's *Triumphal Arch*, 1515. Woodcut. Photo: Courtesy of the National Gallery of Art, Washington, D.C.

11.23. Pegasus, detail from *Map of the Northern Sky*, 1503. Pen and ink on vellum. Germanisches Nationalmuseum, Nuremberg.

11.24. Phoenix, from Horus Apollo, *The Hieroglyphica*, ca. 1513 (cod. 3255). Pen and ink with watercolor. Staatsbibliothek, Vienna.

11.25. Phoenix, from Horus Apollo, *The Hieroglyphica*, ca. 1513 (cod. 3255). Pen and ink with watercolor. Staatsbibliothek, Vienna.

11.26. *Satyr*, no date. Pen and ink. Staatliche Museen, Berlin. Photo: Jörg P. Anders, Berlin.

11.27. Satyrs, detail from *Funerary Monument for the Fuggers of Augsburg*. Pen and ink, heightened with white, on green-prepared paper. Staatliche Museen, Berlin. Photo: Jörg P. Anders, Berlin.

11.28. Satyr, detail from *Hercules*, 1498–99. Engraving. National Gallery of Art, Washington, D.C. Rosenwald Collection. Photo: Courtesy of the National Gallery of Art.

11.29. *Satyr's Family*, 1505. Engraving. National Gallery of Art, Washington, D.C. Rosenwald Collection. Photo: Courtesy of the National Gallery of Art.

11.30. Peter Corduër, copy after Dürer. Fauns, detail from *Landscape with Satyrs* (on reverse of a portrait of Crescentia Pirckheimer), late sixteenth century. Oil on panel.

11.31. Detail, *Satyrs Playing Panpipes*, no date. Pen and ink. Svépművészeti Múzeum, Budapest.

11.32. Dürer after Mantegna. Sea horses, from hunters' hanging whistle design, no date. Pen and ink with gouache. Kunsthalle, Bremen. Photo: Stickelmann, Bremen.

11.33. Sphynx, from Maximilian's jousting saddle, 1517. Pen and ink. Pierpont Morgan Library, New York.

11.34. Detail from *Sea Monster*, 1489. Engraving. National Gallery of Art, Washington, D.C. Rosenwald Collection. Photo: Courtesy of the National Gallery of Art.

11.35. Mermaids, detail from *Sirens and Dragons*, ca. 1517. Pen and ink. Staatliche Museen, Berlin. Photo: Jörg P. Anders, Berlin.

11.36. Mermaids, detail from Maximilian's *Triumphal Arch*, 1515. Woodcut. Photo: Courtesy of the National Gallery of Art, Washington, D.C.

11.37. Harpies, detail from Maximilian's *Triumphal Arch*, 1515. Woodcut. Photo: Courtesy of the National Gallery of Art, Washington, D.C.

11.38. Attributed to Dürer. *Two Stymphalian Birds*, 1510. Pen and ink with watercolor. Kestner-Museum, Hannover.

11.39. Unicorn, detail from *Horse's Armor*, 1517. Pen and ink. Pierpont Morgan Library, New York. Photo: Gab. Fotographica, Florence.

11.40. Martin Schongauer. *Woman Seated Holding a Shield with a Unicorn*, 1480–90. Engraving. National Gallery of Art, Washington, D.C. Rosenwald Collection. Photo: Courtesy of the National Gallery of Art.

11.41. Unicorns in great archway of Solomon's temple, detail from *The Marriage of the Virgin*, ca. 1504–5. Woodcut. National Gallery of Art, Washington, D.C. Gift of W. G. Russell Allen. Photo: Courtesy of the National Gallery of Art.

11.42. Unicorns, detail from Maximilian's *Book of Hours*, 1515. Pen and ink. Staatsbibliothek, Munich.

11.43. Unicorn, detail from *Rape on a Unicorn*, 1516. Etching. National Gallery of Art, Washington, D.C. Rosenwald Collection. Photo: Courtesy of the National Gallery of Art.

11.44. Workshop of Michael Wolgemut. "The Berkeley Witch," from the *Nuremberg Chronicles*, 1493. Woodcut. Library of Congress, Washington, D.C. Rare Book Division, Rosenwald Collection.

11.45. Vulpanser, from Horus Apollo, *The Hieroglyphica*, ca. 1513 (cod. 3255). Pen and ink with watercolor. Nationalbibliothek, Vienna.

11.46. *Wild Man with Shield*, no date. Pen and ink. Staatliche Kunstsammlungen, Dresden.

Chapter Twelve: Beastly Temptations, Monstrous Sins

12.1. Master of Allegory. *Composite Medieval Monster*, midfourteenth century. Line drawing. Austrian National Library, Vienna.

12.2. Master E.S. *Five Beasts*, midfifteenth century. Engraving.

12.3. Martin Schongauer. *The Tribulations of Saint Anthony*, ca. 1470–75. Engraving. National Gallery of Art, Washington, D.C. Rosenwald Collection. Photo: Courtesy of the National Gallery of Art.

12.4. Devil, detail from *Der Ritter vom Turn*, Basel, 1493; also known as Chevalier de la Tour Landry, *Examples of the Fear of God and of Respectability*. Woodcut. Library of Congress, Washington, D.C. Rare Book Division, Rosenwald Collection. Photo: Hugh Talman.

12.5. Satan, from Maximilian's *Book of Hours*, 1515. Pen and ink. Staatsbibliothek, Munich.

12.6. *Four Naked Women*, 1497. Engraving. National Gallery of Art, Washington, D.C. Rosenwald Collection. Photo: Courtesy of the National Gallery of Art.

12.7. *The Dream of the Doctor (Temptation of the Idler)*, 1498–99. Engraving. National Gallery of Art, Washington, D.C. Rosenwald Collection. Photo: Courtesy of the National Gallery of Art.

12.8. *The Mass Celebrated by Angels*, 1510. Pen and watercolor over silverpoint. Musée des Beaux-Arts, Rennes.

12.9. Devil, detail from *Knight, Death and Devil*, 1513. Engraving. National Gallery of Art, Washington, D.C. Gift of W. G. Russell Allen. Photo: Courtesy of the National Gallery of Art.

12.10. *A Coat of Arms with Man by Stove*, ca. 1493. Pen and ink. Museum Boymans–van Beuningen, Rotterdam. Photo: Jannes Linders.

12.11. Head of a bird, detail from *Christ in Limbo*, from *The Large Passion*, 1510. Woodcut. National Gallery of Art, Washington, D.C. Rosenwald Collection. Photo: Courtesy of the National Gallery of Art.

12.12. Detail, *Bird with Dragonfly*, 1513. Pen and ink. Szépmüvészeti Múzeum, Budapest.

12.13. Workshop of Michael Wolgemut. Manbeasts, from the *Nuremberg Chronicles*, 1493. Woodcut. Library of Congress, Washington, D.C. Rare Book Division, Rosenwald Collection.

12.14. Conrad von Megenberg. Hybrid creatures, from *Bidpai: The Book of Nature*, Ulm, 1483. Woodcut. Library of Congress, Washington, D.C. Rare Book Division, Rosenwald Collection.

12.15. *The Monstrous Pig of Landser*, 1496. Engraving. National Gallery of Art, Washington, D.C. Rosenwald Collection. Photo: Courtesy of the National Gallery of Art.

12.16. Antichrist as a boy perched on rainbow, from Sebastian Brant, *The Ship of Fools*, Basel, 1494. Woodcut. Library of Congress, Washington, D.C. Rare Book Division, Rosenwald Collection. Photo: Hugh Talman.

12.17. Multiheaded dragon, detail from illustration from *Gruninger Bible*, Anton Koberger, Strasbourg, 1485.

12.18. *Avenging Angels*, from *The Apocalypse*, ca. 1496–98. Woodcut. National Gallery of Art, Washington, D.C. Ailsa Mellon Bruce Fund. Photo: Courtesy of the National Gallery of Art.

12.19. *The Battle of the Archangel Michael with the Dragon*, from *The Apocalypse*, 1498. Woodcut. Albertina, Vienna.

12.20. Dragon, from *Ecce Homo*, from *The Large Passion*, 1498–99. Woodcut. National Gallery of Art, Washington, D.C. Rosenwald Collection. Photo: Courtesy of the National Gallery of Art.

12.21. *The Apocalyptic Woman*, from *The Apocalypse*, ca. 1496–98. Woodcut. Metropolitan Museum of Modern Art, New York. Gift of Junius S. Morgan.

12.22. *The Beast with Two Horns Like a Lamb*, from *The Apocalypse*, 1496–98. Woodcut. National Gallery of Art, Washington, D.C. Gift of W. G. Russell Allen. Photo: Courtesy of the National Gallery of Art.

12.23. Dürer's workshop. Devil, detail from *The Fall of Simon Magus*, 1512. Pen and ink. Staatliche Galerie, Dessau.

12.24. Unknown artist. Dragon and beast, woodcut from *Quentell Bible*, Anton Koberger, Cologne, 1480.

12.25. Unknown artist. Woodcut from *Gruninger Bible*, Anton Koberger, Strasbourg, 1485.

12.26. Hans Hoffman after Dürer. *Monstrous Stag Head*, 1589. Pen and watercolor. Staatliche Museen, Berlin. Photo: Jörg P. Anders, Berlin.

12.27. *Stag Head with Monstrous Antlers*, no date. Drawing. Staatliche Museen, Berlin. Photo: Jörg P. Anders, Berlin.

12.28. Detail from *The Babylonian Whore*, from *The Apocalypse*, ca. 1496–98. Woodcut. National Gallery of Art, Washington, D.C. Gift of Philip Hofer. Photo: Courtesy of the National Gallery of Art.

12.29. Satan, detail from *The Angel with the Key to the Bottomless Pit*, from *The Apocalypse*, ca. 1496–98. Woodcut. National Gallery of Art, Washington, D.C. Rosenwald Collection. Photo: Courtesy of the National Gallery of Art.

12.30. Detail from *Christ in Limbo*, from *The Large Passion*, 1510. Woodcut. National Gallery of Art, Washington, D.C. Rosenwald Collection. Photo: Courtesy of the National Gallery of Art.

12.31. Satan, detail from Maximilian's *Triumphal Arch*, 1515. Woodcut. Photo: Courtesy of the National Gallery of Art, Washington, D.C.

12.32. Dragon, detail from Maximilian's *Triumphal Arch*, 1515. Woodcut. Photo: Courtesy of the National Gallery of Art, Washington, D.C.

12.33. Dragons, detail from Maximilian's *Triumphal Arch*, 1515. Woodcut. Photo: Courtesy of the National Gallery of Art, Washington, D.C.

12.34. Dragons, detail from Maximilian's *Triumphal Arch*, 1515. Woodcut. Staatliche Museen, Berlin. Photo: Jörg P. Anders, Berlin.

12.35. *Flying Dragon Chandelier*, ca. 1513. Design for chandelier. Pen and watercolor. Wessenberg Gemäldegalerie, Konstanz.

12.36. Willibald Stoss. Flying dragon chandelier, 1522. Gilded lindenwood and reindeer antlers. Germanisches Nationalmuseum, Nuremberg.

12.37. Dragon fountain, 1527. Design for table fountain. Pen and ink with wash. Kunsthistorisches Museum, Vienna.

12.38. Dragon ring for Maximilian, ca. 1517. Pen and ink. Staatliche Museen, Berlin. Photo: Jörg P. Anders, Berlin.

Bibliography

Albert & Thomas: Selected Writings. Trans. and ed. Simon Tugwell. New York: Paulist Press, 1988.

Albert the Great. *Man & the Beasts: De Animalibus* (Books 22–26). Trans. and introduction by James J. Scanlan. Binghamton: Medieval & Renaissance, 1987.

Ambrose, Saint. *Commentary on the Sixth Day of Creation.* Fathers of the Church, vol. 42. Trans. John J. Savage, New York. 1961.

———. *Letters.* Trans. Sister Marie Melchior Beyenka. Fathers of the Church, vol. 44. Washington, D.C., 1954.

———. *Seven Exegetical Works.* Trans. Michael P. McHugh. Fathers of the Church, vol. 65. Washington, D.C., 1971.

———. *Theological and Dogmatic Works.* Trans. Ray J. Deferarri. Fathers of the Church, vol. 44. Washington, D.C., 1954.

Anzelewsky, Fedja. "A propos de la topographie du parc de Bruxelles et du quai de L'Escaut à Anvers de Dürer." *Bulletin des Musées Royaux des Beaux-Arts* 6 (1957): 87–107.

———. *Albrecht Dürer, das malerische Werk.* Berlin: Deutscher Verlag für Kunstwissenschaft, 1971.

———. *Dürer-Studien: Untersuchungen zu den ikonographischen und geistesgeschichtlichen Grundlagen seiner Werke zwischen den beiden Italienreisen.* Berlin: Deutscher Verlag für Kunstwissenschaft, 1983.

Aratus. "The Starry Sphere." In *The Phaenomena.* Trans. G. R. Mair. Cambridge: Harvard University Press, 1955.

Behaim, Canon. Horoscope of Dürer, sent to Willibald Pirckheimer, 1507. Nuremberg Stadtbibliothek, Pirckheimer-Papiere, ad. 375.8.

The Book of Hours of Maximilian I, Decorated by Albrecht Dürer ... and other Artists, Printed in 1513 by Johannes Schoensberger. Ed. Walter L. Strauss. New York, 1974.

Bulfinch, Thomas. *Bulfinch's Mythology: The Greek and Roman Fables Illustrated.* Compiled by Bryan Holme. Introduction by Joseph Campbell. New York: Viking Press, 1979.

Columbus, Christopher. *The Columbus Letter of 1473.* Ann Arbor: University of Michigan Press, 1952.

———. *The Journal of Christopher Columbus During His First Voyage (1492–1493).* London, 1893.

Conway, William Martin. *The Writings of Albrecht Dürer.* New York: Philosophical Library, 1958.

Cortés, Hernán. *Praellara Ferdinadi Cortesii de novo maris hispania narratio sacratissimo.* Nuremberg: Frederic Peypus, 1524.

David, Harry. "Die Darstellung des Löwen bei Albrecht Dürer. Zur Geschichte der deutschen Tiermalerei." Ph.D. diss., Halle-Wittenberg, 1909.

———. "Dürers Tierdarstellung." *Sitzungsberichte der kunstgeschichtliche Gesellschaft* 7 (1910): 37–40.

———. "Zum Problem der Dürerschen Pferdekonstruktion." *Repertorium für Kunstwissenschaft* 33 (1910): 310–17.

———. "Zwei neue Dürer-Zeichnungen." *Sitzungsberichte der kunstgeschichtliche Gesellschaft* 7 (1911): 83–86.

Dürer, Albrecht. *Diary of His Journey to the Netherlands, 1520–1521*. Greenwich, Conn., 1971.

———. *The Writings of Albrecht Dürer*. Trans. and ed. Martin Conway. New York, 1958.

Ehlers, Ernst. "Bemerkungen zu den Tierabbildungen im Gebetbuche des Kaisers Maximilian." *Jahrbuch der königlich Preussischen Kunstsammlungen* 38 (1917): 151–76.

Eisler, Colin. "Masses of Monkeys." *Source* 3 (1983) 1: 4–9.

Fisher, Jonathan. *Scripture Animals: A Natural History of the Living Creatures Named in the Bible*. New York, 1971.

Germanisches Nationalmuseum Nürnberg. *Albrecht Dürer, 1471–1971* (Catalog of an exhibition held at the Germanisches Nationalmuseum, 21 May–1 August 1971). Munich: Prestel, 1971.

Giehlow, Karl. *Kaiser Maximilian I Gebetbuch und Zeichnungen von Albrecht Dürer und anderen Künstlern*. Munich: Facsimile, 1907.

Gothic and Renaissance Art in Nuremberg, 1300–1550. Exhibition catalogue. New York: Metropolitan Museum of Art, 1986.

Grote, Ludwig. "Dürer-Studien. 2. Eryngium und Eule im Werke Albrecht Dürers." *Zeitschrift des deutschen Vereins für Kunstwissenschaft* 19 (1965): 156–69.

John of Hildesheim. *The Story of the Three Kings*. Trans. Margaret B. Freeman. New York, 1955.

Horapollo. *The Hieroglyphics of Horapollo*. Trans. George Boas (Bollingen Series 23). New York: Pantheon Books, 1950.

Hutchison, Jane. *Albrecht Dürer: A Biography*. Princeton: Princeton University Press, 1990.

Jerome, Saint. *Dogmatic and Polemical Works*. Trans. John N. Hritzu. Fathers of the Church, vol. 53. Washington, D.C., 1965.

———. *Homilies*. Trans. Sister Marie Liguordi Ewald. Fathers of the Church, vols. 48, 49. Washington, D.C., 1964, 1966.

Killerman, Sebastian. "Albrecht Dürers Rasen- und Blumenstücke." *Naturwissenschaftliche Wochenschrift*, n.s. 131 (1906): 481–86.

———. *Albrecht Dürers Pflanzen- und Tierzeichnungen und ihre Bedeutung für die Naturgeschichte* (Studien zur deutschen Kunstgeschichte 119). Strasbourg: J. H. E. Heitz, 1910.

———. "Albrecht Dürer als Naturfreund." *Der A.A.R. Illustrierte Monatsschrift für das gesamte katholische Geistesleben der Gegenwart* 1 (1910/11): 751–65.

———. "Feldhase und Hermelin. Ein neues Dürerbild?" *Natur und Kultur* 14 (1916/17): 176–78.

———. *Albrecht Dürers Werk. Eine natur- und kulturgeschichtliche Untersuchung*. Regensburg: Druck und Kommission bei der vormals Manz'seen Buchdr. und Verlag, 1953.

Klingender, Francis. *Animals in Art and Thought*. London: Routledge and Kegan Paul, 1971.

Koreny, Fritz. "A Hare among Plants by Hans Hoffman." *Art at Auction* (1983/84): 18–23.

———. *Albrecht Dürer und die Tier- und Pflanzenstudien der Renaissance* (Catalog of an exhibition held at the Graphische Sammlung Albertina, 18 April–30 June, 1985) Munich: Prestel-Verlag, 1985.

Kurthen, Joseph. "Zum Problem der Dürerschen Pferdenkonstruktion. Ein Beitrag zur Dürer- und Behamforschung." *Repertorium für Kunstwissenschaft* 44 (1924): 77–106.

Lenz, Eduard von. "Albrecht Dürers Jagdtierzeichnungen." *Deutsche Jäger-Zeitung* 75 (1920) no. 16/17: 133–37; no. 18: 257–59.

Meder, Joseph. "Die grüne Passion und die Tier- und Pflanzenstudien Albrecht Dürers in der Albertina." *Repertorium für Kunstwissenschaft* 30 (1907): 173–82.

———. *Dürer-Katalog, ein Handbuch über Albrecht Dürers Stiche, Radierungen, Holzschnitte, deren Zustände, Ausgaben und Wasserzeichen*. Vienna: Gilhofer & Ranschburg, 1932.

Mende, Matthias. *Dürer-Bibliographie. Zur 500. Wiederkehr d. Geburtstages von Albrecht Dürer*. Wiesbaden: Harrassowitz, 1971.

Mielke, Georg. "Das Naturstudium Albrecht Dürers. Das Verhältnis des Künstlers zum Object. Eine entwicklungsgeschichtliche Untersuchung." Ph.D. diss., Humboldt University, 1956.

Müller, Johannes. [Regiomontanus]. *Epytoma in Almagestum Ptolemaei*. Venice: Johannes Hamann, 1496.

National Gallery of Art. *Dürer in America: His Graphic Work*. Ed. Charles W. Talbot. (Catalog of an exhibition held at the National Gallery of Art, 25 April–6 June 1971) Washington, D.C.: National Gallery of Art, 1971.

Neubert, Eberhard. *Albrecht Dürer, Pflanzen und Tiere. Mit einer Einleitung von Georg J. Reimann*. Leipzig: E. A. Seemann, 1960.

Nissen, Claus. *Die zoologischen Buchillustration, ihre Bibliographie und Geschichte*. 2 vols. Stuttgart: A. Hiersemann, 1966, 1971.

Panofsky, Erwin. *Albrecht Dürer*. 2 vols. Princeton: Princeton University Press, 1945.

Pirckheimer, Willibald. Letter on Agnes Dürer to Johann Tschertte, 1530. Nuremberg Stadtbibliothek, Pirckheimer-Papiere 396.

Polo, Marco. *Buch des Edlens Ritters und Landfahrers Marco Polo*. Nuremberg: Friedrich Creussner, 1477.

Pompen, Aurelius. *The English Versions of the Ship of Fools: A Contribution to the History of the Early French Renaissance in England*. New York: Octagon Books, 1967.

Richter, Jean Paul. *The Notebooks of Leonardo da Vinci*. 2 vols. 1883. Reprint. New York: Dover, 1970.

Rowland, Beryl. *Animals with Human Faces: A Guide to Animal Symbolism*. Knoxville: University of Tennessee Press, 1973.

Rupprich, Hans, ed. *Dürer: Schriftlicher Nachlass*. 3 vols. Berlin: 1956.

Smith, Jeffrey C. *Nuremberg: A Renaissance City, 1500–1618*. Austin: University of Texas Press, 1983.

Strauss, Walter L. *Albrecht Dürer, Woodcuts and Woodblocks*. New York: Abaris Books, 1980.

———. *The Complete Drawings of Albrecht Dürer*. 6 vols. New York: Abaris Books, 1974.

Strauss, Walter L., ed. *Albrecht Dürer: The Painter's Manual*. New York: Abaris Books, 1977.

———. *The Book of Hours of the Emperor Maximilian the First*. New York: Abaris Books, 1974.

———. *Intaglio Prints of Albrecht Dürer: Engravings, Etchings, and Drypoints*. New York: Abaris Books, 1975.

Strieder, Peter. *Albrecht Dürer, Paintings, Prints, Drawings*. Rev. ed. New York: Abaris Books, 1982.

Tietze, Hans. "Dürerliteratur und Dürerprobleme im Jubiläumsjahr." *Wiener Jahrbuch für Kunstgeschichte* 7 (1930): 232–59.

———. *Dürer als Zeichner und Aquarellist*. Vienna: A. Schroll, 1951.

Tietze, Hans, and Erika Tietze-Conrat. "Neue Beitrage zur Dürer-Forschung." *Jahrbuch der Kunsthistorischen Sammlungen in Wien*, n.s. 6 (1932): 115–39.

———. *Kritisches Verzeichnis der Werke Albrecht Dürers*. Basel: Holbein-Verlag, 1937–38.

Veth, Jan, and Samuel Muller. *Albrecht Dürers niederländische Reise, I. Bd. Die Urkunden über die Reise, II. Bd. Geschichte der Reise*. Berlin: C. Grote, 1918.

Volkmann, Ludwig. *Bilder Schrifte der Renaissance*. Leipzig: 1923.

Voragine, Jacobus de. *The Golden Legend of Jacobus de Voragine*. Trans. Granger Ryan and Helmut Ripperger. New York: Arno Press, 1969.

Waetzoldt, Wilhelm. *Dürer und seine Zeit*. Vienna: Phaidon-Verlag, 1935.

Winkler, Friedrich. *Albrecht Dürer, Pflanzen und Tiere. Mit einer Einleitung von F. Winkler*. Berlin: Ganymed Verlag, 1949.

Woodward, William Harrison. *Desiderius Erasmus Concerning the Aim and Method of Education*. New York: Columbia University Press, 1964.

Wustmann, Rudolf. "Von einigen Tieren und Pflanzen bei Dürer." *Zeitschrift für bildende Kunst*, n.s. 22 (1911): 109–16.

Wuttke, Dieter. "Dürer und Celtis: Von der Bedeutung des Jahres 1500 für den deutschen Humanismus: Jahrhundertfeier als symbolische Form." *Journal of Medieval and Renaissance Studies* 10 (1980): 73ff.

Index

Aachen, 200, 206, 247, 258
Abduction on Horseback, 245
Adam and Eve of 1504, 22, 31, 48–49, 52, 102, 107, 112, 134, 177, 201, 205, 268, 324
Adoration of the Magi, 42, 44–45, 88, 123, 127, 130, 135, 136, 137, 191, 228, 264
Aelian, 74, 312
Aesop, 27, 108, 137, 324
Africa, 4, 20, 255–56, 266
Agostino Veneziano, 328
Alberti, Leon Battista, 8, 168
Albertina Passion, 18
Albertus Magnus, 6–9, 32, 58, 63, 114, 145, 175, 200–201, 309
Aldovrandi, Ulisse, 333
Aldus Manutius, 19, 21, 46, 134, 189, 288
Alfonso V of Aragon, 63, 77
Altdorfer, 127
Ambrose (Saint), 57, 72, 88, 126, 139
America, 4, 257–59, 264–65, 312–13
Angel Appearing to Joachim, 47, 214, 329
Animals' Dialogues Moralized, 269, 285, 295
Antwerp: copied Dürer work, 326; Dürer's death, 125–26, 249; Dürer's travel and work, 24, 156, 200, 249, 269; natural wonders, acquisitions, 4, 24–26, 28, 107, 124, 137, 175, 262, 268, 313; New World artifacts, 24, 258–59
Apelles, 22, 31, 130, 244
Apocalypse, 21, 66, 68, 78–79, 153, 198, 202, 228–30, 234, 302, 304, 310–18, 321, 327
Apollo and Diana, 102
Aratus, 153, 253
Arch. See *Triumphal Arch*
Aristotle, 6, 8, 39, 46, 164–65, 187, 236, 288, 310
Aristotle and Theophrastus, 100
Augustus II the Strong, 273

Baboon, 262
Baldung, Hans, 55
Bannissis, 153
Barbara of Hohenzollern, 19

Bartholomew the Englishman, 8, 63, 309
Basel, 15, 16, 33, 143, 192, 254, 308
Battle of the Sea Gods, 280, 292
Bayer, Herbert, 333–34
Behaim, Lorenz, 254, 305, 323
Bellini, Gentile, 227
Bellini, Giovanni, 20, 48, 109, 140, 148, 226
Bellini, Jacopo, 140, 226, 243, 280
Berchorius, 153
Bernard of Clairvaux, 302
Berri, duc de, 170–71
Bestiary of Love, 295
Bidpai: The Book of Nature, 6, 62–63, 120, 130, 133, 309
Blue Roller, 71, 112, 140, 331–32
Bologna, 21
Book of Hours of Maximilian: 43, 328, 330; birds, 72, 74–75, 77–78, 79, 81, 86, 87, 89, 259; classical allusions, 278, 283, 287, 296; dogs, 174, 177–79; exotic animals, 256–57, 259, 261–66, 270; farm life, 195, 199, 201, 206, 258; horses, 232–34; infernal creatures, 303, 307, 321; insects and reptiles, 127, 129, 133, 135–36, 137; lions, 156, 158; wildlife, 97, 98, 100, 103, 107, 108, 112
Book of Wisdom, 260
Bora, Katharina von, 197
Borgia, Cesare, 305
Bosch, 305
Both Sides of a Bittern Wing, 71
Brant, Sebastian, 16–18, 192, 254, 310; portrait, 16. See also *Ship of Fools*
Breu, Jorg, 281
Breydenbach, Bernhard von, 257
Brueghel, Jan, 44, 330, 332
Brussels, 322; Charles V's zoo, 24, 102, 113, 161, 258, 330; imperial processions, 247; natural wonders, acquisitions, 124, 200, 262
Buch, Franz, 116
Buncho, Tani, 274
Burgkmair, Hans, 257, 266, 271

Campagnola, Giulio, 328
Caravaggio, 240, 328
Catherine de Medici, 271
Cavalcade, 12, 93, 223–24, 225
Celestial Map: The Northern Celestial Hemisphere, 78, 81, 91, 133, 153, 249–50
Celestial Map: The Southern Celestial Hemisphere, 209
Celtes, Conrad, 8, 42, 89, 166, 168, 170, 277, 281, 288
Centaur Carrying Off Woman, 283, 285
Centaur Family, 283, 287, 293
Chancelaria, 257
Charles V: as Dürer's patron, 24, 156, 247, 330; as emperor, 24, 26, 159, 247, 258; zoo, 24, 102, 161, 258, 264
Charles VIII, 236
Chelidonius, 47
Chevalier de La Tour Landry, 16, 82–83, 130–31, 181, 223, 302–3, 304
Christ among the Doctors, 171–72, 261
Christ before Caiaphas, 174
Christ Carrying the Cross, 171, 216, 264
Christ Expelling the Moneylenders from the Temple, 213
Christ in Limbo, 319, 333
Christian II of Denmark, 156, 247
Cima de Conegliano, 130
Circumcision, 47
Closed Garden of Mary's Rosary, 173
Coat of Arms with a Skull, 69–71, 92
Cologne, 206, 266
Cologne Bible, 228, 311–12, 315
Columbus, Christopher, 3, 6, 254, 255, 258, 309
Copernicus, 251
Cortés, Hernán, 258, 259
Cranach, Lucas, 97, 103, 320–21
Crescenzi, Pietro de, 185
Cyriaco d'Ancona, 287

David, Gerard, 24
Dead Blue Roller, 331–32
Dead Heron, 69, 80, 116
Dead Partridge, 63
Defense of Astrology, 254
Donatello, 19, 132, 139, 226, 243
Dream of the Doctor, 303
Dürer, Agnes Frey, 5–6, 24, 93, 94, 103, 107, 124, 125, 213, 268
Dürer, Albrecht (father): 3, 5, 24; goldsmith craft, 3, 9–10, 12, 33, 93, 94, 251; portrait, coat of arms, 61, 213
Dürer, Albrecht: coat of arms, 91; heraldry, 153–55; horoscope, 254; self-portraits, 22, 28, 45, 117, 159, 166, 169–70, 278; techniques, 16, 21–22, 28, 102–3, 107, 110, 133, 164, 243
Dürer, Barbara, 3, 176, 211
Dürer, Endres, 206, 234, 291

Ecce Homo, 313
Eligius, 10–11
Elk, 107
Entry into Jerusalem, 199
Erasmus, 5, 26–27, 189, 240, 264, 281, 324; portrait, 26
Este, Lionello d', 8, 140
Eusebius, 148
Eyck, Hubert van, 24
Eyck, Jan van, 15, 24, 69, 144, 159, 221, 310, 333

Facetiae, 293
Falconer, 237
Fall of Man, 52–53, 98, 100, 103
Fall of Simon Magus, 315
Family Journal, 185
Faust, Johann, 323
Feast of the Rosegarlands, 130, 333
Felix (lute player), 124
Ferdinand I, 259
Ferdinand, Valentine, 269
Ferrara, 225
Ficino, Marsilio, 31
Fishing Code, 124
Flagellation, 171
Flight into Egypt, 47, 132–33, 190, 198–99
Florence, 21, 94, 311, 333
Fortuna, 204, 310
Four Avenging Angels of the Euphrates, 312
Four Books of Love, 277
Four Horsemen of the Apocalypse, 21, 228–30, 311, 312
Four Naked Women, 303
Francis of Assisi, 57–58
Francis of Retz, 33, 43, 133–34
François I, 272
Frankfurt, 266
Frederick II, 57, 58
Frederick III, 3
Frederick the Wise of Saxony, 28, 64, 96–97, 107, 168, 171–72, 198–99, 228, 229, 261, 278, 295
Frey, Agnes. See Dürer, Agnes
Frey, Hans, 94
Fugger family, 249, 290, 311

Galeazzo de San Severino, 236
Galle, Phillip, 272
Gama, Vasco da, 255
Garden of Love, 34–35
Geiler von Kaisersberg, Johannes, 18, 121, 181
Gerson, Jean, 17, 170, 179–81
Gessner, Conrad, 113, 329, 333
G. H., 329
Ghent, 159, 161, 221
Ghiberti, Lorenzo, 95
Ghiberti, Vittorio, 95, 119
Giovanni d'Andrea, 142
Giovanni de' Grassi, 20
Giusto de' Menabuoi, 317
Glorification of the Virgin, 37, 87, 95, 109, 213
Golden Legend, 191
Gossaert, Jan, 329
Granvella (Cardinal), 330
Great Fortune, 68
Great Piece of Turf, 31
Grien, Baldung, 201
Groland, Leonard, 206

Hainvogel, 252
Hare, 21, 75, 103, 109, 110, 112, 205, 331, 332
Head of a Red Deer, 18, 94, 102
Head of a Roebuck, 103
Heller, Katherine, 133
Henri II, 271
Hercules, 87, 203, 278–80
Hercules Conquering Cacus, 66, 150–51

Hercules Shooting the Stymphalian Birds, 27–28, 97, 132, 278, 294
Herman of Nuremberg and Company, 225–26
Herodotus, 288
Hesiod, 133
Hieroglypyhica (Horus Apollo), 24, 325; birds, 72, 73–74, 75, 79, 80, 85–86, 87, 88; classical allusions, 283, 284, 289, 298; dogs, 165, 175; exotic animals, 262, 264, 267; farm animals, 199, 201, 206, 209; insects, fish, and reptiles, 126, 127, 130, 131, 134, 135, 137; lions, 152, 153; wildlife, 100, 112
Hoefnagel, Georg, 137, 333
Hoffman, Hans, 110, 114, 136, 161, 316, 330–31
Holper family, 211
Holtzel, 262
Holy Family with the Mayfly, 18, 34, 36, 47, 75, 130
Holy Famliy with the Three Hares, 37, 95, 109
Hondius, Hendrick, 271
"Honey Thief," 126–27
Horace, 302
Hortus sanitatis, 266
Horus Apollo. See *Hieroglyphica*
Hours. See *Book of Hours* of Maximilian
Housebook Master, 257, 296
Hrabanus Maurus, 84, 164
Hroswitha of Gandersheim, 323–24
Hutchison, Jane C., 8, 325
Hutten, Ulrich von, 242
Hypnerotomachia Poliphili, 21, 281

Ill-Assorted Couple, 224, 231–32
Imhoff family, 114, 330, 331
India, 4, 125, 255–56, 266, 269
Italy: Dürer's travels, 19–24, 61, 71–72, 93, 95, 123–24, 163, 166–67, 170, 203, 220–22, 225–27, 317, 322, 327, 333; Pirckheimer education, travels, 4–5, 187

Jacopo de' Barbari, 63–64, 75, 239, 280, 287, 290
Jerome (Saint): 27, 32, 139, 140, 211; as Dürer subject, 15, 18, 81, 142–49
Joachim and Anna at the Golden Gate, 66
Joachim's Offering Rejected, 75, 212
Job altarpiece, 219–20, 262
Joesten, Jan, 274, 333
John of Hildesheim, 42

King Death Riding a Horse, 47, 85, 176–77, 231
Kirchner, 273
Knight, Death and Devil, 14, 22, 24, 132, 144, 176, 239, 240–45, 305, 318, 327, 328
Knight of Turn. See Chevalier de La Tour Landry
Knight on Horseback and the Lansquenet, 171, 231
Koberger, Anton, 3–4, 126, 143, 153, 293, 298, 311–12, 325
Kolb, Anton, 64
Koreny, Fritz, 81, 114
Kulmbach, Hans von, 100, 109

Ladenspelder, 328
Lapwing, 81
Large Horse, 232, 239–40, 328
Large Passion series, 171, 318
Last Supper, 216
Leo X (Pope), 272, 275

Leonardo da Vinci: 5, 14, 21, 272, 310; birds, 64, 69; farm animals, 186–87; horses, 8, 64, 221, 230, 236–39, 243, 245, 246, 298; insects, 123; mathematics, 28, 29; techniques, 112, 166–67
Leopold Wilhelm, 330
Letters of Saint Jerome, 15
Life of the Virgin series, 27, 47, 98, 173, 191, 212, 329
Lisbon, 4, 257, 269
Lobster, 133
Locher, Jacob, 168
Lombardy, 225
Lowlands. See Netherlands
Lucas van Leyden, 149, 328
Lucian, 287, 320
Luther, Martin: 3, 27, 242; on animals, 88, 125, 201, 261; astrology and eschatology, 254, 310–11, 316, 324; Dürer's religious ideas, 45, 55, 100, 214–15, 321–25; German social conditions, 196–97
Lynx, 113

Madonna and Child with Monkey, 37, 86, 261, 327–28
Madonna of 1503, 47
Madonna of the Iris, 127
Madonna with Eight Saints and Musical Angels, 275
Madonna with Siskin, 86
Malines, 259
"Mandeville, Sir John," 308–10
Manfred, 58
Manilius, 253
Mantegna, Andrea, 19–20, 28, 109, 148, 231, 280, 291–92, 296, 303, 311, 317, 319, 328
Mantua, 148, 225
Manuel (king of Portugal), 257
Margaret of Austria, 24–26, 259
Marriage of the Virgin, 47, 75, 85, 296
Martial, 20–21, 324
Martyrdom of Saint Catherine, 234–35
Martyrdom of Saint John, 171
Martyrdom of the Ten Thousand, 66, 168, 170
Mary of Burgundy, 14, 33, 119
Mass of Saint Gregory, 206
Master E. S., 12, 151, 302
Master of Allegory, 299
Master of Mary of Burgundy, 119
Master of the Berlin Passion, 93
Master of the Playing Cards, 58–59, 93, 148
Master Prints, 24, 175, 310
Mauritius, 265
Maximilian: armor, 108, 116, 129, 292, 296; classical allusions, 22, 28, 130, 150, 278, 288; courtiers and patronage, 5, 14, 64, 89, 155–56, 236, 241, 251–52, 254, 257; as Dürer's patron, 24, 85, 281, 293; interest in animals, 58, 100, 124, 266, 325; life and character, 100, 107, 158, 159, 195, 294, 316; portrait, 22, 130, 288. See also *Book of Hours*; *Triumphal Arch*
Maximilian of Bavaria, 331
Maximus, 253
Meckenem, Israhel van, 93, 151, 172
Medici, Alessandro de, 272
Medici family, 5, 271–72, 311, 312–13
Megenberg, Conrad von, 6, 62–63, 114, 130, 309
Melanchthon, 29, 323
Melencolia I, 22, 24, 64–65, 98, 145, 177–79, 324
Memling, Hans, 61

Michelangelo, 87, 202, 246, 303
Michellino da Besozzo, 20
Milan, 236
Mirror of Human Salvation, 192
Modest Woodcuts, 66
Mohammed II, 226
Moluccan Isles, 271
Monstrous Pig of Landser, 270, 310
Montezuma, 258–59
Müller, Johann, 251–52

Nativity, 42, 88, 212
Negroponte, Antonio, 33
Nemesis, 69, 82, 204, 310
Netherlands: Dürer's travel, 4, 15, 21, 24, 26, 29, 93, 124–25, 149, 175, 183, 222, 259–60, 275, 329; economic conditions, 216
Nicolas of Cusa, 98
Nourishment for Painters' Apprentices, 239, 329
Nuremberg: artistic, intellectual life, 14–15, 64, 120, 265, 272, 293, 321, 329; coat of arms, 294; coin, 78; economic and social conditions, 3, 22, 61, 64, 116–17, 251; expulsion of Jews, 325; natural history, 42–43, 88, 96, 103, 133, 136; in Reformation, 27, 55
Nuremberg Chronicles, 15, 120, 245, 298, 306–7, 319

Oberhuber, Konrad, 331
Old Woman with Young Man, 198
Our Lady of the Animals, 13, 22, 31–55, 85, 88, 89, 102, 108, 126, 127, 130, 131, 136, 172–73, 202, 211, 261, 264, 268, 330, 336
Ovid, 166, 188, 249, 277, 280
Owl, 85

Pacioli, Luca, 236
Padua, 4–5, 7, 19, 20, 21, 123, 124, 131, 137, 139, 187, 226, 243, 290, 307, 314, 317, 333
Panofsky, Erwin, 230
Parrhasius, 166
Parrot, 39, 268, 332
Passion cycles, 27, 52–53, 98, 103, 171, 179, 199, 319
Paumgartner Altar, 211
Pavia, 4–5, 236
Peasants' Defeat, 197, 206, 216
Philip II, 330
Philostratus, 293
Physiologus, 74, 84, 131
Piero della Francesca, 28
Piero di Cosimo, 20
Pietro da Birago, Giovanni, 294
Pinder, 173
Pirckheimer, Caritas, 29, 305
Pirckheimer, Crescentia Rieter, 189, 290, 294, 296
Pirckheimer, Willibald: 12, 29, 96, 134–35, 223, 254, 257, 259, 305, 319; aid to Dürer's education and career, 4–6, 24, 109, 187, 236, 277, 333; coat of arms, 288, 290; as collector of natural wonders, 24, 72, 103–7, 200, 268, 293, 294, 296, 316; Dürer book purchases, illustrations, 46, 100, 112, 189, 266–67, 281, 287; Dürer letter to, 167; and expulsion of Jews, 325; heirs, 114, 331; marriage portraits, 19, 189, 201, 290
Pisanello, Vittore, 5, 20, 63, 77, 140, 225, 280
Plato, 26, 29, 219, 239
Pleasures of the World, 35–36

Pliny, 7, 26, 46, 69, 81, 114, 121–23, 130, 139, 143–45, 149, 164, 166, 264, 266, 267, 284, 287, 293, 310, 312
Plutarch, 266
Poggio Bracciolini, 293
Poliziano, Angelo, 69, 187, 272, 280
Pollaiuolo, Antonio, 243, 245, 278, 298, 311
Polo, Marco, 3, 255–56, 269, 309
Porta, Giacomo della, 272
Portugal, 257
Praxiteles, 220
Praying Hands, 109
Presentation in the Temple, 47, 75
Prodigal Son, 18, 88, 145, 149, 187, 191–93, 201, 206, 210, 310, 327
Ptolemy, 251, 253, 266

Queen Mary Psalter, 32

Raimondi, Marcantonio, 327–28
Rape of Europa, 21, 187, 204–5, 280, 285, 296
Rape on a Unicorn, 28, 245, 283, 296–98
Raphael, 194, 322, 327, 328, 329
Ravensburg, Lazarus von, 125
Rembrandt, 149, 194, 260, 318, 332–33
Rhinoceros, 27, 264, 269–73, 310
Rieter. See Pirckheimer, Crescentia
Rodrigo, 24, 258, 268
Roe Deer, 103
Roggendorf family, 155–56, 200, 268
Rome, 220, 281, 322
Rubens, Peter Paul, 245, 329, 333
Rudolph II, 44, 137, 265, 330, 332
Russia, 116–17

Sadeler, Giles, 44, 330
Saint Anthony and Saint Paul in the Wilderness, 72–73
Saint Eustace, 13, 22, 66, 164, 231, 245, 310, 328–31
Saint George and the Dragon, 232–34
Saint Jerome and the Lion, 15–16, 143
Saint Jerome by the Pollard Window, 28, 148
Saint Jerome in His Cell, 144
Saint Jerome in His Study, 24, 144, 175–76, 329
Saint Jerome in the Wilderness, 80, 145–48
Samson and the Lion, 66, 151, 247
Savery, 265
Savonarola, 311
Scandinavia, 116
Scanlan, James J., 6, 8
Scheurl, Christoph, 166, 168
Schongauer, Martin, 15, 60, 133, 163, 171, 185, 190, 192, 221–22, 266, 296, 302, 314, 329
Sea Monster, 137, 274, 292–93
Self-Portrait, 22, 117, 159
Seven Sorrows of the Virgin, 171–72, 198–99, 261
Sforza, Bianca Maria, 294
Sforza, Ludovico, 236, 245
Ship of Fools: 16–18, 168, 254; birds, 68, 72, 74, 79; exotic animals, 260–61; farm life, 191–93, 195, 198, 202–3, 208, 210; horses, 223, 224–25; insects, 126, 131, 133; wildlife, 97, 100
Siberia, 116
Sketches of Animals and Landscapes, 331
Sky maps. See Star charts
Small Horse, 238–40, 242, 328

Small Woodcut Passion, 52–53, 98, 103, 181
Sol Iustitiae (Sun of Righteousness), 152
Solis, Virgil, 329
Spengler, Lazarus, 148
Squirrel, 328
Stabius, Johannes, 78, 252, 253, 281, 294
Stag Beetle, 136–37, 331
Star charts: 4, 24, 251–53; birds, 73, 77, 78, 81, 90–91, 252; classical allusions, 135, 249, 252, 285, 287, 289; farm animals, 204, 211, 216; insects, fish, and reptiles, 127, 129, 133; lion, 153; wildlife, 100, 108, 112
Stimmer, Tobias, 115
Stork, 18, 88
Stoss, Veit, 321, 325
Strasbourg, 17, 121, 170
Strasbourg Bible, 311–12, 314, 315
Strauss, Walter L., 6
Strife of Love in Poliphilus's Dream, 281
Study of a Dead Duck, 63, 75
al-Sufi, 253
Susanna of Brandenberg-Ansbach, 181
Switzerland, 15, 102, 319, 325
Syphilitic Man, 251, 252, 255

Tacitus, 219
Temptation of Saint Anthony, 98–99
Temptation of the Idler, 303
Tenochtitlán, 259
Terence, 15, 109, 170, 173
Theocritus, 127
Theophrastus, 46
Theory of Proportion, 55
Thomas Aquinas, 7
Thomas of Cantimpre, 8
Titian, 100, 194, 224
Topsell, Edward, 174, 329, 333
Triumphal Arch: 24; birds, 72, 79, 81, 86; classical allusions, 284, 287, 288, 292, 293, 294; dogs, 174; exotic animals, 262, 266, 270–71; farm animals, 196, 209, 216; infernal creatures, 320; insects, 133; lions, 157; wildlife, 107, 112

Triumphal Procession, 24, 100, 248, 257, 288
Trivulzio, 236
Two Squirrels, 114

Uccello, 20, 324
Ulsenius, 252

Vartoman, 257
Vasari, Georgio, 327
Venice: copied Dürer art, 22, 327; Dürer's travels, 48, 68, 88, 93, 119, 136, 254; economic, political, and social conditions, 72, 158, 189, 226, 257–58; influence of art on Dürer, 19, 20, 63, 130, 133, 139–42, 148, 164, 189, 225–27, 243, 274, 277, 280–81, 287, 293, 333
Verrocchio, 19, 21, 139, 226, 243
Vespucci, Amerigo, 258, 312–13
Villard de Honnecourt, 119, 139
Virgil, 187–89, 268, 294
Virgin and Child with Bird on String, 86–87
Vision of the Seven Candlesticks, 153, 288
Visitation, 47, 173

Walrus, 175, 259, 275
Walther, Bernhard, 4, 251
Weyden, Roger van der, 24
Wheel of Fortune, 108, 268
Whore of Babylon, 317
Wierix, 329
Wing, 69, 331
Witches' Hammer, 305–7
Wittenberg, 261
Wolgemut, Michael, 3, 12, 15, 130, 137
Woman of the Apocalypse, 67, 314, 320
World Upside Down, 93
Wuttke, Dieter, 8

Zeuxis, 22, 60, 166, 285
Zierikzee, 29, 125
Zoppo, Marco, 20
Zwingli, Huldrych, 262